THE TUDORS

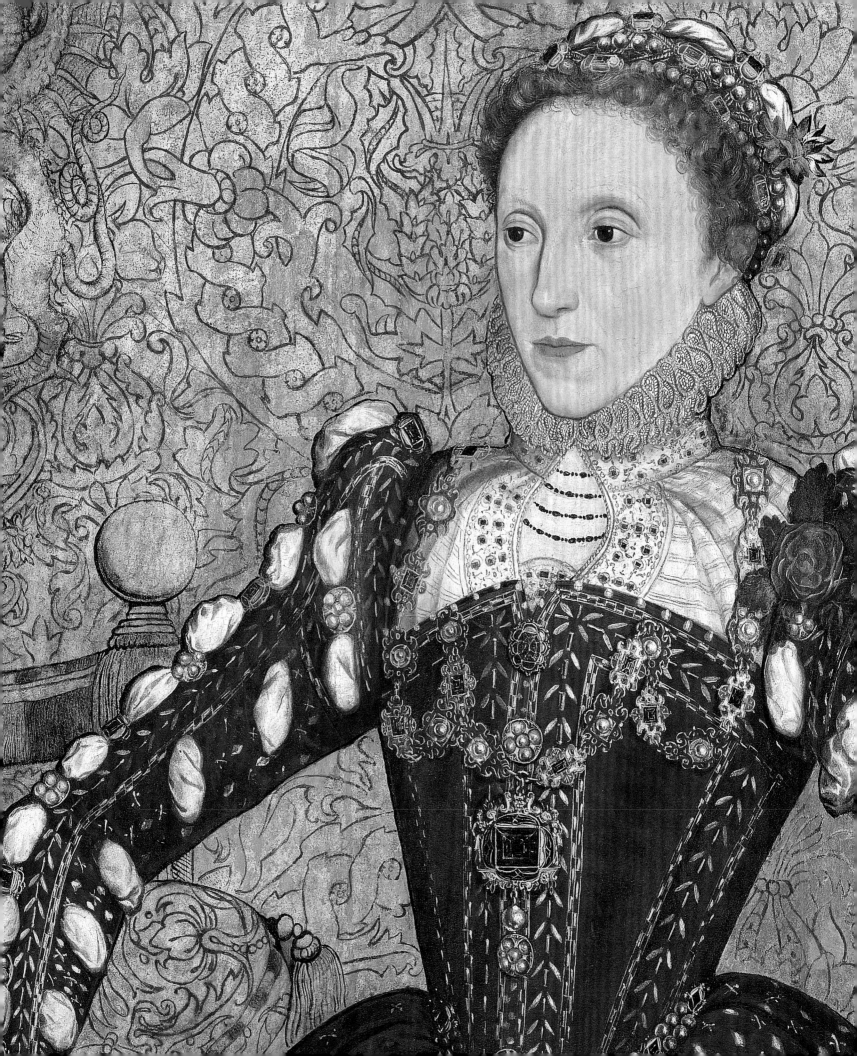

THE TUDORS

ART AND MAJESTY IN RENAISSANCE ENGLAND

Elizabeth Cleland and Adam Eaker

WITH CONTRIBUTIONS BY
Marjorie E. Wieseman and Sarah Bochicchio

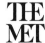

THE METROPOLITAN MUSEUM OF ART, NEW YORK
Distributed by Yale University Press, New Haven and London

This catalogue is published in conjunction with *The Tudors: Art and Majesty in Renaissance England*, on view at The Metropolitan Museum of Art, New York, from October 3, 2022, to January 8, 2023; the Cleveland Museum of Art from February 26 to May 14, 2023; and the Legion of Honor, San Francisco, from June 24 to September 24, 2023.

The exhibition is made possible by Alice Cary Brown and W.L. Lyons Brown, Frank Richardson and Kimba Wood, Barbara A. Wolfe, the Diane Carol Brandt Fund, The Coby Foundation, Ltd., The Klesch Collection, Ann M. Spruill and Daniel H. Cantwell, and Sharon Wee and Tracy Fu.

This exhibition is supported by an indemnity from the Federal Council on the Arts and the Humanities.

It is organized by The Metropolitan Museum of Art and the Cleveland Museum of Art, in collaboration with the Fine Arts Museums of San Francisco.

The catalogue is made possible by the Diane W. and James E. Burke Fund.

Additional support is provided by the Hata International Foundation and the Samuel H. Kress Foundation.

Published by The Metropolitan Museum of Art, New York
Mark Polizzotti, Publisher and Editor in Chief
Peter Antony, Associate Publisher for Production
Michael Sittenfeld, Associate Publisher for Editorial

Edited by Marcie M. Muscat
Production by Christina Grillo
Image acquisitions and permissions by Elizabeth De Mase
Designed by Christopher Kuntze, with Tina Henderson
Bibliographic editing by Livia Tenzer

Photographs of works in the collection are by the Imaging Department, The Metropolitan Museum of Art, New York. Additional photography credits appear on page 352.

Typeset in AJenson Pro, Palatino SansLTPro, Magma, and William Text
Printed on 130 gsm Arctic Volume White
Color separations by Professional Graphics, Inc., Rockford, Illinois
Printed and bound by Ofset Yapimevi, Istanbul

Jacket illustrations: (front) Unknown artist, *Queen Elizabeth I (The Darnley Portrait),* ca. 1575 (cat. 113, detail); (back) Hans Holbein the Younger (1497/98–1543), *Henry VIII of England*, ca. 1537 (cat. 9, detail). Cover illustration and pp. 302–3: *Furnishing Textile*, Florence, late 15th–mid-16th century (cat. 15, detail). Additional illustrations: p. 2: Attributed to George Gower (ca. 1540–1596), *Elizabeth I (The Hampden Portrait)*, ca. 1567 (cat. 30, detail); p. 6: Designed by Pieter Coecke van Aelst (1502–1550), *Saint Paul Directing the Burning of the Heathen Books*, before September 1539 (cat. 49, detail); p. 8: Designed by unknown artists, probably English and Netherlandish, *The Lewknor Table Carpet*, ca. 1562 (cat. 70, detail); p. 16: Marcus Gheeraerts the Younger (1561–1635/36), *Ellen Maurice*, 1597 (cat. 102, detail); pp. 18–19: *Chasuble*, probably London, ca. 1550–1600 (cat. 68, detail); pp. 100–101: *Chess and Tric-Trac Game Board*, Germany, ca. 1550 (cat. 43, detail); pp. 188–89: Nicholas Bellin da Modena (ca. 1490–1569), *Design for an Interior at Whitehall*, ca. 1545 (cat. 53, detail); pp. 284–85: *Blackwork Embroidery*, probably London, ca. 1590 (cat. 69, detail)

The Metropolitan Museum of Art
1000 Fifth Avenue
New York, New York 10028
metmuseum.org

Distributed by Yale University Press, New Haven and London
yalebooks.com/art
yalebooks.co.uk

Cataloguing-in-Publication Data is available from the Library of Congress.
ISBN 978-1-58839-692-1

CONTENTS

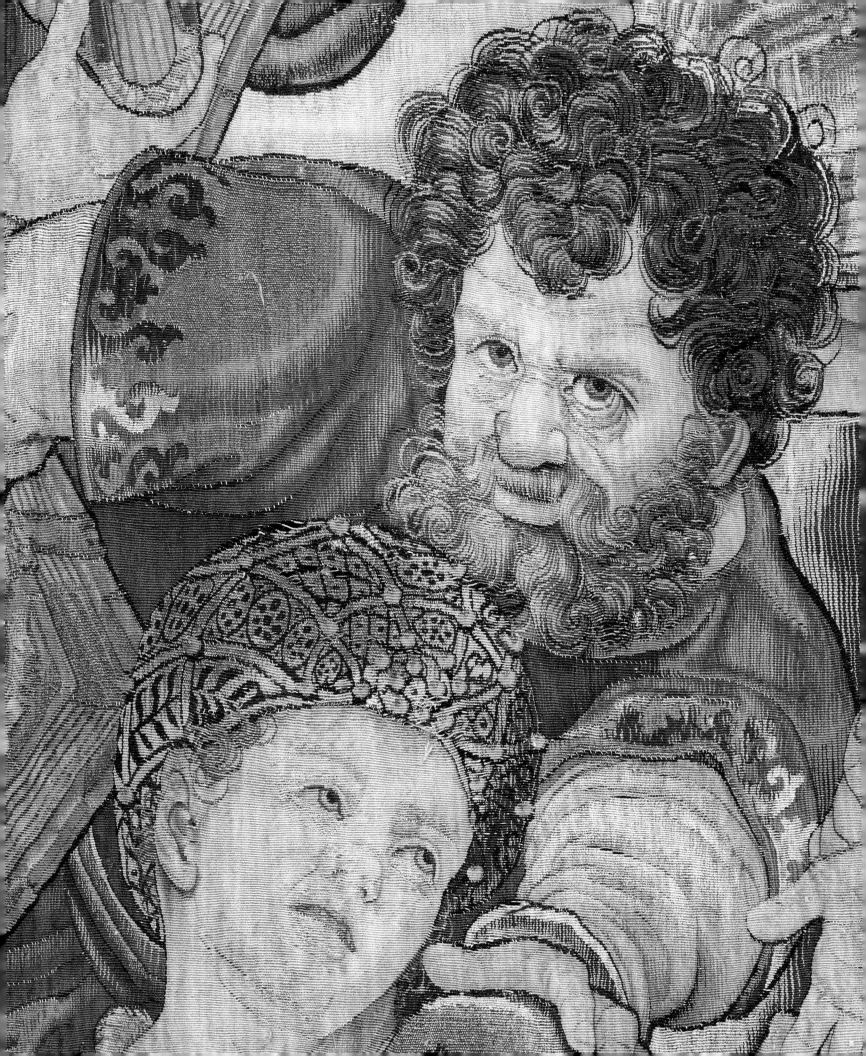

FOREWORD

The Tudor monarchs have captured the popular and historical imagination for centuries. Playing a defining role as rulers and patrons, these outsize personalities are forever connected to a transformative moment in European history and culture. Their lives and deeds are swathed in myth and misinformation, at the same time that their iconic portraits are instantly recognizable to many people around the world. The visual familiarity of the Tudor monarchs is not an accident of history—no English rulers before them invested so heavily in the artistic trappings of majesty.

The Tudors: Art and Majesty in Renaissance England traces the development of art at the English courts, from Henry VII's seizure of the throne in 1485 to the death of his granddaughter Elizabeth I in 1603. These dates overlap with the Italian High Renaissance and the Protestant Reformation, both of which profoundly shaped English culture in this period, as this volume and the exhibition it accompanies demonstrate. In this tumultuous era, the Tudor monarchs called upon the finest European and English sculptors, painters, goldsmiths, weavers, printers, and armorers to stabilize, legitimize, and advertise their reigns. These collaborative efforts eventually generated a distinctly English style—immediately recognizable, esoteric, evocative, and magnificent.

The Tudors is, remarkably, the first American exhibition to survey Tudor artistic patronage. This milestone was conceived and organized at The Metropolitan Museum of Art by Elizabeth Cleland, Curator in the Department of European Sculpture and Decorative Arts, and Adam Eaker, Associate Curator in the Department of European Paintings, who have worked tirelessly to do justice to this fascinating period. They were supported in this effort by Marjorie E. Wieseman, Curator and Head of Northern European Paintings at the National Gallery of Art, Washington, D.C., and formerly Curator of European Paintings and Sculpture, 1500–1800, at the Cleveland Museum of Art. The Met and the Cleveland Museum are joined in co-organization of this ambitious exhibition by the Fine Arts Museums of San Francisco, once again demonstrating all that can be achieved from the strong and long-standing spirit of collaboration shared by our three institutions.

The staffs of our museums demonstrated their exceptional talents in bringing *The Tudors* to fruition. We extend our thanks

and admiration to them, as well as to the institutions and collectors throughout Europe, the United States, and Canada who have shown tremendous generosity in lending us so many of their national and personal treasures. Their names are listed in full on page 12. We are especially grateful to Her Majesty Queen Elizabeth II and the Royal Collection Trust, and to the many institutions in the United Kingdom whose willingness to lend significant groups of objects has been pivotal to this project's success: the British Library, the British Museum, the National Portrait Gallery, the National Trust, and the Victoria and Albert Museum. Many lenders entrusted us with spectacular objects that have rarely, if ever, been seen beyond their homes, and we are forever in their debt.

A project of this scope and complexity could never have been realized without the generosity of our donors. We extend our gratitude to Alice Cary Brown and W.L. Lyons Brown, Frank Richardson and Kimba Wood, Barbara A. Wolfe, the Diane Carol Brandt Fund, The Coby Foundation, Ltd., The Klesch Collection, Ann M. Spruill and Daniel H. Cantwell, and Sharon Wee and Tracy Fu. Additional thanks are owed to the William W. Donnell Fund at Community Funds, Inc., Beth Swofford, the Malcolm Hewitt Wiener Foundation, and Elizabeth A.R. and Ralph S. Brown, Jr. For making this splendid publication possible, we thank the Diane W. and James E. Burke Fund, as well as the Hata International Foundation and the Samuel H. Kress Foundation for their additional support. This exhibition is supported by an indemnity from the Federal Council on the Arts and the Humanities. We are grateful for their help in bringing the visual splendor of this storied English dynasty to life.

Max Hollein
Marina Kellen French Director,
The Metropolitan Museum of Art, New York

William M. Griswold
Director and President, Cleveland Museum of Art

Thomas P. Campbell
Director and CEO, Fine Arts Museums of San Francisco

ACKNOWLEDGMENTS

In the course of planning this exhibition over many years and on two continents, we have incurred debts on a scale to make even the prodigal Tudors blanch. Above all, we extend our warmest gratitude to President and CEO Daniel H. Weiss and Marina Kellen French Director Max Hollein at The Metropolitan Museum of Art, as well as to William M. Griswold, Director and President of the Cleveland Museum of Art, and Thomas P. Campbell, Director and CEO of the Fine Arts Museums of San Francisco, for the institutional leadership that let this ambitious project become a reality.

Next, we thank the many lenders, museum directors, and curators for their trust and generosity: Her Majesty Queen Elizabeth II; the Marquess of Anglesey; the Marquess of Salisbury; Alexander Sturgis and An Van Camp at the Ashmolean Museum, Oxford; Hannah Bennet and Teresa Harris at the Avery Architectural and Fine Arts Library, Columbia University; Gilles Eboli, Nicolas Galaud, and Jérôme Sirdey at the Bibliothèque Municipale, Lyon, and the City of Lyon; Laurence Engel and Pauline Chougnet at the Bibliothèque Nationale de France, Paris; Anne Collins Goodyear and Frank H. Goodyear at the Bowdoin College Museum of Art; Roly Keating, Scot McKendrick, Claire Breay, and Karen Limper-Hertz at the British Library, London; Hartwig Fischer, Hugo Chapman, Philip Attwood, Jane Portal, and Thomas Hockenhull at the British Museum, London; Duncan Dornan and Rebecca Quinton at the Burrell Collection, Glasgow; Jean-Luc Martinez, Laurence des Cars, Xavier Salmon, and Dominique Cordellier at the Musée du Louvre, Paris; Michel Roussel, Hélène Palouzié, Laurent Barrenchea, Didier Mouly, and Flore Collette at the Cathédrale Saint-Just-et-Saint-Pasteur, Narbonne, and the City of Narbonne; Julie Finch and Annelise Hone at Compton Verney Art Gallery and Park; Luke Syson, Henrietta Ward, Adi Popescu, Martin Allen, and Richard Kelleher at the Fitzwilliam Museum, Cambridge; Jan Werquet, Anna Greve, Uta Bernsmeier, and Silke Nienstedt at the Focke Museum, Bremen; Michael Whitmore, Greg Prickman, Renate Mesmer, Emily Snedden Yates, Heather Wolfe, and Caroline Duroselle-Melish at the Folger Shakespeare Library, Washington, D.C.; Ian Wardropper and Xavier Salomon at the Frick Collection, New York; Sabine Haag, Peter Kerber, Guido Messling, and Sabine Pénot at the Gemäldegalerie, Kunsthistorisches Museum, Vienna; Jan Gerchow and Frank Berger at the Historisches Museum Frankfurt; Stephen Power SJ and Keith McMillan SJ at the Jesuits in Britain; Martine Gosselink, Emilie Gordenker, Edwin Buijsen, and Quentin Buvelot at the Mauritshuis, The Hague; Suzanne Sauvage, Christian Vachon, and Sylvie Dauphin at the McCord Museum, Montreal; Thierry Crépin-Leblond and Matteo Gianeselli at the Musée National de la Renaissance, Château d'Ecouen; Paola D'Agostino of the Musei del Bargello, Florence; Don Marco Viola, Prior of the Basilica of San Lorenzo, and Francesca de Luca at the Museo delle Cappelle Medicee and Tesoro della Basilica di San Lorenzo, Florence; Guillermo Solana, María del Mar Borobia, and Dolores Delgado at the Museo Nacional Thyssen-Bornemisza, Madrid; Matthew Teitelbaum and Thomas Michie at the Museum of Fine Arts, Boston; Kaywin Feldman, John Hand, and Alexandra Libby at the National Gallery of Art, Washington, D.C.; Sasha Suda and Christopher Etheridge at the National Gallery of Canada, Ottawa; Paddy Rodgers, Sue Pritchard, Allison Goudie, Imogen Tedbury, and Megan Barford at the National Maritime Museum, Royal Museums Greenwich, London; Nicholas Cullinan, Charlotte Bolland, and Catharine MacLeod at the National Portrait Gallery, London; Tarnya Cooper, David Taylor, and Christopher Rowell at the National Trust; Stefano Casciu, Axel Hemery, and Maria Mangiavacchi at the Pinacoteca Nazionale, Siena/Polo Museale della Toscana; Clare Mullet, Genevieve Adkins, and Jenny Lance at the Research and Cultural Collections, University of Birmingham; Taco Dibbits and Ilona van Tuinen at the Rijksmuseum, Amsterdam; Tim Knox, Martin Clayton, and Kate Heard at the Royal Collection Trust; Sir John Leighton, Michael Clarke, and Tico Seifert at the Scottish National Gallery, National Galleries of Scotland, Edinburgh; Canon Ludo Collin and the Trustees of the Sint-Baafskathedraal, Ghent; Tom Hage, Jaap van Rijn, Ad van der Schoot, Winnie Verbeek, and the church commissioners of the Sint-Janskerk, Gouda; John Lewis and Kate Bagnall at the Society of Antiquaries of London; Mikkel Bogh and Eva de la Fuente Pedersen at the

Statens Museum for Kunst, Copenhagen; Tristram Hunt, Antonia Boström, Peta Motture, Richard Edgcumbe, Kirstin Kennedy, Lesley Miller, Silvija Banić, Mark Evans, and Ruth Hibbard at the Victoria and Albert Museum, London; Laura Pye, Sandra Penketh, Xanthe Brooke, and Kate O'Donoghue at the Walker Art Gallery, National Museums Liverpool; and those generous lenders who wish to remain anonymous. As intramural lenders at The Met, Pierre Terjanian, Arthur Ochs Sulzberger Curator in Charge, Department of Arms and Armor; Nadine Orenstein, Drue Heinz Curator in Charge, Department of Drawings and Prints; and C. Griffith Mann, Michel David-Weill Curator in Charge, Department of Medieval Art and The Cloisters, have been unstintingly generous. We thank all our curatorial colleagues who so readily shared access and expertise to works under their purviews: Maryan Ainsworth (Curator Emerita), Denise Allen, Wolf Burchard, John Byck, Donald LaRocca (Curator Emeritus), Stuart Pyrrh (Curator Emeritus), Melanie Holcomb, Wolfram Koeppe (Marina Kellen French Senior Curator, Department of European Sculpture and Decorative Arts), and Iris Moon.

In New York, we acknowledge the leadership of Quincy Houghton, Deputy Director for Exhibitions; Sarah E. Lawrence, Iris and B. Gerald Cantor Curator in Charge, Department of European Sculpture and Decorative Arts; and Stephan Wolohojian, John Pope-Hennessy Curator in Charge, Department of European Paintings. In the project's early years, Luke Syson, former Iris and B. Gerald Cantor Chairman of European Sculpture and Decorative Arts, now Director and Marlay Curator of the Fitzwilliam Museum, Cambridge; and Keith Christiansen, former John Pope-Hennessy Chairman of European Paintings, now Curator Emeritus, were both tireless advocates. We likewise extend our thanks to Andrea Bayer, Deputy Director for Collections and Administration, and Inka Drögemüller, Deputy Director for Digital, Education, Publications, Imaging, Libraries, and Live Arts.

Our partners in Cleveland include Heather Lemonedes Brown, Virginia N. and Randall J. Barbato Deputy Director and Chief Curator; Heidi Strean, Chief Exhibition, Design, and Publications Officer; and Cory Korkow, Curator of European Paintings and Sculpture, 1500–1800, and the organizing curator of The Tudors at the Cleveland Museum. Marjorie would also like to thank Louis Adrean, Beth Edelstein, Andrew Gutierrez, Robin Hanson, Lauren Lovings-Gomez, Emily Mears, Meghan Olis, Sarah Scaturro, Lauryn Smith, Colleen Snyder, Moyna Stanton, Marcia Steel, Jeffrey Strean, Mary Suzor, Dean Yoder, and Laura Ziewitz. In San Francisco, the project is indebted to Krista Brugnara, Chief Exhibitions and Collections Officer, and

Martin Chapman, Curator in Charge of European Decorative Arts and Sculpture and the organizing curator of The Tudors at the Legion of Honor. We also acknowledge Monique Abadilla, Amy Andersson, Emily Beeny, Victoria Binder, Ryan Butterfield, Elise Effmann, Sarah Gates, Isabella Holland, Hilary Magowan, Kimberley Montgomery, Tristan Telander, Jane Williams, and Thomas Wu.

Creation of this book reflects the effort and care of the Publishing and Editorial Department at The Met, led by Publisher and Editor in Chief, Mark Polizzotti, with Peter Antony, Michael Sittenfeld, and the now retired Gwen Roginsky. We particularly thank our editor, Marcie Muscat, who has been a paragon of organization and attention to detail throughout. We also extend our deep gratitude to Elizabeth De Mase for sourcing and licensing the images in the book and to Christina Grillo for managing its production, as well as to bibliographic editor Livia Tenzer, designers Christopher Kuntze and Tina Henderson, and our co-authors Sarah Bochicchio and Giulia Chiostrini. Much of the new photography was provided by The Met's Imaging Department, formerly under the direction of Barbara J. Bridgers, and now led by Scott Geffert.

At The Met, the beautiful accompanying exhibition was designed by Fabiana Weinberg, with graphics by Alexandre Viault and didactics edited by Briana Parker. Planning and preparation of the exhibition were kept on an even keel by exhibition manager Gillian Fruh and registrar Mary Frances Allen, who navigated our vessel through the most complex of logistical waters. The exhibition depended on the skills and expertise of many colleagues in the conservation departments: for paintings, Michael Gallagher, Sherman Fairchild Chair of Paintings Conservation, with Michael Alan Miller; for textiles, Janina Poskrobko, Conservator in Charge of Textile Conservation, with Cristina Balloffet Carr, Giulia Chiostrini, and Olha Yarema-Wynar; for works on paper, Marjorie Shelley, Sherman Fairchild Conservator in Charge of Paper Conservation, with Yana van Dyke; for objects and sculpture, Lisa Pilosi, Sherman Fairchild Conservator in Charge of Objects Conservation, with Mecka Baumeister, Linda Borsch, Jack Soultanian, Jennifer Schnitker, Karen Stamm, and Wendy Walker; and for arms and armor, Edward Hunter and Sean Belair. We are indebted to Rebecca Ben-Atar, Stephen Bluto, Lisa Cain, Laura Corey, Michael Doscher and the handlers' team, David Del Gaizo, Kristen Hudson, Eva Labson and the staff at the Antonio Ratti Textile Center, Ricky Luna, John McKanna, Jennifer Meagher, Taylor Miller, Rachel Robinson, Juan Stacey, Denny Stone, Jill Wickenheisser, Sam Winks, and Elizabeth Zanis for art handling, collections management, administration, and other

logistical matters. The project was enthusiastically promoted by publicist Jennifer Isakowitz, and its realization depended on the essential fundraising undertaken by Senior Vice President for Institutional Advancement Clyde B. Jones III and his team, including Jennifer Brown, Evie Chabot, Jason Herrick, Kimberly McCarthy, Caterina Toscano, and John L. Wielk. For the lively program of events marking the exhibition, thanks are due to Limor Tomer, Lulu C. and Antony W. Wang General Manager of Live Arts, with Erin Flannery; Heidi Holder, Frederick P. and Sandra P. Rose Chair of Education, with Marianna Siciliano; and, for the accompanying digital content, Douglas Hegley, Chief Digital Officer, with Nina Diamond.

For his key collaboration in the early stages of this project, special thanks go to Alan P. Darr, Head of European Paintings, Sculpture and Decorative Arts and Walter B. Ford II Family Curator of European Sculpture and Decorative Arts at the Detroit Institute of Arts. For their intellectual insights, support, and general contributions to the field, we gladly acknowledge Andrea Achi, Maryan Ainsworth and all members of her Early Netherlandish Painting discussion group, Andy Augenblick, Vicky Avery, Colin Bailey, Muriel Barbier, Gareth Bellis, Monica Bietti, Rufus Bird, Daphne Butler Birdsey, Koen Brosens, Caroline Campbell, Federico Carò, Tara Cederholm, Kathrin Colburn, Jorge Coll, Jessica David, Guy Delmarcel, Eugenio Donadori, Susan Foister, Margaret Lane Ford, Simon Franses, Lori Gast, Charles Gillow, Anne Goldgar, Elizabeth Goldring, John Goodall, Titi Halle, Karen Hearn, Paula Henderson, Lawrence Hendra, Sabine Heym, Joachim Homann, Elizabeth Honig, Maurice Howard, Dan Jackson, Catherine Jenkins, Brooks Jones III, Kristine Kamiya, Lorraine Karafel, Denise, Baroness Kingsmill, Daniëlle Kisluk-Grosheide (Henry R. Kravis Curator, Department of European Sculpture and Decorative Arts), Janis Mandrus, John McQuillen, Ariane Mensger, Tessa Murdoch, Denise Murrell, Elyse Nelson, Marietta Poerio, David Pollack, David Pullins, Chris Riopelle, Anne Robbins, Michael Roth, Cécile Scailliérez, Timothy Schroder, Margi Schwartz, Desmond Shawe-Taylor, Nobuko Shibayama, Mimi Smith and Leo Pardon, Freyda Spira, Eleanor Standley, Kisook Suh, Dora Thornton, Jennifer Tonkovich, Edward Town, Elizabeth Weinfeld, Joelle Wickens, David Williams, Barry Windeatt, Lucy Worsley, and Anne Woollett.

For their financial support of this exhibition in New York, thanks are due to Alice Cary Brown and W.L. Lyons Brown, Frank Richardson and Kimba Wood, Barbara A. Wolfe, the Diane Carol Brandt Fund, The Coby Foundation, Ltd., The Klesch Collection, Ann M. Spruill and Daniel H. Cantwell, and Sharon Wee and Tracy Fu, as well as to the William W. Donnell Fund at Community Funds, Inc., Beth Swofford, the Malcolm Hewitt Wiener Foundation, and Elizabeth A.R. and Ralph S. Brown, Jr. This exhibition is supported by an indemnity from the Federal Council on the Arts and the Humanities. This beautiful catalogue would not be possible without the Diane W. and James E. Burke Fund, and the additional generosity of the Hata International Foundation and the Samuel H. Kress Foundation.

All exhibitions at the Cleveland Museum of Art are underwritten by the CMA Fund for Exhibitions. Major annual support is provided by the Womens Council of the Cleveland Museum of Art. Generous annual support is provided by Mr. and Mrs. Walter R. Chapman Jr., Janice Hammond and Edward Hemmelgarn, Bill and Joyce Litzler, Henry Ott-Hansen, Mr. and Mrs. Michael F. Resch, and Claudia C. Woods and David A. Osage.

The Fine Arts Museums of San Francisco gratefully acknowledge those who made generous gifts in support of their own presentation of The Tudors.

The curators particularly applaud Sarah Bochicchio, who provided essential research assistance and project support. The entire Tudors team benefited immensely from her conscientiousness and intellectual stimulation. Finally, Elizabeth acknowledges the unfailing support and enthusiasm of her gloriously un-Tudor-like family, James, Karina, and Andrew; her husband, Wiley; and her dear daughter, Adriana. Adam thanks Brandon Patrick George for his love and background music. Marjorie gives special thanks, always, to Allen Wright for his wide and eclectic enthusiasms, and for his willingness to journey beside her with humor and abiding love.

Elizabeth Cleland
Curator, European Sculpture and Decorative Arts,
The Metropolitan Museum of Art, New York

Adam Eaker
Associate Curator, European Paintings,
The Metropolitan Museum of Art, New York

Marjorie E. Wieseman
Curator and Head of Northern European Paintings,
National Gallery of Art, Washington, D.C.

LENDERS TO THE EXHIBITION

Her Majesty Queen Elizabeth II

The Ashmolean Museum, University of Oxford

Avery Architectural and Fine Arts Library, Columbia University, New York

Bibliothèque Municipale (Part-Dieu), Lyon, and the City of Lyon

Bibliothèque Nationale de France, Paris

Bowdoin College Museum of Art, Brunswick, Maine

The British Library, London

The British Museum, London

The Burrell Collection, Glasgow, and the City of Glasgow

Cathédrale Saint-Just-et-Saint-Pasteur, Narbonne, and the City of Narbonne

Compton Verney Art Gallery and Park, Warwickshire

The Syndics of the Fitzwilliam Museum, University of Cambridge

Focke Museum–Bremer Landesmuseum für Kunst und Kulturgeschichte, Bremen

Folger Shakespeare Library, Washington, D.C.

The Frick Collection, New York

Gemäldegalerie, Kunsthistorisches Museum, Vienna

Historisches Museum Frankfurt

Trustees of the British Jesuit Province–Jesuits in Britain

Marquess of Anglesey, Plas Newydd, Anglesey

Marquess of Salisbury, Hatfield House, Hertfordshire

Mauritshuis, The Hague

McCord Museum, Montreal

Musée du Louvre, Paris

Musée National de la Renaissance, Château d'Ecouen

Museo delle Cappelle Medicee and Tesoro della Basilica di San Lorenzo, Florence

Museo Nacional Thyssen-Bornemisza, Madrid

Museum of Fine Arts, Boston

National Gallery of Art, Washington, D.C.

National Gallery of Canada, Ottawa

National Maritime Museum, Royal Museums Greenwich, London

National Portrait Gallery, London

National Trust, Hardwick Hall (The Devonshire Collection)

Pinacoteca Nazionale, Siena

The Church Commissioners of the Protestant Congregation of Gouda, Sint-Janskerk, Gouda

Research and Cultural Collections, University of Birmingham

Rijksmuseum, Amsterdam

Scottish National Gallery, National Galleries of Scotland, Edinburgh

The Church Wardens of Sint-Baafskathedraal, Ghent

Society of Antiquaries of London

Statens Museum for Kunst, Copenhagen

Victoria and Albert Museum, London

Walker Art Gallery, National Museums Liverpool

and those who wish to remain anonymous

CONTRIBUTORS

SB **Sarah Bochicchio**, PhD candidate in art history at Yale University, and former Research Assistant for European Sculpture and Decorative Arts and European Paintings, The Metropolitan Museum of Art, New York

GC **Giulia Chiostrini**, Conservator, Textile Conservation, The Metropolitan Museum of Art, New York

EC **Elizabeth Cleland**, Curator, European Sculpture and Decorative Arts, The Metropolitan Museum of Art, New York

AE **Adam Eaker**, Associate Curator, European Paintings, The Metropolitan Museum of Art, New York

MEW **Marjorie E. Wieseman**, Curator and Head of Northern European Paintings, National Gallery of Art, Washington, D.C.

NOTE TO THE READER

This catalogue reflects the exhibition as it was conceived to open in the fall of 2020. The subsequent postponement of the show due to the COVID-19 pandemic resulted in several loans being cut from the exhibition when it opened in October 2022. These loans have been retained in the catalogue in order to tell as broad a narrative of Tudor art as possible.

In the notes that accompany entries and essays, abbreviations are used for frequently cited archival sources, the full titles of which are provided in the Bibliography. In general, historical spelling has been retained in quotations, except for citations from published editions with modernized spelling.

Dimensions are given in the following sequence: height precedes width precedes depth. When necessary, the abbreviations H. (height), L. (length), W. (width), and Diam. (diameter) are given for clarity. Unless otherwise specified, given diameters are the maximum, and dimensions for manuscripts are for a single folio.

GENEALOGY OF THE TUDOR DYNASTY

Edward III (1312–1377), King of England (r. 1327–77)

HOUSE OF LANCASTER

John of Gaunt (1340–1399), Duke of Lancaster

m1. Blanche of Lancaster (1346?–1368)
m2. Constanza of Castile (1354–1394)
m3. Katherine Swynford (ca. 1350–1403)

Henry IV (1367–1413), King of England (r. 1399–1413)

Henry V (1386–1422), King of England (r. 1413–22) m. Catherine of Valois (1401–1437) m2. Owen Tudor (ca. 1400–1461)

Henry VI (1421–1471), King of England
(r. 1422–61, 1470–71)

Edmund Tudor (1430–1456), Earl of Richmond

Margaret Tudor m. James IV (1473–1513), Arthur (1486–1502), m. Katherine of Aragon m2.
(1489–1541) King of Scotland Prince of Wales (1485–1536)

James V (1512–1542), m. Mary of Guise (1515–1560)
King of Scotland

Mary I (1516–1558), m. Philip II (1527–1598),
Queen of England King of Spain
(r. 1553–58)

Mary Stuart (1542–1587), m1. François II (1544–1560), King of France
Queen of Scots m2. Henry Stuart (1545/46–1567), Lord Darnley
 m3. James Hepburn (1534/35–1578),
 Earl of Bothwell

James VI and I (1566–1625),
King of Scotland (r. 1567–1625) and
King of England (r. 1603–25)

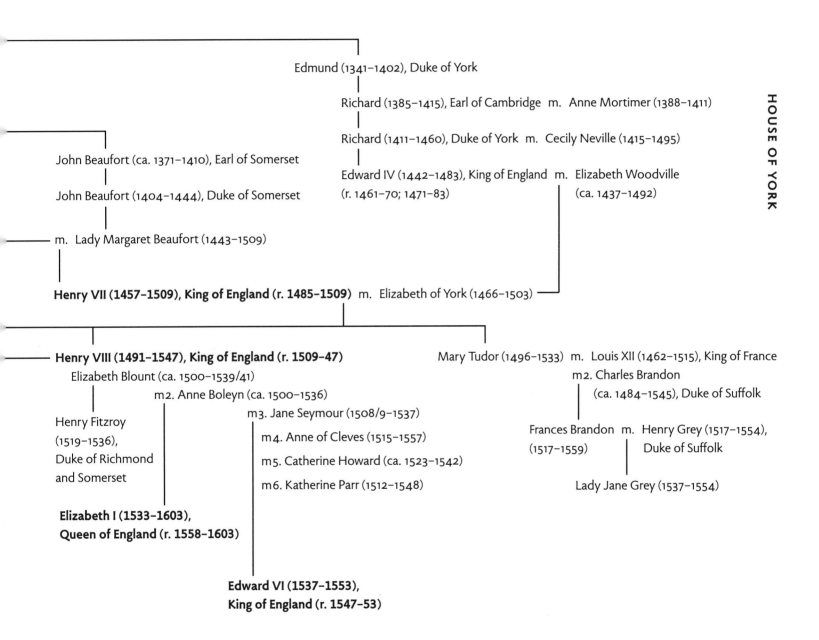

Edmund (1341–1402), Duke of York

Richard (1385–1415), Earl of Cambridge m. Anne Mortimer (1388–1411)

John Beaufort (ca. 1371–1410), Earl of Somerset

Richard (1411–1460), Duke of York m. Cecily Neville (1415–1495)

John Beaufort (1404–1444), Duke of Somerset

Edward IV (1442–1483), King of England m. Elizabeth Woodville
(r. 1461–70; 1471–83) (ca. 1437–1492)

m. Lady Margaret Beaufort (1443–1509)

Henry VII (1457–1509), King of England (r. 1485–1509) m. Elizabeth of York (1466–1503)

Henry VIII (1491–1547), King of England (r. 1509–47)

Elizabeth Blount (ca. 1500–1539/41)

m2. Anne Boleyn (ca. 1500–1536)

m3. Jane Seymour (1508/9–1537)

m4. Anne of Cleves (1515–1557)

m5. Catherine Howard (ca. 1523–1542)

m6. Katherine Parr (1512–1548)

Henry Fitzroy
(1519–1536),
Duke of Richmond
and Somerset

Mary Tudor (1496–1533) m. Louis XII (1462–1515), King of France
m2. Charles Brandon
(ca. 1484–1545), Duke of Suffolk

Frances Brandon m. Henry Grey (1517–1554),
(1517–1559) Duke of Suffolk

Lady Jane Grey (1537–1554)

**Elizabeth I (1533–1603),
Queen of England (r. 1558–1603)**

**Edward VI (1537–1553),
King of England (r. 1547–53)**

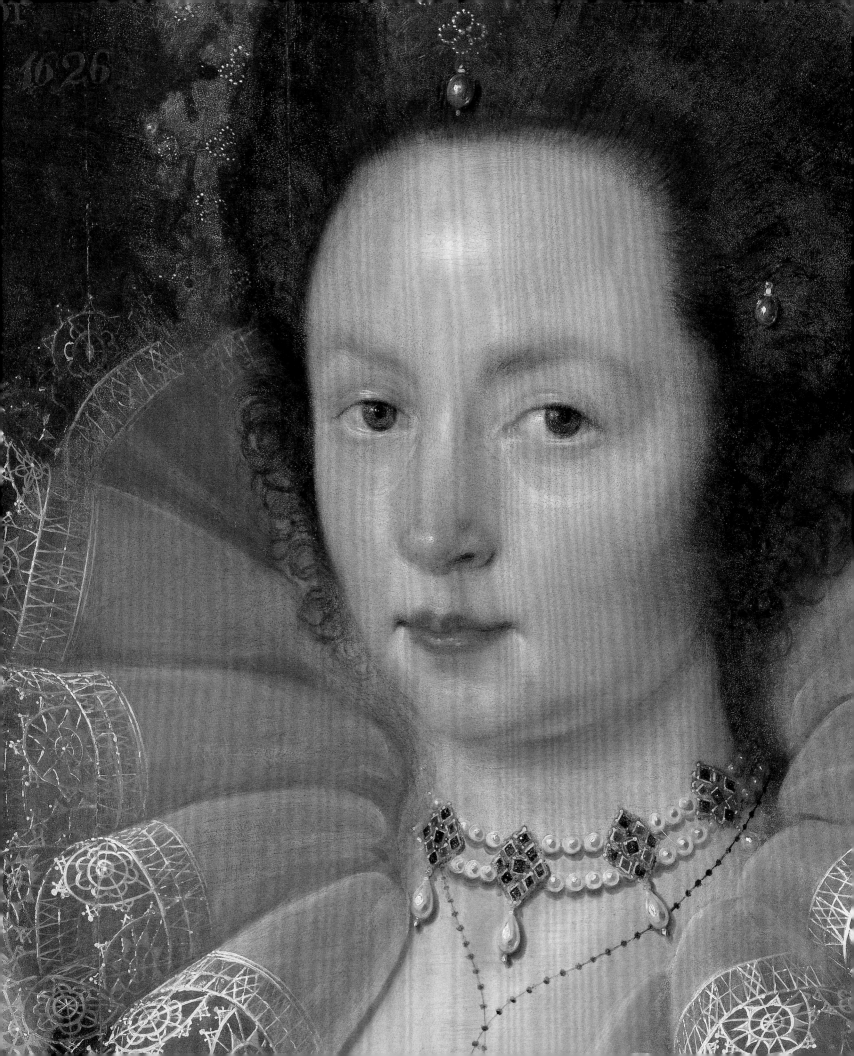

PREFACE: AN INSULAR ART?

Elizabeth Cleland and Adam Eaker

When it comes to the visual arts, the English have a long-standing tradition of national self-deprecation. Writing at the end of the Elizabethan era, Richard Haydock lamented that the art of painting "never attained to any great perfection amongst us."[1] Almost two centuries later, Horace Walpole apologetically prefaced his *Anecdotes of Painting in England* by acknowledging that its "chief business . . . must be to celebrate the arts of a country which has produced so few good artists."[2] Both Haydock and Walpole measured the history of English art against an Italian standard, centered on painting and the achievements of individual geniuses. By contrast, this book surveys and, indeed, celebrates the art of the English Renaissance in very different terms.

The Tudors: Art and Majesty in Renaissance England is not an illustrated history of the Tudor monarchy (1485–1603) but, instead, a fresh look at the figurative and decorative arts made or acquired for the Tudor courts. As a dynasty with tenuous claims to legitimacy, tasked with rebuilding a nation devastated by civil war, the Tudors skillfully recruited the visual arts as tools of diplomacy and the backdrop to royal ritual. Tudor works of art circulated as gifts among princes and courtiers, as tools in marriage negotiations, and, sometimes controversially, as objects of religious veneration. In Tudor palaces, tapestries, panel paintings, metalwork, and jewels created an environment of brilliant overlapping surfaces only fragmentarily preserved in the material record today.

As this book reveals, Tudor art was cosmopolitan, fully implicated in the exchanges of objects and ideas that defined the European Renaissance. To furnish their palaces, the Tudor monarchs relied on the commercial acumen and technical skill of itinerant artists and craftspeople, many of them refugees from war and religious persecution; they enjoyed extraordinary access via dealers and agents to the best of European luxury production, whether Italian velvets or Flemish tapestries; and they practiced competitive consumption as a means to assert themselves in the company of fellow monarchs. At the same time, by the death of Elizabeth I in 1603, a distinctly English—even insular—style had emerged at court, defined by esoteric symbolism, decorative surfaces, and a close interplay between the visual arts and literature. This story of exchange and conflict, innovation and retrenchment, merits being told anew.

Notes to this preface appear on p. 304.

INVENTING A DYNASTY

England, Europe, and the World: Art as Policy

Elizabeth Cleland

"An unknown Welshman whose father I never knew," declared Richard III, the last Yorkist king of England, of his challenger, Henry Tudor (fig. 1), "captain [of] rebels and traitors . . . descended of bastard blood, both of father's side and of mother's side."[1]

The Tudor claim to the English throne was indeed tenuous, resting primarily on the fact that Henry Tudor's maternal great-grandfather was the child of John of Gaunt (son of Edward III) and his mistress (later wife) Katherine Swynford. Though John of Gaunt's son Henry IV officially recognized his illegitimate half-siblings, he barred their offspring from ever becoming heirs to the English throne.[2] Henry Tudor was considerably closer to royal blood on his father's side, his grandfather Owen Tudor—a Welshman of the minor nobility who arrived at the Lancastrian court as a page—having scandalously become lover, and eventually secret husband, of Henry V's young French widow, the queen Catherine of Valois. Henry Tudor's father, therefore, was a younger half brother of Henry VI, Catherine's royal offspring from her first marriage.

Contrary to Richard III's expectations, Henry Tudor did defeat him, taking the English Crown at the Battle of Bosworth Field in August 1485 and reigning as Henry VII for the next twenty-four years. That a grandson of Owen Tudor could claim, win, and retain the English throne was unexpected; that his offspring would hold the Crown for the next 118 years and three

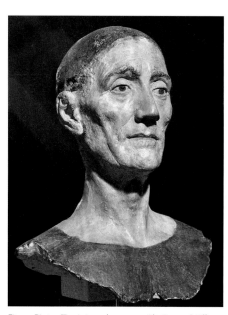

Fig. 1. Pietro Torrigiano (1472–1528), *Funeral Effigy of Henry VII*, 1509. Painted plasterwork on wood, H. 13 in. (33 cm). Westminster Abbey, London

generations, becoming feared and even respected by far older European dynasties, in turns marrying and warring with them, was astonishing (fig. 2). Each of the Tudor monarchs—Henry VII, his son Henry VIII, and the latter's successively reigning children, Edward VI, Mary I, and Elizabeth I—grappled with perpetual questions of legitimacy, whether of their recent ancestors or, indeed, their own, crafting policy to convey the confidence and authority they needed to survive. They used artistic commissions and court spectacle to create and maintain what many of their contemporaries must have perceived to be an elaborate fiction with such style and tenacity that, by the time of Elizabeth's death in 1603, Tudor supremacy went largely unquestioned. Though they shied away from overuse of the family surname—associated as it was with that amorous Welsh page, Owen—subsequent generations latched onto the name, and the adjective, "Tudor" as the embodiment of an English golden age.[3] The Tudor dynasty's extraordinary achievement, creating national and international kudos from such unpromising beginnings, and in turn becoming posterity's most recognizable British royal house, comes down to wily statecraft, audacious and often unprecedented conduct, and the wise use of art.

Only twenty-three years after Richard III's insulting dismissal of Henry Tudor as "the Welsh milksop," Henry VII could in all seriousness plan a life-size statue with his own facial features,

dressed in armor and bearing on its head the very circlet that he had seized from Richard III at Bosworth Field.[4] This extraordinarily theatrical sculpture (unfortunately never made, but planned in detail in Henry's will) was to be placed kneeling, as if in perpetual prayer, at the foot of the shrine of Edward the Confessor, immediately behind the high altar of Westminster Abbey. The message would be clear: this warrior king, no less pious and humble for it, was the true successor of the royal forebears buried nearby. The statue would present Henry VII as the vanquishing hero of the cruel and murderous Richard; the long-prophesied successor of the legendary—and Welsh—King Arthur; the descendant of a line of ancient kings, including the twelfth-century Cadwallader the Great, through Arthur himself, and even farther back to Brutus, fabled Trojan exile and subsequent "King of Britons." Henry VII claimed this lineage, celebrated in Geoffrey of Monmouth's *Historia regum Britanniae* (*History of the Kings of Britain*, ca. 1136), and even had the documents to prove it, having commissioned an ersatz pedigree for his father leading back to the Trojans.[5] It was probably no coincidence that one of Henry VII's earliest extravagant tapestry purchases, less than three years after the events at Bosworth Field, was a complete set of the *Story of Troy*, customized with red and white rose detailing (fig. 3).[6] Speaking to this romanticized history, the appropriation of early medieval decorative motifs became recurrent in Tudor art (see "Honing the Tudor Aesthetic" in this volume). No matter if the reality was more prosaic than the armor-clad statue's resonance suggested: rather than Henry's military prowess (in fact, severely limited), it was his strength as a negotiator and administrator that raised royal revenue, held in check quarrelsome nobles, and eventually brought some modicum of peace to England after more than thirty years of fighting during the Wars of the Roses. As champion of the Lancastrians, whose symbol was the red rose, Henry VII cannily took as his wife Elizabeth of York, niece of the deposed Richard III and daughter of his more popular predecessor, Edward IV, whose symbol was the white rose. Showing a characteristically shrewd sensitivity to the power of imagery, Henry had the Lancastrian red rose and the Yorkist white rose—for so long, signs of bitter antagonism—superimposed to create the red-and-white Tudor rose, symbolic of his role bringing peace and harmony to the land (see cat. 1). Indeed, it is tempting to hypothesize that Henry VII struck upon this distinctive badge by appropriating a stock motif used in the pricey Florentine velvets with which he liberally surrounded himself (such as cat. 15). In much the same way, his contemporaries Their Most Catholic Majesties, Isabella of Castile and Ferdinand of Aragon, adopted these velvets' ubiquitous pomegranate as their

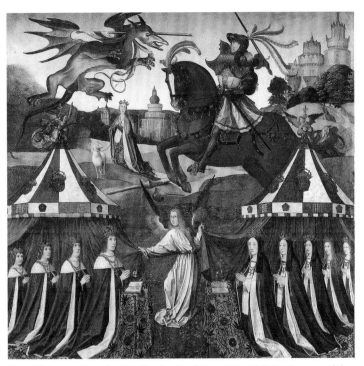

Fig. 2. Unknown Flemish artist, *The Family of Henry VII with Saint George and the Dragon*, ca. 1503–9. Oil on panel, 57⅜ × 56⅛ in. (145.6 × 142.6 cm). The Royal Collection / HM Queen Elizabeth II (RCIN 401228)

own, in a nod to their military victory at Granada. Henry VII insisted on first refusal of all cloths of gold entering the country, while his son Henry VIII enacted sumptuary laws rendering such velvets exclusive to the Crown and its immediate circle.[7]

The stability of Henry VII's reign was due in great part to his policy of looking outward to Europe—by building diplomatic and financial alliances through his children's marriages, by hosting Europeans at court, and through acquisitions of art objects from the mainland. Indeed, continental Europe, at least initially, was more familiar to this "King of Britons" than was England or Wales, for he had spent much of his prime, from age fourteen to twenty-eight, at the court of François II, duc de Bretagne. More than half of Henry's troops at Bosworth Field were, in fact, French mercenaries, and his loyal official chronicler, Edward Hall, remarked on his formation of a personal guard of soldiers who accompanied his every move, "whome he named Y[e]omen of his garde, which president [precedent] men thought that he learned of the Frenche kyng when he was in France: For men remember not any kyng of England before that tyme whiche used such a furniture of daily souldyouers [soldiers]."[8]

Nothing embodied Henry VII's subtle and deliberate use of artistic patronage to legitimize his reign quite so superbly as his plans for his tomb and the setting he created for it. His death in April 1509 set into motion a grand scheme for his salvation and

Fig. 3. *Andromache and Priam Urging Hector Not to Go to War*, from the *Story of Troy* series. Designed by the Coëtivy Master (active ca. 1455–75), ca. 1465; woven in the Southern Netherlands, ca. 1470–90. Wool and silk, 190⅛ × 104 in. (483 × 264 cm). The Metropolitan Museum of Art, New York, Fletcher Fund, 1939 (39.74)

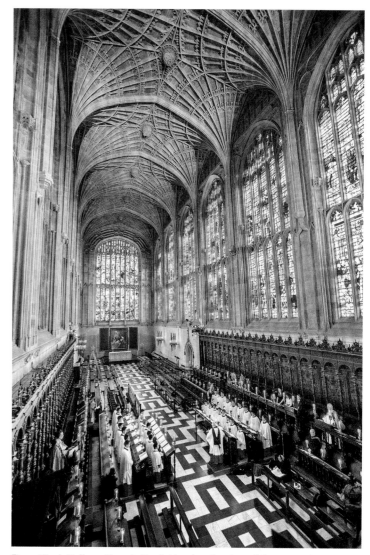

Fig. 4. King's College Chapel, Cambridge, interior view of the east end

posthumous commemoration while simultaneously signaling the might and anticipated longevity of the Tudors. Chantries—regular Masses scheduled in perpetuity for the good of his soul—were established and paid for throughout the country, including at the great university churches in both Oxford (cat. 6) and Cambridge, and funding was earmarked for the anticipated completion of King's College Chapel, sanguinely as it transpired (fig. 4; see also cat. 18). In addition to the statue at the Confessor's shrine, his will also left ample instructions directing,

and sizable monies financing, completion of his chosen resting place, including an elaborate double tomb chest for him and his wife, Elizabeth of York (see cat. 8), and another for his mother, Margaret Beaufort, Edward III's great-great-granddaughter (albeit by illegitimate descent).[9] The space Henry envisioned was a new Lady Chapel extending beyond the east end of Westminster Abbey, the planning, construction, and embellishment of which had already been underway since 1502. Henry VII planned to use his sepulcher as the ultimate symbol of the legitimacy of his family's claim to the English throne by stressing his dynastic roots and shared blood with earlier generations of English royalty. In addition to his mother's tomb, he would share his burial chapel with the shrine to the last Lancastrian king and his father's half brother, Henry VI, to whom he referred in documents as "our uncle of blissed memorie," and whose sainthood

he was actively seeking. To further drive home the message of his illustrious lineage, as the site of this new chapel, Henry co-opted the area of Westminster Abbey then housing the tomb of Henry V's queen, Catherine of Valois—who was, of course, Henry VII's own grandmother, thanks to her second marriage to Owen Tudor. Although many of Henry's plans remained unfulfilled, not least the sanctification of Henry VI and the translation of his remains, the Lady Chapel was completed, and praised in 1545 by the antiquarian John Leland as "the wonder of the entire world."[10] It is something of an oversized jewel box, combining stained glass, carved masonry, gilded bronze, and shining paving, and it leaves no doubt as to whose memory it glorifies, with every surface encrusted with Tudor roses and Beaufort portcullises, accompanied by Welsh dragons, English lions, and French fleurs-de-lis (fig. 5).

Henry VII's foreign policy outlived him: by 1514 his three surviving children all held European thrones, Henry VIII as his successor in England; Margaret, at least until August of that year, as regent for her young son James V, King of Scotland; and Mary, who from October reigned as queen in France, albeit briefly (see cats. 13, 14). Henry VIII chose the north of France rather than England as witness to one of his most spectacular and costly displays: his meeting near Guisnes in the summer of 1520 with the French king, François I. The event would become known as the Field of the Cloth of Gold, evocatively alluding to the extraordinary wealth of textiles on display (fig. 6), the result of competitive splendor between the two monarchs, both still in their twenties and proud of their dashing reputations.[11] Married as a young man to the Spanish princess Katherine of Aragon, Henry VIII initially enjoyed such warm relations with the Vatican that he was Pope Leo X's candidate for election as the new Holy Roman Emperor following Maximilian I's death in 1519. Henry shared with the Vatican and his ostensible ally, the pope, advice as well as generous gifts—tapestries, goldsmiths' work, horses, even a Roman palace—and he loudly declared his support for the Roman Catholic Church with (claimed) authorship and publication of the anti-Protestant disquisition *Assertio septem sacramentorum* (*Defense of the Seven Sacraments*, 1521), for which he was subsequently granted the title Defensor Fidei, or defender of the faith.[12] All the same, already by 1518, Henry had not shied from eroding papal authority by insisting on the elevation of the ambitious English Lord Chancellor, Cardinal Thomas Wolsey (see cats. 16, 17), to match the seniority of the papal legate, Lorenzo Campeggio. Later that year, Henry even scooped the pope's efforts at Europe-wide diplomacy by achieving the extraordinary, if short-lived, Universal and Eternal Christian Alliance for International Peace. This accord was

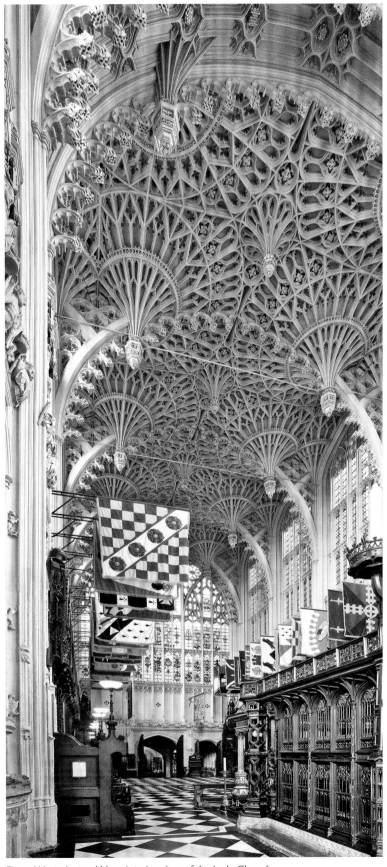

Fig. 5. Westminster Abbey, interior view of the Lady Chapel

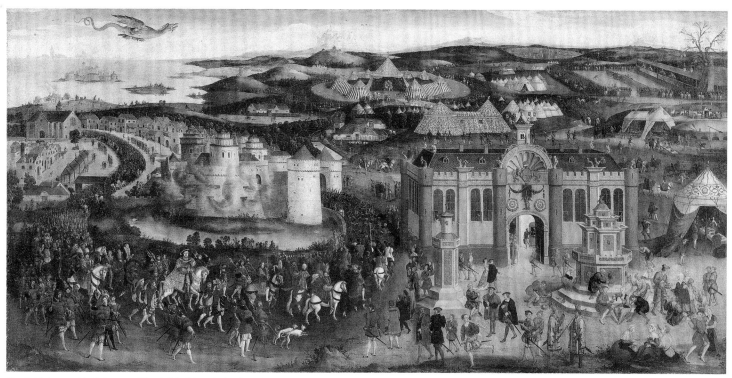

Fig. 6. Unknown English artist, *The Field of the Cloth of Gold*, ca. 1545. Oil on canvas, 66½ × 136½ in. (169 × 347 cm). The Royal Collection / HM Queen Elizabeth II (RCIN 405794)

signed by representatives of every major European power as well as the pope, following a Mass at Saint Paul's Cathedral led by Wolsey—the actual architect of the scheme—attended by all the signatories.[13]

Henry VIII's break with Rome was catalyzed by what his contemporaries called "the King's Great Matter": his desire, thwarted by the papacy, to be granted a divorce from Katherine of Aragon. Whether driven by a need to produce a male heir for the country, fearful of having offended God by bedding his brother's widow (citing Leviticus 18:16, but conveniently ignoring Deuteronomy 25:5), or motivated by frustrated carnal desire for Anne Boleyn—depending on the sympathies of his biographers—the results led to Henry's declaration in 1531 that he be recognized as Supreme Head of the Church in England. Although drastically eroding the Vatican's authority, the declaration was not an outright rejection of the Catholic Church, for it did not yet condone the Protestant Reformation in England. All the same, ramifications included the widespread distribution of the Bible in English (see cats. 20, 21); the Dissolution of the Monasteries, as Henry claimed their wealth and lands; and increasing suspicion of three-dimensional figurative art in church practice.[14] Yet within ten years, under the influence of the conservative bishop of Winchester, Stephen Gardiner (a distant cousin whose mother, Helen, was an illegitimate daughter of

Henry VII's uncle, Jasper Tudor), Henry was similarly burning bridges with European Protestants: in 1540 the German Lutheran reformer and scholar Philipp Melanchthon, disgusted by Henry's treatment of his fourth wife, Anne of Cleves, and by the execution of Thomas Cromwell (see cat. 21), begged, "Let us cease to sing the praises of the English Nero!"[15]

In 1547 Edward VI, only nine years old at his coronation, inherited a country somewhat in debt but emancipated from the remnants of the English feudal system and its troublesomely powerful barons, as well as from canon law. Although much was done to present Edward as the spitting image (see fig. 95) and true successor of his late father—popular despite his murderous faults—Edward, and ensuing royal policy, was heavily influenced first by his uncle Edward Seymour, Duke of Somerset, who styled himself Lord Protector; and subsequently by John Dudley, Duke of Northumberland, whose son, Robert, would later catch Elizabeth I's eye (see cats. 107, 108). With startling rapidity, any remnant of authority of the Catholic Church, Roman or English, was swept aside with a series of acts that firmly established the Protestant Church in England.[16] Edward's death at fifteen, however, stalled English Protestantism before it could truly become established as the new modus vivendi.

When Mary came to the throne in 1553, she was England's first uncontested female monarch, testing the waters later made

famous by her younger sister, Elizabeth.[17] Perhaps unexpectedly, the whole country, regardless of religious persuasion, united behind her as Henry VIII's eldest daughter to oust Dudley's unfortunate political puppet, the Protestant Lady Jane Grey (granddaughter of Henry VIII's sister Mary Tudor and Charles Brandon; see cat. 14). Celebrations the evening she came to power were such that, as one Italian resident in London evocatively remarked, all London shone with enough light that "from a distance the earth must have looked like Mount Etna."[18] In gruesome contrast, not so long after, London was again aglow, but with execution bonfires: while Henry VII had ordered 10 heretics burned alive during his 24-year reign; Henry VIII, 81 in 38 years; Edward VI, 2 in 6 years; and, later, Elizabeth, 5 in 44 years, Mary ordered a horrific 283 public burnings during her 5 years in power—reckoning out at more than one per week.[19] By the time of her premature death, local folklore claimed that, to ward off the queen, the letter *M* had joined the hex marks carved into superstitious country folks' mantles. And in his admittedly skewed history, *Actes and Monuments of These Latter and Perillous Dayes*, popularly called the *Book of Martyrs* (1563; fig. 7), it was the Elizabethan historian John Foxe who first coined the name "Bloody Mary."[20] For Katherine of Aragon's daughter, granddaughter of Their Most Catholic Majesties, Queen Isabella and King Ferdinand, it was imperative to reverse her father's anti-Vatican policies, which were, after all, broadly unpopular when they first came into effect, as witnessed by the populist uprising of 1536, the so-called Pilgrimage of Grace.[21] However, the shift in national devotional practice during her younger brother's reign, combined with the cold reality of the decade-old redistribution of monastic lands to private hands, meant that large swathes of the population were no longer prepared to revert to the old ways.[22] Uniting England with the fiercely Roman Catholic Habsburgs, Mary married perhaps the most powerful, and certainly the richest, prince in Europe, the future King Philip II of Spain. Their marriage led to a short-lived harmony of English and mainland European aesthetic taste: on display in London were Willem de Pannemaker's magnificent, and magnificently expensive, Brussels-woven *Conquest of Tunis* tapestries (fig. 8)—a tellingly conquistador-themed wedding present from her father-in-law (and cousin), Holy Roman Emperor Charles V.[23] And the Milanese medalist Jacopo da Trezzo, probably a member of Philip's entourage in London, created splendid medals in the Roman style celebrating Mary and her husband (cat. 95), designs bastardized in coinage reaching every member of her population (fig. 9). Mary was unpopular at home thanks to her Catholic policies and Spanish husband (at whose representatives the populace threw

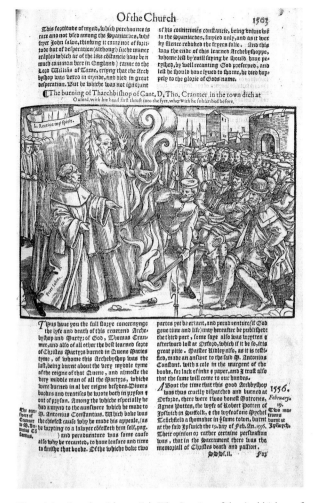

Fig. 7. John Foxe (1516/17–1587), "The Burning of the Archbishop of Canterbury, Thomas Cranmer," from *The Book of Martyrs* (London, 1563). British Library, London (C.37.h.2)

snowballs), and in Europe, her allies insultingly sidelined her to the supporting role of Philip's royal consort (cat. 28), while adversaries even more insultingly belittled her status as a female monarch.[24] King Henri II of France, for instance, staged a snub in front of all the foreign ambassadors at his court by ignoring Mary's herald, declaring, "Consider how I stand when a woman sends to defy me to war?!" The episode was gleefully recounted by the Venetian ambassador Giacomo Soranzo in a dispatch to the doge and senate, noting that, because the herald "came in the name of a woman it was unnecessary for [Henri] to listen to anything farther, as he would have done had he come in the name of a man, to whom he would have replied in detail."[25]

After this brief period of what has been called the "Habsburgization of England,"[26] Elizabeth, Henry VIII's youngest daughter, came to the throne in 1558. As Elizabeth was the child of the executed Anne Boleyn, European Catholics,

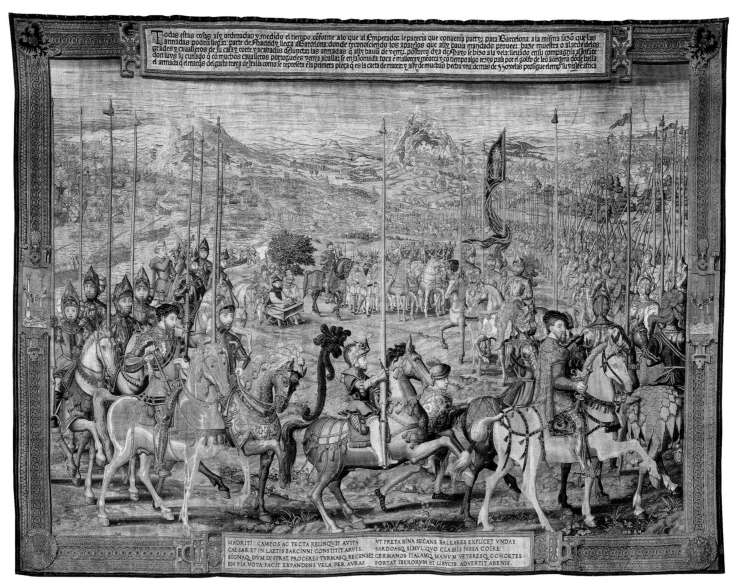

Fig. 8. *Muster of the Troops at Barcelona*, from the *Conquest of Tunis* series. Designed by Jan Cornelisz. Vermeyen (ca. 1504–1559), with Pieter Coecke van Aelst (1502–1550); woven under the direction of Willem de Pannemaker (active 1535–78), Brussels, 1548–51. Wool, silk, and precious-metal-wrapped threads, 209½ × 281½ in. (532 × 715 cm). Patrimonio Nacional, Palacio Real de Madrid (TA 13/2, A32510761)

who regarded her parents' marriage as unlawful, branded her illegitimate—"the Concubine's little bastard," the imperial ambassador Eustace Chapuys called her in correspondence with Charles V.[27] Elizabeth parried this disdain by glorying in her English mother and styling herself a queen "of no mingled blood of Spaniard or stranger, but born mere English here among us and therefore most natural unto us."[28] Ostensibly prioritizing national, rather than international, relations, Elizabeth carefully shepherded her image on coins, seals, and medals (cats. 97, 116); encouraged painted and printed celebrations of her reign as a culmination of her father's and grandfather's (cats. 1, 33);

made sure to reach her subjects in her much-vaunted annual progresses around the country; and nurtured an elegant, sophisticated court culture (discussed further in Adam Eaker's essays in this volume).[29] Retaining her father's and grandfather's administrative structures, and following the fractious hiccups of her siblings' reigns, Elizabeth eventually achieved a nationwide perception of peace, tolerance, and stability. When inherited religious conflict threatened, and conspiracy was afoot to usurp the English throne in favor of her Catholic cousin, Mary Stuart, Queen of Scots (granddaughter of Henry VIII's sister Margaret Tudor and James IV of Scotland), Elizabeth accommodated

Mary—under guard—for years before, finally, condoning her execution in 1587.[30] Proving she could rise to the challenge when national well-being was threatened from the outside, her Tilbury speech, before the routing of her former brother-in-law's Spanish Armada, was embellished into the stuff of legend and, for posterity, a gratifying riposte to Henri II's earlier disdain for her sister's monarchy: "Let tyrants fear. . . . I know I have the body but of a weak and feeble woman: but I have the heart and stomach of a king—and a king of England too—and take foul scorn that Parma or any Prince of Europe should dare to invade the borders of my realm."[31] Elizabeth, the "Virgin Queen," succeeded in dominating the European political stage (cat. 122), with even Pope Sixtus V reputedly remarking, "What a valiant woman. She braves the two greatest kings [of France and Spain] by land and sea. It is a pity that Elizabeth and I cannot marry; our children would have ruled the whole world."[32]

Politically, each of the Tudors needed to maintain a delicate network of communication and shifting alliances with European powers, and this wily pavane is reflected by the ebb and flow of artistic talent, trade, and travel between England and Europe. Indeed, scholars have long recognized this overlap: merchants, bankers, and agents served as conduits between the European potentates to whom they catered.[33] In the virtual cacophony of mercantile and artisanal voices recorded in sixteenth-century London, it is striking how closely court and city connected: the merchant Pregent Meno apparently ferried Perkin Warbeck, pretender to Henry VII's crown, to the British Isles together with a shipment of sumptuous Italian silks; the goldsmith Affabel Partridge (cats. 41, 60, 61) may have been Lady Jane Grey's dinner companion in the Tower in the days before her execution; and the Antwerp-based Portuguese merchant-speculator García de Yllán curried favor with the Spanish Crown so that it would turn a blind eye to his Brazil-to-London direct shipments.[34] The Flemish agent and entrepreneur Pieter van Edingen, called van Aelst, enabled both Henry VII and Henry VIII to acquire tapestries from the same series as their Burgundian, Trastámara, Valois, and Habsburg counterparts, and on a footing not just matching but surpassing their collections (see cats. 4, 42). It was the Lucchese merchant-banker Antonio Cavallari who financed the Florentine sculptor Benedetto da Rovezzano's Wolsey and Tudor tomb projects (cats. 16, 17). Giovanni Cavalcanti, from Florence, apparently not only orchestrated, with Pierfrancesco di Piero Bardi, Henry VIII's invitation to the painter Rosso Fiorentino to come to London (albeit one he passed up for a position at François I's court), but also negotiated with Pope Leo X on behalf of Henry VIII for Baccio Bandinelli's services.

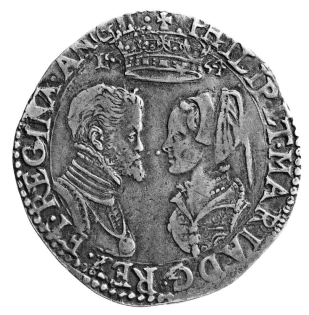

Fig. 9. *Shilling of Philip and Mary*, England, 1554. Silver, Diam. 1¼ in. (3.1 cm). The Metropolitan Museum of Art, New York, Gift of Assunta Sommella Peluso, Ada Peluso, and Romano I. Peluso, in memory of Ignazio Peluso, 2001 (2001.432.11)

The Antwerp- and Seville-based banker-dealers Matteo and Jacopo Botti chartered the sculptor Pietro Torrigiano's transfer from Henry VIII's court to that of his wife's nephew Charles (see cat. 76), while Giovanni Gaddi, the Florentine banker, negotiated a 75,000-ducat contract for Jacopo Sansovino from Henry VIII at the same time that François I wanted Sansovino in France.

The English frequently traveled to continental Europe, and not only for trade, like Thomas Cromwell, who lived in Antwerp as a merchant before taking to England's political stage. Scholars such as Thomas Linacre and John Colet visited Florence and Padua to study; Linacre, future physician to Henry VII and tutor to his daughter Mary, studied alongside Giovanni de' Medici (the future Pope Leo X), while Colet was converted by his experience witnessing Savonarola's reformist preaching and "bonfire of the vanities" in the Piazza della Signoria, returning to London as future dean of Saint Paul's, confessor of Erasmus, firebrand preacher, and advocate of free education.[35] Others, such as Thomas Wyatt and, later, Robert Dudley (cats. 66, 67), traveled on diplomatic missions; some crossed the Channel to meet the European Protestant vanguard, like young Anthony Bacon (son of Sir Nicholas Bacon, Elizabeth's Lord Keeper of the Great Seal, and brother of the more famous Francis). Bacon's curiosity was apparently something of a front for spying on behalf of Elizabeth's secretary of state, and reputed spymaster, Sir Francis Walsingham. He sometimes pushed his brief such to

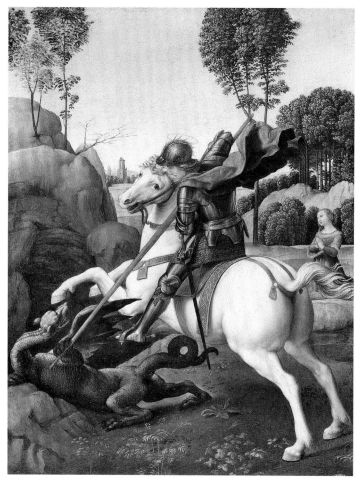

Fig. 10. Raphael (1483–1520), *Saint George and the Dragon*, ca. 1506. Oil on panel, 11¼ × 8⁷⁄₁₆ in. (28.5 × 21.5 cm). National Gallery of Art, Washington, D.C. (1937.1.26)

Europe's considerably older institutions in Bologna and Paris and its more recent foundations in Padua and Leuven.[39]

In turn, world visitors came to England, either to settle or to pass through. London, in times of prosperity, was described in glorious terms by the Edinburgh poet William Dunbar:

> Soveraign of cities, seemliest in sight,
> Of high renoun, riches and royaltie;
> Of lordis, barons, and many a goodly knyght;
> Of most delectable lusty ladies bright;
> Of famous prelatis, in habitis clericall;
> Of merchauntis full of substaunce and of myght:
> London, thou art the flour of Cities all.[40]

At the turn of the sixteenth century, an anonymous Venetian noted the conspicuous arrays of silverware in merchants' homes and the many goldsmiths' shops—fifty-two in Cheapside alone—the latter point reiterated by his countryman the merchant Alessandro Magno, visiting six decades later.[41] For Erasmus, Oxford's "good cheer would have satisfied Epicurus; the table talk would have pleased Pythagoras."[42] Already during Henry VII's reign, scholars flocked to England's court and universities, from the friar Bernard André from Toulouse and the king's librarian Quintin Paule from Lille, to the chronicler Polydore Vergil from Urbino and the poet and friar Filippo Alberici from Mantua (cat. 5). Baldassare Castiglione, visiting in 1506 as the envoy of Guidobaldo da Montefeltro, Duke of Urbino, is said to have brought Raphael's painting *Saint George and the Dragon* as a gift from the duke to Henry VII (fig. 10). (European artists sojourning in London are discussed in "Hans Holbein and the Status of Tudor Painting" in this volume.) The list of world-class artists enjoying the patronage of both the Tudor monarchs and their courtiers is lengthy, spanning painters and designers such as Hans Holbein, Susanna and Lucas Horenbout, Nicholas Bellin, Bartolommeo Penni, Federico Zuccaro, and Marcus Gheeraerts; sculptors such as Guido Mazzoni (fig. 11), Pietro Torrigiano, and Benedetto da Rovezzano; medalists such as Jacopo da Trezzo and Steven Cornelisz. van Herwijck; and musicians such as Charles Tessier and the Bassano brothers. Beyond these known luminaries, anonymous craftspeople were welcomed in droves to supplement English talent: Henry VII encouraged refugee Flemish cloth weavers to settle in Suffolk and assist English manufacturers' newfound dominance of the cloth industry, creating pockets of incredible wealth in former villages like Lavenham and Long Melford; Henry VIII set up German armorers in his new Greenwich Royal Armoury (cats. 22, 72); and Elizabeth hosted copper miners and smelters from Augsburg to run her mines in the Lake District and to furnish the copper needed for superior cannonry.[43]

excite the censure of his compatriots, although he always enjoyed the protection of his uncle William Cecil, 1st Baron Burghley and Lord High Treasurer.[36] Others, like the architectural scholar John Shute (cat. 55) and the poet George Puttenham, sought to emulate the aesthetics of the Italian peninsula.[37]

The English explored outward, with John Cabot landing at and claiming Nova Scotia as an English territory in 1497, and Sir Francis Drake twice circumnavigating the globe and bringing Elizabeth great trade opportunities, as well as souvenirs from the Americas. The Merchant Adventurers' Company, founded in 1552, sought trade with the East, so successfully achieving a monopoly with Czar Ivan the Terrible of Russia that it transformed into the Moscovy Company.[38] Elizabeth hosted ambassadors from North Africa (cat. 101), ostensibly to discuss trade, but doubtless also to plot against their shared enemy, Spain. The Tudors poured money into the universities, matching the University of Cambridge, in particular, with the glamour of

Simultaneously, Tudor England also witnessed a steady upturn in ethnic diversity. Every year saw an increase in visitors and settlers, particularly North and West Africans and Arabs, whose first taste of Europe had been under the Spanish. Many were attracted to England by its commercial opportunities and enlightened attitudes, the latter ratified in 1569 when the court ruling of the Cartwright case pronounced that "England was too pure an air for a slave to breathe in," frequently cited in subsequent decades to legally infer that an enslaved individual would automatically become free at their arrival in England.[44] Some African visitors, like Moroccan ambassador Abd al-Wahid bin Mas'ood bin Mohammad 'Annouri (cat. 101), were passing through; others chose to settle, like Marrion Soda of Bodmin, Cornwall, or Mary Fillis, baptized at Saint Botolph's in London (both "of Morisco," meaning Morocco). Many, including the Black yeoman Henrie Jetto of Holt in Worcestershire, established first generations of what would become centuries-long English family lineages.[45] When the documentary record does specify ethnicity, we find Black musicians working at the royal court and farther afield in ports like Southampton; Black needle makers plying their trade in Cheapside and Aldgate; and other Black professionals working in London—Fillis of Morrisco, "a basket and shovel maker"; "Reasonable Blackman, silk weaver." African mariners, at least one of whom had apparently grown up in England, were among crew members lost at the sinking of Henry VIII's *Mary Rose* warship; others, like the West African Jacques Francis, were professional divers contracted in 1545 to salvage the wreck.[46]

Slippery diplomatic relations and the swinging pendulum of religious tolerance regularly jeopardized the status quo: Protestant Flemish, Dutch, and French artisans, welcomed by Edward VI, were expelled by Mary, whose agents even alerted the Habsburgs to refugee crossings so as to arrange their arrest upon landing. Under Elizabeth, English Protestants returned from refuge in Frankfurt and other overseas sanctuaries (cat. 29). Already under Henry VII, the challenger to his throne, Perkin Warbeck, was feted at the Burgundian court, protected by the dowager duchess, Margaret of York (who, as sister of the deposed Richard III, was no fan of Henry's), even having his portrait included in the *Recueil d'Arras* (fig. 12).[47] Henry VII's retaliation, chronicled by Edward Hall, temporarily banned English merchants from importing "all Flemyshe wares and marchaundises" into England, instigating a reciprocal ban by Maximilian of "all Englishe clothes, yarne, tynne, leade and other commodities" into Flanders.[48] Exempt from these restrictions, the Hanseatic merchants in London did not pass up the opportunity to take over various English mercantile routes

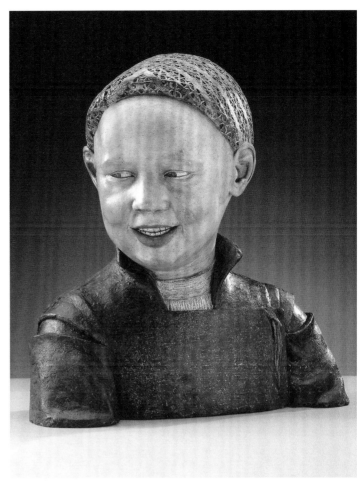

Fig. 11. Attributed to Guido Mazzoni (ca. 1450–1518), *Henry VIII When a Young Boy(?)*, ca. 1498. Polychromed and gilded terracotta, H. 12½ in. (32 cm). The Royal Collection / HM Queen Elizabeth II (RCIN 73197)

and suppliers, leading to rioting outside the Hanse headquarters at the Steelyard (cats. 40, 41), only quashed by the arrival of "ye Magestrates and officiers of the citie."[49] The "Evil May Day" of 1517 saw a similar uprising by English apprentices who begrudged foreigners' share of local trade and profit.[50] Such pockets of unrest reveal undercurrents of resentment on the part of the native populace; there were similarly regular, if less violent, complaints about visiting artisans who brought their skills and enviable designs from Flanders and beyond, but managed to sidestep membership and the rules of the trade guilds and city corporations. Stained-glass makers were a case in point: like the immigrant Flemish tapestry weavers, they opted to settle in Southwark, just beyond the City of London corporation limits, yet they actively enjoyed royal patronage, despite this breach of protocol (cat. 18; fig. 42).

Frequent royal events witnessed the overlap of the court with local and international traders. All the guilds of the City

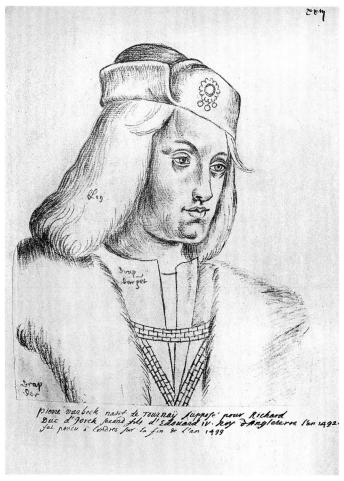

Fig. 12. Jacques Le Boucq (d. 1573), "Perkin Warbeck," from the *Recueil d'Arras* (Arras, ca. 1566–74). Black chalk on paper, 16 × 11 in. (41 × 28 cm). Bibliothèque Municipale, Arras (MS 266)

Earl of Northumberland, who led her entourage, relished how "the riches of his coat being goldsmithes worke, [were] garnished with pearle and stone, and what for the gallant apparell of his Henchmen, and brave trappers of his horsse . . . [he] was esteemed both of the Scots and Englishmen more like a prince than a subject."[53] Accounts of Henry VII's funeral similarly inventoried the textile trappings, including "a Chariot, covered with blacke clothe of golde drawen with v. greate Corsers [horses], covered with blacke Velvet, garnished with Cusshions of fine golde . . . and the chariot was garnished with banners and Pencelles [pennants]."[54] Glorifying the taste and largesse of the monarchy, such expenditure must also have been appreciated by the suppliers, traders, and artisans employed to carry it out. Henry VIII's excesses at the Field of the Cloth of Gold, over and above the pricey textiles involved, gave work to six thousand laborers erecting the tents and pavilions and to two thousand masons, glaziers, and carpenters.[55]

Bernard André's evocative description of Henry VII's marking of the Feast of the Nativity is peppered with references to the sensory wealth of the occasion:

> it cannot be expressed in words . . . such a rare, previously unseen spectacle . . . sweet songs . . . highly tuneful singing-men . . . the glorious company of all those nobles . . . our most pious king . . . sitting on a golden throne . . . gleaming with gold and gems . . . the pontiff, wearing his linen chasuble decorated with purple and gold . . . thanks had been given up to God with the most musical and angelic voices . . . Afterwards, . . . a royal banquet . . . that eloquent feast with its dainties fetched from all quarters.[56]

Yet such a celebration jars against the fact that subsequent periods of the Tudor dynasty were characterized by the dismantling, degeneration, and destruction of huge swathes of sacred art and ceremony. Something of this dichotomy is captured in the extraordinary disconnect made by the chronicler Hall, jumping immediately from his description of the glitter and pageantry of baby Elizabeth's christening ("All the walles . . . were hanged with Arras [gold-woven tapestries]. The Font was [made] of silver") to a horrific anecdote recounting how a town clerk of the City of London had hanged himself because he "in nowise could abide to here [hear] that the Gospell should bee in Englishe."[57] Accounts of Tudor England contain many such segues from the rosy and glorious to the graphically repellent: compare the young Henry VIII, so proud of his "good calf" that he displayed it to the Venetian ambassador, who in turn admired Henry's "fair skin glowing through a shirt of the finest texture," with the Jacobean historian Gilbert Burnet's descriptions of Henry in old age, with sores pustulating on his legs and so fat that servants used a pulley system to raise and lower him from

of London, for example, put on an impressive display when their barges accompanied Anne Boleyn from Greenwich to Westminster for her coronation. Accounts capture the pageantry of such experiences, like the additional money shelled out by the Merchant Taylors' guild to pay minstrels to serenade them on the trip, or the rowdy and splendid "Barge made like a ship, called the Batchelers barke, decked with cloth of gold, penons, pencels [pennants], & targetz in great nombre."[51] In a generous goodwill gesture, the Hanse created a virtual river of free Rhenish wine to flow in Gracechurch Street, perhaps delighting the populace more than the tableau-vivant they commissioned from Holbein to celebrate the coronation (see cat. 89).[52] Descriptions of Tudor royal gatherings, from coronations to funerals, set store on material splendor, lingering on the wealth and variety of luxury goods, especially textiles (see fig. 19). For example, when Henry VII's daughter Margaret met with her Scottish fiancé's escort, the chronicler Raphael Holinshed's description of the

his chair.[58] Tudor chronicles are filled with both vivid flashes of color—the poetic "swarme of whit[e] buttarflyes" at Calais marking the (ultimately thwarted) betrothal of the first Mary Tudor to the future Charles V; the brilliant yellow costume in which Henry VIII cruelly cavorted with his queen, Anne, at the news of Katherine of Aragon's death; the crimson red petticoat worn by Mary, Queen of Scots, at her execution[59]—and horrendous visuals—the severed arms of a Carthusian monk, executed for refusing to recognize Henry VIII as Supreme Head of the Church, suspended above the door of his monastery as a deterrent to others; the bodies of Cumberland peasants hanging from the trees of their own gardens for their part in the Pilgrimage of Grace to protest Henry VIII's rejection of traditional Catholic practices; the awful moment when the executioner held aloft the head of Mary, Queen of Scots, and was left clutching an auburn wig as her head fell free and rolled across the floor. Henry VII, Henry VIII, Edward VI, Mary I, and Elizabeth I all understood how the splendor of their courts could be a mask, or dressing, to hide such ugly fissures and maintain what many abroad, and even some at home, still held to be an elaborately fabricated inheritance. Wrestling with ingrained prejudice against female regents, both in England and worldwide, Mary and Elizabeth appreciated the capacity of artistry and splendor to bolster perceptions of their status as reigning monarchs. Elizabeth, in particular, crafted a powerful new iconography of lone, virgin, sovereign queenship. All three generations of Tudors appreciated the power of spectacle and pageantry, the propagandistic potential of figurative art and theatrical space, the language of portraiture, and the capacity of good design to smooth international diplomacy. Their splendor actualized Tudor majesty and power, manifesting the grandeur befitting a royal dynasty.

Notes to this essay appear on pp. 304–5.

1. *The Union of the Roses of the Famelies of Lancastre and Yorke, With the Armes of Those Which Have Been Chosen Knights of the Most H[o]norable Order of the Garter from that Tyme unto This Day 1589*

Jodocus Hondius (1563–1612), after Thomas Talbot (1535–1595/99)
London, 1589
Engraving, 20⅛ × 14½ in. (51.2 × 36.8 cm)
The British Museum, London (1848,0911.244)
Exhibited New York and Cleveland only

Created approximately one hundred years after the foundation of the Tudor dynasty, this engraving occluded the instability of the family's foundations via repeated references to a strategically articulated iconography. To symbolize and bolster the union of the houses of Lancaster and York, the newfound dynasty had adopted the crowned double rose as its heraldic symbol, combining the floral emblems of the two houses (see also p. 21 in this volume).[1] Here, Jodocus Hondius depicts the arms of every knight admitted to the Order of the Garter—England's highest chivalric order—over the course of the Tudor period up to the date of the print's execution (1589). The arms nestle within the sculptural petals of an elaborate rose, the whole encircled by a garter, while tiny portraits of the Tudor monarchs, sprinkled between the arms, peer out. Henry VII and Elizabeth of York—the founding monarchs—oversee the array like guardians. Just beneath the crown, Saint George, dedicatee of the order, slays the dragon, as in legend.

Each element of this complicated arrangement serves a strategic communicative and symbolic function. The garter, for example, appears around not only the central rose, but also each set of arms. Roses, in addition to being the focus of the engraving, surround the half-length portraits of Henry VII and Elizabeth of York. As has been argued, the language used to describe the family—the very name *Tudor*; the narrative of a "dynasty"—disguises the illegitimacy and anxiety of representation faced by each monarch.[2] Reluctant to draw attention to a tenuous claim and Welsh heritage, contemporary Tudor representations focused on generalized antecedents and the cultivation of a new visual vocabulary.[3] In the succeeding decades, arms, roses, garters, portcullises, dragons, and greyhounds, all Tudor family symbols, would decorate grand architectural settings, diplomatic portraits, popular prints—even spoons.[4] Tudor roses occur, for example, as decorative motifs in several splendid textiles and manuscripts (cats. 7, 12, 15), while the Lancastrian red rose appears in portraits of Henry VII and Elizabeth I (cats. 3, 30). Here, the symbols of the Garter additionally echo the lateral power derived from association with other aristocrats and princes.

Inscribed in both Latin and English, this so-called Talbot's Rose participates in the rewriting of history through the combined didactic power of visuals and text. The petals feature manicules, hands that readers of the era drew in margins of pages to call out specific passages. Here, the manicules act as guides, pointing to prominent figures such as the naval commander Charles Howard, 2nd Baron Howard of Effingham and, later, 1st Earl of Nottingham. The inscriptions instruct the viewer/reader in an approved royal history, ignoring the civil war and strife that preceded "that most happie mariage [o]f King Henry the 7, of the howse of Lancastr whose ensigne was the red rose, with Elizabeth the doghter of Eduard the 4, of the howse of Yorke, wich gaue the white rose for an ensigne."

As noted in the bottom corners, an unidentified designer, AEg. P., and Thomas Talbot, a member of the Elizabethan Society of Antiquaries, "invented" and "composed" the engraving, which was then produced by Hondius.[5] As Clerk of Records at the Tower of London, Talbot collected and examined English archival and genealogical records and may have published a book "containing the true portraiture" of English monarchs in 1597.[6] Hondius, best known for his maps, globes, and scientific instruments, moved to London to escape religious persecution in Flanders. This engraving was produced a few years later, revealing how he tactfully learned to adopt this potent royal iconography.[7] SB

Notes to this entry appear on p. 305.

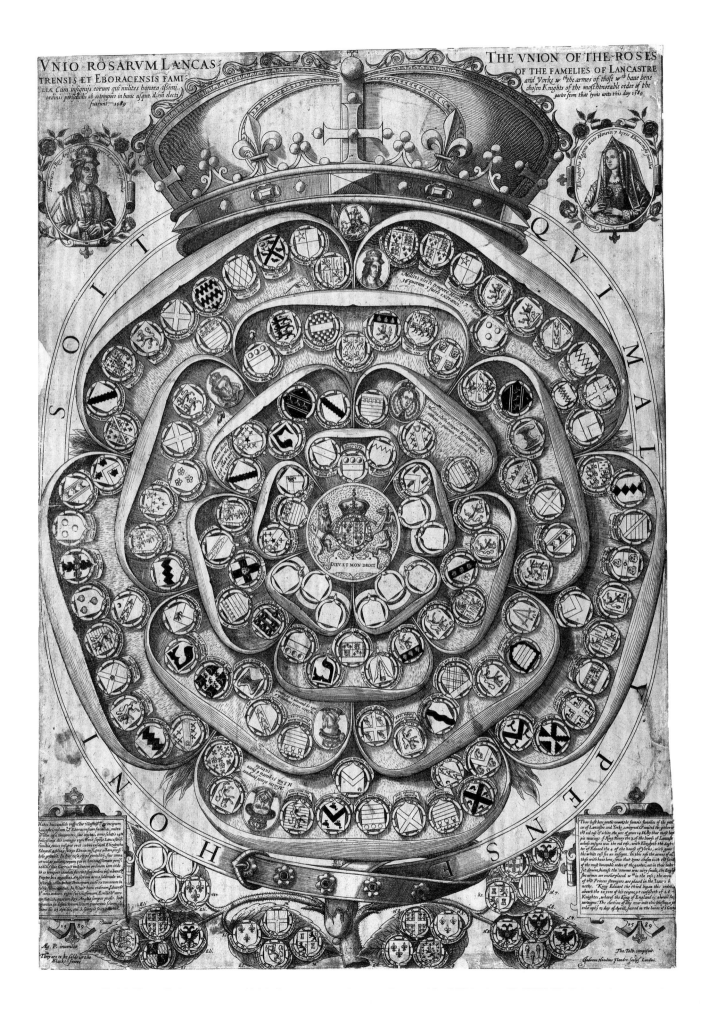

2. A Collection of Armes in Blazon; Taken from an Antient Booke of Ordinaries, Tricked and Extracted, from Visitations & Pedigrees in the Heralds Office

London, ca. 1585–90
Ink and watercolor on paper, H. 11⅞ in. (30 cm)
Folger Shakespeare Library, Washington, D.C. (V.b.375, p. 53)
Exhibited New York only

Detail of cat. 2, showing Owen Tudor's treatment

Bursting from Edward III's belly, leafy stems wind through centuries of elite marriages, coats of arms, and shifts in power. The red-rosed Lancastrians take the left side, while the white-rosed Yorkists claim the right—until their offshoots finally merge around Henry VIII. Atop the page Elizabeth I grows from a rose, flanked by her siblings. Literalized with branches, leaves, and flowers, this colorful Elizabethan family tree spells out the pedigree of the final Tudor monarch.

The family tree originally formed part of a "book of ordinaries," a type of armorial compilation used by officers to avoid granting repetitive arms and to build a vocabulary of "recognizable symbols of gentility."[1] The empty escutcheons, ink smudges, afterthought additions, and the switching between humanist and secretary script suggest that the pedigree was a working document for an Elizabethan herald. Someone, for example, appears to have—intentionally or not—snubbed Owen Tudor by scribbling him under Catherine of Valois, underlining him with the number 2 (for being the second husband), and depriving him of the rose-shaped frame given to every other featured family member. The generalized royal portraits resemble well-known depictions of the monarchs, such as the woodcuts by Giles Godet in *Genealogie and Race of All the Kynges of England* (ca. 1560).[2]

Based on visitation books and pedigrees in the Herald's Office, *A Collection of Armes in Blazon* also contains pedigrees of the courtier and poet Edward de Vere, Earl of Oxford, and of Anne Morgan, Baroness Hunsdon, a lady-in-waiting and the wife of the queen's cousin, among others.[3] This lengthy, researched compilation represents one facet of the Elizabethan gentry's—and monarch's—obsession with lineage. Heraldic insignia, propped up by historical research, allowed for self-conscious construction and justification of social standing. Upstart gentry substantiated their rise by sometimes falsifying their pedigrees, while established nobles flaunted their heritage in an attempt to stabilize existing boundaries.[4] The monarchs were no exception. The Brudenell pedigree roll, devised as a gift for the queen, draws Elizabeth's lineage back to the Creation. Carefully avoiding illustrating the Tree of Knowledge, the roll sanctioned Elizabethan rule with divine precedent rather than associating her with Eve's shame.[5] The family tree in *A Collection of Armes in Blazon*, however, extracts Elizabeth's authority by way of her actual ancestor, Edward III.

Unlike polished engravings (cat. 1) or beautifully illuminated grants (cat. 25), *A Collection of Armes in Blazon* highlights the work behind heraldry in early modern culture—the active and operational construction of the past, in service of the present. SB

Notes to this entry appear on p. 305.

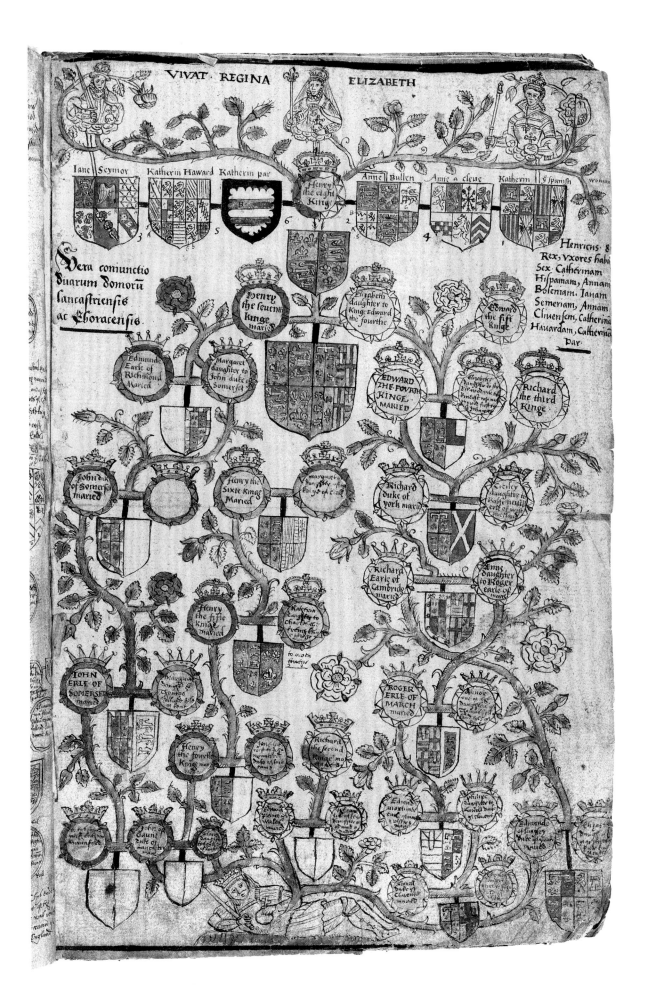

VIVAT · REGINA ELIZABETH

Iane Seymor Katherin Haward Katherin par Henry the eight Kinge Anne Bullen Anne a cleue Katherin Ỹ Spanish woman

Vera coniunctio duarum domorũ lancastriensis et Eboracensis.

Henricus 8 Rex, vxores habuit Sex. Cathérinam Hispamam, Annam Bolemam. Ianam Semeriam, Annam Cluensem, Catherinã Hauardam, Catherinã par.

Henry the seuenth kinge maried Elizabeth daughter to Kinge Edward the fourthe Edward the fift kinge

Edmunde Earle of Richmond Maried Margaret daughter to John duke of Somerset EDWARD THE FOVRTH KINGE. MARIED Elizabeth daughter to Sr Richard wildoswell Richard the third Kinge

John duke of Somerset maried Henry the Sixte Kinge Maried margaret daughter of Ỹ Kynge of Cisal Richard duke of york maried Cicely daughter to Raffe neuill erle of westmerland

Henry the fifte Kinge maried Kateryn daughter to Charles the fyrenshe King Richard Earle of Cambridge maried Anne daughter to Roger earle of marsh

IOHN ERLE OF SOMERSET maried Margaret daughter of Thomas holland erle of Kent Henry the fowrthe Kinge maried Iane the wyfe to Ỹ Kinge of Nauern Richard the second Kinge maried ROGER ERLE OF MARCH maried Anne one of daughter

Henry the fowrth Kinge maried Edward prince of Wales Edmund mortimer erle of marsh Philip daughter to Lionell duke of clarens Edmunde of langley Duke of yorke maried

John of Gaunt duke of Lancaster Lionel duke of clarens maried

3. *Henry VII*

Unknown Netherlandish artist
1505
Oil on panel, 16¾ × 12 in. (42.5 × 30.5 cm)
National Portrait Gallery, London (NPG 416)
Exhibited New York only

On February 11, 1503, Henry VII's queen, Elizabeth of York, died from complications of childbirth. The untimely death of their eldest son and heir, Arthur, Prince of Wales, the year before had left the king with just one male successor—the future king Henry VIII—to ensure the continuation of the Tudor dynasty. Understandably, the king began to think strategically about a possible remarriage to generate additional heirs and strengthen key political alliances. Several opportunities presented themselves: Ferdinand of Aragon proposed his daughter Katherine (Arthur's widow) as a possible new wife for King Henry himself, and his niece Joanna, dowager queen of Naples, for Henry VIII; while Philip the Fair, Duke of Burgundy, offered his sister, Margaret of Austria, for Henry VII and his daughter Eleanor for Henry VIII. Not to be outdone, Louis XII of France offered his cousin Margaret of Angoulême as wife to either father or son. By 1506 Henry was simultaneously pursuing three potential partners: the "ever reluctant" Margaret of Austria, the equally reluctant Margaret of Angoulême, and Philip's widow, Joanna of Castile. None of these alliances came to fruition, and Henry VII remained a widower, but it was against this background that the present painting was created.

This modestly scaled portrait is the most important surviving image of Henry VII. The king is shown at the age of forty-eight: deep-set eyes, prominent cheekbones, thin lips, and a heavy chin define a visage honed by experience and determination, and often described as shrewd and calculating. He wears a fur-lined robe of red and gold brocade over a black vest, and a black cloth hat. Around his neck is a heavy gold chain from which is suspended the Order of the Golden Fleece, to which order he was elected in 1491. His hands rest lightly on a ledge at the bottom of the painting, the right one holding a rose, the ubiquitous symbol of the Tudor dynasty.[1] The inscription on the ledge records that the portrait was painted on October 29, 1505, by order of Herman Rinck, an agent for Holy Roman Emperor Maximilian I.[2]

Rinck had been dispatched to England to facilitate a marriage between Henry VII and Maximilian's daughter, Margaret of Austria. He brought with him two likenesses of the archduchess for the king's approval, and presumably returned to the Netherlands with this portrait of the king. Inventories of Margaret's collection at her palace at Mechelen, taken in 1516 and 1524, describe a portrait of Henry VII that appears to correspond to the present painting.[3] It is no accident that Henry here wears the Order of the Golden Fleece: founded by Philip the Good, Duke of Burgundy, in 1430, it was a highly exclusive order, its members limited to just thirty. Henry's wearing of the order signaled his role as a major political ally of the Burgundian Habsburg court.[4]

This portrait was for many years attributed to the Estonian painter Michel Sittow but, as has been pointed out, it lacks that artist's delicate touch and sophisticated modeling of forms.[5] Indeed, because of differences in painting style—the chain, the Golden Fleece, and parts of the costume are painted with skill and subtlety, while the eyes and face are more summarily executed—it has been suggested that there might have been more than one hand involved in the creation of this likeness.[6] The artist was likely a Netherlandish painter resident in England who undertook the portrait on commission from Rinck, or one who traveled with him for the purpose. MEW

Notes to this entry appear on p. 305.

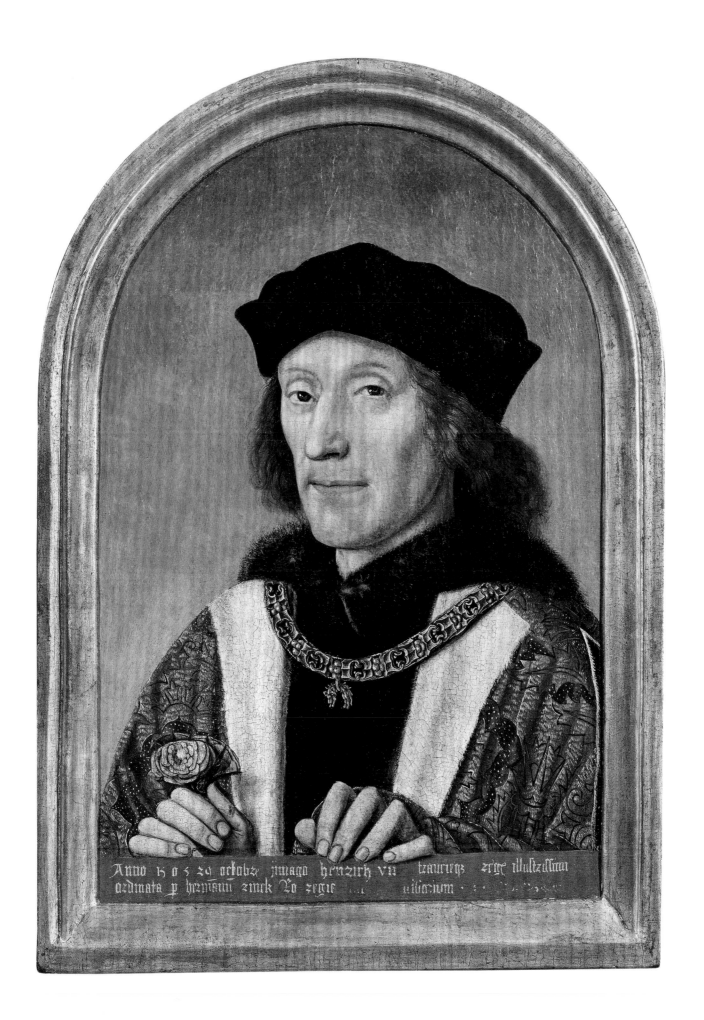

Anno 1505 20 octob: jmago hrnzirh vij briaurrug: zrige illuiz:llun
ozimata p hrzmann zinck Po zegie uiiizinum ·

4. *Creation and Fall of Man, from a Ten-Piece Set of the Story of the Redemption of Man*

Designed by an unknown Flemish artist, ca. 1497–99
Probably Brussels, before 1502
Wool (warp), wool, silk, silver, and gilded-silver metal-wrapped threads (wefts), 167¾ × 329⅛ in. (426 × 836 cm)
Cathédrale Saint-Just-et-Saint-Pasteur, Narbonne

With this tapestry, Henry VII demands to be grouped with the most fiscally extravagant and visually sophisticated European patrons of his time. In a glorious marriage of massive scale, physical sumptuousness, and a design that manages to be both decorative and narrative, this work epitomizes the finest tapestry available in Europe at the turn of the sixteenth century.

At the apex of the composition, the Trinity—God the Father, the Son, and the Holy Ghost—are enthroned in Heaven, surrounded by a host of musical angels and flanked by allegorical figures embodying Mercy and Justice. Echoing the seven days of the Creation of the World, as described in the biblical book of Genesis, the Trinity group appears seven times within the tapestry, at center creating Heaven and Earth, then, respectively, separating light from darkness, causing plants to grow, creating the sun, moon, and stars, filling the waters with fish and fowl, creating Adam and Eve, and, ultimately, having created the paradisiacal Garden of Eden, causing sinful Adam and Eve to be driven from it.

Though measuring more than 384 square feet and representing the full story of the Creation, this tapestry was actually only the first piece in a series originally composed of ten hangings, acquired by Henry VII in 1502.[1] Displayed side by side at Henry's court, the set would have stretched more than a fifth of a mile. The whereabouts of the other nine tapestries originally accompanying this hanging have been unknown since 1673. Their subjects and general appearance can, however, be reconstructed thanks to other surviving editions of this series.[2] The ten tapestries' core narrative told the Christian version of the history of the world, from the Creation, through the Infancy and the Passion of Christ, to the Last Judgment. As in the popular morality play *Elckerlyc* (1495), by Pieter van Diest, and its English free translation, *Everyman*, the narrative was approached through an allegorical lens, following the path of humanity as it vacillated between virtuous and sinful behavior, variously lured and encouraged by allegorical figures embodying vices and virtues. In English sixteenth-century descriptions this series was called "the Old Law, and the New," evoking the Creation and early days of mankind as described in the Old Testament, followed by the redemption of humanity foretold in the New

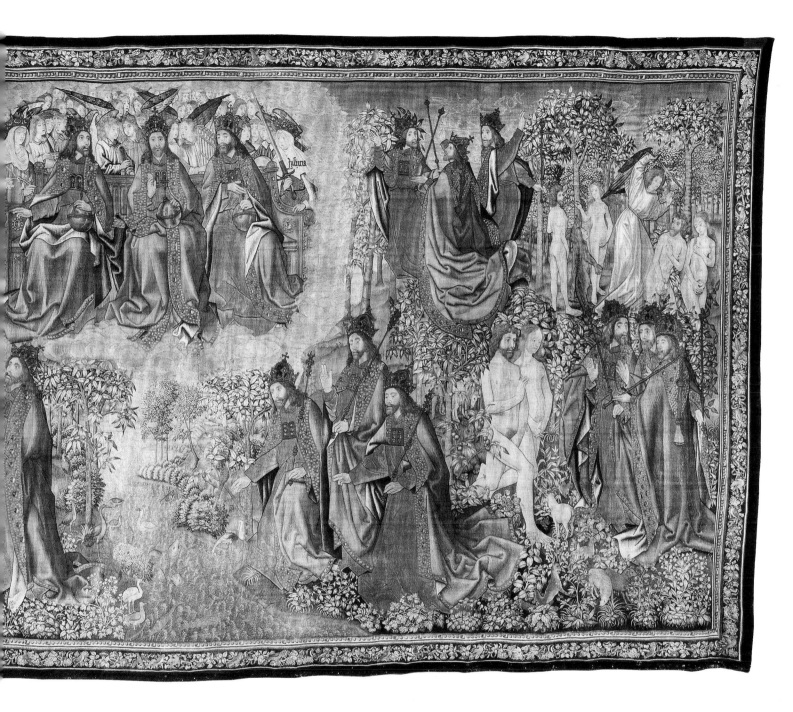

Testament.[3] Twentieth-century scholars coined the more descriptive title used here, the Story of the Redemption of Man.

Beyond Henry VII's acquisition of this set from the Brussels-based agent Pieter van Aelst, no further protagonists are documented. An as yet unidentified scholar must have conceived the series' general iconographic program, probably shared in written format.[4] An extraordinarily talented designer translated this complex schema into visual terms, managing to represent the narrative and allegorical messages in a deceptively simple and admirably coherent set of compositions. Beautifully observed details of the natural world such as waterfowl wading in a stream flow seamlessly into the fantastical and the mystical. Though the tapestries in this series were probably designed in the late 1490s, elements in all ten hangings respond to precedents of admired earlier fifteenth-century artists, like Hans Memling, cited here in the musical angels, and—above all—Rogier van der Weyden, whose figure types can be spotted throughout the series.[5] Contemporary Brussels-based artists such as the Master of the View of Sainte Gudule and Colijn de Coter, to whom this series is often attributed, are both conceivable, either working independently or, indeed, in collaboration, as was certainly common practice for such massive tapestry design projects only a few decades later.[6] Either or both painters' workshops could likewise have painted the huge, tapestry-sized cartoon models provided to the weavers.

The master weaver in whose workshop this tapestry was woven also remains undocumented. Given the size of the hangings, a team of about six journeymen weavers would have worked on each tapestry at the same time. With each weaver working at an estimated rate of approximately five square feet every month, it is likely that this large set was executed simultaneously on multiple looms, rather than each tapestry consecutively on a single loom, ensuring that it would be ready to deliver to the English king in a matter of months rather than years. Such was Pieter van Aelst's commercial acumen, he may well have subcontracted the ten tapestries across multiple workshops, meaning that the complete set could have taken as little as eighteen months to weave. Their technical virtuosity implies that these tapestries were most likely woven in Brussels, Pieter van Aelst's working base and the de facto center of weaving excellence, with accordingly higher prices than less exalted production towns like Tournai or Bruges.

As tapestry cartoons were reusable multiple times, it is perhaps not surprising that the Story of the Redemption of Man was woven in multiple editions. At least fifteen sets are documented or partially survive. The series' huge size and cerebral subject matter, however, meant that the potential patrons able to pay for and display these tapestries comprised a limited and prestigious club. Aside from Henry VII, sixteenth-century owners included Don Juan Rodriguez de Fonseca, bishop of Burgos and Palencia, as well as, probably, King Manuel I of Portugal and Philip of Burgundy, bishop of Utrecht and half brother of Charles the Bold.[7] In England by 1523, Cardinal Wolsey also owned his own edition, doubtless in conscious emulation of the royal edition.[8] Numerous small differences between the surviving examples reveal not only that different weavers were involved—none matching the sophistication of Henry's—but also that the painted cartoons seem to have been copied in minutely different duplicates, allowing for multiple sets to be on many different weavers' looms simultaneously to answer the extraordinary demand in the first two decades of the sixteenth century to own these tapestries. Although the documentation is lacking, it is likely that it was Pieter van Aelst who met, and even perhaps instigated, this demand. All these documented and surviving sets, however, were markedly less rich than Henry's, his being the only known version woven with precious silver and gilded-silver metal-wrapped threads. Given its early dating, delivered by 1502, and this most splendid and highest quality weaving, Henry VII's set is unanimously believed by scholars to have been the primary edition of the series. Certainly, eighteen years after its delivery, this set accompanied Henry VIII to France as part of the gorgeous and glittering textiles used to ornament the English pavilions at the Anglo-French royal meeting that came to be known as the Field of the Cloth of Gold.[9] EC

Notes to this entry appear on p. 305.

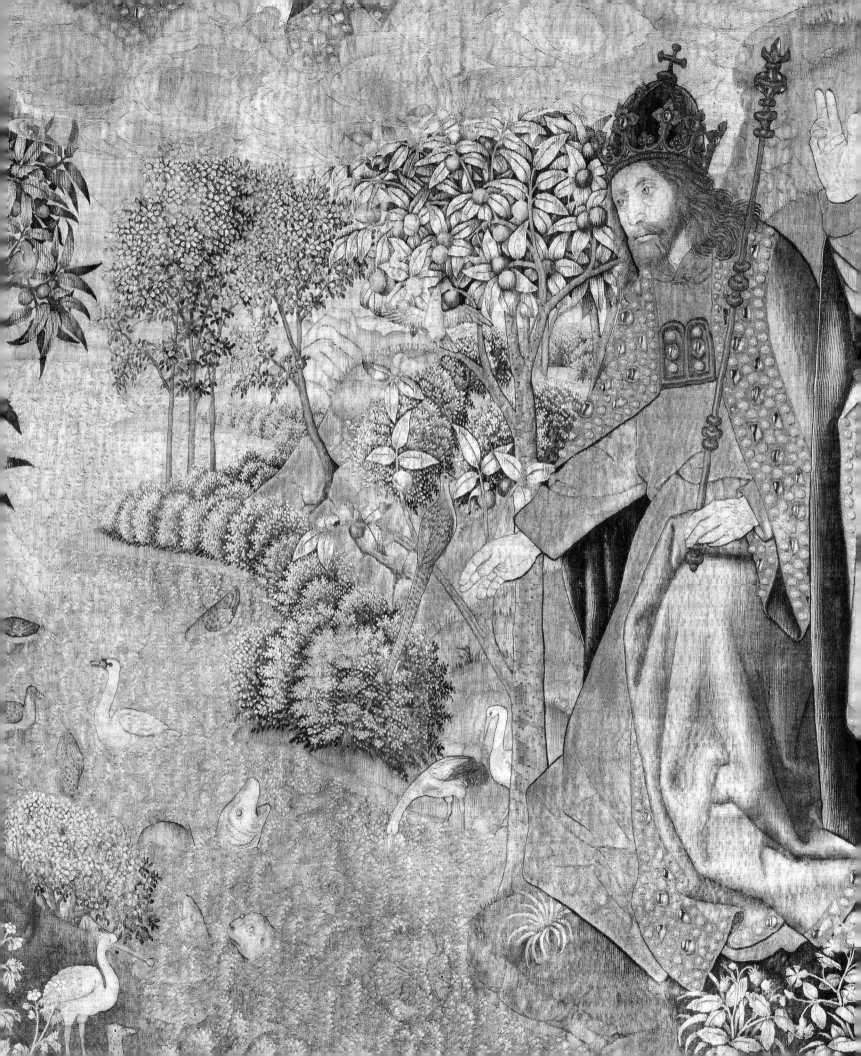

5. *Tabula Cebetis, and De Mortis Effectibus*

Written by Filippo Alberici (1470–1531); miniatures attributed to an unknown Parisian artist, with one addition (fol. 25) by an unknown English artist
Paris, 1507; additional miniature: Cambridge, after 1507
Tempera on parchment, 8 × 5½ in. (20.5 × 14 cm)
British Library, London (Arundel MS 317)
Exhibited New York and San Francisco only

Filippo Alberici, a Mantuan scholar and Servite friar of noble parentage, believed that Henry VII embodied the ideal of kingship: a triumphant, virtuous meeting of *studium* and *mars*, combining scholarship and military prowess. Or, at least, Alberici believed that Henry would be receptive enough to this praise to suitably reward his eulogizer. Accordingly, traveling in northern Europe, Alberici caused to be illuminated in Paris this manuscript dedicated to the Tudor king, which he had probably transcribed himself. It features the text of the *Tabula Cebetis*, or *Table of Cebes*, which Alberici had already translated from Greek to Latin and published in 1496, to considerable success, as a Latin primer.[1]

The *Tabula Cebetis* was so named because it had long (wrongly) been believed to have been written by Socrates's disciple Cebes. The text is an ekphrasis, a detailed description of a work of visual art as a literary device. It describes a painting purported to have been displayed in the Temple of Saturn in Thebes, which showed, via three tiered enclosures, the journey through life and the pathway to true happiness. The painting's protagonist is tempted from his path by characters such as False Learning, thus risking distraction from wisdom and happiness by dedicating too much energy to the pursuit of knowledge.[2]

Fig. 13. "Death," fols. 24v–25r of cat. 5

Alberici's manuscript for Henry VII was no hasty transcription: it was expensively illustrated with six full-page miniatures, which Alberici clearly planned very carefully. He developed the original textual ekphrasis into a clever circular conceit of images that respond to a text itself describing a lost representation. This early illustrated version of the ancient text has been described in modern scholarship as visualizing the tiers of the *Tabula Cebetis* as though they were scenes in a pageant or morality play.[3]

That Henry VII would receive Alberici and his *Tabula Cebetis* sympathetically is highly likely, given his support of other visiting European scholars like Bernard André, an Augustinian friar from Toulouse; his librarian Quintin Paule, who hailed from Lille; and the eventual scribe of his official chronicle, Polydore Vergil, from Urbino.[4] Henry clearly hoped to foster and maintain a reputation for the English court as a seat of modern learning. Unfortunately for Alberici, however, it seems that he never gained the opportunity to present his work to the king. Instead, Cambridge—home to the university then enjoying considerable attention and patronage from the king's powerful mother, Margaret Beaufort—offered a suitable reception. The final text, *De mortis effectibus*, apparently added slightly later by Alberici on blank pages at the back of the book, was dedicated not to Henry but to Joachim Bretoner, seneschal of one of the Cambridge colleges, King's Hall. Alberici also caused another miniature to be added, illustrating his contemplation of death (fig. 13).[5] Considerably different in style and execution from the Parisian miniatures in the rest of the book, the later image exhibits a startling immediacy in its muted palette, thunderous sky, and distant, sun-lit, mountainous landscape, apparently owing to a Cambridge-based, perhaps English, artist. EC

Notes to this entry appear on p. 305.

6. *Funeral Pall of Henry VII*

Florence or Lucca and London, ca. 1505
Velvet cloth of gold with applied velvet and padded satin, with laid and couched embroidery in silk and silver metal-wrapped threads, 141 × 97⅝ in. (358 × 248 cm)
Ashmolean Museum, University of Oxford (AN2009.52)
Not exhibited

On November 20, 1504, Henry VII signed an indenture with the chancellor of the University of Oxford—co-signed by John Islip, abbot of Saint Peter's Monastery, Westminster, and by the mayor of the City of London—that, in return for an annuity of £10, an annual Mass would be held in the king's honor: "for [his] good and prosperous estate . . . duryng his lif," and for the good of his soul "after [his] deceas . . . from thensforth as long as the world shall endure."[1] The arrangement also included chantry prayers foreseen for his mother, Margaret Beaufort, after her death, and for his late wife, Queen Elizabeth, and father, Edmund, 1st Duke of Richmond. An identical indenture was signed the same day between Henry and the chancellor of the University of Cambridge, John Fisher, his mother's protégé and confessor (see cat. 76).[2] Both indentures specified annual services to take place on February 11 until Henry's death, when they would shift to that anniversary. The Oxford indenture prescribed that each service after that time should have "an herse to be sette in the myddes of the same churche before the high crucifixe . . . coverd and appareled with the best and moost honorable stuffe. . . . And also foure tapers of wexe . . . to be sette aboutes the same herse." The arrangement must have resembled that of the Mass of the Dead illustrated in Henry's book of hours, subsequently given to his daughter, Margaret (fig. 14).

Although the wording is vague—the cloth covering the hearse should be "to the said universite belongyng"—it seems that Henry VII provided the requisite funeral palls, called hearse cloths, both of which have survived. Oxford's pall, seen here, is an expanse of white velvet cloth of gold; Cambridge's is of black cloth of gold, albeit lightened following centuries of corrosive oxidization of its black dye.[3] The white cloth of gold "tissue" has a design of pomegranates, thistles, and other flowers. Against crimson velvet crosses on both palls are embroidered appliqués proclaiming their Tudor donor: the royal arms of England supported by the Tudor red dragon and greyhound at center, flanked by crowned Beaufort portcullises and crowned by Lancastrian red roses. Both palls apparently were prepared by Stephen Jasper, King's Tailor, who on February 8, 1505, was paid £4 9s. 9d. to assemble a black pall and a white pall, embellished with roses and portcullises, and lined with buckram. Both textiles were likely delivered that same month.[4] In the massive expanses of

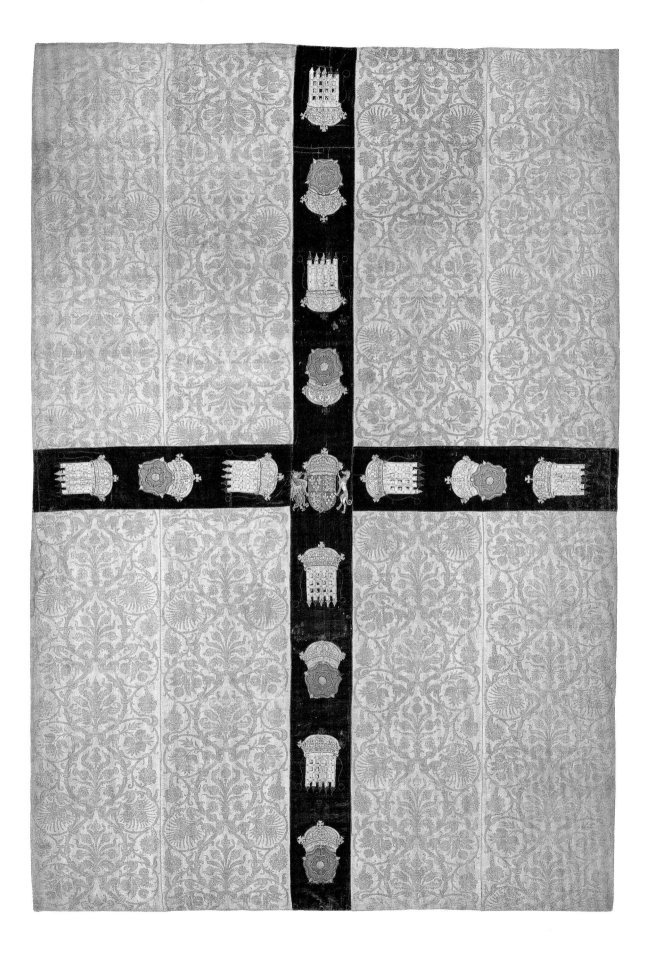

Fig. 14. "Mass of the Dead," in Henry VII's Book of Hours, ca. 1500. Tempera on vellum, 8 × 5½ in. (20.5 × 14 cm). Collection of the Duke and Duchess of Devonshire, Chatsworth House

their conspicuously expensive, imported velvets, the Oxford and Cambridge palls differ from other surviving English examples, such as the Fayrey pall (fig. 15) and the Hussey pall,[5] which have much smaller velvet panels, not much larger than a coffin's lid, with side flaps designed to snugly contain and box a coffin. In contrast Henry's university palls would envelop their symbolic—empty—coffins in a rich abundance of folds and pleats.

A remarkable survival, having been treasured for centuries after the English Reformation put an end to Henry's chantry Masses, this cloth combines English embroidery with the finest Italian textile, speaking to the Tudors' taste for sumptuous mainland European manufacture. The Oxford and Cambridge university palls are reminders that Henry VII was not only commissioning and acquiring fabulous, large-scale Italian velvets for his own use, and to accompany his regular observances at Westminster Abbey (see cat. 7). He was also concerned with the good of his soul, not to mention a more worldly desire to perpetuate and reiterate the splendid and immediately recognizable presence of his new royal dynasty throughout English seats of power. EC

Notes to this entry appear on p. 305.

Fig. 15. *The Fayrey Funeral Pall*, Italy and England, ca. 1470–1530. Velvet cloth of gold, embroidered with silk and precious-metal-wrapped threads, 100⅜ × 52¾ in. (255 × 134 cm). The Rector and Churchwardens of the Priory Church of Saint Peter, Dunstable, on loan to the Victoria and Albert Museum, London

7. Henry VII Cope

Cope: Florence or Lucca, 1499–1505
Velvet cloth of gold brocaded with loops of gilded silver and silver metal-wrapped threads
Orphrey and hood: England, ca. 1500
Linen embroidered with silk and gilded-silver metal-wrapped threads
Overall, 64⅛ × 130¾ in. (163 × 332 cm)
Trustees of the British Jesuit Province–Jesuits in Britain

This vestment is one of the most evocative and splendid survivals of Henry VII's policy of using artistic commissions to outdo his predecessors, to match his European counterparts, and to emblazon English seats of power with the highly recognizable emblems of his family's new royal dynasty.

Surviving documentation reveals that this cope was part of an ambitious and phenomenally expensive commission of a vast set of vestments, numbering well over thirty-two items, conspicuously celebrating the Tudor monarch, for use at Westminster Abbey.[1] Henry VII turned to two Italian suppliers, with whom he had already dealt on many occasions, to provide the velvets: Antonio Corsi of Florence and the Buonvisi brothers, Lorenzo and Ieronimo, of Lucca.[2] There was an urgency to complete the set quickly, but also an expectation of superlative quality. Corsi and the Buonvisi tapped both Florentine and Lucchese weavers, apparently subcontracting the velvets between multiple workshops and completing delivery of the vestments within five years.

Expediency, however, did not mean shoddy execution: the vestments were woven to shape rather than assembled from cut and sewn-together lengths, with the velvets executed in the richest, most labor-intensive technique—*riccio sopra riccio*—creating two heights of weft loops for a strongly articulated pattern, achieved using reams of gold and silver threads.[3] Though the full sum is not recorded, the cost of the set must have approached £100,000: the advance alone for just twenty copes was £1,000, while £2,259 18s. 3½ d. was the deposit for six others, temporarily returned to Italy to enable the Buonvisi to copy the pattern of those that Corsi had already supplied. Clearly, the efficacy of the message, relayed within the woven pattern, was not compromised. With extraordinary beauty and striking scale, the portcullis of Henry VII's mother's family, the Beauforts—now crowned—seems suspended from a graceful vine of Lancaster

red roses, with two Tudor roses—white petals rendered in silver thread—and a border of Lancastrian *S*'s with Tudor roses. As the vestments arrived in London, they were sent to two yeomen of the King's Wardrobe of Robes, embroiderer John Fligh and tailor Richard Smyth, who supervised nineteen "orpherers" in their addition of embroideries.[4] It should be noted, though, that the orphrey and hood now on the cope, while contemporaneous, are not the originals, since lost.[5]

Henry VII's pride in the vestments is evident in his will, in which they are singled out: "the hoole sute of vestimentes and coopes of clothe of gold tissue, wrought with our badgieus of rede roses and poortcoleys, the which we of late at our propre costes and charges caused to be made, bought and provided at Florence, in Ittalie."[6] The entry mentions that the set contained complete vestments for a priest, deacon, and subdeacon, as well as twenty-nine copes.[7] Bequeathed to the monastery at Westminster, the vestments must already have been used there, to magnificent effect, as part of the same campaign that led to Henry's building of the Lady Chapel and his tomb; all were likely commissioned about the same time. The huge size of the set and the fact that the garments were not listed among those specifically bequeathed to the Lady Chapel reveal that they were intended for use mainly at the abbey and convent rather than the chapel. The specific, uneven number of copes may have been intentional, however, and appropriate for the Lady Chapel during its annual anniversary Mass, at which the bishop (as priest), abbot (as deacon), and prior (as subdeacon) were accompanied by a decreed maximum of precisely twenty-nine monk-priests.[8]

Given the set's extraordinary richness, still appreciable in this single cope, it is not surprising that Henry VIII decreed that it should accompany him to the 1520 Anglo-French summit, the Field of the Cloth of Gold.[9] Indeed, the vestments were so much to Henry VIII's taste that, following the Dissolution of the Monasteries, he contravened the wishes of his father's will and appropriated fourteen of the vestments from Westminster for the royal collection.[10] Somewhat unexpectedly, even the austerely Protestant Edward VI was prompted to transfer additional pieces of his grandfather's sumptuous vestments away from Westminster Abbey to the royal apartments.[11] EC

Notes to this entry appear on p. 306.

8. *Saint John the Evangelist and an Unidentified Saint*

London, ca. 1505
Terracotta, *Saint John*: H. 19 in. (48 cm); *Unidentified*: H. 20½ in. (52 cm)
Victoria and Albert Museum, London (A.76-1949, A.77-1949)

These two statuettes are related to the gilded-bronze enclosure, called the "grate" in Henry VII's will, which he caused to be made for his planned tomb, itself envisioned as the culmination of the glorious chantry chapel—and shrine to Tudor legitimacy—he was constructing at Westminster Abbey (see fig. 5). Well before any work commenced on the actual tomb, the grate was begun in Henry VII's lifetime, commissioned in 1505, or possibly even earlier, from a Flemish artist documented only as "Thomas, the Dutchman."[1]

The grate was designed in the manner of an intricate, miniature building: pierced with trefoils and lancets and sporting narrow colonnettes, crocketed doorways, and fan vaulting, it echoed the late Gothic of the chapel surrounding it. Affording only glimpses of the tomb within, with entry limited to chantry priests and almsmen, the grate kept the sepulcher a private space within the chapel. Two stories of canopied niches envelop all four sides, originally intended to house thirty-two statuettes of saints, of which only six survive: John the Evangelist, Bartholomew, James the Greater, George, Edward the Confessor, and an unidentified saint, possibly Basil.[2] Although some effort has been made to suggest a possible pattern in the distribution of the twelve apostles alongside local English saints and other saints of special significance, the scheme may actually have been rather haphazard, with apparent replications of saints who also appeared elsewhere on the tomb itself, and on a planned reredos.

The present sculptures are probably casts, called squeezes, taken from the bronze statuettes made by Master Thomas for the grate. A common practice in the fifteenth and sixteenth centuries, the making of squeezes created cheap, portable, three-dimensional copies of bronze sculpture, whether as duplicates for the artist's record or as working tools from which new plaster molds could, if necessary, be made; contemporaneously in Florence, they were also used as a means to make affordable, salable replicas of pricier sculpture.[3] Saint John the Evangelist replicates identically his bronze counterpart (fig. 16), except for a slight difference in size, being marginally smaller. The second terracotta is believed to be a cast of one of the lost statuettes, given how closely it resembles the bronze figures in style, size, and silhouette. Although identification of this second statuette as Saint James the Greater is tempting—the shape on the upturned brim of his hat resembles the cockleshell symbolic of his shrine at Santiago de Compostela—the bronze figure of Saint James

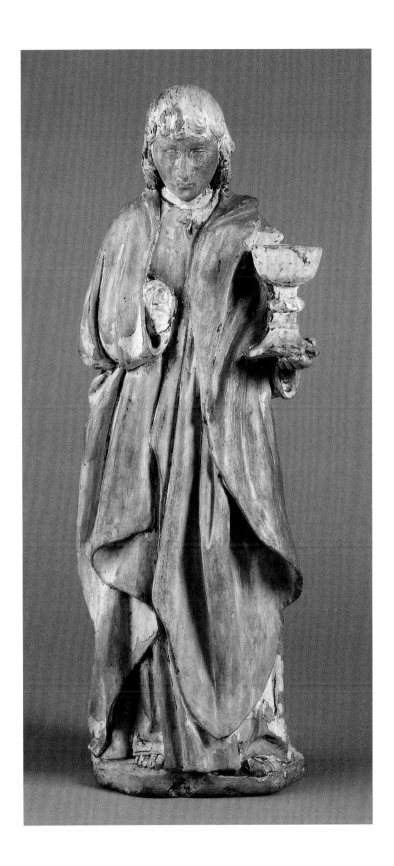

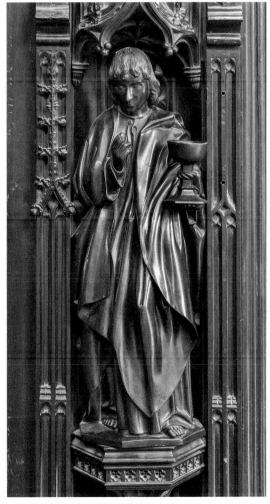

Fig. 16. *Saint John the Evangelist*, from the bronze grate surrounding the tomb of Henry VII and Elizabeth of York, Westminster Abbey, London, ca. 1505

survives on the grate and differs substantially from the terracotta. When these squeezes were made remains debatable. Stylistically and technically, they are typical of the early sixteenth century, when Master Thomas's bronzes were accessible before installation on the grate; thermoluminescence testing, on the other hand, suggests a considerably later, eighteenth-century dating, by which time the figure of the Evangelist, at least, was recorded as permanently attached to the grate, where it has apparently remained ever since.[4]

Although Master Thomas's gilded-bronze grate was underway during Henry VII's lifetime, no work had yet been started on the grand tomb that Henry intended it to encircle, located in the center of his new chapel, in front of the high altar and beside a shrine to Henry VI.[5] In any event Henry VIII met very few of his father's wishes: lobbying for Henry VI's sainthood was abandoned; his earthly remains were never transferred from Windsor to Westminster; the ornate two-tiered tomb designed by the Modenese artist Guido Mazzoni that Henry VII had approved for himself was dropped; and the tomb's location within the chapel shifted east, apparently leaving the plum central spot free for Henry VIII himself to use (although he never did; see cats. 16, 17).[6] Even the inscriptions were amended, declaring, "The parents were happy in their offspring, to whom you, land of England, owe Henry VIII"![7] Henry VIII did, however, honor his parents by selecting the Florentine sculptor Pietro Torrigiano, newly arrived from Margaret of Austria's court in Mechelen, to create the effigy figures and tomb chest. Torrigiano was already working on the nearby monument to Margaret Beaufort, and soon after would undertake a handful of commissions for Tudor courtiers (cat. 76).[8] With its shield-bearing naked putti and the disarming naturalism of the childlike angels seated at its corners, Torrigiano's tomb for Henry VII and Elizabeth of York brought the Italian Renaissance to the heart of Tudor England, and makes for an unexpected juxtaposition glimpsed through the late Gothic tracery of the Netherlandish Thomas's grate, with its somber ranks of drapery-shrouded saints. EC

Notes to this entry appear on p. 306.

9. *Henry VIII of England*

Hans Holbein the Younger (1497/98–1543)
ca. 1537
Oil on panel, 11 × 7⅞ in. (28 × 20 cm)
Museo Nacional Thyssen-Bornemisza, Madrid (191 [1934.39])
Exhibited New York only

Although Hans Holbein's portraits have indelibly shaped the public imagination of Henry VIII and his court, this panel portrait is the only autograph painted likeness of the king by Hans Holbein the Younger known to survive today. Closely linked to Holbein's lost mural of the Tudor succession for Whitehall Palace (fig. 17), this portrait is nonetheless distinct in its medium, function, and costly materials.

The king appears splendidly attired in cloth of silver and gold, his broad chest patterned with rubies and arabesque blackwork embroidery. A chain of linked gold *H*'s hangs around his neck. At the panel's bottom edge, Henry grasps a leather glove in one bejeweled fist, while the knuckles of his other hand seem to rest on a ledge just cropped from view. The feathers trimming Henry's hat and the linen pulled through the slashing of his doublet rhythmically punctuate the painting's surface with flashes of white.

Holbein's use of precious materials gives an indexical quality to his depiction of regal splendor. Susan Foister notes that the portrait's "relatively small size and its lavish use of gold and the precious blue pigment ultramarine . . . make it a precious object as much as a painting," comparable to the similarly exquisite miniatures of Lucas Horenbout (see, for example, cat. 50).[1] Flat blue backgrounds link both the panel portrait and Horenbout's miniatures. These backgrounds heighten the iconic quality of the likeness; in the words of Stephanie Buck, "By renouncing the spatially defined surroundings that would have served to localise them, by instead setting them against a flat plane of colour, Holbein . . . lifts his sitters out of the temporal dimension."[2] The relatively flattened and ornamental surfaces of these royal portraits point the way toward the aesthetic that flourished under Henry's daughter Elizabeth, suggesting that the caesura between Holbein's portraits and later English painting may not be as wide as it initially seems.

Although Henry appears in three-quarter profile in both this portrait and the Whitehall cartoon, surviving copies based on the final mural indicate that at some point Holbein altered the likeness to be fully frontal (see cat. 10).[3] Both the cartoon and the present panel painting probably derive from the same, lost preparatory portrait drawing, although their exact sequence has been the subject of debate. Unlike the full-length, swaggering

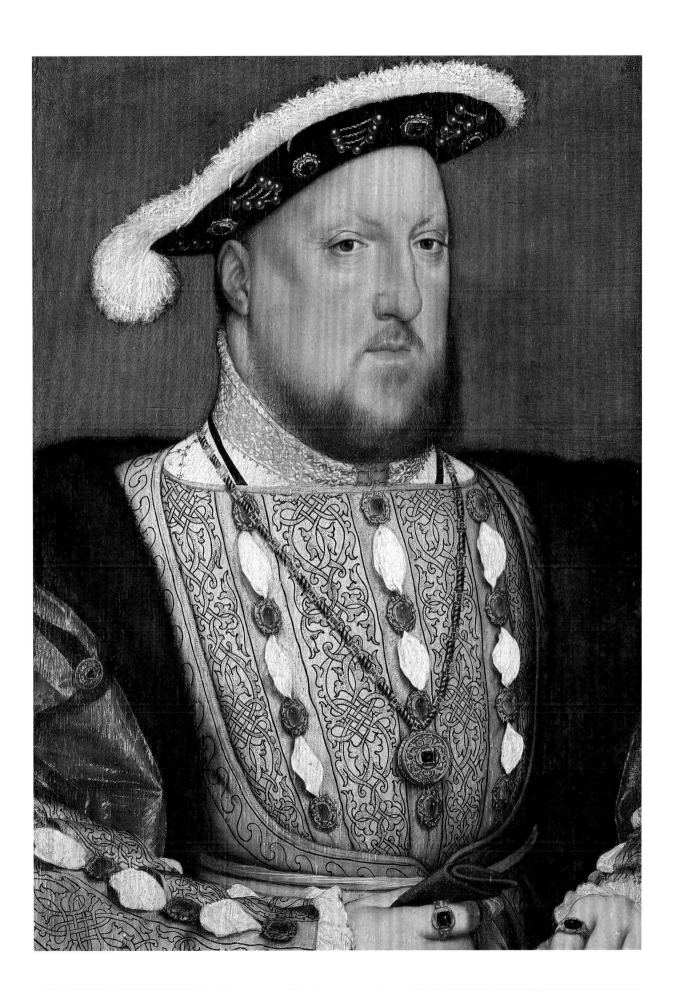

Fig. 17. Hans Holbein the Younger (1497/98–1543), *Henry VIII and Henry VII*, detail from a preparatory cartoon for *The Whitehall Mural*, ca. 1536–37. Ink and watercolor, 101½ × 54 in. (257.8 × 137.2 cm). National Portrait Gallery, London (NPG 4027)

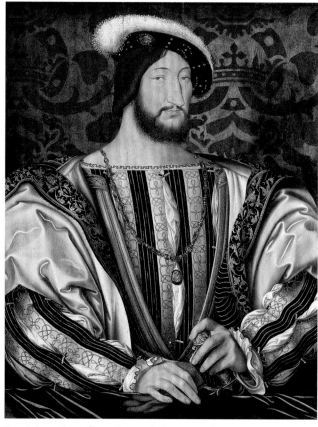

Fig. 18. Jean Clouet (ca. 1485–1540), *François I of France*, ca. 1525–30. Oil on panel, 37¾ × 29⅛ in. (96 × 74 cm). Musée du Louvre, Paris (3256)

depiction that Holbein devised for the Privy Chamber at Whitehall, this portrait's bust-length scale perhaps aided its movement as a diplomatic gift. It has been argued convincingly that the portrait was destined for the king's great rival, François I of France, part of the regular traffic in royal likenesses that included the first portrait miniatures.[4] In both its composition and its material richness, the present painting responds to the sophisticated portraits of François I by Jean Clouet and his circle (fig. 18). The lack of surviving French royal inventories from the period leaves this theory speculative; it is intriguing, however, that unlike the Whitehall cartoon, cat. 9 does not appear to have inspired any sixteenth-century copies, suggesting that it left England shortly after it was painted, only to return sometime in the seventeenth century.[5]

A number of scholars have attempted to connect the present portrait with English royal inventories listing folding diptychs with the portraits of Henry VIII and Jane Seymour.[6] However, the painting's original unpainted verso mitigates against the notion that it once formed part of a diptych.[7] Nonetheless, this panel portrait of Henry; the *Jane Seymour* in the Kunsthistorisches Museum, Vienna (cat. 85); and the *Edward VI as a Child* in the National Gallery of Art, Washington, D.C. (cat. 51), form a distinct subgroup within Holbein's English portraits, in which rich materials and an almost obsessive reproduction of royal attire created some of the most recognizable likenesses of the Tudor court. A E

Notes to this entry appear on p. 306.

10. *Henry VIII*

Workshop of Hans Holbein the Younger (1497/98–1543)
ca. 1540
Black, red, and white chalk, on pink paper, 12⅛ × 9⅝ in. (30.7 × 24.4 cm)
Staatliche Graphische Sammlung, Munich
Not exhibited

11. *Henry VIII*

Workshop of Hans Holbein the Younger (1497/98–1543)
ca. 1540
Oil on panel, 93⅝ × 52¾ in. (237.9 × 134 cm)
Walker Art Gallery, National Museums Liverpool (WAG 1350)
Exhibited New York and Cleveland only

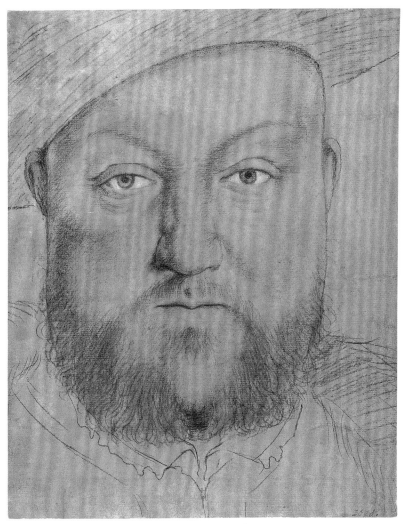

Cat. 10

The full-length likenesses that Hans Holbein and his assistants or emulators produced of Henry VIII marked a major turning point in English royal portraiture, endowing it with an unprecedented aggression and scale.[1] Yet despite their influence, these portraits present significant problems of attribution, connected to the many unanswered questions about Holbein's English workshop.

A fire at Whitehall Palace in 1698 destroyed Holbein's largest image of Henry VIII, a mural that depicted him with his father, mother, and third wife, Jane Seymour. Our primary pieces of evidence for the mural's appearance are Holbein's cartoon for the figures of Henry VII and Henry VIII (see fig. 17) and a copy painted in 1667 by Remigius van Leemput (see fig. 92). A comparison of cartoon and copy reveals that, at some point, Holbein altered his composition to replace the three-quarter view of Henry VIII from the portrait now in Madrid (cat. 9) with a fully frontal likeness.[2] The drawing seen here, now in Munich (cat. 10), may be a copy after Holbein's preparatory study for this new depiction of the king.[3] Although the quality of the draftsmanship is high, the outlines of the head and ears have a heaviness distinct from Holbein's portrait drawings. The inscription "Hans Swarttung" on the drawing's verso may refer to an otherwise unknown assistant in Holbein's workshop.

Holbein's Whitehall mural soon prompted copies that removed Henry VIII from the larger composition to make him the focus of a single-figure portrait. Two of these—the versions now in the Walker Art Gallery, Liverpool (cat. 11), and at Petworth House—retain architectural elements of the Whitehall mural, with its shell-shaped alcove framing the king's head, while introducing new elements such as the damask curtain occupying the place of Henry VII in the Liverpool version.[4] The full-length painted copies give a sense of the sumptuous environment of the royal palace, enlivening the outlines of the Whitehall cartoon with vivid color. Henry plants his feet on an

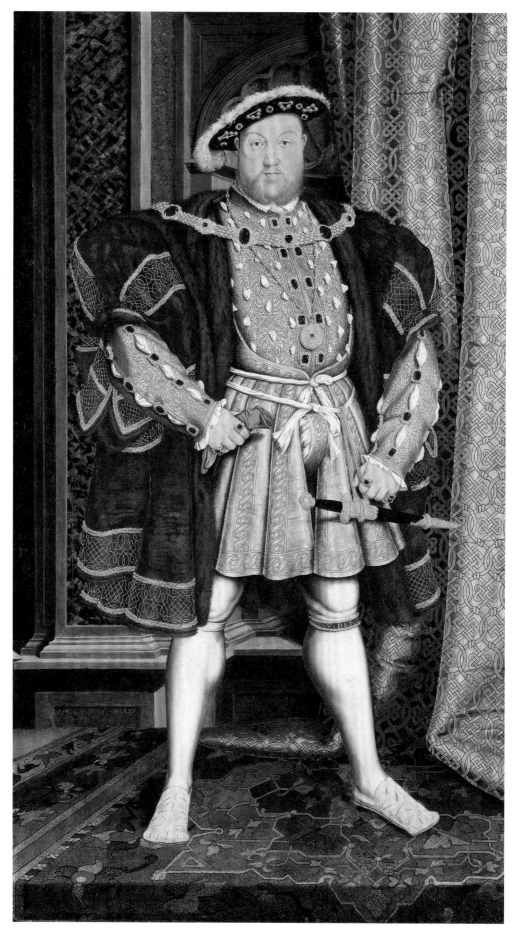

Cat. 11

Islamic carpet, standing in front of walls apparently paneled in precious malachite and porphyry.

Both the Walker and Petworth portraits have provenances connecting them to the family of Jane Seymour, the queen who appears in the Whitehall mural and whose brothers were prominent courtiers after her death and during the reign of her son, Edward VI.[5] Never in recent decades convincingly attributed to Holbein himself, the portraits' authorship remains unclear; the artists of both works must have had access to Holbein's drawings or to the Whitehall mural itself, and dendrochronological dating places them within Holbein's lifetime, suggesting that they may have been produced under his supervision.[6] Yet almost nothing is known today about Holbein's assistants in England; as Susan Foister has noted:

> Although more than one version exists of some of his English portraits, there are no surviving secondary versions which are the work of Holbein himself, and few which appear close to him in style. Moreover, although one or two assistants to a foreign painter in royal service might have been tolerated, a very large workshop producing multiple replicas might have attracted protests from Holbein's English contemporaries. The existence of a Holbein workshop remains an open question.[7]

This uncertainty about the attribution of major royal portraits commissioned by leading courtiers is itself informative about the place of painting in Tudor England (see "Hans Holbein and the Status of Tudor Painting" in this volume). Henry VIII's portraits served as statements of his authority, the lavish palaces he occupied, and the wealth and power he commanded. As the originator of pictorial prototypes, Holbein was a valued royal servant. But his particular authorship of a given portrait does not seem to have been of primary importance to those seeking out the imposing likeness of his most powerful patron. AE

Notes to this entry appear on p. 306.

12. *Acts of the Apostles and the Apocalypse*

Translated by Desiderius Erasmus (1466–1536); transcribed by Pieter Meghen (1466/67–1540); one miniature (fol. 4r) attributed to Lucas Horenbout (ca. 1490/95–1544) or Susanna Horenbout (active ca. 1520–50), and another (fol. 168) to an unknown Netherlandish artist
London, ca. 1519–27
Tempera on vellum, 17⅞ × 13 in. (45.5 × 33 cm)
Marquess of Salisbury, Hatfield House, Hertfordshire (Cecil Papers, MS 324)
Exhibited New York and Cleveland only

This manuscript suggests that Henry VII's bibliographic interests (see cat. 5) were shared and developed by his son, for it is the fruit of the European talent that Henry VIII likewise continued to lure to the English court. Heraldically, its major illumination reiterates Henry VIII's marital alliance with the Trastámara dynasty (and, by extension, their Habsburg cousins), the conspicuous *H+K* monogram celebrating Henry and his Spanish wife, Katherine of Aragon. In the early years of their marriage, when Katherine was still feted at court, this monogram must have been ubiquitous, for instance, in the "pavilion of crimsin damaske and purple, powdered with H. and K. of fine gold, valansed and fringed with gold of damaske: on the top of everie pavilion a great K. of goldsmiths worke," documented at the 1511 tournament following the birth of Katherine and Henry's short-lived son (fig. 19).[1] Here, against the green and white Tudor heraldic colors, the monogram is accompanied by the arms of England, crowned and supported by the Tudor dragon and greyhound, and flanked by the Beaufort portcullis of Henry's grandmother and by the Tudor rose. Appearing twice on the page, the rose is portrayed *en soleil*, as if emitting golden rays of sunlight. The fleur-de-lis is a flattering allusion to Henry VIII's Valois great-grandmother and the English Crown's continued claim to French sovereignty, albeit now reduced to Calais and its immediate environs.

Speaking to the flourishing scholarship in England at this date, Erasmus's Latin translation of his new Greek edition of the Bible is presented literally in parallel with the traditional Latin Vulgate text, in two columns side by side. The texts are those of the biblical book of the Acts of the Apostles, as well as the account of the Apocalypse from Revelation. The Acts of Saint Peter and Saint Paul were particularly relevant about this time, as Henry championed Paul (see cat. 49) while increasingly questioning Petrine authority, and with it the papacy and the Roman Catholic Church, eventually culminating in his 1534 Act of Supremacy declaring himself the head of the English Catholic Church. The book's scribe was the Fleming Pieter Meghen, and based on the style of his script, the text is dated sometime after 1518.[2] Meghen, or Meghen working for Erasmus, might originally

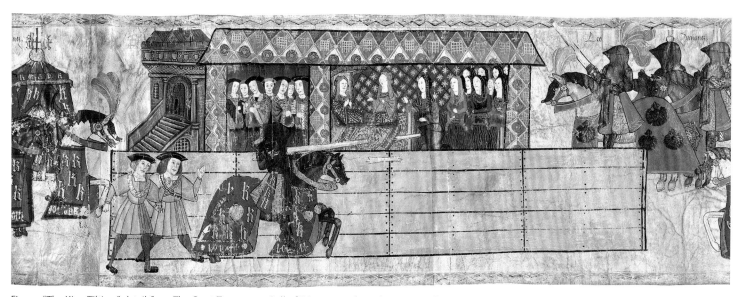

Fig. 19. "The King Tilting," detail from *The Great Tournament Roll of Westminster* (membranes 24–27), ca. 1511. The College of Arms, London

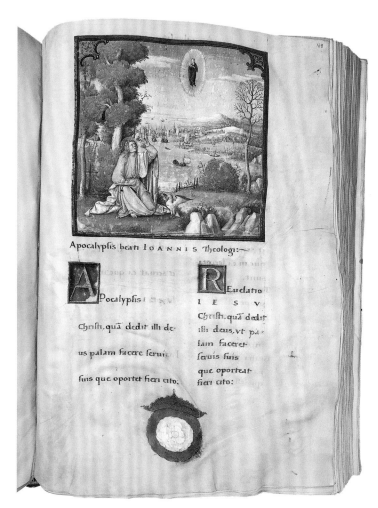

Fig. 20. "John the Evangelist on the Island of Patmos," fol. 168 of cat. 12

have intended this manuscript as a final volume to an earlier three-piece set made for John Colet, Erasmus's confessor and the dean of Saint Paul's Cathedral (see p. 27 in this volume), from which Acts and Revelation are missing.[3] Colet's death in September 1519 apparently prompted Meghen, or Erasmus, to instead complete the manuscript as a standalone work to present to Henry VIII, commissioning two illuminations to customize and embellish it accordingly.[4]

The miniature representing John the Evangelist on the island of Patmos (fig. 20), magnificently rendered within a sweeping landscape, reveals a Netherlandish artist, perhaps from the circle of the Master of James IV of Scotland, working at the forefront of the profession. This artist was probably not also responsible for the first miniature in the book, representing Saint Luke in his study, with the splendid border, discussed above, celebrating Tudor England.[5] The Luke miniature is often attributed to one of the Horenbout siblings, Lucas or Susanna, who arrived in England from Flanders, briefly accompanied by their father, Gerard, in the 1520s.[6] Gerard Horenbout, a celebrated master from Ghent, had been named Painter to Margaret of Austria, Governor of the Habsburg Netherlands, in 1515. By 1525 his son, Lucas, was receiving payments for work for Henry VIII. It was, however, Gerard's daughter, Susanna—about whom the English royal account books remain frustratingly mute—who had been noticed by Albrecht Dürer back in Antwerp in 1521, when he bought and admired her work, albeit with slightly double-edged praise: "It is very wonderful that a woman can do so much."[7] Saint Luke is represented in his study in bold, saturated colors,

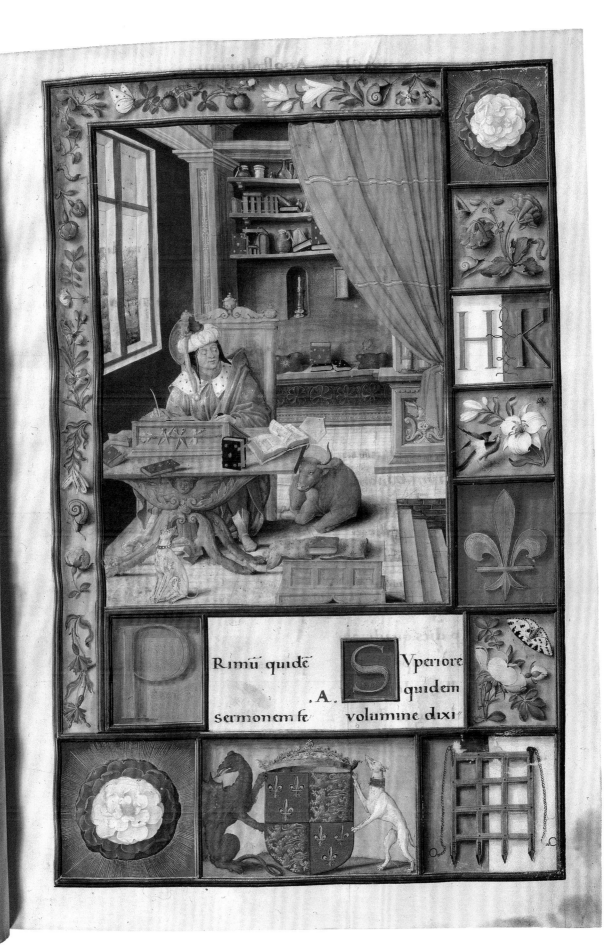

Rimū quidē S Vperiore
 .A. quidem
sermonem fe volumine dixi

with the same fine level of detailing appreciable in the formative portrait miniatures attributed to Lucas around this date (cats. 77, 78). Whether Lucas or Susanna, the artist developed the narrative appeal of the scene as a book miniature; in composition and setting, it meets the challenge of Dürer's immensely successful engraving of Saint Jerome in his study, made some years earlier.

Apparently reaching the king (and subsequently passing to the Cecils, perhaps as a gift from Elizabeth I), the manuscript might have helped promote the careers of its creators: Pieter Meghen was appointed Writer of the King's Books in March 1530, and Lucas Horenbout was named King's Painter in 1531, conferred for life by 1534. Famously, his annual salary of £33 6s. was more than Hans Holbein's, and his annuity, at well over £60, more than double. Alongside the miniatures associated with Lucas, other work for Henry might have included the design of the frontispiece of the Great Bible (cat. 21) and, perhaps, the illumination of some of its interior pages (see fig. 27). Susanna's role remains woefully opaque.

The Acts manuscript is often dated to later in the Horenbouts' London career, to between 1528 and 1533.[8] Such a date would disregard its evident association with Colet's much earlier project. More particularly, even the least informed courtier would have realized that the conspicuous *H+K* monogram would earn them no favors from Henry VIII: already in May 1527, the king had assembled a body of lawyers and bishops to deliberate how to void his marriage to Katherine, and by 1529 the marriage was under trial in open papal court. By 1531 Katherine had been effectively banished from court, and Henry was living openly with Anne Boleyn as his queen—a matter ultimately legitimized in May 1533. EC

Notes to this entry appear on p. 306.

13. *Mary Tudor, Later Queen of France and Duchess of Suffolk*

Michel Sittow (1468–1525/26)
ca. 1514
Oil on panel, 11⁵⁄₁₆ × 8¼ in. (28.7 × 21 cm)
Gemäldegalerie, Kunsthistorisches Museum, Vienna (GG 5612)
Exhibited New York only

The sitter in this sensitive portrait of a woman in her teens or early twenties has recently been identified as Mary Tudor, younger sister of Henry VIII, by the Estonian painter Michel Sittow.[1] Posed frontally before a green background now darkened with age,[2] she wears a deep red gown with a low, square neckline; a close-fitting, multilayered headdress covers her reddish-gold hair. Finely sculpted facial features, sumptuous garments, and glittering jewels are all meticulously rendered with smooth, virtually undiscernible brushstrokes.

In 1915 Max J. Friedländer identified the subject of this portrait as Katherine of Aragon.[3] His argument was largely informed by the jewels that feature so prominently in the painting: the border of gold cockleshells centered by a tiny *C* that ornaments the neckline of the bodice; and a heavy gold collar necklace set with jewels, pearls, and alternating enameled roses and the initial *K*. As roses were a symbol of the Tudor dynasty and cockleshells the symbol of Santiago (Saint James), the patron saint of Spain, Friedländer theorized that the woman was a Spanish princess with ties to the Tudor court and a name commencing with C or K—plausibly Katherine of Aragon, who married Henry's brother Arthur, Prince of Wales, in 1501 and Henry himself in 1509. However, the physiognomy of the sitter differs considerably from documented likenesses of Katherine, which show her to be stout with small eyes, a pointed chin, and a tightly held mouth.[4] The style of the painting fits most comfortably with Sittow's portraits of about 1515, by which time Katherine would have been about thirty—considerably older than the young woman depicted here.

The identification of the artist as Michel Sittow was first proposed in 1933 by Gustav Glück.[5] Originally from Reval (Tallinn) in Estonia, Sittow came to Bruges in 1484 and may have completed his artistic training under Hans Memling. From 1492 until 1502, Sittow worked for Isabella I of Castile at the Spanish court, painting portraits and some religious works. By late 1505 or early 1506, he was working for Isabella's son-in-law, Philip the Fair, Duke of Burgundy. Following a period in Reval, by 1515 Sittow was back in the Netherlands in the service of Philip's sister, Margaret of Austria, and her nephew Charles V, the future Holy Roman Emperor. In attributing the present portrait (then still assumed to be a likeness of Katherine of Aragon) to Sittow,

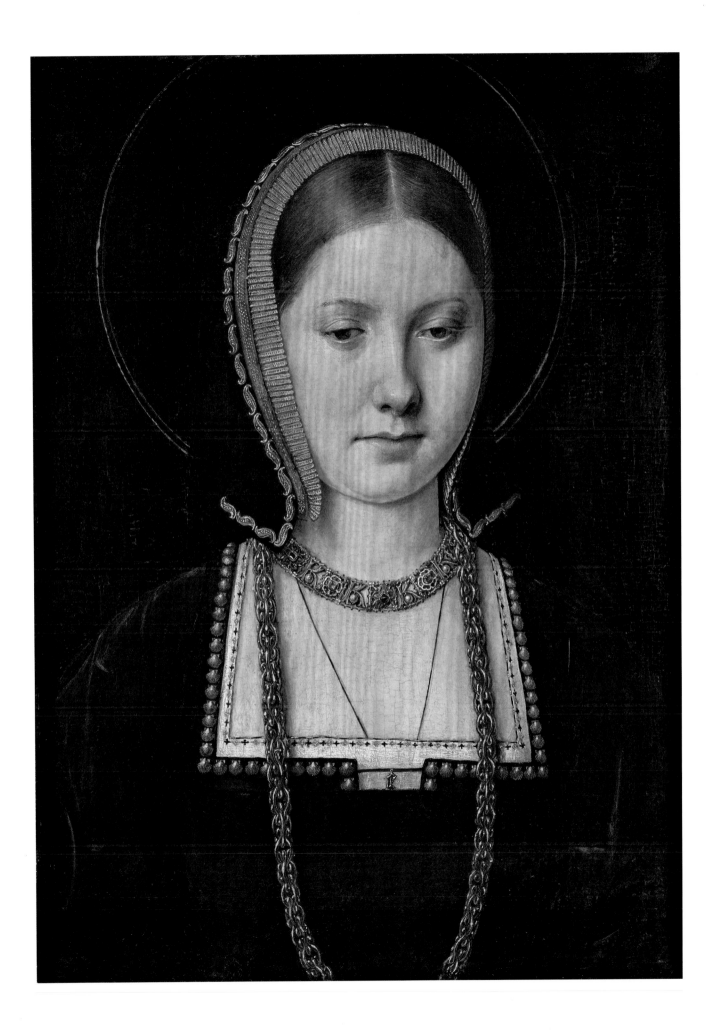

Glück proposed that it had been painted during a hypothetical visit by the artist to England in 1505.[6]

While there is no documentary evidence to support either Friedländer's proposed identification of the sitter or Glück's revised chronology for the artist, an identification as Mary Tudor appears better substantiated. In 1506 Mary was betrothed to Charles V, then aged six, in an alliance that would potentially unite two of the most powerful ruling houses in Europe. A marriage by proxy took place in late 1508, celebrated by a week of festivities, during which the imperial ambassadors presented Mary with a gift from her young groom: a large piece of jewelry with a *K* (for "Karolus") garnished with diamonds and pearls and an inscription praising Mary's holy namesake.[7] It is not known what Charles's gift looked like, whether it was similar or identical to the necklace worn in cat. 13, but this type of jewelry, incorporating initials and devices alluding to royal or noble lineage and marital alliance, was a popular fashion among the Burgundian nobility.[8] The stylized roses seen here may allude to both the Tudor dynasty and Mary's second name, Rose. Mary is clothed in Franco-Burgundian fashions, characterized in part by a close-fitting cloth hood instead of the gabled headdress then popular in England.[9] It was customary that, upon betrothal, princesses adopt the national costume of their future partners. Indeed, Henry VIII wanted Mary's wedding dress to be in the Burgundian style,[10] and Mary herself wrote to her aunt, Margaret of Austria, "for a long time I have had the desire to know how the ornaments and clothing that are used over there [in Flanders] will fit me and now that I have tried them I am greatly contented with them."[11] Despite the long betrothal, however, the marriage ceremony between Mary and Charles planned for 1514 did not take place, and in October of that year, Mary was married to Louis XII of France.

Mary was regarded as one of the beauties of her age, with blue eyes and golden hair tinged with red. There is, however, no consistency to portraits assumed to have been made of her, and thus no concrete evidence of her appearance. If this sweetly haunting portrait is a likeness of Mary Tudor, it is possible that Sittow painted it in London on commission from Margaret of Austria. In the mid-1510s the archduchess ordered a number of portraits in connection with the betrothals of her nieces and nephews, from Sittow and from other artists in her employ. The inventory of her extensive art collection lists multiple portraits of Mary Tudor, although none are explicitly described as by Sittow and cannot by their description be associated with the present painting.[12] How and when Sittow might have made it to England is not known. In late June 1514 the Habsburg envoy sent to London to placate Henry VIII over the failed marital alliance wrote to the archduchess, "The painter has made a good likeness of Mary."[13] It is possible that Sittow visited London en route to the Danish court at Copenhagen, where he is documented on June 1, 1514, and painted this portrait of the king's sister at that time.

As has frequently been noted, there is a marked similarity between the face of the sitter in this portrait and that of Mary Magdalene in Sittow's painting in Detroit (fig. 21) and of the Virgin in his *Madonna and Child* in Berlin,[14] both of which have been dated to about 1515. Most likely, Sittow adopted his subject's refined facial features to express the perfect beauty of the religious exemplars who shared her name. MEW

Notes to this entry appear on p. 306.

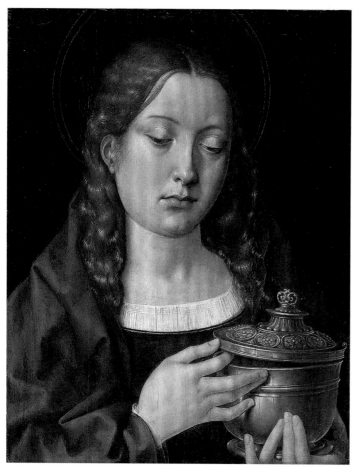

Fig. 21. Michel Sittow (1468–1525/26), *Mary Magdalene*, 15th–16th century. Oil on panel, 12 1/16 × 9 7/16 in. (30.7 × 24 cm). Detroit Institute of Arts (40.50)

14. Book of Hours of Mary of England, Queen of France

Miniatures attributed to Jean Poyet (active 1483–1503), with additions by Jean Bourdichon (1457–1521) and Master of Claude de France (active ca. 1514–26)
Tours, ca. 1495–1500, with additions ca. 1514
Tempera on vellum, 5¼ × 3½ in. (13.2 × 9 cm)
Bibliothèque Municipale (Part-Dieu), Lyon (MS 1558)
Exhibited New York only

Henry VIII continued his father's policy of using marital alliances to build political allegiance; it was Cardinal Wolsey who brokered the marriage of Henry's younger and reputedly favorite sister, Mary, to the French king Louis XII. In October 1514 the eighteen-year-old Tudor princess sailed to France to wed Louis, who died within three months of the marriage, aged fifty-two.

The pageantry, albeit short-lived, surrounding this important Anglo-French union and the elevation of Henry's sister to Queen of France was eagerly watched by the rest of Europe, evidenced with particular evocation by the diarist Marino Sanuto's summaries of dispatches sent to Venice from the French court: "In truth the pomp of the English was as grand and costly as words can express; and the princes and nobles of France, and the ladies likewise, vied with them, for the whole of the French court sparkles with jewels, gold, and brocades."[1] Showering his young Tudor wife with appropriately luxurious gifts, Louis also apparently customized some very high-end secondhand objects.[2] This small but finely executed book of hours is such an example, having been created about fifteen years earlier, with miniatures attributed to Jean Poyet, a talented artist who enjoyed

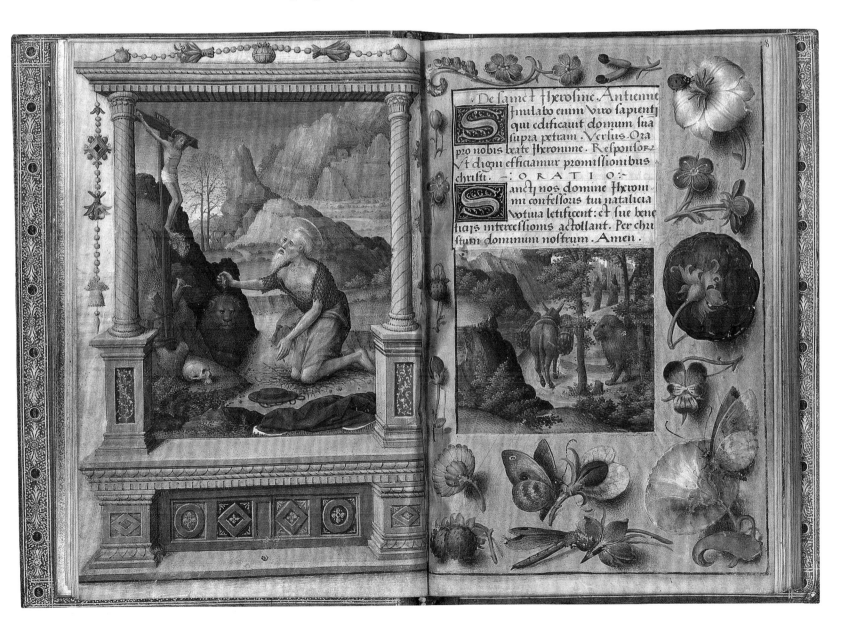

Fig. 22. "Adoration of the Magi," fols. 35v–36r of cat. 14, with Mary Tudor's inscription

the patronage of, among others, Louis's second wife, Anne of Brittany, and whose miniatures also embellish another book of hours putatively associated with Henry VIII.[3]

In preparing to gift this book of hours to Mary, the French king caused extra pages to be tipped into the manuscript. One of these added illuminations, with two angels holding a chalice and Host, is by Jean Bourdichon, who had also illuminated work for Anne of Brittany, as well as a further book of hours for Louis XII that then traveled to England, perhaps also with Mary.[4] A second added pair of pages, with miniatures of Saint Jerome in penitence and of a landscape with a donkey and a lion, was decorated by another manuscript painter who often enjoyed court patronage; he was known as the Master of Claude de France, owing to his work for Anne's daughter, Princess Claude.[5] His contribution to Mary's book of hours is rendered distinct from the rest of the manuscript by the rich, golden ground of its border, against which exquisitely observed insects, fruits, and blooms seem to rest on the page's surface beside a large and lovely rose, suitably red for the Lancastrian lineage of Louis's bride.

That Mary handled this manuscript, and possibly used it during her daily devotions, is witnessed by the two inscriptions she has noted in it, in her own hand.[6] One regifts the book onward to another recipient: "Henrico, ejus nomins octavo, Anglie et Francie regi illustrissimo, Maria, Francorum regina, ejus soror serenissima, hunc librum D.D. 1530 [In 1530, Mary, Queen of France, his most serene sister, gave this book to the most illustrious Henry, eighth of his name, King of England and France]." The other inscription, in less formal script and a different ink, is perhaps also intended for her brother's attention, placed as it is opposite the Adoration of the Magi (fig. 22): "Your louffing frend and evere vole be dowryng my lyffe Marie, the

French queen [Your loving friend and ever will be during my life Mary, the French queen]." Mary's gift of the manuscript to Henry was part of an endeavor to regain her brother's good opinion: following Louis's sudden death, concerned that she would be forced into a second marriage of political convenience by the new French king, François I, or indeed by her own brother, Mary had instead raised Henry's ire by famously marrying—without the Tudor king's permission—her lover, Henry's good friend Captain Charles Brandon, her retinue's escort to France.

This manuscript bears witness not only to the brief reign of the Tudor queen of France, but also to the subsequent reconciliation efforts between the Tudor siblings. Louis XII thought the manuscript's artistry worthy of his new queen; Mary believed it covetable enough to win back her brother's good regard, eventually succeeding in regaining Henry's trust. The Brandons' grandchildren were recognized as Henry's heirs, second only to his own offspring and above the heirs of their elder sister, Margaret Tudor Stuart, Queen of Scots: in July 1553, Mary's granddaughter, Lady Jane Grey, would hold the English throne for all of nine days, before her dethroning and eventual execution by her mother's cousin, the other Mary Tudor: Mary I. EC

Notes to this entry appear on p. 306.

15. *Furnishing Textile*

Florence, late 15th–mid-16th century
Three loom widths of velvet cloth of gold with *allucciolato* effect and bouclé loops of gilded-silver metal-wrapped threads, 125½ × 68 in. (318.8 × 167.6 cm)
The Metropolitan Museum of Art, New York, Bequest of Susan Dwight Bliss, 1966 (67.55.101)

This magnificent cloth of gold is made of three loom widths of cut-and-voided silk velvet enhanced by precious gilded-silver metal-wrapped threads.[1] Woven in crimson silk pile and exhibiting a typical Renaissance Florentine asymmetrical design, with a pomegranate as the central motif, the panel suggests an original function as a furnishing textile: the structurally strong weave coupled with the large design pattern indicates that it was created for display as a wall covering, rather than for clothing.[2]

This velvet was recently cited as an example of the portable, luxurious furnishing textiles that Henry VIII purchased from the Florentine market to decorate his temporary palaces (see "Furnishing the Palace" in this volume).[3] An attribution to Henry is suggested by the tentative identification of the Tudor rose among the floral elements suspended between the main curve line of the design, on the proper right side of each loom width. The flower's red interior, white contours, and pointy leaves recall those

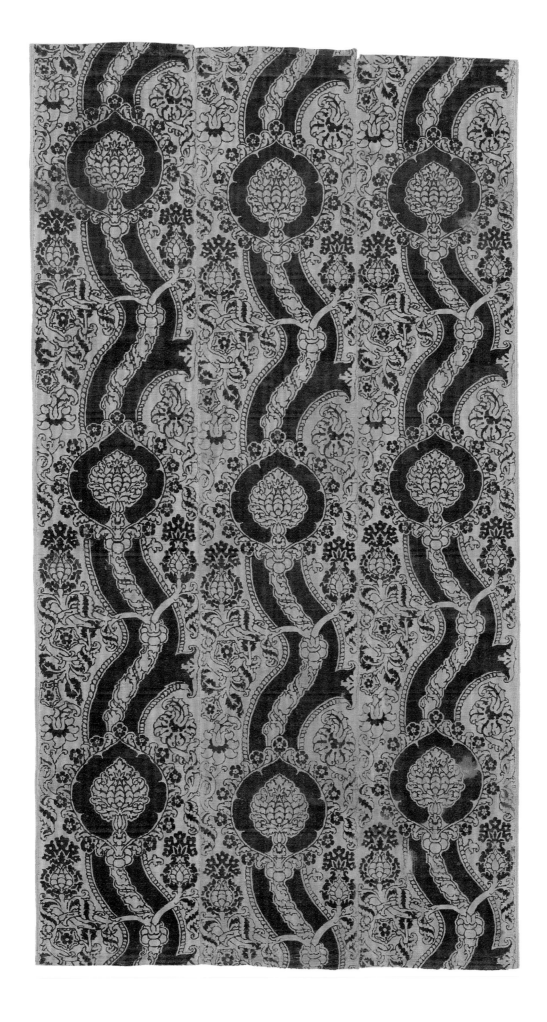

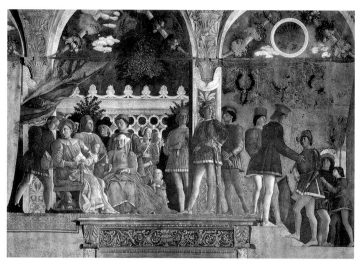

Fig. 23. Andrea Mantegna (1430/31–1506), fresco in the Camera Picta, Palazzo Ducale, Mantua, ca. 1474

of the five-petal Tudor rose.[4] However, it is worth noting that, in Florentine velvet manufacture of the late fifteenth century, not only is this motif common, but it also appears on textiles similar in composition to this "tissue."[5] Moreover, one commentator has raised the possibility of a Christological meaning, with the five-petal rose symbolizing the wounds suffered by Christ on the cross, and the pomegranate the "eternity, of the communion of saints and the blood of Christ."[6] A new hypothesis (suggested in this volume; see p. 21) is that Henry VII based the Tudor rose on this motif, capitalizing on its popularity in Italian velvets.

A similar velvet hanging appears in a mural in the Camera Picta, completed by 1474, in the Palazzo Ducale in Mantua, demonstrating the use of such textiles to embellish European court interiors from at least the fifteenth century (fig. 23). Even more remarkable is the work's resemblance to the fifteenth-century furnishing textiles in velvet preserved in the Badia Fiorentina Church, Florence.[7] The Badia textiles share with cat. 15 not only a similar color scheme and design, including the five-petal rose, but also a significant similarity in weaving structure; these observations further support an attribution to Florence rather than to other Italian centers of production.[8] Indeed, the splendor of such cloths of gold could only be achieved by expert weavers with exhibited mastery in fine and precious materials, as well as the skills needed to weave velvets of sufficiently strong structure to function as furnishing textiles.

The magnificence of this Florentine cloth of gold would certainly have been both desired and appreciated at the Tudor court. Although there is no particular evidence of its commission, the velvet shares all the characteristics of other significant textiles whose creation in Florence and journey to England are well documented in the royal Tudor collections (see cats. 6, 7). GC

Notes to this entry appear on pp. 306–7.

16. *Angels Bearing Candlesticks*

Benedetto da Rovezzano (1474–1554)
London, 1524–29
Bronze, each 39¾ × 19¾ × 13 in. (101 × 50 × 33 cm)
Victoria and Albert Museum, London (A.1-2015, A.2-2015)

17. *Candelabrum*

Benedetto da Rovezzano (1474–1554)
London, 1529–40
Bronze, 106¼ × 17¾ × 17¾ in. (270 × 45 × 45 cm)
Sint-Baafskathedraal, Ghent

These monumental bronze sculptures, designed and cast in London by the Florentine Benedetto da Rovezzano, embody the audacious confidence of England in the 1520s and 1530s under Henry VIII. Considering artistic sculptural endeavor across Europe at this date, they were hugely ambitious and innovative in design, raw materials, and scale. These three pieces are part of a group of nine surviving elements that are all that remain of a stunningly massive tomb project intended for Henry VIII. The other surviving pieces are two further angels, three candelabra, and the tomb chest.

Though commissioned, financed, and made in England, these bronzes were designed and cast by Italians, and the group takes central importance in the development of great Italian metalwork sculpture in the sixteenth century; it also represents the most substantial survival of Benedetto's work, not only in England but also dating from the periods he was active in Florence, Rome, Genoa, and Paris.[1] Both a sculptor in marble and designer of bronze work, Benedetto initially came to London to work under Pietro Torrigiano on his royal projects, including a subsequently abandoned one in 1519—for another tomb, for Henry VIII and Katherine of Aragon—that Benedetto took over when Torrigiano left for Spain to work for Katherine's nephew (discussed further in cat. 8).[2] About the same time, Benedetto also worked on, and completed, Torrigiano's tabernacled high altar to the west of Henry VII's tomb in the Lady Chapel at Westminster Abbey.[3]

The tomb for which cats. 16 and 17 were designed, though never completed, embodies something of a palimpsest commemoration, for although the tomb project was ultimately claimed by Henry VIII, it was initially conceived by, and planned for, Cardinal Thomas Wolsey.[4] The son of a tradesman—believed to have been a butcher—from the Suffolk town of Ipswich, Wolsey benefited from an education at Ipswich's public grammar school and then Magdalen College, Oxford.[5] In his meteoric rise to national and international dominance, Wolsey embodied par

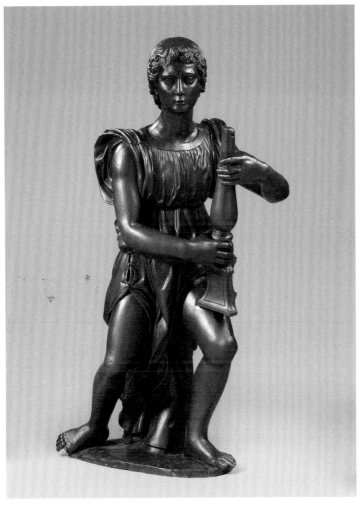
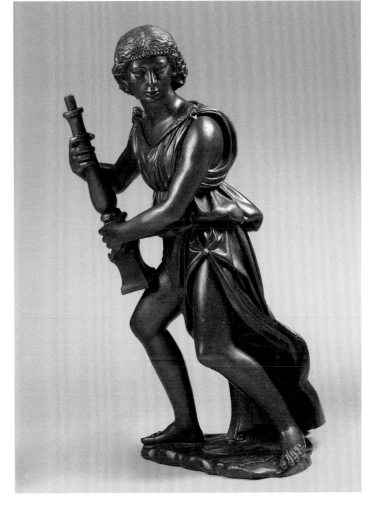

Cat. 16

excellence the new breed of self-made, politically wise power players who, enabled in part by Tudor policy shifts first developed by Henry VII, wrested administrative power away from the feudal barons once and for all. By 1519 Venice's ambassador to England, Sebastiano Giustiniani, reported to the Venetian Senate that "this Cardinal is the person who rules both the King and the entire kingdom."[6] At the height of his political ascent, in favor with both Henry and the pope, Wolsey simultaneously held the posts of Lord Chancellor of England, papal legate a latere (signifying the highest degree), cardinal, archbishop of York, bishop of Winchester, bishop of Durham, and abbot of Saint Albans, with an estimated income exceeding £30,000 per year, wildly more than the Crown's.[7] John Skelton's *Speke, Parott*, a satirical poem circulated throughout court in manuscript form from 1521, lambasted Wolsey as "So bold and so braggyng, . . . so baselye borne; / . . . So fatte a magott, bred of flesshe-fly,"[8] although only two years earlier, Giustiniani, apparently impressed by him, had provided a rather more appealing description of Wolsey as "very handsome, learned, extremely eloquent, of vast ability, and indefatigable."[9]

Benedetto, distracted from the largely abandoned royal tomb project started by Torrigiano, instead worked for Wolsey on his own tomb, which he understood "should not be inferior in workmanship, magnificence or cost to the tomb of Henry VII" (see cat. 8).[10] Work began in June 1524, with Wolsey using the successful London-based Lucchese master merchant Antonio Cavallari as his funding agent; Cavallari advanced money to Benedetto as needed for materials, workmen, and expenses. Between 1524 and 1529 more than £950 had been spent on the as yet unfinished tomb. The gilder Benedetto contracted to work on some of the completed bronze elements came especially from Antwerp, and indeed, the gilding of Wolsey's tomb cost four times that of Henry VII's.[11] In October 1529 this lavish productivity paused when Wolsey's political machinations, unpopular control of the Court of Requests, and perceived greed and arrogance came home to roost with his spectacular failure to persuade Clement VII to grant Henry an annulment of his marriage to Katherine of Aragon. Charged by truculent Henry for having overstepped his authority as papal legate and stripped

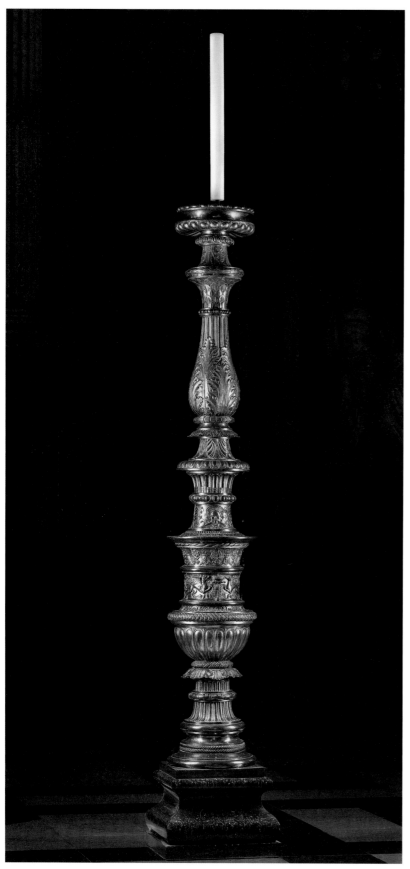

of all his offices except that of Archbishop of York, Wolsey left London—and the tomb project—for York. Arrested there and charged with treason in November 1529, Wolsey died while en route back to London to face trial.

A pair of surviving inventories written about this time, one by Benedetto and one in an English hand, apparently for the perusal of Henry VIII, documents the work for the tomb that Benedetto had already completed.[12] Considering these elements, the design for Wolsey's tomb probably centered around the black-touchstone-and-white-marble tomb chest and plinth. (Both survive in part, repurposed for use in Admiral Horatio Nelson's tomb in Saint Paul's Cathedral, London.) This structure was surrounded by twelve small bronze figures of saints, which have not survived, but probably stood six to either side, flanking the chest like sixteenth-century ripostes to the *pleurants* (mourners) of the Burgundian ducal tombs. Originally, the simple black-and-white tomb chest would have been ornamented for Wolsey with a sheet of bronze cover, shaped and patterned to resemble a draped woven textile, with individual bronze plaques bearing epitaphs attached to the touchstone chest's sides; none has survived. At each corner of the marble plinth would have stood four massive, nine-foot-high, decorated bronze pillars, supporting four (surviving) bronze angels with candlesticks (among them the two shown here). Four slightly smaller, kneeling bronze angels were made but do not survive; probably planned to sit on the plinth near the head and foot of the tomb, they might have been inspired by Torrigiano's pairs of angels seated, legs dangling, at the corners of Henry VII's tomb chest. At the head and foot of Wolsey's tomb were to have been two pairs of bronze naked boys holding the cardinal's escutcheons. The arrangement would probably have been not unlike that in terracotta on the clock tower at Hampton Court Palace, perhaps by Giovanni di Benedetto da Maiano, conceivably after a model by Torrigiano (fig. 24); and, thirty years later, that in wool and silk on the Lewknor table carpet (cat. 70).[13]

As scholars have discussed in detail, Benedetto apparently looked for inspiration as far afield as the royal Valois-Orléans tomb in Paris, on which he had worked during his French sojourn, and the sepulcher of Pietro da Noceto in Lucca, known to Wolsey's financial agent, Cavallari.[14] With their dramatic sense of arrested movement, the candle-bearing angels responded to Andrea Sansovino's recent, comparable inventions in marble, which Benedetto would have seen in Rome and Florence.[15] Each angel is individualized, with varied details of costume and hair adornment; their wings, cast separately and since lost, were intended to be inserted into slots cut into their backs. The use of freestanding pillars, reminiscent of those Wolsey caused to

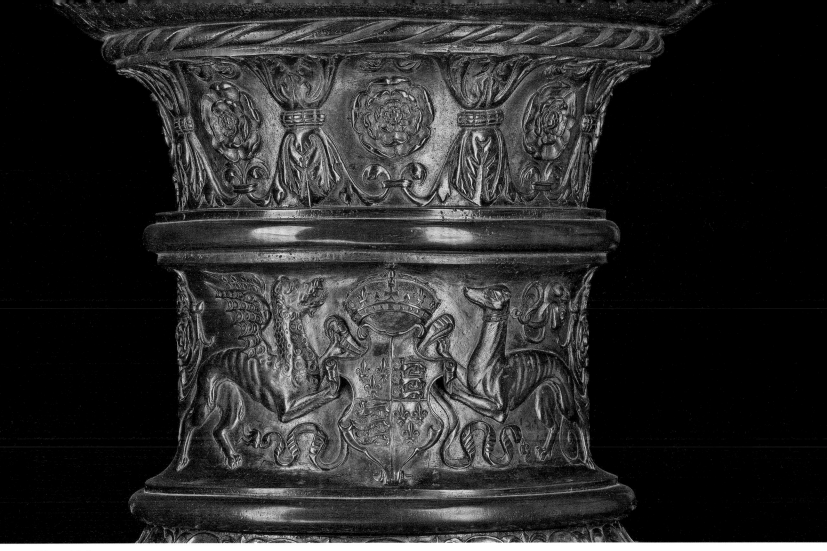

Cat. 17, detail

be carried before him in processions, might also have alluded to traditional shrine arrangements, not least that of Edward the Confessor in Westminster Abbey.[16] These precursors aside, had it been completed, Wolsey's freestanding tomb would have been almost unprecedented in scale, grandiosity, and copious use of bronze. As such, a year after Wolsey's fall from grace, the Milanese ambassador Agostino Scarpinello, with the benefit of hindsight, censured the project as "a more costly *mausoleum* than any royal or papal monument in the world."[17]

With characteristic opportunism—and in parallel to his means of supplementing his collection of homes and tapestries—after Wolsey's fall, Henry VIII immediately appropriated the cardinal's tomb project as his own. As encountered time and again—by Katherine of Aragon, Anne Boleyn, and Catherine Howard; by Sir Thomas More and Cardinal John Fisher; by Thomas Cromwell and countless other subjects—the king's overly effusive and larger-than-life favor, once lost, was replaced by a rigid coldheartedness. In a pathetic letter to Cromwell,

Fig. 24. Attributed to Giovanni di Benedetto da Maiano (1486/87–ca. 1542/43), perhaps after a design by Pietro Torrigiano (1472–1528), *Putti Flanking Wolsey's Coat-of-Arms, Cardinal's Hat, and Episcopal Cross*, Hampton Court Palace, Surrey, 1525

Wolsey, sensing his approaching death, humbly asked to be sent to Yorkshire "such part of the tombe as it shall please the King that I shall [have]."[18] Although both versions of Benedetto's inventory of completed work separated out the personal and ecclesiastic devices particular to Wolsey, thus excluding them from the list of bronze components deemed appropriate "For the King's Highness," these elements apparently were melted down. Indeed, not a single one was sent north, and it seems as though Wolsey was instead interred without any significant marker in Leicester Abbey (itself demolished within a few years of the Dissolution of the Monasteries). The tomb chest, monumental pillars, bronze cover, boys, and angels were retained, to be adapted for a revised and substantially enlarged tomb for Henry VIII himself. Although subsequent rival projects for such a tomb were considered—one each by Baccio Bandinelli, Jacopo Sansovino, and Baccio da Montelupo—Benedetto da Rovezzano's design endured the longest. Payments to Benedetto, working with Giovanni di Benedetto da Maiano, are recorded in the royal accounts as late as Benedetto's return to Florence, about 1540 or soon after.[19] Moreover, another Italian, Nicholas Bellin da Modena (see cat. 53), was still being paid for work on the sepulcher in 1544, and possibly even in 1551, four years after Henry's death.[20]

Beautifully worked with the English royal arms and copious Tudor roses, their foliate motifs picking up those of the miniature candlesticks held by the angels, the four candelabra (including cat. 17) tend to be associated with the second, grander set of plans for Henry's tomb, perhaps completed by Benedetto only months before his permanent return to Florence. In design the candelabra are purely ornamental and not, like Wolsey's column shafts, made to support the angel figures. All the same, they coincide precisely with the nine-foot height and ten-piece assemblage recorded for the four similarly "curyouslye graven" columns listed as completed by Benedetto for Wolsey before 1530. Although they are usually dated to the late 1530s, it has been suggested that these columns may in fact be the very ones made for Wolsey, subsequently refashioned by Benedetto into candelabra for Henry.[21]

Despite its huge expense, met by both Wolsey and Henry, and many completed elements, the tomb was neither assembled nor ever occupied, although all three of Henry's children did broach the idea of using it for their father's remains.[22] Elizabeth considered it seriously enough to commission a model in 1574, yet she also failed to carry it through. Perhaps her reticence to complete the grandiose, even bombastic tomb her father had envisioned reflected the fact that the era for such unabashed self-aggrandizement had passed, even for a Tudor monarch. EC

Notes to this entry appear on p. 307.

18. Three Designs for Stained-Glass Windows in King's College Chapel, Cambridge

Dirck Vellert (ca. 1480/85–ca. 1547)
Antwerp, ca. 1536–38
Pen and brown ink, gray wash, over black chalk, 6⅝ × 6⅞ in. (16.8 × 17.5 cm)
Bowdoin College Museum of Art, Brunswick (1811.109)

Of great beauty in its own right, this drawing provides a rare example of the working method that enabled cutting-edge Renaissance design by one of the leading artists of Antwerp, the greatest artistic center north of the Alps, to be executed in England. This design contributed to one of Tudor England's most glorious architectural projects, the design of King's College Chapel at the University of Cambridge, bearing witness to the escalating power of the university under the Tudors.

Attributed to Dirck Vellert, the six lancets on the drawing represent designs for one full window and the lower half of another, part of the twenty-five windows, each containing four lancets, lining the walls of the chapel of King's College (see fig. 4).[1] The complete scheme, illustrating the theme of "the Old Law, and the New"—that is, New Testament episodes with their Old Testament precursors—was envisioned decades earlier by Henry VII, who had financed renewed efforts to complete the half-built chapel, ostensibly continuing the legacy of his father's Lancastrian half brother, Henry VI.[2] Vellert's design dates from the tail end of the glass production's second phase, resuscitated yet again in 1526 as part of Cardinal Wolsey's efforts to woo the increasingly powerful university. This phase lasted well over a decade and was ultimately left incomplete. Vellert's design postdates Henry VIII's break with Rome, being drawn at least six years after Wolsey's own ignominious fall from grace (for more on which, see cats. 16, 17). Vellert's late participation in the project may have been catalyzed by the need to replace some of the older designs with less Petrine iconography, laying greater emphasis on the other disciples, particularly Paul, in line with Henry's newfound identification with that apostle (see cat. 49).

The first two lancets on the drawing show the resurrected Christ's appearance to the apostles at Emmaus (planned as the lower scene of window 19). The remaining four lancets relate to window 21, the central two illustrating Peter and John healing the lame man (upper scene), and the righthand two, the death of Ananias, who fell from a window while listening to Paul's preaching, and his subsequent resurrection by Paul (lower scene; fig. 25). In a clever conceit, Vellert designed the windows as if we the observers were outside, looking into an elegant Renaissance domestic interior at Emmaus, or catching a glimpse of a lofty arcaded loggia, at whose steps the lame man

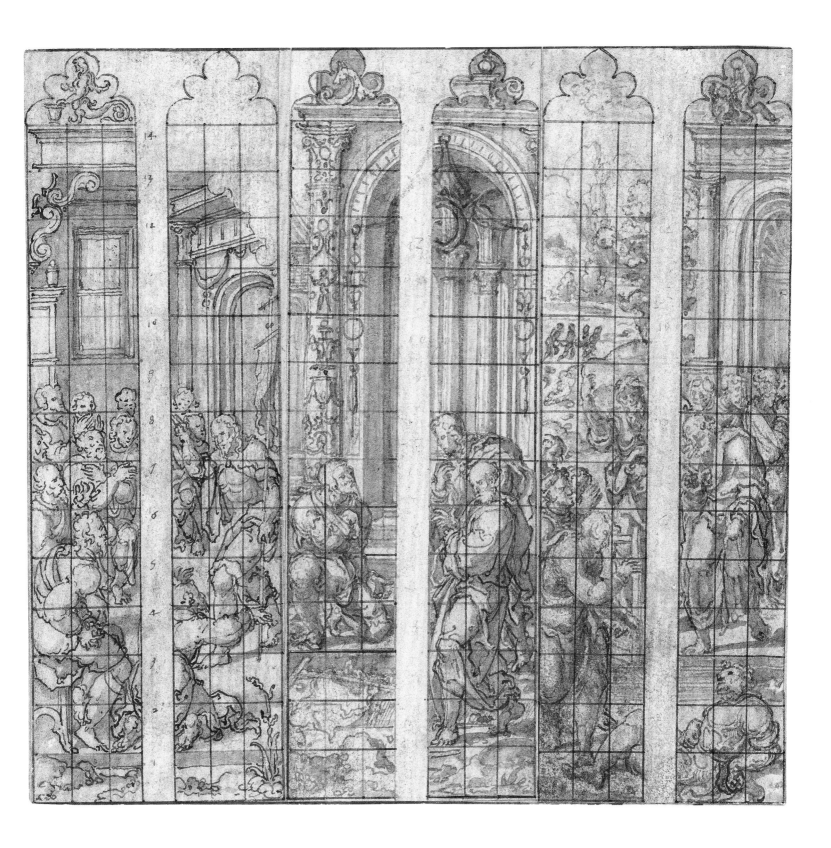

begs. The compositions, particularly of the healing and Ananias scenes, show awareness of Raphael's 1515–16 *Acts of the Apostles* tapestry designs (the cartoons for which were in Brussels in the later part of that decade), but with a twisting dynamism injected into the figures clearly inspired by Pieter Coecke van Aelst's *Life of Saint Paul* cartoons, made in Vellert's hometown of Antwerp about 1527–28 and woven in Brussels in the 1530s (cat. 49).[3] Comparison with a stained-glass panel by Vellert now in The Met (cat. 19) reveals just how successfully his dramatic forms and animated gestures looked in glass. Peter healing the lame man in the King's College design finds particularly close parallels in the enthroned Antiochus on The Met's panel.

Although this drawing is often called a vidimus, made to show the patron the mutually agreed-upon design, it probably represents a subsequent stage in the working process: the small but highly detailed model, called a *petit-patron*, given to the cartoon painters to copy precisely when making the full-scale cartoon used by the glaziers. Vellert included the lead lines, a detail that suggests he was not expecting to be present for the glass-cutting and -painting stages, which he would normally supervise and participate in himself, being trained and expert in all phases of stained-glass making. Although copious documentation for the King's College glass project survives, Vellert's name is not mentioned. The first director was the Fleming Barnard Flower, who operated in London but lived and worked in Southwark, on the southern banks of the Thames, and was thus free from the guild oversight that was obligatory within the City of London. At Flower's death in 1517, direction of the King's College glass project transferred to his affluent, royally protected compatriot Galyon Hone, like Vellert born in the northern Netherlands but trained in Antwerp; a team of five named master glaziers worked under Hone in his workshop in Southwark.[4] It is likely that Vellert did not leave Antwerp himself, instead relying on drawings such as this one, and leaving the actual production of the windows to his Southwark-based colleagues, who would have transported the finished panels from London to Cambridge, probably by waterway. EC

Notes to this entry appear on p. 307.

Fig. 25. *The Death of Ananias* (window 21, detail), King's College Chapel, Cambridge, ca. 1540–45

19. *Martyrdom of the Seven Maccabee Brothers and Their Mother*

Dirck Vellert (ca. 1480/85–ca. 1547)
Antwerp, ca. 1530–35
Stained glass, 27¾ × 18½ in. (70.5 × 47 cm)
The Metropolitan Museum of Art, New York, Mr. and Mrs. Isaac D.
Fletcher Collection, Bequest of Isaac D. Fletcher, 1917 (17.120.12)

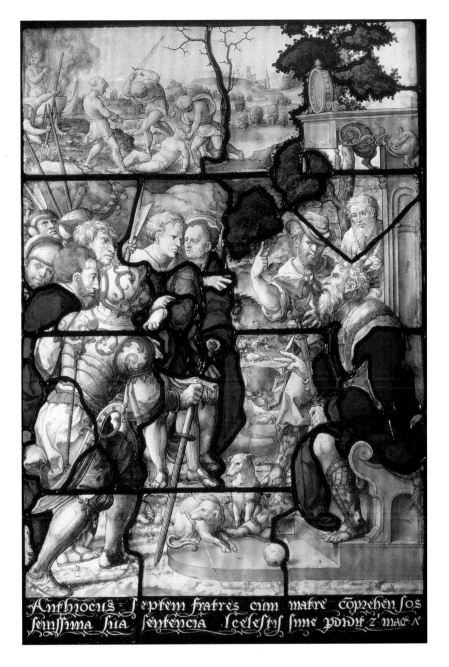

Henry VIII did not let strained political relations with his European counterparts such as the Habsburgs interfere with his desire to commission art on an international scale. Among the great and successful artists enjoying his patronage in Antwerp—itself undergoing an artistic resurgence as the center of what would come to be called the Flemish Renaissance—was the glass designer, glazier, and printmaker Dirck Vellert.

In his lifetime, and for a handful of decades after his death, Vellert was celebrated as the de facto leader of his profession. Lauded in print by the Florentines Giorgio Vasari and Lodovico Guicciardini—who called him one of the top five glass painters in Flanders—Vellert was twice dean of the Antwerp painters' guild of Saint Luke (in 1518 and 1526) and thrice mentioned by Albrecht Dürer in his Netherlandish travel diary, where he is described as the affluent and well-connected "Master Dietrich, the Antwerp glasspainter, [who] invited me and many others to meet me; and among them especially Alexander the goldsmith, a rich, stately man, and we had a costly feast and they did me great honour."[1] Vellert was prolific as a printmaker, and his work in glass was commissioned throughout northern Europe: in addition to his projects for Henry VIII (see cat. 18), he is also documented to have provided a monumental window for the aldermen of Leiden to gift to the council of Mechelen, and he is believed to have designed and executed a window for the great Marienkirche in Lübeck.[2] Although these examples, like his windows for Antwerp cathedral, have been destroyed, the glass he designed for King's College Chapel survives. Vellert designed at least two of the great windows lining the nave of the chapel (cat. 18), although it is unlikely that he ever traveled from Flanders to Cambridge to execute part of the project. Loftily positioned and huge in scale, the King's windows boast dynamic compositions and clever coloration that are readily appreciable. It is only in a panel like cat. 19, however, intended to be viewed in much closer proximity and on a more human scale, that the true virtuosity and dexterity of Vellert's skill as a glass painter can be perceived in full.

Surviving from an unknown project, the window depicts the Old Testament narrative from the second book of Maccabees (7:1–41) when King Antiochus IV Epiphanes tortured a group of Jewish brothers, grotesquely boiling alive one after the other as each in turn refused to eat pork, all witnessed by their mother before she, too, was put to death. The horror of the story, mostly relegated to the top left-hand corner of the panel, is mitigated by patches of exquisite mastery—Antiochus's face and gesturing hand—and even timeless charm, like the two hounds at the cruel king's feet. EC

Notes to this entry appear on p. 307.

20. *Coverdale Bible*

Title page designed by Hans Holbein the Younger (1497/98–1543);
printed by James Nicolson (active ca. 1518–57)
Probably Antwerp or Cologne, with title page printed in London, 1535
Ink on paper, 9½ × 6⅝ in. (24 × 16.7 cm)
British Library, London (C.132.h.46)
Exhibited New York and San Francisco only

The title page of the Coverdale Bible represented a hugely important step, encouraging Henry VIII to visualize in artistic terms his role and authority as Supreme Head of the Church in England, which had been posited less than a year previously in the 1534 Act of Supremacy. Designed by Hans Holbein, much of the title page retained the convention of other printed Bibles, like Erhard Altdorfer's title page to the German-language Lübeck Bible of 1533. It also returned to the theme of Holbein's earlier painting pairing Old Testament precedents with New Testament fulfillments (cat. 90), a theme likewise encountered in many other media (cats. 4, 18, 48).[1] Though the careful choice of episodes speaks specifically to Henry's concerns, from preaching to divorce, Holbein responded to a gamut of visual sources, from Dürer's *Fall of Man* print to Raphael's *Acts of the Apostles* tapestry designs.[2] Holbein made certain to nuance representations in keeping with Henry's break with Rome; in Christ's charge to the apostles, for example, Christ hands keys to all the disciples, not just to Peter, so closely associated with the Roman Catholic Church. Most strikingly new, however, is the arrangement at the foot of the title page where, centrally located in direct alignment with the radiating Tetragrammaton of God above, Henry VIII, impressively enthroned, holds the sword of office in his right hand. Echoing this symbol of temporal authority, with his left hand he imparts sacred wisdom, sharing the book containing the Word of God with the row of bishops who kneel before him, facing an opposite flank of kneeling knights of the realm. Emerging from niches to either side are King David, Henry's favorite Old Testament patriarch (see also cats. 42, 48), and Saint Paul, the alternative apostle to Peter (see cat. 49). Their respective banderoles declare, "O how sweet are thy words unto my throat, yea more than honey" (Psalms 119:103) and "For I am not ashamed of the gospel of Christ: for it is the power of God, which saveth all" (Romans 1:16).

As has been argued elsewhere, Henry's giving rather than receiving of the text subverts traditional literary dedication portraiture.[3] However, it is important to remember that Henry did not authorize this book: he did not commission this title page from Holbein, and it is highly unlikely that he saw Holbein's preliminary sketches or approved his finished design before the book went to press. Instead, the Coverdale Bible was an unauthorized translation, still unlawful in England, hence the need for the book—if apparently not the Nicolson-printed title page—to be printed in mainland Europe.[4] In response to formal petitions to the Crown by the English clergy to sanction a Bible in English, this new translation was conceived almost certainly with the direct backing—for doctrinal and political reasons—of both Thomas Cranmer, archbishop of Canterbury, and Thomas Cromwell, who by 1535 was enjoying Henry's ever-increasing favor as Chancellor of the Exchequer, Master of the Rolls, and Principal Secretary to the King. Indeed, Holbein may even have included Cromwell's portrait in the mitre-less figure immediately behind the bishops receiving the Word from Henry.[5] Rather than supporting one of the more potentially divisive translations, like that of William Tyndale with his doctrinally subversive annotations, a new, commentary-free English translation was provided by Miles Coverdale, who enjoyed the protection and support of Cromwell. On the second opening, following Holbein's impressive title page, an inscription in large typeface declares:

> Unto the most victorious Prynce
> and oure most gracyous soveraigne Lorde, king Henry the eyght,
> kynge of Englonde and of Fraunce, lorde of Irlonde, etc.
> Defendour of the fayth, and under God
> the chefe and supreme
> heade of the
> Church of Englonde.

In the passage immediately following this greeting, Coverdale played to Henry VIII's desire to be perceived in the same breath as the Old Testament patriarchs, with the final line—in hindsight, rather unfortunate—calculated to appeal to Henry's preoccupations with begetting an heir:

> The ryght and just administracyon of the lawes that God gave unto Moses and unto Joshua: the testimonye of faythfulnes that God gave of David: the plenteous abundaunce of wysdome that God gave unto Salomon: the lucky and prosperous age with the multiplicacyon of sede whiche God gave unto Abraham and Sara his wyfe, be given unto you most gracyous Prynce, with your dearest just wyfe, and most vertuous Pryncesse, Quene Anne, Amen.

In this light, Holbein's title page needs to be understood as more of a persuasive manifesto: the dedication of the book to Henry was unsolicited, an illegal gamble primed to win over the king, who, remaining staunchly Catholic (if no longer Roman Catholic), was wary of unleashing the Bible in the vernacular to the literate masses, envisioning for England the same sort of interpretive anarchy taking grip in much of mainland Europe.[6] As it was, the Bible did find an audience; such was its popularity

BIBLIA
The Bible that
is, the holy Scripture of the
Olde and New Testament, faith-
fully and truly translated out
of Douche and Latyn
in to Englishe.

M. D. XXXV.

S. Paul. II. Tessa. III.
Praie for vs, that the worde of God maie
haue fre passage, and be glorified. zc?.

S. Paul Col. III.
Let the worde of Christ dwell in you plen
teously in all wyßdome zc?.

Josue I.
Let not the boke of this lawe departe
out of thy mouth, but exercyse thyselfe
therin daye and nighte zc?.

Fig. 26. "All the Prophets in English," fol. 271 of cat. 20

21. *Great Bible*

Title page attributed to Lucas Horenbout (ca. 1490/95–1544); printed by Richard Grafton (1506/7–1573) and Edward Whitchurch (d. 1562)
London, 1540
Ink on vellum, with additional illuminations, 17 × 11¾ in. (43 × 30 cm)
British Library, London (C.18.d.10)
Exhibited New York and San Francisco only

In an image that would have been unthinkable during the reign of his father, and even in the early years of his own sovereignty, the title page of the Great Bible glorifies Henry VIII as the Supreme Head of the Church in England, in direct communication with God. Three years after Thomas Cranmer and Thomas Cromwell had sown the seeds for royal authorization of an English translation of the Bible with their unsanctioned Coverdale Bible (cat. 20), they achieved their aim: in September 1538, Cromwell, now elevated to the position of Henry's Lord Privy Seal, issued the injunction to English clergy that they should provide "one boke of the holy bible . . . in english . . . in sum convenient place within the said churche that ye have cure of where as your parishoners may most commodiously resorte to the same and read yt."[1]

In preparation for this moment, Cromwell and Cranmer had been supporting two merchant-publishers, Richard Grafton and Edward Whitchurch, in achieving a massive print run of Miles Coverdale's English translation of the Latin Vulgate text, so as to have the authorized Bible ready to furnish every church in the realm. Given the illegality of the project preceding the injunction's announcement, printing began in Paris, at the press of François Regnault, but faced considerable political persecution—"we be daylye threatened," Coverdale and Grafton wrote to Cromwell—culminating in the confiscation of the printed sheets by the Inquisition.[2] Notwithstanding, hundreds of copies of the book, called the Great Bible because of its size, were printed in Paris, with the completion of the first edition and six subsequent re-editions printed in the parish of Christchurch Greyfriars in the City of London. Supplying every church in England, and meeting general demand, the Great Bible was a best seller, within two years reaching more than 9,000 copies, and perhaps as many as 21,000.[3] In the midst of this success, the architect of the scheme, Thomas Cromwell, fell precipitously from royal favor, arrested in June 1540 and beheaded a month later, without trial and at Henry's behest. By 1541 Cromwell's patent to sell the Great Bibles had been transferred to a London-based merchant, Anthony Marler, who, to mark this honor, apparently presented Henry VIII with the present luxury copy, printed on vellum in three volumes with hand-tinted illustrations.[4]

that it was reprinted four times, twice in 1537 (with a revised naming of the king's "dearest just wyfe"), in 1550, and in 1552. Holbein also seems to have played a role designing internal title pages. Although most of the interior illustrations copied Hans Sebald Beham's designs for the *Biblische Historien* (*Biblical Histories*) of 1533, the title page to the New Testament, like that to the Old Testament's prophetic books (fig. 26), includes cavorting naked babies playing on elegant candelabra, enclosed with arabesque-like foliage recognizable from Holbein's designs for goldsmiths' work and plastering (see cats. 37–39).[7]

With its impressive heft and scale, this printed book embodies the endeavors of Cranmer and Cromwell to engage Henry VIII with their efforts to approve the dissemination of an English translation of the Bible. Ultimately, they were successful with the authorization, in 1539, of the Great Bible (cat. 21), largely reusing Coverdale's translation, and with a title page both responding to and building on Holbein's precedent. EC

Notes to this entry appear on p. 307.

Fig. 27. Title page to the third book of the Great Bible (cat. 21, vol. 2)

The title page of the Great Bible, often attributed to the miniaturist Lucas Horenbout (cats. 12, 50, 77, 78),[5] takes Holbein's title page to the Coverdale Bible as its inspiration but jettisons the potential pitfalls of the Old and New Testament visual commentary, perhaps because royal sanction of biblical interpretations proved much too fickle. Instead, the Great Bible title page adopts Holbein's representation of an enthroned Henry receiving the Word of God, but elevates this motif from its position at the foot of Holbein's Coverdale design to the top of the Great Bible title page: in a swirl of banderoles, God and Henry communicate in biblical quotations (Isaiah 55:11; Acts 13:22; Psalm 119:105), given, like all the texts on the title page, in the Latin Vulgate rather than Coverdale's English. With startling confidence on the part of the Bible's patron, Henry is told by God, "I have found a man close to my own heart, which shall fulfill all my will," leaving out Acts phrase "David, son of Jesse" that usually precedes "a

man"; Henry replies, "Thy word is a lantern unto my feet." In the upper right corner this dialogue is reiterated in the single biblical episode to be illustrated on the title page, as God speaks to David, the clothing and facial features of the Old Testament patriarch clearly Henry's.[6] The rest of the title page presents the dissemination of God's Word, given by Henry to the Anglican bishops (to the left of his throne) and the peers of the realm (to the right), all of whom have respectfully removed their headgear. One tier below, it is the turn of Thomas Cranmer, archbishop of Canterbury, to present the Word to the clergy (at left) and Thomas Cromwell, Lord Privy Seal, to the nobility (at right)— a cruel irony, given Cromwell's fate within months of the Great Bible's completion. In the lowest register the clergy share the Word with the populace, who gratefully hail the king for this vernacular Bible. All but two of these proclamations are in Latin—"Vivat Rex"—the outliers reading "God save the king" in English. So idiosyncratic and heavy-handed is the message of the title page, it has been suggested that Henry himself may have dictated the program.[7]

The internal illustrations within different copies of the Great Bible differ. Historiated initials, for example, vary considerably between print runs, in some editions filled with conventional woodcut narrative designs from the circle of Hans Sebald Beham; in others, with ornamental knotwork patterning. Later editions reused the principal title page, with the enthroned Supreme Head Henry disseminating the Word of God to the English people, at the start of the New Testament and for all additional section breaks, such as the Hagiographa of the Old Testament.[8] In earlier editions, however, the title page to the New Testament adopted Holbein's device from the Coverdale Bible, using boxes to distinguish different scenes; Marler's luxury presentation copy for Henry added an unprinted, hand-illuminated page along these same lines. In the earlier editions the title pages to section breaks also ranked miniature scenes within boxes, purportedly illustrating the narratives to come, although with notable emphasis on enthroned figures of authority and on instances of direct communication from God (fig. 27). Perhaps these multinarrative scenes were discarded from later editions as potentially too problematic, given the continually shifting notions of royally sanctioned orthodoxy in the Church of England. Images like the Maccabee brothers' torture at the misguided hands of King Antiochus IV Epiphanes (see cat. 19) would prove an unfortunate foreshadowing of the horrific results of fluctuating authorized religious practice in Tudor England under Henry VIII's children. Already in 1542–43, Henry VIII retracted the 1539 invocation that the Great Bible be made as available as possible to as many parishioners as possible, issuing

a new injunction attempting to limit its readership.[9] By 1545 he is quoted to have said, "I am very sory to knowe & here, how unreverently that moste precious juel [jewel] the worde of God is disputed, rymed, song and jangeled in every Alehouse and Taverne."[10] John Foxe's *Book of Martyrs* traces Henry's increasingly negative reaction to the Great Bible, a change of opinion nurtured by Bishop Gardiner's conservative faction following Cromwell's demise, and resulting in the interrogation, and eventual imprisonment, of the bible's publisher, Richard Grafton.[11] EC

Notes to this entry appear on p. 307.

22. *Field Armor, Probably Made for King Henry VIII*

Greenwich, 1527
Etched and gilded steel, copper alloys, leather, H. 73 in. (185 cm)
The Metropolitan Museum of Art, New York, Purchase, William H. Riggs Gift and Rogers Fund, 1919; mail brayette: Gift of Prince Albrecht Radziwill, 1927 (19.131.1a–r; 27.183.16)

Henry VIII rated military prowess highly, seeking to be celebrated as champion of both his chivalric court (see fig. 19) and the church, whether as the Roman Catholics' suitably martial-sounding Defender of the Faith or, by the later years of his reign, as Supreme Head of the Church in England. Glorying in physical, tangible signs of his regal magnificence—in settings both palatial and ecclesiastic—as a young and a middle-aged man, Henry also took immense pride in his peak physical condition and sportsmanship. Armor complemented all these preoccupations, in the sixteenth century connoting not only breeding and training for a military role, but also glamour, fashion, and heroism, as much as its now more familiar associations with authority, virility, strength, and readiness for battle.[1]

It is therefore perhaps not surprising that, less than two years after acceding to the English throne, Henry invited Milanese and Flemish armorers to London to work under his protection, despite the likely reservations of the Armourers' Company of London to this influx of foreign talent.[2] By 1515 Henry had had "Almain" (perceived as German) armorers brought to England and, following the example of Maximilian I's imperial armor workshop in Innsbruck, installed them in a specialized workshop located within the precinct of Greenwich Palace. These "Almains" created armor both for the king's personal use and as potential diplomatic gifts. Though the salaries and living conditions of these mostly European armorers working under the direction of the Fleming Martin van Royne are well documented, early productions by the workshop are unknown. This suit, attributed to the Greenwich Royal Armoury on stylistic grounds, includes

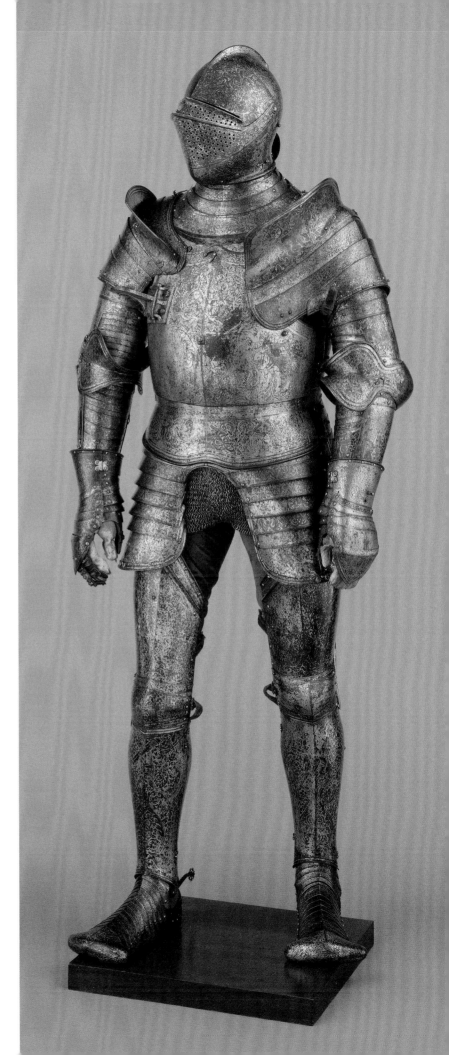

Cat. 22, detail

the date 1527 in its etched decoration, making it the earliest dated surviving armor associated with Greenwich.[3] By then the master armorer Erasmus Kyrkenar, probably a German, was also working there. He had been appointed "Armourer for the [King's] Body" by October 1519, only later, in 1539, becoming the master workman in charge of the royal workshop.[4]

The suit was part of an expensive and labor-intensive garniture that included multiple interchangeable pieces of armor, designed to be worn on the field—that is, in battle—or at tournaments and jousts; it also includes horse armor and an armored saddle. An innovative feature apparently shared by only one other armor, also made at Greenwich, is the ventral plate, designed to be worn strapped to the chest beneath the breastplate, thereby distributing the weight of the armor and lessening the shoulder burden borne by the wearer.[5]

In a testament to the importance of this project, the entire armor is gilded and embellished with etched decoration. The effect, no doubt originally complemented by colorful plumes and lavish textile accessories, must have been incredibly rich and splendid, like a gleaming, solidified cloth of gold. Scrolling rinceaux and arabesques cover every available surface and articulated plate, even those of the neck's gorget, the arms, and the thigh-covering tassets. Smiling putti adorn the fauld, which protects the waist and lower abdomen. On the broad expanse of the breastplate, naked little boys tussle, climb gnarled vines, and even ride atop elephants (detail). Four of Hercules's feats

are represented on the leg defenses, while one of the putti on the breastplate bears aloft a banner with the device of a dragon, wyvern, or griffin.[6] Such is the sophistication and inventiveness of this line decoration that it has been attributed to Hans Holbein. There are certainly similarities with the censer-wielding, winged anamorphic figures in Holbein's *Design for a Footed Cup with Cover* (cat. 38) and with his candelabrum-clambering putti inside the Coverdale Bible (fig. 26). Alternatively, the sketchy motility of the lines might suggest an Italian designer, perhaps Giovanni di Benedetto da Maiano, who is often said to have collaborated with the Greenwich armorers alongside his work for Cardinal Wolsey (see fig. 24).[7] Certainly, Giovanni would have been deeply familiar with the scrolling, grotesque-like decorative motifs used on the armor; despite the divergences in material and scale, they deploy the same visual language developed by Giovanni's father and uncles in monumental marble in Florence, as recorded in surviving works such as the fountain with the arms of Jacopo de' Pazzi, now in The Met's collection.[8] In their exuberance the putti hoards predict Giulio Romano's *Puttini* tapestries, designed in the 1530s.[9]

This exceedingly rich armor was likely made for Henry VIII himself. Certainly, he was the recipient of the only other armor with the innovative ventral plate.[10] Edward Hall, the contemporary chronicler, evocatively describes "the kyng hymself, in a newe harnes all gilte, of a strange fashion that had not been seen," participating in a tournament held in honor of the visiting French ambassadors François II de La Tour d'Auvergne, vicomte de Turenne, and Gabriel de Gramont, bishop of Tarbes, on March 12, 1527.[11] In his enthusiasm to delight his guests, Henry presented Turenne with "a suit of armour . . . like his own," as reported by the French secretary, Claude Dodieu.[12] It seems that this armor was the very one—in fact, his own—that Henry gifted to the French ambassador. At Turenne's death only five years later, it passed to his friend Galiot de Genouilhac, grand master of artillery at François I's court. This armor garniture survives as witness to the sophistication of Henry's court armory, to the king's glamour, and to the sometimes stunning generosity occasioned by diplomatic exchange. EC

Notes to this entry appear on p. 307.

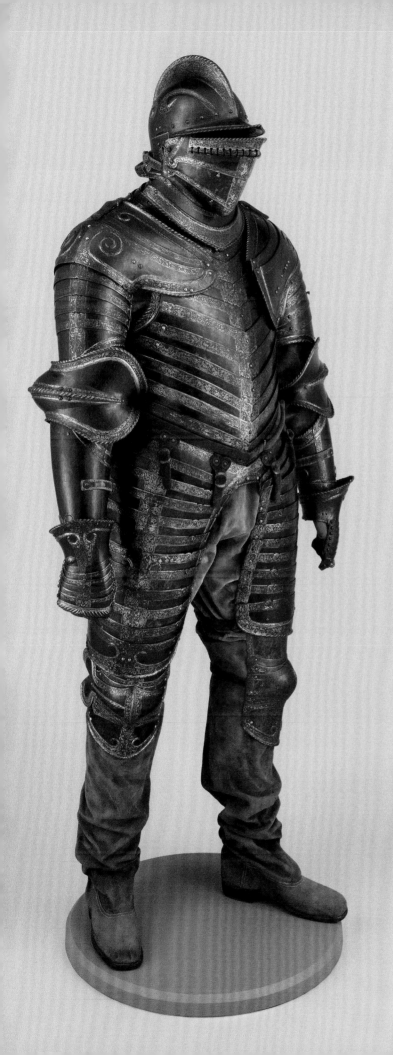

23. *Field Armor for King Henry VIII*

Milan or Brescia, ca. 1544
Steel with etched and gilded steel, leather, H. 72½ in. (184.2 cm)
The Metropolitan Museum of Art, New York, Harris Brisbane Dick Fund,
1932 (32.130.7a–l)
Exhibited New York only

Age took a heavy toll on Henry VIII's physical health and
appearance. In striking contrast to the king's armor from almost
thirty years earlier (cat. 22), the present ensemble provides a
vivid sense of Henry's swollen physical proportions and corre-
spondingly increased body weight in his mid-fifties. Although
the Greenwich Royal Armoury was still in operation, and would
continue to be so during Elizabeth I's reign and beyond (see
cat. 72), this armor is northern Italian. Henry VIII had contin-
ued throughout his reign to commission armors from the most
prestigious European centers in addition to supporting his local,
royal armorers.

The general style of this armor, not to mention its description
in Henry's inventory, reveals it to be the work of Italian crafts-
men; although no longer enjoying their phenomenal success
of the fifteenth century, armorers in Lombardy, particularly
workshops in Milan, continued to meet international demand
for special kinds of commissions.[1] Designed without greaves
or sabatons (protective plates below the knees), this suit is a
three-quarter field armor, equally suitable for use on foot and
horseback, and was made with a second, detachable, reinforcing
breastplate. The restrained but refined decoration of the armor
has been described as typically Italian, achieved by the contrast-
ing heat-blackened surface and beautifully worked etched and
gilded borders of the plates, ornamented with miniature putti,
scampering hounds, scrolling foliage, and other grotesques. At
some point after it arrived in London, the armor was modified,
probably at the Greenwich Royal Armoury, to better fit the
king, with alterations at the waist and thighs and the addition of
extension plates at the shoulders—carefully decorated to match
the rest of the suit, but adorned on the backplate with brass
studs shaped as Tudor roses.[2]

Depending on when the armor was delivered, it is possible
that Henry wore it, or intended to, for the final military campaign
in which he actively participated: the 1544 siege of Boulogne
against the troops of François I. In fact, it is likely that the armor
was specifically ordered for the king to wear during this much-
anticipated, if ultimately frustrating, campaign.[3] Made in the
mid-1540s, this nearly new armor was among those recorded in
Henry's posthumous 1547 inventory, described as "one Complete
harnesse of Italion makinge with Lambes blacke and parcell
guilte for the feilde," kept in the armory of Greenwich Palace.[4]

Within eleven years it had passed to William Herbert, 1st Earl of Pembroke, who had been a member of the king's close circle, serving from 1526 as one of his esquires of the body (in charge of dressing and undressing the king).[5] Pembroke would subsequently have his facial features immortalized in a medal commissioned from Steven Cornelisz. van Herwijck (cat. 105). EC

Notes to this entry appear on pp. 307–8.

24. *Edward VI*

Attributed to Guillim Scrots (active 1537–53)
ca. 1547–50
Oil on panel, 22⅞ × 26¾ in. (58 × 68 cm)
Compton Verney Art Gallery and Park, Warwickshire (CVSC:0037.B)

After nearly thirty years as king, and as many years of marriage, Henry VIII was anxious for a son and male heir. The birth of Edward VI at Hampton Court Palace on October 12, 1537—the first, and only, legitimate son of Henry VIII by his third wife, Jane Seymour (see cats. 84, 85)—was greeted with celebration and tears of joy.[1] From about age seven, Edward received the sort of humanistic education deemed appropriate for a Christian prince: the Bible, classical literature, languages (French, Greek, and Latin), rhetoric, mathematics and astronomy, penmanship, and epistolary elegance. He was, by all accounts, a charming, intelligent, and sociable youth. Edward became king upon his father's death in January 1547, and was officially crowned on February 20 of that year. His uncle, Edward Seymour, Duke of Somerset, was appointed Lord Protector of the Realm, entrusted with governing the country until Edward attained his majority at age eighteen. Somerset assumed tremendous power but failed in exercising judgment; in 1550 he was succeeded by John Dudley, Earl of Warwick and later Duke of Northumberland. Edward became ill in January 1553—probably with a lung infection—and died less than six months later. Although he reigned for only six years and was just fifteen when he died, Edward VI's avowed commitment to Protestantism was a decisive factor in the religious transformation of England.

Edward's brief reign generated a surprising number of portraits, including numerous copies and variants produced posthumously to perpetuate the Protestant cause in opposition to the Catholic reign of his sister, Queen Mary I. Among the most familiar images are several profile portraits depicting Edward between about six and ten years of age, the years before and immediately after his coronation in 1547. The popularity of the profile format reflects a current and developing interest in antiquity and in classicizing modes of portraiture, like those found on coins and medals: a profile portrait invested its subject

with allusions to the mighty rulers and mythological heroes of the classical world (see cats. 94, 95, 104, 105, 115).

The earliest painted version of the young prince in profile appears to be a roundel in The Metropolitan Museum of Art, formerly attributed to Hans Holbein the Younger and now considered a product of his workshop.[2] The remaining profile portraits of Edward VI all seem to derive from a now-lost drawing, evidently also by Holbein, which survives in a copy attributed to a follower of that artist (fig. 28). This drawing (or the original) likely passed to Edward after his father's death, and may have served as a pattern made available to court artists seeking to produce a likeness of the monarch, sparing him the time and tedium of a live sitting.[3]

Two related types of profile portraits of Edward VI (each existing in multiple versions) have been ascribed to the

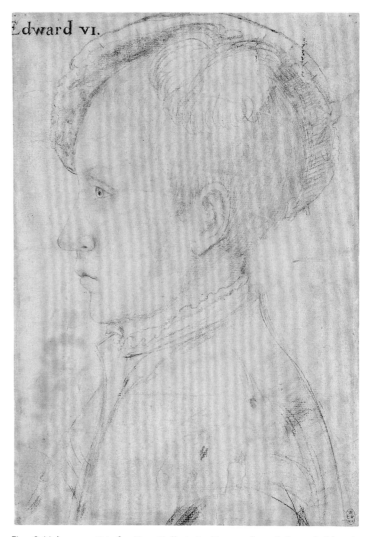

Fig. 28. Unknown artist after Hans Holbein the Younger (1497/98–1543), *Edward, Prince of Wales*, ca. 1543. Black and colored chalk on pale pink prepared paper, 10¾ × 7⁷⁄₁₆ in. (27.3 × 18.9 cm). The Royal Collection / HM Queen Elizabeth II (RCIN 912202)

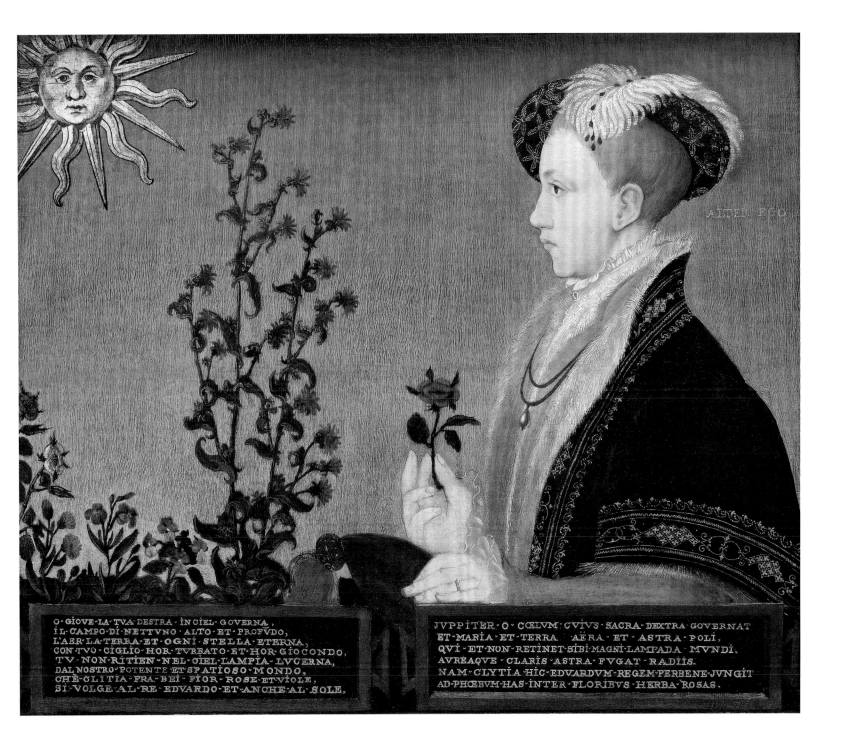

ALTER EGO

O · GIOVE · LA · TVA · DESTRA · IN · CIEL · GOVERNA ,
IL · CAMPO · DI · NETTVNO · ALTO · ET · PROFVDO,
L'AER · LA · TERRA · ET · OGNI · STELLA · ETERNA ,
CON · TVO · CIGLIO · HOR · TVRBATO · ET · HOR · GIOCONDO,
TV · NON · RITIEN · NEL · CIEL · LAMPIA · LVCERNA,
DAL · NOSTRO · POTENTE · ET · SPATIOSO · MONDO,
CHE · CLITIA · FRA · BEI · FIOR · ROSE · ET · VIOLE,
SI · VOLGE · AL · RE · EDVARDO · ET · ANCHE · AL · SOLE.

JVPPITER · O · CŒLVM · CVIVS · SACRA · DEXTRA · GOVERNAT
ET · MARIA · ET · TERRA · AERA · ET · ASTRA · POLI ,
QVI · ET · NON · RETINET · SIBI · MAGNI · LAMPADA · MVNDI.
AVREAQVE · CLARIS · ASTRA · FVGAT · RADIIS.
NAM · CLYTIA · HIC · EDVARDVM · REGEM · PERBENE · JVNGIT
AD · PHŒBVM · HAS · INTER · FLORIBVS · HERBA · ROSAS.

Netherlandish émigré painter Guillim Scrots, the main difference between the types being in the subject's clothing.[4] Apart from the extraordinary anamorphic portrait of Edward at age nine (cat. 93), the present painting is by far the most elaborate. The right half of the panel contains a profile portrait of the king, holding a red rose in his right hand and clutching a purse or moneybag with his left. The left half is dominated by an anthropomorphized sun; heliotropic plants including red and white roses (representing, respectively, the dynastic houses of Lancaster and York, united by Edward's grandfather Henry VII), pansies or violas, and sunflowers turn their backs on the sun to face the king. Along the bottom of the panel are verses in Italian and Latin praising Edward VI as a ruler more brilliant and more powerful than the sun:

Jupiter, whose sacred power governs the sky, the sea and the earth,
Jupiter whose power governs the ether and the heavens.
Jupiter who does not keep the flames of the mighty earth to himself,
But who puts to flight the golden stars with their bright rays.
We ask you to witness how Clytia, a flowering plant amongst
 these roses,
Rightly unites King Edward with Phoebus the Sun.

Jove, whose might reigns in the sky, in the realms of Neptune,
In the highest places and in the lowest.
Jove who rules the sky, the earth, and every eternal star.
In good humour or bad you do not deprive us, or the expanse of
 the world, of the fullness of light in the sky.
Witness that Clytia, growing between roses and violets, turns
 herself to both King Edward and to the Sun.[5]

In Greek mythology, the water nymph Clytie, or Clytia, tried to win the love of the sun god Phoebus Apollo. Failing to do so, she lay naked, staring longingly at the sun for nine days; at the end of this time she was transformed into a heliotrope, a flower that always turns in the direction of the sun. In Elizabethan emblem books, sunflowers and other heliotropic plants functioned as metaphors for a loyal subject's pliant devotion to their ruler.[6] The repeated invocation of Jupiter / Jove in the painting's inscription has been interpreted as "a pagan variation on the concept of divine right, by which the temporal ruler is invested with the right to govern from heaven."[7]

The painting's coherent message of unquestioning devotion to a king whose sovereign right to rule was divinely given suggests that it was commissioned by someone closely associated with Edward's court. Until it appeared at auction in 2004, this painting had been the property of the Stanhope family in Derbyshire since at least the seventeenth century. It may have been commissioned by Sir Michael Stanhope, brother-in-law of the Lord Protector, Edward Seymour.[8] Following Edward's coronation, Seymour promoted Stanhope's career at court; successive appointments as Groom of the Stool and Chief Gentleman of the Privy Chamber made him effectively the young king's keeper. Stanhope fell from favor in 1549, was briefly rehabilitated, but was subsequently imprisoned and executed in 1552. If the painting was indeed commissioned by Stanhope, it would have been made either before 1549, when he was in service to the king, or during his brief period of freedom in 1550, in the hope of defending an allegiance that had come into question. MEW

Notes to this entry appear on p. 308.

25. *Letters Patent Granting Arms to William Paget, 1st Baron Paget de Beaudesert, by King Edward VI*

March 25, 1553
Ink and bodycolor on vellum, with wax seal, 34¼ × 36⁷⁄₁₆ in. (87 × 92.5 cm)
Marquess of Anglesey, Plas Newydd, Anglesey (NT 1175689)

"The valiaunt and vertuous actes of excellent parsonnes shuld be notoryouslye commended to the worlde with sundry monumentes and remembraunces," ordain these letters patent issued by King Edward VI. Granting arms and crest to William Paget, the letters patent reinstate these privileges following Paget's 1552 degradation, desiring that his heraldry would "move stirre and kindle" the hearts of "negligent cowarde and ignoraunt subjectes" in "the imytacion of vertue and noblenes." These letters—and the blazon they empower—smooth over a tumultuous rise, fall, and restoration, mobilizing art to erase, legitimate, and honor past and posterity alike.

William Paget, subsequently 1st Baron Paget, enjoyed the unusual distinction of surviving political service to multiple Tudor monarchs. Born in 1506, at the tail end of Henry VII's reign, Paget was a self-made political figure who may have intentionally obscured his humble origins.[1] After studying at Trinity Hall, Cambridge, and the University of Paris, he rose through the ranks of royal service, eventually becoming a diplomat, clerk of the Privy Council and Parliament, and one of Henry VIII's closest advisers.[2] Henry VIII, for example, planted Paget as a judge on the Earl of Surrey's trial (see cat. 98) in order to guarantee the latter's condemnation. (Surrey, in turn, allegedly spurned Paget for his background: "for the kingdom has never been well since the King put mean creatures like thee into the government.")[3]

In 1541 the Clarencieux King of Arms granted Paget arms featuring a tiger and a peach tree, which he, three years later, replaced with those illustrated here: four eaglets crossed with

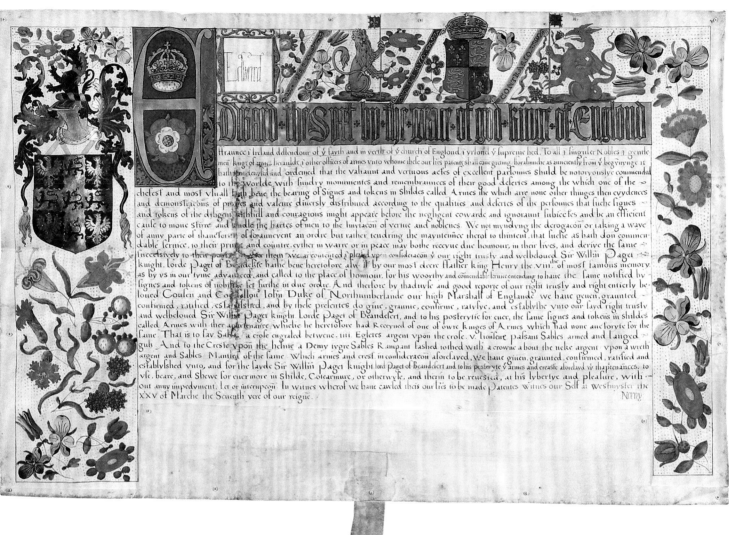

...Fraunce & Ireland defendour of y fayth and in verth of y church of England & yrlond y supreme hed. To all & singuler Nobles & gentlemen kinges of armes heraulde & other officers of armes vnto whome these our lres patent shall come greting. Forasmuche as auncyently from y begynynge it hath bene deuysed and ordeined that the valiaunt and vertuous actes of excellent parsonnes shuld be notoryouslye commendat to the worlde with sundry monumentes and remembrauntes of their good desertes among the which one of the chefest and most vsuall hath bene the bearing of Sygnes and tokens in Shildes called Armes the which arre none other thinges then evydences and demonstracons of proves and valeure diuersly distributed according to the qualities and desertes of the personnes that suche sygnes and tokens of the dilligent faithfull and couragious might appeare before the negligent cowarde and ignoraunt subiectes and be an efficient caule to moue stirre and kindle the hartes of men to the Imytacon of vertue and noblenes. We not myndyng the derogacon or taking a wave of anny parte of thauctoritie of sorauncvent an ordre but rather tendring the mayntenence therof to thintent that suche as hath don commendable seruice to their prince and countre eyther in warre or in peace may bothe receyue due honnour in thar lives and derive the same succesively to their posty after them we are contented & pleased vpon consideracon y our right trusty and welbeloued Sir Willm Paget knight, Lorde Paget of Beaudesete hathe bene heretofore alwyf by our most deere flather king Henry the viij[the] of most famous memory as by vs in our tyme advaunced and called to the place of honnour for his woorthy and comendable seruice entending to haue the same notified by sygnes and tokens of nobilite set furthe in due ordre. And therfore by thaduyse and good reporte of our right trusty and right enterely beloued Cousen and Coumsellour Iohn Duke of Northumberlande our high Marshall of Englande we haue geuen graunted confirmed ratified establysshed, and by these presentes do giue graunte confirme ratyfye and establyshe vnto our sayd right trusty and welbeloued Sir Willm Paget knight Lorde Paget of Beaudesert, and to his posterytie for euer, the same sygnes and tokens in shildes called Armes with ther appertenance whiche he heretofore had Receyued of one of owre kinges of Armes which had none auctoryte for the same. That is to say Sables, a crose engrailed betwene iiij Egletes argent vpon the crose v lionsette palsant Sables armed and langed guls And to the Creste vpon the helme a Demy tygre Sables Rampant tashed tothed with a crowne about the neke argent vpon a wreth argent and Sables Mantled of the same Which armes and crest in consideracon aforesayed we haue giuen graunted confirmed ratified and establysshed vnto and for the sayde Sir Willm Paget knight lord Paget of Beaudesert and to his posteryte y armes and creaste aforesayd w thappitenances to vse beare, and Shewe for euer more in Shilde Cotearmure, or otherwyse, and therin to be reuested at his lybertye and pleasure with out anny impedyment let or interrupcon In witnes wherof we haue cawsed theis our lres to be made Patentes witnes our Self at Westmynster the xxv of Marche the Seuenth yere of our reigne.

Nonay

five lions, symbols of nobility and courage, from the Garter King of Arms.[4] From these years, Paget's influence thereafter multiplied: he was a chief executor of Henry VIII's will and, upon the king's death, briefly became an influential figure in Edward VI's protectorate. However, when the Earl of Warwick displaced the Lord Protector, the Duke of Somerset, Paget was arrested, stripped of his arms, and disgraced from the Order of the Garter for corruption.

These letters patent mark Paget's restoration to the government, after he settled a hefty fine and received a pardon. The illumination reveals something of Paget's priorities, as he, the beneficiary, would have financed the decoration.[5] Unlike other royal documents, these letters are in English (not Latin) and rely mostly on arms, rather than monarchical portraits, to represent royal participation and confer authority.[6] Although the large, gold *E* does not feature a portrait miniature, it does contain two stand-ins: an imperial crown lined with regal ermine and a Tudor rose. The Tudor devices riposte the still-attached seal portraying the enthroned, youthful king.

Paget's arms, crest, helmet, and mantling dominate the left side of the document, emanating outward in inky, elegant motions. Paget's blazon rests among bright natural motifs, like strawberries, roses, carnations, lilies, and pansies, which appear flatter, and thus more analogous to the crisp, humanist script than the multidimensional heraldry. Although similar arrays appear in an earlier manuscript (cat. 12), here the floral motifs are even more stylized, nodding to the sprightly ornamental language that developed on charters and grants (see cat. 31). In these letters organic iconography simultaneously downplays and reflects the manufactured—yet unstable—nature of political survival, career, and identity.

After Edward VI's death, Paget remained in royal service. Mary I restored him to the Garter and the Privy Council, and, in 1556, appointed him Lord Privy Seal, but when Elizabeth I took the throne in 1558, Paget was in ill health. He still advised the new queen on foreign policy but started to withdraw from politics after 1561, and had effectively retired by the time he died in 1563. Henry Machyn, a diarist and funeral clothier, described Paget's funeral as resplendent with heraldry: "[The . day of June was the funeral of the lord Paget] . . . with a standard and a grett banar . . . banar-rolles of armes and a cott armur . . . garter, helme, and crest, and mantylles and sword . . . and a IIIJ dosen of penselles [about the] herse."[7] SB

Notes to this entry appear on p. 308.

26. *Mary I*

Hans Eworth (ca. 1525–after 1578)
1554
Oil on panel, 41 × 30¾ in. (104 × 78 cm)
Society of Antiquaries, London (LDAL 336; Scharf XXXVII)
Exhibited New York only

Mary's ascension to the throne in 1553 was hard-won. Eldest child of Henry VIII and Katherine of Aragon, she was declared a bastard after that marriage was dissolved in 1533. Her allegiance to the old religion of Roman Catholicism and her refusal to acknowledge Anne Boleyn as queen, or her half sister Elizabeth as princess, led to estrangement from her father and exclusion from court. Although Mary was eventually "rehabilitated" and reconciled with Henry, it was not until the Act of Succession of 1543 that she was legitimized and her place in the succession restored. However, after Henry's death Mary's half brother, King Edward VI, arranged his own will to exclude Mary from the throne, nominating Lady Jane Grey as his successor to ensure that the monarchy remained in Protestant hands. Edward died on July 6, 1553, and Jane was proclaimed queen three days later. Upon learning of her brother's death, Mary declared herself queen "by divine and human law"—also on July 9. In the ensuing days the rival queens each fought to gather strength and support, but Mary soon won the edge, and on July 19 was proclaimed "direct and legitimate heir" of Edward VI and (perhaps more compellingly) of Henry VIII.

Barring Jane's nine-day reign, at her coronation on October 1, Mary became the first female sovereign of England in four centuries.[1] It was vitally important that any official image of the queen communicate the strength and efficacy of her rule. While Henry (and Edward, to a lesser extent) had transformed royal portraiture in England with memorable images "predominantly dynastic, chivalric, martial, patriarchal—and priapic,"[2] Mary needed to find a way to depict female authority in a world habituated to masculine rule.

Hans Eworth was granted a sitting from life with the new queen in early 1554, just a few months after her coronation.[3] The resulting portrait, formal and hierarchical, was the first major portrait of Queen Mary and, as such, became the image upon which most successive likenesses were based.[4] Eworth himself (with varying degrees of studio assistance) produced at least five portraits derived from this sitting.[5] Although they vary widely in scale, from miniature to nearly life-size, and were executed over a period of several years, the basic delineation of the face remained largely the same.

In her youth Mary was considered somewhat of a beauty, but as she aged she began to look older than her years (probably

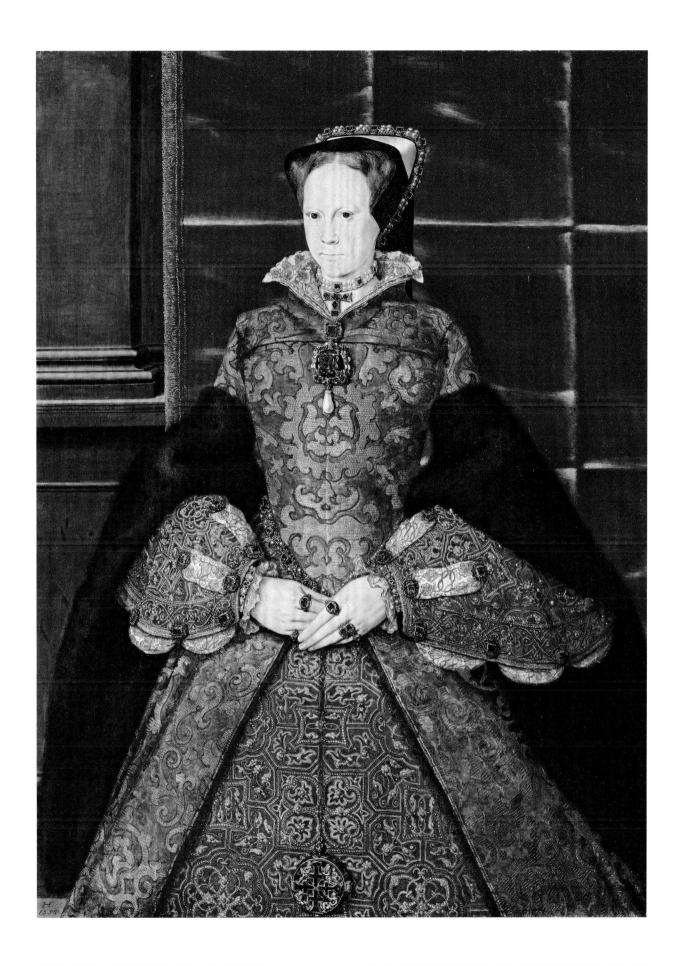

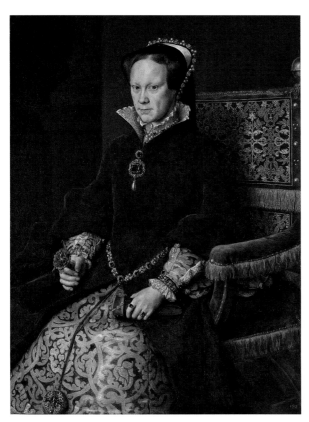

Fig. 29. Anthonis Mor (1519–1575), *Mary Tudor, Queen of England, Second Wife of Philip II*, 1554. Oil on panel, 42⅞ × 33⅛ in. (109 × 84 cm). Museo del Prado, Madrid (P002108)

with paned folds accentuating the fabric's sheen.[9] But it is Mary's sumptuous costume and extravagant jewels that dominate the likeness and proclaim her elevated status without resort to overtly royal attributes.

Eworth's exceptional talent for re-creating every nuance of the expensive fabrics, laces, embroideries, and jewels favored by his elite patrons (see also cat. 92) was an ideal match for Mary's notorious love of costume and personal adornment. The wide bands of sable fur that cover the hanging sleeves of her heavy gown indicate that she is wearing formal state apparel appropriate for winter; on this evidence, Eworth's portrait has been dated to the early months of 1554. The gown itself, and the stiff kirtle (underskirt) revealed at the front opening, are of red cloth of gold in two different patterns.[10] Both kirtle and lower undersleeves are encrusted with pearls and gems; even Mary's voluminous white shirt—visible at her collar and puffed through openings in her lower sleeves—is decorated with gold embroidery.

A description of Mary about the time this portrait was painted makes special note of her fondness for jewelry: "She also makes great use of jewels, wearing them both on her chaperon and round her neck, and as trimming for her gowns; in which jewels she delights greatly, and although she has a great plenty of them left her by her predecessors, yet were she better supplied with money than she is, she would doubtless buy many more."[11] Much of the jewelry worn here had specific historic interest: the Tau cross hanging from Mary's pearl and ruby choker had belonged to her mother, Katherine of Aragon; the large diamond brooch with pendant pearl worn on her bodice had belonged to her last stepmother, Katherine Parr. The reliquary suspended from the Garter chain around her waist is described in Henry VIII's 1521 Jewel Book as "broken in many placys and diuerse of the Reliques shaken oute lacking on claspe [with several of the relics shaken out, because lacking a clasp]";[12] Mary had had it repaired for her own use. One of her rings is her coronation ring, and the other, a gift from her future father-in-law, Charles V, was effectively her engagement ring.

The highly mimetic detail suggests that Eworth had firsthand access to the queen's jewels, but personal and familial connections undoubtedly also influenced his recording of these precious accessories. The artist's brother François Eeuwouts was a jeweler and diamond cutter; another relative, Nicholas Eeuwouts (who also emigrated to London), was a jeweler, and his son, Lancelot Eeuwouts, was a ruby cutter. Eworth himself may have later worked as a jeweler and goldsmith in Antwerp in the 1560s and 1570s.[13] MEW

Notes to this entry appear on p. 308.

the result of chronic illness) and—in the words of the Venetian ambassador, Giovanni Michele—her features took on "a grave and sedate cast."[6] The appearance of age was of considerable concern, as at the time of her coronation, Mary was thirty-seven years old and unmarried (although she was betrothed to Philip II of Spain and would marry him later that year); it was crucial that her ability to produce an heir be perceived as viable. When compared with Anthonis Mor's rigidly iconic (and somewhat intimidating) portrait of Mary painted just a few months later (fig. 29), it is evident that Eworth's image aimed to flatter its subject, lightly idealizing her features and making her appear more youthful.[7]

Mary stands nearly frontally in Eworth's portrait, with her hands clasped loosely at her waist, a pose introduced into English portraiture by Hans Holbein the Younger in his portrayals of Christina of Denmark (see fig. 115) and Anne of Cleves (see fig. 82). For female sitters, this pose "strongly denoted rank and high status."[8] From Mary's stiffly spreading skirts and opulently cascading sable sleeves to her high, pale forehead, the pyramidal geometry of Eworth's composition underscores her royal authority. Behind her hangs a red velvet cloth of estate,

A VERY
FRVTEFVL AND
PLEASANT BOKE CAL
led the Inſtruction of a chꝛi
ſten woman, made firſte in
latyne, by the right fa
mous clerke mayſter
Lewes Uiues, and
tourned out of
latyne into
Engliſhe
by Ry
chard Hyꝛde.

Londini.
ANNO. M D. LVII.
1556.

T.P.

27. *Instruction of a Christen Woman*

Written by Juan Luis Vives (1492/93–1540); translated by Richard Hyrde; printed by Thomas Powell
London, 1557
Ink on paper, 7½ × 11⁷⁄₁₆ in. (19 × 29 cm)
British Library, London (C.115.n.17)
Exhibited New York and San Francisco only

Originally written in Latin in 1523 for the young princess Mary, *De institutione feminae christianae* (*On the Instruction of a Christian Woman*) was an educational guide for the morally upright Christian daughter. This English translation—one of the nine editions of the sixteenth century—appeared during Mary's reign.[1]

The author, Juan Luis Vives, was born in Valencia, Spain, in 1493 to a *converso* Jewish family; his father, grandmother, and other relatives were all murdered by the Inquisition (an institution founded by Katherine of Aragon's parents).[2] After completing his studies in Paris, Vives lectured at the University of Louvain, tutored high-profile students, and entered the powerful intellectual orbit of Erasmus and Thomas More.[3] When he moved to England in 1523, he had already published on education and philosophy and, once there, quickly gained the favor of Cardinal Wolsey, who granted him a position at the University of Oxford. He also befriended Henry VIII and Katherine of Aragon, serving as a spiritual adviser to the queen and directing

Princess Mary's studies. When the monarchs' divorce proceedings unfolded years later, Vives found himself in the awkward position of being a scholar—asked to weigh in on the marriage debate—and a Spaniard—a countryman and confidant of the queen. When Wolsey requested full disclosure of his communications with her, Vives asked, "Can anyone blame [me] for attempting to console her?"[4]

Indeed, *Instruction of a Christen Woman*, which accompanied a practical lesson plan for Princess Mary, is dedicated to "the moste gracious princesse, Katharine of Englande."[5] "I have bene moved," he effused in the preface, "by the holynes and goodnes of your livyng."[6] The text that followed offered a lifestyle guide, from birth to marriage to widowhood, showing how a child, girl, and woman "ought to passe the tyme of hir life well and vertuously with hir husband." Vives recommended, for example, that women breastfeed their own children, as opposed to hiring a nursemaid, because "we sucke out of our mothers . . . not only love but also condicions and disposicions." On finding a husband, Vives suggested that a daughter should step back and let her wise parents choose, but "helpe the matter forwarde with good praier."[7]

Although Vives advocated for the education of women (the book even contains a reading list), he actually reasserted traditional views on gender roles—and a supposed feminine lack of judgment ("because a woman is a frayle thyng").[8] He bound women first to their parents, then to their husbands, calling for supervision and general confinement to the domestic sphere. Likewise, he warned that women should never teach, because they were unstable, morally weak, and likely to misinform their pupils. According to Vives, a woman's education was necessary only insofar as it would make her a better wifely companion. Above all, and lest the reader forget, "fyrst let hir understande, that Chastitie is the principall vertue of a woman."[9]

Vives's attitude represents a broader equivocation toward the education of women. Despite flourishing humanist debates, education in the early modern period remained "class driven and vocational," particularly among women.[10] Even in the exceptional case of Henry VIII's royal daughters, Mary and Elizabeth's educations shifted in accordance with their political situations. Before her restoration to the succession, Mary's early education prepared her for Vives's role of a wife rather than a sovereign. Elizabeth's restoration precipitated a more princely education guided by the Cambridge scholar Roger Ascham, though her education was, like Mary's, often described in conventional terms.[11]

As an enormously popular conduct book, *Instruction of a Christen Woman* illustrates how Mary, Elizabeth, and their subjects were primed to observe the gender hierarchies of leadership.

Already for two centuries, in discursive tracts and books read across England and Europe, *la querelle des femmes* (the woman question) had queried to what extent women were inferior or superior to men.[12] In some cases *la querelle* complemented legislation; in France Salic law barred women from succession. Vives's advice was an ambivalent addition to the conversation—widely published in English, French, German, Dutch, Spanish, and Italian—that clearly suggested women were inherently unfit to rule.[13] Others, like John Knox, echoed such sentiments even more sensationally, proclaiming "that a woman promoted to sit in the seate of God, that is, to teache, to iudge or to reigne aboue man, is a monstre in nature, contumelie to God, and a thing most repugnant to his will and ordinance."[14] It is in this context that Vives's student, Mary, became England's first ruling queen and Elizabeth her emphatically virgin successor. SB

Notes to this entry appear on p. 308.

28. Cartoons for the Donor Panels of Philip and Mary, for the Last Supper "King's Window"

Dirck Crabeth (active 1539–74)
Gouda, 1557
Lead white and black chalk, left: 236½ × 28¼ in. (601 × 71.7 cm); right: 236¼ × 28½ in. (600 × 72.2 cm)
Sint-Janskerk, Gouda (A2, B2)
Exhibited New York only

With the window for which these drawings served as preparatory models (fig. 30), a Tudor monarch takes her place alongside a range of European royalty and nobility that Henry VII could only have dreamed of counting among his cohort: Margaret of Parma, Regent of the Netherlands; Eric II, Duke of Brunswick-Lüneburg; Jean de Ligne, Stadtholder of Friesland, Groningen, Drenthe, and Overijssel and Duke of Arenberg; Margaretha van der Marck, Countess of Arenberg; Philippe de Ligne, Lord of Wassenaar; Elburga van den Boetzelaer, abbess of Rijnsburg; and William the Silent, Prince of Orange and Stadtholder of Holland, Zeeland, and Utrecht (although he eventually withdrew from such a Habsburg-allied assemblage). Mary Tudor appears among them, not as an equal but, with her Habsburg spouse, Philip II of Spain, as their principal—"I dictate what is just" (IUSTA IMPERO) and "I control the times" (TEMPORA TEMPERO), their window declares. The window was designed for, and remains in, the north transept of the massive sixteenth-century church dedicated to Saint John in Gouda, in the Netherlands. The top half of the window, which overall is almost twenty feet (six meters) tall, represents the dedication of the Temple of Solomon; the Last Supper appears below it,

along with a dated and inscribed cartouche flanked by allegorical figures of Justice and Temperance bearing aloft the banderoles with those exalted declarations of Philip and Mary's might. In the representation of the Last Supper, the monarchs take their privileged, if appropriately humble, positions as kneeling patrons, inhabiting the same space as Jesus and his disciples and witnessing the very moment when Jesus tells his followers that one among them will betray him.[1]

Philip and Mary's window was the crowning element in an artistically and politically ambitious project by the wardens of the Sint-Janskerk to persuade secular and ecclesiastic potentates of the period to donate windows to the edifice, which had to be all but rebuilt following a disastrous fire in 1552.[2] The formidable project envisioned sixty-four windows, but not all were executed; of the fifty-two windows that were designed, nineteen are attributed to Dirck Crabeth and his workshop, and an additional five to his younger brother, Wouter, both artists Gouda-born. Dirck in particular was a successful master designer, glass painter, and glazier who returned to his hometown to work on the Sint-Janskerk glass project after high-profile commissions for Holy Roman Emperor Charles V at Sint-Jacobskerk in The Hague, for Count Floris of Egmont at the Catherijnekerk in Utrecht, and for the Chapter of the Oude Kerk in Amsterdam.[3] Crabeth's drawn cartoons for the Gouda project are distinguished by arresting artistry, sureness of line, and subtlety of modeling, proving him to be master of his medium. Though the distinctive features and hard outline of Philip's portrait reveal it to be closely based on a specific, sanctioned portrait, Mary's features, in contrast, are soft and considerably less individualized. Their generic femininity suggests that Crabeth, certainly not having had the benefit of seeing Mary in person, perhaps had not even been provided with a realistic likeness of her to copy.[4]

The Gouda glass project took place against a background of festering relations between the Catholic Habsburgs and the increasingly Protestant provinces of the Netherlands, culminating in the Dutch War of Independence.[5] Work to complete the scheme of sixty-four windows lasted almost fifty years, and was ultimately left unfinished. The resulting fifty-two windows lining the nave (which remains the longest of any church in the Netherlands), the ambulatory, and part of the choir were stunning in effect. In fact, it was so glorious and such a monument to Gouda civic pride that, when iconoclasts stormed the church first in 1566 and again following the ouster of the Spanish Habsburgs in 1572, the windows were left intact. Within Crabeth's lifetime, this monument to Catholic Spain and its allies was declared, and has remained ever since, a center of the Protestant Dutch Reformed Church. As a mark of the importance of the project,

Fig. 30. Dirck Crabeth (active 1539–74), *The King's Window* (detail), Sint-Janskerk, Gouda, 1557

and with the more practical awareness that repairs might prove necessary, the church wardens acquired and retained all of Crabeth's cartoons and those of his successors on the project, carefully storing the drawn models in a strong room adjoining the church.[6] They remain an incredible record of the most significant stained-glass project of the sixteenth century.

The window in Gouda was not the only monumental stained-glass window to depict Philip and Mary as royal spouses; others, in Ghent and Antwerp, have long since been destroyed.[7] But the Gouda Last Supper window and its cartoons survive as a telling testament to the three years when Mary Tudor, thanks to her alliance with Philip, could claim pan-European dominance. Mary's proud—if short-lived—Catholic supremacy in Europe must have seemed all but unthinkable only four years before the window's creation, during the austere reign of her Protestant half brother, Edward VI. Likewise, it is difficult to imagine her otherwise glorious half sister, Elizabeth, thus triumphantly represented in a Dutch great church more than two hundred and fifty miles from London. That said, the Gouda window concretizes the qualms of those English who had reputedly pelted Philip's ambassadors with snowballs, "so hateful was the sight of their coming . . . this news [of the marriage] very much disliked," their fears stoked by the French ambassador's claims that "if the alliance were to take place the Spaniards would try to dominate England."[8] For although the arms of England are proudly represented in the window, level with and at the same scale as those of Spain, and Mary and Philip's equal royal status is signified by their crowns and ermine robes, Philip does sit in front of his queen. Moreover, the lengthy inscription in the cartouche makes not a single reference to Mary Tudor, instead celebrating "The most illustrious Philip, son of invincible and august Emperor Charles V by the grace of God, king of Spain [and] England." In any event, Philip would lose the last component of that title within a year of the window's installation. EC

Notes to this entry appear on p. 308.

29. Cup and Cover (The "English Monument")

Antwerp, 1558–59
Gilded silver, H. 21½ in. (54.5 cm)
Historisches Museum Frankfurt (X00041)

Mary I's reign saw Tudor England re-engaging with Europe on a scale that even the queen herself, with her Spanish husband, might not have anticipated. The Habsburg alliance did bring Europeans into England. However, the greater movement was of English and resident European refugees out of the country into

Europe, principally as a result of the Roman Catholic Mary's persecution of Protestants, subsequently reported (not without some bias) by John Foxe in his *Book of Martyrs* (1563).

Frankfurt, an imperial free city, enjoyed an international reputation for tolerance and refuge, hosting significant numbers of religious asylum seekers—Jewish and Protestant, Fleming and Walloon, English and Scottish—fleeing persecution. Among the influential proponents of the new religion seeking shelter in Frankfurt were the Walloon Valérand Poullain, the Scot John Knox, and even John Foxe himself, en route from Strasbourg to Basel.[1] Indeed, such was the fervor in the city that sectarian disagreements broke out among the refugee communities, the English faction split by the question of whether or not to use the new English liturgy and prayer book.[2]

This discord aside, a large group of English Protestants chose to spend the duration of Mary's five-year reign in Frankfurt. At Elizabeth's accession to the throne in late 1558, most opted to return to England. Within months, as a group, they commissioned this large cup and cover to thank the city that had given them refuge. Fashioned as a composite column, the hollow shaft forms the cup; the shallow dome, its cover; and the heroic figure on the cylindrical pedestal, the handle to lift the lid. The rectangular block base provides ample space to represent Elizabeth's royal arms of England, alongside a Latin inscription from the English to their Frankfurter hosts, dated 1559, thanking the city council for the shelter they offered and recognizing their "humanitas." The armor-clad figure strikes an appropriate note of concord and shared bounty, with his shield at rest and proffering a sizable horn of plenty, marked with Frankfurt's coat of arms.

Rather than commission a piece of silverwork from one of the many London workshops (for instance, cats. 60, 63, 64), the English Protestants turned to Antwerp. Indeed, they may have commissioned the gift during their homeward journey as they were passing westward through northern Flanders. The silversmith responsible for this work, not identifiable by name but recognizable from his mark of panpipes in a shaped shield, was an inventive master unafraid to design in unexpected ways; another of his covered cups takes the form of a falcon perched on an earthy block.[3] The "English Monument" is appropriately monumental in design and—for a silver cup—scale. As testament to its patrons' taste, the work displays a comprehension of, and a sympathy for, classical form as sophisticated as anything being made on the Italian peninsula at this date.[4] Commissioned by the English, produced in Flanders, and given to Frankfurt, the cup represents the network of experience undergone by English Protestant refugees from Catholic Tudor England. E C

Notes to this entry appear on p. 308.

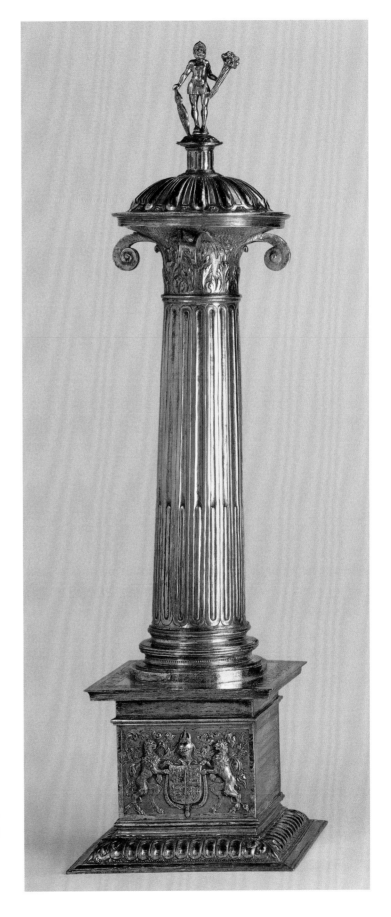

30. Elizabeth I (The Hampden Portrait)

Attributed to George Gower (ca. 1540–1596)

ca. 1567

Oil on canvas, transferred from panel, 77³⁄₁₆ × 55⅛ in. (196 × 140 cm)

Private collection

In her earliest surviving full-length, life-size portrait, Elizabeth I stands on a Turkish carpet in front of an armorial hanging made from cloth of gold. With arms held out stiffly alongside her body, she rests her right hand on the finial of her throne, pinching a carnation between her fingers, and holds a glove in her left. She wears a crimson dress with extensive cutwork ornamentation over a richly embroidered partlet with a high ruff collar. Along with a rope of pearls around her waist and massive table-cut stones, the queen displays a red rose pinned at the seam between her left sleeve and bodice, and green leaves tucked under her cap. At the far right of the composition, the background opens up to a wall of greenery, either a represented tapestry or a "real" arbor, with pears, honeysuckle, pomegranates, and grapes entangled in a vision of abundance.

The Hampden portrait is the finest example of the "Barrington Park" pattern, a group of early images of the queen that may have responded to the 1563 draft proclamation calling for the creation of an official royal likeness.[1] This group of portraits has been associated with Elizabeth's marriage negotiations of the 1560s with such figures as Archduke Charles of Austria and Erik XIV of Sweden.[2] With the amorous emblem of the carnation and the backdrop of fruit and flowers, Elizabeth appears in the Hampden portrait as a marriageable beauty, well before the iconography of virginity came to dominate her portraits (see, for instance, cat. 114). Intriguingly, the leaves surrounding the rose pinned to Elizabeth's dress have been identified as oak, a possible allusion to the device of Robert Dudley, Earl of Leicester, the longtime royal favorite.[3] For all its individuality, the portrait demonstrates continuities in the queen's depiction, with such features as the cloth of honor, throne, and hand resting on the finial recurring in portraits from the very end of her long reign (cat. 118).

Family tradition contends that the queen presented this portrait to Griffith Hampden, the sheriff of Buckinghamshire, during a visit to his estate, but there is no evidence to verify this.[4] Other full-length portraits were commissioned by courtiers to commemorate the queen's progresses (cat. 119), but this portrait could also have been dispatched abroad to play a role in marriage negotiations, or displayed by a courtier wishing to promote the queen's marriage.

The most frequent attribution of the painting has been to Steven van der Meulen, a Flemish artist who in 1562 was granted denization in England, obtaining certain rights normally denied to foreign artisans resident in that country. Van der Meulen is also probably the "famous paynter steven" whose work was recorded in the collection of John, 1st Baron Lumley, in 1590, and the "Master Staffan" who accompanied an English embassy to Sweden in 1561 and painted the portrait of Erik XIV.[5] The envoys who presented "Master Staffan's" portrait to Elizabeth I as part of their marriage negotiations also commissioned several likenesses of her, although none of these has yet been identified.[6] (Another theory identifies this "Steven" with the medalist Steven Cornelisz. van Herwijck [see cats. 104, 105], but there is no persuasive evidence that he was a painter.)[7]

The artist of the Hampden portrait appears to have been the same painter who depicted Frances Sidney, Countess of Sussex, in a likeness now at the Cambridge college she founded and which bears her name (fig. 31). In fact, the right hands of the

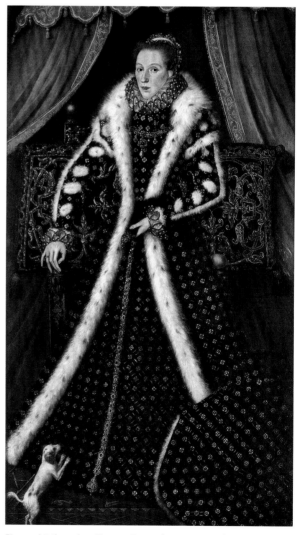

Fig. 31. Attributed to George Gower (ca. 1540–1596), *Frances Sidney, Countess of Sussex*, ca. 1572. Oil on panel, 76 × 43¾ in. (193 × 111.1 cm). The Master, Fellows, and Scholars of Sidney Sussex College, Cambridge

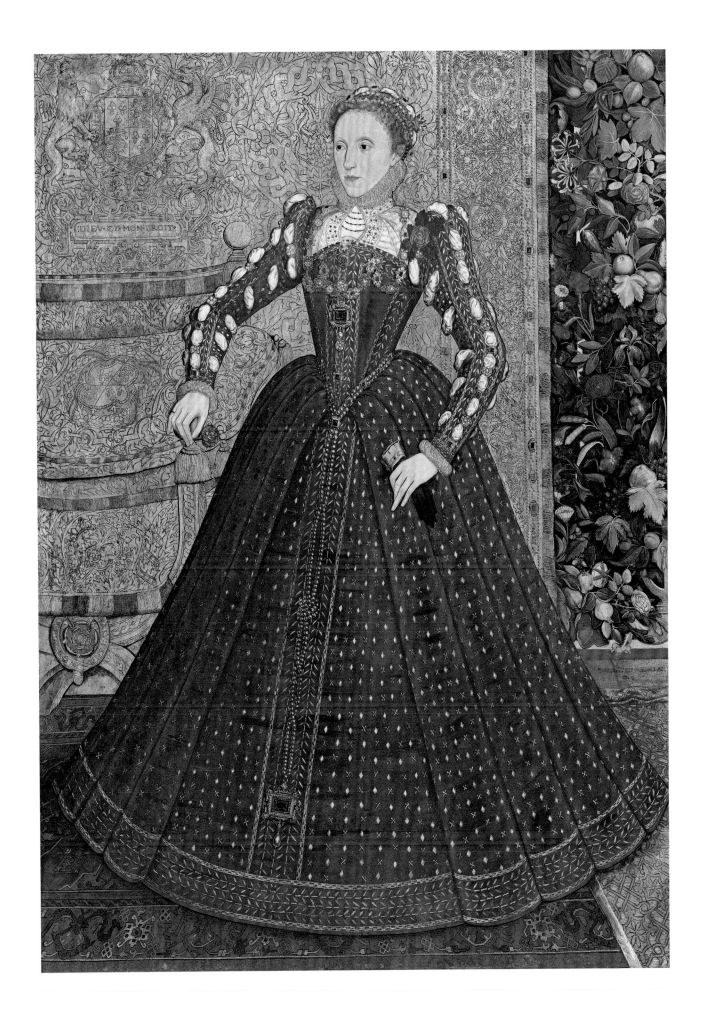

sitters in both portraits, grasping the finials of chairs, are nearly identical, derived from the same studio pattern. But the style of the countess's costume in the portrait places it well after Van der Meulen's death in 1563 (or Van Herwijck's in 1566/67).[8] More recently, Edward Town and Jessica David have suggested that both the Hampden and the Sussex portraits belong in the oeuvre of the native-born painter George Gower, an assertion based in part on infrared photography showing that the Countess of Sussex's portrait was painted over an image of Elizabeth I that closely resembles the Hampden portrait.[9] Town and David propose that Gower played a critical role in generating the portraits of Elizabeth that circulated during the marriage negotiations of the late 1560s, as well as introducing the "sieve" imagery that Quentin Metsys the Younger would later take up (see cat. 114). By reconstructing Gower's oeuvre and service to the Crown in this pivotal early chapter of Elizabeth I's reign, this theory makes a major contribution to our understanding of the queen's evolving image. AE

Notes to this entry appear on p. 308.

31. *Founding Charter of Emmanuel College, Cambridge*

Nicholas Hilliard (ca. 1547–1619) and workshop
London, 1583–84
Watercolor and bodycolor, with silver and gold, on vellum, with cord and wax seal, without cord: 22⁷⁄₁₆ × 31½ in. (57 × 80 cm)
The Master and Fellows of Emmanuel College, Cambridge
Not exhibited

The historical links between limning, or miniature painting, and manuscript illumination are well established.[1] The earliest limners in England, such as Lucas and Susanna Horenbout, trained in the tradition of Flemish illuminators (see cat. 12).[2] Later practitioners, such as Nicholas Hilliard, applied their skills across media, with Hilliard not only limning portraits, but also designing royal seals and illuminating official documents (see cats. 97, 116). This charter for the foundation of Emmanuel College, Cambridge, "is a graphic illustration of the technical links between Hilliard's miniature-painting practice and manuscript illumination," as well as one of the most beautiful surviving official documents from the Tudor age.[3]

Emmanuel College was founded by Sir Walter Mildmay, who made his fortune as a financial administrator for the Crown and was knighted in 1547 by Edward VI.[4] Mildmay played a key role in the state appropriation of chantry funds (those dedicated to Masses for the souls of the dead, a practice banned by the Reformed church). Under his supervision, these funds were redirected toward government or educational purposes,

including the foundation of Emmanuel College, intended to educate Reformed clergy, on the site of a former Dominican priory. Having kept a relatively low profile under Mary I, the Protestant Mildmay served as a successful Chancellor of the Exchequer to Elizabeth I. The social elevation enabled by Mildmay's many years of competent service to the Crown is apparent from the portrait of his eldest son, Sir Anthony Mildmay, by Nicholas Hilliard, depicting him as a gallant knight (cat. 74).

Hilliard's illumination of the college charter shows the queen enthroned beneath a canopy of state, bearing her orb and scepter. A voluminous farthingale further transforms her into an iconic image of the Virgin Queen, whose authority allows for the establishment of Emmanuel College and, by extension, the defense of the Protestant cause. By contrast, the framing architecture features female caryatid figures, whose drapery clings to their curves. The floral and strapwork borders may well be in another hand, specialized in this type of document illumination. Like the letters patent also included in this volume (cat. 25), the charter attests to the continued power of the illuminated and handwritten document, even in an age of large-scale printing. Later calligraphers like Esther Inglis harnessed precisely this aura of the manuscript in their carefully tailored gifts to the queen (cat. 59). AE

Notes to this entry appear on p. 308.

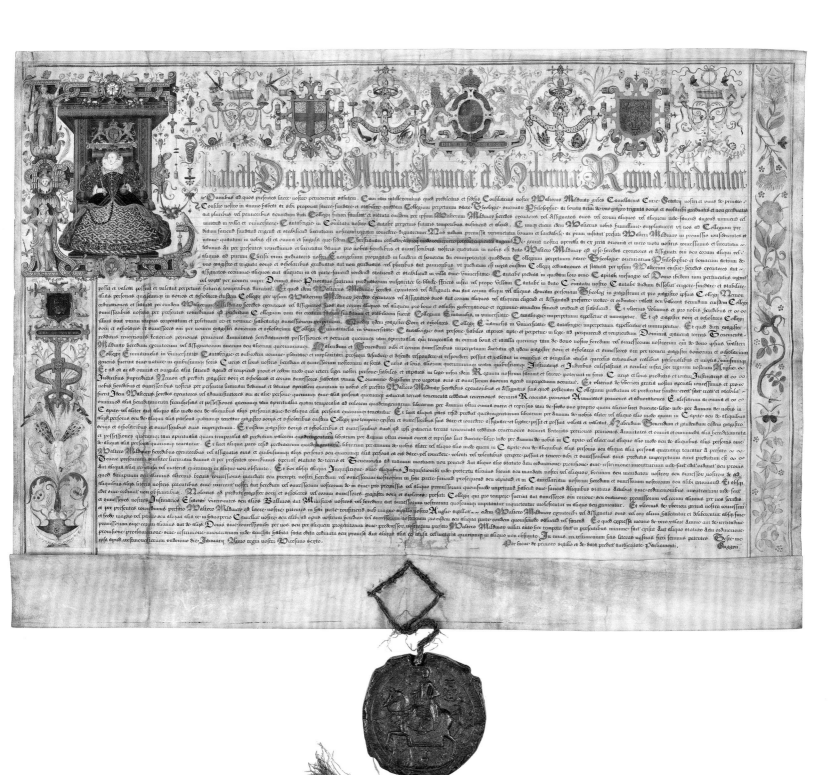

32. *Ewer and Basin*

London, 1567–68
Silver, gilded silver, ewer: 13⁵⁄₁₆ × 4⁵⁄₁₆ in. (33.8 × 10.9 cm);
basin: 2⅛ × 19¹¹⁄₁₆ in. (5.4 × 50 cm)
Museum of Fine Arts, Boston (1979.261-262)
Exhibited Cleveland and San Francisco only

Marked with the mysterious engraver's initials *P* over *M*, this silver ewer-and-basin set is an extraordinary survival of Tudor court plate. Although their maker and patron remain uncertain, the ewer and basin represent the highest-quality artisanship of the London goldsmiths' trade and continental engraving.[1] Lady Anne Clifford—the diarist, literary patron, builder, and daughter of George Clifford, 3rd Earl of Cumberland (see cats. 72, 73)—carefully recorded them in her will in the mid-seventeenth century. Having acquired them by way of her late husband, she bequeathed "my silver bason and ewer, with the Scripture history, and some of the kings of England, curiously engraven upon them" to her heirs.[2]

As Lady Anne described, the raised basin contains biblical scenes interspersed with portrait medallions of English monarchs. The biblical depictions, helpfully labeled with their chapters in the Old Testament, nod to thematic notions of family, birthright, faith, itinerant lifestyles, and the unquestioned authority of God. In Genesis 22, for example, God tested Abraham's faith by asking him to sacrifice his only son, Isaac. As Abraham prepared to slay Isaac, God intervened and blessed Abraham and his descendants for his obedience. On the basin, the engraver depicted the action all at once: Abraham raising his sword above a cowering Isaac; the angel hovering above; a ram—the replacement sacrifice—appearing from the bushes. The engraver adapted and elaborated the scenes from Barnard Salomon's illustrations in *Quadrins historiques de la Bible* (1553), a popular French source with woodcuts accompanied by verse.[3]

Borrowing from the genealogical fascination seen in prints (cat. 1) and manuscripts (cat. 2), the four most recent monarchs

encircle the basin's core; their predecessors, such as Edward IV and Henry VI, contextualize them from the outer ring. The vase-shaped ewer depicts a full-length Richard I prying open the mouth of a lion, and William the Conqueror holding scepter and orb, organized within oblong cartouches. Precisely rendered sea monsters, acanthus leaves, laurel wreaths, and columns highlight the liberal combination of biblical and classical imagery in honor of the monarchy (for more, see "Honing the Tudor Aesthetic" in this volume).

Unlike the other monarchs on the basin, who hold royal orbs, Elizabeth I clasps a Bible (or prayer book) with a single carnation peeking from its leaves.[4] The book symbolizes her devotion to the Protestant faith, further intensified by the cast of figures around her. As in the Hampden portrait (cat. 30), the carnation holds amorous connotations, perhaps amplifying her relationship to God or offering the young queen as an eligible bride-to-be. The inclusion of the carnation certainly supports the suggestion that William Herbert, 1st Earl of Pembroke (immortalized in cat. 105), commissioned the set out of concern for the succession.[5] Its potentially ill-advised nature, at a contentious moment for the earl, may explain why it remained in the family collection.

If not in this precise combination, the iconographic program is consistent with that on courtly plate used for ritual hand washing, ceremonies, or gifts.[6] In Elizabeth's inventories, many examples of such display-worthy buffet plate are listed ("oone very faire Basone guilt of Flaundours making wrought with divers histories with iiij scriptures in the border"). Rather than by portrait, however, the monarch is usually personified on such plate by "the Quenis Armes."[7] SB

Notes to this entry appear on p. 308.

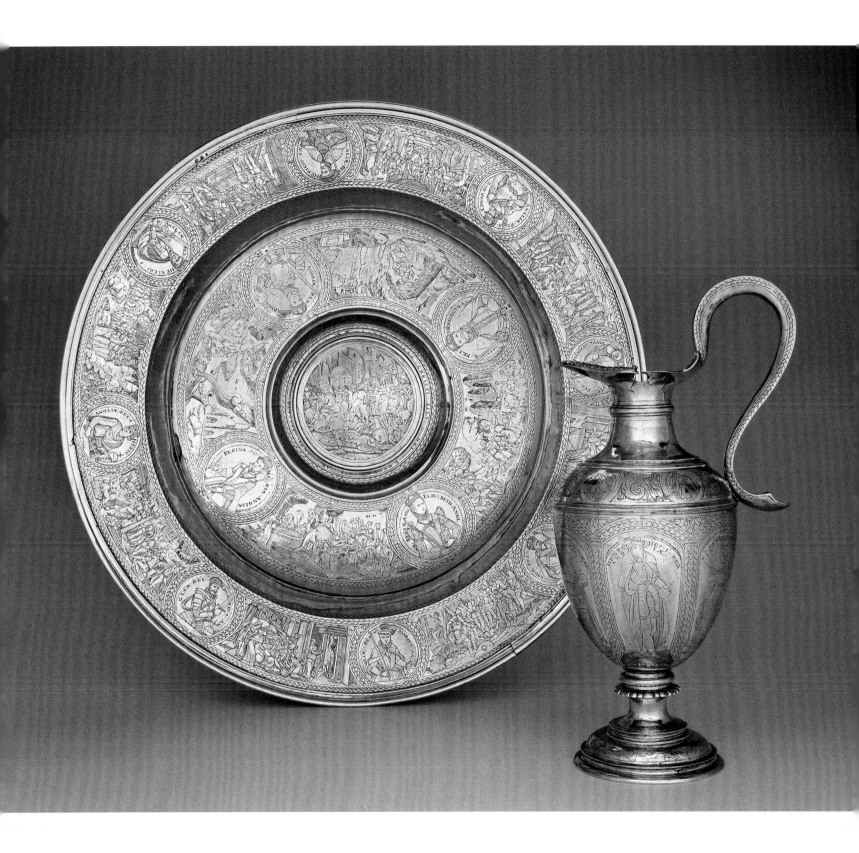

33. *Allegory of the Tudor Dynasty*

William Rogers (active 1584–1604), after Lucas de Heere
(ca. 1534–ca. 1584)
London, ca. 1595–1600
Engraving, 14⅛ × 19⅜ in. (36 × 49.1 cm)
The British Museum, London (1842,0806.373)
Exhibited New York and Cleveland only

This allegorical family portrait breaks down the Tudor dynastic narrative in an almost didactic manner. As the print collapses and conflates time, its maker, William Rogers, simultaneously cultivated nostalgia for Henry VIII and posited Queen Elizabeth I as the inevitable apotheosis of the Protestant succession, reorienting the past to justify the present.

Rogers was a member of the Goldsmiths' Company of London, and an English copperplate engraver.[1] Heralded as "the founder of a domestic school of engraving," Rogers cultivated a highly ornamented, Flemish-influenced style in which he produced multiple portraits of Queen Elizabeth, such as his *Eliza Triumphans* (1589), as well as title pages, maps, and illustrations.[2] He based the composition for his *Allegory of the Tudor Dynasty* on a painting of about 1572 attributed to Lucas de Heere (fig. 32). At the center Henry VIII sits on his throne, passing a sword to his son and heir, Edward VI, who kneels beside him. To their

Fig. 32. Lucas de Heere (ca. 1534–ca. 1584), *Allegory of the Tudor Dynasty*, ca. 1595–1600. Engraving, 14³⁄₁₆ × 19⁵⁄₁₆ in. (36 × 49.1 cm). National Museum of Wales, Cardiff (NMW A 564)

left, Mary I and Philip of Spain stand slightly apart, with Mars, god of war, lurking from the rear. On the right Elizabeth dominates the scene, rendered larger and in greater detail than her family members. Figures of Peace and Plenty, the latter of whom also appears in *Eliza Triumphans*, accompany the queen. The allegorical figure of Peace, her hand intertwined with Elizabeth's, crushes weapons underfoot.

Some of the modifications to the original composition are contemporary updates, such as Elizabeth's fashionably exaggerated 1590s silhouette, drum-shaped farthingale, and French wired veil. Other differences are stylistic: Rogers lavished attention on sumptuous details such as the ceiling studded with roses, the canopy dripping with pearls, and the strapwork-surrounded inscription that appears to hang off the frame. One particularly important alteration is the change of setting from a loggia dressed up with a throne and cloth of state to an enclosed room hung with two tapestries. Instead of Elizabeth entering from the right, she walks across the gallery, underscoring the idea of a predestined, seamless continuation of the dynasty. The tapestry shown at right—with its landscape and arabesque border punctuated by profiles—bears strong compositional similarities to the *Story of Vulcan and Venus* tapestry series that Henry VIII purchased for Whitehall Palace.[3] Although the seascape depicted on the tapestry is barely legible, Rogers used it to allude obliquely to English naval power and a specifically Henrician inheritance of Tudor majesty.

The inscription below the scene further orients Henry, Edward, and Elizabeth as rightful English, Protestant heirs. Rogers held Mary and Philip responsible for the suppression of truth and the "decay" of English glory, whereas he sympathized with Elizabeth's tumultuous upbringing, emphasizing how "All the world admyr's this mayden Queen." In the third panel of the inscription, either Rogers or a later hand outfitted the verses with numbers that correspond to the figures. This diagrammatic touch, which does not appear in the edition of the print preserved in the Royal Collection, points to genealogies and biblical title pages (see cats. 20, 21), but most of all ensures accurate identification of each monarch, thus enacting the ultimate Protestant tenet of "vernacular accessibility."[4] SB

Notes to this entry appear on p. 308.

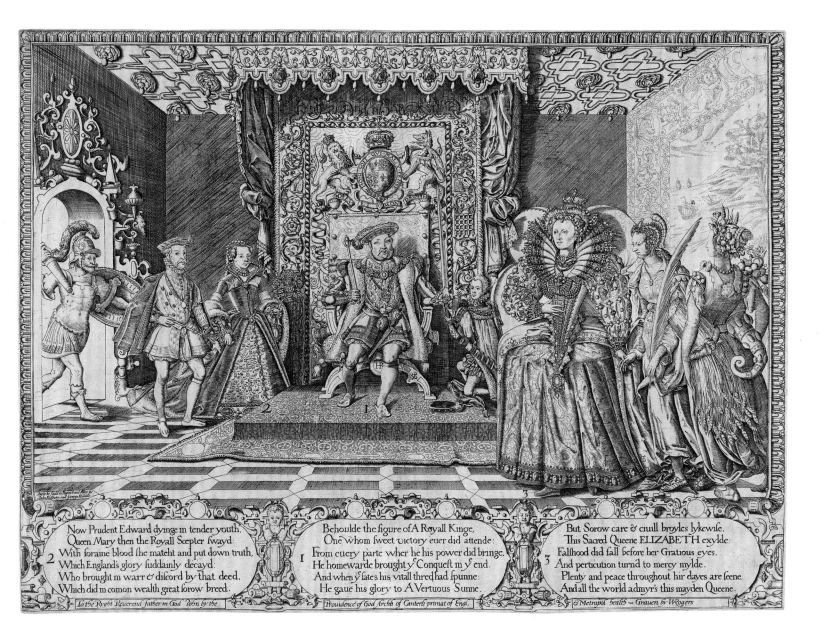

2 1 3

Now Prudent Edward dyinge in tender youth,	Beholde the figure of A Royall Kinge,	But Sorow care & ciuill broyles lykewise,
Queen Mary then the Royall Scepter swayd:	One whom sweet victory euer did attende:	This Sacred Queene ELIZABETH exylde:
With foraine blood she mateht and put down truth,	From euery parte wher he his power did bringe,	Falshood did fall before her Gratious eyes,
Which England's glory suddainly decayd:	He homewarde brought y Conquest in y end.	And perticution turnd to mercy mylde.
Who brought in warr & discord by that deed,	And when y sates his vitall thred had spunne:	Plenty and peace throughout hir dayes are seene.
Which did in comon wealth great sorow breed.	He gaue his glory to A Vertuous Sunne.	And all the world admyr's this mayden Queene.

To the Ryght Reuerend father in God Iohn by the | Prouidence of God Archb of Canterb primat of Engl. | & Metrapol health ~ Grauen by Wrogers

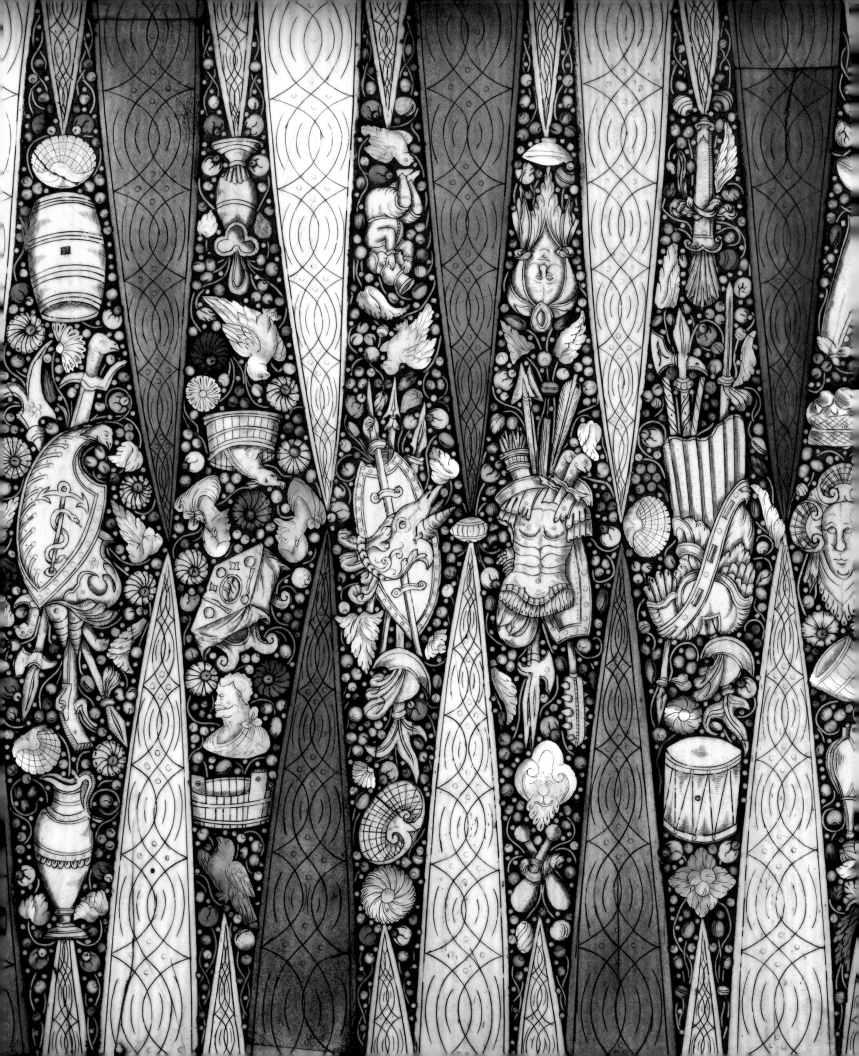

COURTLY SPLENDOR

Furnishing the Palace

Elizabeth Cleland

John Fisher (cat. 76) recognized the pleasures of the princely lifestyle in early Tudor England, which he witnessed at court as confessor to Henry VII's mother, Margaret Beaufort; at the University of Cambridge, where he served as chancellor; and in his experience as bishop of Rochester, with the often scandalously secularized circles of some senior ecclesiastics:

> They had all their pleasures at the full, both of delicious and good welfare, of hawking, hunting, also goodly horses, goodly coursers, greyhounds and hounds for their disports, their palaces well and richly beseen, strongholds and towns without number; they had great plenty of gold and silver, many servants, goodly apparel for themself and for their lodgings.[1]

If Fisher's words were intended to reflect on the transience of life, they also evoke the largely lost world of the Tudor palace, redolent with diversions and sensuous comforts. Whichever residence was taken up by the monarch took on an importance, not only as the national seat of power of the moment, but also as the standard-bearer of splendor, perceived as a necessary indication of the Crown's authority.[2]

The new Tudor palaces—Henry VII's Richmond (rebuilt after a fire in late 1497) and Greenwich (built ca. 1501–7), and Henry VIII's Nonsuch (1538–41)—were characterized by energetic rhythms of space: stretching vistas of relatively private long galleries punctuated with intimate, closeted royal cabinets, accessible only to the very favored.[3] Greenwich, like the Tudors' medieval seat at Westminster, also boasted a lofty-beamed, open, semipublic great hall, while the smaller Nonsuch had a processional stair leading from the inner court to the king's lodgings. Richmond, like Hampton Court after Henry VIII's building campaigns (fig. 33), had both a great hall and a state stair.

Richmond was the only one of the three new palaces deemed, like Windsor, Woodstock, Hampton Court, and a handful of others, large enough to "keep hall" and accommodate the full body of the court, estimated at 1,500 people. Though splendid, Nonsuch was so small that it has been dubbed "a privy palace" (cat. 34).[4]

The plans of these three palaces built from scratch hint at the Tudor monarchs' shifting priorities of intellectual and physical comforts. Henry VII made certain to include small, private libraries and oratories at Richmond and Greenwich, as he did in his extensions to the Tower of London and Windsor. His enclosed gallery in the riverside royal lodgings at Richmond was probably inspired by his experience of French architecture, particularly the Château de Saumur.[5] With Nonsuch, constructed on two thousand acres of prime estate land not far from Hampton Court, Henry VIII built a stylish miniature palace intended primarily to lodge royal hunting parties. Despite the meaning of Nonsuch—"beyond compare"—the building was very much about comparison, and competition, again with the French, particularly François I and his residence at Chambord. Indeed, Henry VIII employed French clockmakers and French gardeners, who planted French pear trees.[6]

In most cases Tudor residences, being extensions and conversions of existing, older buildings, could not rely on their floor plans to articulate their aesthetic. Such was true of Windsor, Westminster, Bridewell, Beaulieu, Eltham, Baynard's Castle, and Whitehall (formerly York Place, Thomas Wolsey's London seat as archbishop of York). Their tumble of spaces, odd junctures, and sharp turns could be improved by expensive and fashionable fenestration, galleried corridors, and wainscoting, all increasingly a feature of royal residences and of the emulative great houses

Fig. 33. Hampton Court Palace, Surrey, interior view of the great hall

built by the aristocracy, most appreciably in Hardwick New Hall (see fig. 123).[7] At Whitehall and Nonsuch, Henry VIII employed talented designers—Nicholas Bellin (cat. 53), Hans Holbein (cat. 35)—to embellish the spaces on a par with anything François could enjoy at Fontainebleau. For the most part, though, it was the job of furnishings to dress spaces, match contemporary fashions, and imply their owners' good taste and affluence.

Chronicles relishing the material sumptuousness of royal occasions, as noted on pp. 29–30 of this volume, are reminders of the sixteenth-century predilection for precious plate and costly textiles. In addition to the hundreds of objects lost (Edward Hall describes spectators cutting strips off the "cloth of Ray" walked upon by Henry VIII and Katherine of Aragon at their coronation) and given away as gifts (see pp. 110–13 in this volume), surviving inventories of the Tudor royal collections list page after page of goldsmiths' work, textiles, and precious objects retained.[8] The excess of Henry VIII's personal apparel, as witnessed by the Venetian ambassador's remark that "round his neck he had a gold collar, from which there hung a rough cut diamond, the size of the largest walnut I ever saw . . . [and] his fingers were one mass of jewelled rings,"[9] was matched by his taste in furnishings. At Henry's death in 1547, his Jewel House was the wealthiest of any English monarch, while his collection of tapestries alone,

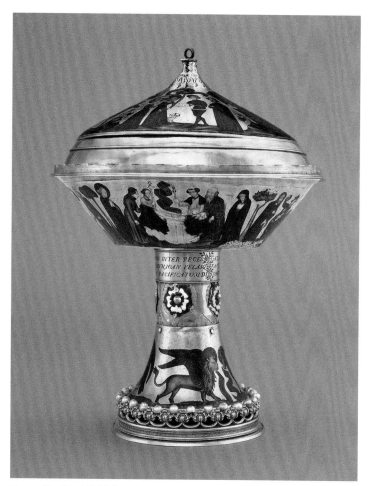

Fig. 34. *The Royal Gold Cup*, Paris, ca. 1370–80, with English additions, 16th century. Gold, enamel, pearl, H. 9¼ in. (23.6 cm). The British Museum, London (1892,0501.1)

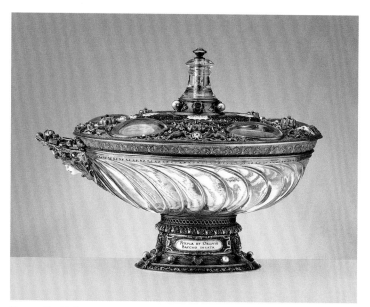

Fig. 35. *The Holbein Cup*, Paris or London, ca. 1540. Gold, enamel, rock crystal, H. 6¼ in. (16 cm). Schatzkammer, Residenz, Munich

not counting velvets, embroideries, and other precious textiles, topped 2,770 pieces.[10] Only three works listed in the 1547 inventory of the Jewel House have survived (figs. 34–36), thus taking on a relic-like importance.[11] They hint at the splendor of additional, lost objects, like the "Looking glasse sett in golde" garnished with rubies, sapphires, emeralds, pearls, and diamonds and containing a clock, rock-crystal decorations, and miniature gold naked boys bearing shields, also listed in the 1547 inventory; or the "very faire Laire [layer] of mother of pearle being a Shell . . . garnisshid with golde" with a glittering foot of diamonds, rubies, emeralds, and sapphires recorded in Elizabeth's possession.[12] Pieces like these filled tiered credenzas to be admired by visitors to the court, such as the magnificent array of silver plate ("the greate Riche copborde, wch Continually stoode in the greate Halle wth all gilte Plate") displayed in Windsor great hall during the visit of the king and queen of Castile, Philip the Fair and Joanna the Mad, in 1506.[13] Some of the inventoried tapestries have survived (cats. 4, 42, 49, 52), among them the

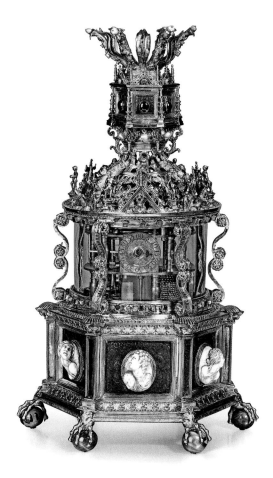

Fig. 36. Attributed to Pierre Mangot (active 1514–ca. 1540), *The Royal Clock Salt*, Paris, ca. 1530. Gilded silver set with intaglios, shell cameos, rock crystal, precious stones, H. 11¹³⁄₁₆ in. (30 cm). Goldsmiths' Company Collection, London

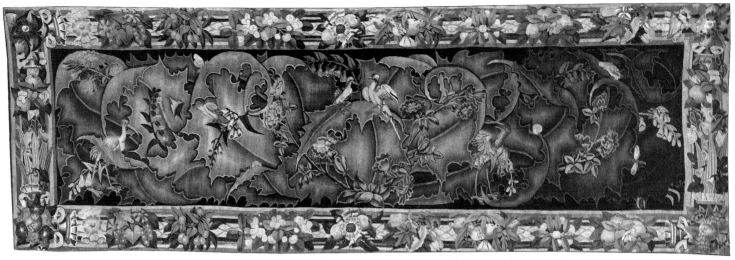

Fig. 37. *Verdure*. Unknown designer; weaving attributed to Enghien, ca. 1545. Wool and silk, 53 × 157 in. (135 × 399 cm). Private collection, London

"verdoures of the brode blome with apples and a flower in the myddes at thupper Corners and a pomide garnett with redd flowers and blewe at the nether corners [verdure with large foliage, with apples and a flower in the middle at the upper corners, and a pomegranate with red and blue flowers at the lower corners]" that Elizabeth, when still a princess, had hanging in her garderobe (fig. 37).[14] The appearance of others is suggested by other survivals, including early and later (fig. 38) tapestry-woven cloths of estate bearing the royal arms.[15] Other documented furnishings are more elusive, like the "xɪɪ p[i]eces of leather layde with golde and silver foyle"—probably gilded leather wall hangings—in the Tower of London.[16] Like those recorded in Thomas Cromwell's home, as well as at Hardwick, these may have been imported from the Iberian peninsula or the Netherlands, perhaps not unlike later surviving examples (fig. 39).[17] Indeed, the tapestry-like, bold floral backgrounds of cats. 30 and 92 might instead imitate such embossed figurative leather hangings.

The wealthiest Tudor subjects, like their monarchs, looked even farther afield than Europe for their special furnishings. Among Cardinal Wolsey's collection of more than 230 rugs and carpets were many imported from Turkey, Syria, and Egypt, some of which were inventoried as "of beyond-sea making," to distinguish them from those "of English making." Aware of Wolsey's tastes, successive Venetian ambassadors gifted him in total more than sixty-seven rich Damascene carpets between 1518 and 1520. Already in 1492, a merchant from Genoa, Antonio Gallo, shipped forty Turkish carpets from Chios to London.[18] Such precious wool- and silk-woven imported carpets were principally used to cover table- and cupboard-tops, as well as window seats, although some were also placed on floors, described in documents as "foot carpets." Of the approximately eight hundred

carpets listed in Henry VIII's posthumous inventory, fifty-one were expressly identified as "foot carpets," many being Turkish imports (comparable in appearance to fig. 40). They are also visible at the royals' feet in portraits (cats. 11, 30, 118), a visual cue of privileged extravagance. Bess of Hardwick's 1601 inventory of Hardwick New Hall included only five Turkish "foote carpetes," with three a luxury in her bedchamber "to laye about the bed." Perhaps as early as 1610, massive Ushak table carpets adorned Hardwick's long gallery, alongside the Flemish tapestry-hung walls. Asian and North African imported carpets were emulated by local practitioners: the extraordinary survival of sizable English copies of Ushak rugs at Boughton House, dated 1584 and 1585, which have been customized to include the arms of Sir Edward Montagu, are a fascinating visual hybrid of northwestern European armorial table carpets (like cats. 70, 75) and star Ushak carpet designs.[19] Great house interiors were further embellished by rich, portable luxury textiles. The Met's *Bearing Cloth* (fig. 41), for example, combines crimson silk satin with an ornamental border embroidered in precious-metal thread. It is of a type used to wrap privileged infants of royalty, the upper echelons of the nobility, and rare commoners of excessive means, such as, for a few years at least, the extended household of Thomas Cromwell.

Small luxury objects were also part of royal daily life. For recreation, increasingly associated with the long gallery, chess and backgammon were popular, played on sumptuous boards like the "paire of plaieng tables made of white boone and brassell wrought with white & grene workes [pair of game boards made of white bone and brass, wrought with white-and-green work]" in Henry VIII's collection, the gorgeous appearance of which is suggested by cat. 43.[20] Devotional practices generally took place

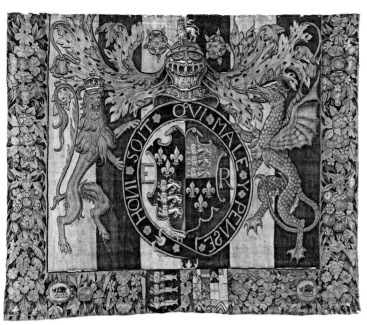

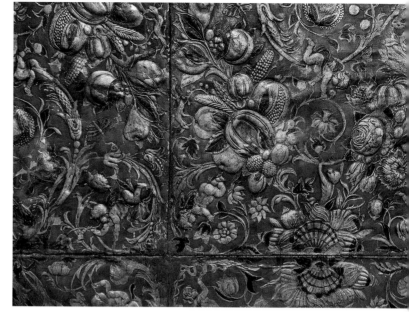

Fig. 38. *The Great Yarmouth Cloth of Estate with English Royal Arms.* Unknown designer; weaving attributed to Enghien or to Flemish weavers active in London, 1547–94. Wool and silk, 82¼ × 99¼ in. (209 × 252 cm). Burrell Collection, Glasgow (47.4)

Fig. 39. *Gilded Leather Wall Hangings* (detail). Attributed to De Gecroonde Son or De Vergulde Roemer, Amsterdam, ca. 1650–70. Silvered, painted, and varnished leather, 96 × 211 in. (243.8 × 535.9 cm). The Metropolitan Museum of Art, New York, Gift of Rosine Lamboitte Donhauser, in honor of Victor and Marie De Meulemeester, 2012 (2012.332.1)

in more intimate spaces, like the oratory Henry VII added to his private apartments at Windsor, which were equipped with prie-dieux, timepieces to keep track of set periods of contemplative prayer (cat. 46), and small-scale painted or woven figurative representations. An example of the latter (cat. 47) recalls the nineteen such miniature devotional tapestries in Henry VIII's collection at his death. Additionally, copious records document Elizabeth I's collections of apparel and keepsakes, among them small functional objects such as the embroidered box gifted by Princess Mary to the four-year-old Princess Elizabeth in 1538.[21]

Contrary to popular perceptions of a tightfisted Henry VII, the first Tudor was fully aware of the political import of splendor and thus shopped prodigiously, spending as much as £360,000—millions in modern equivalence—on goldsmiths' work over the course of eighteen years.[22] For just one set of chapel vestments, he acquired about £100,000 worth of "cloth of gold" velvets from Lucca and Florence (see cat. 7). Having "inherited" a respectable tapestry collection from his Yorkist predecessors,[23] Henry VII nonetheless continued to add to it: three years into his reign, he purchased an edition of the prized eleven-piece *Story of Troy* series from the dealer-entrepreneur Pasquier Grenier of Tournai (fig. 3).[24] Fourteen years later, his acquisition of the ten-piece *Story of the Redemption of Man* (cat. 4) from Brussels-based Pieter van Aelst again set him on a par with the other European

royalty owning this series, but this time surpassing them by acquiring the most splendid known edition, heavy with precious silver and gilded-silver metal-wrapped threads. Van Aelst's impressive roster of clients included Holy Roman Emperor Charles V and Popes Leo X and Clement VII; the same year that he sold the *Redemption of Man* to Henry, he provided Katherine of Aragon's elder sister Joanna the Mad, then Duchess of Burgundy, with a set of four *Life of the Virgin* tapestries so sumptuous, they have been called ever since the *paños d'oro* (golden hangings).[25] Although the price Henry VII paid for the *Redemption of Man* remains unrecorded, the similarly rich *Acts of the Apostles* tapestries that Van Aelst later sold to Pope Leo X cost one-tenth their weight in gold.[26]

Henry VIII bettered his father's expenditure, continuing to acquire from Van Aelst (see cat. 42) as well as from a roll call of taste-setting European dealers, including the Van der Walle family from Antwerp. The entrepreneurial reach of the latter extended to Constantinople where, together with designer Pieter Coecke van Aelst, they endeavored to sell tapestries to Suleiman the Magnificent. In turn, the Van der Walles' imports from the Ottoman Empire included silk cupboard, window, and foot carpets, among them thirty-four such examples that they sold to Henry VIII. These dealers met Henry's tastes across the board, also selling him tapestry-woven bed hangings and goldsmiths' work in such quantity that, at his death, the king owed the

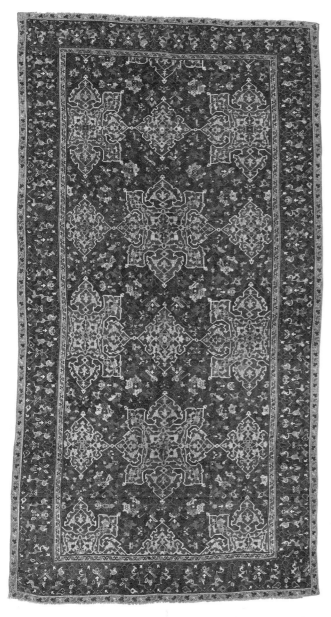

Fig. 40. *Star Ushak Carpet.* Attributed to Turkey, late 15th century. Wool, 169¾ × 91⅜ in. (431 × 232 cm). The Metropolitan Museum of Art, New York, Gift of Joseph V. McMullan, 1958 (58.63)

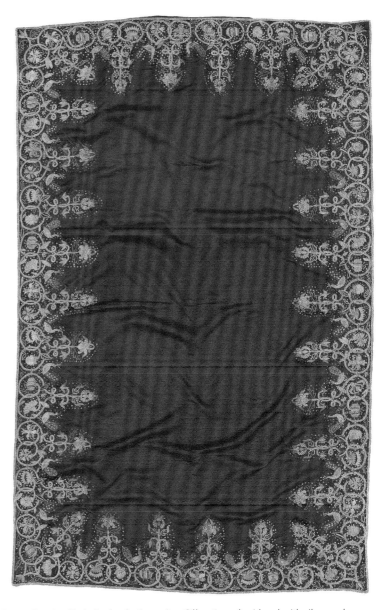

Fig. 41. *Bearing Cloth.* England, 1600–1620. Silk satin embroidered with silver and gilded-silver metal-wrapped threads, 65¾ × 42½ in. (167 × 108 cm). The Metropolitan Museum of Art, New York, Purchase, Friends of European Sculpture and Decorative Arts Gifts, 2016 (2016.526)

Van der Walles £8,700.[27] Henry VIII possibly also bought tapestries from the Antwerp-based dealer Joris Vezeleer, whose other clients included François I and his successor, Henri II.[28] Emulating their monarchs, nobles such as the Shrewsburys acquired their splendid furniture via agents in France (cat. 71). For their tapestries the English nobility increasingly looked to Protestant weavers such as the Mennonite Frans Spiering, who had relocated to Delft from Antwerp to escape Catholic persecution, or to the small community of immigrant weavers working in Southwark, some independently (fig. 42), others under the protection of the Crown (cat. 67).[29]

Henry VII was able to spend on this scale thanks to a clever accumulation of wealth, which he achieved via diplomacy, such as the annual £5,000 pension he politicked out of Charles VIII of France; the massive dowry (at least partially paid) brought by Katherine of Aragon for her betrothal to Prince Arthur and retained with her contract to his brother; and new laws and taxes like the "tunnage and poundage," granted to Henry by his

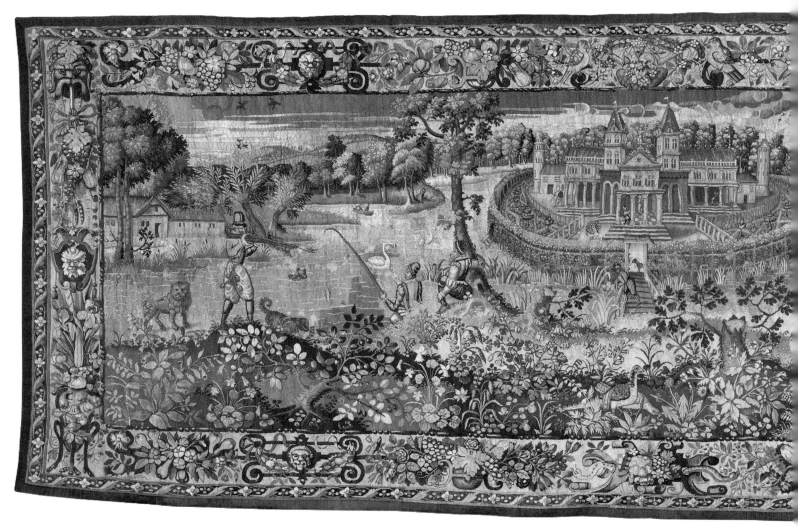

Fig. 42. *Hunters in a Landscape*. Unknown designer; probably woven in Southwark, London, ca. 1575–95. Wool and silk, 70⅞ × 181⅞ in. (180 × 462 cm). The Metropolitan Museum of Art, New York, Purchase, Walter and Leonore Annenberg Acquisitions Endowment Fund, Rosetta Larsen Trust Gift, and Friends of European Sculpture and Decorative Arts Gifts, 2009 (2009.280)

first Parliament, which awarded the Crown a cut of all English import and export customs duties. Another such measure was the 1509 Statute Against Liveries, which not only curbed his nobles' power but also brought in hundreds of thousands of pounds in penalties when breached, even by his own cousin, Lord Abergavenny, whom Henry fined £70,650.[30] Causing royal revenue to be paid directly to his own chamber rather than via the Office of the Exchequer, Henry VII had tighter control over, and easier access to, his funds. He also had the great wealth of London's prosperous professional classes to call upon for loans when needed (all, apparently, repaid). In 1488, for example, he received £4,000 primarily from the crafts and fellowships of mercers, grocers, drapers, goldsmiths, fishmongers, and tailors.[31]

In addition to his purchases, Henry VIII's national policies infamously supplemented not only his coffers—the Dissolution of the Monasteries alone raised royal revenue tenfold—but also his art collections. The Acts of Attainder ensured that, beyond monastic holdings, all the goods of anyone charged with treason passed to the Crown. Thomas Wolsey (see cats. 16, 17) was only one in a cast of hundreds: the ballooning lists of aristocrats and ecclesiastics falling out of royal favor as Henry's policies grew increasingly restrictive and his humor increasingly vindictive led to a spike in the Crown's accumulation of properties, wealth, and luxury goods.[32] All the same, at his death Henry VIII owed £75,000 to Antwerp bankers, despite having launched in 1544 the "great debasement" of national coinage with base metals, a misstep that took years to rectify.[33] Following their father's excess, the third generation of Tudors reined in spending, with Elizabeth in particular realizing the full potential of reciprocal gift giving (discussed by Adam Eaker in the following essay).

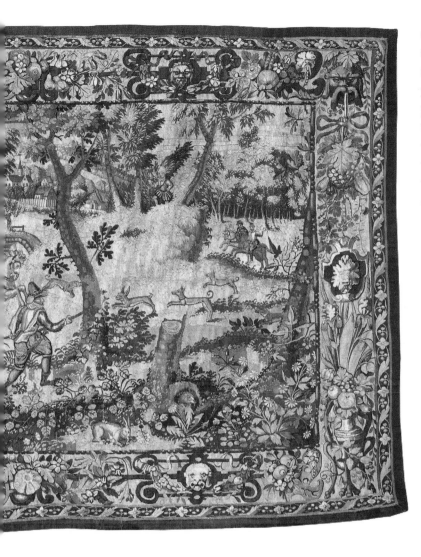

crippling—onto the noble elite, all while stoking the perception of her "mere English" accessibility by traveling to her subjects rather than demanding that they wait upon her at court.[35] The perpetual movement of her father's court between his own palaces at times necessitated the temporary installation, removal, transportation, and storage of large-scale tapestries under the watchful eye of the king's arrasman, who oversaw handling of his tapestries, and officers of the Great Wardrobe.[36] (The latter was the massive department that—together with its subdepartments of the Removing Wardrobe of Beds, the Wardrobe of Robes, and the Stables—was responsible for the commission, creation, repair, safe storage, and movement of all royal textiles, furnishings and furniture, carriages, horse trappings, clothing, robes, and liveries.)[37]

Elizabeth, by contrast, largely rejected the medieval notion of portable splendor—that is, of dressing residences with magnificent yet transitory tapestry architecture within what were often quite bare stone-walled and wood-paneled shells—in favor of the more modern practice of leaving textiles permanently installed. The queen was emulated by her subjects, among them Elizabeth Talbot, Countess of Shrewsbury. At her home in Hardwick Hall, as the collection of paintings grew, there was a move to extend the display of painted portraits in the long gallery over the tapestries permanently hanging there.[38] Characteristically aware of the need to appear both accessible and splendid, Elizabeth encouraged public admittance to Whitehall, where, even during her prolonged absences, awed visitors like tourist Thomas Platter witnessed how the floor "was strewn with rush matting, the walls were hung with fine pictures and tapestries. . . . We were also shown the Queen's library containing many books written in Latin with her own hand."[39]

Though John Fisher's commentary invoked at the beginning of this essay alluded to the transience of (princely) life, his words are as applicable to the splendid homes the noble elite inhabited: "But where be they now? Be they not gone and wasted like unto smoke?"[40] With almost all the Tudor palaces, excepting Hampton Court, either demolished or altered beyond recognition, drawings by Holbein, Bellin, and Joris Hoefnagel offer tantalizing records of their splendor (cats. 34, 35, 53). Their furniture and furnishings are also in large part either destroyed or distributed across the globe, but extraordinary survivals like the San Lorenzo cup (cat. 36), the *Story of David and Bathsheba* tapestries (cat. 42), and the *"Sea-Dog" Table* (cat. 71) are reminders of the tactile riches, the glitter, gleam, and magnificent design, enjoyed at home by the Tudor monarchs and their wealthiest subjects.

Notes to this essay appear on pp. 308–9.

By Henry VIII's death in 1547, the Crown owned more than sixty manors, hunting lodges, and great houses, more than it had before or would again.[34] As holds true in so many instances, however, what applied to Henry VII and Henry VIII was not the case with Edward, Mary, and Elizabeth: the two Henrys' taste for building, appropriating, and traveling between royal residences was unmatched. Elizabeth did build, for example, an additional wing at Windsor, and she liked Nonsuch enough to buy it back from the heirs of the Earl of Arundel, to whom her sister, Mary, had sold it, but she also developed the habit of spending parts of the year visiting and residing with her courtiers around the country during her famous progresses. In a single masterstroke she saved at least some of the cost of maintaining multiple residences, and of transporting portable furnishings between them, by shifting part of the expense—often

The Tudor Art of the Gift

Adam Eaker

For all of the shifts in royal taste that this book reveals, an emphasis on ritualized gift giving united the Tudor courts from Henry VII's early days on the throne to the death of his granddaughter Elizabeth I in 1603. Every Tudor monarch observed the ceremony of the New Year's gift exchange between ruler and favored subjects.[1] Furthermore, gifts played a crucial role in diplomacy, spurring competitive spending and curiosity about artistic developments abroad.

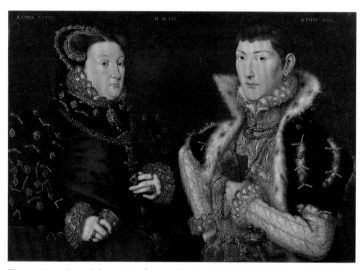

Fig. 43. Hans Eworth (ca. 1525–after 1578), *Mary Neville, Lady Dacre, and Gregory Fiennes, 10th Baron Dacre*, 1559. Oil on panel, 19¾ × 28⅛ in. (50 × 71.4 cm). National Portrait Gallery, London (NPG 6855)

Artists made gifts of their own work in bids for royal patronage. The centrality of gift giving to Tudor court life had direct consequences for the development of the visual and decorative arts in this period, driving the creation of works that were novel, materially luxurious, and rich in symbolism.

Literary and cultural historians have productively applied anthropological theories of the gift to the elaborate rituals of Tudor society.[2] Whether a sonnet, a pair of sleeves, or the two-year-old lion that Queen Elizabeth received for New Year's in 1589, Tudor gifts represented a powerful symbolic currency.[3] A gift derived value not just from its materials and craftsmanship, but also from the status of its giver. The queen's glove, bestowed on a favorite, became a treasured talisman displayed on the body and recorded in portraits (cat. 73).[4] The monarch herself might display the gift of a favorite, as when Queen Elizabeth told Thomas Heneage she

would wear the jewel he gave her upon her ear, as a sign that she would "heare nothing that sholde hurte him" during his absence from court.[5] In the so-called Rainbow portrait (cat. 120), Elizabeth wears another symbolic jewel, in the form of a gauntlet, perhaps symbolizing her support of a favorite in the tiltyard.[6]

The royal hand that gave could also take away, with traitors to the Crown suffering attainder, a form of legal death that stripped the victim of rights, titles, and assets. While he enjoyed Henry VIII's favor, Henry Howard, Earl of Surrey, received gifts of purple clothing, normally reserved for the royal family. But after Surrey's arrest for treason, Henry VIII claimed possession of the collar and pendant the earl wears in his overweening portrait (cat. 98).[7] Hans Eworth's painting of Mary Neville, Lady Dacre (cat. 92), commemorates her long campaign to reverse her executed husband's attainder; a second portrait, including her son and featuring far more sumptuous clothing, celebrates the royal decree that restored the family's honors (fig. 43).[8] On the scaffold, Tudor aristocrats made ritualized gifts of their clothing to the executioner in hopes of an easy death.[9]

In parallel to these dramatic courtly rites, humanist exchanges of letters and portraits promoted the transmission of ideas, styles, and objects across national borders.[10] The portraits of Hans Holbein the Younger, to name one salient example, circulated as both courtly and humanist gifts (see "Hans Holbein and the Status of

Tudor Painting" in this volume). Desiderius Erasmus's bestowing of his portraits by Holbein on English friends and patrons first introduced the artist to English court circles (fig. 44).[11] Holbein later cultivated royal favor through the New Year's gift to Henry VIII in 1539 of his portrait of the young Prince Edward (cat. 51). In Holbein's portrait, Edward appears behind a table covered in green velvet, which suggests the fictive parapets of earlier devotional painting as well as the trestle tables that were specially constructed for the display of Henry's New Year's gifts.[12] Holbein heightened the material splendor of the picture itself with the inclusion of shell gold and silver leaf alongside his more ordinary pigments.[13]

Surviving gift rolls attest to the meticulousness with which the Tudor monarchs tracked the gifts they received (cats. 56, 57). The shift during the reign of Edward VI to keeping these records on vellum, as opposed to the usual bureaucratic paper, gave them a costly materiality aligned with the sumptuous objects they recorded.[14] While monarchs themselves gave standardized gifts of gilded plate at the New Year, courtiers were much more inventive in their presents, seeking out the advice of favorites with insider knowledge; Elizabeth's bedchamber women may have been especially valuable in this regard.[15] A savvy courtier might please the monarch with a gift that was not only sumptuous but also original. The jewel Thomas Heneage gave the queen, mentioned above, pleased her "both for the rarenes and devyse," that is, for its clever symbolism.[16] The esoteric iconography of Tudor portraits and jewelry derives from a competitive climate in which wit represented a potent social asset.

As a princess whose mother had been beheaded as an adulteress and whose legitimacy was repeatedly called into question, Elizabeth used gifts to secure her ever-shifting position at court. Unlike the gilded plate she most often gave as a queen, the young Elizabeth's gifts to her father or her stepmother, Katherine Parr, were manuscripts that combined her accomplishments in languages, calligraphy, and embroidery (fig. 45).[17] As queen, Elizabeth was herself the frequent recipient of printed and manuscript books, including the calligraphy of the French Protestant refugee Esther Inglis (cat. 59). Works of calligraphy and embroidery, commonly associated with female donors, made up for their material modesty with elaborate displays of accomplishment and dexterity.[18]

Elizabeth I's annual progresses, lengthy visits to towns and country houses in the southern half of her kingdom, provided a prime opportunity for gift exchanges, and often proved ruinously expensive for her aristocratic hosts.[19] Courtiers like the Earl of Leicester or Sir Henry Lee might commission paintings to function within the dramatic revels they staged for the queen, which then "remained *in situ* afterwards as vivid, semi-permanent memorials to ephemeral events" (see cat. 119).[20] These entertainments

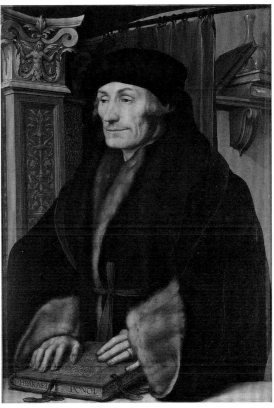

Fig. 44. Hans Holbein the Younger (1497/98–1543), *Erasmus*, 1523. Oil on panel, 29 × 20¼ in. (73.6 × 51.4 cm). National Gallery, London, on loan from Longford Castle (L658)

were an important form of Tudor gift, though poorly preserved in the material record. The pageant of Mount Parnassus designed by Holbein for the coronation procession of Anne Boleyn was one such fugitive gift, staged by the Hanseatic merchants of the Steelyard to curry favor with the new queen (cat. 89).[21]

The display of a prestigious gift upon the body, as recorded in portraiture, was a particularly powerful tool for royal Tudor women seeking to cultivate international ties and craft new models of queenship. Mary I's portraits by Hans Eworth (cat. 26) and Anthonis Mor (see fig. 29) both record gifts that played an important role in her identity as simultaneously an English queen and a Habsburg consort.[22] In her portraits, Mary wears a striking brooch consisting of two diamonds and a pearl pendant; the jewels were wedding gifts from her father-in-law, Holy Roman Emperor Charles V, at the time of her marriage to Philip II of Spain. In her will, Mary spoke to the value of these gifts as she bequeathed them back to their donor, asking Philip "to kepe [them] for a memory of me."[23]

Diplomatic missions spurred the creation of sumptuous gifts for the Tudor monarchs to present to their fellow sovereigns. Before the breakdown of his relationship to the papacy, Henry VIII participated in a steady traffic of gifts with Rome

that was an important conduit for the arrival of High Renaissance pictorial ideas in England.[24] As trade routes expanded, so did the reach of Tudor gift exchanges. In 1568, for example, Elizabeth I had her ambassador to Muscovy present Czar Ivan the Terrible with "a notable great Cup of silver curiously wrought, with verses graven in it."[25] One distinctive genre of Tudor court art, the miniature portrait, began with an exchange of diplomatic gifts between the French and English courts in the 1520s.[26] Both precious and portable, miniature portraits lent themselves to gift giving at a distance. In 1599 the mother of the Ottoman sultan requested Elizabeth I's portrait, and by the early seventeenth century, English royal miniatures had reached the Mughal court at Delhi.[27]

Their jewel-like size and display upon the body lent these gifts a frisson of intimacy unusual for diplomatic exchanges.[28] In one of the earliest English royal miniatures, Henry VIII's illegitimate son, Henry Fitzroy, Duke of Richmond and Somerset, appears in a nightcap and undershirt, revealing the unblemished chest against which such a locket might hang (cat. 50). Miniatures blurred boundaries between political loyalty and personal or even erotic devotion. In 1595 Sir Henry Unton, Elizabeth's ambassador to France, reported on the following exchange with Henri IV, centered on a miniature portrait of the queen. Unton boasted to the French king that he "had the Picture of a farr more excellent Mistress [than the king's own], and yet did her Picture come farr short of her Perfection of Beauty."[29] With the king pleading for a glimpse of the portrait, Unton "made some Difficulties; yett, upon his Importunity, offred it unto his Viewe verie seacretly, houlding it still in my Hande."[30] As objects that might be viewed "secretly," miniatures make frequent appearances in love poetry of the period.[31]

The making of difficulties, as Unton termed his show of reluctance, was a key prelude to the intimacy of showing the miniature, and one he had learned from the queen herself. Sir James Melville, the ambassador of Mary, Queen of Scots, to Elizabeth's court, reported on one such episode involving the display of miniatures in Elizabeth's bedchamber:

> She appeared to be so affectionate to the queen [Mary] her good sister, that she expressed a great desire to see her. And because their so much, by her, desired meeting could not be so hastily brought to pass, she appeared with great delight to look upon her majesty's picture. She took me to her bed-chamber, and opened a little cabinet, wherein were divers little pictures wrapt within paper, and their names written with her own hand upon the papers. Upon the first that she took up was written, "My Lord's picture." I held the candle, and pressed to see that picture so named. She appeared loath to let me see it; yet my importunity prevailed for a sight thereof, and found it to be the Earl of Leicester's picture. I desired that I might have it to carry it home to my Queen; which she refused, alleging that she had but that

Fig. 45. Elizabeth Tudor, later Queen Elizabeth I (1533–1603), *The Glass of the Sinful Soul*, with embroidered binding for Katherine Parr, 1544. Bodleian Library, University of Oxford (MS Cherry 36)

one picture of his. . . . Then she took out the Queen's picture, and kissed it; and I adventured to kiss her hand, for the great love therein evidenced to my mistress.[32]

The conditions for the miniature's display, wrapped in paper in a cabinet in the most private and inaccessible room in the palace, reinforced the privileged status of its few beholders. The fact that these paper wrappings were inscribed in the queen's own hand heightened their prestige.

Alongside these textual accounts, a remarkable piece of furniture now at Longford Castle preserves some of the conditions under which Elizabethan miniatures were first viewed.[33] Acquired in 1796 by the Earl of Radnor, this *bijoutière*, or jewelry box, contained not only portrait miniatures (now at the Victoria and Albert Museum, London), but also a letter in Queen Elizabeth's own hand, a "curious smelling Bottle (oval), Spoon, Hair Pins, Coins, and Sundry Antiquities."[34] Mrs. Anne Lewis, who sold the cabinet, claimed that it "was given by Queen Elizabeth to Lady Rich and by her Ladyship it was given to the family of the present Possessor and has never been in any other hands."[35] Whatever its authenticity, this provenance was strengthened by the letter, the scent bottle, spoon, and hairpins that all powerfully reinforced the miniatures' status as jewels worn on the body and as tokens

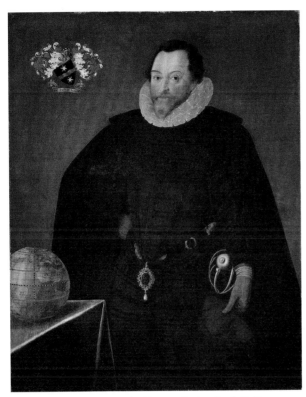

Fig. 46. Marcus Gheeraerts the Younger (1561–1635/36), *Sir Francis Drake*, 1591. Oil on canvas, 46 × 36 in. (116.8 × 91.4 cm). National Maritime Museum, Royal Museums Greenwich, London (BHC2662)

Fig. 47. *Funeral Monument to Blanche Parry*, Saint Faith's Church, Bacton, ca. 1590

of royal intimacy. The jewelry box—apparently an eighteenth-century pastiche of original Elizabethan components—could itself function as a surrogate body, scented and made up of secretive cavities. The original turned-ivory boxes housing the miniatures further condition their display, encasing them in a precious material that warms to the touch.

The practices of mounting or encrusting that characterize so much Tudor art attest to these objects' function as courtly gifts. In their transit from donor to recipient (and sometimes back again), artworks might acquire new layers of embellishment, as well as accretions of family lore emphasizing royal provenance. For example, Sir Francis Drake's descendants still possess a trophy in the form of an engraved coconut that the navigator supposedly gave to the queen, which she then returned to him with an elaborate silver mount.[36] Portrait miniatures were particularly subject to this process (for example, cat. 58). Following the Protestant Reformation, miniatures may have served the English aristocracy as surrogate reliquaries, encasing iconic royal images with gold, jewels, or cameos.[37] Indeed, in Elizabethan portraits, miniatures are sometimes displayed on the body as a key marker of identity in much the same way that a Catholic sitter would wear a relic. In one portrait, Francis Drake wears the "Drake Jewel," a royal

gift, suspended from his belt (fig. 46), just as Mary I displayed a reliquary in her portraits (see cat. 26 and fig. 29).[38] Most of the elaborate jewels displayed in Tudor portraits, like the brooch of garnets and diamonds in Marcus Gheeraerts's portrait of the Welsh heiress Ellen Maurice (cat. 102), cannot be associated with documented or surviving pieces; nonetheless, their inclusion positions these sitters within an elite gift economy.

Representations of gift giving provided courtiers with the opportunity to commemorate their proximity, real or desired, to the monarch. The portrait of Elizabeth I that Bess of Hardwick, Countess of Shrewsbury, displayed at her home (cat. 118) likely recorded her own gifts of embroidery to the queen. In her funerary monument, Elizabeth's Chief Gentlewoman, Blanche Parry, kneels to present the queen with a pomander or jewel, perhaps the diamond she bequeathed to Elizabeth in her will (fig. 47).[39] In her career at court, Parry had been responsible for receiving the queen's gifts of fine linen and for looking after her jewels. Elizabeth in turn paid for the cost of Parry's funeral and accorded her the honors of a baroness.[40] For the most savvy of Tudor courtiers, gift giving was a social strategy that paid dividends well beyond the grave.

Notes to this essay appear on pp. 309–10.

Honing the Tudor Aesthetic

Elizabeth Cleland

Such as *Diana* by the sandie shore
Of swift *Eurotas*, or on *Cynthus* greene,
Where all the Nymphes have her unawares forlore,
Wandreth alone with bow and arrowes keene,
To seeke her game: Or as that famous Queene
Of *Amazons*, whom *Pyrrhus* did destroy,
The day that first of *Priame* she was seene,
Did shew her selfe in great triumphant joy,
To succour the weake state of sad afflicted *Troy*.

(*The Faerie Queene*, bk. 2, canto 3, st. 31)[1]

Elite Tudor audiences were versed in classical history and mythology and could cite antique protagonists as well as any mainland European. Such was true during the reign of Henry VII—hailed as "greater . . . than Hercules" by Bernard André in 1497[2]—and even more so during those of his Tudor progeny (Sir Thomas Wyatt likened Henry VIII and Katherine of Aragon to Jupiter and Juno during their divorce).[3] Enthusiasm for the antique approached a crescendo in the 1590s with Edmund Spenser's *Faerie Queene* and Sir Philip Sidney's *Arcadia*, and culminated with William Shakespeare's *Titus Andronicus*, *Julius Caesar*, and *Troilus and Cressida*, all apparently performed before Elizabeth's death in 1603. Classical exempla and Roman gravitas, already celebrated at Henry VII's court (see cat. 5), were seized upon by Elizabethan courtiers like William Cecil, Baron Burghley, and William Somerset, Lord Herbert, whose respective homes at Theobalds and Raglan Castle incorporated marble statuary of Roman emperors.[4]

Antique motifs permeated the decorative arts in sixteenth-century England. At the monumental scale of tapestry, the *Antiques* (cat. 52), acquired by Henry VIII in 1542, brought not only classical protagonists and near-life-size nude figures

into Tudor palace interiors, but also the visual language of Roman wall paintings, with their bold, blank color grounds, tiered and flattened spatial planes, and fantastical hybrids of flora and fauna, recently christened *grotteschi* (anglicized as *grotesques*) after the grotto-like caverns of Nero's excavated Roman palace, the Domus Aurea.[5] Probably thanks to printed sources, tapestries such as the largest of the armorial verdures of Robert Dudley, Earl of Leicester (fig. 72), incorporated the classicized fountains and pavilions devised by contemporary Flemings like Hans Vredeman de Vries. Actual built fountains might feature Neptune, like the one apparently commissioned by William Fitzwilliam, Lord Admiral, from Benedetto da Rovezzano for his new home at Cowdray House; or Justice, such as the splendid nude figure (now lost) atop a hexagonal peristyle erected for Elizabeth I at Hampton Court (fig. 48).[6] Curling acanthus leaves, supine dolphins, masks, arabesques, and rinceaux enveloped goldsmiths' work, both in design (cats. 37–39) and in practice (cats. 61, 64). Coupled with aedicules, friezes, and caryatids, such elements decorated the frontispieces of printed books (cats. 27, 45, 55).[7] Manuscripts increasingly displayed a clear humanist hand rather than Gothic blackletter script (cats. 5, 48).

Familiar as these antique elements would have been at the Tudor courts, it is nonetheless worth noting that, almost without exception, these examples were brought into the British Isles from mainland Europe. Such was the case with Henry VIII's tapestries (themselves a re-edition of a series commissioned by Pope Leo X) and prints by Hans Vredeman de Vries, Cornelis Floris the Younger, and their contemporaries. These examples were introduced mostly thanks to the presence in England of continental practitioners like the German Hans Holbein, the

Fleming Richard Hyckes, and the Italians Filippo Alberici, Benedetto da Rovezzano, and Nicholas Bellin da Modena. Other times, Englishmen produced material following extended periods of study abroad, among them Thomas Wyatt and John Shute. A piece like the "English Monument" (cat. 29), a drinking vessel styled as a column upon a pedestal, probably never crossed the Channel. Though created as a gift and commissioned by English patrons, it was made in Antwerp and sent directly to its recipients in Frankfurt.

Tudor masons were likewise aware of Roman precedent. Shute's *First and Chief Groundes of Architecture* (1563; cat. 55) presented elegant cross sections of the classical orders, and both John Dee, in his preface to Henry Billingsley's translation of Euclid (1570), and William Harrison, in his rather more accessible *Description of England* (1577), referenced the Roman Vitruvius's *De architectura* and Sebastiano Serlio's sixteenth-century *Tutte l'opere d'architettura, et prospetiva*. All three architectural treatises were widely available in printed form to practitioners and dilettante readers alike, as were Pieter Coecke van Aelst's best-selling extended French, Dutch, and German translations (1542–58) of Serlio's multivolume work.[8] Columns and pilasters plucked from their pages adorn the facades of ambitious new great houses like Kirby Hall (built for Sir Humphrey Stafford in 1570–75), while Longleat House (rebuilt for Sir John Thynne beginning in 1572), Wollaton Hall (built for Sir Francis Willoughby in 1580–88), and Hardwick New Hall (built for Elizabeth Talbot, Countess of Shrewsbury, in 1590–97) likewise include multiple quotations from these sources, whether in plan or architectural detailing. Elements of Wollaton, for example, are lifted from Serlio's take on the Poggio Reale at Naples, and of Hardwick from the Villa Valmarana at Lisiera.[9]

Yet, these quotations aside, and as the four-story courtyard clock tower at Sir William Cecil's new home at Burghley indicates (fig. 49), English Tudor architecture was ultimately unique, enjoying an extraordinary sense of theater unlike anything actually constructed on the Continent. The same inventive spirit that translated the elongated nudes, tiered aedicules, and fruit swags of Floris's *Fantastic Chariots* (1552) and de Vries's *Artis perspectivae* (1568) into pictorial framing devices and ephemeral pageantry (cats. 54, 89) applied to permanent constructions. The queen's master mason, Robert Smythson, created at Wollaton (fig. 50) an unprecedented and extraordinary central great hall, thrusting up above the rooflines with distinctive turreted corners.[10] At Hardwick (fig. 51), also associated with Smythson, the massive masonry lettering ES set on the roofline declared ownership by Elizabeth, Countess of Shrewsbury. The great architectural historian John Summerson, grappling with the

Fig. 48. *Design for the "Justice Fountain," Hampton Court Palace*, ca. 1584. Ink and colored wash, 10¼ × 6⅛ in. (26 × 15.5 cm). Hatfield House, Hertfordshire

intangible oddness of Smythson's work, described Wollaton as "a sort of fantastic castle, something Arthurian or like the symbolic castles of Spenser," and Hardwick as "a house of great and romantic beauty."[11]

This yearning to realize magical fantasies in the bricks and mortar of courtly life was matched by a taste for capturing the beauty of the natural world. The perceived symbolism of particular elements of nature, well established across Europe, was also recognized in Tudor England in, for example, herbal books and, above all, embroidered floral "slips," furnishing textiles (cat. 70), and apparel (cats. 68, 103). The symbolic language of flowers was

Fig. 49. Burghley House, Lincolnshire, exterior view of courtyard clock tower

Long after the popularity of millefleurs tapestries had waned on the Continent, English patrons remained seduced by the abundance of tiny, minutely observed flowers scattered across a blank ground (cats. 67, 70).

But just as the English grasped the theatrical possibilities of a fantastical coupling of conventionally disparate classical architectural elements, the Elizabethan telescopic capture of nature, whether in visual, written, or spoken form, was neither limited to mere mimesis nor constrained by the received wisdom of symbolic meanings ascribed to particular plants and flowers. Instead, in the same way that architecture could open the door to Arthurian fantasy, nature—at once beautiful and wild—could evince for the court a frisson of enchantment and thrilling, if potentially rather frightening, poetry, in some ways predicting the eighteenth-century fascination with the Sublime. Bewitching nature serves as the setting for miniatures (cats. 65, 110), literature, plays, and pageantry (cat. 112). For example, Henry VII's court was transported to a mythical garden setting by Stephen Hawes in his popular allegorical poem *Pastime of Pleasure* (written in 1505–6, published in 1509). This conceit is fully developed in Spenser's *Faerie Queene*, in which the titular regent, Gloriana, is the recognizable embodiment of Elizabeth, also evoked as Queen Helen of Corinth in Sidney's *Arcadia*.[13] Shakespeare's *A Midsummer Night's Dream*, probably written in the 1590s, sets court culture in confrontation with the liberating and disconcerting wilderness of the forest. The artifice of nature in the court setting sought even to capture its scents: in 1507 dignitaries from the University of Cambridge presented to Henry VII and his mother, Margaret Beaufort, the gift of "Damask water"— rosewater—to perfume their fingers.[14] During a Thames-set pageant laid on for Henry VIII's court in 1539, during which "the Bishop of Rome and his cardinalles" battled "the Kinges Grace" on barges, bankside courtiers watched under the shelter of an artificial arbor of foliage, from which rosewater sprinkled down upon them.[15]

Surpassing the earlier, and more conventional, royal taste for curiosities and mirabilia, such as Henry I's menagerie at Woodstock, sixteenth-century monarchs and their courtiers appreciated the potential of gardens to create a safe and contained fairy-tale experience. Topiary transformed hedges into imaginary beasts, such as those encountered by the diarist Thomas Platter at Hampton Court, in "all manner of shapes, men and women, half men and half horse, sirens, serving-maids with baskets, French lilies and delicate crenellations."[16] The antiquarian John Leland enjoyed decorative manmade mounds, cut with concentric paths "like Turninges of Cokilshilles [cockle shells]," at Wressle Castle.[17] Such encounters were carefully

voiced inimitably by Shakespeare's Ophelia in *Hamlet*, the earliest known performance of which was in July 1602:

> There's rosemary; that's for remembrance. Pray you, love, remember. And there is pansies; that's for thoughts.
>
>
>
> There's fennel for you, and columbines. There's rue for you— and here's some for me. We may call it herb of grace o' Sundays.
>
>
>
> There's a daisy. I would give
> you some violets, but they withered all when my father died.
>
> (4.2.170–76)[12]

Fig. 50. Wollaton Hall, Nottinghamshire

Fig. 51. Hardwick Hall, Derbyshire

choreographed in series of reveals of terracing and earthworks, like those seen as the setting of the embroidered miniature of Elizabeth (cat. 65) that opened onto vistas of mazes and water-works.[18] Architecture mediated between this tightly controlled ideal of nature and the sophisticated world of courtiers: garden-side loggias like those built for Henry VII at Richmond and evoked in the background of cat. 114 became popular. Myriad similar temporary structures and semiprivate pavilions were created, such as the banqueting house, since demolished, made for Elizabeth at Whitehall; the "herbers" (circular brick arbors) and pleasure galleries in the grounds at Hampton Court; the Thames-side banqueting house in the garden of Leicester's residence on the Strand; and Burghley's Roman pavilion at Theobalds.[19] In grand houses, windowed long galleries allowed dramatic shifts of light occasioned by the weather to be experienced safely from indoors while also enabling sweeping views of gardens and parklands.[20] When nature could not be seen directly, it was evoked in decorations, like the tableau vivant unveiled at Henry VIII's court in 1511, of which "everie post or piller thereof was covered with frised [friezed] gold, therein were trees of ha[w]thorne, eglantine, rosiers, vines, and other pleasant floures [flowers] of diverse colours, with gillofers [gilly-flowers], and other hearbs all made of sattin, damaske, silver and gold."[21] This fashion for fake foliage is further evidenced by the number of silkwork flowers recorded in Henry's 1547 posthumous inventory, as well as in the many known wall tapestries depicting greenery, called verdures, among them the "Hangings of Forest work" recorded at Hardwick Hall in 1601.[22]

Chronicles abound with descriptions of planned outdoor encounters between Tudor royalty and courtiers masquerading as unfettered inhabitants of nature. One was the supposedly happenstance meeting of Henry VIII and Katherine of Aragon, accompanied by a royal party, with Robin Hood and his merry men:

> The king and the queene, accompanied with manie lords and ladies, road to the high ground of shooters hill to take the open aire; and as they passed by the waie, they espied a companie of tall yeomen, clothed all in greene with greene hoods. . . . Then Robin Hood desire[d] the king and queene to come into the greene wood, and to see how the outlawes lived.[23]

The royal party did accompany "Robin Hood" and his men, visiting a great chamber as if set into the hillside, decorated with foliage, where they feasted on venison and wine. During her progresses Elizabeth frequently encountered wildmen, some naked like the stone fountain figure at Hawstead Hall that was made for the queen's visit in 1578 (fig. 52).[24] Meetings with "wise hermits" were also frequent, such as those in the bookend festivities, beautifully choreographed by Sir Henry Lee, marking Elizabeth's visits to Woodstock in 1575 and 1590. At the first of these, the queen and her ladies were "transformed" into fairies and led by a "hermit" to a pavilion in the woods decked with ivy, flowers, and shimmering gold plate, where they dined at tables shaped like the phases of the moon.[25] An Arthurian, Merlin-like character had already been evoked in 1511 in spirited fashion by Charles Brandon, strapping companion to the young Henry VIII (see

Fig. 52. *Wild-Man Fountain Figure*, Hawstead Hall, Suffolk, ca. 1578

Fig. 53. *King Arthur's Round Table*, England, probably made 1250–1350, with substantial alterations ca. 1516. Painted and varnished oak, Diam. 18 ft. (550 cm). Great Hall, Winchester

cat. 14), when he presented himself theatrically to Katherine of Aragon, then still the belle of her husband's court, "in a long robe of Russet satyn, like a recluse or a religious person and his horse trapped in the same sewte [suit]."[26]

This evocative mindset, blending antique heroes with pastoral or fairy folk, reached an apex in the annual celebrations marking November 17, the date of Elizabeth I's accession to the monarchy.[27] These nationwide festivities provided the now Protestant English with an opportunity to channel their enthusiasms traditionally satisfied by Roman Catholic feasts. Indeed, Accession Day was announced to the populace from the pulpits of their parish churches, expressly heralded in 1575 as "a holiday which [sur]passed all the Pope's holidays."[28] Sir Henry Lee (fig. 124), who is credited with developing the concept and pageantry of the accompanying tilts, gloriously conjured the setting of medieval chivalry by presenting Elizabeth, the chaste Virgin Queen,

as the ultimate romantic heroine, worshipped by all the knights of the realm. Indeed, according to the twentieth-century historian Frances Yates's captivating theory, both Spenser and Sidney adopted much of their iconography from these Accession Day festivities.[29]

If Henry VIII shared his father's taste for mock battle in the form of tournaments, then Elizabeth's court seized upon this quintessentially masculine sport, likewise beloved of sixteenth-century European counterparts from Maximilian I to Henri II, and, by switching emphasis from combatants to spectators, subverted it into a homage to their lady queen. The spectacular colored and patterned armor commissioned by Elizabeth's courtiers from the Greenwich Royal Armoury speaks to the reinvigorated role of the tournament for the Elizabethan court (cat. 72). Sir Nicholas Bacon's decision to erect in a peristyle "cloister" at his home, Gorhambury, a life-size statue of Henry VIII

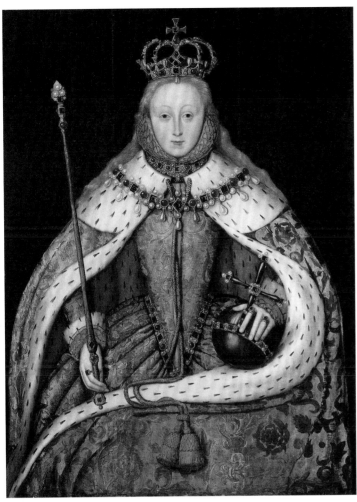

Fig. 54. Unknown English artist, *Coronation Portrait of Elizabeth I*, ca. 1600. Oil on panel, 50⅛ × 39¼ in. (127.3 × 99.7 cm). National Portrait Gallery, London (NPG 5175)

Fig. 55. Unknown French or English artist, *Coronation Portrait of Richard II*, ca. 1390. Mixed media on panel, 84 × 42 in. (213.4 × 106.7 cm). Westminster Abbey, London

dressed in gilded armor—displayed to Elizabeth during her visit in 1577—seems an endeavor to retrospectively locate his queen's father within this chivalric narrative.[30] Enthusiasm persisted for the notion of martial champions, from the favorites displaying their lady's token (cat. 73) to Sir Robert Dymoke and his heirs, who, by inherited feudal right, mounted and armor-clad, interrupted every coronation feast from Henry VII's to Elizabeth I's to challenge any impugner of the royal title.[31]

Elizabethan nostalgia for the chivalric exploits of long ago furthered a narrative first presented by Henry VII, who bolstered his rather tenuous claim to the English throne by claiming a lineage that traced back to King Arthur and beyond, to Brutus (see "England, Europe, and the World: Art as Policy" in this volume). Building upon the period's slightly skewed idea of Britain as a unified England and Wales (though not Scotland), as it had been presented in Geoffrey of Monmouth's *Historia*

regum Britanniae, the Tudors worked harder than their predecessors to nurture the perception of a united England, Wales, and Ireland.[32] Inspired by Sir Thomas Malory's *Morte d'Arthur*, published in 1485 (the year Henry came to power), followed by the first complete printed edition of the *Historia regum Britanniae* in 1508, Henry VII's biographers, whether contemporaneous (David Llwyd ap Llywelyn) or posthumous (Edward Hall; George Owen of Henllys), celebrated him as fulfilling the prophesied return of glorious British kings of yore, hailing him as the augured "stocke and progeny [of] Cadwalader, last kyng of Brytons."[33] At Richmond, he self-consciously commissioned sculptures of all English kings back to Brutus and reinstituted wearing his crown in public on feast days.[34] He christened his firstborn Arthur, a name at which "outwarde [other] nacions and foreyne prynces trymbled and quaked," and speeches to Arthur's Spanish bride welcomed her to "Brytayn, / The Land

Fig. 56. Illustration from *The Gardeners Labyrinth . . .* by Didymus Mountain and Henry Dethick (London, 1577). British Library, London (41.a.6, p. 81)

Fig. 57. Illustration from the *Trevelyon Manuscript* by Thomas Trevelyon (London, ca. 1603). University College London (MS Ogden 24, fol. 101r)

of Arthure, your spouse most bounteous."[35] Henry VIII's own Arthurian self-identification inspired his enthusiastic, intensive restoration of what was believed to be King Arthur's Round Table at Winchester (fig. 53). At Henry's order, the features and facial hair of the portrait of Arthur painted on the table were transformed to resemble Henry's; the figure's pose was amended to recall Henry's Great Seal; the color scheme was replaced by the Tudors' heraldic green, white, and red; and, above all, the representation of a massive Tudor rose was inserted at the center of the table.[36] Elizabeth's commission of her iconic coronation portrait to echo that of the fourteenth-century King Richard II soon after it was rediscovered likely speaks to this same endeavor to present the Tudors within the more established chronology of English rulers (figs. 54, 55).[37]

In the visual arts, a revival of Celtic knotwork is appreciable in textiles (cats. 26, 75; fig. 73), garden design (fig. 56),

and—gloriously—book illustration, not least the scrapbooks assembled from about 1600 to the reign of James I by Thomas Trevelyon (fig. 57).[38] In architecture, while many castles fell into disrepair during the reign of the Tudors, a fashion grew for erecting "new castles" that deliberately, sometimes playfully, evoked the past.[39] Manor houses built for the new landed gentry, like Oxburgh Hall in Norfolk (fig. 58), celebrated their owners' receipt of a royal "license to crenellate" with mock battlements and bridged moats, more in aesthetic emulation of medieval castles than out of any serious need for defense.[40] Just as Henry VII nurtured a perceived echo of Arthurian legend to legitimize his reign, and Henry VIII cited "olde autentike histories and cronicles" as evidence of the preeminence of English kings in both the temporal and spiritual realms,[41] Tudor builders' mock castles suggest not only a nostalgia for the chivalric past but a parvenu pretense at inherited family prestige. In much the same way,

Fig. 58. Oxburgh Hall, Norfolk

Cardinal Wolsey went to great lengths to acquire decades-old, secondhand tapestries during his short-lived period as bishop of Tournai, one of the core tapestry-weaving towns of the previous century.[42] With age and pedigree these "antiques" counteracted the brand-new palettes and styles of the many tapestries he commissioned from scratch.

Taken individually, these languages of ornament inspired by the antique, nature, and nostalgia were not unique to England. The Renaissance revival of interest in classical antiquity, initially nurtured in Florence, was by 1500 ubiquitous throughout western Europe: Henry VIII could take his place in a queue that included Maximilian I, François I, and Leo X, who all proclaimed themselves alter egos to Hercules (see cat. 52).[43] The taste for garden mazes and topiary had been developed both on the Italian peninsula and in France, as popularized by Serlio and Jacques Androuet du Cerceau, both of whose designs were

known in England (cats. 55, 71). The Italians likewise could lay claim to the development of *imprese* and allegorical pictorial devices, while pageantry and court spectacle were as prized by Catherine de' Medici as they were by Elizabeth I.[44] Yet, blended in the melting pot of Tudor England, the result—in turns romantic, charming, bombastic, nostalgic, and always decorative—achieved a unique aesthetic whose appeal lasted late into the Jacobean age, and whose nineteenth-century revival has, arguably, still not entirely waned.

Notes to this essay appear on p. 310.

34. *Nonsuch Palace from the South*

Joris Hoefnagel (1542–1600)
1568
Black chalk, pen and ink, with watercolor, heightened with white and gold, 8½ × 12¾ in. (21.6 × 32.5 cm)
Victoria and Albert Museum, London (E.2781-2016)
Exhibited New York and Cleveland only

In April 1538, to celebrate the thirtieth anniversary of his accession to the throne (as well as the birth of his son, the future King Edward VI, in October 1537), Henry VIII directed work to begin on a new palace near the village of Cuddington, in Surrey. Ostensibly a hunting lodge, Nonsuch delivered a carefully calculated message: "a celebration of the birth of the long awaited heir, . . . a vaunting of the Tudors and . . . a talisman for the dynasty. It was the single greatest work of artistic propaganda ever created in England."[1]

The building was laid out around two adjoining courtyards: visitors entered the complex from the north, proceeding from the imposing outer court to the dazzling inner court at the south end of the palace. While the plan was traditional, the decorations of the exterior walls and the facade of the inner court were anything but: Nonsuch was one of the first buildings in England to show an awareness of Italian Renaissance architecture (see "Honing the Tudor Aesthetic" in this volume). Henry VIII's growing interest in Italian design may have been sparked by competition with François I, whose building projects at Chambord and Fontainebleau were among the crowning artistic achievements of his reign.[2] The similarities are not coincidental: Nicholas Bellin (see cat. 53), who had worked for François I at Fontainebleau, was responsible for the stucco decorations covering the facade of the inner court and portions of the exterior walls. Above the ground floor, the inner court featured three tiers of stucco panels in high relief, framed by bands of fine black stone with applied gilding. The lower tier on the king's (west) side depicted the life and labors of Hercules; the queen's (east) side featured the Liberal Arts and the Virtues. The middle tier depicted pagan gods and goddesses, respectively; and the upper tier, twenty-four Roman caesars. Surveying this remarkable ensemble from an elevated position at the center of the south wall were statues of Henry VIII and Edward VI.[3] The iconographic program was designed (conceivably by the king himself) to place Henry among emperors and gods, supported by the Arts, Virtues, and heroic deeds; it perhaps served as a tutelary model for the young Edward as he prepared to follow in his father's footsteps.[4] As Joris Hoefnagel's exquisitely detailed drawing shows, similarly themed stucco decorations adorned the southern elevation of the palace as well.

Hoefnagel's drawing is not only the earliest surviving visual record of Nonsuch—and the only one to show the palace's striking south front, flanked by octagonal towers—it is one of the first examples of a landscape watercolor executed in England.[5] Working from an elevated vantage point, the Flemish artist probably began the drawing *en plein air* as a sketch in brown ink and then elaborated it in the studio with watercolor washes and white and gold highlights, transforming it into a finished drawing worthy of presentation. The palace appears deceptively long and low in Hoefnagel's drawing, nestled into the gently rolling landscape and its lower story hidden behind a brick wall; Jodocus Hondius's bird's-eye view of 1610 (fig. 59) may more accurately convey the structure's proportions.[6]

A second, simplified version of this drawing, now in the British Museum,[7] situates the palace more centrally and adds in the foreground a vignette of Elizabeth I in a carriage progressing to Nonsuch. This drawing was used as the model for an engraving published in Georg Braun and Franz Hogenberg's *Civitates orbis terrarum* of 1598; that this royal hunting lodge was one of only three views of English panoramas included in the atlas indicates its extraordinary renown.[8]

Fig. 59. Jodocus Hondius (1563–1612), detail of Nonsuch Palace from "Map of Surrey," in *Theatre of the Empire of Great Britain* by John Speed (London, 1611–12). Huntington Library, San Marino (69520 v.1)

Nonsuch was a costly undertaking: by 1545, £24,536 had been spent on the palace (equivalent to about $13 million today), yet it remained incomplete at Henry's death in 1547. In 1556 Mary Tudor sold the palace to Henry Fitzalan, 12th Earl of Arundel; he, in turn, bequeathed it to his son-in-law, John, Lord Lumley, who in 1592 gave it to Elizabeth I in settlement of a debt. Nonsuch was eventually given by Charles II to his mistress Barbara Villiers, who seems to have considered the aging palace an unwelcome liability. In 1682 she began dismantling the building and selling the raw materials to settle her gambling debts, and by 1690 little remained of the palace that had inspired such awe at home and abroad: "This, which no equal has in art or fame, / Britons deservedly do *Nonesuch* name."[9] MEW

Notes to this entry appear on pp. 310–11.

and central overmantel contain tumultuous battle scenes. White highlighting reiterates the deep relief planned for the modeling.

Although an early seventeenth-century account identified this design as "bespoke for [Henry VIII's] new built pallace at Bridewell," it is much more likely to have been intended for Whitehall or Oatlands, given its grandiosity and Bridewell's virtual abandonment by 1530.[1] Already ascribed to Holbein by the early 1630s, this drawing sits comfortably within his surviving oeuvre, revealing that Holbein set his skills to conceiving architectural elaboration and plasterwork, as well as his more widely known panel paintings and designs for goldsmiths' work, jewelry, prints, and book illustrations.[2] The roundels and compartmentalization, with curvaceous and scrolling foliage borders—so akin to his designs for goldsmiths' work (cats. 38, 39)—reveal quite a different aesthetic to Nicholas Bellin's mannerist decoration for Whitehall (cat. 53).[3] With painterly flourish, Holbein has filled the hearth with burning and smoking logs, making for lively animation within this otherwise, perforce, static representation.

The flames and the royal arms, being the only areas of color, are all the more striking because of it. It is possible that Holbein intended the rest of the plasterwork to be a muted monochrome, although it has been suggested that the actual mantel, if constructed, would have been brightly polychromed, as convention decreed.[4] Surviving Tudor chimneypieces, like that in Elizabeth's 1580s extension to Windsor Castle, reveal how effective such palatial mantels could be, blurring the distinctions between architecture and sculpture (fig. 60).[5] EC

Notes to this entry appear on p. 311.

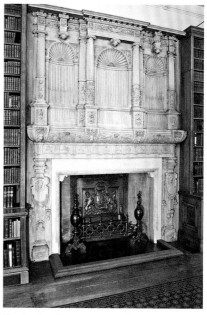

Fig. 60. Fireplace in Queen Elizabeth's Gallery, Royal Library, Windsor Castle, 1583

35. *Design for a Chimneypiece*

Attributed to Hans Holbein the Younger (1497/98–1543)
ca. 1537–43
Pen and black ink, with gray, blue, and red wash, 21⅛ × 16⅞ in. (53.9 × 42.7 cm)
The British Museum, London (1854,0708.1)
Exhibited New York and Cleveland only

In sumptuous contrast to the plain hearth, with its simple firedogs, this chimneypiece is encrusted with imagery. The royal arms of Henry VIII, his *H* and *HR* badges, Tudor roses, a single fleur-de-lis, and a single Beaufort portcullis appear within a balanced, geometric framework, defined by Tuscan and Ionic engaged columns and caryatid herms. Roundels frame classical-style, idealized portrait heads and figurative scenes of Charity, Justice, and a female supplicant before a king, probably Esther before Ahasuerus, or perhaps Abigail pleading with David to dispense with his plans to kill her husband. The lunette

36. Cup and Cover

London, 1511–12
Rock crystal, gilded silver, colored enamel, H. 12¾ in. (32.3 cm)
Museo delle Cappelle Medicee, on permanent loan to the Tesoro di
San Lorenzo, Basilica di San Lorenzo, Florence (1945, n. 87)

Embellished with the devices of Henry VIII and his Spanish
wife, Katherine of Aragon, and precisely hallmarked as made in
London in 1511–12, this cup with cover is a rare secular relic of
Tudor precious-metal workmanship. For the last 491 years, it
has also been a sacred reliquary, holding first the bones of Saint
Bridget and Saint Apollonia, and then, since the late eighteenth
century, the relics of Saint John the Almsgiver.[1] This functional
transformation from secular to sacred vessel has guaranteed its
survival and preservation.

Applied to a fine framework of scrolling foliage and set
within ropework-bordered panels, Lancastrian red roses, Yorkist
white roses, Katherine of Aragon's pomegranates, and bande-
role-bearing putti decorate the foot, body, and cover. Originally,
the ogee-shaped lid was topped with a delicate finial in the form
of England's patron saint, Saint George, killing the dragon, as
recorded in a sixteenth-century drawing.[2] These gilded-silver
mounts, and their colorful enameling, provide a suitable embel-
lishment for the treasure they contain: the large, probably
considerably older, rock-crystal handled vase. The absolute
transparency and physical heft of this natural substance was so
highly valued during the medieval and Renaissance periods that
it was reputedly worth its weight in gold.[3] The maker's mark (a
cross within a shield) struck on the cover, lip, and foot of the
vessel unfortunately remains unidentified, although it has been
tentatively attributed to Nicholas Warley, a prosperous and
successful master in the Goldsmiths' Company who was among
those goldsmiths paid by the Crown for making New Year's gifts
in 1510.[4]

If Elizabethan London experienced an influx of international
talent—and competition—in the field of goldsmiths' work, it
was negligible in comparison with the industriousness occa-
sioned by the prodigious expenditure of Henry VIII and his
court on precious metalwork earlier in the sixteenth century.
One year saw the king spending almost £5,000 on plate and
jewels.[5] Already during Henry VII's reign, in 1498, a visiting
Italian had marveled at the presence of fifty-two goldsmiths'
shops in Cheapside alone.[6] The present cup and cover is prob-
ably representative of a much larger, related group of types
made in London. Indeed, similar objects abound in the royal
inventories, not least in Henry's posthumous 1547 inventory,
when (at least fifteen years after this piece had left England)
a very similar "Cuppe of Cristall the fote and cover of silver

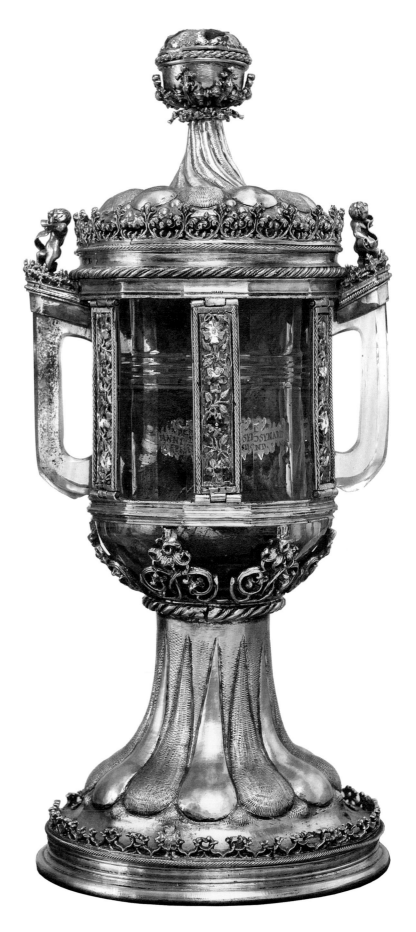

and guilt garnysshed with flower deluces [fleurs-de-lis] and Scriptures upon the Cover with saynt George on the toppe thereof" remained in the royal collection.[7] The missing finial also makes for a close connection with that of the slightly later, London-made Howard Grace Cup.[8] Yet very little London-made goldsmiths' work from the early Tudor years survives, having been variously melted down, sold, or given away. It is likely that some still survives in European treasuries, as yet unrecognized as English. This was indeed the case with cat. 36, which until relatively recently was erroneously believed to be fifteenth-century Tuscan.[9]

Though apparently either made at the request of Henry and Katherine or given to them, the cup and cover had already left England within twenty years of its manufacture: in 1532, the set was documented in Florence, with a new function as a reliquary, among a gift of forty-four other reliquaries presented to the Church of San Lorenzo by the Medici pope Clement VII. Already in 1532 the original connection with the Tudors apparently went unmarked, or was, at least, considered of too little importance to record. There is no trace of how, when, or why this cup and cover crossed the Channel and the Alps to arrive in Tuscany. The set may have been a royal gift from Henry VIII to Pope Clement VII or, indeed, his predecessor Pope Leo X, both of whom are convincing possibilities.[10] While Leo's 1521 conferral on Henry VIII of the title Defender of the Faith represented the culmination of an escalating gift exchange between England and the Vatican, the catalyst for Henry's subsequent gifts to both Clement and his legate, Cardinal Lorenzo Campeggio, was, ironically, his effort to effect a divorce from Katherine, whose union with Henry this cup celebrates. Whatever its path to conversion into a Roman Catholic reliquary, this Tudor cup's arrival at San Lorenzo guaranteed its survival, providing a tantalizing record of the largely lost art of early sixteenth-century English goldsmiths' work. EC

Notes to this entry appear on p. 311.

37. *Three Designs for Friezes*

Hans Holbein the Younger (1497/98–1543)
ca. 1534–38
Black ink over chalk, top: 1 11/16 × 8 1/8 in. (4.3 × 20.7); middle: 1 3/4 × 7 15/16 in. (4.5 × 20.2 cm); bottom: 1 3/4 × 8 1/16 in. (4.5 × 20.5 cm); mounted as one
Amerbach-Kabinett, Kupferstichkabinett, Kunstmuseum Basel (1662.165.22–.24)
Not exhibited

38. *Design for a Footed Cup with Cover*

Hans Holbein the Younger (1497/98–1543)
ca. 1532–38
Black ink over chalk, 9 7/8 × 6 1/2 in. (25.1 × 16.4 cm)
Amerbach-Kabinett, Kupferstichkabinett, Kunstmuseum Basel (1662.165.104)
Not exhibited

39. *Design for a Cup for Jane Seymour*

Hans Holbein the Younger (1497/98–1543)
ca. 1536–37
Pen and brown ink, with gray and pink wash, heightened in gold, on laid paper, 14 3/4 × 6 1/8 in. (37.6 × 15.5 cm)
Ashmolean Museum, University of Oxford (WA1863.424)
Exhibited New York and Cleveland only

Some two hundred of Holbein's design drawings for goldsmiths' work survive.[1] These complement a number of references in archival sources to collaborations between Holbein and goldsmiths, as well as an extremely small number of known objects that can plausibly be associated with the artist (see cat. 40 and fig. 35). Goldsmiths translated Holbein's virtuoso draftsmanship into trophies that played a crucial role in court practices of gift giving and display. Like Holbein, many of these highly skilled artisans were émigrés from continental Europe. Holbein seems to have had a particularly close relationship with the goldsmith known in the royal accounts as "Hans of Antwerp," whose name (as "HANS VON ANT.") Holbein inscribed on the design for an elaborate cup (cat. 38), and who later served as a witness to Holbein's will (see fig. 63).[2]

The large group of design drawings now in the Kunstmuseum Basel, many of them fragments, attests to Holbein's inventiveness as he devised ornamental motifs for objects ranging from cups to mirror frames to the hilts of daggers. The selection of ornamental friezes (cat. 37), in which vegetal and grotesque motifs blend seamlessly into one another, might have provided borders for various kinds of objects. Often loosely drawn and only partly finished, these are working drawings that Holbein probably retained and could have repurposed in multiple commissions.[3] In the case of symmetrical objects, he often drew only one half, or he duplicated the design through a counterproof method, folding

Cat. 37

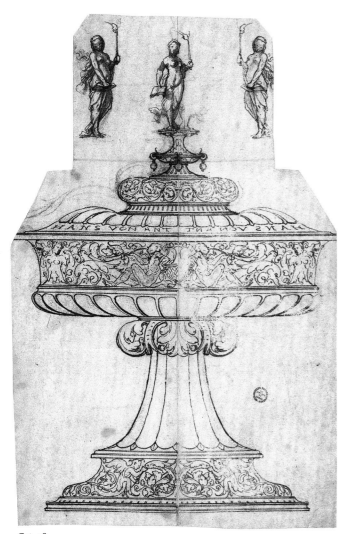

Cat. 38

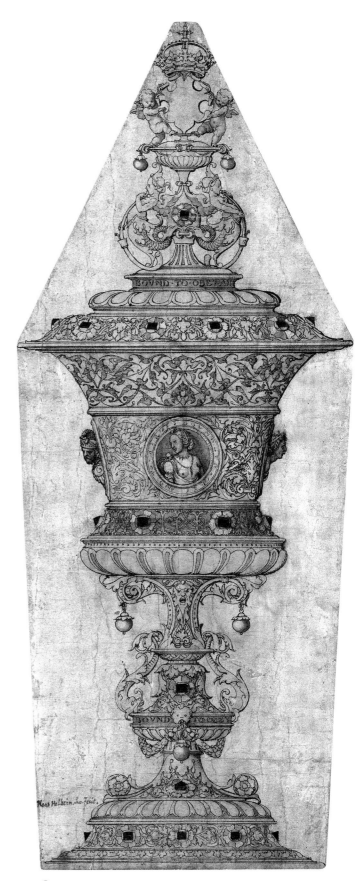

Cat. 39

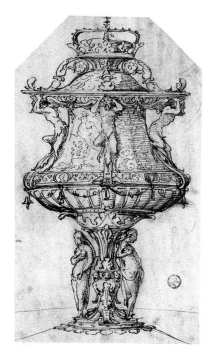

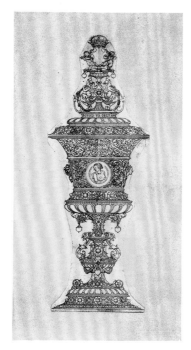

Fig. 61. Hans Holbein the Younger (1497/98–1543), *Design for a Table Fountain with the Badge of Anne Boleyn*, 1533. Pen and black ink, over chalk, 9⅞ × 6½ in. (25.1 × 16.4 cm). Kupferstichkabinett, Kunstmuseum Basel (1662.165.89)

Fig. 62. Hans Holbein the Younger (1497/98–1543), *Design for a Cup for Jane Seymour*, 1536–37. Pen and black ink, 14¾ × 5⅝ in. (37.5 × 14.3 cm). The British Museum, London (1848,1125.9)

the dampened sheet to transfer the design. Such is the case with the cup for "Hans of Antwerp," for which Holbein first drew the left side, then duplicated it with a counterproof on the right, and finally inserted the crowning element of a female torch-bearing figure (cat. 38).[4] Holbein took the extra step of including three distinct views of this figure, aiding its translation into three dimensions by the goldsmith.

Holbein's metalwork drawings also included proposals for objects explicitly associated with Henry VIII and his queens. At New Year's in 1534, Anne Boleyn presented a table fountain to Henry VIII based on a drawing by Holbein now with the group in Basel (fig. 61);[5] her patronage of the artist may have been prompted by the pageant he had designed for her coronation procession a few months before (see cat. 89). Holbein later designed a cup for Anne's successor Jane Seymour, most likely as

a gift from the king himself (cat. 39).[6] A royal inventory from 1574 shows that the cup eventually passed to Jane Seymour's stepdaughter Elizabeth I, describing it as a "faire standing Cup of golde garnished" with diamonds and pearls.[7] The cup was still in royal hands at the accession of Charles I but was pawned and melted down in 1629, meeting a similar fate to that of most Tudor royal goldsmiths' work.[8]

The elaborate ornamentation of the Seymour cup ranges from mermaids and putti to the bust-length Antique figures who emerge from roundels on the cup's central band. (Similar cameo-style heads, carved in shell, appear on Henry VIII's surviving clock salt, made by the French goldsmith Pierre Mangot; see fig. 36.)[9] As in Holbein's other ornamental designs, the classicizing ornament of the cup derives from his training at the trans-alpine crossroads of Augsburg and Basel. A particularly striking feature of the Seymour cup is the prominent repetition of the queen's self-effacing motto: "Bound to obey and serve." Rosettes, inset with diamonds and likely enameled, along with the dangling pearl pendants, would have added to the cup's ostentation.

Exceptionally, two separate drawings by Holbein for the Seymour cup survive, giving insight into the separate stages of his design process. The first drawing, now in the British Museum (fig. 62), is somewhat looser, without the gray and pink washes or gold heightening that give polish and three-dimensionality to cat. 39.[10] The latter was likely the presentation drawing submitted by the artist for royal approval, once the design had been finalized. The British Museum drawing also features alterations to the original, almost certainly in Holbein's hand, that were later incorporated in the finished drawing. Slight variations in the draftsmanship between different sections of these drawings have led some commentators to perceive in them the participation of Holbein's workshop;[11] in any case, they remain key survivals of the collaboration between Holbein, his assistants, and the virtuoso goldsmiths who supplied the Tudor court with some of its most cherished trophies. AE

Notes to this entry appear on p. 311.

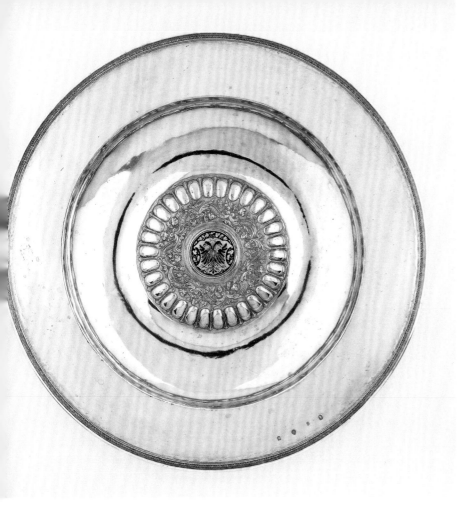
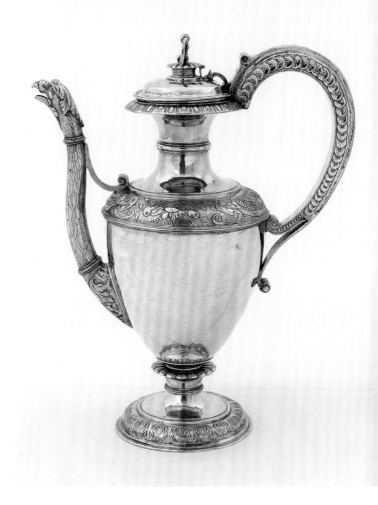

40. *Basin*

London, 1535–36
Silver, gilded silver, colored enamel, H. 2⅟₁₆ in. (5.2 cm),
Diam. 17½–17⅝ in. (44.5–44.9 cm)
Focke Museum–Bremer Landesmuseum für Kunst und Kulturgeschichte,
Bremen (1977.510)
Exhibited New York only

41. *Ewer*

Attributed to Affabel Partridge (active ca. 1551–80)
London, 1562–63
Silver, gilded silver, 11⅛ × 8⅞ in. (28.5 × 22.5 cm)
Focke Museum–Bremer Landesmuseum für Kunst und Kulturgeschichte,
Bremen (1977.511)
Exhibited New York only

Both these pieces bear the hallmark of the London Goldsmiths'
Company—a crowned leopard's head—as well as official
London date letter stamps and unidentified makers' marks (a
tent on the basin; a bird on the ewer). The hallmark of the bird is
a very close variant to that associated with the English goldsmith
Affabel Partridge, clearly visible on cats. 60 and 61. The ewer is
also marked with the English quality mark for sterling, the lion-
passant stamp. The basin, however, bears instead the imperial
double-headed eagle, indicating that it was made under the

purview of the Hanseatic League in London. The same symbol,
boldly executed in black enamel, reiterates the Hanse commis-
sion of the basin.[1]

The Hanse merchants, and their associated circle of German,
Flemish, and Dutch nationals, played a major role in Tudor
London trade. At times their privileged exemptions raised the
ire of local traders; not for nothing did they choose to operate
out of a walled and gated, defensible Thames-side compound,
the Stalhof, translated (inaccurately) by the English as the
"Steelyard." (Edward Hall's *Chronicle* vividly describes the
apprentices' riots of 1493, when "the multitude rushed and bete
at the gates with clubbes and levers," although the timely arrival
of the city magistrates and officers prevented bloodshed.)[2]
Diplomatically, the Hanse celebrated with the populace—
including with fountains of free wine (see cat. 89)—when
royal occasion presented itself.

It was to this powerful German-speaking Steelyard com-
munity that Hans Holbein turned upon his return to London
in 1532, in his effort to attract commissions and reestablish his
reputation in the city.[3] In addition to a group of portraits and the
Parnassus pageant design that Holbein undertook for the Hanse
(see cats. 79, 89), it is likely that he also designed this basin. The
delicate foliage and scrolls of the embossed and chased pattern

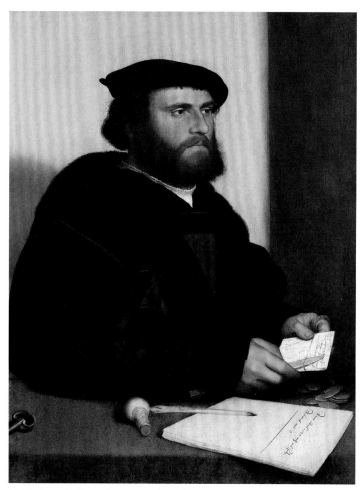

Fig. 63. Hans Holbein the Younger (1497/98–1543), *Hans of Antwerp*, 1532. Oil on panel, 24¾ × 19 in. (63 × 48.4 cm). The Royal Collection / HM Queen Elizabeth II (RCIN 404443)

decorating the basin's shallow bowl recall Holbein's strips of designs for this type of work (cat. 37). The striking contrast with the broad, bold lozenges repeats the device he developed about this same time in his design for a cup and cover (cat. 38). The London-based goldsmith whose name Holbein inscribed on this same design was one of his Hanse connections: Hans of Antwerp, whose actual name, recorded in documents, was Hans van der Gow.[4] Van der Gow was such a close associate of Holbein's that the goldsmith would later witness, and be named executor of, the painter's last will and testament, rushed through during the sweating-sickness epidemic of 1543. Holbein had portrayed Van der Gow in 1532 (fig. 63), firmly documenting the goldsmith's association with the Steelyard by naming it in the inscription on the letter held in the sitter's hands.

Given the network between the basin's patrons, its designer, and this goldsmith, it may well have been Hans van der Gow who created the piece. Although the Hanse basin bears a London goldsmith's mark, it was apparently accepted practice

for English-born masters to accede their mark to foreign goldsmiths, unrecognized by the Goldsmiths' Company guild, to enable the vital quality-control assay process.[5] Though he had lived in London since 1504, Van der Gow only petitioned to become licensed as a freeman of the Goldsmiths' Company in 1537.[6] Clearly, his work must have matched the high caliber of the Hanse basin: already in 1533, Holbein and Van der Gow collaborated on a silver cradle for the princess Elizabeth.[7] A year after the basin was made, Van der Gow's name—as Hans of Antwerp—appears in the royal accounts, as being paid for goldsmiths' work undertaken for the princess Mary. From December 1537 until December 1539, he enjoyed regular commissions from Thomas Cromwell, then master of the royal Jewel House, including, in January 1539, for a "gold cup which my lord gave the King for his New Year's gift."[8] It was, indeed, Cromwell who wrote a letter of recommendation on Van der Gow's behalf, petitioning for his guild license, which was successful.

Though dated almost three decades later, the ewer may have been created as a belated companion piece—or perhaps a replacement of a lost original element—to the basin, apparently commissioned from the highly successful Affabel Partridge. The ewer shares the same elegant coloration, combining polished silver with gilded-silver decoration, and corresponds neatly in scale to the basin. Finely executed, it has an elegant but conventional silhouette (echoed by cat. 32).

These two fine examples of English hallmarked silverwork made in Tudor London embody the complicated interconnectivity between local guild members and the European designers and practitioners, like Holbein and Van der Gow, who worked within their professional precincts, in plain sight of but largely unacknowledged by the guilds. Echoing the position of their Hanse patrons and the role of the Steelyard in London, European artisans negotiated a tense coexistence with the locals, sweetened by the shareable professional skill sets, resources, and financing they brought to the capital and sometimes ruptured when the uneasy balance of mutual satisfaction was felt to tip too unfairly out of local favor. It was this ebb and flow of national tolerance that eventually led to the Hanse silverware's departure from England: in the face of rising tensions, in 1604 the Hanse executed a plan already posited in 1578 to send the Steelyard's silverware, together with trunks of deeds and registers, to the safety of Lübeck.[9] Though none of the other London Steelyard silverware survives, the Lübeck office sold these two pieces to the city of Bremen in 1609, where they were preserved as part of the city council treasury. EC

Notes to this entry appear on p. 311.

42. *The Division of the Booty, from a Ten-Piece Set of the Story of David and Bathsheba*

Designed by an unknown Flemish artist, ca. 1524
Probably Brussels, ca. 1526–28
Wool (warp), wool, silk, silver, and gilded-silver metal-wrapped threads (wefts), 179¼ × 232¾ in. (455 × 591 cm)
Musée National de la Renaissance, Ecouen (E. Cl. 1617)

It is perhaps unsurprising that, unlike his father, Henry VIII died leaving behind enormous debts, given sums such as the £1,548 he paid to the dealer Richard Gresham for one tapestry set in 1528. As has been remarked by the scholar Thomas P. Campbell, the same money would have bought Henry a fully equipped battleship.[1] Certainly, the £1,548 tapestry set was one of the priciest that Henry acquired, and there is good reason to suppose that cat. 42 and the other nine tapestries with which it forms a set represent this extravagant purchase.

The ten tapestries, all of which survive, illustrate the latter part of King David's life, starting with his triumphant translation of the Ark of the Covenant into Jerusalem; his campaign against the Ammonites and his *affaire* with Bathsheba, the wife of his absent military commander, Uriah; Bathsheba's subsequent pregnancy and David's reception of her at court following Uriah's death; Nathan's remonstrations against David's sinful behavior, and the death of Bathsheba's child; and David's penitence toward God and his ultimate forgiveness and victory.[2] Cat. 42, the last work in the set, celebrates a triumphant David, having regained God's favor and defeated the Ammonites. The burning, vanquished city of Rabbah (looking more Flemish than Arab) can be seen in the distance, the orange glow of the flames enlivening the uppermost register of the tapestry. In a steady stream from the city gates, soldiers mingle with David's retinue as they bring booty from the vanquished and lay it before the king's feet.

Doing due justice to this epic tale, the tapestry set is monumental in scale, stretching more than 230 feet when placed end to end. A preparatory drawing for the fourth tapestry in the series survives, and has been linked with the master Jan van Roome, the early sixteenth-century Brussels-based designer of stained glass, tapestries, and sculpture.[3] In their decorative massing of figures and delight in representing patterned textiles, floral and faunal detail, and architectural ornament, the *David and Bathsheba* tapestries culminate the tradition of successful series like the *Story of the Redemption of Man* (cat. 4) while not yet anticipating the deeper recessions of perspective and illusionistic spatial acrobatics of Pieter Coecke van Aelst's designs (cat. 49), let alone the Antique-inspired restraint of Raphael (cat. 52). Owning examples from across this spectrum, Henry VIII

appreciated and acquired modern tapestry design in step with the medium's developments.

While *David and Bathsheba* predates the 1528 imperial edict to include city marks in tapestries' outer borders, it is nonetheless possible to attribute the series to Brussels, such is the quality of the weaving. Among the large, new sets that Henry bought from dealers were three different *David and Bathsheba* sets. The first, and smallest, woven with precious-metal-wrapped threads, was supplied in 1517 by none other than Pieter van Aelst, the same dealer-entrepreneur who provided Henry VII with his *Redemption of Man* tapestries and who also supplied sumptuous tapestries to clients in Spain and Rome (see cat. 4).[4] Henry bought the second set, also woven with precious-metal-wrapped threads, over the course of several months in 1520, via two transactions with the London-based Florentine merchant Giovanni Cavalcanti and, again, with Pieter van Aelst.[5] Immediately after Henry acquired it, this set was displayed—and remarked upon—at the Field of the Cloth of Gold meeting with François I, and conspicuously put on show again during the 1527 reception for the French ambassador marking the (ultimately unfulfilled) betrothal of Princess Mary with Prince Henri of France. The third and largest, most sumptuous, most expensive of Henry's *David* sets was that acquired from the London-based Richard Gresham for £1,548.[6] On the basis of size, it is most likely that the surviving Ecouen *David and Bathsheba* tapestries, including cat. 42, form the Gresham set, although it has been observed that the tapestries' great design, ambitious dimensions, and superlative weaving share the characteristics of Pieter van Aelst's other known tapestry projects.[7]

Intriguingly, Campbell has suggested that Henry VIII owned two different editions of the same Jan van Roome–designed *David and Bathsheba* set, the Ecouen edition being a second, enlarged, and more luxurious version of the same *David*, now lost, that he had acquired earlier from Pieter van Aelst, which was smaller but based on the same cartoons.[8] Certainly, Henry had a taste for owning multiple editions of tapestries he liked, also acquiring—across almost a decade—two editions of Pieter Coecke van Aelst's *Life of Saint Paul* (cat. 49).[9] Like so many of his European royal counterparts, Henry VIII sought to be associated with the Old Testament patriarch King David: in addition to collecting tapestries depicting him (Henry left twelve *David* sets and two additional, stand-alone pieces at his death), he had himself represented in the guise of David throughout his psalter (cat. 48) and on the title page of the Great Bible (cat. 21).[10] Henry, disenchanted with Katherine of Aragon and developing his divorce-justifying rhetoric that God was offended by his marriage to his erstwhile sister-in-law, saw parallels

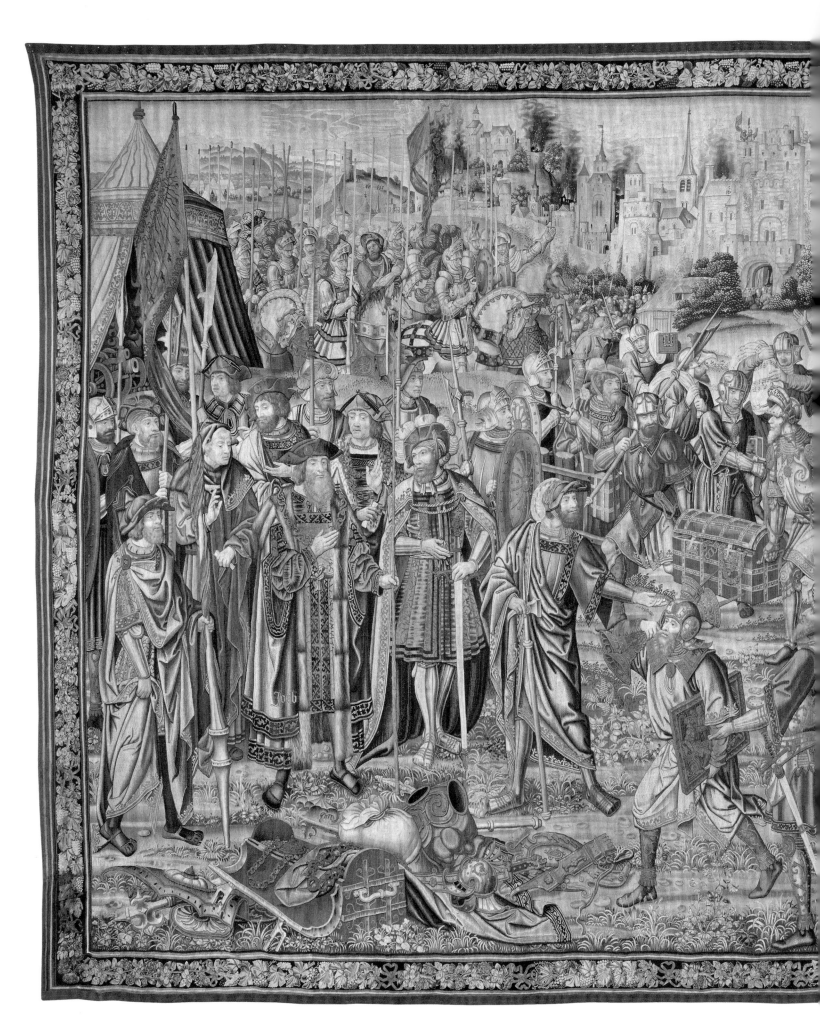

between his story and David's penitence following his ill-fated liaison with the married Bathsheba.[11] All the same, it remains unclear whether Jan van Roome's *David and Bathsheba* tapestry designs were especially commissioned in the late 1510s by Henry, or whether these documented *David* acquisitions, which may or may not have belonged to the same series, were canny speculative sales by dealers targeting a spendthrift king with subject matter they knew would strike a chord. Certainly, the Jan van Roome–designed *David and Bathsheba* series was woven in multiple editions, with other sets sold elsewhere: two duplicate pieces, for example, still survive in Toledo and in Padua.[12]

The exploits of David were an exceedingly popular subject for tapestry in the early sixteenth century, perhaps second only to the Passion of Christ.[13] Certainly, David's story had narrative and emblematic appeal for modern royalty, and likewise provided designers with plenty of fodder for exciting narrative compositions, combining God-given sanction to rule, victory against Goliath's unjust might, and even flawed romance, what with his seven marriages and entanglement with Bathsheba. By 1505 King Manuel I of Portugal owned a different series (now in Spain).[14] And in 1518, not long before Henry bought his first set, Emperor Maximilian I ordered one from Pieter de Pannemaker in Brussels, whose workshop produced some of the most exquisite and beautifully woven tapestries extant.[15] Unlike Henry's *David* set now in Ecouen, however, Maximilian's is unfortunately not known to have survived, making it difficult to gauge whether it was another edition of the same Jan van Roome–designed series (though its smaller dimensions suggest not).[16]

Henry's *David and Bathsheba* tapestries provide some hint of how gloriously bedecked his palaces could be, enveloped by these huge series, peopled with life-size protagonists portrayed in a rainbow of silken threads, glittering and heavy with gold and silver. At the king's death the tapestries were stored in the Tower, appropriately impressing even the inventory scribe who, surrounded by treasures, distinguished them as the "riche historye of king david."[17] E C

Notes to this entry appear on p. 311.

43. *Chess and Tric-Trac Game Board*

Germany, ca. 1550
Wood, ivory, bone, mother-of-pearl, 17¾ × 17¾ × ¼ in. (45 × 45 × 0.5 cm)
The Metropolitan Museum of Art, New York, Pfeiffer Fund, 1964 (64.51)
Exhibited New York only

At his death in 1547, Henry VIII left at least thirty game boards dispersed throughout his palatial homes.[1] Most were stored in coffers; others, in intriguing locations like that on "the Fourth Shelve" "in the Study nexte [to] the Kynges olde Bedde chambre at Westminster."[2] The most sumptuous of them were embellished with gilded silver and must have looked something like a game board in The Met's collection that bears the device of Don Diego Lopez Pacheco, Marquess of Villena and Duke of Escalona, who hosted Mary Tudor's envoys during her 1554 marriage negotiations with Philip of Spain.[3]

The present game board does not display similarly conspicuous armorials. However, the center point of its cover does bear a bilayered, five-petaled rose with five spiky aristae, and the interior features three-petaled lilies. If read as the Tudor rose and fleur-de-lis, these insignia would indicate that the board's

German creators were designing it for a Tudor owner, a point reiterated by its striking white-and-green palette, the Tudor colors (see cat. 12).[4] Certainly, Henry VIII owned such a board, described as "a paire of plaieng [playing] tables made of white boone and brassell [bone and brass] wrought with white & grene workes," and which he kept in the garderobe at Nonsuch.[5]

Designed for chess on one side and tric-trac (a precursor to backgammon) on the interior, the board is part of a small group of stylistically related survivals—the others are in Munich and London—that are all similarly rich in coloration and inlays.[6] They were likely produced in multiples for the high end of the market, perhaps on speculation, customized for special orders. A fourth board, though considerably later (ca. 1720–30), adopts the same distinct geometric pattern on its lid, its central square bearing the device of its first owner, Frederick the Great, King of Prussia.[7] The design motifs in the borders have been sourced from prints by the likes of Virgil Solis.[8] The skillful workmanship suggests an artisan who was as comfortable crafting inlaid gun stocks and other weaponry as he was creating recreational objects like this one.[9] EC

Notes to this entry appear on p. 311.

44. *Astronomicum Caesareum*

Written by Petrus Apianus (1495–1552); illustrated by Michael Ostendorfer (ca. 1490–1549)

Ingolstadt, 1540

Printed text on paper with hand-colored woodcut illustrations, 17⁷⁄₈ × 12¹¹⁄₁₆ in. (45.4 × 32.3 cm)

The Metropolitan Museum of Art, New York, Gift of Herbert N. Straus, 1925 (25.17)

45. *Astronomicum Caesareum*

Written by Petrus Apianus (1495–1552); illustrated by Michael Ostendorfer (ca. 1490–1549)

Ingolstadt, 1540

Printed text on paper with hand-colored woodcut illustrations, 18⅛ × 13⅛ in. (46 × 33.3 cm)

National Maritime Museum, Royal Museums Greenwich, London (PBC1352)

Henry VIII's book collection reflected the breadth of scientific endeavor and exploration that flourished alongside raging theological debates in sixteenth-century Europe. Stored together with "a Charte of Astronomy," "a paier of Compasses of Silver," and "twoo paier of Spectacles garnished with gold" in Henry VIII's Secret Jewel House in the Tower of London were various books of astronomy, likely including a copy of this printed text.[1]

Written by Petrus Apianus, mathematics professor at Ingolstadt University and court astronomer to Holy Roman Emperor Charles V, the book is ostensibly an instructional manual, teaching mariners how to navigate using the stars and an astrolabe device to determine their latitude and longitude at any given time.[2] Rotating disks with string markers attached to seed pearls reiterate the practical functionality of the book. However, Michael Ostendorfer's glorious illustrations, all hand colored,

Cat. 45

suggest a different target audience, with the title page displaying the arabesques and rinceaux of the most cutting-edge contemporary design, and nearly every page enlivened with splayed dragons, glories of sunrays, or planets represented with human features. Ostendorfer's contributions and the physical heft and sumptuousness of the book, printed on unusually thick paper, reveal that it is actually a luxury text. Copies were decorated and presented as gifts to the wealthiest and most privileged of collectors. Apianus's intent to present Henry VIII with one such special copy was noted to the king in a letter of 1544 from the dean of Canterbury Cathedral, Nicholas Wotton, who was also ambassador to the court of Charles V.[3] Although in this 1544 letter Apianus claimed to have made only seventeen such copies, his book seems to have become a sought-after text. Working carefully in tandem with Ostendorfer, whose workshop apparently hand colored all the woodcut pages

before they were cut and bound into separate books, Apianus and his family eventually caused more than one hundred editions of the *Astronomicum caesareum* to be printed privately.[4]

Henry VIII's maritime interests, though significant, had much more to do with transforming the English Navy into one of Europe's most impressive military forces than with any particular explorational urge.[5] His own copy of the *Astronomicum* is preserved in the Bibliotheca Thysiana, Leiden University. Cats. 44 and 45 reveal how the quality and aesthetic heft of these books were not compromised by the fact that they were produced in multiples. On the contrary, their owners were, implicitly, members of an elite club of privileged potentates, ostensibly regarded as intellectual luminaries. The title "Astronomy of the Caesars"—in plural—was thus entirely apropos. EC

Notes to this entry appear on p. 311.

46. Sandglass

England or Germany, ca. 1540
Gilded silver, blown glass, sand, gold thread, 8¾ × 7 × 2½ in.
(22 × 18 × 6.5 cm)
Museum of Fine Arts, Boston (57.533)
Exhibited New York only

An elaborate wall-mounted frame worthy of a small-scale devotional image instead contains an ingenious mechanism supporting a sandglass. Disarmingly simple to use, but a feat of technical precision to craft, the bracket is horizontally hinged and, swinging through forty-five degrees, clicks into place alternatively in the left- or right-hand socket of the wall-mount, enabling the turning of the sandglass in just the same way that a handheld sandglass would be flipped manually.

The object's distinctive red sand was probably sourced from Weissenbrunn, near Nuremberg, which enjoyed some renown as a center of sandglass production, while the fine glass ampules have the clarity of Murano-blown *cristallo* glass, bound with sumptuous golden thread. The silverwork of the frame is gilded and variously wrought, embossed, chased, die struck, and flat chased. Without hallmarks, the object might therefore have been a courtly commission, outside guild jurisdiction. The design of its elegant motifs is attributable to Hans Holbein or his circle, from the scrolling acanthus leaves and dolphins supporting a putto's head (compare to cat. 39) to the struts and foliate frieze of the sandglass's armature (see cat. 37), to even the delicate dentiled border of the hinged framework. The design may date to Holbein's second visit to England (1532 until his death in 1543), or alternatively be associated with his designs made in Basel.[1]

Considerably easier to operate and maintain than early modern clocks or watches, sandglasses provided a practical means of measuring units of time. This distinctive example—probably a half-hour glass, judging by its size—was intended for installation in either an oratory or chapel space, or in a study or library. On such permanent display, it would have met the exhortations of the scholar Petrus Paulus Vergerius in his *De ingenuis moribus* (ca. 1401) to keep sandglasses on view, "so that we can see time itself flowing and fading away, as it were."[2] In devotional terms their presence effectively prompted users to reflect on the passing of time and, by implication, the transience of life. More practically, they also enabled set periods of time for prayer, meditation, or study.[3] Henry VIII kept sandglasses in his "Study at the hether ende of the Longe Gallorie" and in "the kynges secrete studie called the Chaier house," both at Westminster. In the former space, there were also "VI Instrumentes of Astronomye hanging uppon the walle," although there is no record of such a wall-mounted sandglass among his possessions.[4]

Transforming a conventional and centuries-old method of measuring time into the most up-to-date of gadgets while simultaneously embracing the highest-end raw materials, workmanship, and design, this sandglass can only have belonged to the royally wealthy. It is a remarkable survival of the type of covetable object available to the Tudors and their circle. EC

Notes to this entry appear on p. 312.

47. Infant Christ Pressing the Wine of the Eucharist

Designed by an unknown artist, ca. 1490–1500
Probably Brussels, before 1509
Linen (warp), wool, silk, silver, and gilded-silver metal-wrapped threads (wefts), 19⅞ × 18¼ in. (50.5 × 46.4 cm)
The Metropolitan Museum of Art, New York, Bequest of Benjamin Altman, 1913 (14.40.709a)
Exhibited New York only

A tapestry such as this one provides some sense of the distinctive appeal of the limited but precious holdings of single-piece, small-scale devotional tapestries recorded in the royal collection at the time of Henry VIII's death (see "Furnishing the Palace" in this volume). A fraction over two and a half square feet, this tapestry was designed for close looking, accommodating only one viewer at a time in compelling and intimate proximity. Almost certainly not kept hanging, it instead would have been stored alongside precious objects in its owner's garderobe or antechamber, carefully lined with stiffened buckram, kept in a leather box, case, or fabric sleeve, and only taken out for contemplation as part of its owner's devotional routine.[1] The composition serves as a kind of treasure hunt on which this privileged viewer could meditate, lingering on the allegorical details dotted throughout the design: despite his infancy, the Christ Child appears, unusually, alone, directly engaging the viewer in a knowing gaze, as if inviting this contemplative journey.

The infant squeezes a bunch of grapes above a chalice-like cup, a reference to the future shedding of his blood to redeem mankind, and the liturgy's remembrance of this in the transubstantiation of the wine during Eucharistic Mass, which would not have been lost on the viewer. The inscription on the vertical borders reiterates the message: taken from the apocryphal book of Ecclesiasticus (50:15), it describes how the high priest Simon "stretched out his hand to the cup, and poured of the blood of the grape," prefiguring the Eucharist.[2] The cloth of honor at the child's back, the orb, and the balcony-like setting are accoutrements of his royal status as son of God, though the rough smock he wears, like the brown habit of the Carmelites and Franciscans, denotes humility. Visual prompts allude to his incarnation as a fulfillment of Old Testament prophecies (the book on the shelf) and as fruit of the Virgin's womb (the pomegranate atop the glass), as well as to the Virgin's purity (the glass again), countering Eve's original sin in the Old Testament (the pomegranate, in turn, recalling the tempting apple). The orb in the foreground, traditionally held by the adult Christ in representations of the Salvator Mundi, alludes to the infant's predestined fate as the redeemer; the reflection of his left hand in the rock crystal points to the cross, underscoring this destiny while, in its reflected state,

being transformed into a right-handed blessing-like gesture. The pomegranate, embodying the countless souls saved by the shedding of his blood, reiterates the message. The circle-shaped composition—both a talisman against evil and a celebration of God's all-encircling and infinite power, in the manner of a rose window or a mandorla—leaves the corner spandrels free to contain two red roses, traditional symbols of the blood spilled at Christ's martyrdom; two pansies, emblematic of remembrance, and thus a prompt to the viewer to celebrate the Eucharist, just as Christ would urge his disciples to "do this in remembrance of me"; and a strawberry, conventionally understood as a good but humble fruit of the spirit. With these fruit and flora embodying the beauty of the natural world as God's work, the tapestry's design recalls Vincent of Beauvais's much-read *Speculum naturale* commentary, composed in the mid-thirteenth century; the slight distortions of the infant's elongated cranium and seemingly disjointed right arm perhaps intentionally mimic the effects of a circular convex mirror, so popular in the early sixteenth century.

Like many of the small-scale devotional tapestries documented in Henry's collection, cat. 47's jewel-like appearance reflects the wealth of its precious raw materials. Largely woven with gilded-silver metal-wrapped threads, the surface shimmers when handled, an effect that must have been accentuated even more compellingly in flickering candlelight or when catching the gleam of sunbeams by a window. The unusual linen, rather than wool, warp allowed the weaver a very tight support on which to work. It was probably prepared dampened and stretched even more tautly upon drying, enabling an exceedingly fine weave.[3] Contrary to orthodox Flemish tapestry technique, which called for multiple weavers collaborating on a single hanging, this tiny tapestry would have had the working space for only a single weaver. Instead of working with the painted cartoon turned through ninety degrees, as convention decreed, causing the warp to be horizontal to the design of the finished tapestry, this weaver worked with the design upright against the vertical warp, in its correct orientation, the representation becoming immediately legible as the weaving progressed across the loom. The weaver's virtuosity shows in his or her ability to mimic characteristics of other artistic media: the cropped and cramped composition adopts the intentionally disconcerting close-up, half-length format popularized in the paintings of Rogier van der Weyden; the beautifully observed blooms and foliage set against golden grounds recall the effects of contemporary manuscript borders (see cat. 14); and the framing device evokes sumptuous embroidery in gold thread against the rich pile of a velvet ground (see cat. 6).[4]

This particular tapestry almost certainly belonged to Henry VIII's sister-in-law Joanna the Mad, Queen of Castile.[5] Owning two versions of the same design and format, she gave

one to her daughter-in-law Isabella of Portugal. These light and portable, yet clearly lavish and distinctive, miniature devotional tapestries held manifest appeal as gifts. Indeed, it seems to have been Henry's first mother-in-law, Isabella of Castile, who encouraged a taste for these tapestries in her daughters. (One buying trip to Brussels saw Isabella spending more than 245,000 maravedis for twelve tapestries—the equivalent of ten years' salary paid to the master of a ship on Christopher Columbus's first voyage to the New World in 1492).[6] It is entirely likely that Katherine of Aragon brought small tapestries like this with her to England. A group of surviving, visually related tapestries showing the Christ Child pressing the mystic grapes—some representing the infant alone, others accompanied by the Virgin Mary and

Joseph—perhaps owe their creation to related versions made by court tapestry makers, copied by eye without recourse to reusable cartoons in emulation of existing hangings.[7] Henry apparently asked his arrasman, a Flemish weaver who looked after his tapestry collection, to make such versions: stored at Hampton Court in 1547 was, for example, a "square pece of Arras of Christe and one geving him grapes & our Ladie standing by . . . by tharrise man [by the arrasman]," slightly larger than cat. 47, at five foot square.[8] Sharing the same devotional theme, this documented tapestry might even have been part of this emulative group, originally belonging to Henry's first wife, Katherine, like the examples owned by her mother, elder sister, and niece-in-law. EC

Notes to this entry appear on p. 312.

48. *The Psalter of Henry VIII*

Transcription and miniatures attributed to Jean Mallard (active 1534–53)
London, 1540
Tempera on parchment, 8⅛ × 5½ in. (20.5 × 14 cm)
British Library, London (MS Royal 2 A XVI)
Exhibited New York and San Francisco only

Though created in London, this psalter has the appearance of
a French manuscript, written and, apparently, illustrated by
Henry VIII's Orator to the Crown, Jean Mallard from Rouen.
Mallard had previously served at François I's court, to which
he would eventually return.[1] With seven large miniatures and
a Latin text rendered in Mallard's crisp, legible, humanist-style
hand, this manuscript was made for Henry's personal use. It
provides an extraordinary window into the king's self-perception.
The Old Testament patriarch David appears in the psalter no
fewer than five times with Henry's own facial features and dress.
Psalm 52 even shows the harp-strumming king accompanied by
Henry's fool, the court jester Will Somer (fig. 64). The Tudor
king's desire to be identified as a new Hercules (see cat. 52) was
matched by his special identification, already celebrated in one of
his most costly tapestry acquisitions (cat. 42), with the biblical
David—divinely chosen vanquisher of Goliath, God's agent on
earth, and progenitor of the royal house of David.[2] Only two
years earlier, Henry would showcase this same notion on the title
page of the Great Bible (cat. 21).

Contrary to the rather implausible, if appealing, sugges-
tion that Mallard conceived the iconography to tweak Henry's
conscience and confront him with a vision of his own mor-
tality, it is much more likely that Mallard aimed to delight
the king with this flattering appeal to his self-congratulatory
and self-justifying notions.[3] Certainly, it has been shown that,
two years previously, Mallard had used the same conceit with
Henry's French counterpart, presenting François I with a book
of hours in which a penitent King David has the French king's
features.[4] The delivery of Henry's psalter alongside a printed
volume of the biblical books attributed to Solomon suggests
that it may have been Henry himself who conceived this group
of portraited miniatures, tipping himself into Old Testament
narratives as if a protagonist and embodying his chosen biblical
alter ego.[5] It may be that Henry opted to commission a psalter,
which conventionally paired Old Testament precedent with

Fig. 64. "Psalm 52," fols. 63v–64r of cat. 48

New Testament fulfillment (see cats. 4, 18), rather than a more
voguish book of hours specifically in order to juxtapose King
David's writings with more recent fulfilments—that is, his own,
in sixteenth-century Europe.

Mallard's miniatures reinforce the king's loudly proclaimed
rhetoric of blessed and righteous kingship. However, Henry's
own notes, added in the margins, record his thoughts and
reactions on a private platform, not necessarily intended for
posterity's eyes (though he did have them transcribed).[6] With
an almost endearing insecurity, he chided himself, "Note who is
blessed" ("N[ota] quis sit beat[us]"), written beside a Henrician
David contemplating God day and night (Psalm 1:1); declared it
"a sad saying" ("dolens dictum") in response to "I was young and
now am old" (Psalm 37:25); and, ominously reading in Christ's
precedence approbation of his own actions, wrote, "Note what
he says about Christ's enemies" ("N[ota] quid ait de Christi
inimicis"). This last exhortation appears beside Psalm 21, verse 8:
"Your hand will lay hold on all your enemies; your right hand
will seize your foes."[7] E C

Notes to this entry appear on p. 312.

ᴮᴱᴬᵀᐺ S vir qui non abiit
in confilio impiorum, & in via
peccatorum non ſtetit, & in cathedra pe=
ſtilentiæ non ſedit.

49. *Saint Paul Directing the Burning of the Heathen Books, from a Nine-Piece Set of the Life of Saint Paul*

Designed by Pieter Coecke van Aelst (1502–1550), ca. 1535; possibly woven under the direction of Paulus van Oppenem (active ca. 1510–45)
Brussels, before September 1539
Wool (warp), wool, silk, silver, and gilded-silver metal-wrapped threads (wefts), 134 × 216 in. (340 × 550 cm)
Private collection

Throughout the 1520s and 1530s, Henry VIII regularly ordered public burnings of heretical books, including William Tyndale's unauthorized English translation of the Bible, ceremoniously burned at Cheapside Cross in 1530 (see cat. 20).[1] It was probably no coincidence, therefore, that when the king ordered an edition of the sumptuous and sought-after *Life of Saint Paul* tapestry series from Brussels weavers in about 1535, he requested that two additional episodes be added to his set: the *Stoning of Saint Stephen* and *Saint Paul Directing the Burning of the Heathen Books* (cat. 49).

Speaking to Henry's evident love of monumental-scale tapestries, the *Saint Paul* series brought to the Tudor court the modern style and audacious spatial illusionism of Pieter Coecke van Aelst, an Antwerp-based artist and future court painter to Holy Roman Emperor Charles V.[2] The subject matter must have particularly attracted Henry, celebrating as it did the life of Saint Paul, whose gospel paralleled that according to Saint Peter and thus provided an apostolic alternative to the Petrine authority of the Vatican. The fact that the ancient Salisbury Liturgy, which had been the principal liturgy for the Catholic Church in England for centuries, was based on Paul's Liturgy of Ephesus rather than the Roman Catholic Church's Liturgy of Saint Peter must have made the subject even more appealing. At the time of Henry's commission, the *Saint Paul* tapestry series was already enjoying popularity among the most privileged echelons of European royalty: sets were recorded by this date in the collections of King François I of France and of Mary of Hungary, Governor of the Habsburg Netherlands, while a third edition subsequently made its way into the hands of Charles III, duc de Lorraine. Yet these earlier sets numbered only seven tapestries each: Henry's was the first to include the two additional scenes of the stoning of Stephen and the burning of the books.

Both episodes provided apostolic precedent for Henry's own behavior following the 1534 Act of Supremacy, which proclaimed him Supreme Head of the Church in England, as well as the Act Concerning Peter's Pence and Dispensations, issued that same year. The latter symbolically minimized papal authority by abolishing an annual tax paid to the pope and by granting England's archbishop of Canterbury the power (formerly held by the pope)

Fig. 65. *Saint Paul Directing the Burning of the Heathen Books*, from the *Life of Saint Paul* series. Designed by Pieter Coecke van Aelst (1502–1550), ca. 1535; probably woven under the direction of Jan van der Vyst (active before ca. 1546–62), Brussels, before 1546. Wool and silk, 159 × 270⅛ in. (405 × 686 cm). Museum of Fine Arts, Boston (65.596)

to issue dispensations. Treading a careful tightrope to shake off Vatican jurisdiction in England, but remaining fiercely suspicious of any overtly Protestant activity, Henry embraced Stephen as a New Testament precedent challenging a purportedly unjust status quo, while in Paul, Henry identified a fierce and pious counterpart to himself in his continued role as Defender of the Faith. Stephen was martyred for questioning the blind acceptance of the faithful, calling out to the crowd not to be swayed by the pomp and circumstance of the Jewish Temple and declaring that "the Highest of all dwelleth not in temples that are made with hands" (Acts 7:48).[3] Paul safeguarded the Catholic faith from heretical writings by burning them, just as Henry believed himself to have done in his 1529 Proclamation Against Erroneous Books and Heresies and his 1534 Proclamation Against Seditious Books. Doubtless, Henry saw himself echoed in the righteous figure of Paul standing immediately to the left of the bonfire, directing proceedings, elegantly unruffled by the flurry of activity around him.

As apparently had been his practice with other tapestry design projects, Coecke returned to the *Saint Paul* series he had designed six years previously to add the extra scenes; his autograph drawing for this episode survives today.[4] The composition unites Coecke's appreciation of classical architecture (having published pirated translations of Sebastiano Serlio's treatise on architecture) with his flair for capturing movement,

of figures as well as objects. Pushing the weavers to showcase their skill, Coecke had them render the effervescent effect of billowing clouds of smoke, partially obscuring the stately library at Ephesus in the background. With characteristic audacity of design, flames seem to take hold of the textile support; books tumble from the bonfire as though out of the composition and into the viewer's space. This effect is even more appreciable in a slightly later edition of the *Burning of Books* that still retains its border, and in which putti panic to avoid the path of falling books overlapping the frieze (fig. 65).

Although the arrival of this sumptuous tapestry set in London can be dated sometime between September 1538 and September 1539, there is no record of either its purchase or the price Henry VIII paid for it. However, it must have been in the same region as the £1,548 paid ten years earlier for his *David and Bathsheba* tapestries (cat. 42). Although part of a nine-piece set, cat. 49, superbly woven in wool, silk, and precious-metal-wrapped threads, is the only tapestry from the set known to have survived. The silver and gilded silver is so abundant that the palette has been deliberately toned down to showcase their sparkle, in marked contrast to the brightly colored but less splendid later edition (fig. 65). As the outer frame is now lost, identifying weavers' marks are absent, but the tapestry's glittering and virtuoso style suggests a Brussels manufacture and is very similar to that of Paulus van Oppenem's workshop, responsible for both an earlier, seven-piece edition of the *Life of Saint Paul* and Henry's *Seven Deadly Sins* tapestries, also designed by Coecke.[5] Henry was undoubtedly pleased with his extended *Saint Paul* set, acquiring a second nine-piece edition some years later, between 1545 and 1546. It was less expensively woven in only wool and silk, making it possible that fig. 65 formed part of that set (since dispersed).

Having been delivered between 1538 and 1539, and allowing time for design, the painting of cartoons, and weaving, Henry's first, golden *Saint Paul* set was probably commissioned about 1535, when his zeal to protect the Catholic Church and his own authority as Supreme Head of that church in England had escalated beyond public book burnings to human bonfires. Indeed, there were twenty-four such executions in the three years between commission and delivery of this tapestry. EC

Notes to this entry appear on p. 312.

50. Henry Fitzroy, Duke of Richmond and Somerset

Lucas Horenbout (ca. 1490/95–1544)
ca. 1533–34
Watercolor on vellum, laid on playing card (ace of hearts),
Diam. 1¾ in. (4.4 cm)
The Royal Collection / HM Queen Elizabeth II (RCIN 420019)
Exhibited New York and Cleveland only

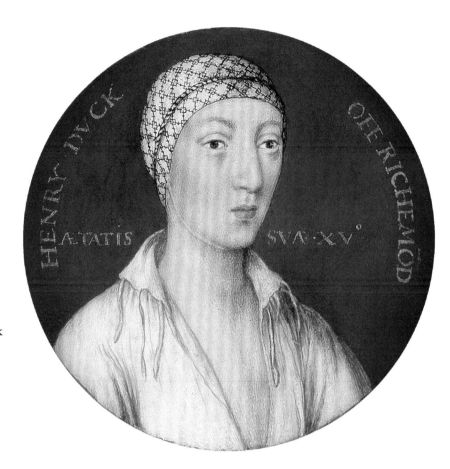

One of the earliest Tudor portrait miniatures, this likeness of Henry VIII's illegitimate son is also one of the most intimate. Here, the fifteen-year-old Henry Fitzroy, Duke of Richmond and Somerset, appears against a blue background, dressed in a nightcap and shift or undershirt. Like Lucas Horenbout's portrait of Richmond's father (see cat. 77), this likeness responded to the arrival at the English court of miniature portraits depicting members of the French royal family. Given Henry VIII's lack of a legitimate male heir, the portrait likely played a role in the king's attempt to shore up the status of his one surviving son, whom he considered promoting as his successor, even though he was born out of wedlock. Both the portrait of the king and that of Richmond, which are documented in the English royal collection beginning only in the seventeenth century, may originally have been dispatched to the French court in order to promote Henry's image abroad and the possibility of Richmond's succession.[1]

Henry Fitzroy was the king's son with his mistress Elizabeth Blount, who had been a maid of honor to Katherine of Aragon.[2] His father elevated him in early childhood to a double dukedom, and also appointed him Lord Admiral of England and a Knight of the Garter. Richmond received a chivalrous and humanist education, first under the guardianship of Cardinal Wolsey, and then of Thomas Howard, 3rd Duke of Norfolk. The latter's son, Henry Howard, Earl of Surrey, became Richmond's close

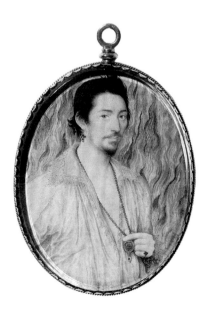

Fig. 66. Nicholas Hilliard (ca. 1547–1619), *An Unknown Man*, ca. 1600. Watercolor on vellum, laid on card, 2¾ × 2⅛ in. (6.9 × 5.4 cm). Victoria and Albert Museum, London (P.5-1917)

companion and would commemorate their friendship in the celebrated elegy "So Crewell Prison" (see cat. 98).[3] The two young men sojourned together at the French court in 1532–33, and on their return, Richmond married Surrey's sister, Lady Mary Howard. In 1536 he rapidly succumbed to tuberculosis, dying at the age of seventeen, little more than a year before the birth of a legitimate male heir to the throne, the future Edward VI.

Responding to the duke's striking state of undress in his only known likeness, past commentators have speculated that it "reflects the boy's failing health" or "physical frailty."[4] Yet Richmond's consumption appears to have come on rapidly, two years after the date of this portrait.[5] Instead, like later Elizabethan miniatures depicting male sitters with chests exposed (fig. 66), Richmond's portrayal may allude to the inherent intimacy of the miniature genre and its function within rites of love and courtship.[6] The nightclothes and bare, unblemished chest cast Richmond not as an invalid but, rather, a youthful bridegroom, whose marriage to Mary Howard took place at roughly the same time that Horenbout painted this portrait.[7] In his elegy for Richmond, Surrey recalled the "active games of nymblenes [nimbleness] and strengthe, / Where we dyd straine . . . / Our tender lymes [limbs] that yet shott upp in lengthe" (lines 22–24).[8] Just such an impression of a handsome knight on the brink of manhood characterizes this portrait. A E

Notes to this entry appear on p. 312.

51. Edward VI as a Child

Hans Holbein the Younger (1497/98–1543)
1538
Oil on panel, 22⅜ × 17⁵⁄₁₆ in. (56.8 × 44 cm)
National Gallery of Art, Washington, D.C. (1937.1.64)

Henry VIII's New Year's gift roll for the year 1539 records the presentation "By hanse holbyne [of] a table of the pictour of the p[ri]nce['s] grace," and the king's reciprocal gift to the painter of a gold cup and cover.[1] The portrait of the young Prince Edward inscribed in the gift roll is almost certainly this famous likeness of the king's long-awaited male heir. It is both a powerful statement of dynastic ambition and a testament to the importance of gift giving for self-advancement at the Tudor courts.

Artists made frequent gifts to their royal patrons throughout the Tudor period. In the same year that Holbein gave the prince's portrait to Henry VIII, his fellow artist Lucas Horenbout gave the king "a firescreen of blue worsted."[2] But Holbein's portrait

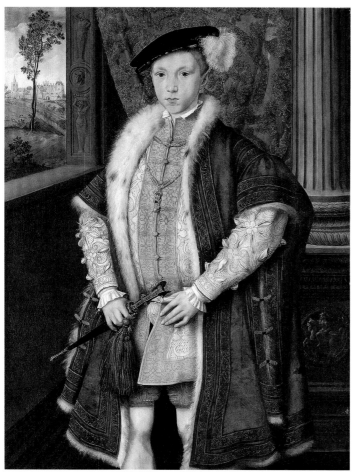

Fig. 67. Attributed to Guillim Scrots (active 1537–53), *Edward VI as Prince of Wales*, ca. 1546. Oil on panel, 42¼ × 32¼ in. (107.2 × 82 cm). The Royal Collection / HM Queen Elizabeth II (RCIN 404441)

was particularly astute as a bid for royal favor. By the time he made his New Year's gift, Holbein had already painted portraits of Edward's parents (cats. 9, 85). Like these portraits, his painting of the prince combines mimetic virtuosity with material costliness, incorporating real shell gold and silver leaf (now tarnished) into the infant prince's attire. The background, by contrast, would have been a bright blue created with the pigment smalt, long since discolored. In this it differs from the enduring ultramarine used in the background of Holbein's portrait of Henry VIII in Madrid (cat. 9).[3]

Rich clothes, a confident speechifying gesture, and a rattle that resembles a scepter make Edward into a miniature version of his father. The long Latin inscription on the *cartellino* occupying the foreground drives this theme home by exhorting the prince to "emulate thy father and be the heir of his virtue; the world contains nothing greater."[4] The *cartellino* identifies its author as the courtier Sir Richard Morison, one of a long line of humanists with whom Holbein collaborated in making his paintings. It is intriguing that Morison's name, but not Holbein's, appears on the panel. Morison was a royal propagandist and defender of Henry VIII's divorce; his collaboration with Holbein prompted Roy C. Strong to argue that the Holbein portraits were "one facet of the whole apparatus which was unloosed around the Crown in the 1530's to create an image potent enough to hold together a people in loyalty to the Crown in the face of a break with the ancient historic claims of a united Christendom."[5] The inscription's placement, lettering, and themes of patrilineal succession recall the even more prominent inscription on Holbein's lost Whitehall mural, painted one year earlier (see fig. 92).[6]

Holbein also depicted the prince in two drawings, one a portrait drawing, now at Windsor, related to the present painting, and the other a design for a badge or miniature.[7] Although preliminary to cat. 51, the Windsor drawing was not incised for direct transfer to the panel; instead it is a quick study made in advance of the final composition.[8] Edward's placement behind a parapet recalls a long tradition within devotional painting of setting a barrier between sacred figures and the viewer. In appropriating this device for Henry's heir, Holbein may have made a conscious reference to Henry's self-declared status as Supreme Head of the Church in England. Edward's emulation of his father was a consistent theme of his portraiture, even more apparent in later images where the frail adolescent dons padded clothing to pose with legs wide and arms akimbo (fig. 67). Unlike his half sisters, whose official images had to be improvised upon their accession, Edward was incorporated into Tudor artistic propaganda from the earliest years of his short life. A E

Notes to this entry appear on p. 312.

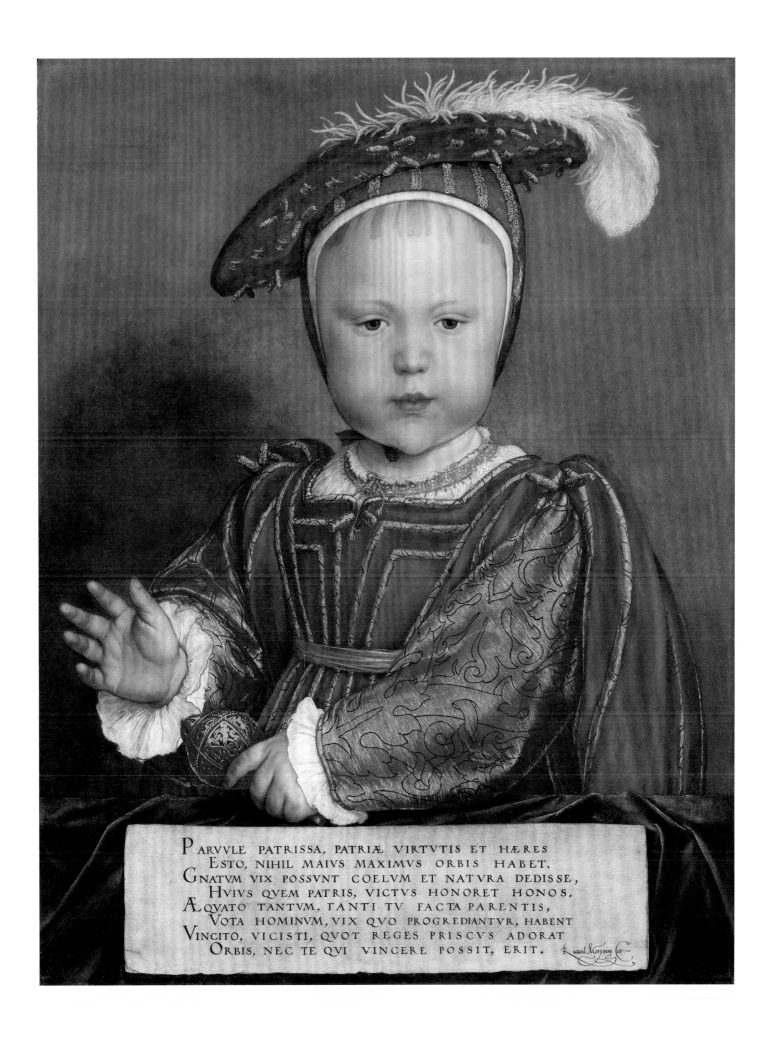

PARVVLE PATRISSA, PATRIÆ VIRTVTIS ET HÆRES
ESTO, NIHIL MAIVS MAXIMVS ORBIS HABET.
GNATVM VIX POSSVNT COELVM ET NATVRA DEDISSE,
HVIVS QVEM PATRIS, VICTVS HONORET HONOS.
ÆQVATO TANTVM, TANTI TV FACTA PARENTIS,
VOTA HOMINVM, VIX QVO PROGREDIANTVR, HABENT
VINCITO, VICISTI, QVOT REGES PRISCVS ADORAT
ORBIS, NEC TE QVI VINCERE POSSIT, ERIT. Ricard. Morysin. Car.

52. *The Triumph of Hercules, from a Seven-Piece Set of the Antiques*

Designed by Raphael (1483–1520), with Giovanni da Udine (1487–1564), Perino del Vaga (1501–1547), and Gianfrancesco Penni (ca. 1496–ca. 1528), ca. 1516–20; probably woven under the direction of Jan and Willem Dermoyen (active ca. 1528–49)

Brussels, before 1542

Wool (warp), wool, silk, silver, and gilded-silver metal-wrapped threads (wefts), 191¼ × 254 in. (486 × 645 cm)

The Royal Collection / HM Queen Elizabeth II (RCIN 1363)

Exhibited New York and Cleveland only

This tapestry, originally part of a set of seven, attests to the sophisticated Antique style of decoration that was appreciable on a truly monumental scale in Henry VIII's London. With his acquisition of this tapestry series in 1542, Henry set his artistic tastes on a par with those of the Medici pope Leo X. Observant mid-sixteenth-century visitors to Whitehall Palace and the Vatican would recognize the same distinctive designs on display. Combining contemporary Roman design with much-admired Brussels tapestry weaving, Henry once again proved himself to belong to the first rank of Europe's royal patrons.

The two surviving tapestries from Henry's set represent the *Triumph of Hercules* and *Triumph of Bacchus*, originally joined by five other hangings and described in 1542 as "hanginges of Arras of thistory of Antiques," and again in 1547 as "hanginges of arras wrought with antiques."[1] Scholars have long recognized these tapestries as a second edition of a documented but lost set made for Leo X, inventoried in the Vatican from 1536 to 1770 under the title the *Grotesques*.[2] Thanks to detailed Vatican inventories, as well as additional surviving sixteenth- and seventeenth-century re-editions of the tapestries, the complete series delivered to Leo can be reconstructed as depicting triumphant scenes of Venus, Apollo, Minerva, and Mars in addition to Hercules and Bacchus, accompanied by Faith among the Virtues and Grammar among the Liberal Arts. It is not known which of these eight subjects was dropped from Henry VIII's edition, nor why.

As tapestry scholar Lorraine Karafel has shown, Pope Leo X commissioned the tapestries with a specific site in mind, the Sala dei Pontefici in the Vatican. Their subject matter was conceived hand in glove with the room's painted ceiling, the whole playing on Leo's birth horoscope and presenting his papacy as a golden age.[3] Raphael designed the series, developing daringly unconventional compositions with grotesque foliage, beasts, and figures against bands of nearly blank color grounds. The motifs were conceived in response to the Roman paintings uncovered in the newly excavated Domus Aurea, with figure types borrowed from Roman sculpture.[4] The series came in quick succession to other Brussels tapestry commissions for the pope: the *Acts of the Apostles*, *Playing Children*, ceremonial bed hangings, and possibly the *Life of Christ*.[5] Though the design of the *Grotesques* is credited to Raphael, the Renaissance biographer Giorgio Vasari's assertion that Giovanni da Udine executed the cartoons is probably correct, with Raphael's workshop, including Giovanni da Udine, Perino del Vaga, and Gianfrancesco Penni, all contributing elements, probably during the cartoon-painting process.[6]

Despite the set's initial design being so personal to Leo X, it also spoke directly to Henry VIII: by prioritizing the *Triumph of Hercules*, Henry reiterated his desire to be perceived as a new Hercules, whose iconography he had already adopted in 1520 during his meeting with François I at the Field of the Cloth of Gold, where he arrived dressed as the classical hero. He repeated the gesture in the 1540s with the *Feats of Hercules* designs provided by Nicholas Bellin (see cat. 53) to decorate a courtyard at Nonsuch Palace.[7]

It was apparently an Antwerp-based Florentine merchant, Gian Battista Gualteroti, who recognized the appeal of the *Antiques* for Henry. He delivered the first two tapestries in the set in April 1542, perhaps as a sample; in June he was paid for all seven tapestries in the set, with the remaining five shipped to London in November.[8] Simultaneously, as part of the same arrangement, Gualteroti provided Henry with a (since lost) set of the *Acts of the Apostles*, also designed by Raphael for an initial commission by Pope Leo X for the Vatican. Henry paid more than £1,100 for each of these tapestry sets, making them among his most expensive tapestry acquisitions.[9] Alternatively, it is conceivable that Gualteroti was acting as an agent for the master weavers responsible for Henry's sets: the *Triumph of Hercules* includes a small portion of a weavers' mark, probably that of Jan and Willem Dermoyen. The Dermoyens had created on speculation and supplied rich tapestry sets to Holy Roman Emperor Charles V, Mary of Hungary, Hendrik III of Nassau, and François I, and they had undertaken an (ultimately failed) venture with Pieter Coecke van Aelst to persuade Suleiman the Magnificent to purchase tapestries.[10] They may have acquired the various Raphael tapestry cartoons from the estate of the dealer-entrepreneur Pieter van Aelst, who had overseen the weaving and delivery of all the original Raphael tapestry series, including the *Grotesques*, to Leo.[11] It is certainly likely that the Dermoyens also wove Henry's edition of the *Acts of the Apostles*, delivered at the same time by Gualteroti, having also just sold a set to François I.

Initially delivered to Whitehall, the *Antiques* tapestries were in the Tower at the time of Henry's death, in 1547. However impressive the monumental allegorical sets, like Henry VII's *Story of the Redemption of Man* (cat. 4), and the large narratives, like the *Story of David and Bathsheba* (cat. 42) and even Henry's

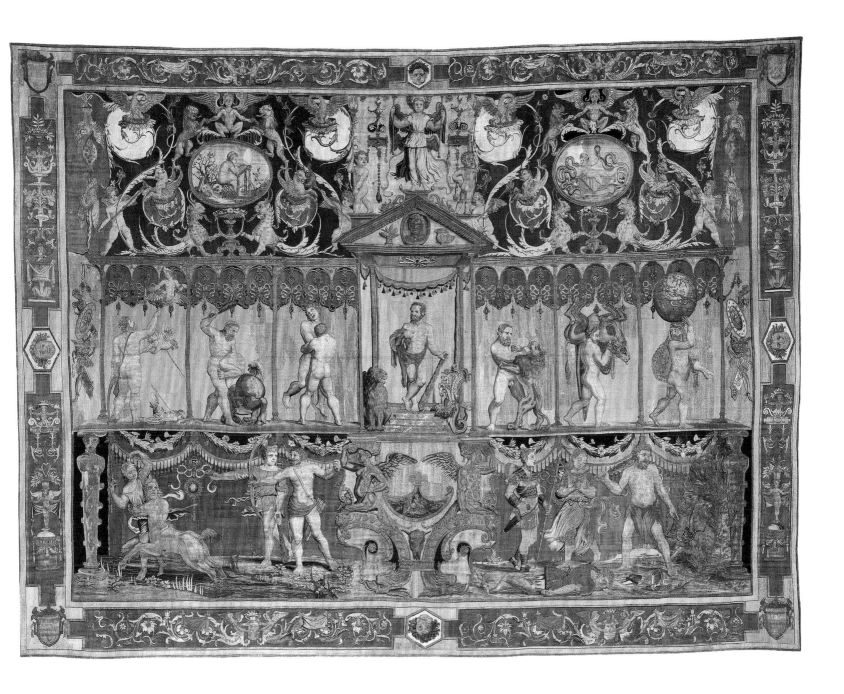

lost *Acts of the Apostles*, to experience Raphael's *Antiques* tapestries must have been stunning: their three-tiered compositions were quite unlike any tapestry design before them. A room enveloped with these tapestries would seem to hold a classical peristyle, peopled with nearly nude mythological gods and heroes and bracketed by the bold intensity of the solid blue and red grounds of attic and stylobate stories. The latter was illusionistically hung with curtains, while both were variously enlivened with centaurs, putti, hippalectryons, and other mythical hybrid creatures. **EC**

Notes to this entry appear on p. 312.

53. *Two Designs for an Interior at Whitehall*

Nicholas Bellin da Modena (ca. 1490–1569)
ca. 1545
Pen and brown ink, with gray wash and stylus, on beige paper, top:
3¹⁵⁄₁₆ × 7⅞ in. (10 × 20 cm); bottom: 8⅛ × 10⅞ in. (20.5 × 27.5 cm)
Cabinet des Dessins, Musée du Louvre, Paris (19215r; RF 31930)
Top: exhibited Cleveland only; bottom: exhibited New York only

This pair of drawings provides a tantalizing taste of the decorative stucco schemes envisioned, and perhaps executed, for Henry VIII's palaces during the last decade of his life. The Italian designer and decorator Nicholas Bellin da Modena had worked for François I before arriving in Henry's employ in 1538.[1] Contemporaries like Sir John Wallop noticed the connection between Bellin's work for the two kings, remarking on the similarity between the "all antique" decorations seen at Fontainebleau and "Your Majesties chemenyes" provided by Bellin.[2] The nude boys—some urinating, all clambering upon swags of fruit—in the smaller drawing would indeed work as well at Fontainebleau as they would at Whitehall. The accompanying, larger drawing has, however, been further developed, incorporating a lower register of plasterwork and with both sections containing conspicuous Tudor devices across the right side of the sheet.[3] Bolstering the impression that Bellin was customizing what might seem otherwise a somewhat generic, albeit exquisite, design, the Tudor devices—the arms of England; the Tudor rose; the Beaufort portcullis; the seal of the Order of the Garter—have been drawn with a firmer contour, and in some places over the existing lines of the composition. This is noticeable, for example, at the head of the swag-holding naked boy beside the portcullis. The design manages to be at once quirkily humorous and elegantly, languorously Antique, with its heroic nude male figures, crisp entablatures, and perfectly proportioned fluted columns. Unexpectedly comic touches are, for example, introduced by the two herms flanking the doorway, whose feet protrude "somewhat incongruously" beneath the bases of their piers,[4] and whose facial expressions betray some unease about the weight of the projecting portico pressing upon their heads, thoughtfully provided cushions notwithstanding.

Bellin was paid for work at Whitehall in 1540.[5] However, the inclusion of the maiden's head within the Tudor rose, which was Katherine Parr's device, dates the larger design to after Henry's marriage to Parr in July 1543. While depleted documentary evidence in the royal works' accounts has left a patchy record, it is known that Henry VIII completely reorganized his privy lodgings at Whitehall during the 1540s.[6] Very little survives, though one could envision Bellin's designs utilized in a transitional space such as the Privy Gallery within the royal suite of apartments. These works took place at a point when Henry's triumph completing the Dissolution of the Monasteries—his unquestioned authority, as well as his massively increased income and landholdings—began to wane, with his disastrous debasement of the coinage, begun in 1544, resulting from the crippling war debts of his final years. If Bellin's designs were executed, this marvelous space would have remained essentially unchanged during the tumultuous reigns of Edward and Mary, as works at Whitehall ceased between Henry's death in 1547 and Elizabeth's accession in 1558—a time capsule of Henrician confidence and Tudor swagger. EC

Notes to this entry appear on p. 312.

54. *The Apotheosis of Henry VIII*

Robert Pyte (active 1546–52)
1546
Pen and ink, with wash, on vellum, 26¾ × 17¾ in. (67.9 × 45.1 cm)
Victoria and Albert Museum, London (3337)
Exhibited New York and Cleveland only

Robert Pyte, an engraver at the Royal Mint, created this presentation drawing with great care and dexterity, in fine line enlivened with shadowy wash and on vellum rather than simple paper. In a gloriously fanciful arrangement, Henry VIII kneels in prayer in a shallow, curtained-off, niche-like space. He is exposed to the viewer by two angels who pull back the curtains while offering the king a crown and a book. Above him are exhortations to "WERE THE CROWN OF LYFE" and "EATE THE BOKE OF LYFE." Flanking, standing angels carry the orb and sword of just government, while kneeling figures—a cleric and a patrician, like donors in an altarpiece—pray either to the book-bearing female personifications of Faith and Hope in the niches or, indeed, to the king himself, made even more godlike by the dove in a nimbus just above his head. Repeating some of the heavy-handed iconography of the frontispiece to Henry's authorized Great Bible (cat. 21), inscriptions in English paraphrase Miles Coverdale's biblical translations in flattering allusion to the king's role in transforming the devotional life of his people. Among others, these read: "I IHS [JESUS] SENT MYNE ANGELL TO TESTYFY UNTO YOU THESE THYNGS FO[R] THE CONGREGATIONS. I AM THE ROTE [ROOT] AND GENERACON OF DAVYD" (REV. 22:16); and "RECEVE YE THE WATER OF LYFE Y COMYTH FROME THE SEATE OF GOD AND WYTH THE LEVIS OF THE WOOD OF LYFE HEALE OWR PEOPLE FOR THE LORD COMYTH SHORTLY" (Rev. 22:1–2).

The setting resembles a triple-height arcade, clearly unbuildable but suitably grandiose for such a grandiloquent vision. The copious use of classical architectural vocabulary suggests Pyte's familiarity with architectural treatises, confirmed by the third story's identifiable roots in an illustration in Book IV of Sebastiano Serlio's architectural treatise—which probably reached Pyte by way of Pieter Coecke van Aelst's best-selling (if pirated) translations of 1540, 1542, and 1543.[1] (Intriguingly, Pyte was inspired not by one of Serlio's facades but by a design for a chimneypiece.) Pyte was perhaps also emulating temporary triumphal arches he must have seen during pageants or joyous entries, although it is worth noting that all printed records of such ephemeral constructions (such as Coecke's seminal *Triomphe d'Anvers*) postdate Pyte's drawing.[2] The unusual stacked design with its dynamic kneeling angels has points in common with ornate wall-tomb monuments like those by Jacopo Sansovino in Florence and Rome (see cats. 16, 17). This has prompted the intriguing suggestion that Pyte might also have looked for inspiration to Baccio Bandinelli's lost model for a tomb for Henry VIII, sent from Florence to London by Pope Leo X under the cost and care of the merchants Pierfrancesco di Piero Bardi and Giovanni Cavalcanti.[3]

The drawing is signed and dated by Pyte, whose status as an ambitious engraver at the Royal Mint might hold the key to its context.[4] The year he made this work, Pyte was promoted to the post of deputy engraver, and by 1550 would become chief engraver. Whether at royal command or perhaps on his own initiative, it is possible this design is the presentation copy made for Henry himself for a proposed project of monumental proportions, consciously emulating Holy Roman Emperor Maximilian I's extraordinary *Arch of Honor* (fig. 68). Maximilian's *Arch*, conceived by Albrecht Dürer and executed by a team of artists, was composed of 36 sheets of large folio paper, printed with roughly 195 woodblocks; the first printing likely created 20 complete sets of the *Arch*.[5] Maximilian was motivated strongly by the desire to control this huge, but reproducible, memorial of his achievements and to promote his fame after his death. It is not inconceivable that Henry VIII, with his own mortality and commemoration in mind, doubtless aware of this mammoth undertaking by his older Habsburg counterpart, was entertaining the idea of his own massive, engraved *Arch of Honor*, which would have been undertaken under the purview of the engravers of the Royal Mint. Unfortunately for Henry, his death in January 1547 apparently came too soon for such a project to get underway. Neither Edward, nor Mary, nor Elizabeth executed Pyte's extraordinary vision of their father's apotheosis. EC

Notes to this entry appear on p. 312.

Fig. 68. Designed by Albrecht Dürer (1471–1528), *Arch of Honor of Maximilian I*, 1515 (1799 edition). Woodcut and etching on laid paper, 139⅜ × 117½ in. (354 × 298.5 cm). National Gallery of Art, Washington, D.C. (1991.200.1)

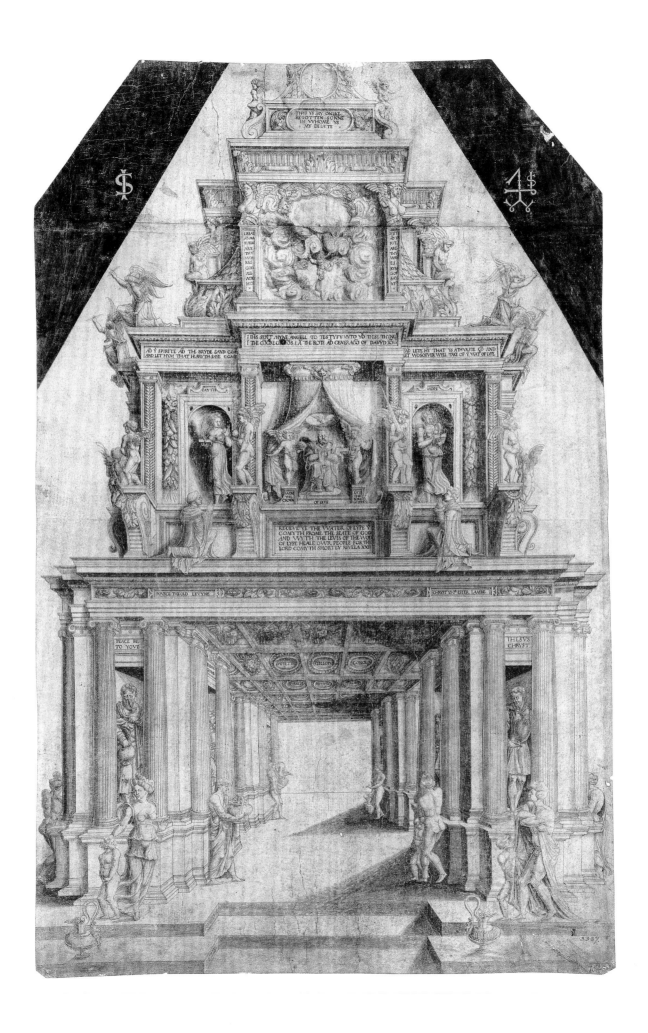

THYS YS MY ONLYE
BEGOTTEN SONNE
IN WHOME YS
MY DELAYTE

I IHS SENT MYNE ANGELL TO TESTYFY VNTO YOW THESE THYNGS
I AM THE OGRE & IOS I AM THE ROTE AND GENERACO OF DAVYD IO

AND Y SPIRITE AND THE BRYDE SAYD COME
AND LET HYM THAT HEARYTH SAYE COME

AND LETE HY THAT YS ATHYRSTE CO AND
LET WOSOEVER WYLL TAKE OF Y WAT OF LYFE

FAYTH HOPE

RECEYVE YE THE WATER OF LYFE Y
COMYTH FROME THE SEATE OF GOD
AND VVYTH THE LEVIS OF THE WOD
OF LYFE HEALE OWR PEOPLE FOR THE
LORD COMYTH SHORTLY REVELA XXII

PORGE THE OLD LEVYNE GHOST YS O ESTER LAMBE

PEACE BE THESVS
TO YOVE CHRYST

55. The First and Chief Groundes of Architecture Used in All the Auncient and Famous Monymentes . . .

Written by John Shute (d. 1563); printed by Thomas Marshe (active 1554–87)
London, 1563
Avery Library, Columbia University, New York (AA2812 Sh91)
Exhibited New York only

In 1550 John Dudley, Duke of Northumberland, sent the painter-stainer John Shute to Italy to "confer with . . . skilful maisters in architectur, & also to view such auncient Monumentes."[1] Shute dutifully produced drawings of the buildings, ruins, paintings, and sculptures he there encountered and, upon returning, shared his work with King Edward VI, "whose delectation and pleasure was to se[e] it, and suche like."[2] However, when Northumberland was convicted and executed for high treason in 1553, the project fell dormant. Possibly conceived as the first of a series, this book was not published until 1563, the same year that Shute died.[3]

The First and Chief Groundes of Architecture is the first English-language architectural treatise.[4] Building off the ancient Roman antecedents laid out by Vitruvius, as well as the nearly contemporary work of Sebastiano Serlio and Guillaume Philander, Shute's treatise introduced the basics of classical architecture to an English audience. It was also a pioneering intellectual defense of architecture as a highly skilled, mathematical art, and of the architect as a specialist practitioner.[5] Shute called himself an "architect" (though there is no evidence he designed buildings) and insisted on his own knowledge, referencing his predecessors and his understanding of "latin and Italian . . . french and dowche [Dutch] writers."[6]

Shute structured his treatise around the five established orders—Tuscan, Doric, Ionic, Corinthian, and Composite—as well as the Attic. Its typeface replicates clear humanist italic script and accompanies elaborate foldout engravings that Shute designed and may have executed himself.[7] Each foldout features a structure supported by three columns, including the discussed pillar and a typecast caryatid.[8] Shute detailed his caryatids with lively embellished sandals, lengths of cloth, strapwork-like metallic accessories, and defined muscles that reflected the mythological associations of the orders. Corynthia, for example, is a "mayden . . . garnished beatifuly," in allusion to the vestal (or "some lyke") virgins.[9] The caryatids' dynamic balance suggests Shute's admiration for Vitruvius, who had outlined the importance of proportion in *De architectura*.[10]

Despite additional print runs in 1579, 1584, and 1587, *The First and Chief Groundes of Architecture* does not appear to have served as a touchstone reference for Elizabethan builders.[11] Scholars

Cat. 55, title page

have variously seen Shute's influence in Kimbolton Castle, Kirby Hall, Longleat House, and Middle Temple Hall, but his primary contribution seems to have been intellectual, satisfying interest in and reverence for Italian style among the English middle and noble classes.[12] Fashionable classical and Italianate vocabularies rhymed with humanist ideology, implying knowledge of figures such as Plato, Cicero, and Baldassare Castiglione.[13]

Shute emphasized this parallel between civic and visual order in his ingratiating dedication to Queen Elizabeth I, claiming that he wrote "in a publike weale [well-being]" and "for the profit of others" by presenting his "poore and simple laboures."[14] His epitaph also acknowledged that fame was best won by those who took "care for Common-weale, / as here Iohn Shute hath done."[15] As Shute elucidated an architectural style for "nobility of public service," he participated in a language that would last for centuries.[16] Indeed, English translations of the continental texts he cited appeared throughout the seventeenth century; in 1611 Serjeant-Painter Robert Peake issued the first English translation of Serlio, dedicated to the Prince of Wales (cat. 123).[17] SB

Notes to this entry appear on pp. 312–13.

Cat. 55, foldout

¶ COMPOSITA OR ITALICA THE TRYMPHANT
pillor deuised by the Romanes and fetcheth his compoundes out
of all the other before rehersed and written.

His pillor named Composita shalbe 10. Diameters in height, the which Dyameters are drawen ouertwart the pillor, whereof the Capitall, is a wholle Diameter in height, and Spira or Base is halfe a Diameter in height. Now as concerning ỹ measures of the Pedestal, the bredth of the square stone which is the body of the Pedestall shalbe doubled in the height, whiche Philander nameth the quadrante of the double proportiō which is marked with A whose height shalbe deuided into 8. partes one suche part ye shall adde to the height of his Coronix, marked with B asmuche you shall adde vnto his Base marked with C the other measures they in belonging shalbe as before is rehersed in the Corinthia, but in this Base is added Cymatium which lieth betwene Astragalus, & the square of the pedestall. Also Coronix is to be made as before is rehersed in Corinthia but that in this, they haue added Denticulos, the which lie betwene Cymatium and Echinus through the which it mounteth to a forther Proiecture, the which the Romaynes haue done for the more pleasure of the eye. As touchinge the bodye of the Pedestall they haue garnished it beautifully after diuers sortes as by these finished figures, ye maye perceiue. Nowe as the other Pedestalles before mencioned, were parted and deuided into so many partes as the pillors were Diameters in height, so is this Pedestall 10. partes in height of the which, the Base occupieth the lowest part, which is marked with C. Also ỹ double square occupieth eight partes to his height, & the tenth part is admitted to Coronix, marked with B.

BASIS or SPIRA.

Right and directly vpon the middell of the Pedestall shalbe set Spira or the Base of the pillor marked with D. whose height shalbe a Modulus or halfe the thicknes of the pillor, ỹ which height ye shal deuid into 6. partes gene one part vnto Torus aboue marked with E. ỹ other 5. partes shalbe deuided into 2. partes gene one part vnto Plunthus marked with F. the other 2. partes you shall deuide into 12. partes wherof ye shal gene 5. partes vnto Torus the lower marked with G. geue also 2. partes to the two Astragali with their Rule whose marke is, H. the which edge or regula, is in height ỹ one half of 1. Astragales, geue also 1. part e vnto that, which is marked with I some name it Echinus, but the garnishing therof is not like Echinus, which lieth vnder the higher Torus whose edge shalbe half a part. So that the highest Torus & Scotia marked with K (the which ỹ grekes call Trochelion) be very nigh of one height. The Proiectures of this Base are as before is rehersed in Corinthia.

SCAPVS.

The body of ỹ pillor shalbe 8. ⅓ Diameters in height ỹ which are drawen ouertwart the pillor. Now as touching the diminishing of the pillor aboue ye shall begin thus vppon the third Diameter there ye shal trie the middle of the pillor vnder the Capital. Then deuid the thicknes of your pillor into 6. partes that is 3. on eche side of ỹ middle of the pillor and ye shall sette 5. suche partes for the thicknes of the pillor vnder the Capitall,
 which

E.ij.

56. *New Year's Gift Roll of Elizabeth I, Queen of England*

England, 1585
Ink on vellum, 130¾ × 15¾ in. (332 × 40 cm)
Folger Shakespeare Library, Washington, D.C. (Z.d.16)
Exhibited New York only

57. *New Year's Gift Roll of Elizabeth I, Queen of England*

England, 1564
Ink on vellum, 92⅛ × 16⅛ in. (234 × 41 cm)
Folger Shakespeare Library, Washington, D.C. (Z.d.12)
Exhibited Cleveland only

Important as both bureaucratic and symbolic documents, Tudor gift rolls recorded the ritual exchange of gifts between monarchs and subjects at the New Year. As discussed elsewhere in this volume (pp. 110–13), gift giving was a major cultural practice at the Tudor courts, an expression of fealty and favor that spurred much of the artistic ingenuity of the age. Gift rolls documented these exchanges on vast sheets of costly vellum (a practice adopted during the reign of Edward VI), making the rolls themselves monumental scribal testaments to royal power and prestige. Such rolls "clearly demonstrate that the exchange of gifts was an important social, political and religious activity in sixteenth-century England, resonant with the nuances of rank, reciprocity, obligation and cost."[1]

Cat. 56

Cat. 57

Detail of cat. 57, showing Queen Elizabeth I's official signature

Twenty-four gift rolls survive from the reign of Elizabeth I, recording some 1,200 gift givers and more than 4,400 gifts received by the queen.[2] As a form of authentication, the rolls feature the queen's sign manual, or official signature (detail). Many feet in length, these rolls list gift givers according to their social rank, proceeding from duchesses and bishops to gentlemen and artisans. On their versos these rolls also document Elizabeth's munificence, as she reciprocated with her own gifts of gilded plate, according to a hierarchical scale, and cash rewards for the messengers who delivered the gifts to her. Courtiers might give cash to the queen as well, but were often more creative, seeking out the advice of her bedchamber women to commission garments or jewels according to the latest fashions.[3] Gift rolls serve as important evidence for items of clothing whose survival is fragmentary today.[4]

The rolls exhibited here, from the exchanges of 1564 and 1585, document a wide variety of gifts. They include elaborate and luxurious garments, such as the "Mantyll of Tawny Satten enbrawdred with aborder [sic] of venice golde and Siluer lyned with white Taphata / and faced with white Satten" that Elizabeth received from Bess of Hardwick, Countess of Shrewsbury (see cat. 118).[5] In return, the countess received, like others of her rank, "a guilte bole withe a couer," by the goldsmith Robert Brandon.[6] But the rolls also document more humble gifts, such as the eighteen "larkes in a Cage" that a certain Morrys Watkins delivered to Elizabeth's Chief Gentlewoman, Blanche Parry.[7] Watkins received twenty shillings in return, another link in the chain of transactions that knit together the different echelons of Tudor society.[8] AE

Notes to this entry appear on p. 313.

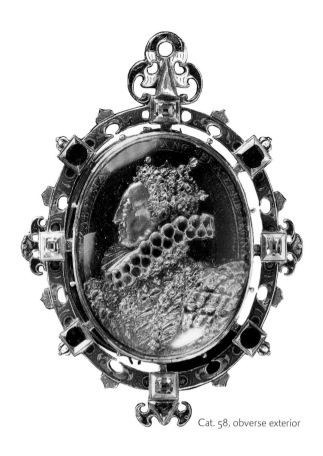

Cat. 58, obverse exterior

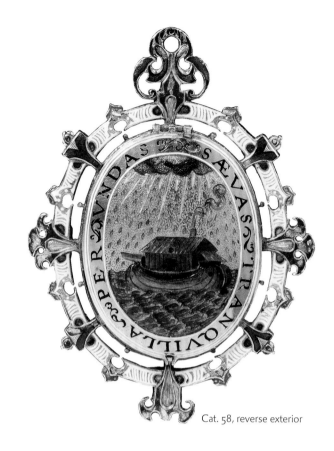

Cat. 58, reverse exterior

58. *The Heneage Jewel*

Nicholas Hilliard (ca. 1547–1619) and workshop
ca. 1595–1600
Enameled gold, table-cut diamonds, Burmese rubies, rock crystal,
and a miniature, 2¾ × 2 in. (7 × 5.1 cm)
Victoria and Albert Museum, London (M.81-1935)

Among the most complex of surviving Tudor artifacts, the Heneage Jewel reveals the interplay between painting and the goldsmith's art at the Elizabethan court. Within the medium of a locket, it juxtaposes two very different images of Elizabeth I, as well as iconographic emblems glorifying her reign. Intended to be worn on the body or examined in the hand, such a jeweled portrait locket was both a private artwork, destined for a limited and elite audience, and a public declaration of loyalty and favor.

The locket's obverse exterior features a profile portrait of the queen cast in gold within an enameled frame embellished with table-cut diamonds and Burmese rubies.[1] In its use of the rigid profile, this portrait resembles the queen's medals and cameos (see, for example, cat. 115). The reverse exterior features an image of Noah's ark sailing on tempestuous seas, encircled by the inscription "SAEVAS. TRANQUILLA. PER. VNDAS" (Tranquil through fierce waves). This lid opens to reveal Nicholas Hilliard's painted portrait of the queen, depicted facing forward as an ideal, ageless beauty. The interior of the lid has an enameled red

Tudor rose and the inscription, in Latin, "Alas, that so much virtue suffused with beauty should not last forever inviolate."

The exterior of the locket emphasizes Elizabeth's majesty and constancy, while the interior conveys her mortal charms. As Patricia Fumerton aptly noted, "the queen outside provides the passage to the lady within. The outer representation of the queen also protects and hides the inner lady, just as the many antechambers to the royal bedroom did not simply offer access to Elizabeth but also defended and concealed her."[2] In this reading the process of handling, examining, and opening the Heneage Jewel duplicates the courtier's sequential approach to the queen's Privy Chamber.

By family tradition the Heneage Jewel was a gift from the queen, marking the defeat of the Spanish Armada, to her favorite Sir Thomas Heneage, who served, along with his wife, Anne, in the Privy Chamber.[3] However, the style of the miniature indicates that it was made well after the Armada victory.[4] Catharine MacLeod, moreover, has recently noted the lack of surviving evidence that Elizabeth gave such jewels to her courtiers, arguing that, "given her parsimonious ways and patterns of gift-giving, it seems likely that, even if she gave a miniature herself, the case would have been commissioned by the recipient to house the miniature in a sufficiently magnificent and flattering way."[5] Indeed, Heneage's will gave instructions that a jewel be made for

the queen.[6] Nevertheless, surviving correspondence reveals that the queen did give Heneage at least one jewel in return for his own gifts to her. During an absence from court in the summer of 1583, Heneage had his retainer William Poyntz present a jewel, perhaps an earring, to the queen. Poyntz reported to Heneage as follows:

> I delivered . . . your token to her Majesty . . . and received this answer from her: [that] her highness esteemed much of the jewel . . . but she esteemed much more of the good will of him that sent it, for whose sake she would wear it till his return. . . . And besides that, for so gently remembering of her she sent you ten thousand millions thanks and will send you a token again before your return, which she prayeth may be soon, as she misseth you already.[7]

A subsequent letter from Poyntz to Lady Heneage described the "token" the queen sent to her favorite in return for his gift:

> It was a butterfly of mother of pearl as I take it, with this message, that her Excellency knowing that [Heneage] was far in the cold north country where no [butter]flies were, did send him that butterfly to play with, that he might always remember her that sent it, and she herself did and would wear the bodkin and pendant that he sent her on the ear that should hear nothing that should hurt him.[8]

These exchanges, with their playful, even flirtatious language, reveal the intimacy of such gifts that were, after all, intended to be worn on the body. Indeed, "the exchange of jewels between Sir Thomas Heneage and the queen was not an exchange of mere trifles, but an exchange of pledges of fidelity to each other."[9] A E

Notes to this entry appear on p. 313.

59. *Octonaries upon the Vanitie and Inconstancie of the World*

Written by Antoine de la Roche Chandieu (1534–1591); transcribed and with miniatures by Esther Inglis (1570/71–1624)
Edinburgh, ca. 1600
Ink and watercolor, 3¾ × 2⁷/₁₆ in. (9.4 × 6.2 cm)
Folger Shakespeare Library, Washington, D.C. (V.a.91)

A female artist, the child of religious refugees, and a skilled negotiator of courtly patronage, Esther Inglis is one of the most intriguing artistic figures of the late Elizabethan age. Operating at the margins of courtly society, she created a large body of work in the form of roughly sixty gift manuscripts—composite works of calligraphy, drawing, and embroidery—with which she cultivated royal favor.

Inglis was born in London but raised in Edinburgh, the daughter of French Huguenot refugees.[1] Her father was a schoolmaster and her mother a noted calligrapher. About 1596 she married a Scottish rector, Bartholomew Kello, whose preferment she advocated through her royal patrons. The dedications that Inglis included with her manuscripts reveal her lifelong cultivation of elite Protestant circles and give a sense of how she defined her own artistic project. In a manuscript intended as a New Year's gift to Elizabeth I in 1591, Inglis termed her work "a portrait of the Christian Religion, that I have drawn with the pen, which I send to your Majesty to honor the small knowledge that God has given me in the art of writing and portraying."[2] By taking printed devotional texts and turning them into works of calligraphic art, Inglis gave them a status akin to "miniature portraits and emblematic jewels, as tiny treasures to be kept in the possessor's inner sanctum."[3] As one commentator has noted,

Fig. 69. Fols. 1v–2r of cat. 59, with self-portrait of Esther Inglis

Inglis "assumed in her audience the skills to appreciate a gift that was a conscious archaism: illuminated manuscript in the age of the black-and-white printed book."[4]

Unlike most of Inglis's manuscripts, the example displayed here does not include a dedication to a well-placed recipient. The frontispiece is dated to 1600, but the next page contains

Fig. 70. Unknown artist, *Esther Inglis*, 1595. Oil on panel, 29⅜ × 24⅞ in. (74.6 × 63.2 cm). Scottish National Portrait Gallery, National Galleries of Scotland, Edinburgh (PG 3556)

a self-portrait dated to 1624 (fig. 69); this indicates that Inglis held on to the manuscript and "may have used it as her master copy for the English translation" of Antoine de la Roche Chandieu's *Octonaires sur la vanité et inconstance du monde* (1586), a devotional text Inglis returned to in other manuscripts.[5] Demonstrating her command of roman and italic hands, Inglis copied out the French originals and their English translations on facing pages, ornamented with floral specimens that recall contemporary embroidery. This manuscript has its original tooled calf binding, unlike the elaborately embroidered bindings Inglis created for her most august recipients. The self-portrait was pasted into the manuscript, perhaps as a form of updating; like many of Inglis's self-portraits, it emulates the printed portrait of the French Calvinist writer Georgette de Montenay.[6] But it also recalls a panel portrait of Inglis, painted about the time of her marriage, in which she holds a small book, likely one of her own creations (fig. 70).[7] The artist of this portrait is unknown, but it is possible that Inglis, with her variety of artistic accomplishments, may have painted it herself.

The frontispiece of cat. 59, with a decorative border of flowers, butterflies, and a bird perched on a branch, connects it back to earlier Flemish manuscript illumination, a tradition with noted female practitioners, particularly at the Tudor courts. Although their work is difficult to reconstruct today, Susanna Horenbout and Levina Teerlinc established a precedent for women to use artistic accomplishment to curry royal favor at the courts of Henry VIII and his children.[8] With her multiple artistic talents and commitment to the Protestant cause, Inglis carried this tradition forward into the Stuart age. A E

Notes to this entry appear on p. 313.

Cat. 60

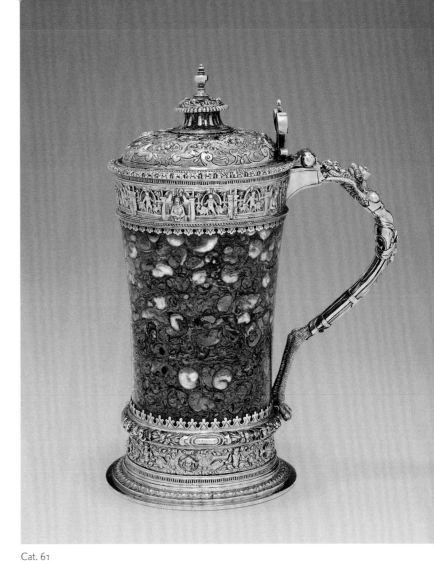

Cat. 61

60. *Cup and Cover*

Cup: China, Ming dynasty (Jia Jing period), ca. 1507–66
Mounts: attributed to Affabel Partridge (active ca. 1551–80), London, ca. 1570
Porcelain, gilded silver, 7½ × 5¼ × 5¼ in. (19 × 13 × 13 cm)
The Metropolitan Museum of Art, New York, Gift of Irwin Untermyer, 1968 (68.141.125a, b)

61. *Tankard*

Attributed to Affabel Partridge (active ca. 1551–80)
London, ca. 1575
Marble, gilded silver, fishskin case, 9½ × 6½ × 4¼ in. (24 × 16.5 × 11 cm)
Private collection

The goldsmith with the mark of the bird has been celebrated as one of the most talented working in Elizabethan London. In addition to these two pieces and the Hanse ewer (cat. 41), his mark—a bird in a shaped shield—also appears on a splendid nautilus cup in the Victoria and Albert Museum, London, and a standing salt in the Royal Collection.[1] It has often been proposed that this mark might be that of the documented

master goldsmith Affabel Partridge.[2] Archival accounts attest to Partridge's association with the royal Jewel House, such as the time in 1558 when, together with another royal goldsmith named Robert Brandon, he executed a substantial order for the queen, being paid more than £1,000 for 3,098 ounces of gilded-silver plate, which was given out by Elizabeth as New Year's gifts.[3] Two years later, in 1560, Partridge and Brandon were issued with 4,000 ounces of silver plate, "so olde, broken and unservisable as the same is unmete to remayne in any service," to be melted down "the better to furnysh our service towching newyeris [New Year's] guifts and plate to be provided and new made for rewards to be gevon to Ambassatours and other."[4] His work for the court continued into the following decade, when he supplied Queen Elizabeth with three gilded-silver standing salts "of the French making."[5] Partridge's connections with the Tudors apparently preceded Elizabeth: it was he to whom certain jewels, retrieved from the Tower, were delivered, by order of Queen Mary, in 1554, and it has been suggested that he might have been the "Master Partridge" in whose home Lady Jane Grey was lodged during

her confinement to the Tower shortly before her execution (see "England, Europe, and the World: Art as Policy" in this volume).[6]

Any Chinese porcelain reaching sixteenth-century England was much more highly valued than the sum of its raw materials, as discussed further in cat. 62. In this instance, the porcelain bowl of cat. 60 is particularly fine, and rather older than other known examples reaching the British Isles at this date. Its dark red exterior would originally have been complemented by fine golden paintwork on its surface, since, unfortunately, all but erased. This rich effect, called *kinrande*, was created by the Chinese primarily to meet Japanese demand. The interior of the bowl, in striking contrast, is white porcelain with a delicate blue central motif. The perfect simplicity of the mounts complements the bowl, their only embellishment being the stem's dentiled frieze and foliate ring and the egg-and-dart detailing of the foot, echoed by the cover's overhanging egg-and-dart rim. Capturing the goldsmith's skill, the fine handle of the cover is composed of a head-to-tail coiled serpent. The absence of any quality-control silver assay marks reveals that the cup was not made for sale on the open market; the patron might even have supplied before-hand the quantity of silver required. It is possible that the goldsmith—likely Partridge—was working for a certain Mr. Lychfelde, who in the autumn of 1588 gave to Queen Elizabeth "one Cup of Pursseline thonesyde [the one side] paynted Red the foute and Cover sylver guilt."[7]

Proving that he could amend his style to meet the demands of his material, the same goldsmith complemented the richly varied appearance of Purbeck marble—actually a fossiliferous limestone—in cat. 61 with a profusion of textured and figurative gilded silver. Just as Chinese porcelain vessels were prized display objects to be mounted with silver, the beauty of natural substances likewise prompted their precious-metal embellishment. Nautilus shells, coconuts, ostrich eggs, and mother-of-pearl (see cat. 63) all embodied the exoticism of distant continents, but even a local material like Purbeck "marble," quarried in Dorset, merited elevation and was proudly displayed on credenzas. In a conventional conceit of the period, the mounts give this vessel the characteristics of a functioning object—the handle and hinged lid of a tankard—although, in reality, it would never have been intended for use. The naked herm of the handle antici-pates those of the so-called Burghley mounted porcelains of the following decade (cat. 62), here unexpectedly terminating as a dog's bent leg and paw. The friezes at brim and foot, peopled with nude anamorphic figures in strapwork settings (detail), meet perfectly the period's decorative taste, recalling the *Fantastic Chariots* prints of Cornelis Floris the Younger, also recognizable as grotesque tapestry borders of this date.[8]

Cat. 61, detail

Likewise unmarked by the assay process, this tankard was likely commissioned from the bird master—again, probably Affabel Partridge—by a member of the Dutton family, among the new landed gentry enriched by Tudor policy. Thomas Dutton, a great-grandson of Sir Piers Dutton, had made his fortune as Henry VIII's Surveyor of Monastic Lands in Gloucestershire, marrying the daughter of an alderman of London and, in 1551, pur-chasing the former Winchcombe Abbey as the site of the family seat, Sherborne House, where he hosted Queen Elizabeth during her progress of 1574.[9] Alternatively, the tankard may have reached

the Duttons via Thomas's son, William, who had increased the family's wealth with his marriage to the daughter of Sir Nicholas Ambrose, Lord Mayor of London, and vastly enlarged the family's footprint with land acquisitions. He likewise maintained the Duttons' standing at court by hosting Elizabeth a second time, for almost a full week, during her 1592 progress. As such, the tankard is compelling evidence of the wealth, and pride, of the Tudors' nascent gentry; remaining with the Dutton heirs until the early twenty-first century, it is known as the Sherborne Tankard. EC

Notes to this entry appear on p. 313.

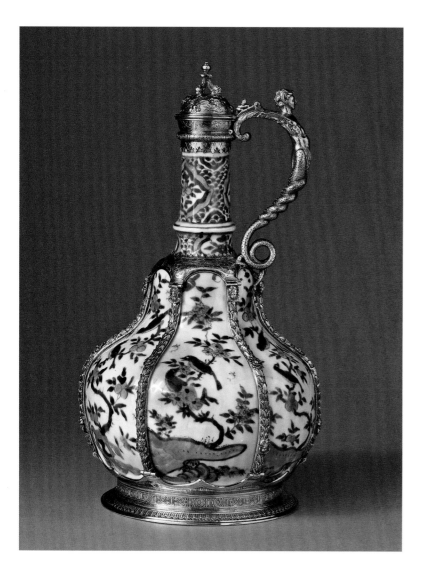

achieve, Chinese porcelain—called "chinaware"—was believed to hold magical properties. Various gloriously improbable rumors circulated about its production process, which was largely held by Europeans to be a natural wonder, achieved by burying shells.[1] Already in 1498 Giovanni Pontano, at the court of Naples, waxed lyrical on the appeal of rarity and of variety in color, texture, and shape in precious-metal credenza displays, stressing that there should be "cups . . . of various types. Some should be in gold, silver and porcelain; and they should be of different forms."[2] For Pontano, chinaware merited being highly valued over and above the price of its raw materials, because "occasionally the excellence of the gift is not judged so much by its cost, as by its beauty, its rarity and its elegance."[3] Some noteworthy examples of chinaware appear in Queen Elizabeth's inventories (see cat. 60). In or before March 1588, she received, for example, two pieces: one "Porrynger of white Purselyn garnisshid with golde the Cover of golde with A Lyon one the Toppe thereof [porringer of white porcelain garnished with gold, the cover of gold with a lion on the top thereof]," and one "Cup of Grenne Pursselynne the Foute Shanke and Cover Sylver gylte Chased Lyke Droppes [cup of green porcelain, the foot, stem, and cover gilded silver chased like drops]."[4] The former was given to the queen by William Cecil, 1st Baron Burghley, her Secretary of State and Lord High Treasurer; the latter, by his son Robert, who would eventually succeed his father in these positions and be named 1st Earl of Salisbury by James I.

Perhaps not coincidentally, this ewer and bowl are part of a group of five pieces of mounted blue-and-white Wan Li porcelain with a shared provenance stretching back to the Cecils, all of which have gilded-silver mounts of the same design, and four of which bear the maker's mark of three trefoils slipped in a shaped shield.[5] They are traditionally ascribed to William, but it is perhaps more likely that their association with the Cecil family dates to Robert, who was bequeathed "one suite of Porcellane sett in silver and gylt" by the explorer, adventurer, and queen's favorite Sir Walter Raleigh following Raleigh's death in 1618.[6] In 1629 an unusually large group of "China dishes" "bound with silver and gilte" was inventoried at Hatfield.[7] Although Europeans tended to enthuse about any and all Chinese porcelain, it should be noted that the Burghley pieces represent a gamut of quality and design. This two-handled bowl, for example, is an extraordinarily important work: bearing the phoenix in its design, it must originally have been made for Chinese imperial use, and it remains perplexing to envision how such a fine piece, intended for the emperor's court, instead left China, mixed together with a group of less noteworthy porcelain. The ewer, conversely, appearing as a tall, narrow-necked vase without its English mounts, was clearly specifically produced for the export market, adopting as it does a standard Persian form.[8]

62. Ewer and Two-Handled Bowl

Ewer and bowl: China, Ming dynasty (Wan Li period), ca. 1573–85
Mounts: London, ca. 1585
Porcelain, gilded silver, ewer: H. 13⅝ in. (34.6 cm); bowl: H. 4⅞ in. (12.5 cm), Diam. 9 in. (22.9 cm)
The Metropolitan Museum of Art, New York, Rogers Fund, 1944 (44.14.2, .3)
Exhibited New York and Cleveland only

For a period lasting only four decades, from about 1560 until about 1600, Chinese porcelain was considered so desirable, but remained so rare, that when examples did make it to London, they were treated as the most precious of objects. Like those fashioned from prized rock crystal, agate, or other natural wonders, porcelain vessels like these two were embellished by London goldsmiths with custom-made gilded-silver mounts.

With its perfectly flawless surface, crisp, pure white coloration, and glossy finish quite unlike anything European potters could

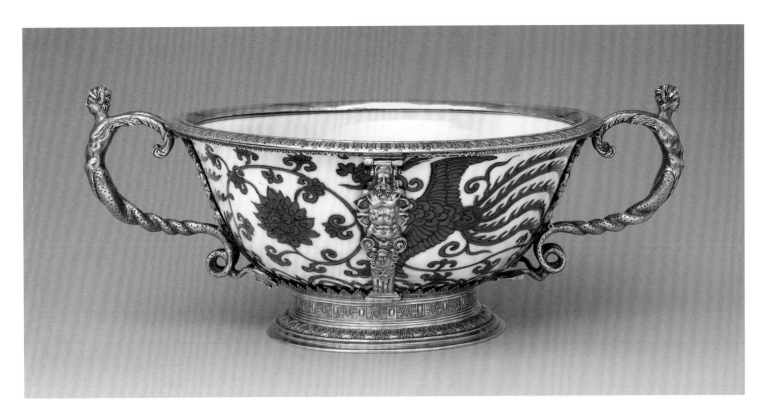

With one or two exceptions, it was only after the Portuguese annexed Macao and expanded trade with China in 1557 that porcelain started to arrive in England in any numbers. Of the surviving examples bearing silver mounts, four of the Burghley pieces, as well as a ewer in the Victoria and Albert Museum, bear the same maker's mark.[9] It is possible that the as yet unidentified goldsmith with the three-trefoil mark specialized in this material. He seems to have been a freeman of the London Goldsmiths' Company; even though the Burghley pieces, including those shown here, seem not to have been assayed, the Victoria and Albert Museum's ewer was. It bears the lion-passant English quality mark for sterling, the crowned leopard's-head London assay mark, and a recognized letter date stamp (for 1585–86). Additional pieces of Chinese porcelain with early English provenance, though mostly markless, bear the same style of mounts, with their distinctive double-coiled, serpent-tailed merfolk and muscular herms.[10] These might also be the work of the three-trefoil master; alternatively, it has been suggested that an anonymous goldsmith specializing in casting these distinctive, customized handles and straps might have provided them to different master goldsmiths to chase, perfect, retail, and mark as their own.[11] If Raleigh was the original owner of the Wan Li blue-and-white Burghley series, then he may have provided the three-trefoil master with the necessary silver (reclaimed and melted down from older pieces), thereby eschewing the need for the finished works to be assayed. Alternatively, the guild's assaying could be bypassed if the three-trefoil master were working directly for the court, and the possibility should not be ruled out that Queen Elizabeth herself gifted the mounted Wan Li porcelain to Raleigh, before he in turn bequeathed it to Robert Cecil.

A surge of translations of Spanish and Portuguese travel accounts reflected intensifying English curiosity about China around this period, motivated by interest in trade and profit rather than subsequent generations' obsession with colonization or conquest. In 1598 Richard Hakluyt's trading manual, *The Principal Navigations, Voyages Traffiques and Discoveries of the English Nation*, identified porcelain as a key import, celebrating its appeal as "pure white, & is to be esteemed the best stuffe of that kind in the whole world . . . for three qualities; namely, the cleannesse, the beauty, & the strength thereof."[12] Reflecting this burgeoning market, by 1604 one captured Portuguese ship was estimated to be carrying an astonishing 200,000 pieces of porcelain.[13] With hundreds of thousands, perhaps even more than a million, porcelain vessels arriving yearly in Europe by the early seventeenth century, the medium—though still admired for its technical virtuosity—was no longer prized for its rarity, becoming more associated with aspirational, functional tableware than with credenza displays. The Burghley porcelain survives as a glorious relic of the preceding, and short-lived, period when it was truly treasured in Tudor England. EC

Notes to this entry appear on p. 313.

63. *Cup with Cover*

London, 1590–91
Mother-of-pearl, gilded silver, 7¾ × 4 × 4 in. (19.5 × 10 × 10 cm)
The Metropolitan Museum of Art, New York, Gift of Irwin Untermyer, 1968 (68.141.120a, b)

64. *Wine Cup on a High Foot*

London, 1599–1600
Gilded silver, H. 7¼ in. (18.4 cm)
The Metropolitan Museum of Art, New York, Gift of Irwin Untermyer, 1968 (68.141.104)

The wealthy professional classes of sixteenth-century England emulated the taste for precious metalwork enjoyed at the court and in aristocratic circles (see cats. 60–62). Indeed, the quantities of silver worked, used, and gifted, as well as the scale of the gold-smiths' local trade, was a source of constant comment for visitors. An anonymous Venetian, for example, reported home that anyone hoping to be considered "a person of any consequence" must have "in his house silver plate to the amount of at least £100 sterling."[1] Evoking the sophistication of the capital's goldsmiths' quarter, the same Venetian exclaimed:

> the most remarkable thing in London, is the wonderful quantity of wrought silver. . . . the shops . . . [are] so rich and full of silver vessels, great and small, that in all the shops in Milan, Rome, Venice, and Florence put together, I do not think there would be found so many of the magnificence that are to be seen in London. And these vessels are all either salt cellars, or drinking cups, or basins to hold water.[2]

The two cups seen here suggest the types of silver objects arrayed for sale in the London shops. Both are fully marked by the Goldsmiths' Company's assay control process, bearing (as yet unidentified) makers' marks;[3] the crowned leopard's head of the London assay office; the lion-passant English quality mark for sterling; and official letter date stamps (*N* for 1590–91, and *B* for 1599–1600). It is likely that both, thus marked, were prepared for sale on the open market.

The covered cup (cat. 63), with its mother-of-pearl staves, would have been the more expensive of the two. Principally sourced from the interiors of exotic shells, Indian mother-of-pearl was admired and sought after in Europe, with imports fetching high prices.[4] Though some vessels made by Gujarati craftsmen, working in western India, were kept in their original forms, others—such as this one—were carefully dismantled on arrival in England, and their mother-of-pearl inlays were set in new precious-metal mounts. The present mounts are enlivened by the stippled "hit-and-miss" ground, and an engraved frieze

of scrolling foliage with miniature five-petaled roses decorates the foot and lip of the cup. With its baluster stem, spreading bowl, and domed cover with finial, this piece emulates, as a more affordable version, courtly commissions of the period. In 1592 Queen Elizabeth apparently gave to one of her many goddaughters, Elizabeth Bowes, a covered cup with similar, if finer, lines though no mother-of-pearl (fig. 71); it bears the maker's mark *IS*, which is attributed to John Spilman (or Spylman), a craftsman originally from Lindau, in Bavaria, who was licensed by the Goldsmiths' Company and became one of the queen's royal jewelers.[5] Accordingly, the cup brings to mind the enlivening, and challenging, presence of hundreds of foreign goldsmiths also at work in London.

Rather less conventionally, the wine cup (cat. 64) adopts a form more familiar from Venetian glass: the *tazza*, with its broad, spreading bowl so shallow, it would seem almost impossible to drink from it without spillage. Venetian *cristallo* glassware, admired for its delicacy and crystal-clear coloration, was being imported into England in some quantity by the 1590s.[6] This homage—or riposte—in silverwork celebrates London's local craftsmanship and specialty while also benefiting from the

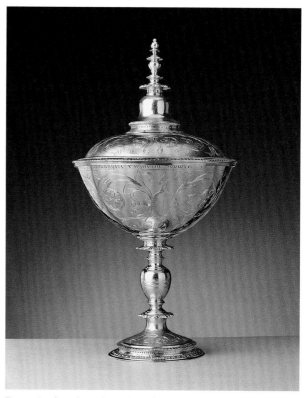

Fig. 71. Attributed to John Spilman (active 1588–ca. 1604), *The Bowes-Hutton Cup with Cover*, London, 1589–90. Gilded silver (maker's mark: *IS*), H. 15⅛ in. (38.3 cm). The Royal Collection / HM Queen Elizabeth II (RCIN 15956)

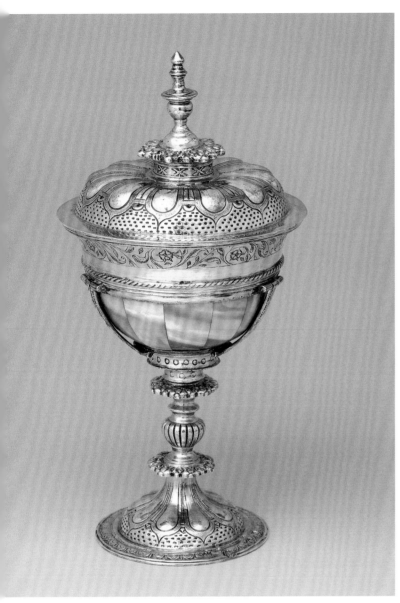

Cat. 63

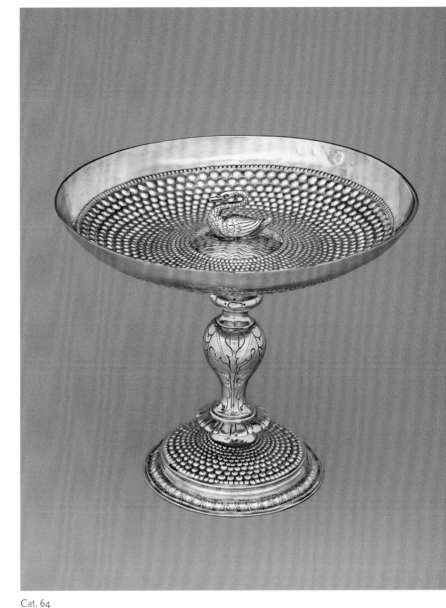

Cat. 64

undeniable advantage of the medium's strength and durability. Evoking twinkling glass, the silver is designed to sparkle, reflecting the light thanks to the radiating punchwork pattern of the bowl and foot. The swan rising from these watery ripples could suggest an association with the Vintners' Company, the trade association largely responsible for the import, regulation, and sale of wine. Their prestigious right to own and mark swans (a practice called "swan-upping") on the Thames led to their adoption of the swan as one of their devices, in later years added as supporters to their coat of arms.[7] EC

Notes to this entry appear on p. 313.

65. *Elizabeth I in a Garden*

England, ca. 1590
Satin worked with silk, precious-metal-wrapped threads, seed pearls,
spangles, and glass beads, with watercolor on vellum, human hair,
6¾ × 6½ in. (17.1 × 16.5 cm)
Private collection

Against a poetic, distant landscape, knotwork hedging, and lush,
blooming bushes of honeysuckle and bicolored Tudor roses,
the monarch strolls in an Elizabethan palace's terraced garden,
gazing directly outward from the composition as though the
viewer has just happened upon her. This hybrid object unites the
physical sumptuousness of covetable precious textiles with the
intimate scale and informality of miniature portraiture.

Elizabeth—recognizable from Hilliard's idealized minia-
ture portraits (see cats. 58, 97)—adopts a stance comparable to
that in his representation of the queen in the Mildmay Charter
(cat. 31), and in other contemporaneous manuscript representa-
tions; here, she holds a glove and a feathered fan (not dissimilar
to that in cat. 113).[1] Her face and hands are delicately painted
in watercolor on vellum, enveloped in an embroidered setting
worked on a satin support. Her bound auburn tresses are actual
human hair.[2] Her wide farthingale skirt, tight bodice, and broad
sleeves are rendered in silk, gold and silver threads, pearls,
beads, and spangles, with her ruff created from a lacework of
fine linen threads, just as an actual full-scale collar of this period
would have been. So dexterous and accurate is the sewing of
the costume that it has been evocatively described as "almost as
if an actual textile [had been] produced on a Lilliputian scale."[3]
The relative informality of the rest of her dress—it is unusual
to see Elizabeth sporting a short cloak and such fashionable
headgear—makes more sense when this work is understood
within what Adam Eaker refers to elsewhere in this volume as

"the inherent intimacy of the miniature genre" (see cat. 50). Like
the Vredeman de Vries–inspired fountains and abundant flora
of the Earl of Leicester's tapestries (cat. 67), the setting speaks to
the Elizabethan taste for both tamed and wild nature.

The professional skill of execution, pricey raw materials,
magical design, and prestige of the sitter reveal the work to have
been an exceedingly special commission. Although it is believed
to be a unique sixteenth-century survival of this type of textile
portrait, documentary evidence suggests three precedents, all of
which were royal: Henry VIII owned, among a group of por-
traits at Saint James's Palace, "a Table wherein is a man holdinge
a Swourde in his one hande and A Septer in his other hande of
nedlework partelie garnisshed with seede pearle"; at Nonsuch, a
miniature tapestry-woven cupboard carpet "with a Quenes hed"
inscribed "Quene Katheryne of Englonde"—probably Katherine
of Aragon—was recorded in 1547; and already in 1523, Margaret
of Austria owned a "rich portrait" of herself, "executed in tapestry
from life."[4]

It is unclear whether this embroidered portrait was intended
to be sewn onto a larger support or, like a painted miniature,
stored in a cabinet, handled, and even worn as a token. The
unusual textile frame, sprouting leaflike appendages as if the
depicted garden is spreading into the viewer's space, may or
may not be original: if it is, it is worth considering the intrigu-
ing suggestion that it was a textile response to ornate enameled
frames—of which there are some examples in The Met's col-
lection, a later emulation of which is appreciable in cat. 77.[5] The
work is a remarkable survival, and an evocative reminder of the
myriad layers of interaction between painting and the applied
arts in the sixteenth century. EC

Notes to this entry appear on p. 313.

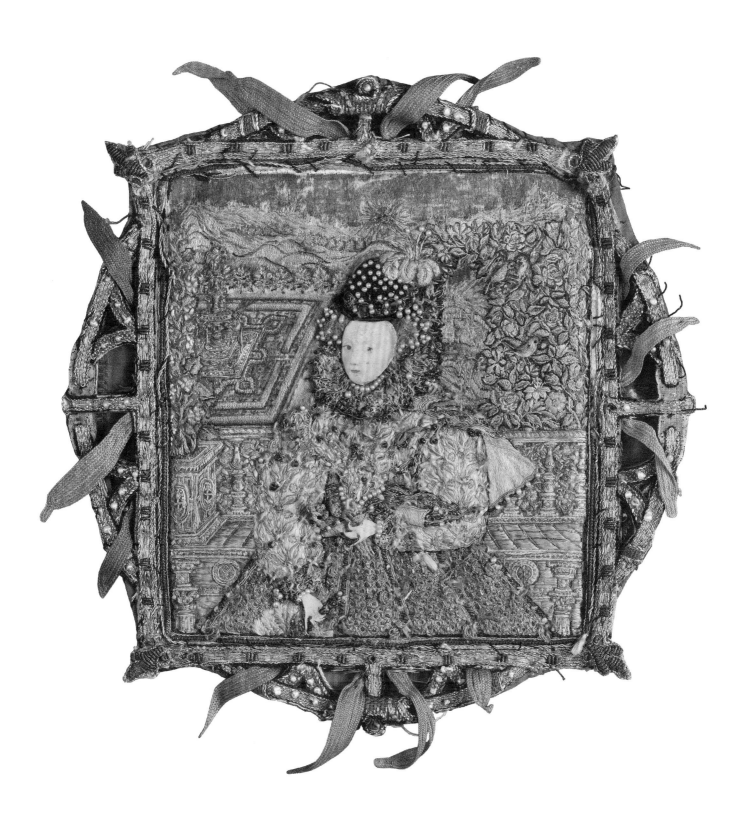

66. *Box with the Device of Robert Dudley, Earl of Leicester*

Probably London, 1579
Iron damascened with gold and silver, 1½ × 3¾ × 2¼ in. (3.9 × 9.4 × 5.8 cm)
Victoria and Albert Museum, London (M.665-1910)

This tiny box possesses a startling immediacy, its scale suggesting the intimacy of being carried around by its privileged owner. Its rich appearance singles it out as a special survival, uniting sumptuous materials and dexterous technique with a visual sophistication drawing simultaneously from Middle Eastern, Italian, and English ornament.

Inscribed "1579," the box was almost certainly a gift to celebrate New Year's. Its donor remains undocumented. Although Queen Elizabeth cannot be ruled out, similar-sounding boxes listed in her gift rolls reveal her to be more often the recipient than the giver of such objects.[1] This box's recipient is, however, clearly identified, celebrated by the device revealed at opening, on the inside of the lid: Robert Dudley, Earl of Leicester, whose badge was the bear and ragged staff (see also cat. 67). Although this piece is not specifically recorded in inventories of Leicester's possessions, his accounts reveal that he himself gave more modest examples of this kind to acquaintances.[2] The archival record is rich with accounts of such gift boxes, intended to hold confectionary sweetmeats, also called comfits.[3] Sweetmeats were locally

produced or, more exotically, brought to England on Venetian and Neapolitan galleys alongside sweet wines and oils. They consisted of candied fruits or hardened sugar syrup, sometimes flavored with rose or violet water, with cores of almond, ginger, clove, caraway seed, and musk. They were enjoyed for their sweet taste and used to freshen breath—as with Shakespeare's "kissing comfits" of *The Merry Wives of Windsor* (5.5.15).[4]

The box's elegant appearance is due to a technique called damascening, in which iron is darkened almost to black with heat or chemicals, and designs are introduced by making impressions in the metal's surface into which polished gold and silver are pressed. Such inlaid metalwork had been exported to the West from Syria, Egypt, and Persia, becoming exceedingly popular throughout the fifteenth and sixteenth centuries, and is recorded in examples such as the vase owned by Ferdinando de' Medici now in the Bargello, Florence.[5] Western craftsmen learned the technique, which took its name from this Eastern heritage, and applied it in particular to the decoration of arms and armor—for instance, The Met's Milanese burgonet dating from the 1560s, and a wheel-lock pistol in the Victoria and Albert Museum made in London about 1580.[6]

The arabesques inside the lid surrounding Leicester's device belong to the Syrian tradition; the flowering, bicolored Tudor rose, the pinks, and the pimpernels on the exterior, however, speak to English tastes, recognizable in textiles (cats. 68, 69) and metalwork (cat. 63). These motifs are so similar to those on the damascened breech of the London-made pistol that both pistol and box may conceivably have been crafted in the same workshop. On the lid of the box, a cartouche surrounds the scene of King David spying on Bathsheba bathing, probably based on an as yet unidentified print. The classicized nude figure of Bathsheba belongs firmly in contemporaneous European design, repeating a figure type used variously to represent Bathsheba, Herse, and Roxana; all respond to Raphael's now lost drawing for frescoes for the Villa Farnesina in Rome.[7] These versions are gorgeous in print, tapestry, and manuscript illumination; it was incredibly ambitious of the maker of Leicester's box to tackle her in damascened metalwork. The skilled artist, perhaps having grown accustomed to the task by creating similar figurative panels for weaponry, rose to the challenge. Whether the iconography of a monarch gazing upon the object of their love held especial significance for the donor and recipient of this gift remains speculative. EC

Notes to this entry appear on p. 313.

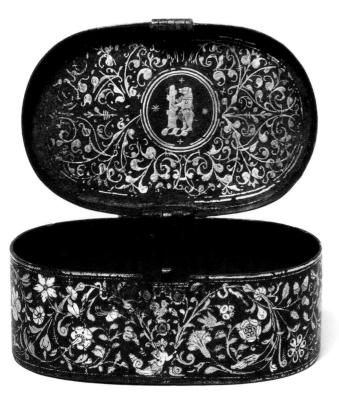

Cat. 66, view of side and inside lid

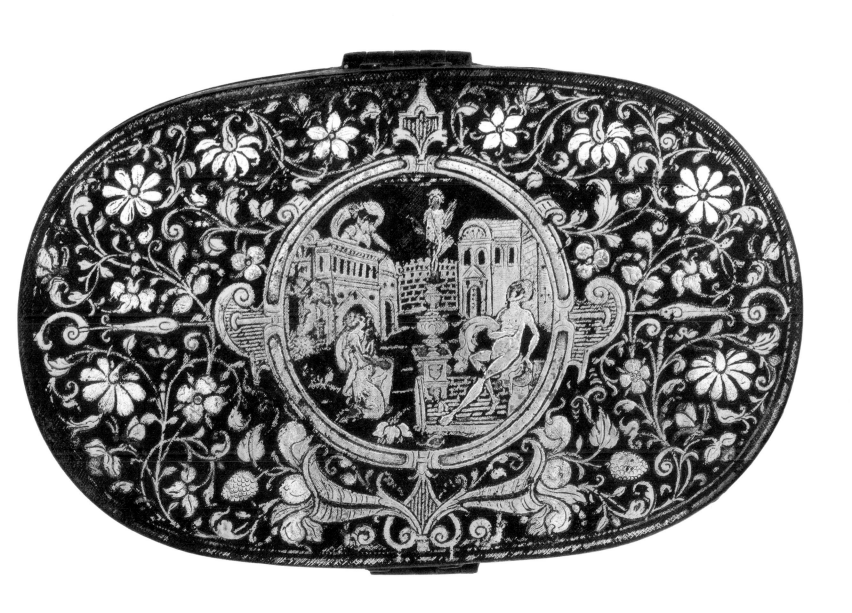

67. *Verdure with the Arms of Robert Dudley, Earl of Leicester*

Designed by an unknown artist, probably English, ca. 1582
England or the Southern Netherlands, ca. 1585
Wool (warp), wool and silk (wefts), 113 × 104¾ in. (287 × 265 cm)
Burrell Collection, Glasgow (47.1)

When Elizabeth's long-standing favorite Robert Dudley, Earl of Leicester, was decorating his new banqueting house—a free-standing stone building for hosting entertainments in the garden of his London property, Leicester House—he spared no expense, choosing to line the walls with a glorious thicket of floral abundance, plump game birds, and his own impressive armorials. A set of three tapestries sporting these devices was commissioned via the queen's chief arrasman, Richard Hyckes, and delivered by his agents to Leicester House about January 1585.[1] Cat. 67 was one of two hangings each displaying Leicester's arms encircled by the Order of the Garter (to which he had been admitted in 1559), flanked by his supporters, a tethered lion and a crowned lion. The whole is surmounted by the coronet marking his elevation to the peerage in 1564, a chivalric helm, and his device of a bear with a ragged staff. A scrolling banderole beneath declares his (appropriate) motto, *Droit et loyal*. The third, larger tapestry in the set (fig. 72) flanked these arms with two medallions; countering the shallow perspective of the floral grounds like windows into a receding landscape, they display lavish fountains.[2]

The scale, not to mention the technical dexterity, of Leicester's armorials suggest an attribution to the internationally celebrated center of verdure tapestry weaving, Enghien, where the Lewknor

table carpet (cat. 70) had almost certainly been created some twenty years previously. However, a delivery date of early 1585 would set the commission of this series to early 1583 at the latest, precisely when the Catholic Duke of Parma's saber-rattling Treaty of Arras (1579) was escalating toward the disastrous siege of Antwerp of 1584–85. During this campaign, Enghien, like Brussels, Bruges, and all the other great Netherlandish tapestry-weaving towns in Hainaut, Brabant, and Flanders, fell to the Duke of Parma's marauding forces. Leicester's picture-buying trip to Antwerp in 1582 notwithstanding, it would have been well-nigh impossible for him to justify a Netherlandish commission in these circumstances.[3] Hyckes, the queen's arrasman, did, however, operate a tapestry weaving workshop in London, employing many émigré Netherlandish weavers fleeing the belligerent uncertainties and religious persecution of the Habsburg Netherlands.[4] It is, therefore, more likely that Leicester's tapestries were woven in London, a commission supporting local trade that would behoove such a vocal champion of the Protestant cause.[5]

The cartoons provided to these weavers were probably likewise English. Their profusion of gently stylized, decoratively massed flora—even boasting bicolored red-and-white Tudor roses, colorful and lush against a black ground—speaks to the design tradition of the Lewknor table carpet. But by the 1580s they represented a distinctly English taste—discernible in works ranging from miniature paintings to precious metalwork—entirely remote from both the massive "cabbage leaf" verdures (see fig. 37) and the blank-grounded armorials popular in mainland Europe.[6] Leicester's cartoon painter sourced much of the figurative detail from existing designs. The fountained landscapes in the set's largest tapestry, for example, replicate types by Hans Vredeman de Vries, published in *Artis perspectivae* in 1568, and their strap-work borders are based on designs published by Cornelis Floris in 1557.[7] The game birds were, similarly, copied from existing models taken from other landscape tapestries known to have been woven in Brussels, Antwerp, and London in the second half of the sixteenth century.[8]

The resultant armorials, far from suffering from their apparent magpie cartoons and the newly established London looms of refugee weavers, represent a triumphant combination of Netherlandish design and workmanship, probably nurtured on English soil, certainly nuanced to meet the aesthetic tastes of their affluent, and influential, English patron. EC

Fig. 72. *Verdure with Two Fountains and the Arms of Robert Dudley, Earl of Leicester*, from the *Verdures with the Leicester Arms* series. England or the Southern Netherlands, ca. 1585. Wool and silk, 114⅛ × 188⅛ in. (290 × 478 cm). Victoria and Albert Museum, London (T.320-1977)

Notes to this entry appear on p. 314.

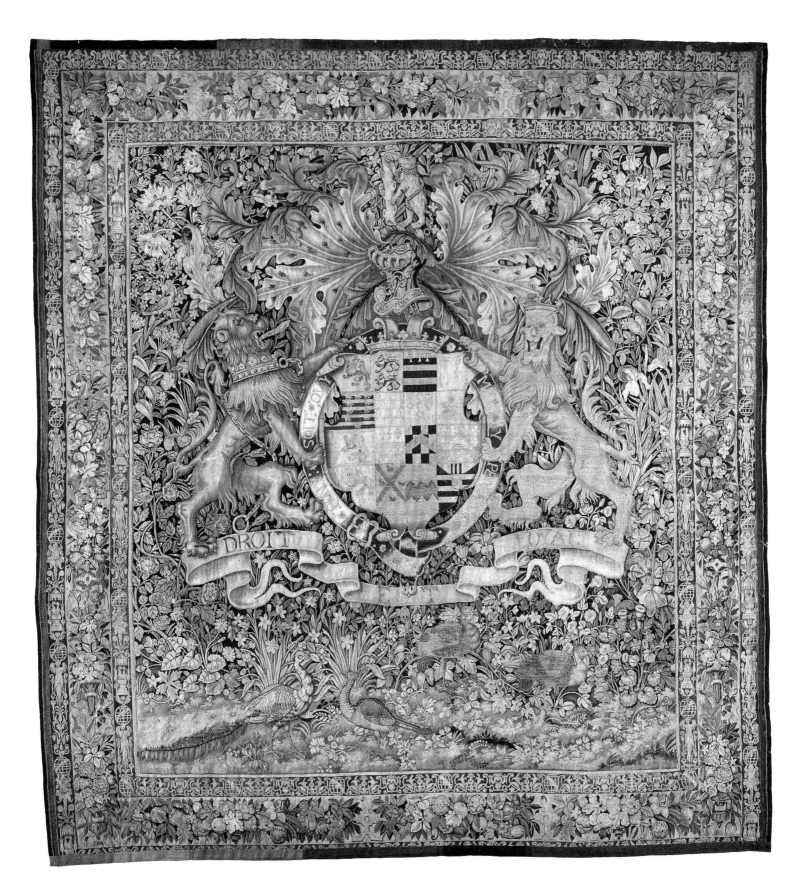

68. Chasuble

Probably London, ca. 1550–1600
Satin embroidered with gilded-silver metal-wrapped threads, with applied embroidered velvet, 46¹⁄₁₆ × 26⅜ in. (117 × 67 cm)
Victoria and Albert Museum, London (T.257)

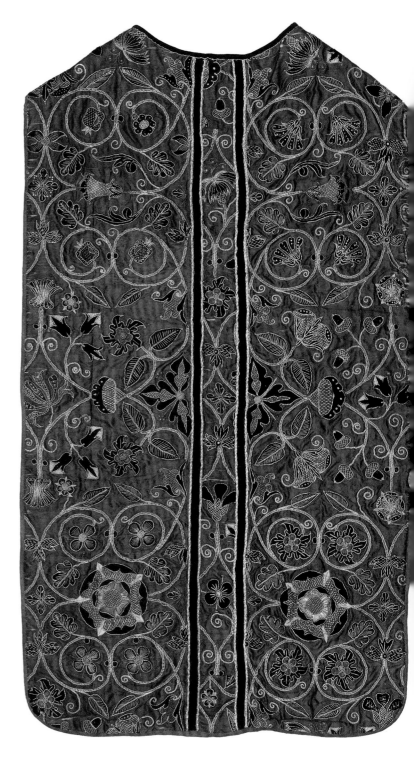

With its deep crimson, satin ground, copious amounts of precious-metal-wrapped threads, and applied embroidered black velvet patches—"cutwork," in sixteenth-century parlance—this chasuble provides a rare record of the visual sumptuousness, the rich color, the glitter and gleam of Tudor embroidery. Here, imported satin combines with the English specialty, needlework (then enjoying something of a revival since its thirteenth-century heyday), to create gently symmetrical patterns of large Tudor roses, oak leaves, and pimpernels contained within a delicate filigree of tendrils.

Although the records of the London Broderers' [Embroiderers'] Company were destroyed during the Great Fire of 1666, inventories and other archival accounts nonetheless reveal the popularity of this type of embellished textile among the wealthiest households, and the considerable expense of embroiderers' fees and raw materials.[1] Such was the prestige of this type of work that examples of it were retained and reused, even apparently by Queen Elizabeth, who in 1591 had "John Parr our Embrother" repurpose into a new pair of sleeves old "sleves embroidered with dead Trees & other braunches richly wrought with gold silver and colored silkes."[2] This chasuble provides another such example: the cutting of the embroidered motifs at the vestment's edges reveals that it has been very neatly assembled from an existing textile made to serve a different purpose. It probably originally functioned as a large wall hanging, like those of figured velvet "enbrowdered withe the armes of Englande and Spayne, crowned with a crowne Imperialle, having boordres likewise enbrowdered with rooses, flouredelucis, and pomegarnettis," posthumously recorded in 1536 among Katherine of Aragon's possessions at her former London residence, Baynard's Castle; or the "hanginges of . . . Coulored damask and sattin wrought with golde flowers and trees and lyned with Canvas," recorded at Hardwick Hall in 1601.[3] There was an established taste for embroidered floral motifs to decorate sumptuous interior furnishings: Henry VIII, for example, kept "one carpette of nedleworke with Rooses & Trees of silke" at Hampton Court; and at Nonsuch, he had three cushions of "clothe of silver & russet vellat embrawdered upon with trees & sondry smale cuttes of white clothe of goulde bordred rounde about with an embrawdery of clothe of gould and Silver upon crymsen silke."[4]

Silk embellished with appliqué embroidery also enjoyed an established popularity for altar cloths and matching sets of

vestments for the priest and his acolytes to wear during Mass.[5] Although in the first half of the sixteenth century, there are documented examples with floral decoration like cat. 68, such as the two copes of blue velvet, "th['] one enbrodered with flower Deluces and th['] other with flowers onely," among the possessions appropriated by Henry VIII from Thomas Howard, 3rd Duke of Norfolk, embroidered figurative decoration with saints or biblical scenes tended to predominate.[6] Following Thomas Cromwell's 1538 injunction against "popish and superstitious" practices, and certainly during the Protestant austerity of Edward VI's reign, however, less contentious ornamental decoration grew immeasurably more appealing. It was probably in such circumstances that this chasuble was assembled: still as visually rich and sumptuous as could be, and appropriate attire for a church officiant, while avoiding any potentially controversial sacred iconography. EC

Notes to this entry appear on p. 314.

69. Blackwork Embroidery

Probably London, ca. 1590
Linen embroidered with silk and gilded-silver precious-metal-wrapped threads, 8½ × 14¼ in. (21.6 × 36 cm)
The Metropolitan Museum of Art, New York, Purchase, The James Parker Charitable Foundation Gift, 2013 (2013.598)

Whereas the embroidered satin of cat. 68 revels in saturated colors, this needlework achieves, with deceptive simplicity, extraordinary richness using nothing more than outlines and patterns of black silk, paired with gold infill. Worked on the finest Flemish linen, probably the "lawne" or "cambric" noted by various

inventory clerks, with precious-metal-wrapped threads, called by contemporaries "Gold of Venice," the expense of the raw materials is matched by the dexterity of the embroiderers, almost certainly professionals.[1] More than ten embroidery patterns can be discerned in this small fragment: cleverly juxtaposed, like hatching on a print, they introduce just enough tonality to render the foliate design legible without sacrificing its key decorative effect.

Royal inventories abound with references to this type of decorated textile, called blackwork, which could be used for both clothing and the finest furnishing linens. Jane Seymour owned a pair of sleeves, for example, "of Lynnen . . . embrawdred allouer with blacke silke and venice golde"; and at his death, Henry VIII left counterpanes and pillowcases of "Lynnen Clothe wrought with golde and silke" in the "secret Guarderobe" in Westminster, as well as loose collars or neckerchiefs, called partelettes, "of Lawne wrought with golde and blacke Silke."[2] More than fifty years later, the inventories of Queen Elizabeth's wardrobe included multiple fine linen garments—sleeves, kirtle panels, gown "coveringes"—"of blacke cloth of golde embroidered with venice golde" and "embroidered alover with flowers of venice golde and blacke silke."[3] Additional surviving textile fragments in Edinburgh and Chicago seem to have been cut from the same set of panels as cat. 69: together, they reveal that honeysuckle and daffodils originally joined the Tudor rose, pomegranate, rosehips, and pimpernel discernible here.[4] The extraordinary effect of this type of gold- and blackwork linen used as a garment can be appreciated on the shirt Captain Thomas Lee retains in his otherwise dressed-down portrait by Marcus Gheeraerts (see fig. 90). EC

Notes to this entry appear on p. 314.

70. The Lewknor Table Carpet

Designed by unknown artists, probably English and Netherlandish,
ca. 1562
Probably woven in Enghien, 1564
Wool (warp), wool and silk (wefts), 92¾ × 197 in. (236 × 500 cm)
The Metropolitan Museum of Art, New York, Fletcher Fund, 1958 (59.33)

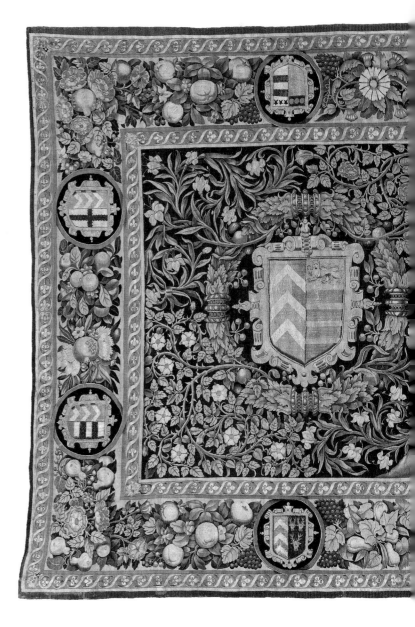

Probably woven in Enghien, thirty miles southwest of Brussels, for a patron in Surrey, this tapestry's design benefits from an unusual combination of English and Flemish motifs. Displayed as a ceremonial table carpet, it matched any splendor mainland Europe had to offer.

In keeping with the English taste for ceremonial armorial table carpets, whether embroidered, knotted (fig. 73), or, more unusually, tapestry woven like cats. 70 and 75, small coats of arms in the borders are oriented to be read when hanging from the tabletop. In cat. 70, as in cat. 75, three larger garlanded coats of arms fill the main field. A dated cartouche at the lower right reveals the tapestry to have been made in 1564. The central armorial celebrates Sir Roger Lewknor of Camoys Court and Bodiam Castle in Sussex, and his third wife, Elizabeth Messant.[1] Two of the smaller armorials in the borders commemorate his first and second marriages, to Eleanor Audley and Elizabeth Hussey. Sir Roger having died twenty-one years before the tapestry was made, the Lewknor patron was apparently one of his female survivors. By 1564, Elizabeth Messant had been remarried for many years to Sir Richard Lewknor of Trotton—one of Sir Roger's distant cousins, who is not featured in the table carpet. Given Elizabeth's remarriage, and that the tapestry remained at Camoys Court in the possession of Constance, Sir Roger and Elizabeth's unmarried youngest daughter, it is most likely that it was Constance, not Elizabeth, who commissioned it.[2] By reaching far back into her ancestry, Constance could celebrate the family of both her father and stepfather: the shield to the left records Sir Roger's and Sir Richard's shared great-great-great-grandparents, Sir Thomas Lewknor and Joane D'Oyley. The shield on the right celebrates a union between the Camoys and the Despencer or Echingham families, both of whom were connected to the fifteenth-century Lewknors by marriage, boasting an impressive female lineage.

As the heraldry made clear to all observers, the Lewknors were a long-established, noble family. The Wars of the Roses had divided them, like many other families, and the tapestry's floral field tactfully incorporates both red Lancastrian and white Yorkist roses. Though his uncles supported Richard III, Sir Thomas, Constance's grandfather, whose arms appear in the border, had (happily) backed the Earl of Richmond—the future King Henry VII—occasioning his attainder for treason and

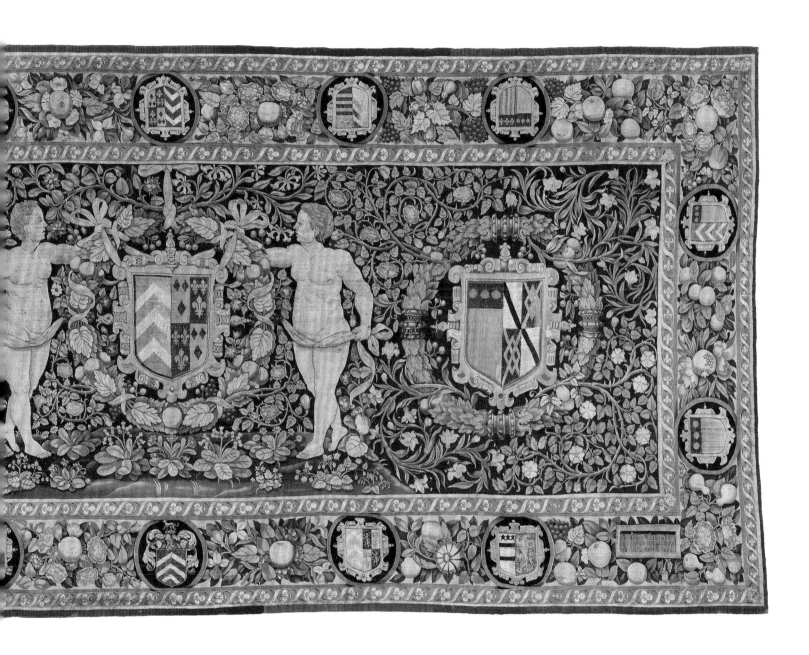

the confiscation of his lands, all reversed after the Tudors took the throne.[3]

The table carpet is attributed to weavers in Enghien on the basis of technique and border style. That Constance commissioned this carpet from Enghien—one of the most celebrated centers of verdure tapestry weaving anywhere in Europe—would leave all observers in no doubt of her wealth and good taste, as well as her independence. She thus joined the ranks of other English patrons of Enghien, apparently including the wealthy Gryce family of Great Yarmouth (see fig. 38). The floral ground, with its elegantly curvaceous stems, and the fruit-filled borders draw from the same design repertoire recognizable in other, contemporaneous Enghien tapestries. In a nod to the Antique, the two naked boys supporting Sir Roger's arms similarly find their counterparts in the Enghien weavers' popular series *Children's*

Games, although their calmer contrapposto and modestly positioned ribbon swags appear to be in deference to their English patroness.[4] Detailed drawings of the heraldry, and directions to prioritize red and white roses, likewise must have been sent from England when the table carpet was commissioned. Recently unearthed documents reveal that Constance apparently also commissioned a set of six matching tapestry-woven cushion covers.[5] The complete effect when these tapestries were new, their palettes unfaded—originally with much stronger greens and yellows, still appreciable in the probably English-made, contemporaneous Luttrell table carpet (cat. 75)—must have been a glorious demonstration of Constance Lewknor's family pride. EC

Notes to this entry appear on p. 314.

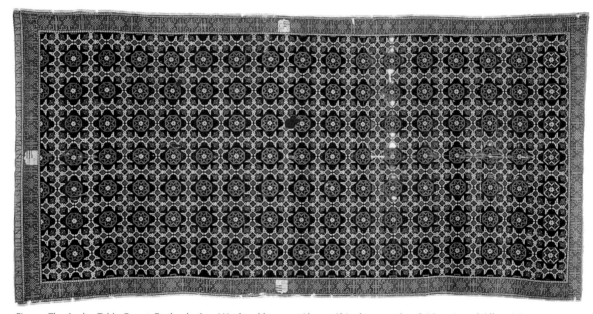

Fig. 73. *The Apsley Table Carpet*, England, 1603. Wool and hemp, 99¼ × 199¼ in. (252 × 506 cm). Victoria and Albert Museum, London (710-1904)

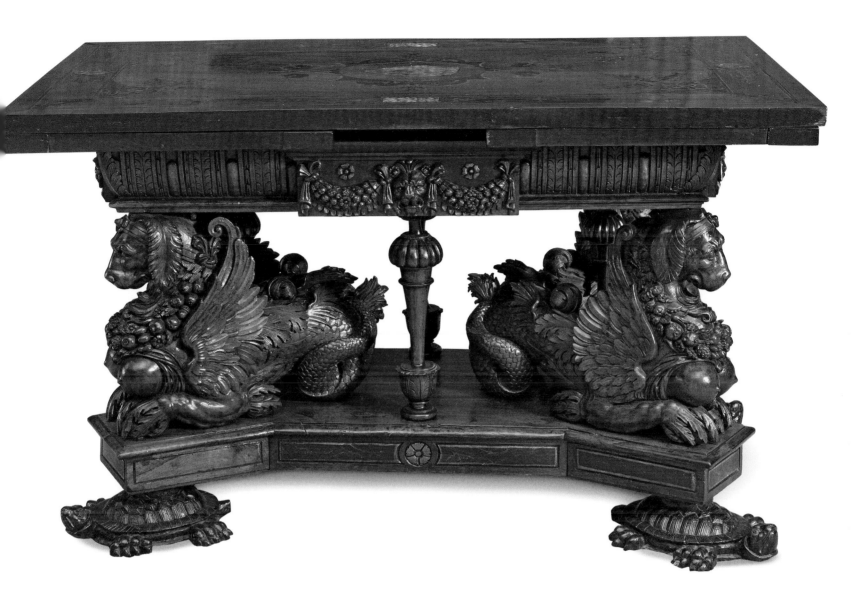

71. The "Sea-Dog" Table

Probably Paris, ca. 1575
Walnut wood, gilded silver, marbled inlay, 33½ × 58 × 33½ in.
(85 × 147 × 85 cm)
National Trust, Hardwick Hall, The Devonshire Collection
(NT 1127744)

On the whole, we depend on brief descriptions in inventories to gain a sense of the appearance and range of the furniture embellishing and used within Tudor great houses. Sometimes, inventory clerks' deviations from their set terminology hint at lost treasures; at Westminster in 1547, for instance, one noted a "square Table fynelye [finely] wrought with sondrye [sundry]

coloured wooddes the foote of the same likewise wrought," or the "Twooe Chestes of wood paincted and guilte [gilded]."[1]

It is, therefore, hard to exaggerate the importance and exceeding rarity of this extraordinary table, preserved at Hardwick Hall for the past 420 years. With it, the description in the 1601 inventory of Hardwick of "a drawing table Carved and guilt standing upon sea doges inlayde with marble stones and wood" comes to life.[2] The table's importance lies not just in its survival, but also in its design, workmanship, and condition (the turtles at its base being the only conspicuous replacements).[3] Among the designs for furniture by Jacques Androuet du Cerceau, published about 1560, is a page of chimera-like figures, some with hounds' heads (fig. 74); the

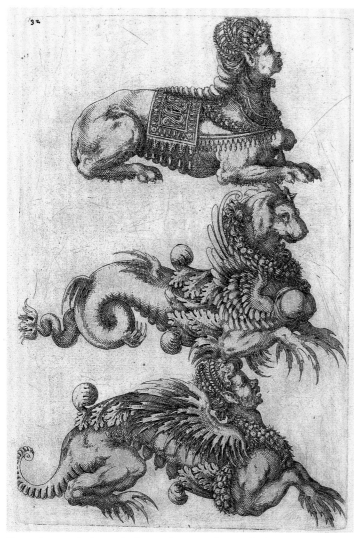

Fig. 74. Jacques Androuet du Cerceau (ca. 1515–after 1584), *Three Sphinxes*, from an album of furnishing designs, ca. 1545–65. Etching, pasted in, 12⅝ × 8½ in. (32 × 22 cm). Formerly Collection of the Earls of Macclesfield, Shirburn Castle, Oxfordshire

Hardwick table reveals how these actually looked when translated into three-dimensional, polished walnut.[4]

For much of the time, the tabletop with its inlaid marbles and marquetry fruit, flowers, and arabesques must have been hidden under textile coverings, like the needlework "Carpet for [the table]" representing the Old Testament story of King Saul and David, also mentioned in the inventory. However, it seems as though this table carpet made "for it" must have had very little overhang at the sides in order not to obscure the view of these seated beasts. Unlike the clerk at Westminster, the compiler at Hardwick was prompted to describe this table in enough detail for it to remain clearly recognizable; according to the clerk, these are "sea dogs," whence the table's modern name. It is conceivable that the decision to include these beasts was not simply to realize

Du Cerceau's fantastical design, but also to appeal to the table's probable patron, George Talbot, 6th Earl of Shrewsbury, talbots being an ancient breed of large hound.[5] These strange creatures would have been even more dramatic when the table was new, being embellished with gilded paint, as described in the inventory ("guilt") and borne out by technical examination during conservation.

The table is also outstanding in terms of its workmanship, which is almost certainly—like its design—French. The table was most likely acquired in France by Lord Shrewsbury's agents for a hefty sum, as part of a larger group of other pieces, also gilded, and probably including the sixteenth-century Du Cerceau–inspired French cabinet that also remains at Hardwick.[6] The Countess of Shrewsbury, Elizabeth Talbot, known to posterity as Bess of Hardwick, appreciated this furniture enough to appropriate it from the home she shared with the earl, Sheffield Hall, when she left him, taking it with her first to her home at Chatsworth and subsequently to Hardwick. In his complaint about this, Lord Shrewsbury particularly described "bedsteads, tables, cupboards, stools etc. varnished like brass and other that [agents] Cornish and Trumpeter bought in France and cost £100-0-0 and above."[7] This route from France to England via the Shrewsburys, with their taste for French artistry (they also acquired French tableware, tiling, paneling, and textiles), is certainly much more convincing than the suggestion that the table was part of a commission made by Mary, Queen of Scots, but confiscated by Queen Elizabeth and subsequently given to Bess.[8] It is entirely possible that the Scottish queen, who is known to have ordered furniture from France for herself and for her English "hosts," might have shared her contacts with Shrewsbury, under whose care she lived during much of her enforced English residence. Not only did the French artisans do justice to Du Cerceau's marvelous beasts in their carving, but they also crafted a smooth-working mechanism to extend the table (the "drawing" noted in the inventory refers to a draw leaf). Beneath the tabletop are extra leaves, which can be drawn out when needed. The table is also composed of multiple detachable elements, allowing for less cumbersome transportation across the Channel, to be reassembled upon delivery.

The survival of this table, inspired by printed models by one of the most imaginative French artists of his generation, and of its companion cabinet proves the exceedingly high caliber of European design and production available to the wealthiest English clientele—though at a price, as subsequently rued by the Earl of Shrewsbury. EC

Notes to this entry appear on p. 314.

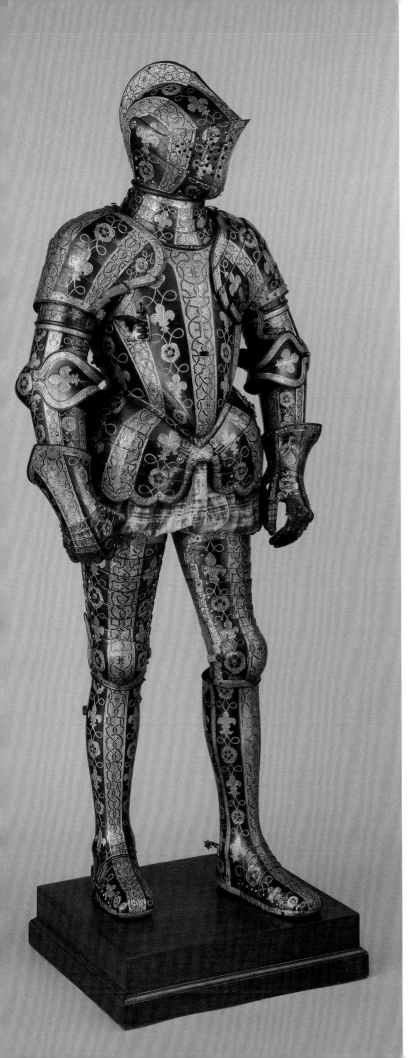

72. *Field Armor for George Clifford, 3rd Earl of Cumberland*

Greenwich, 1586
Steel with etched and gilded steel, leather, H. 69½ in. (177 cm)
The Metropolitan Museum of Art, New York, Munsey Fund, 1932
(32.130.6a–y)

The astonishing splendor of the Greenwich Royal Armoury's early work for Henry VIII (cat. 22) was maintained by its successive generations of armorers. This armor—made for the Elizabethan courtier George Clifford, the young Earl of Cumberland—was produced under the direction of the master armorer Jacob Halder (originally from Landshut, in Bavaria) and has been called one of the most spectacular survivals of Greenwich manufacture.[1] A costly commission, perhaps a royal present from the queen, it consists of a full garniture, including detachable and interchangeable elements to convert this field armor, intended for use in battle, into a tournament and jousting armor, to be worn at court events.[2] Given Cumberland's elevation soon after the suit's completion to the role of Queen's Champion at the annual Accession Day tilts (see "Honing the Tudor Aesthetic" in this volume), it doubtless would have been seen, and admired, multiple times.

Though at first glance quite different in silhouette and decorative flourish when compared with Henry's 1527 garniture, both armors represent the height of cutting-edge fashion, technology, and artistic sensibility of their day. For Henry that meant the square shoulders, straight waist, and bear's-paw shoe silhouette of the 1520s, sheathed in a shimmery, golden steel exterior alive with etched grotesques. For twenty-eight-year-old Cumberland in the 1580s, his armor had taken on the Elizabethans' distinctive,

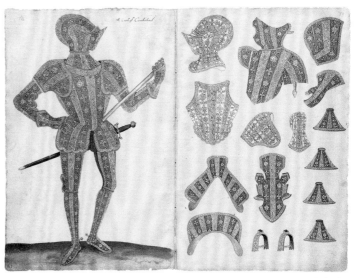

Fig. 75. Jacob Halder (active 1576–1607), "Designs for Armor for George Clifford, 3rd Earl of Cumberland," from *The Almain Armourer's Album* (*The Jacobe Album*), 1587. Pen, ink, and wash, 17 × 23 in. (43.2 × 58.5 cm). Victoria and Albert Museum, London (D.605&A-1894)

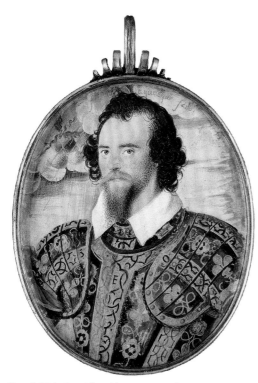

Fig. 76. Nicholas Hilliard (ca. 1547–1619), *George Clifford, 3rd Earl of Cumberland*, ca. 1587. Watercolor and shell gold on vellum, 2¾ × 2³⁄₁₆ in. (7 × 5.6 cm). Nelson-Atkins Museum of Art, Kansas City (F58-60/188)

73. George Clifford, 3rd Earl of Cumberland

Nicholas Hilliard (ca. 1547–1619)
ca. 1590
Watercolor and bodycolor, with gold and silver leaf, on vellum, laid on panel, 10⅛ × 6⅞ in. (25.8 × 17.6 cm)
National Maritime Museum, Royal Museums Greenwich, London (MNT0193)
Exhibited New York only

In this celebrated miniature, armor, jewels, and emblematic imagery transform a courtier into a dashing royal champion. George Clifford, 3rd Earl of Cumberland, was a soldier and privateer whose exploits included the 1598 capture of San Juan in Puerto Rico.[1] In November 1590 Cumberland "achieved his greatest distinction as a courtier," succeeding Sir Henry Lee (see cat. 119), as the Queen's Champion, responsible for organizing tournaments and defending the monarch's honor at the tiltyard.[2] Hilliard's miniature most likely commemorates this occasion, depicting the earl in a splendid suit of armor decorated with stars, beneath a bejeweled surcoat whose rolled-back sleeves boast the queen's emblem of an armillary sphere. Cumberland prominently displays the queen's favor, a glove, attached to his hat like a coxcomb.

Cumberland's portrait shares its tiltyard imagery with many of Hilliard's other full-length "cabinet" miniatures, whose expanded format allowed for the depiction of armor and emblematic landscapes or accessories (see cat. 74). For example, the shield hanging next to Cumberland depicts an eclipse, along with the Spanish motto *Hasta quan[do]*—"Till when"—alluding to his anticipated term of service to the queen.[3] At the same time as he drew on the tiltyard's medieval imagery, Hilliard borrowed his composition from a contemporary continental engraving, the *Pike Bearer* by Hendrik Goltzius.[4] In doing so Hilliard adapted his source's robust silhouette to an Elizabethan ideal of male beauty, with a nipped waist and slender calves.

Cumberland appears to have had a particular investment in commemorating specific pieces of armor in his portraits. His surviving armor by Jacob Halder (cat. 72) appears in another portrait by Hilliard, now in the Nelson-Atkins Museum of Art, Kansas City (see fig. 76). The armor portrayed in cat. 73 does not survive but must have presented an equally striking contrast between blued steel and gilded ornamentation. At the time of Cumberland's anointing as Queen's Champion, he referred to Elizabeth I's eyes as "his two Starres," and the imagery of his armor may have played on this metaphor.[5] Cumberland has a more theatrical appearance in this full-length depiction than in the Kansas City miniature, with long hair falling down his shoulders to give him the untamed look of an Arthurian champion.

ideal male silhouette, with a cinched waist, full hips, slight peascod belly, and slim, shapely legs, seemingly elongated by short trunk-hose breeches.[3]

The elaborate ornament that renders the suit so distinctive is achieved by the bold contrast between the heat-darkened, "blued" steel background, accentuating complex designs of heraldic devices highlighted with mercury gilding. With admirable clarity across the articulated plates of the suit, the design encases the queen's future champion from head to toe in the bicolor Tudor rose; the fleur-de-lis (by that time somewhat sanguinely alluding to the English Crown's all-but-dashed traditional claim to the French throne); Elizabeth's cipher of two back-to-back *E*'s; and Cumberland's own badge of annulets (small rings). Speaking to the nostalgia for the perceived chivalry of Arthur's early Britain (see "England, Europe, and the World: Art as Policy" in this volume), Celtic-style knotwork borders these elements, crisply rendered in black against the etched and gilded banding. Halder's album of his armor designs carefully records the detailing of this embellishment across all the garniture's elements (fig. 75).[4] Cumberland himself chose to be portrayed at least twice in such recognizably decorated blue-gold armor, once in the actual suit (fig. 76) and once in a more fanciful rendition, closer in spirit than in detail (cat. 73).[5] EC

Notes to this entry appear on p. 314.

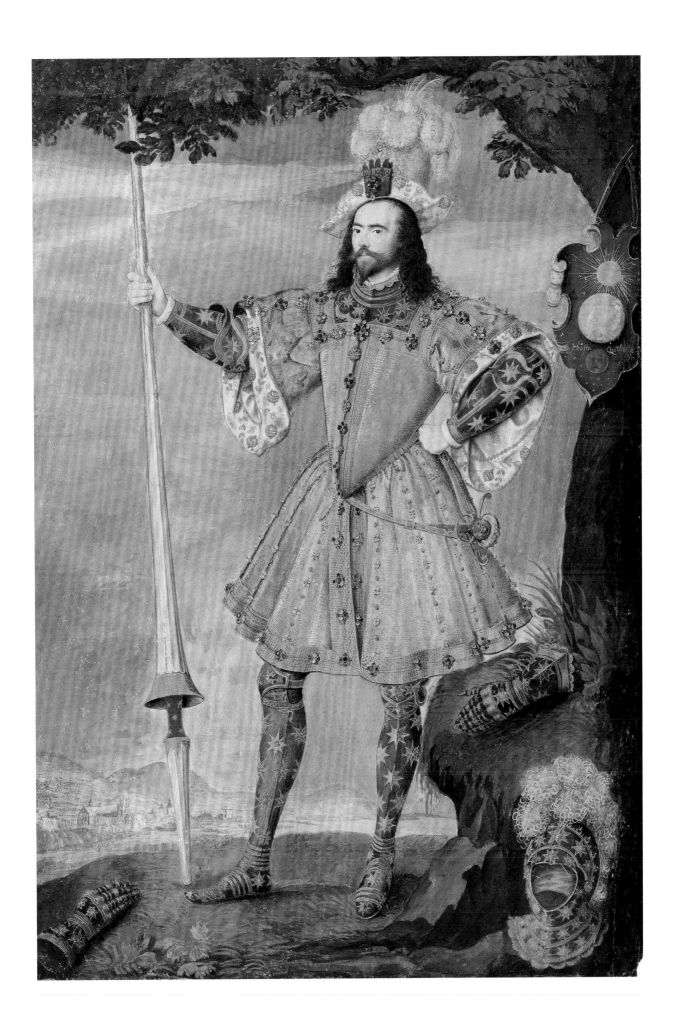

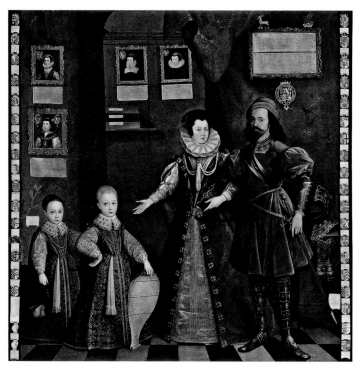

Fig. 77. Attributed to Jan van Belcamp (ca. 1610–1653), *The "Great Picture"* (detail of central panel), 1646. Oil on canvas, overall 100 × 196¾ in. (254 × 500 cm). Abbot Hall Art Gallery, Kendal (AH 2310/81)

The earl's daughter, the magnate and diarist Lady Anne Clifford, ruefully recalled that his "extreme love for horse races, tiltings, bowling matches and shooting . . . and hunting, and all such expensive sports did contribute the more to the wasting of his estate."[6] In the so-called *Great Picture* that Lady Anne commissioned to commemorate her parents in 1646 (fig. 77), the earl appears in the same star-emblazoned armor as in the present miniature, attesting to its significance as a treasured family heirloom and marker of courtly identity.[7] AE

Notes to this entry appear on p. 314.

74. *Sir Anthony Mildmay, Knight of Apethorpe, Northamptonshire*

Nicholas Hilliard (ca. 1547–1619)
ca. 1590–93
Watercolor on vellum, laid on card, mounted on wood, 9⅛ × 6⅞ in. (23.3 × 17.4 cm)
Cleveland Museum of Art, Purchase from the J. H. Wade Fund (1926.554)

Framed by the folds of a circular tent, Sir Anthony Mildmay strikes a relaxed and confident pose, with his right hand resting on a cloth-covered table and his left grasping the hilt of his rapier. Mildmay's upper body is encased in steel armor lavishly

trimmed with bands of etched and gilded metal. The polished breastplate swells extravagantly and then tapers at the groin, the so-called peascod belly fashionable in men's garments (and armor) after about 1560 (see cat. 100). Helmet, gauntlet, and tassets (leg coverings) are scattered about, as if Mildmay has been interrupted in the act of putting on or taking off his armor. Also on the table is a highly decorated wheel-lock pistol, partly wrapped in a cloth. Hilliard's meticulous brushwork and his lavish use of shell gold accentuate the highly refined nature of this exclusive world of courtly tournaments and jousts.

Hilliard's full-length cabinet miniatures are often described as "a response to, and an imaginative reinvention of," European court portraits in large.[1] He would likely have seen such large-scale images, many of men in armor, in the collection of his patron, Robert Dudley, Earl of Leicester, who had returned from the Netherlands in December 1587 with a number of impressive portraits for display in his London home.[2] Perhaps a more direct source of inspiration were the smaller drawn portraits in the earl's collection that featured similar compositions, such as François Clouet's 1571 likeness of the future King Henri III of France;[3] or Federico Zuccaro's drawn portrait of the earl himself (cat. 107), made during the artist's visit to England in 1575. Like Hilliard's portrait of Mildmay, these drawings depict their proud, armor-clad subjects at full length with one arm akimbo, standing beside a table and surrounded by armor and weaponry accoutrements. Hilliard adopted a virtually identical format for his miniature of Leicester's illegitimate son, Sir Robert Dudley (fig. 78). The simple interior of the latter painting is perhaps more successful than that of Mildmay in suggesting a three-dimensional space; in the present painting, the imperfect application of single-point perspective results in awkward spatial relationships between figure, furnishings, and the heavy folds of the tent.

The distinguished artistic lineage of Hilliard's composition invests Mildmay with qualities that in person he perhaps did not actually possess. Son of Sir Walter Mildmay, Chancellor of the Exchequer and Privy Counsellor under Elizabeth I, as well as founder of Emmanuel College, Cambridge (see cat. 31), the younger Mildmay served as Member of Parliament for various constituencies but—described by contemporaries as a man of few words—evidently made little impression in the Commons.[4] His one public appointment of any consequence was as ambassador to France. Despite his own protestations of poor health, poverty, and general unsuitability for the post, Mildmay crossed to France and in October 1596 was presented to King Henri IV. The embassy was an unequivocal fiasco, perhaps in part because Mildmay's puritanism was an uneasy match for the king's pragmatic repudiation of his own Protestant faith. At his own urgent request, Mildmay

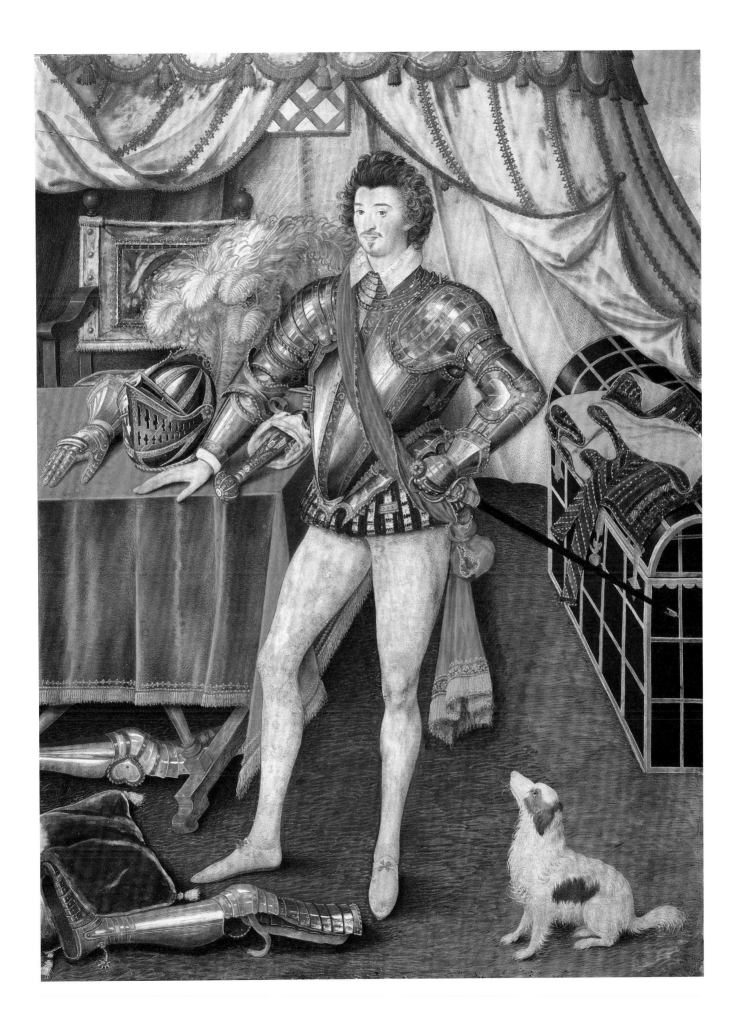

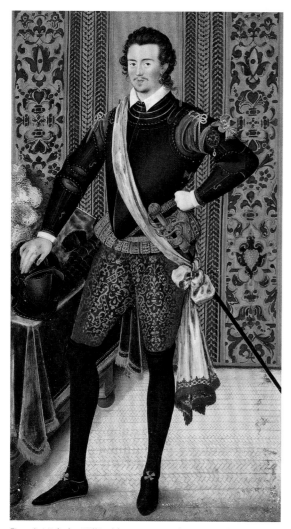

Fig. 78. Nicholas Hilliard (ca. 1547–1619), *Portrait of Sir Robert Dudley*, ca. 1590–95. Watercolor on vellum, 7⅜ × 4¼ in. (18.9 × 10.8 cm). Nationalmuseum, Stockholm (NMB 1669)

head wᵗʰ a bullett, both being very dangerous escapes."[8] Circular canvas tents like the one depicted here were typically associated with military campaigns but may also have served as temporary quarters for contestants in tournaments, many of which went on for days. A comparable tent in a portrait of Robert Devereux, 2nd Earl of Essex, produced in Hilliard's workshop has been interpreted as an allusion to "the proven military experience which lay behind Essex's performance on the tiltyard."[9] Mildmay's military experience, on the other hand, was limited to his service in quashing the Northern Rebellion in 1569. The large black chest to the right of the composition, bound with silvered iron straps, presumably would have stored Mildmay's beautifully decorated Greenwich armor when not in use (see cat. 72).[10] The folded garment draped over the chest—trimmed in glittering gold and lined with blue silk—may be something similar to the resplendent tunic worn by Cumberland over his tilting armor in Hilliard's likeness of him. MEW

Notes to this entry appear on p. 314.

75. The Luttrell Table Carpet

Designed by an unknown artist, probably English, after ca. 1520
England or the Southern Netherlands, 1514–80
Wool (warp), wool, silk, silver, and gilded-silver metal-wrapped threads (wefts), 76 × 217 in. (193 × 551 cm)
Burrell Collection, Glasgow (47.3)

The bold patterning characterizing this table carpet renders it quite unlike anything woven in the Southern Netherlands, or anywhere else in mainland Europe, in the sixteenth century. The design of interlocking quatrefoils, circles, and squares in brilliant yellow, orange, and green is made all the stronger by the intensity of the black ground. These motifs are interspersed with regularly spaced, boss-like roses, honeysuckle, and daisies, the result appearing like some brilliantly colored, pliable reflection of a Tudor plasterwork ceiling.[1]

Ceremonial table carpets, designed to be displayed flat on tabletops, with the armorials on their broad borders correctly oriented to hang downward at all four sides, were part of an established tradition across Europe. Contemporaneous examples made for English clients are numerous, although most were executed in considerably cheaper needlework or knotted by hand (see fig. 73).[2] The Luttrell and Lewknor table carpets (cat. 70) are distinctive as more expensive tapestries, clarifying to all who beheld them the prestige of their owners, both in terms of heraldic lineage, proclaimed by the conspicuous armorials, and in terms of their wealth, sophisticated artistic taste, and logistical capabilities, indicated by the tapestry medium.

was recalled to England in August 1597. His remaining years were quiet ones; upon Mildmay's death in 1617, his will designated funds for an impressive monument in the church of Saint Leonard's, Apethorpe, which "served to commemorate with egregious splendour a life singularly devoid of distinction."[5]

Although it cannot be proven, it is assumed that Hilliard memorialized Mildmay in the process of arming himself for a joust.[6] Unlike George Clifford, 3rd Earl of Cumberland, the subject of another of Hilliard's elaborate cabinet miniatures (cat. 73), Mildmay is not listed as a participant in any of Elizabeth's famed Accession Day tilts.[7] He evidently did compete in other tilts, however: shortly after Mildmay's death, his widow recalled the injuries sustained by her husband in such tournaments: "In running at tilt he had a splinter of a launce rann farre into the middest of his forehead; another tyme he was stricken on the

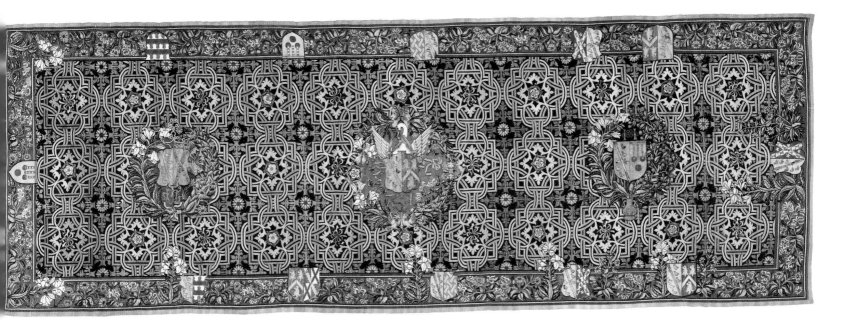

As the central armorial makes clear, this tapestry was commissioned by Sir Andrew Luttrell and his wife, Margaret Wyndham, who married in 1514. Contemporaries would have recognized the swan bearing these arms as an allusion to the family's vaunted, if somewhat stretched, royal connection: Sir Andrew's grandmother, Elizabeth Courtenay, was a granddaughter of Margaret de Bohun, kinswoman of Mary de Bohun, the wife of the Lancastrian king Henry IV and mother of Henry V. The armorial to the right, against a black ground (probably denoting that both were deceased), is that of his grandparents, Sir James Luttrell and Elizabeth (she of the Bohun roots); that to the left, against the half-orange, half-black ground, is that of his parents, Sir Hugh Luttrell (still living) and Margaret Hill (deceased).[3] The same three coats of arms are repeated in the borders, accompanied by four additional arms recording further family connections. In the patterned ground, marguerite daisies, playing

Fig. 79. Hans Eworth (ca. 1525–after 1578), *Portrait of Sir John Luttrell*, 1550. Oil on panel, 43¹⁄₁₆ × 33 in. (109.3 × 83.8 cm). Courtauld Gallery, London (P.1947.LF.119)

on Margaret's name, center each of the circles with Tudor roses alternating with honeysuckle at the center of each quatrefoil.

The Luttrells enjoyed particular prosperity under the Tudors: an entrenched Lancastrian family, they had suffered under Edward IV, who confiscated the family's estates at Dunster. Sir Andrew's father, Sir Hugh, had been among those who welcomed Henry VII when he was still simply the Earl of Richmond, fighting alongside him at the Battle of Bosworth Field. Following his coronation, Henry VII restored Dunster to Sir Hugh, creating him a Knight of the Bath in 1487. Sir Andrew himself had been an attendant servitor at Anne Boleyn's coronation. His son Sir John, eloquently portrayed by Hans Eworth (fig. 79), continued the family's connection with the Tudors and served as a military captain and diplomat for both Henry VIII and Edward VI, fighting—and eventually being captured—in the so-called War of Rough Wooing (attempting to force a marriage between Edward and Mary, Queen of Scots).[4]

The virtuosity of technique implies that the tapestry must have been the work of highly trained Netherlandish weavers. The eccentricity of the knotwork pattern—recalling contemporary English embroidery and garden design (fig. 56), as well as plasterwork—and the necessarily correctly detailed heraldry, on the other hand, suggest a local, English designer. The English-made painted cartoon could have been sent to Flanders to be woven. Alternatively, and perhaps more likely, the tapestry was woven by a member of the fledgling community of émigré Netherlandish tapestry weavers settling in Southwark. Certainly, the extraordinary unfaded intensity of the dyes, especially the black, yellow, and blue, is more characteristic of English-sourced dyed wools surviving from this period (see fig. 42).[5] EC

Notes to this entry appear on p. 314.

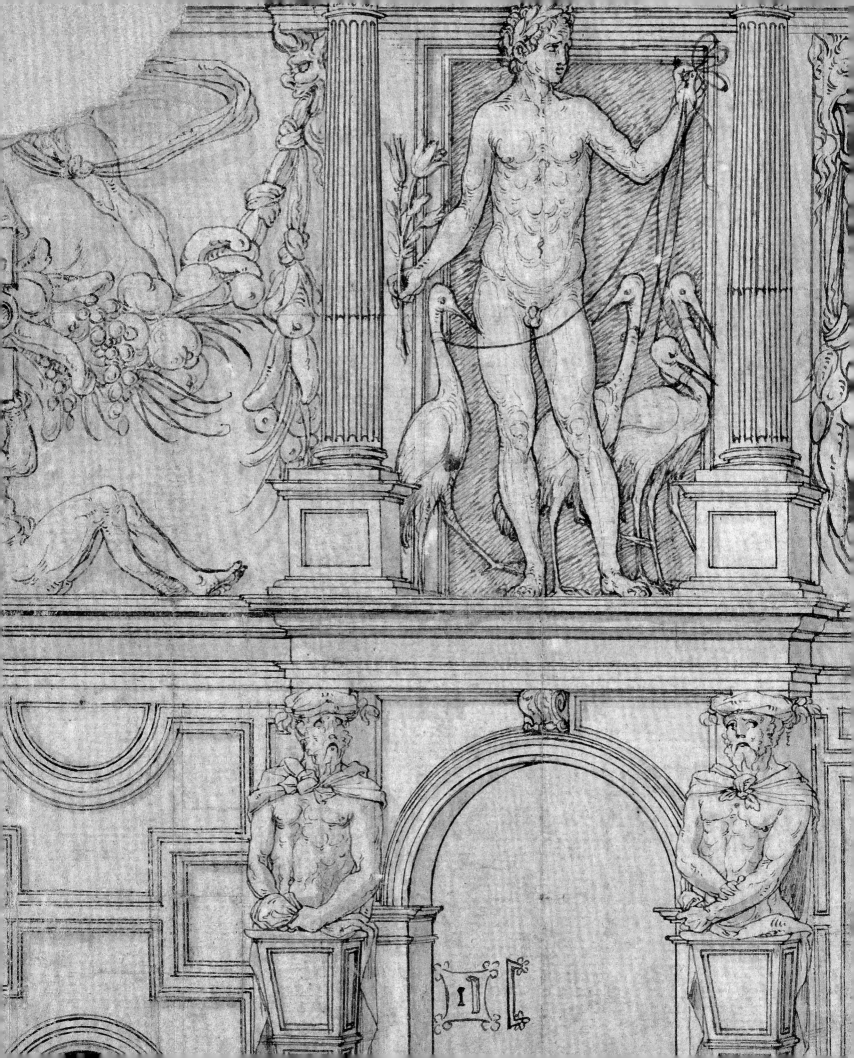

COURTLY IDENTITY

Hans Holbein and the Status of Tudor Painting

Adam Eaker

The prominent place of Hans Holbein the Younger within this volume, as both a portraitist and a designer of sumptuous court objects, reflects an outstanding status in the canon of Tudor art that he has enjoyed since at least the early seventeenth century. For example, Lucy Harington, Countess of Bedford, described herself in a letter of March 7, 1618, as "a very diligent gatherer of all I can gett of Holben's or any other excellent master's hand," declaring she would "rather have them then juels."[1] The countess perceived her collecting as a mark of distinction, recalling that "Som of those I have, I found in obscure places, and gentleman's houses, that, because they wear old, made no reckoning of them." Gathering these "many excellent unknown peeses" with a connoisseur's eye, she embodied a new appreciation for older art, and Holbein in particular, among the English aristocracy.[2] Just a year after the Countess of Bedford's letter, Thomas Howard, 14th Earl of Arundel, thanked a correspondent for indulging his "foolish curiosity" about Holbein;[3] indeed, a number of the artist's works reproduced in these pages were once part of Arundel's storied collection (cats. 51, 83, 85). For Jacobean collectors, Holbein, the portraitist of their grandparents' or great-grandparents'

Fig. 80. Hans Holbein the Younger (1497/98–1543), *The Ambassadors*, 1533. Oil on oak, 81½ × 82½ in. (207 x 209.5 cm). National Gallery, London (NG1314)

generations, had become a byword for artistic achievement.

Holbein's position within the canon of art history is unique for a painter working in Tudor England. Indeed, most commentary on painting from this period has lamented its shortcomings, particularly in comparison to the storied achievements of Tudor poets and playwrights. Writers have likewise emphasized the foreign birth of leading early modern painters active in England, like Holbein. In his translator's preface to an Italian artistic treatise in 1598 (the first such treatise to be published in English), Richard Haydock ruefully acknowledged that the art of painting "never attained to any great perfection amongst us."[4] Two centuries later, Horace Walpole claimed that England "has very rarely given birth to a genius in that profession [painting]. Flanders and Holland have sent us the greatest men that we can boast."[5] This attitude persisted well into the twentieth century.

In the postwar period, the exhibitions and publications of Sir Roy C. Strong made an eloquent argument for the reassessment of Tudor painting, using connoisseurship to establish individual artists' bodies of work and deciphering their political and

Fig. 81. Lucas Vorsterman the Elder (1595–1675), after Hans Holbein the Younger (1497/98–1543), *The Triumph of Poverty*, ca. 1624–30. Pen and brown ink, with bodycolor and wash, 17⅛ × 23 in. (43.4 × 58.5 cm). The British Museum, London (1894,0721.2)

literary symbolism.[6] More recently, scholars have contributed immensely toward a broader picture of Tudor painting, with a focus on archival research and the technical examination of these often poorly preserved works.[7] Such scholarship, emphasizing workshop practices, has shown the degree to which Tudor artists embraced varying "degrees of authorship" in ways very different from the post-Renaissance model of artistic individuality and genius.[8] Recent discoveries about the dating of works long believed to be later copies have given a better picture of the earliest Tudor painting, well before Holbein's arrival in England.[9] Scholars have likewise shown the wide diffusion of painting in Tudor society, beyond the elite world of the court, into the mercantile classes and regional centers.[10] By contrast, this volume's examination of royal patronage and cosmopolitan exchanges returns the focus to Holbein and his legacy for such court portraitists as Hans Eworth and Nicholas Hilliard. In doing so, it reconstructs an artistic lineage that was very much operative in the minds of these elite Tudor artists. Their historical self-consciousness was one element in a radical shift in the understanding of painting at the highest level of English society over the course of the Tudor period.

The frequency with which Holbein's name occurs in sources from the early seventeenth century contrasts with the scarcity of records from his own lifetime and the uneven survival of his artistic creations.[11] Fire and other depredations have destroyed his monumental paintings, the metalwork he designed, and much of the documentary record. Major commissions, like the large-scale *Triumphs of Riches and Poverty* for the Guildhall of

the London Steelyard, are known to us now only through later copies (fig. 81).[12] Our appreciation of Holbein today primarily as a portraitist derives from the far greater survival of his portraits and offers only a very partial vision of his English career. Further complicating efforts to reconstruct his work at the English court, the two inventories of Henry VIII's household goods, from 1542 and 1547, give the subjects of paintings but not artists' names.[13] Continental humanists praised Holbein as a "second Apelles," referring to one of the most celebrated artists of antiquity, but such an attitude made only gradual inroads among the English aristocracy.[14] Holbein's shifting reputation, from a valued court functionary to a posthumously coveted "old master," provides an illuminating case study for the evolving status of painting and painters in early modern England.

The absence of attributions from early Tudor inventories reinforces a long-standing argument that a recognizably modern appreciation of painting, focused on the genius of individual painters, emerged at the English court only in the first decades of the seventeenth century.[15] While the Elizabethan favorite Robert Dudley, Earl of Leicester, provides a counterexample of wide-ranging and sophisticated collecting (cats. 66, 67), Leicester's inventories, like those made for Henry VIII, "provide virtually no attributions."[16] Holbein's work for the court of Henry VIII speaks to painting's reception in Tudor England as a valued but above all functional craft. Tudor court painters supplied coats of arms, designs for metalwork, and decorative backdrops for court pageantry. Even many of the panel portraits that now hang as masterpieces in museums served an eminently

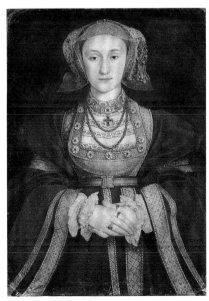

Fig. 82. Hans Holbein the Younger (1497/98–1543), *Anne of Cleves*, ca. 1539. Parchment mounted on canvas, 25⅝ × 18⅞ in. (65 × 48 cm). Musée du Louvre, Paris (1348)

Fig. 83. Nicholas Hilliard (ca. 1547–1619), *Self-Portrait, Aged 30,* 1577. Watercolor on vellum, laid on card, Diam. 1⅝ in. (4.1 cm). Victoria and Albert Museum, London (P.155-1910)

Fig. 84. Unknown artist after Hans Holbein the Younger (1497/98–1543), *Hans Holbein the Younger,* mid- to late 16th century. Bodycolor on vellum, laid on playing card, Diam. 1¾ in. (4.4 cm). Wallace Collection, London (M203)

practical function: giving a sense of a prospective spouse's appearance as part of a marriage negotiation.[17] Holbein enjoyed a relatively high status at Henry's court, as indicated by his salary and prestigious or politically sensitive commissions. His astonishing mimetic gift, almost unrivaled in the history of Western art, meant that he was entrusted with the task of portraying potential brides for the king (fig. 82).[18] Yet all these enterprises point to Tudor painting's divergence from modern notions of the autonomous work of art. Italian humanists had only just begun to articulate this elevated position for painting, which first began to take root in England toward the end of the sixteenth century with translations of Italian texts like Haydock's rendition of Giovanni Paolo Lomazzo, cited above.

In contrast to Tudor inventories, the nascent English-language art writing of the late Elizabethan period sought to elevate representatives of the local tradition, as "the naming of specific artists increasingly became a means of asserting national pride."[19] For an ambitious native-born artist like Nicholas Hilliard, Holbein provided a rare example of an internationally celebrated artist who had worked in England and focused on portraits.[20] In his treatise on the art of "limning," or miniature painting, written near the turn of the seventeenth century in response to Haydock's translation of Lomazzo, Hilliard praised Holbein as "the greatest Master truly in both thosse arts after the liffe [i.e., painting in large and in miniature] that ever was."[21] But while Hilliard professed that "*Holbeans* maner of *Limning* I have ever Imitated,"[22] there are striking divergences between the two artists.

Two miniatures—Holbein's *William Roper* (cat. 87) and Hilliard's portrait of a young man often identified as Robert

Devereux (cat. 109)—provide an instructive pairing. Both portraits use bodycolor on vellum to depict male sitters against blue backgrounds, atop which hover gilded inscriptions giving the subjects' ages. But Holbein's work layers minute brushstrokes to mimic the modeling effects of oil painting, offering a vivid evocation of his middle-aged sitter's weathered and ruddy complexion, reinforced by the wrinkles around his eyes and the gray in his locks and whiskers. Hilliard, by contrast, uses a uniform layer of "carnation," or flesh tone, applied to the vellum in advance of the portrait sitting.[23] Calligraphic stippling and short, curved strokes of the brush suggest the sitter's jawline and whiskers but do not interfere with the impression of an immaculate and ideal beauty. In avoiding shading or strong modeling on the face, Hilliard catered to the taste of his most important patron, Elizabeth I. As the artist himself recorded, during a portrait sitting he and the queen had agreed "that best to showe ones selfe, nedeth no shadow," that is, that strong modeling in a portrait impeded likeness.[24] Hilliard's depiction of Devereux's costume is likewise flat and ornamental, in contrast to the solidity of Roper's fur-lined robe in Holbein's miniature.

The admiration Hilliard felt for Holbein may have had almost as much to do with the standing he achieved at court as with his actual artwork. Hilliard's self-portrait from 1577, now in the Victoria and Albert Museum, London, is, in the words of a recent biographer, "an extraordinary act of self-fashioning," in which "Hilliard presents himself in both garb and mien as barely distinguishable from his aristocratic patrons" (fig. 83).[25] Here, Hilliard appears to be responding to Holbein's own self-portrait, which survives in a limned copy sometimes attributed to Lucas

Horenbout (fig. 84).[26] In this work the artist's brush breaks the frame of the vellum roundel, as though he were in the process of making the portrait we see before us.

At roughly the same time that Hilliard wrote his treatise, the Dutch artist and writer Karel van Mander composed a biography of Holbein that attributed to him an extraordinary degree of self-confidence. According to Van Mander:

> it happened that on a certain occasion an English earl came to visit Holbeen [sic] because he desired to see his works of art. . . . For Holbeen (who was painting something from life or doing something private) this was most inconvenient, he therefore refused the earl very courteously two or three times for this occasion and requested him to pardon the refusal as he was otherwise engaged. . . . But whatever friendly and humble arguments Holbeen used the earl would not be put off and insisted, against his wishes, to come up the stairs at all costs — because he felt that his person should be treated with more honour and respect by a painter. Holbeen, having warned him to stop his insolent rudeness and then the other persevering anyway, took hold of the earl and threw him downstairs.[27]

Van Mander further claimed that when the earl, "carried on a stretcher," sought out the king to avenge himself, he offended Henry with his arrogance, causing Henry to assert, "I tell you earl that I can make seven earls (if it pleased me) from seven peasants—but I could not make one Hans Holbeen, or so excellent an artist, out of seven earls."[28]

While clearly invented, Van Mander's anecdote reveals that, by the end of Elizabeth's reign, Holbein had come to represent painting's nobility, and the degree to which artistic talent might, at least in the imagination of painters, outweigh aristocratic birth as a claim to royal favor.[29] More plausibly, Van Mander recorded "that when Federigo Zuccaro was in England in about the year 1574, he copied [Holbein's portraits] with great diligence with his own hand in pen and wash, at which he declared that these works are just as good and as well executed as if they had been by the hand of Raphael of Urbino."[30] (The trope of an English or, in Holbein's case, naturalized portraitist surpassing Raphael appears to have appealed to late sixteenth-century writers. About 1590, Henry Constable made a similar claim for Hilliard, in a sonnet on the latter's miniature portrait of Penelope, Lady Rich; see fig. 89).[31] According to Van Mander, Zuccaro "also very much admired a portrait of a Countess, full-length and life-sized, dressed in black satin, most excellently accurate and well-made by the art-full Holbein . . . it pleased him so much that he said that he never saw anything like it with regard to artistry and neatness in Rome."[32] If, as seems likely, this portrait was in fact Holbein's *Christina of Denmark, Duchess of Milan* (see

Fig. 85. Detail of Hans Eworth's *Mary Neville, Lady Dacre* (cat. 92), showing a portrait of Thomas Fiennes, 9th Baron Dacre

fig. 115), then its full-length format, prominently featuring elegant fingers that toy with a fashionable accessory, may have inspired Zuccaro's portrait drawing of Elizabeth I (cat. 108).[33]

Such visual citations of Holbein abound in Tudor portraiture, complementing the literary references to his life and work. They are particularly apparent in the work of Hans Eworth, the most gifted artist at the English court in the years immediately following Holbein's death. Eworth's debt to Holbein is most apparent in his portrait of Mary Neville, Lady Dacre (cat. 92), which brims with references to Holbein's portrait of the Hanseatic merchant Georg Gisze (fig. 107), as well as a portrait-within-a-portrait that may refer to a Holbein original or be Eworth's own Holbein-esque pastiche (fig. 85). Including this represented portrait within his own, Eworth positioned himself as Holbein's heir, much as Hilliard would do in his treatise.

Despite his gifts and sophistication, Eworth fell out of favor with the accession of Elizabeth I. The queen, unlike her father, exerted tight control over her official image and pursued an aesthetic that had little to do with Holbein's mimetic realism. Indeed, much of Holbein's work was disregarded or neglected in the decades before his Jacobean revival. The portraits, however, survived because of their function in long-standing practices of aristocratic commemoration and ancestral memory. Tucked away in country houses, these remarkable documents of Henry VIII's court awaited rediscovery by the connoisseurs of a later age.

Notes to this essay appear on p. 315.

Fashioning the Courtier

Adam Eaker

At the start of act 3 of Shakespeare's tragedy *Richard II*, written late in the reign of Elizabeth I, Henry Bolingbroke berates the men who have alienated him from the king and whom he now sentences to death:

> Myself, a prince by fortune of my birth,
> Near to the King in blood, and near in love
> Till you did make him misinterpret me,
>
>
>
> Whilst you have fed upon my signories,
> Disparked my parks, and felled my forest woods,
> From my own windows torn my household coat,
> Razed out my impress, leaving me no sign,
> Save men's opinions and my living blood,
> To show the world I am a gentleman.
>
> (3.1.16–18, 22–27)[1]

Bolingbroke's speech imagines aristocratic dispossession as the erasure of his "household coat" or "impress," the coat of arms that provides the outward "sign" of his status as a gentleman. Outside the theater, heraldry could be a matter of life and death for Tudor courtiers. In 1540, a coat decorated with the royal arms served as evidence in the trials for treason of the Countess of Salisbury and the Marchioness of Exeter, bearing witness to their continuing support for the rival Yorkist claim to the throne.[2] In 1547 Henry Howard, Earl of Surrey, was indicted (and eventually beheaded) on charges including that he had "openly used, and traitorously caused to be depicted, mixed and conjoined with his own arms and ensigns, the said arms and ensigns of the King" (see cat. 98).[3] Refusing to confess, Surrey defiantly wore a new satin coat to his trial.[4]

The significance of both the coat of arms and the coat of satin as outward signs of aristocratic status or even personhood

speaks to the essential role played by objects, clothes, and images in the creation of identity at the Tudor courts. Within English art, coats of arms had a longer tradition than mimetic portraiture. (The sculpted likenesses on medieval tombs were generic types, not accurate physiognomies.) Heraldic badges decorated livery and distinguished servants as members of a royal or aristocratic household (fig. 86).[5] Portraits of the armigerous might prominently juxtapose a likeness with a coat of arms, reinforcing the sitter's identity with two distinct forms of representation (fig. 87). Some Tudor artists, like Sir William Segar, were specialists in both portraits and heraldic art, with Segar serving for several decades as head of the College of Arms, the official regulatory body for English heraldry.[6]

In the Tudor period the heraldic and genealogical preoccupations of the nobility were joined by another model of courtly subjectivity, expressed in the Italian term *sprezzatura*, denoting an elegant and self-possessed nonchalance that one Tudor courtier translated as "recklessness."[7] The sophisticated courtier-poets in the service of Henry VIII, such as the Earl of Surrey and Sir Thomas Wyatt, were avid readers of Italian literature and thus familiar with the model of aristocratic selfhood articulated in such texts as Baldassare Castiglione's *The Courtier* (*Il libro del cortegiano*, 1528). Castiglione, first translated into English in 1561, promoted "knowledge in painting" as an essential courtly

Fig. 86. *Livery Badge for the Household of Arthur, Prince of Wales*, before 1502. Lead alloy, H. 2⅜ in. (6 cm). Museum of London (82.8/16)

attribute, and such an attitude became more widely diffused among English aristocrats in the second half of the sixteenth century.[8] Indeed, the Elizabethan courtier-poet-soldier par excellence, Sir Philip Sidney, distinguished himself with a knowledge of Venetian painting and sat for a now lost portrait by Paolo Veronese (see fig. 111).[9]

The notion that Tudor courtiers constructed their identities through objects, clothing, and public performance owes much to Stephen Greenblatt's argument about the significance of "self-fashioning" to Renaissance culture.[10] Although its subsequent wholesale application across the field of early modern art history has had the unintended effect of diminishing the agency of artists in favor of their patrons, this thesis remains a powerful tool for understanding the culture of the Tudor court. Writing about the poetry of Sir Thomas Wyatt, Greenblatt describes "techniques of self-fashioning" as "weapons in a struggle for power and precedence in which sexual relations are fully implicated."[11] Such a description can also help us recover the urgency and high stakes behind seemingly placid portraits or gilded artifacts.

Following on a devastating civil war, the threat of rebellion haunted the provisional stability of the Tudor period. Organized violence in the form of hunts, tournaments, or duels gave Tudor courtiers outlets for aggression and bodily display. The late Elizabethan historian Robert Naunton captured this climate of male competition for royal favor in an anecdote about the rivalry between Charles Blount, later Baron Mountjoy, and Robert Devereux, Earl of Essex:

> My Lord of *Mountjoy*, who was another child of her [Elizabeth I's] favour, being newly come [to court] . . . had the good fortune to run one day very wel at Tilt, and the Queene was therewith so well pleased, that she sent him in token of her favor, a Queene at *Chesse* in [g]old, richly enamelled, which his Servants had the next day, fastened unto his Arme, with a crymson Ribband, which my Lord of *Essex*, as he passed through the *Privy Chamber*, espying . . . said, now I perceive, every foole must have a favor: This bitter and publique affront, came to [Blount's] eare, at which he sent him the challenge which was accepted by my Lord, and they met neare *Marybone Parke*, where my Lord was hurt in the Thigh, and disarmed . . . and here I note the Iminition [beginning] of my Lords friendship with *Mountjoy*.[12]

At the eroticized court of Queen Elizabeth I, where masculine beauty and athletic prowess could launch a political career, the uneven distribution of favor—here literalized in the form of a gold chess piece—could boil over into violence. But, as Naunton's anecdote reveals, that violence was also a form of same-sex emulation and bonding. The post-duel friendship

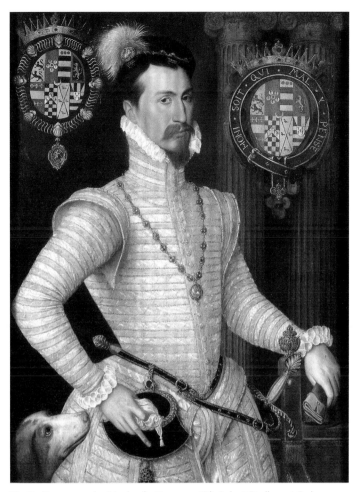

Fig. 87. Steven van der Meulen (active 1543–68), *Robert Dudley, 1st Earl of Leicester, with Dog*, ca. 1564. Oil on panel, 43¼ × 31½ in. (110 × 80 cm). Waddesdon Manor, Rothschild Collection (14.1996)

he records between Mountjoy and Essex finds its analogue in Nicholas Hilliard's miniature portraits of the two men, in which they fashioned themselves according to the same standard of late Elizabethan male beauty (fig. 88 and cat. 109).

Henry VIII's official image, with its massive silhouette, wide-legged frontal stance, and prominent codpiece, made male sexual aggression synonymous with majesty (see fig. 92).[13] Ambitious male courtiers risked disgrace or even death when they intruded too boldly into the space of Henry's Privy Chamber or flirted openly with his queens.[14] His daughter Elizabeth I defused this legacy in promoting a cult of virginity and turning every male courtier into a potential suitor. The queen's appreciation of masculine good looks survives in her coquettish responses to the portraits of potential bridegrooms, as when she noted, upon reading the inscription on the duc d'Alençon's portrait (cat. 99), "that he was not yet half her age."[15] Fencing doublets of the period (cat. 100) attest to the athletic silhouette of the later

Fig. 88. Nicholas Hilliard (ca. 1547–1619), *Charles Blount, 8th Baron Mountjoy and Earl of Devonshire*, 1587. Watercolor on vellum. National Trust, Antony House, Cornwall, Trustees of the Carew Pole Family Trusts

Fig. 89. Nicholas Hilliard (ca. 1547–1619), *An Unknown Woman, Likely Penelope, Lady Rich*, ca. 1589. Watercolor and bodycolor, with gold and silver, on vellum, 2¼ × 1¾ in. (5.7 × 4.6 cm). The Royal Collection / HM Queen Elizabeth II (RCIN 420020)

sixteenth century in which a "peascod belly" replaced the cod-piece, ideally set off by a pair of shapely legs in hose.

For their part, female courtiers might use fashion to emulate the queen, adopting her padded sleeves and farthingale, as well as her personal colors of white and black (cat. 102). Such women aspired to a position in Elizabeth's Privy Chamber that could be the conduit for personal enrichment and political capital.[16] Great court beauties might became figures of fascination in their own right, but they risked the queen's ire if they infatuated her male favorites or married without her permission.[17] The Earl of Essex's sister, Penelope, Lady Rich, inspired the sonnets of Sir Philip Sidney and sat for miniature portraits by Hilliard that circulated as diplomatic gifts.[18] She had a long-term adulterous affair with her brother's erstwhile dueling opponent, Lord

Mountjoy; he notably wore her colors at the Accession Day tilt in 1590 in another instance of the signifying capacity of Tudor fashion.[19] A full-length miniature portrait by Hilliard, plausibly identified as Lady Rich, reveals the degree to which some court women appropriated the queen's colors, silhouette, and anodyne "mask of youth" (fig. 89).[20]

The word "fashion" itself gained a much wider currency in the Renaissance to denote the rapidly shifting tides of taste and style, newly associated with the expression of individual identities.[21] Sumptuary laws in force under Tudor rule attempted to stabilize social hierarchies by restricting access to specific luxury materials such as sable, velvet, or cloth of gold.[22] Portraits in this period commemorated not only the appearance of individual sitters, but also the clothes they were entitled to wear, which

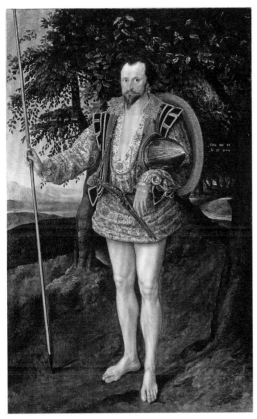

Fig. 90. Marcus Gheeraerts the Younger (1561–1635/36), *Captain Thomas Lee*, 1594. Oil on canvas, 90¾ × 59⅜ in. (230.5 × 150.8 cm). Tate Britain, London (T03028)

Fig. 91. Isaac Oliver (ca. 1565–1617), *A Young Man Seated Under a Tree*, ca. 1590–95. Watercolor on vellum, laid on card, 4⅞ × 3½ in. (12.4 × 8.9 cm). The Royal Collection / HM Queen Elizabeth II (RCIN 420639)

invariably cost vastly more than the paintings themselves.[23] In certain cases these clothes might be theatrical costumes, drawn from the world of the masque and conveying specific messages from courtier to monarch (see, for example, cat. 112). In one of the most astonishing of Elizabethan portraits, the disgraced soldier Thomas Lee pleads for royal forgiveness in an embroidered undershirt and the bare legs associated with the Irish soldiers he had battled in the queen's colonial wars (fig. 90). It is, as one commentator has noted, a costume that combines "a shirt fit for making courtly love" with "a form of cultural cross-dressing involving imperial ambitions."[24]

Despite the signification of surfaces in Tudor art, late Elizabethan portraiture reveals experimental attempts to manifest the inner life through tokens of melancholy.[25] In a cabinet miniature by Hilliard, Henry Percy, Earl of Northumberland, reclines in a garden, resting his head on one hand while his book, hat, and gloves lie discarded on the grass beside him (cat. 110). He wears simple black, and his shirt is disheveled. A handkerchief clutched in one hand hints at recent weeping. In place of dynastic heraldry, the background contains esoteric personal devices and a motto. Yet the very proliferation of such imagery among the elegant young men of the late Elizabethan court cautions against projecting onto it the emergence of a modern or "authentic" selfhood (fig. 91). Instead, the boldness with which these young men performed their melancholy placed them in a long line of courtiers whose "recklessness" was the height of fashion.

Notes to this essay appear on p. 315.

Icons of Rule

Adam Eaker

Under the serried complexities of her raiment—the huge hoop, the stiff ruff, the swollen sleeves, the powdered pearls, the spreading, gilded gauzes—the form of the woman vanished, and men saw instead an image—magnificent, portentous, self-created—an image of regality, which yet, by a miracle, was actually alive.[1]

Two of the Tudor monarchs, Henry VIII and Elizabeth I, are among the most recognizable figures in history. Their characteristic silhouettes, in which padding and posture convey, respectively, exaggerated masculinity and femininity, were part of a conscious strategy of self-presentation and legitimation. Over the course of their long reigns, their official iconography evolved, with consequences for their courtiers, rivals, and successors. All five Tudor monarchs were the subjects of portraits whose nuances reflect the differing circumstances of their reigns and the artistic climates they fostered. Even as they sought to convey an image of timeless legitimacy, the Tudor monarchs were key innovators who reshaped the royal image in England.[2]

The early Tudor royal portraits in this volume of Henry VII and his daughter Mary (or perhaps his daughter-in-law, Katherine of Aragon) reveal the dependence of early sixteenth-century English patrons on Flemish-trained artists and the legacy of Burgundian court portraiture (cats. 3, 13). Both portraits are bust-length,

with Henry's including the traditional device of a fictive parapet on which the king rests his hands. These likenesses combine realistic physiognomic detail—the king's stubble, the princess's soft chin—with the signifying attributes of royal jewelry such as Henry VII's Order of the Golden Fleece or the princess's

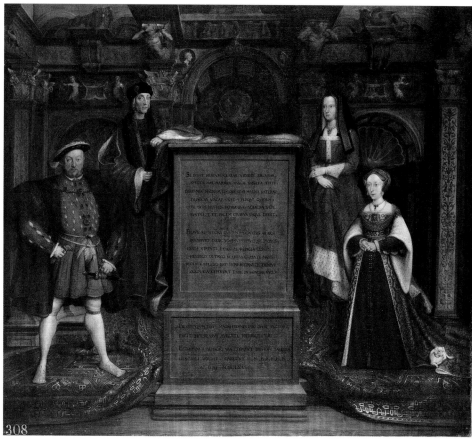

Fig. 92. Remigius van Leemput (1607–1675), after Hans Holbein the Younger (1497/98–1543), *Henry VII, Elizabeth of York, Henry VIII, and Jane Seymour*, 1667. Oil on canvas, 35 × 39 in. (88.9 × 99.2 cm). The Royal Collection / HM Queen Elizabeth II (RCIN 405750)

There is fragmentary evidence for full-length portraits from the early Tudor period as well. For instance, one such representation of Lady Margaret Beaufort, matriarch of the Tudor dynasty, was recently discovered to have been painted shortly after her death in 1509 (fig. 93).[6] In this painting, Lady Margaret kneels at prayer in a richly decorated oratory, in a pose derived from the donor figures of fifteenth-century altarpieces (fig. 94). Such images temper royal majesty with a traditional expression of piety that would be revived in the stained-glass windows commissioned by Mary I and Philip II for the Sint-Janskerk in Gouda (cat. 28).

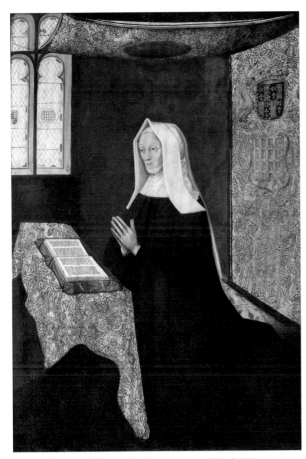

Fig. 93. Meynnart Wewyck (active ca. 1502–25), *Lady Margaret Beaufort*, ca. 1510. Oil on panel, 70⅞ × 48 in. (180 × 122 cm). The Master and Fellows of Saint John's College, Cambridge

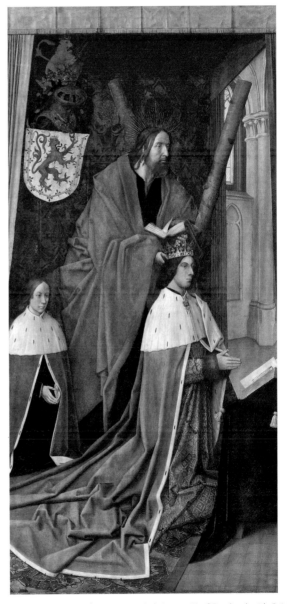

Fig. 94. Hugo van der Goes (ca. 1440–1482), *James III of Scotland with Saint Andrew and Prince James*, from the Trinity Altarpiece, ca. 1478. Oil on panel, 79½ × 39⅝ in. (202 × 100.5 cm). The Royal Collection / HM Queen Elizabeth II (RCIN 403260), on long-term loan to the Scottish National Gallery, National Galleries of Scotland, Edinburgh (NG 1772)

chain of golden *K*'s. The paintings were likely meant to travel as aids to marriage negotiations, a key function of royal likenesses throughout the Tudor period. As early as 1488, Henry VII expressed the desire to dispatch an image of the infant Arthur, Prince of Wales, to Spain, as part of the negotiations for his betrothal to Katherine of Aragon.[3] A few years later, the king sent a group of four family portraits to Scotland in advance of his daughter Margaret's marriage to James IV, so that the princess might "be presented pictorially to her future husband as part of the recently-founded Tudor dynasty."[4] Such visual family trees and dynastic portrait sets became especially popular in the Elizabethan period, with ever more intervening layers between the portrait and a prototype made from life, if such a prototype ever existed.[5]

Seeking to shore up dynastic legitimacy in the face of various crises of succession, the later Tudors commissioned images of their forebears, often on the basis of earlier panel portraits or tomb sculptures, as in Holbein's depiction of Henry VII and Elizabeth of York for the great mural at Whitehall (fig. 92).

Henry VIII radically altered the royal portrait with the life-size image he commissioned from Hans Holbein the Younger for the Privy Chamber at Whitehall, and the many copies on panel painted by Holbein's followers (see fig. 17).[7] These images are critical to an understanding of how Henry refashioned the English monarchy through his images as well as his policies. In the words of one commentator, "It is difficult to view the Holbein-derived images of Henry VIII without a sense of extreme familiarity, but, confronted for the first time with Holbein's image, sixteenth-century viewers might have found it alarming and unsettling. The unwavering gaze of a frontal portrait might have been regarded as indecorous for most people and most occasions."[8] Indeed, in the early seventeenth century, the Dutch art writer Karel van Mander recorded that the Whitehall portrait was "so lifelike that anyone who sees it is afraid."[9]

On the opposite end of the spectrum in terms of scale, miniature portraits were another innovation of Henry VIII's reign, resulting in portable images that fellow monarchs and prospective spouses might hold in their hands (cats. 77, 78). Receiving one of the first English portrait miniatures, an image of Henry VIII, in 1527, François I of France bared his head in a mark of respect and exclaimed, "I pray to God to give him a good and long life."[10] This episode reveals the extent to which portraits functioned as surrogate bodies, representing monarchs to their distant peers and rivals. The small scale of the miniature aided its mobility, as well as its handling and display as an intimate jewel.

Both the life-size, full-length portrait and the miniature persisted as key genres for Henry's surviving children. Henry's much-desired male heir, Edward VI, was assimilated to his father's iconography from his earliest days (cat. 51). In an effort to counter his image as a fragile and sickly Prince of Wales, Edward adopted his father's aggressive posture from the Whitehall mural, with padded torso, codpiece, and martial stance (fig. 95). Other images of Edward draw upon a more humanist prototype, the profile portrait, with its allusions to ancient medals and cameos (cat. 24). In one remarkable example, Edward's likeness appears in anamorphosis, transforming the portrait into a courtly curiosity intending to startle and dazzle visitors to the palace (cat. 93). Beyond explicit formal borrowings from their predecessors' representations, Tudor monarchs asserted historical continuity through the inheritance of jewels, tapestries, and furnishings. One scholar has argued, for instance, that in the Ditchley portrait, Elizabeth I not only provides a feminine redaction of her father's massive, padded silhouette, but also wears the jeweled "truelove" buttons she inherited from him (cat. 119).[11]

Fig. 95. Attributed to Guillim Scrots (active 1537–53), *Edward VI*, ca. 1550. Oil on panel, 66⅛ × 34¼ in. (168 × 87 cm). Musée du Louvre, Paris (RF 561)

As England's first queens regnant, Mary I and Elizabeth I faced particular challenges in shaping their personal iconography. Mary's images assimilate her to both English royal tradition and the Habsburg court culture she embraced through marriage to Philip II of Spain; in portraits that emphasize her status as a consort, jewels and a relic from the Crown of Thorns have a powerful symbolic function (cat. 26).[12] It is also in the guise of a Habsburg bride that Mary appears as a donor figure in the stained-glass windows of the Sint-Janskerk (cat. 28). As an unmarried Protestant queen, Elizabeth needed to develop a new iconography, although she may have had recourse to the imagery developed for the short-lived queenship of her mother, Anne Boleyn (cat. 89).[13] Elizabeth's earliest portraits reflected the ongoing negotiations for her hand in marriage, their imagery emphasizing beauty and fertility (cat. 30). The elaborate and esoteric symbolism of her later portraits propagated the cult of Elizabeth's virginity, drawing on the imagery of masques performed in her honor (cats. 119, 120).[14]

Of all the Tudor monarchs, Elizabeth I appears to have gone to the greatest lengths to control her public image. A 1563 draft proclamation sought to satisfy "the natural desires" of the queen's subjects "to procure the portrait and picture of the Queen's majesty's most noble and loving person" by creating an official prototype based on a sitting from life.[15] It is unclear, however, whether one single face pattern was ever adopted. The queen clearly remained concerned about unauthorized portraits throughout her reign, as the Privy Council issued a warrant in 1596 to the Serjeant-Painter enjoining him to deface the work of "divers unskillful artizans in unseemly and improperly paintinge, gravinge and printing of her Majesty's person and vysage."[16] The queen and her counsellors had good reason to be concerned;

Fig. 96. Daniel Mytens (ca. 1590–1647/48), *James I of England and VI of Scotland*, 1621. Oil on canvas, 58½ × 39⅝ in. (148.6 × 100.6 cm). National Portrait Gallery, London (NPG 109)

writing from Paris in 1583, Elizabeth's ambassador Sir Edward Stafford reported that "a foul picture of the Queen was set up here [at three locations in the city], she being on horseback, her left hand holding the bridle, with her right hand pulling up her clothes."[17] Although the pictures "were soon pulled down again," they vividly demonstrated the power of scurrilous images to demystify the monarchy.[18]

The Tudors appeared before their subjects not only in painted likenesses on panel and canvas, but also as a legitimizing presence on official documents and coins. On charters and letters patent, illumination served both a beautifying and an authenticating purpose (cats. 25, 31). Medals, like prints, were a reproductive medium that allowed for a wider circulation of the royal image, with a hierarchy established by the use of more or less precious metals. Some medals, like Jacopo da Trezzo's portrait of Mary I (cat. 94), anchored their subjects within a continental language of classicism, while the medals made for Mary's sister, Elizabeth, drew their inspiration from the more recent Anglo-French tradition of miniature portraits (cat. 116).

Alongside the painted portraits that adorned royal palaces and courtiers' homes or circulated in international diplomacy, printed images attest to the Tudor monarchs' harnessing of new media to propagate their reign. Henry VIII's appearance on the title pages of the Coverdale and Great Bibles provided a visual language for the 1534 Act of Supremacy that placed him at the head of the church (cats. 20, 21). Particularly during Elizabeth's reign, prints served to shore up the monarch's reign with elaborate allegories of the succession (cat. 33). But enterprising publishers, some based on the Continent, might also create their own royal likenesses, in some cases depicting the queen with more candor than her official portraits (cat. 121), perhaps prompting the Privy Council warrant discussed above.

The Tudor dynasty came to an end with the death of Elizabeth I in 1603, and with it a distinct portrait tradition based on the overpowering image of royal authority. James I largely rejected the iconography of his Tudor forebears (fig. 96), and the portraits of his son, Henry Frederick, were strikingly innovative in displaying the young prince as a man of action, not a static icon (cat. 123). Nonetheless, through all the evolutions of the British royal portrait up to the present day, the images the Tudor monarchs commissioned of themselves have continued to define the face of majesty in this tumultuous period.

Notes to this essay appear on p. 315.

76. *Portrait Bust of John Fisher, Bishop of Rochester*

Attributed to Pietro Torrigiano (1472–1528)
London, ca. 1510–15
Polychromed terracotta, 24¼ × 26 × 13½ in. (61.5 × 66 × 34 cm)
The Metropolitan Museum of Art, New York, Harris Brisbane Dick Fund, 1936 (36.69)

Among the slew of great Italian sculptors documented or believed to have passed through the Tudor court—Guido Mazzoni, Giovanni di Benedetto da Maiano, Benedetto da Rovezzano—Pietro Torrigiano brought a breathtaking lifelikeness to his work that predated by decades the same quality in Holbein's portraits. In cat. 76, masterfully worked in terracotta, a spark of vivacity emanates from the implied movement of the sitter's slightly turning head, his gaze seemingly resting on an object just beyond our field of vision. The impression of skin stretched tautly over cheekbones, the faintly furrowed brow, and the curls suggesting a full head of hair concealed under a scholar's cap—all products of Torrigiano's incredible skill—conjure the living presence of this centuries-dead Tudor ecclesiastic.

An inherited belief identifies the sitter of this bust as John Fisher, whose drawn portrait by Hans Holbein, made some twenty years later, he certainly resembles.[1] John Fisher, former confessor to Henry VII's influential mother, Lady Margaret Beaufort, was already bishop of Rochester and chancellor of the University of Cambridge by the time this bust was sculpted. He played a crucial role in engaging first Lady Margaret's interest, and then that of her son, in the university, injecting much-needed funding and splendor into its institutions (see cat. 18 and fig. 4). His pedagogical innovations established grammar schools across England, affording educations in Latin and even Greek to broader swathes of the populace.[2] As an ecclesiastic Fisher was unashamedly austere, reputed to have worn a hair shirt beneath his robes, taken his meals accompanied by a priest reading Gregorian homilies, and kept a human skull on the altar as he performed Mass. Fisher's exhortations against material excess (see p. 102 in this volume) were repeated during his funeral sermon for Henry VII, in which he admonished the late king's "buyldynges mooste goodly, and after the newest castall of pleasure. But what is all this now as unto hym? All be but *fumus et umbra*; a smoke that soone vanyssheth, and a shadowe soone passynge awaye," praising instead how dying Henry had embraced "the sacrament of penaunce, with a mervaylous compassyon and flowe of teres, that at some tyme he wepte and sobbed."[3]

Given Fisher's ascetic rebuttal of earthly vanities, it seems unlikely that he would have commissioned this portrait bust himself. The existence of two further busts, the first in the Victoria and Albert Museum, London, and the second in The Met (figs. 97, 98), made to the same size and scale and sharing with Fisher's a long provenance, provides some grounds for conjecture of the circumstances of the commission. The second bust is recognizably that of Henry VII but unlikely a royal commission: although the busts were first documented, in the eighteenth century, as coming from Whitehall Palace's "Holbein Gate," they must have arrived there decades subsequent to their creation. No references to these busts are discernible in the royal inventories, and the structure that would become known as the "Holbein Gate" was only erected in the 1530s.[4] About 1769 the identification of the third sitter was put forth to be a teenage Henry VIII.[5] That the jowls of middle age, apparently discrediting this identification, are in fact much later repairs makes the suggestion slightly less unlikely.[6] However, the sitter's costume was apparently originally decorated with golden crowns, roses, and *HR*'s, evocative of Tudor livery (see cat. 86), ruling out the possibility that this is the young king himself.[7] Though unlikely, the presence of the livery would not discount the possibility that the sitter of the third bust is Sir Henry Guildford, Comptroller of the Royal Household and one of Henry VIII's close friends; however, a motivation for him to commission a trio of busts featuring his portrait alongside those of Bishop Fisher and Henry VII remains elusive.[8] Much more persuasive is the theory that the third sitter was one of the Italian merchants so instrumental in facilitating relations between the Tudor monarchs and Italian, especially Florentine, sculptors. Pierfrancesco di Piero Bardi, in whose home Torrigiano even lodged for a time, and Giovanni Cavalcanti are both strong candidates.[9]

Torrigiano's first contact with the Tudor court was the terracotta portrait bust he made of Henry VII's daughter Mary for Margaret of Austria, either during a trip to London (from the life) or in Flanders (from a drawing). Henry VII's extraordinary funeral effigy (see fig. 1) has been convincingly attributed to Torrigiano on technical and stylistic grounds, revealing that he was in London by April 1509.[10] Aside from a brief return to Margaret of Austria's court (to repair the bust of Mary) in 1510, it seems that he remained in London. Given that Henry VII's bust was apparently cast from his death mask—the same used in the cast in his funeral effigy—the busts must date between 1509 and 1519, when Torrigiano left London for the Castilian court of Katherine of Aragon's nephew Charles, apparently without Henry VIII's permission, much to his patron Cavalcanti's discomfort.[11] The compelling theory has been suggested that Cavalcanti or one of his colleagues commissioned the three busts from Torrigiano to advertise the sculptor's incredible skills to Bishop Fisher, who was the executor of Margaret Beaufort's will

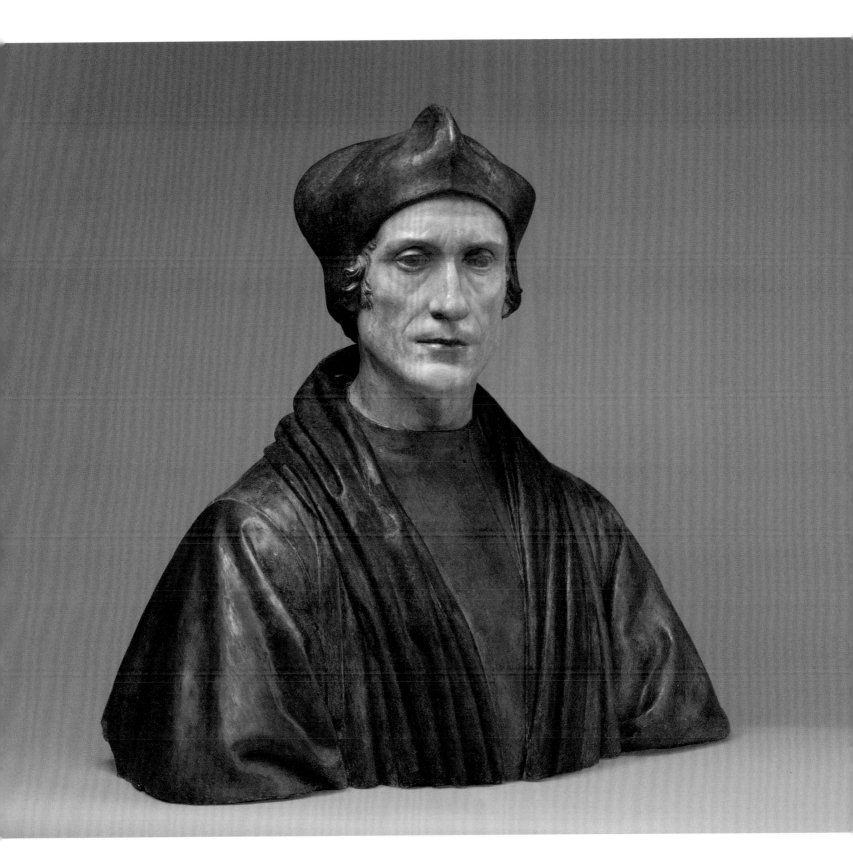

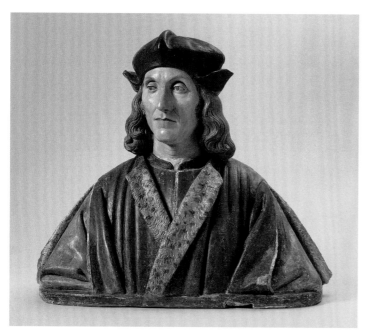

Fig. 97. Pietro Torrigiano (1472–1528), *Portrait Bust of King Henry VII*, ca. 1510–15. Polychromed terracotta, H. 23⅞ in. (60.6 cm). Victoria and Albert Museum, London (A.49-1935)

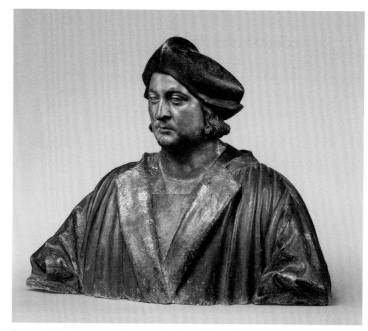

Fig. 98. Pietro Torrigiano (1472–1528), *Portrait Bust of an Unknown Man*, ca. 1510–15. Polychromed terracotta, H. 24⁷⁄₁₆ in. (62.1 cm). The Metropolitan Museum of Art, New York, Fletcher Fund, 1944 (44.92)

and therefore in charge of deciding who would craft her tomb.[12] If so, they were successful: Torrigiano received the high-profile commission, which in turn resulted in Henry VIII's request that he also furnish the splendid tomb of Henry VII and Elizabeth of York (see cat. 8); Cavalcanti and Leonardo Frescobaldi acted as guarantors of the Beaufort project, while Cavalcanti and the Bardi were guarantors of Henry VII's tomb.[13] Torrigiano enjoyed subsequent work for other English prelates and courtiers, and he started a tomb envisioned for Henry VIII and Katherine of Aragon (discussed in cats. 16, 17) before his untimely departure for Spain, where he was to die, purportedly on a hunger strike, imprisoned in Seville following a dispute with a patron.[14]

Considered alongside his royal tombs in Westminster Abbey and his work for other English clients, together with Benedetto da Rovezzano's later tomb elements for Cardinal Wolsey and Henry VIII (cats. 16, 17), and the exterior terracotta sculpture associated with Giovanni di Benedetto da Maiano (see fig. 24), Torrigiano's three portrait busts serve as reminders of the high level of Italian Renaissance sculpture being made and admired

in Henry VIII's England. The contrast with the bland and stylized work of Torrigiano's predecessor at court, Lawrence Emler, suggests something of the shock these new works must have elicited. Despite Fisher's suspicion of material trappings, his selection of Torrigiano to craft Lady Margaret's tomb suggests his approbation of his sculpted portrait. Having enjoyed such authority and high regard under Margaret Beaufort and Henry VII, Fisher's strict principles served increasingly to isolate him during Henry VIII's reign. By 1533, some twenty or so years after this bust was made, Fisher's alarm at Henry's treatment of Katherine of Aragon and her daughter, Princess Mary, prompted him—treasonously—to appeal to Charles V to intervene. He was arrested in April 1534 at his refusal to recognize Henry's new title as Supreme Head of the Church in England, and after thirteen months of imprisonment in the Tower, the Farnese pope Paul III, drawing attention to his plight, made Fisher cardinal. Henry's putative response was to declare that he would send Fisher's head to Rome to receive his cardinal's hat. In June 1535 Bishop Fisher was publicly beheaded. EC

Notes to this entry appear on p. 315.

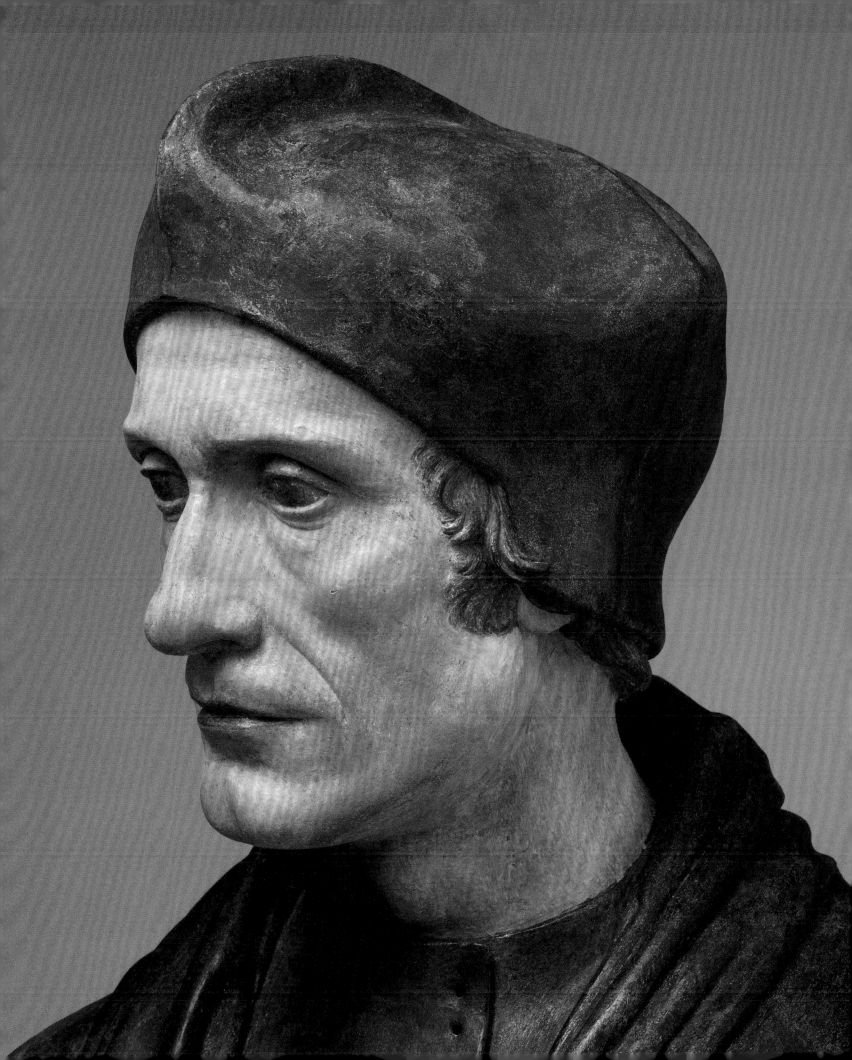

77. Henry VIII

Lucas Horenbout (ca. 1490/95–1544)
ca. 1525–27
Watercolor on vellum, laid on playing card, 2¹⁄₁₆ × 1⅞ in. (5.3 × 4.8 cm)
Fitzwilliam Museum, Cambridge (PD.19-1949)
Exhibited New York only

78. Henry VIII

Lucas Horenbout (ca. 1490/95–1544)
ca. 1526–27
Watercolor on vellum, laid on playing card (ace of diamonds),
Diam. 1¹³⁄₁₆ in. (4.7 cm)
The Royal Collection / HM Queen Elizabeth II (RCIN 420640)
Exhibited New York and Cleveland only

This pair of portraits, both depicting Henry VIII, reveals the close links between manuscript illumination and the portrait miniature. With its framing device of censing angels, the Fitzwilliam Museum miniature in particular (cat. 77) has been viewed by historians of the genre as a "break-through"[1] or "vital touchstone,"[2] both for the origins of the English portrait miniature and for reconstructing the oeuvre of its probable first practitioner, the Flemish artist Lucas Horenbout. Made by Netherlandish illuminators and responding to a particular chapter in Anglo-French diplomacy, the earliest English miniature portraits are emblematic of the cosmopolitan entanglements of Tudor court art.

The origins of the miniature portrait are multiple, building upon precedents in manuscripts, medals, and reliquaries.[3] Their significance at the Tudor courts can be traced, however, to a specific Anglo-French exchange in the reign of Henry VIII. On

Fig. 99. Jean Clouet (ca. 1485–1540), *François, Dauphin of France*, ca. 1526. Watercolor on vellum, laid on card, Diam. 2⁷⁄₁₆ in. (6.2 cm). The Royal Collection / HM Elizabeth II (RCIN 420070)

December 2, 1526, Gasparo Spinelli, secretary to the Venetian ambassador at the English court, described the arrival of a pair of miniature portraits depicting François I of France and his two young sons, the latter of whom were then being held hostage in Spain. François's sister, Marguerite d'Alençon, had dispatched the portraits in hopes of recruiting Henry to the captive princes' cause.[4] From their inception portrait miniatures served as highly mobile surrogates for royal bodies, intended to inspire an emotional response in their princely recipients. Such diplomatic gifts required reciprocity; within a year Henry sent his own likeness to the French court, where it inspired the king to doff his hat and declare, "I pray to God to give him a good and long life."[5]

None of the portraits from this original exchange is known to survive, but a portrait of the Dauphin attributed to Jean Clouet, now in the Royal Collection, gives a good idea of the appearance of the first French miniatures received at the English court (fig. 99).[6] Meanwhile, the two portraits of Henry VIII shown here document the English response. They share with Clouet's *Dauphin* a centering of the head-and-shoulders likeness on a bright blue background. The Fitzwilliam image further reveals its origins in manuscript illumination through the rectangular framing device of gold angels, who swing censers that consecrate the king's image at the same time as their chains twine with the initials of Henry VIII and Katherine of Aragon.

This framing vignette has inspired a general consensus regarding the miniature's attribution to Lucas Horenbout, an illuminator of the Ghent-Bruges school employed by Henry VIII and identified in the early seventeenth century by Karel van Mander as Holbein's instructor in miniature painting.[7] Horenbout's work at the Tudor court, along with that of his father, Gerard, and of his sister, Susanna, is amply documented in archival sources, but his reconstructed oeuvre of miniature portraits rests on cat. 77's attribution.[8] This body of work includes Horenbout's portrait of the Duke of Richmond, itself likely a diplomatic gift to the French court (cat. 50). Characteristic of Horenbout's approach, "which was to descend into the Stuart age unchanged," is the use of vellum laid on card as a support; the highlighting of the likeness in gold; the use of a base layer for the flesh tone, known as the carnation; and the bright, opaque background.[9] The flattened likenesses of Horenbout's portraits, as contrasted with the more mimetic modeling of Holbein's miniatures (see cats. 86–88), would be a key influence on later Elizabethan portraiture. At the same time these foundational representations of Henry VIII, appearing both clean-shaven and bearded, indicate the malleability of his public image before it took its final shape in the work of Holbein. AE

Notes to this entry appear on pp. 315–16.

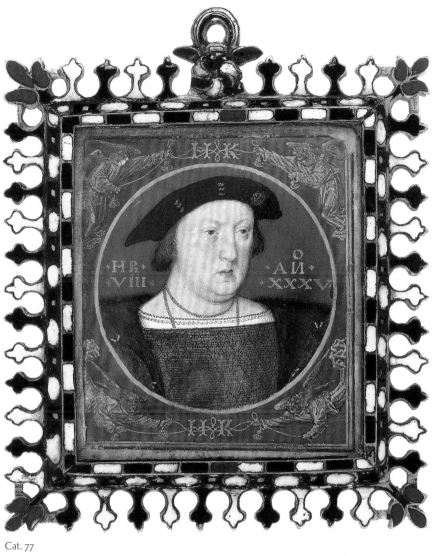

Cat. 77

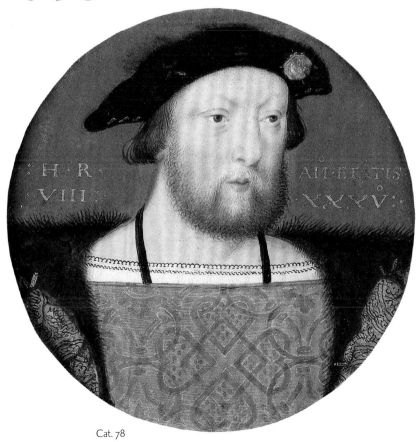

Cat. 78

79. *Hermann von Wedigh III*

Hans Holbein the Younger (1497/98–1543)
1532
Oil on panel, 16⅝ × 12¾ in. (42.2 × 32.4 cm)
The Metropolitan Museum of Art, New York, Bequest of Edward S. Harkness, 1940 (50.135.4)

A young man rests his arm on a table covered in green fabric. A book lies before him, one of its clasps undone and a piece of paper tucked into its gilded-edged pages. The man holds a glove and wears a signet ring. From these simple ingredients, Hans Holbein composed one of his most celebrated—and best preserved—portraits. Although it is dated and inscribed with the sitter's age, much about the portrait remains uncertain, in particular its relationship to Holbein's celebrated likenesses of the Hanseatic merchants of London's Steelyard.

The Steelyard provided an essential link between England and continental trade routes; its merchants were also an important source of patronage for their compatriot Holbein, commissioning designs for metalwork (cat. 40), ephemeral spectacles (cat. 89), wall paintings, and portraits.[1] A small group of surviving portraits depicts identifiable Steelyard merchants in half-length. Several of them feature coins, writing implements, or envelopes that identify their sitters by means of a postal address.[2] The subject of cat. 79, which is often included as part of this group, has been persuasively identified as Hermann von Wedigh III on the basis of his signet ring, the age given in the inscription, and the text "HER W WID." that appears on the edge of the book in the foreground.[3]

Wedigh came from a prominent Cologne family and served as a judge and alderman of the city's assembly; he is documented conducting business with the Steelyard in the 1550s, but not at the time that Holbein painted this portrait. The signet ring links The Met painting to another Holbein portrait of a member of the Wedigh family, now in Berlin, in which the sitter wears a similar ring (fig. 100). There are several distinctions between these two Wedigh family portraits and others associated more securely with the Hanseatic merchants of the London Steelyard. For example, the Wedigh portraits are smaller, and they lack the identifying feature of an envelope addressed with the sitter's name or any attributes conveying mercantile status.[4] In light of the fact that no documentation places Hermann von Wedigh III in the Steelyard in the 1530s, Holbein may have painted him in Cologne, en route to his second English sojourn in 1532.[5] Unlike the corporate portraits painted for the Steelyard, the two Wedigh portraits may have been private commissions intended for a family portrait gallery.[6]

The slip of paper in Wedigh's book quotes the Roman playwright Terence's *Andria*, abbreviating the assertion that "Flattery produces friends, truth hatred." Several writers have connected the quotation and book with Protestant devotional practice, but it is more likely an expression of Wedigh's humanist leanings.[7] Juxtaposing various kinds of text—a gold-lettered inscription in the background, a handwritten fragment of classical wisdom, and the sitter's name in an illusionistic inscription on a book—Holbein combines word and image to convey his sitter's identity in a way that would affect much later Tudor painting. AE

Notes to this entry appear on p. 316.

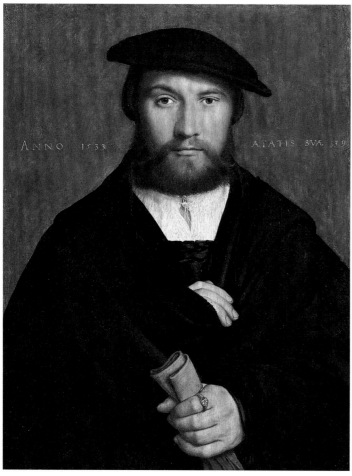

Fig. 100. Hans Holbein the Younger (1497/98–1543), *Member of the Von Wedigh Family*, 1533. Oil and tempera on panel, 15⅜ × 11⅞ in. (39 × 30 cm). Gemäldegalerie, Staatliche Museen zu Berlin (586B)

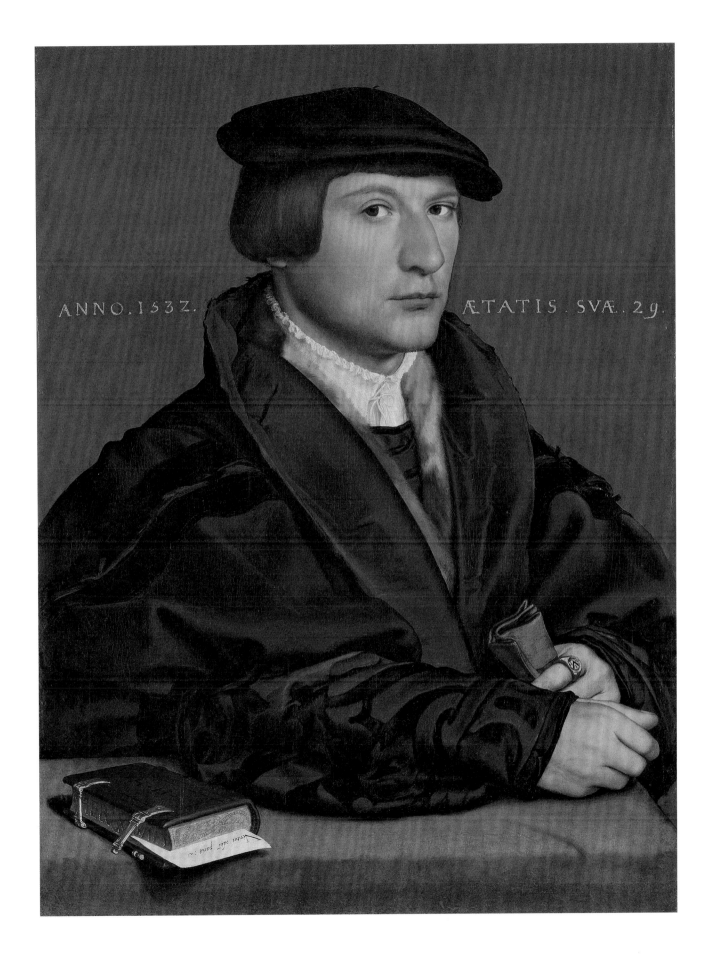

ANNO.1532. ÆTATIS.SVÆ.29.

80. *Sir Thomas More*

Hans Holbein the Younger (1497/98–1543)
1527
Oil on panel, 29½ × 23¾ in. (74.9 × 60.3 cm)
Frick Collection, New York (1912.1.77)
Exhibited New York only

One of the most original of Renaissance thinkers, a major politician at the court of Henry VIII, and, since 1935, a saint in the Roman Catholic Church, Thomas More also played an important role in the development of English portraiture through his patronage of Hans Holbein the Younger.[1] Holbein arrived in England bearing a letter of recommendation to More from his patron Erasmus, and many of his early portraits of English sitters were destined for exchanges of portraits between these cosmopolitan humanists and their network of friends.[2] Holbein's close association with the More family during his early years in England resulted in many portraits, ranging from preparatory drawings (cat. 82) to miniatures (cats. 87, 88) and a monumental group portrait, now only preserved in a composition drawing (fig. 102) and painted copies. Holbein's independent portrait of More is among the artist's greatest paintings, the product of an encounter between two of the foremost figures of English culture in the reign of Henry VIII.

More appears in half-length against a green curtain. He rests his proper right arm on a wooden table and holds a rolled-up piece of paper in one hand. More's pose recurs almost exactly in the drawing for the family portrait, but the sequence and relationship of the two works remains unclear. Indeed, in the words of one scholar, "The most mysterious circumstance around [the portrait] is its purpose."[3] Some writers have perceived in it a first step in the evolution of Holbein's depiction of More, "a straightforward but rather impersonal likeness" that later received elaboration and ironizing commentary in the innovative family portrait.[4] But the Frick composition may also have been extracted from the family portrait to make a portable image suitable for gift giving. Both depictions of More derive from a portrait drawing now at Windsor, similar to those Holbein made of other members of the More family.[5] But unlike many of the portraits known to have circulated as humanist gifts, Holbein's likeness does not emphasize his sitter's achievements as a writer and scholar. Instead, More's dominant attribute is a so-called livery chain, a mark of his service to the king through such offices as the chancellorship of the duchy of Lancaster. Such chains, which appear in a number of other portraits by Holbein, were a more elevated form of the cloth livery worn by lesser court functionaries (see cat. 86 and fig. 104).[6]

A dramatic story about the portrait, recorded in the seventeenth century when it hung in the Crescenzi collection in Rome, suggests that it may have had a royal provenance. According to the biographer Filippo Baldinucci, More's portrait was "displayed in the gallery of Henry VIII, in the room where the portraits of the most celebrated men from antiquity and modern times were kept," only to be thrown out of a window by Anne Boleyn on the day after More's execution.[7] As fanciful as the tale may seem, it does suggest an intriguing context for Holbein's portrait, a courtly gallery of illustrious men. There is some scant evidence for such series of portraits in England by the mid-sixteenth century.[8]

Although it emphasizes More's official status through the inclusion of his chain, Holbein's portrait also vividly conveys the personality and physiognomy of an intensely individual sitter. The stubble shadowing on More's chin conveys both Holbein's virtuosity and the sitter's lack of vanity, as though More had "not shaved to meet the painter."[9] Meanwhile, the ravishing depiction of garnet-colored velvet in More's sleeves is a technical feat only rivaled by Holbein's *Ambassadors* (fig. 80) and *Georg Gisze* (fig. 107).[10] As the defining image of More, Holbein's likeness circulated in painted copies and prints among those who revered More as a Catholic martyr.[11] In the 1620s Peter Paul Rubens painted one of the most significant of these copies, a version that removes both the livery chain and curtain backdrop to concentrate on More's melancholy expression and powerful hands.[12] That one of the most celebrated artists of the seventeenth century made this copy of Holbein's portrait of More attests to the sustained fascination of both figures for succeeding generations. A E

Notes to this entry appear on p. 316.

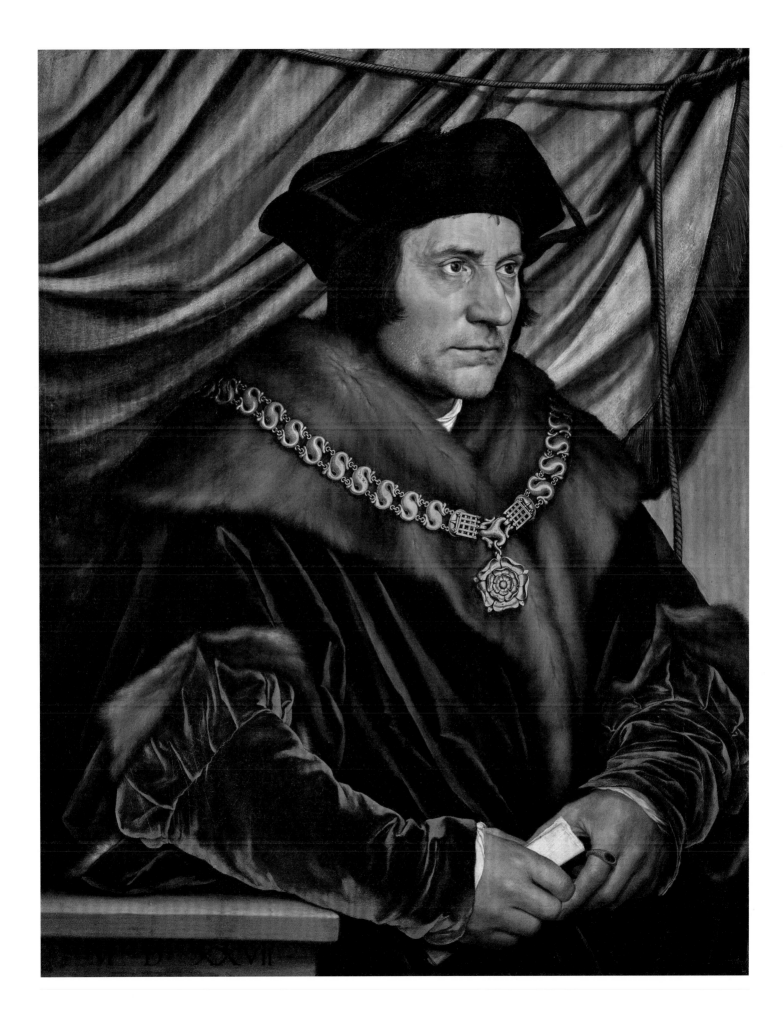

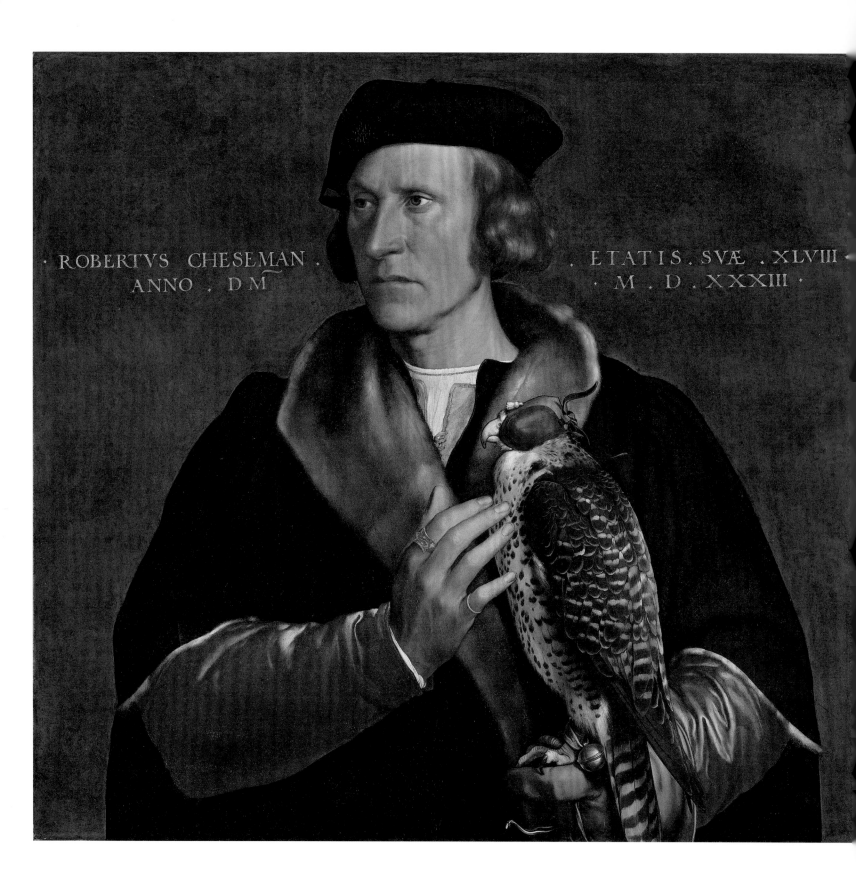

· ROBERTVS CHESEMAN · · ETATIS · SVÆ · XLVIII ·
ANNO · DM̄ · M · D · XXXIII ·

81. *Robert Cheseman*

Hans Holbein the Younger (1497/98–1543)
1533
Oil on panel, 23⅛ × 24¾ in. (58.8 × 62.8 cm)
Mauritshuis, The Hague (276)
Exhibited New York only

Robert Cheseman came from a land-owning family in Middlesex. His father had been cofferer, or treasurer, in the royal household, and he himself served as Falconer to the King, accompanying Henry VIII on the hunts that played a central role in court life.[1] Like Lady Dacre (cat. 92), Cheseman served in the welcoming party for Anne of Cleves in 1540. Here, he displays a gyrfalcon as the mark of his court office, recalling Holbein's sitters who posed in royal livery (see cat. 86). Cheseman's gesture of lifting his fingers to the falcon's feathers draws attention to the illusionary tactility of Holbein's painting and its convincing rendering of such diverse textures as fur, satin, chamois leather, or a polished brass bell.

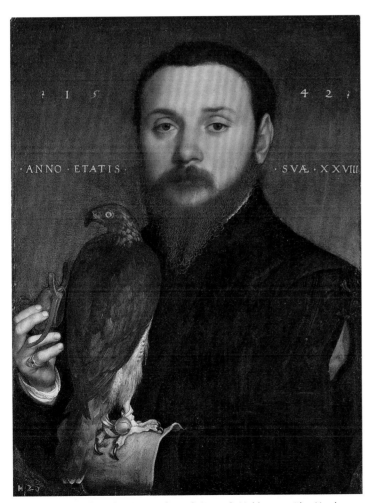

Nine years after painting Cheseman, Holbein depicted an unidentified man with a hawk, now also in the collection of the Mauritshuis (fig. 101).[2] Birds of venery had a long history in European art as an attribute of nobility, but also with connotations of erotic pursuit.[3] Hunters had strong feelings of affection and reliance for their birds, as for their dogs and horses. The Henrician courtier Sir Thomas Wyatt addressed a famous poem to his own hunting birds, declaring, "Ye be my friends and so be but few else."[4] Holbein's *Robert Cheseman* captures just such a relationship of trust between man and animal.

The painting's inscription, reconstructed after previous overpainting was removed, helps situate the portrait within Holbein's English career.[5] In 1533 Holbein was shifting his attention from the humanist patrons of his first English sojourn and cultivating courtly contacts;[6] Cheseman's portrait may be one of the innovative portraits that captured the king's attention and paved the way for the great royal commissions from the second half of the 1530s. This moment appears to have been one of experimentation within Holbein's portraits, when he also painted the elaborate depiction of the Hanseatic merchant Georg Gisze (fig. 107) and *The Ambassadors* (fig. 80), both of which contain similar bravura depictions of pink satin.[7] In *Robert Cheseman* the rhyming profiles of falcon and falconer give the painting a mood of tense watchfulness that goes beyond a mere record of the sitter's likeness or position at court.

Both *Robert Cheseman* and the Mauritshuis *Nobleman with a Hawk* have distinguished provenances, going back to the collection of Charles I and thence to the Dutch royal collection.[8] While their earlier history is unknown, their depiction of noble huntsmen and their avian companions locates them firmly within the orbit of Henry VIII's court. A E

Notes to this entry appear on p. 316.

Fig. 101. Hans Holbein the Younger (1497/98–1543), *Nobleman with a Hawk*, 1542. Oil on panel, 9¹¹⁄₁₆ × 7⁷⁄₁₆ in. (24.6 × 18.8 cm). Mauritshuis, The Hague (277)

82. Elizabeth Dauncey

Hans Holbein the Younger (1497/98–1543)
ca. 1526–27
Black and colored chalk, 14½ × 10¼ in. (36.7 × 26 cm)
The Royal Collection / HM Queen Elizabeth II (RCIN 912228)
Exhibited New York and Cleveland only

Hans Holbein's portrait drawings, the vast majority of which are kept at Windsor Castle, represent one of the most important artistic survivals of the sixteenth century (see also cats. 83 and 84). In addition to their aesthetic value as compelling portraits in their own right, they also offer a wealth of information about Holbein's working method as he took a likeness and transferred it from paper to panel.[1] This beautiful drawing, depicting Elizabeth Dauncey, second daughter of Sir Thomas More and Jane Colt, is representative of both the elegance and the preparatory function of these portrait drawings.

Holbein drew Dauncey as part of his work on a monumental portrait of More's family, destroyed by fire in 1752. Holbein's composition is preserved in a pen-and-ink drawing, now in Basel (fig. 102), and in several painted copies.[2] The portrait depicted the More family in their home, interacting in a natural manner as they gathered to pray. In the lost painting Dauncey appeared on the far left of the scene, pulling off a glove from her right hand as she joined the family group. Her sister, Margaret Roper, the subject of a portrait miniature by Holbein (cat. 88), is seated in the foreground.

The bust-length drawing anticipates Dauncey's appearance in the final painting by showing her in profile. Holbein was particularly attentive to the complex construction of Dauncey's gable hood, with one side of the veil pinned up and over the top of her head. Working on the unprimed paper typical of drawings from his first English sojourn, Holbein used colored chalks to convey the trimming of Dauncey's costume, the pink of her lips, and the flush of her cheeks. He also wrote the German word *rot* (red) on the bodice of her dress,[3] matching its appearance in the surviving copy at Nostell Priory. The inscription identifying the sitter as "The Lady Barkley" is later and erroneous; her correct identity is noted in the Basel composition drawing, which was annotated before being sent as a memento to the Mores' family friend Erasmus. Unlike Holbein's surviving drawing of Sir Thomas More, Dauncey's portrait is not pounced for transfer, but may have been traced using metalpoint.

In 1525 Elizabeth married William Dauncey, son of a Privy Counsellor to the king, with whom she had seven children. Although her personality and accomplishments are less documented than her sister Margaret's, her father's letters do mention her studying the Roman historian Sallust, indicating that she shared her siblings' extensive humanist education.[4] A E

Notes to this entry appear on p. 316.

Fig. 102. Hans Holbein the Younger (1497/98–1543), *Study for the Family Portrait of Thomas More*, 1527. Pen and brush, with black ink, over chalk, 15⁵⁄₁₆ × 20⁵⁄₈ in. (38.9 × 52.4 cm). Kupferstichkabinett, Kunstmuseum Basel (1662.31)

The Lady Barkley.

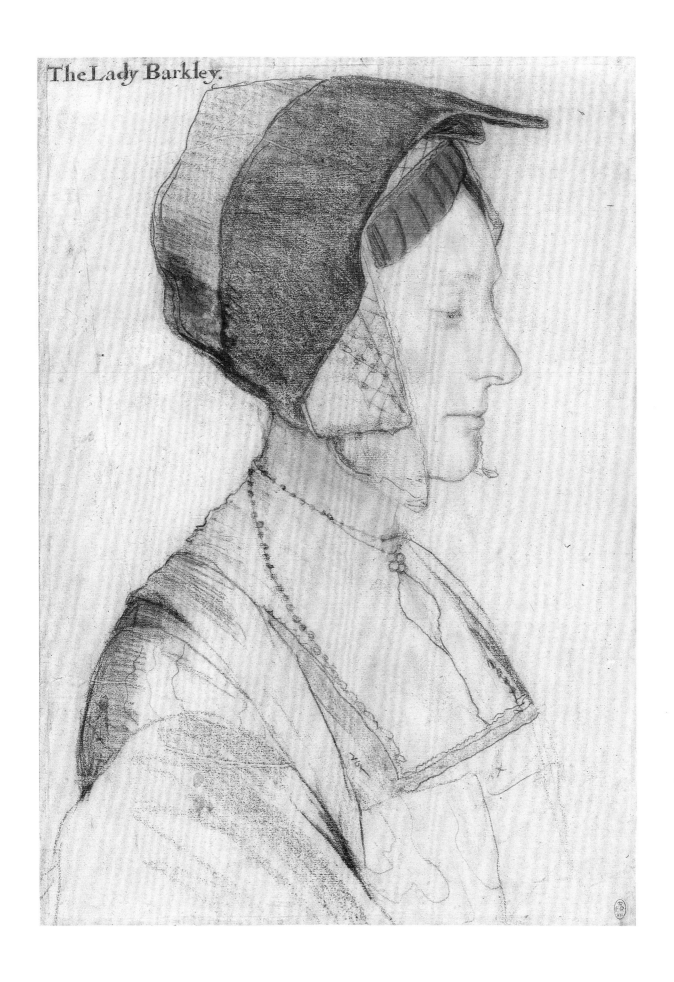

83. *Anne Boleyn*

Hans Holbein the Younger (1497/98–1543)
ca. 1533–36
Black and colored chalk on pale pink prepared paper, 11 1/16 × 7 5/8 in.
(28.2 × 19.3 cm)
The Royal Collection / HM Queen Elizabeth II (RCIN 912189)
Exhibited New York and Cleveland only

Anne Boleyn, among the most famous figures of the Tudor era, was the second wife of Henry VIII. Daughter of the courtier and diplomat Thomas Boleyn and his high-born wife, Elizabeth, née Howard, Anne received a cosmopolitan education at the courts of Margaret of Austria, Governor of the Habsburg Netherlands, and Claude, Queen of France. After nearly nine years abroad, she returned to England, where she soon attracted the attentions of Henry VIII. The familiar story of Henry's passion for Anne, precipitating his break with the Roman Catholic Church, as well as of their brief marriage and her subsequent execution on charges of adultery, has made her a notorious, much romanticized figure.

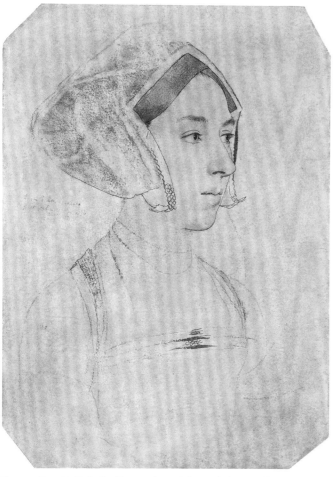

Fig. 103. Hans Holbein the Younger (1497/98–1543), *Portrait of a Woman*, ca. 1532–35. Black and red chalk, with brush and black ink and yellow wash, on pale pink prepared paper, 12 5/8 × 9 1/4 in. (32.1 × 23.5 cm). The British Museum, London (1975,0621.22)

Only recently has scholarship given a more balanced picture of her sophisticated patronage, cultural influence, and promotion of the Reformed faith.[1]

Despite her legendary status in English history, very little is known about Anne Boleyn's physical appearance. Hostile accounts emphasize her swarthiness, or such disfigurements as a goiter or extra finger on one hand. The only surviving contemporary likeness to meet wide acceptance is a damaged portrait medal that gives little sense of her actual features.[2] More often reproduced are late Elizabethan and Stuart paintings of Anne from series of royal portraits intended to decorate country houses; as they postdate her life by decades, their reliability is questionable.[3]

As a possible contemporary portrait of Anne Boleyn by the greatest artist of the Tudor period, the drawing displayed here has featured in most discussions of the queen's appearance. The most convincing argument for the portrait's identification as Anne Boleyn is the inscription in the upper left-hand corner. The identifying inscriptions on the Windsor group of Holbein portrait drawings (see also cats. 82, 84) are believed to derive from Edward VI's tutor, Sir John Cheke, who had benefited from Anne Boleyn's patronage as a young man and presumably could have accurately identified her likeness.[4] Mitigating against the accuracy of the identification of the present drawing is the sitter's golden hair, when the surviving sources indicate Anne was a brunette.[5] The relatively crude application of yellow chalk to this part of the drawing, however, may well be by a later hand.

Another curious feature of the drawing is the sitter's attire, a close-fitting cap and fur-lined nightgown. This may be the black satin nightgown Henry VIII gave to Anne Boleyn before their marriage, prompting the recent proposal that Holbein's portrait commemorates this intimate gift.[6] Lucas Horenbout's portrait of the Duke of Richmond in his nightclothes dates from roughly the same period, demonstrating that a royal portrait in relative undress was hardly unthinkable (cat. 50).

Further complicating matters, another Holbein drawing, clearly depicting a different sitter, also bears an inscription identifying her as Anne Boleyn, and was the basis for prints of the queen in the seventeenth century (fig. 103). This identification has found even less acceptance than the Windsor proposal. Yet despite the problem posed by her portraits, Anne's connection to Holbein is clear, ranging from the pageant he designed for her coronation (cat. 89) to a table fountain Henry gave her at New Year in 1534.[7] Closely associated as both were with continental humanism and the cause of Reform, it may in fact be Anne who was responsible for securing Holbein his epoch-making position at the court of Henry VIII.[8] A E

Notes to this entry appear on p. 316.

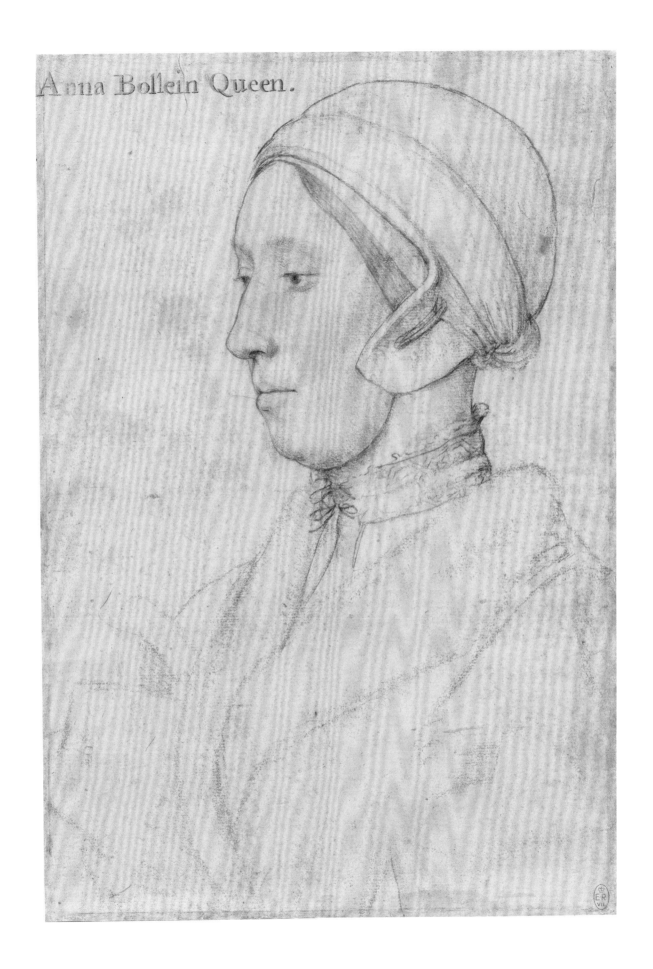

Anna Bollein Queen.

84. *Jane Seymour*

Hans Holbein the Younger (1497/98–1543)
1536–37
Black and colored chalk, reinforced with pen and ink, and metalpoint, on pale pink prepared paper, 19⅝ × 11¼ in. (50 × 28.5 cm)
The Royal Collection / HM Queen Elizabeth II (RCIN 912267)
Exhibited New York and Cleveland only

85. *Jane Seymour*

Hans Holbein the Younger (1497/98–1543)
1536–37
Oil on panel, 25¾ × 18½ in. (65.5 × 47 cm)
Gemäldegalerie, Kunsthistorisches Museum, Vienna (GG 881)
Exhibited Cleveland and San Francisco only

Jane Seymour, third wife of Henry VIII and mother of Edward VI, was the eldest of ten children born to Margery (or Margaret) Wentworth and the courtier Sir John Seymour of Wolf Hall, Wiltshire. Jane's brother, Edward Seymour, Duke of Somerset, was Lord Protector under Edward VI (see cat. 24). As a young woman, Jane served as lady-in-waiting to both Katherine of Aragon and Anne Boleyn. It is not known exactly when she first caught the roving eye of Henry VIII, but a letter of October 13, 1534, from the imperial ambassador Eustace Chapuys refers to an unnamed young lady to whom the king was becoming attached, and notes that her standing was increasing just as Anne's was declining.[1] By early 1536 the relationship between Henry and Anne Boleyn was deteriorating rapidly: accused of adultery (historians believe falsely), Anne was sent to the Tower of London on May 2, tried on May 15, and executed on May 19.

Although Jane had modestly deflected the king's attentions while Anne was still in favor, their marriage plans developed swiftly in the days following the queen's imprisonment. A special dispensation was issued on May 19 allowing Henry and Jane to marry (they were fifth cousins); they were betrothed the following day and married on May 30, 1536. In late February 1537 it was announced that Queen Jane was pregnant; Edward VI (see cats. 24, 51, 93) was born on October 12 following a difficult two-day labor. Although initially the queen seemed to be recovering normally, she died twelve days later, on October 24, 1537, from complications of the birth. Henry was devastated by her death, writing to François I of France that "Divine Providence has mingled my joy [at Edward's birth] with the bitterness of the death of her who brought me this happiness."[2]

Jane was said to be intelligent if not highly educated, skilled in the domestic arts and possessing a gentle, peaceful nature that contrasted with Anne Boleyn's more fiery personality.

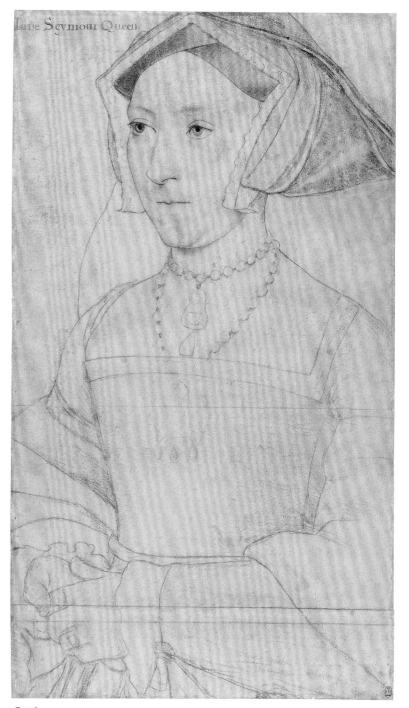

Cat. 84

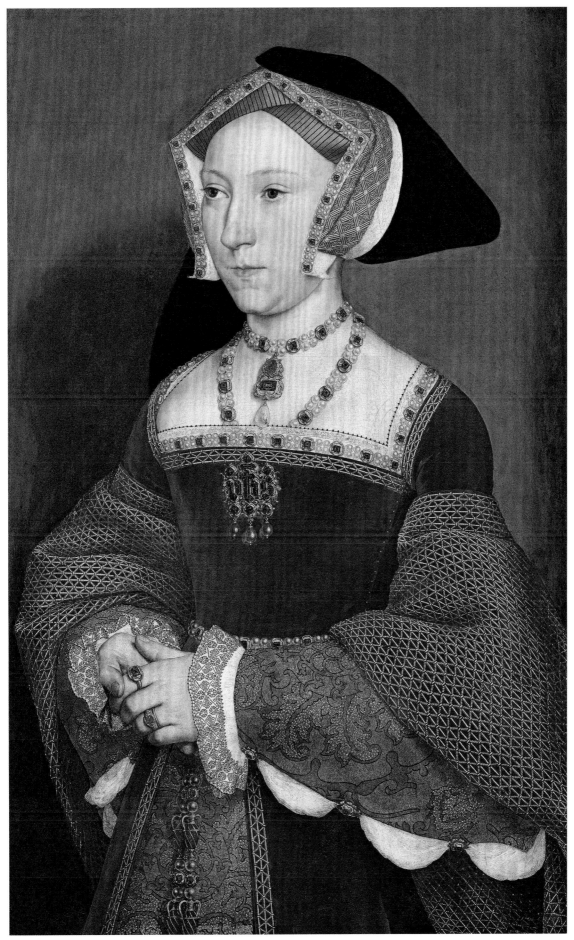

Cat. 85

Contemporaries equivocated on the subject of Jane's beauty: the imperial ambassador described her as "of middle stature and no great beauty, so fair that one would call her rather pale than otherwise."[3] Holbein's two portraits of Jane Seymour show a woman of fair complexion with a steady gaze, a tightly held mouth, and an aura of imperturbable calm. Both drawing and painting were probably produced during Jane's short reign as queen consort: after her marriage in May 1536 and before her pregnancy became visibly advanced the following summer.

During his years in England, Holbein produced dozens of drawn and painted portraits of royalty, courtiers, and prominent citizens. Many of the portrait drawings would have been created in preparation for a painted likeness, but in only eleven instances have both drawing and painting of the same sitter survived, providing rare insight into the artist's working practice and the effects particular to each medium.

The Windsor Castle drawing (cat. 84) depicts Jane Seymour at nearly three-quarter length, a format somewhat larger than was typical for Holbein's portrait drawings (see also cats. 82, 83).[4] The head is delicately rendered in black and colored chalks, with thin ink lines added to define the eyes, eyelashes, nose, and the line between the lips. By contrast, the metalpoint lines reinforcing the chalked outlines of the clothing and jewelry seem stiff and unnuanced, and may have been added by an assistant at a later date, when the original lines had become too faint.[5] The evidence of wear to the drawing, the addition at the bottom, and two horizontal folds in the paper—at 8¼ and 2⅛ inches from the lower edge—suggest that it was extensively used and consulted as a model for subsequent likenesses of the queen, produced either during her lifetime or after her death.[6]

The design of the Vienna painting (cat. 85)—one of Holbein's most beautifully realized portraits—was directly based on the Windsor Castle drawing: contours were transferred to the prepared panel by tracing, using an intermediary sheet coated with black chalk.[7] There are notable differences between the two works, however, the most obvious being the costume, which in the painted portrait is far more elaborate and evidently accurately rendered from items in the queen's wardrobe.[8] The neckline, skirt opening, and wide sleeve turnbacks of the red velvet dress are decorated with a fine embroidered latticework of gold thread. Worn beneath the dress are sleeves and an underskirt of silver brocade; puffing out from between the sleeves' jeweled clasps is a white shift with blackwork embroidery at the cuffs. Jane wears a typically English gabled hood, a style she directed her ladies-in-waiting to emulate, reportedly in pointed contrast to the more modern French hood favored by her predecessor, Anne Boleyn. With a keen eye and extraordinary attention to detail, Holbein recorded the challenge of coaxing the thick gold basket-weave brocade into the crisp peaks the headdress required.

Perhaps the most striking aspect of Jane's costume is her glittering jewelry: while in the drawing she wears a relatively modest double strand of pearls with a pendant, and a large jewel at the center of her bodice, the painting describes a more elaborate display. Here, the alternating pattern of pearls and jeweled gold medallions in the necklace is repeated in jeweled bands at the neckline of her dress, at the edge of her undercap, and for the portion of the belt that encircles her waist. Pinned to her bodice is a pendant jewel with the monogram of Christ—IHS—and three pendant pearls, which may be identical to one noted in a 1519 inventory of Henry VIII's jewels.[9] Henry had an almost insatiable passion for gold and jewelry, and he ensured his wives were equally richly adorned; for Jane, he also commissioned Holbein to design a gold standing cup, for which two sketches survive (see cat. 39).[10]

Pale and placid, Queen Jane's face radiates quiet certitude. It is a testament to Holbein's remarkable talent that, amid the meticulous detailing of the costly garments and exquisite jewels of her royal attire, it is the physiognomy and character of his subject that command our attention: despite the passage of nearly five hundred years, Jane seems utterly real and knowable. In part this is due to the elimination of any background detail that might have served to localize the individual: by setting his subjects against a flat plane of color, Holbein lifts them out of the temporal dimension, creating portraits "that strike the viewer as perpetually present, reconciling the paradox between the here-and-now and eternity."[11]

In addition to the present two likenesses, Holbein included a full-length portrait of Jane Seymour in the monumental Whitehall Palace mural, painted in 1537 and destroyed in 1698. In preparation for this portrait, he would undoubtedly have made a full-length cartoon (as survives for the portraits of Henry VII and VIII; see fig. 17); surviving seventeenth-century copies of the mural indicate that the likeness of Queen Jane closely resembled, and was undoubtedly based upon, the Windsor Castle drawing. A smaller version of the painted portrait in the Mauritshuis, The Hague,[12] was probably executed by a highly accomplished artist working in Holbein's studio. The face is painted with great precision but lacks some of the delicacy of the original; the costume and jewelry are simpler, closer to that of the drawing than the painting in Vienna.[13] MEW

Notes to this entry appear on p. 316.

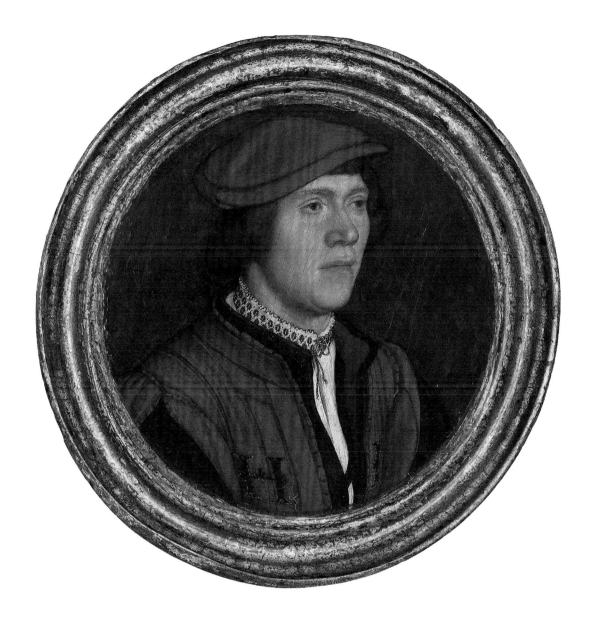

86. *Man in Royal Livery*

Hans Holbein the Younger (1497/98–1543)

1532–35

Oil and gold on vellum, laid on linden panel, Diam. 3¾ in. (9.5 cm)

The Metropolitan Museum of Art, New York, Bequest of Mary Stillman Harkness, 1950 (50.145.24)

Surviving in excellent condition with its original frame, this portrait is an important example of Holbein's distinctive engagement with the tradition of miniature painting at the English court. Although it adopts the round format of contemporary portrait miniatures (see cats. 50, 77, 78), this painting is not a limning, executed in watercolor, but rather a small oil painting on vellum, mounted on linden wood. Holbein harnesses the layered glazes of oil painting to achieve smooth effects of modeling, particularly in the sitter's face, that can only be approximated by dense hatching in limning (compare, for example, Holbein's watercolor portraits of William and Margaret Roper, cats. 87, 88).

The unidentified sitter of Holbein's portrait wears the royal livery, consisting of a coat of red broadcloth embroidered with the king's initials, *HR*, that "was the uniform of men who held positions of some importance at court, but who were craftsmen or attendants, and not of noble or gentle birth."[1] Given the expense of clothing, livery was itself an important form of payment that "incorporated retainers and servants into the social body of their master or mistress."[2] By having himself depicted in livery, Holbein's sitter emphasized his loyalty and service at court, wearing the king's name upon his body. Holbein pays meticulous attention to his sitter's clothing, conveying the individual stitches that attach the royal initials to his coat, the blackwork embroidery of his collar, and the glimpse of bare

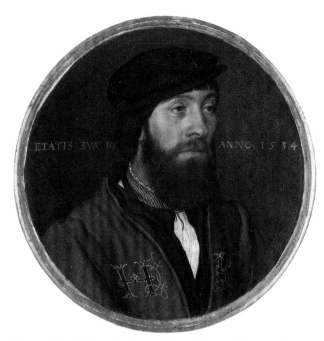

Fig. 104. Hans Holbein the Younger (1497/98–1543), *Miniature Portrait of a Court Official*, 1534. Oil on linden panel, Diam. 4¹¹⁄₁₆ in. (11.8 cm). Gemäldegalerie, Kunsthistorisches Museum, Vienna (GG 5432)

chest where his shirt sags open. In contrast to this specificity, no inscription or personal device assists in identification of the sitter.

Royal livery links the present portrait with a pair of miniatures in the Kunsthistorisches Museum, Vienna, depicting a man and woman, in which the man wears similar attire (fig. 104).[3] On the basis of this livery, the man and woman in Vienna have been speculatively identified as the artist Susanna Horenbout and her husband, John Parker, or Serjeant-Painter Andrew Wright and his wife. Likewise, cat. 86 has been identified with Susanna's brother, the court artist Lucas Horenbout. But there is no particular reason to believe that Holbein portrayed fellow artists in these miniatures, as opposed to any other form of royal servant.[4]

Unlike smaller miniatures that might be worn on the body, Holbein's roundel was intended to be contemplated in the hand. Its excellent preservation and engaged frame indicate that the portrait likely once had a lid, such as survives for Holbein's portrait of Philipp Melanchthon now in the Landesmuseum Hannover.[5] The lid to that portrait identifies the sitter in a learned Latin inscription, offering evidence that may now be lost for The Met's painting. A E

Notes to this entry appear on p. 316.

87. *William Roper*

Hans Holbein the Younger (1497/98–1543)
ca. 1535
Watercolor and gold on vellum, laid on card, Diam. 1¾ in. (4.5 cm)
The Metropolitan Museum of Art, New York, Rogers Fund, 1950 (50.69.1)
Exhibited New York and Cleveland only

88. *Margaret Roper*

Hans Holbein the Younger (1497/98–1543)
ca. 1535
Watercolor and gold on vellum, laid on card, Diam. 1¾ in. (4.5 cm)
The Metropolitan Museum of Art, New York, Rogers Fund, 1950 (50.69.2)
Exhibited New York and Cleveland only

Holbein's portraits of Sir Thomas More and his family are some of his greatest works (cats. 80, 82). As More fell from favor, however, due to his opposition to the king's divorce and the Act of Supremacy, Holbein sought out royal patronage and affiliated himself with the Protestant cause, leading Erasmus to remark in 1533 that Holbein had "deceived those to whom he was recommended."[1] Nonetheless, this pair of portraits, which depicts More's daughter and son-in-law and dates to the year of his execution, in 1535, attests to Holbein's continued association with the martyred statesman's family.

According to his early seventeenth-century biographer, Karel van Mander, Holbein learned to paint in bodycolor while in England, "when in the King's circle he met someone called Lucas, a famous master . . . who was adept at that technique."[2] Scholars have been unanimous in identifying Holbein's teacher as Lucas Horenbout, the court painter responsible for the earliest English portrait miniatures (cats. 50, 77, 78). Some of Holbein's portrait miniatures from his English period, such as cat. 86, are painted in oil on vellum, but his portraits of Margaret and William Roper reveal his engagement with the English tradition of limning, as painting in bodycolor or watercolor on vellum was most commonly known. In adopting this technique, Holbein broke with its conventions, using dense hatchings of tiny strokes to model his sitters' skin, whereas English limners before and after him relied on a single flesh-toned base layer, known as the carnation, to convey an immaculate and scarcely shaded complexion.

Here, Margaret Roper appears as though interrupted in her reading or prayers, her thumb marking her place in a book. More's thirty-year-old daughter had been celebrated from childhood for her learning.[3] Her letters to her father, written in Latin, were admired by his exalted humanist acquaintances,

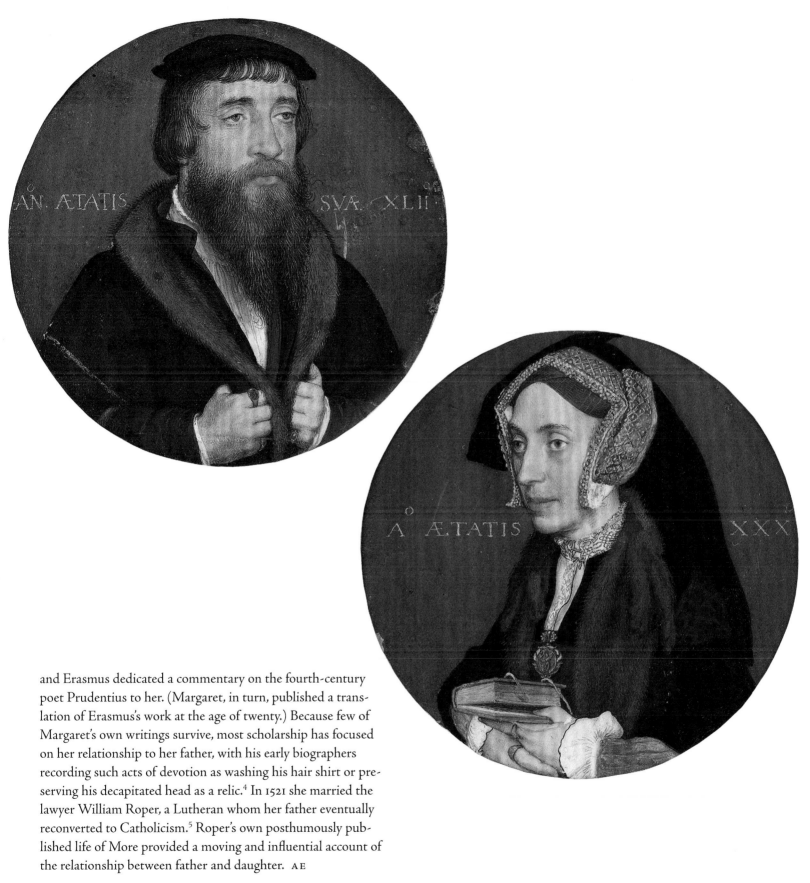

AN. ÆTATIS SVÆ. XLII

A. ÆTATIS XXX

and Erasmus dedicated a commentary on the fourth-century poet Prudentius to her. (Margaret, in turn, published a translation of Erasmus's work at the age of twenty.) Because few of Margaret's own writings survive, most scholarship has focused on her relationship to her father, with his early biographers recording such acts of devotion as washing his hair shirt or preserving his decapitated head as a relic.[4] In 1521 she married the lawyer William Roper, a Lutheran whom her father eventually reconverted to Catholicism.[5] Roper's own posthumously published life of More provided a moving and influential account of the relationship between father and daughter. AE

Notes to this entry appear on p. 316.

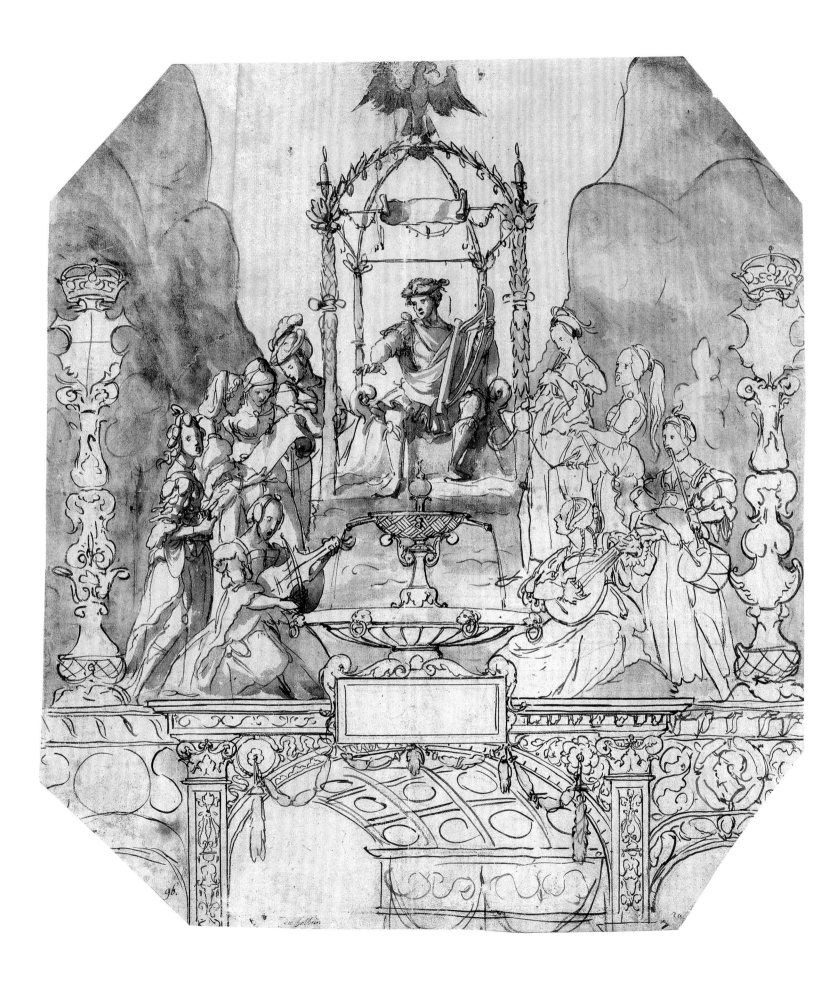

89. *Apollo and the Muses on Parnassus*

Hans Holbein the Younger (1497/98–1543)

1533

Pen and black ink, over traces of black pencil, with gray, blue, and brown wash, 16¹¹/₁₆ × 15⅛ in. (42.1 × 38.4 cm)

Kupferstichkabinett, Staatliche Museen zu Berlin (KdZ 3105)

Not exhibited

On May 31, 1533, Anne Boleyn traveled in a litter of white satin from the Tower of London to Westminster Abbey for her coronation as Queen of England.[1] Accompanied by a magnificent entourage of ambassadors, clerics, and aristocrats, she passed a series of "pageants," or theatrical spectacles, that were a standard feature of such processions. Some of these pageants emphasized a traditional analogy between the queen's entry into the city and the Virgin's assumption into heaven. But others drew on a new language of classical humanism in their glorification of Henry VIII's controversial second wife, who was closely associated with the Reformed faith and widely held accountable for the king's break with Rome.[2] At Gracechurch Street, for example, a tableau of Mount Parnassus, home of Apollo and the Muses, greeted the queen. In the words of the chronicler Edward Hall, this was a "merveilous connyng [clever] pageaunt," with a fountain pumping Rhenish wine, "Muses plaiyng on seueral swete instrumentes," and gold-lettered inscriptions praising the queen.[3] The drawing by Hans Holbein documenting this pageant's design is an important record of ephemeral court pageantry and of the Tudor monarchs' recruitment of classical imagery as they sought an identity outside the fold of Catholic Europe.

The Gracechurch pageant was paid for by the Hanseatic merchants of the Steelyard, who were some of Holbein's most important patrons in London (see cats. 40, 79).[4] Foreign merchants regularly sponsored such displays of loyalty as they cultivated the monarchs who protected their business interests, and the Steelyard had been tasked with such a display by the committee hastily gathered to plan Anne's coronation. The poets John Leland and Nicholas Udall, who were affiliated with the religious Reform, devised the program for the pageants and the panegyric texts declaimed by the performers. As a working proposal for the pageant, the present drawing reveals Holbein's swiftness and economy as a draftsman, only roughing out the minimum amount of detail needed to present his client with a general design. For example, the figures on the left half of the sheet, presumably representing the live performers of the actual pageant, are modeled with wash to give a sense of their dynamism, while those on the right are left in bare pen and ink. The cornice of the triumphal arch below them displays two options for ornament. Holbein's deftness in arranging a convivial group

of figures reflects the innovations of his since-destroyed More family portrait (see fig. 102).

Holbein's drawing may be connected to a tapestry design by Bernard van Orley depicting a musical company gathered around a fountain.[5] Whether or not this was Holbein's immediate source, the two designs share roots in the sophisticated late Burgundian culture that Anne Boleyn encountered as a young girl in the entourage of Margaret of Austria at Mechelen.[6] On a more prosaic level, the gushing fountain of Rhenish wine may have served as a prominent advertisement for one of the many products the Hanseatic merchants imported to London.[7] AE

Notes to this entry appear on p. 316.

90. *An Allegory of the Old and New Testaments*

Hans Holbein the Younger (1497/98–1543)

Early 1530s

Oil on panel, 19⅝ × 23⅞ in. (49.8 × 60.5 cm)

Scottish National Gallery, National Galleries of Scotland, Edinburgh (NG 2407)

Exhibited New York only

A great tree divides Holbein's *Allegory of the Old and New Testaments*, barren and sere to the left and in full leaf to the right. Seated at its base is a naked man, his body contorted in fear and anguish and his hands clasped in pious supplication. The inscription "HOMO" identifies this tortured figure as the embodiment of all humankind. Flanking him are the prophet Isaiah and John the Baptist, who urgently direct his attention to events transpiring in the right half of the picture. Latin inscriptions throughout the painting identify individual scenes. To the left, beneath the heading "LEX" (law), are episodes from the Old Testament: Moses on Mount Sinai, the Fall of Manna, the Brazen Serpent, Adam and Eve, and, in the foreground, a skeleton revealed by a crumbling tomb. These are paralleled by New Testament scenes on the right, labeled "GRATIA" (grace): the Annunciation to the Virgin, the Annunciation to the Shepherds, the Crucifixion, Christ and the Apostles, and, in the foreground, the resurrected Christ emerging triumphant from the tomb, trampling beneath his foot a skeleton and a demon with a globe. The disparate parts of the painting coalesce to communicate a single message: facing death and seeking redemption, humankind must choose the path that leads from law to grace, from fear to faith, from death to eternal life.[1]

The opposition of the old and new dispensations was a recurring theme in Christian imagery from at least the late fifteenth century, often including a dead and a living tree as a metaphor for the contrast between the unforgiving law of the

Old Testament and the forgiveness and eternal life promised in the New. Lutheran theologians adapted the metaphor, presenting the Old Testament not as precursor but as contrast and antithesis to the New: Old Testament law represented the "Old Religion" of Catholicism, in which sins were redeemed through penance, while the New Testament, standing for the Reformed religion, offered redemption and forgiveness through God's grace and faith in Christ's expiation of sin.[2]

Holbein's *Allegory of the Old and New Testaments* adopts the didactic structure of Protestant woodcuts, which employed a combination of image and text to express Reformed beliefs. More specifically, the composition relates to works produced in the workshop of Lucas Cranach the Elder beginning in the late 1520s: a painted *Allegory of the Old and New Testaments* dated 1529, now in Prague, presents a nearly identical arrangement of figures and narrative scenes, albeit with inscriptions in German rather than Latin.[3] Perhaps closer to Holbein's painting in certain details is an anonymous German woodcut from the same period (fig. 105), an impression of which could have been sent to England from Germany and been available to Holbein there.[4] It has been proposed that Holbein's composition (as well as the paintings and prints produced in the Cranach workshop) derives from an undated French woodcut formerly attributed to Geofroy Tory, although the iconography of that image is decidedly Catholic in orientation.[5] It further has been argued that Holbein based his composition on lost originals produced in Erasmian circles in Basel in the early 1520s.[6]

One significant difference between Holbein's composition and the other related works cited above is the substitution of the scene of Christ and the Apostles at center right for the more customary Lamb of God. X-radiographs of the present painting indicate that the artist originally included a lamb just to the left of the figure of Christ, precisely where it appears in other versions of the composition, and then painted it out.[7] A few years later, Holbein included a similar grouping of Christ and the Apostles in his design for the title page of the Coverdale Bible (cat. 20), with minor differences: there, each of the apostles holds a key, reflecting the Reformatory aversion to prioritizing Saint Peter, who, as papal antecedent, stood for the entire Roman Catholic Church. The unusual emphasis given to Christ's charge to all his apostles in the Edinburgh painting, underscored by John the Baptist's outflung arm gesturing in the direction of this scene, suggests that these iconographic details were developed in response to specific requests on the part of the patron.[8]

An Allegory of the Old and New Testaments is not dated, but on stylistic grounds is likely to have been produced in the early 1530s, at the beginning of Holbein's second English period, and in the context of his association with Thomas Cromwell's antipapist circle.[9] In addition to the specifically English iconography—the primacy of Saint Peter downplayed in accordance with Henry VIII's break with Rome—the fact that it is on an oak, rather than linden, panel support also suggests an English origin for the work.[10] The earliest history of the painting is not known; it is first mentioned in the seventeenth century, when it was in the collection of the Earl of Arundel.[11] Several copies after the painting exist, but in general Holbein's distinctive variation on a popular compositional format seems to have had relatively little impact in continental Europe, as might be expected of a painting produced in England for an English patron.[12] MEW

Notes to this entry appear on p. 316.

Fig. 105. Unknown artist, *Allegory of the Old and New Testaments,* early 1530s(?). Woodcut, 14⅞ × 21⅛ in. (37.7 × 53.7 cm). Graphische Sammlung, Universitätsbibliothek, Erlangen-Nuremberg

LEX

GRATIA

MYSTERIVM IVSTIFICATIONIS

IVSTIFICATIO NSTRA

AGNVS DEI

PECCATVM

HOMO

VICTORIA
NOSTRA

MORS

MISER EGO HOMO,
QVIS ME ERIPIET EX
HOC CORPORE MORTI
OB NOXIO. RO. 7

ESAYAS PROPHETA IOANNES BAPTISTA

ECCE VIRGO CONCIPIET. ET PARIET FILIVM. ISA. 7 ECCE AGNVS ILLE DEI, QVI TOLLIT PECCATV MVDI. IO. I

91. *An Allegory of the Wise and the Foolish Virgins*

Hans Eworth (ca. 1525–after 1578)

1570

Oil on panel, 24³/₁₆ × 24⁷/₁₆ in. (61.5 × 62 cm)

Statens Museum for Kunst, Copenhagen (KMSsp172)

Exhibited New York and Cleveland only

Unlike the portraits that dominated Eworth's English production, this painting, among his latest dated works, is a complex multifigure allegory. Its subject derives from the book of Matthew. Pressed by his disciples for details regarding the Last Judgment, Jesus offered the following parable:

> Then shall the kingdom of heaven be likened unto ten virgins, which took their lamps, and went forth to meet the bridegroom. And five of them were wise, and five were foolish. They that were foolish took their lamps, and took no oil with them: But the wise took oil in their vessels with their lamps. While the bridegroom tarried, they all slumbered and slept. And at midnight there was a cry made, Behold, the bridegroom cometh; go ye out to meet him. Then all those virgins arose, and trimmed their lamps. And the foolish said unto the wise, Give us of your oil; for our lamps are gone out.
>
> But the wise answered, saying, Not so; lest there be not enough for us and you: but go ye rather to them that sell, and buy for yourselves. And while they went to buy, the bridegroom came; and they that were ready went in with him to the marriage: and the door was shut. Afterward came also the other virgins, saying, Lord, Lord, open to us. But he answered and said, Verily I say unto you, I know you not. Watch therefore, for ye know neither the day nor the hour wherein the Son of man cometh. (Matthew 25:1–13)

In medieval art, the parable's image of two groups, one granted admission to the heavenly kingdom and the other excluded, complemented the traditional visual binary between the saved and the damned. As such, the Wise and Foolish Virgins became a regular subject of Gothic sculpture, flanking cathedral portals.[1]

Drawing on this venerable tradition, Eworth's painting depicts the Wise and Foolish Virgins as an allegory for the individual believer's relationship to God. The painting is one of many Reformation-era attempts to devise a new type of religious image, much like Hans Holbein's *Allegory of the Old and New Testaments* (cat. 90).[2] Such images frequently juxtaposed the Reformers' ideals with what they saw as the falsehood of the Church of Rome. The slumped virgin in the foreground on the right of Eworth's painting, for example, holds a Catholic rosary.[3] Like many Reformed religious images, Eworth's painting prominently includes text, although his paraphrase of the parable is in Latin and not the vernacular one might expect. Eworth's picture

also draws on the much older imagery of the Last Judgment, with the central figure of the trumpet-brandishing angel Gabriel. Eworth relegates the figure of the risen Christ to the background on the left, acting as the heavenly bridegroom who admits a wise virgin, her lamp lit, into Paradise. The golden illumination of heaven, emerging from billowing clouds and tumbling cherubs in the upper left, contrasts with the realist nocturnal landscape that otherwise dominates the panel and provides one of its most remarkable features. Here, a shepherd uses his staff to separate goats from sheep, reinforcing the binary divisions that structure the entire image.

Eworth's Antwerp contemporary Frans Floris, often cited as a source for the former's motifs, depicted the Wise and Foolish Virgins roughly a decade earlier, but with massive figures that fill the composition, and far less elaboration of the costumes and lamps.[4] Eworth appears to have traveled back and forth between Antwerp and London about the time he painted this image, and it may respond to more recent developments in Flemish painting.[5] Within Eworth's oeuvre, the painting most closely resembles his allegorical portrait of Sir John Luttrell (see fig. 79) or *Elizabeth I and the Three Goddesses*, now in the Royal Collection (see fig. 122). Like cat. 91, this depiction of the queen triumphing over mythological rivals has a binary structure and

Fig. 106. Unknown artist, *An Allegory of Man*, after 1596. Oil on panel, 22⅛ × 20¼ in. (57 × 51.4 cm). Tate Britain, London (T05729)

DVM STERTVNT FATVÆ MEDIA DE NOCTE PVELLÆ VOX SONAT E CŒLO SVRGITE SPONSVS ADEST
PRVDENTES QVARVM RVTILA LVX LAMPADE FVLGET OCCVRRVNT HILARES ET COMITANTVR EVM
PANDITVR EXCELSI SVBLIMIS IANVA CŒLI ET SVBEVNT SVMMI SPLENDIDA TECTA DEI
ACCVRRVNT FATVÆ SED IANVA CLAVDITVR ILLIS QVI SAPIT IS SEMPER LAMPADE LVMEN HABET

reveals Eworth's familiarity with the sophisticated humanist painting of his native Antwerp. Both paintings indicate that, as his portraiture fell out of favor at court, Eworth may have sought to develop a new visual idiom that would appeal to a learned, Protestant clientele. Nothing of the painting's patronage or early ownership is known before it is documented in the Danish royal collection in 1692;[6] it may perhaps have featured in gift exchanges between the Stuart dynasty and the court in Copenhagen.

An allegorical painting now at Tate Britain, London (fig. 106), depicting the figure of Man beset by temptations on all sides, with Christ appearing above, evinces many stylistic similarities to Eworth's *Allegory of the Wise and the Foolish Virgins*.[7] Dendrochronological analysis has recently established, however, that the Tate picture must date later than 1596.[8] It may therefore be the work of an unknown copyist after Eworth's lost original. AE

Notes to this entry appear on p. 316.

92. Mary Neville, Lady Dacre

Hans Eworth (ca. 1525–after 1578)
ca. 1555–58
Oil on panel, 29 × 22¾ in. (73.7 × 57.8 cm)
National Gallery of Canada, Ottawa (3337)

Her pen poised above the pages of a notebook, a woman sits in a richly appointed interior. Hanging on the tapestried wall of the space she occupies is another portrait, the image of a handsome young man. Among the most remarkable paintings of the English Renaissance, Hans Eworth's *Mary Neville, Lady Dacre* juxtaposes a woman's likeness with a dense interplay of symbolic objects to commemorate an important campaign of rehabilitation on the part of an aristocratic widow.

Mary, Lady Dacre, was the daughter of George Neville, Lord Bergavenny, and Mary Stafford, daughter of the Duke of Buckingham; she married Thomas Fiennes, 9th Baron Dacre, in 1536.[1] The Dacres enjoyed some prominence at court, with Lord Dacre carrying the canopy at Jane Seymour's funeral, and both husband and wife serving among the party that welcomed Anne of Cleves to England.[2] Their court careers came to a brutal end in 1541, when Lord Dacre took part in a poaching raid during which a gamekeeper was killed. Convicted, with several others, of murder, Dacre was executed as a common criminal, and he and his descendants were attainted, losing their noble title.[3] Lady Dacre successfully petitioned the king to have certain lands restored to her during her lifetime, as well as "her apparel of velvet, satin, pearls, stones or goldsmiths work."[4] She twice remarried, and in 1559 the newly crowned Elizabeth I reversed the attainder, restoring the family's title to Gregory Fiennes, 10th Baron Dacre and son of this portrait's sitter.

The present painting most likely predates the restoration of the family title, an event commemorated by a double portrait in which Lady Dacre appears alongside her son in finery that conveys their social rehabilitation (see fig. 43).[5] Here, by contrast, she is more soberly dressed, her status as a widow emphasized by the inclusion of a portrait of her late husband and by the symbolic flowers—pinks, rosemary, pansies, and forget-me-nots—she wears on her chest.[6] Eworth's portrait is, according to Barbara Harris, "the first of an English aristocratic woman writing or about to write,"[7] and it emphasizes the widow's agency as the defender of her children's patrimony and steward of her husband's memory.

The painting is also Eworth's most explicit tribute to his predecessor Hans Holbein, brimming with citations of Holbein's elaborate portrait of the Hanseatic merchant Georg Gisze (fig. 107). The two paintings share more than a meticulous attention to

accessories that express a sitter's rank, occupation, or interests. A striking green, pink, and black color scheme links both pictures, as does a prominent use of floral symbolism. A nearly identical sandbox with a clockface appears in the foregrounds of both paintings, along with other writing implements. Both Holbein and Eworth portray their sitters as readers and writers, with Gisze opening a letter to which he will respond with the quill pen before him, while Lady Dacre's own pen hovers above a notebook, and her thumb marks her place in another volume.

Eworth's clear reference to Holbein's portrait within his own depiction of Lady Dacre is remarkable. But he made his debt to Holbein even more explicit by including the picture-within-a-picture of the baroness's late husband. The head-and-shoulders format of the latter makes it unlikely to be a reproduction of an actual, now-lost Holbein portrait of the late Lord Dacre.[8] Yet the inclusion of the blue background and Latin inscription distinguish Lord Dacre's portrait from his wife's, making it an identifiable relic from an earlier era. As Elizabeth Honig has written, "By doubling representation, Eworth demonstrates the power of the image to join past to present."[9] Decades before English art writers began to construct an artistic genealogy beginning with Holbein, Eworth staged just such a lineage in this remarkable portrait. AE

Notes to this entry appear on pp. 316–17.

Fig. 107. Hans Holbein the Younger (1497/98–1543), *Georg Gisze*, 1532. Oil on panel, 37¹⁵⁄₁₆ × 33¾ in. (96.3 × 85.7 cm). Gemäldegalerie, Staatliche Museen zu Berlin (586)

93. *King Edward VI*

Attributed to Guillim Scrots (active 1537–53)
1546
Oil on panel, 16¾ × 63 in. (42.5 × 160 cm)
National Portrait Gallery, London (NPG 1299)
Not exhibited

In August 1584 the German travel writer Lupold von Wedel visited Whitehall Palace and described a curious and noteworthy object:

> the portrait of Edward, the present queen's brother. . . . If you stand before the portrait, the head, face, and nose appear so long and misformed that they do not seem to represent a human being, but there is an iron bar with a plate at one end fixed to the painting; if you lengthen this bar for about three spans and look at the portrait through a little hole made in the plate in this manner O you find the ugly face changed into a well-formed one. This must indeed be considered a great piece of art.[1]

Only when viewed from a point beyond and in line with the right edge of the frame does the likeness of the prince become legible (fig. 108), a type of distortion known as anamorphic perspective. Although the technique had been known since antiquity, developing interest in optics and perspective during the Renaissance led to a more scientific approach to anamorphic projection. The best-known English example is undoubtedly the distorted image of a skull, skewed across the foreground of Hans Holbein's *The Ambassadors* (see fig. 80).[2] Von Wedel's description of the portrait of Edward VI specifies an integral device that guided viewing of the image; the need to accommodate such a device, no longer extant, explains the unusual depth and notched right edge of the (original) engaged frame.[3]

An inscription on the lower member of the frame— "GUILHELMUS PINGEBAT," or "Guillim painted it"—would appear to support an attribution to the Netherlandish émigré painter Guillim Scrots (or Stretes).[4] Certainly, there was no other artist named "Guillim" (or William) working in England at this time capable of producing such a sophisticated image. Scrots spent the first part of his career as portrait painter at the court of Mary of Hungary, Governor of the Habsburg Netherlands, in Bruges. He came to England in 1545 to take up a position at the court of Henry VIII, for which he received £62 10s. annually, making him the highest-paid court artist at that time.[5] Despite his prestigious position as court painter, there are few works that can be securely attributed to Scrots's hand.

The present painting probably developed from the same life study that Scrots used for his more conventional portrait of

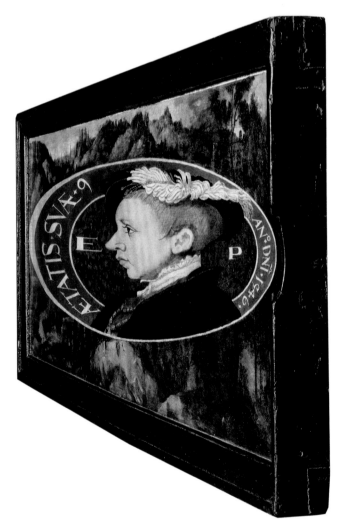

Fig. 108. When seen at an oblique angle, cat. 93 offers an undistorted view of Edward VI.

Edward VI in profile (cat. 24). Here, the prince's distorted profile is encircled by an oval medallion (which would have appeared circular from the specified viewing point) and set before a freely painted imaginary landscape.[6] Scrots may have created the anamorphosis as an entertaining gift (and advertisement of his own talents) for the nine-year-old Edward, shortly before he became king. Just how Scrots achieved such a successful anamorphosis is not known, but recent mathematical and technical studies have confirmed that the image's distortions were precisely calculated to create a convincing illusion.[7] MEW

Notes to this entry appear on p. 317.

94. *Portrait Medal of Queen Mary I with Allegory of Peace*

Jacopo da Trezzo (1515/19–1589)
London or Antwerp, 1554
Cast and chased gold, Diam. 2¹¹⁄₁₆ in. (6.9 cm)
The British Museum, London (1927,0622.1)

95. *Portrait Medal of Queen Mary I of England and Philip, Prince of Spain*

Jacques Jonghelinck (1530–1606)
Probably Antwerp, 1555
Cast and chased gold, Diam. 1½ in. (3.7 cm)
The British Museum, London (M.6831)

Though posterity has tended to judge Mary Tudor's marriage to the future Philip II of Spain as a political misstep—an unfortunate hiccup in the story of Tudor England's often brazen antagonism with the rest of Europe—these medals prove that there were undeniable artistic compensations. The four years of Philip and Mary's marital alliance temporarily brought to England some of the most glorious visual proponents of Habsburg style.

In cat. 94, a likeness made less than five months into her marriage, Mary is presented as Habsburg royalty. Without question, Mary's portrait medal was instigated by the medalist Jacopo da Trezzo's Habsburg patrons, whether her brand-new husband, Prince Philip—who, two years later, would become King Philip II of Spain—or, indeed, her father-in-law, Holy Roman Emperor Charles V himself. As has often been remarked, the decision to represent the first female Tudor monarch on a large medal fitted her into a Habsburg convention, speaking to the dynasty's inherited tradition of sizable imperial show coins: Charles V; his late wife, Isabella of Portugal; his

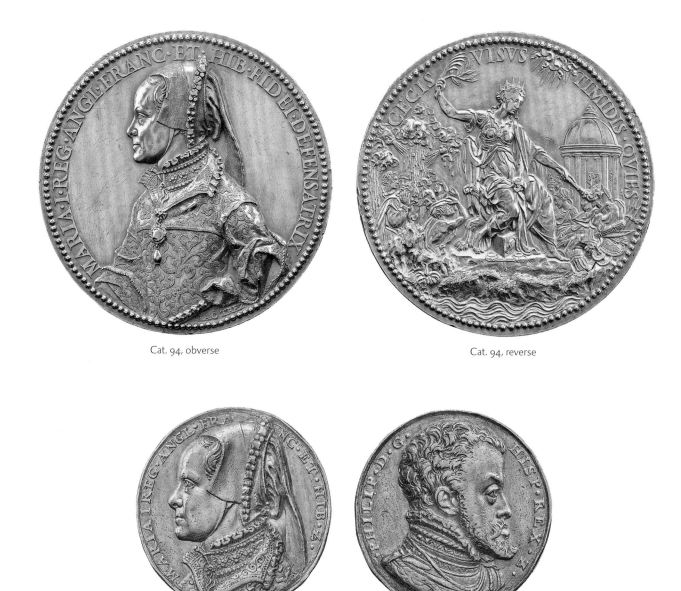

Cat. 94, obverse

Cat. 94, reverse

Cat. 95, obverse

Cat. 95, reverse

brother, Ferdinand of Habsburg; and his son Philip had all been immortalized on portrait medals by the Florentine sculptor and goldsmith Leone Leoni in the 1540s, and not long before Jacopo worked on Mary's medal, in about 1552, he was busy in Brussels fashioning portrait medals of Philip's sisters, Maria and Joanna of Austria.[1] Jacopo was a Milanese artist whose work for the Habsburgs included goldsmithery—cameos, cups, reliquaries—and sculpture in addition to medals and seals; for Vasari, he had "no equal in making portraits from life."[2] In the early 1550s he was based at the Brussels court, moving thence to Spain. In between, Jacopo apparently visited England, likely as part of Philip's retinue, and perhaps along with the painter Anthonis

Mor (whom he knew) was granted a sitting with the Tudor queen. The medal's resemblance to Mor's painting of Mary (see fig. 29) has been noted, although—given the high worth of the medal—there is little reason to presume that its artist was directed to copy an existing sketch instead of meeting the sitter in person.

The strong profile that Jacopo gives the Tudor queen speaks to Antique conventions on coins, medals, and cameos. The representation on the medal's reverse likewise emulates Antique motifs: an allegorical figure embodying Peace, with facial features not unlike Mary's own, alludes to Mary's restoration of Roman Catholicism as the official English religion. An inscription

declares, "Sight to the Blind, Peace to the Fearful," while scales symbolize justice; clasped hands, unity (and the Habsburg-Tudor marriage); and a cube, stability, the whole evoking Psalm 66:12 ("We went through fire and through water").[3] After being cast, the medal apparently was chased by Jacopo himself, displaying great skill in its varied areas of polish and textured stippling.

Like tapestries, cast medals—with their pricey raw materials, great artistry of design, and difficult, multiphase production processes—combine exceeding exclusivity in terms of value with the seemingly contradictory potential to be reproduced and replicated in multiple editions. At least two gold casts of Mary's portrait medal are known, both almost certainly made for the Habsburg and Tudor royals; a silver version was documented in Brussels by December 1554, presented by Jacopo to Antoine Perrenot de Granvelle, the Habsburg statesman and future cardinal who had spearheaded the marriage negotiations. Additional editions were cast in bronze and lead.[4]

Jacopo's medal designs were likewise reusable and adaptable. The following year, in 1555, his portrait of Mary was, for example, used in combination with one of Philip on its opposite face.[5] His designs for this Philip-and-Mary medal were themselves reworked by his Flemish contemporary Jacques Jonghelinck. In cat. 95 Jonghelinck focuses in on Jacopo's composition to represent only the heads and necks of the sitters. What is lost in terms of the portraits' psychological heft is gained in gorgeous surface detailing: Jonghelinck lingered on Mary's gown's brocaded patterning, the crisp folds of her smock, and the minute elements of her embroidered collar.

Though these two gold medals would have been admired and handled by only the most elevated of the royal elite, echoes of Jacopo's designs did reach the general English populace, in Mary's shilling (see fig. 9), for which he apparently made designs and perhaps even engraved the dies. In it, his two portraits are brought to gaze upon each other on the same face, occasioning the popular rhyme, "Still amorous, cooing and billing / Like Philip and Mary on a shilling."[6] EC

Notes to this entry appear on p. 317.

96. Design for Queen Mary I's Great Seal

Here attributed to Jacques Jonghelinck (1530–1606)
Probably Antwerp, ca. 1553
Pen and brown ink, with pink-red wash and gold, on prepared paper, Diam. 5 in. (12.7 cm)
The British Museum, London (1987,0516.87)
Exhibited New York and Cleveland only

97. Design for Queen Elizabeth I's Great Seal of Ireland

Nicholas Hilliard (ca. 1547–1619)
London, ca. 1584
Pen and black ink, with gray wash, over graphite, on parchment, Diam. 4⅞ in. (12.4 cm)
The British Museum, London (1912,0717.1)
Exhibited New York and Cleveland only

It is difficult to exaggerate the importance of the English monarch's Great Seal. Embodying their authority and edict, it endowed royal approval on any document bearing this large waxen disk, hanging by a parchment strip, cord, or silk lace (see cats. 25, 31). Nomination of the new Lord High Chancellor was marked by delivery of the Great Seal matrix to their safekeeping; return of the matrix symbolized the end of their appointment. Counterfeiting the seal was treason.[1] Tellingly, Henry VII retained the Plantagenets' Great Seal for years after he took the throne, perhaps to maintain an aura of continued, recognized royal authority.[2]

When Mary I acceded to the English throne in July 1553, she used her brother Edward VI's seal for some months, like her grandfather opting to retain her predecessor's familiar representation of established royal decree and, in doing so, leapfrogging for posterity the unfortunate nine-day interregnum of Lady Jane Grey.[3] Mary's own Great Seal, eventually in use by December 1553, was a simple affair, awkwardly representing an enthroned female with unrecognizable features and a hat-like crown, flanked by the royal arms and a large Tudor rose.[4] However, cat. 96 reveals that the original drawn design (if this is it) was incomparably more intricate. As the first English Great Seal to embody the authority of an uncontested sovereign queen (the twelfth-century Empress Mathilda's reign never having been ratified), it would have been all the more important to endow the representation with the legitimacy of inherited, dynastic authority: not for nothing does the ornate architectural setting of the throne clearly look back to the third Great Seal of Mary's father, Henry VIII.[5] Enthroned Mary, with her recognizably stern, narrow mouth, noticeable cheekbones, and button nose, holds the orb and scepter of rule, flanked by crowned, empty shield cartouches encircled by the English royal Order of the Garter.

Cat. 96

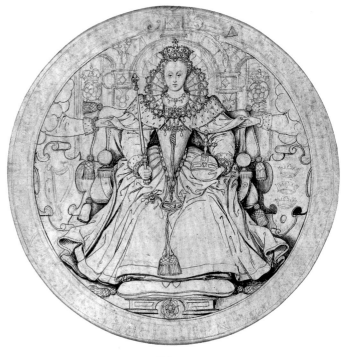

Cat. 97

Usually attributed to an anonymous Netherlandish artist working in England, this design bears the stylistic traits of the Antwerp goldsmith and medalist Jacques Jonghelinck, who was official caster and engraver of seals to Mary's future husband, Philip of Spain, and who came from a long line of seal-engraving goldsmiths.[6] It is not difficult to envision this design as a gift from Philip's camp to Mary in celebration of her accession. If undertaken by Jonghelinck, who by this date was working close to the Habsburg court in Brussels, he understandably left the shield cartouches and garter empty, to be completed on the drawing's arrival in England by a local specialist familiar with the royal English arms and the Garter motto, "Honi soit qui mal y pense" (Shame be to him who thinks evil of it). The relish in detailed surface patterning recalls Jonghelinck's medals, not least the flourishes he added to his version of Jacopo da Trezzo's designs (see cat. 95). Though it would have been difficult to translate the composition into the deep engraving of a silver or bronze seal matrix—clearly beyond the capabilities of the graver of the Royal Mint responsible for Mary's actual Great Seal—Jonghelinck himself would doubtless have been up to the task, given the Brussels goldsmiths' guild's records of the multiple seal matrices he not only designed but also engraved during the time he was enrolled with them between 1553 and 1573. The mammoth importance of the Great Seal matrix, though, would

have ruled out entirely that it be engraved and cast anywhere other than at the Royal Mint in London. By 1556 Mary had replaced her Great Seal with an elaborate design in which both she and Philip sat side by side on two thrones under a single baldachin, each holding a sword of office, both with their free hand upon the same, central orb beneath the garter-encircled arms of England.[7]

Elizabeth, unsurprisingly, issued her own Great Seal soon after her accession in 1558. By 1584, however, the seal's silver matrix was considered "unserviceable" due to "much use," and in July she requested Derick Anthony, her Graver of the Mint, "to emboss in lead, wax, or other fit stuff, patterns for a new one, according to the last pattern made upon parchment by you, Hildyard [sic], and allowed by us."[8] Although Nicholas Hilliard's pattern on parchment for Elizabeth's second seal does not seem to survive, cat. 97 hints at its appearance. This carefully and clearly contoured drawing, designed to be translated in close copy in the engraved matrix, is exceedingly close to surviving impressions of the second Great Seal (fig. 109), but it represents Elizabeth flanked not by the royal arms of England and France (to which the Tudors still, in principle, laid claim), but by the Irish harp and the three crowns of Munster, traditional symbol of English lordship of Ireland. This amendment to customize Hilliard's design to create a Great Seal of Ireland (never

apparently actualized) reflects the complicated and precarious situation in which Elizabeth—building upon the subjugation of Ireland that had begun in earnest only during her father's reign—endeavored to govern the kingdom via troublesome proxies. The 1580s, date of Hilliard's core design, for example, saw the massacre by English forces of more than 1,500 souls in Ireland, including papal mercenary forces as well as the populace at large.[9]

Though Elizabeth appears here gloriously enthroned as Mary had been, Hilliard's design pares down the detailing to focus on the key figure of the queen and her coats of arms, with celestial hands reaching down from either side to support her mantle of state, a device of God-given sovereignty first used on an English Great Seal by Henry IV in about 1407.[10] Despite the composition's majestic yet decorative simplicity, and Hilliard's timeless and elegant stylization of her facial features, Elizabeth apparently tired of the design she had approved. Already in 1592, the queen requested "sondrye paterns" from Hilliard for a new, third Great Seal which, though approved and paid for in May 1600, seems never to have been completed.[11] EC

Notes to this entry appear on p. 317.

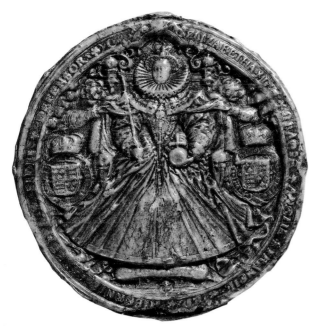

Fig. 109. Nicholas Hilliard (ca. 1547–1619), *The Great Seal of Elizabeth I*, 1586–1603. Wax, Diam. 4¾ in. (12 cm). National Archives, Kew (SC 13/N3)

98. *Henry Howard, Earl of Surrey*

Unknown painter, perhaps North Italian
1546
Oil on canvas, 87½ × 86½ in. (222.3 × 219.7 cm)
National Portrait Gallery, London (NPG 5291)
Not exhibited

A monumental testament to fatal ambition at the court of Henry VIII, this portrait of Henry Howard, Earl of Surrey, also represents a rare survival of Tudor painting on canvas. Its outstanding scale allowed for a combination of portraiture, heraldry, and sophisticated decorative motifs that suited the worldliness of both the sitter and the court he inhabited.

The Earl of Surrey was the eldest son of Thomas Howard, Duke of Norfolk, and thus heir to one of the most ancient and ambitious aristocratic families at the court of Henry VIII.[1] The Howards were particularly assiduous in using marital alliances to strengthen their ties to the throne; two of Henry VIII's wives, Anne Boleyn and Catherine Howard, were Surrey's cousins, and at the end of his life he stood accused of pressuring his sister, the widowed Duchess of Richmond, to seduce the aging king. The duchess was herself the widow of Henry VIII's illegitimate son, Henry Fitzroy (cat. 50), whom Surrey had accompanied to the French court in 1533. As the earl recalled in his poetry, "I in lust and joye / With a kinges soon [son] my childishe yeres did passe."[2] Surrey was a soldier who led the English to a disastrous defeat against the French in 1546, but also an innovative poet. Along with his mentor and friend Sir Thomas Wyatt, Surrey had a transformative effect on English literature and is particularly celebrated for the introduction of blank verse. Increasingly open about his discontent with the social-climbing "new men" who thrived at Henry VIII's court, Surrey was arrested and tried for treason at the end of 1546, the same year this portrait was painted. His beheading on January 19, 1547, was the last political execution of the king's reign.

Here, Surrey appears in full length, framed by an elaborate architectural setting. With hips cocked he rests an elbow against a broken pillar of fluted, colored marble, the base of which bears the Latin motto "SAT SUPER EST," roughly, "Enough is left over."[3] Sculpted male and female figures flank the earl on either side, while bucrania, gamboling putti, and grotesque faces complete the classical references of the ornamentation. The barely draped male figure's pose rhymes with the earl's own, suggesting the athletic body, hardened at the ball court and the tiltyard, underneath his rich attire.

Recent technical examination of the painting has put to rest earlier suspicions that it was a seventeenth-century copy while also ruling out the long-standing attribution, based on archival

Fig. 110. Bedchamber of the duchesse d'Etampes, Château de Fontainebleau, with paintings by Francesco Primaticcio (1504/5–1570), 1541–44

his carefully modeled decorative surround, and likely indicates the participation of more than one hand. Indeed, the framing of a central image by elaborate fictive plasterwork evokes the splendid composite interiors of the Château de Fontainebleau, which Surrey visited as a companion to the Duke of Richmond (fig. 110).[7]

Two prominent features of the painting, the coats of arms and the broken column, figured in Surrey's trial for treason. The sculptures depicted to either side of the sitter display the arms of Brotherton (on the left) and those of Woodstock (on the right), in what "appears to be an allegory representing the earl's royal descent."[8] Indeed, one of the primary charges against Surrey was that he had used heraldry to assert his descent from Edward the Confessor, and thus a superior claim to the throne than the Tudors themselves.[9] For Surrey's recent biographer the whole portrait serves as an argument for his fitness to assume the role of Protector to the young Edward VI—a possibility that motivated his enemies at court to conspire successfully against him.[10]

The broken column against which Surrey leans also featured in his trial. According to a later account, the earl was accused of designing a tapestry featuring "a pillar broken in the middest" with the king's initials (HR) on either side of it, suggestive of the aging king's loss of physical and political power. Surrey countered that the pillar symbolized his own beleaguered state, and that "the H and the R did stand for Hereditas restat [the inheritance remains], because he hadd nothing to trust to but his inheritance."[11] Surrey likely derived this imagery from the poetry of his friend Wyatt, who began one sonnet by lamenting, "The pillar perished is whereto I leant." Wyatt's metaphor of the broken pillar went back to Petrarch and also supplied a frequent motif for Italian portraits.[12] With the inclusion of this introspective device, Surrey's portrait, for all its heraldic bombast, prefigures the melancholy poses of later Elizabethan portraiture (see cat. 110).[13] A E

Notes to this entry appear on p. 317.

sources, to Guillim Scrots.[4] In a significant interpretation of the painting, Charlotte Bolland has emphasized that it is not "an anomalous stylistic commission, but a rare survivor [of painting on canvas] that exemplifies the work being produced at the highest levels at court."[5] Bolland tentatively attributes the painting to a North Italian painter, perhaps one in the orbit of Giovanni Battista Moroni, pointing to the documented presence of Italian painters in Surrey's entourage and at the court of Henry VIII.[6] Nevertheless, the flattened, decorative surfaces of Surrey's rich clothing show that the painter, whatever his origins, had assimilated himself to the dominant aesthetic of Tudor portraiture. The depiction of the earl stands in strong contrast to that of

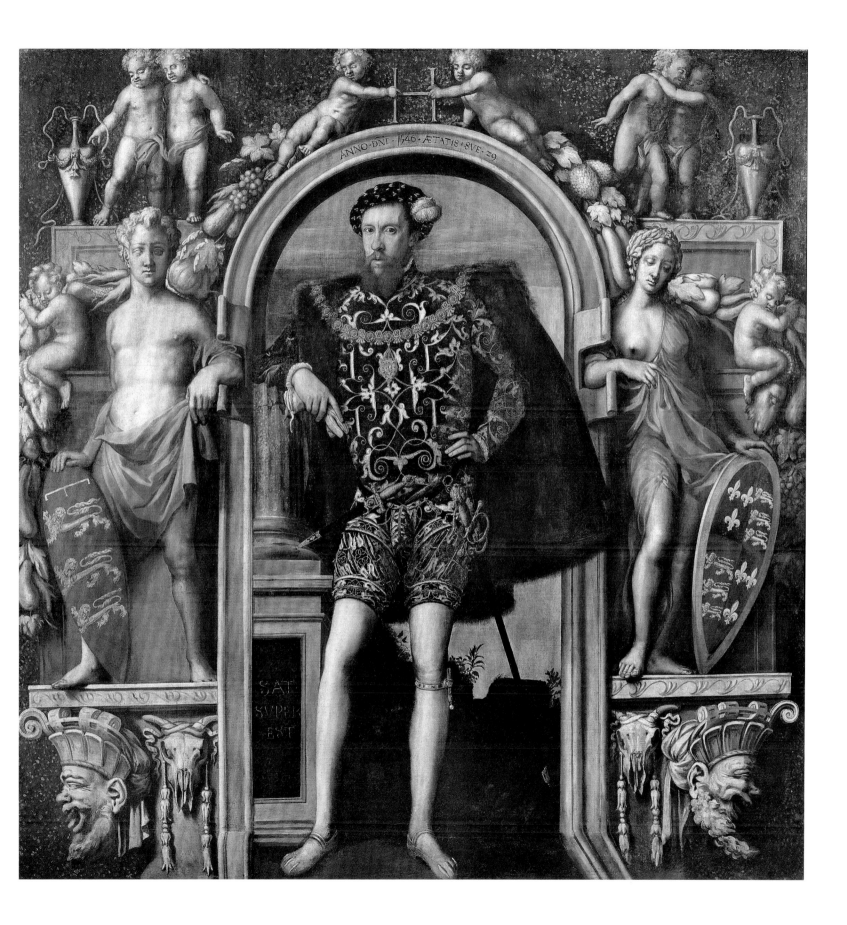

ANNO·DNI·1546·ÆTATIS·SVE·29

SAT
SVPER
EST

99. *Hercule-François, Duc d'Alençon*

Unknown French artist (circle of François Clouet, ca. 1516–1572)
1572
Oil on canvas, 74¼ × 40¼ in. (188.6 × 102.2 cm)
National Gallery of Art, Washington, D.C. (1961.9.55)

Depicted at life size and full length, the dashing figure of Hercule-François, duc d'Alençon, youngest son of Catherine de' Medici and Henri II of France, dominates the shallow stage of this formal portrait, dated the day after his eighteenth birthday.[1] His white court costume shimmers from the shadows: leather slippers, silk hose, a finely slashed doublet, pleated ruff, and short trunk hose of silk overlaid with bands of cutwork or lace. With his right hand he holds a pair of gloves; his left rests on the hilt of a rapier suspended from a thin belt. A cape of white fur flecked with black (possibly snow leopard) is draped over one shoulder, and on his head is a black Spanish toque with a jeweled band and white aigrette. Around his neck is a rope of pearls interspersed with jeweled medallions, from which is suspended the royal Order of Saint Michael.

The striking physiognomy and easy elegance of this likeness present a deceptive image of the notorious d'Alençon, however. A severe case of smallpox contracted in his youth had stunted the duke's growth and deformed his facial features, leaving him permanently pockmarked and scarred. Nor did his character compensate for his unfortunate appearance: one modern scholar has described him as "a morally bankrupt *politique* who switched religio-political allegiance with the prevailing winds."[2] He quarreled with and conspired against his siblings, and his own brother-in-law, Henri de Navarre (later Henri IV of France), described him as "sly and two-faced."[3] D'Alençon was not well educated, and although he could be entertaining, he lacked intellectual curiosity; his energies were focused primarily on accumulating power and influence to rival that of his brother, King Henri III of France.

Unappealing as the duke might have been in character and looks, as brother of the reigning king of France and next in line to the throne, he was a figure to be reckoned with on the international political stage. Indeed, from about 1572 to 1582, he was considered a viable marriage prospect for Elizabeth I.[4] In 1572 England and France sought to form an alliance to counter the growing power of Spain, in part by negotiating a marriage between Elizabeth and either Henri III or his younger brother. Henri's staunch Catholicism eliminated his candidacy early on, but d'Alençon's religious equivocation kept him in the running. Any candidate proposed as consort for the queen needed to be thoroughly vetted, and this was particularly true in the case of a prospective groom internationally reputed to be short, ugly, and disfigured. Elizabeth dispatched ambassadors and envoys to provide her with reports, but only an exchange of painted portraits could provide visual confirmation. To promote her youngest son as a prospective suitor for the English queen, Catherine de' Medici sent a portrait of d'Alençon to Robert Dudley, Earl of Leicester. A letter from the French ambassador to Catherine, dated May 24, 1572, described Elizabeth's reaction when she was shown this portrait of the prince:

> After the lord Cavalcanti had delivered the portrait to the Earl of Leicester, the Queen of England had it carried into her Privy Chamber, where she took the opportunity to inspect it carefully, and afterwards the said earl informed me that the said portrait having represented the stature and physical appearance of the person, even though it was not exactly like Monsieur [d'Alençon], nonetheless it did not seem to displease the said Lady, and that, she had judged that the facial disfigurement would go away with time. It is true that, when she came to read the inscription of the age, she said that he was not yet half her age—eighteen as against thirty-eight—and that the things she had feared, in this respect, of his elder brother [Henri] she feared even more with him.[5]

The documented history of the present portrait extends only to 1851,[6] but it has been plausibly suggested that it may be identical to the one delivered to Leicester and shown to Elizabeth in 1572.[7] After the portrait had been viewed by the queen, it seems to have remained in (or reverted to) Leicester's possession. Inventories of one of the earl's country residences, Wanstead Manor, compiled in the mid-1580s list two portraits of d'Alençon in "whole stature on clothe" (i.e., full-length on canvas), one of which depicted him at "xvIII yeres oulde."[8] That the compiler of the second inventory would record the subject's age so precisely suggests that it was inscribed on the portrait itself, just as it is on cat. 99.

Although marriage negotiations collapsed in 1573, by 1578 d'Alençon was once again being considered as a prospective suitor, primarily because the continued refusal of France, Spain, and the papacy to recognize the legitimacy of Elizabeth's rule, and their support of Mary, Queen of Scots, as the "rightful" queen, seriously threatened the Protestant Tudor monarchy. Elizabeth was by then in her mid-forties, and it was increasingly apparent that her succession was unlikely to be assured through issue. A strategic political marriage and the nomination of an alternative heir to the throne was perhaps the most effective way to secure the continuation of Tudor rule to the exclusion of Catholic Mary and her son, James VI, and to win powerful allegiants on the Continent. D'Alençon completely charmed Elizabeth during a secret visit to England in August 1579, and the courtship intensified during a second visit in June 1581. An official visit in November of that year

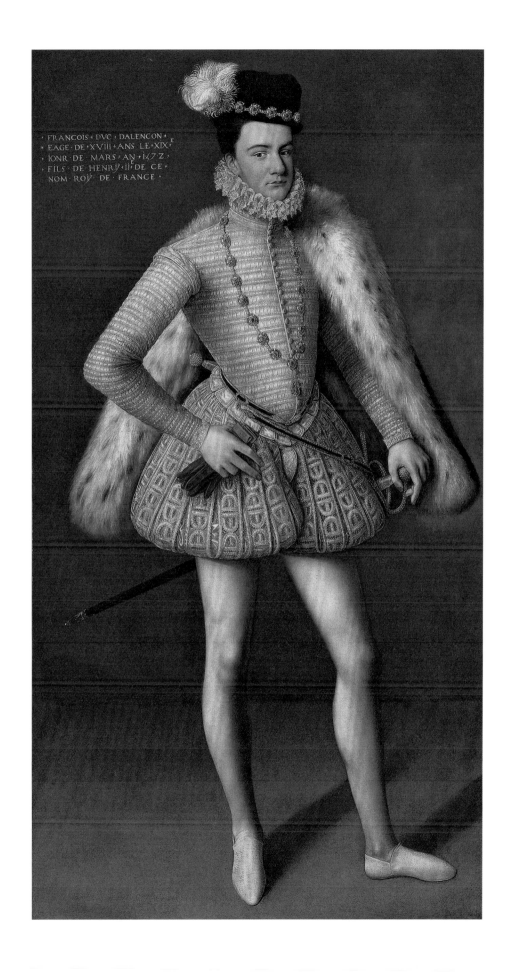

· FRANCOIS · DVC · DALENCON ·
· EAGE · DE · XVIII · ANS · LE · XIX ·
· IONR · DE · MARS · AN · 1572 ·
· FILS · DE · HENRY · II · DE · CE ·
· NOM · ROY · DE · FRANCE ·

brought an exchange of rings and Elizabeth's verbal statement of her intent to marry the prince. The promise was withdrawn the following day, however, although whether over concerns about the political and financial concessions involved in such an alliance, or the personal risk involved in marrying someone twenty years her junior, is not known. MEW

Notes to this entry appear on p. 317.

100. *Fencing Doublet*

Western Europe, ca. 1580
Leather, silk, linen, and cotton, 30 × 23¾ × 14¼ in. (76.2 × 60.3 × 36.2 cm)
The Metropolitan Museum of Art, New York, Bashford Dean Memorial Collection, Funds from various donors, 1929 (29.158.175)
Exhibited New York only

Probably used for fencing practice, this padded, cream-colored doublet would have offered a modish protective layer to its courtly male wearer. Each element reinforces the dialogue between armor and elite court dress: stylish "pickadils," or small looped tabs, trim the wings, collar, and cuffs, and the quilting and embroidery on the torso emulate the vogue for decorative scrollwork, paning, pinking, and slashing. A civilian fashion that emerged in the twelfth century, slashing partially emblemized the romantic, chivalric knight and the violent process of constructing both the garment and the hero.[1] In a 1576 portrait, Sir Philip Sidney wears a similar doublet of white slashed leather, accessorized with an actual piece of armor (fig. 111).

The doublet boasts a "peascod" belly, padded to protrude forward, that became fashionable in the 1570s. The stuffed peascod belly, like a woman's bodice, reshaped the masculine silhouette, elongating the torso, widening the waistline, and eventually replacing the codpiece as a symbol of masculine virility. Responding to the unnatural shaping and effort the padded peascod doublet demanded, the contemporary pamphleteer Philip Stubbes complained in his conservative tract *Anatomie of Abuses* (1583), "there was never any kinde of apparell ever invented that could more disproportion the body of man then these Dublets with great bellies hanging down beneath their Pudenda (as I have said), & stuffed with foure, five or six pound of Bombast at the least."[2] The ubiquitous silhouette appears in countless portraits of fashion-conscious sitters (cat. 99; fig. 117), as well as in armor (cat. 72).

In its construction and attention to trends, this fencing garment is typical of protective doublets of the era. A Venetian visitor to England wrote in 1557, "they usually wear . . . certain canvas doublets, quilted with many layers, each of which is two inches or more in thickness; and these doublets are considered the most

secure defence."[3] The surviving examples, which are usually leather and lined, resemble those in Michael Hundt's illustrated fencing manual *Ein new künstliches Fechtbuch im Rappier* (1611) and, with their cushioning, would have protected swordsmen from a practice rapier's blows.[4] As with civilian garments and armor alike, this doublet consisted of many interlocking parts. The dip leads into a peplum skirt, to which the owner would have likely tied his trunk hose. The sleeves are detachable, laced on through hidden eyelet holes beneath the wings. Although the doublet appears to fasten down the front, the buttons are nonfunctional, hence the additional lacing along the left and right side-back seams. The silhouette of cat. 100 differs from surviving examples, as the construction of such garments was sensitive to shifting sartorial trends.[5]

Swordsmanship permeated courtly life, particularly under Elizabeth I, as both a mode of defense and a popular social institution upholding honor, romance, and masculinity among combatants.[6] Requiring equal parts expertise and strength,

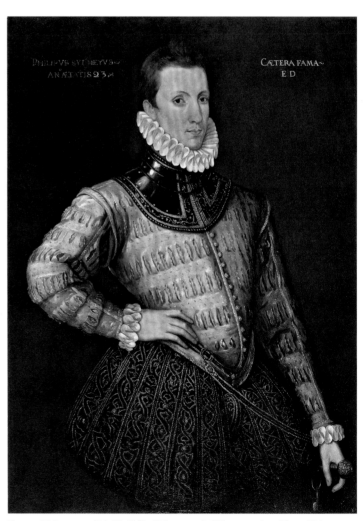

Fig. 111. Unknown artist, *Sir Philip Sidney*, 1576. Oil on panel, 44⅞ × 33⅛ in. (113.9 × 84 cm). National Portrait Gallery, London (NPG 5732)

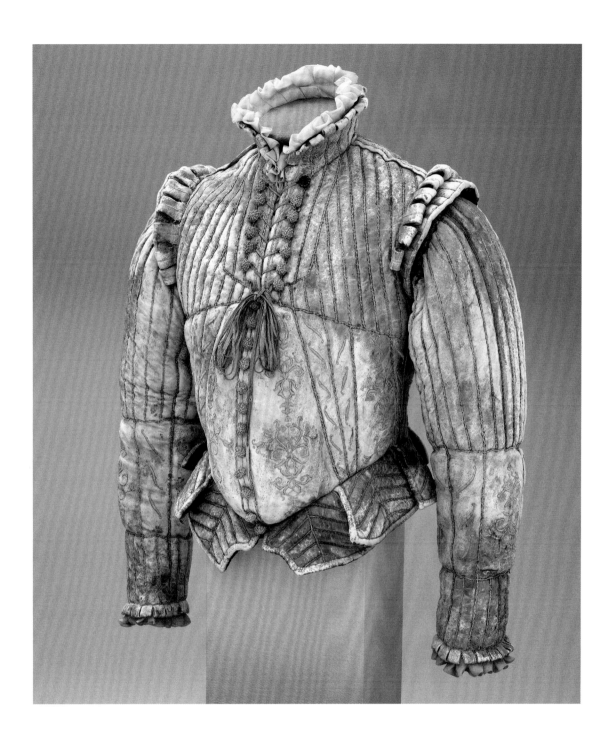

fencing communicated an elite education, giving rise to a cul-
ture of fencing manuals, courtesy books, plays, and anti-dueling
tracts.[7] Mastering this courtly ideal also inherently repudiated
"demonized opposite" qualities like femininity and clownishness,
as courtiers flaunted power, position, and reputation by wearing
armor and defensive garments during civil occasions, proces-
sions, tournaments, and pageants.[8] In the wrong setting, how-
ever, the public transferability of such attire could be dangerous;
in 1579 the queen prohibited "whatsoever the wearing of any

such privy or secret kind of coat or doublet of defense," because
the apparel caused "frays upon other unarmed."[9] The proclama-
tion—much like Stubbes's fear-mongering text—betrays the
early modern notion that outward clothing not only reflected but
also shaped inward identity and behavior.[10] This fencing doublet
similarly conveys the sculptural, active quality of menswear, and
the refined social mores of those who would have worn it. SB

Notes to this entry appear on p. 317.

101. 'Abd al-Wahid bin Mas'ood bin Mohammad 'Annouri

Unknown English artist
1600
Oil on panel, 44¼ × 34½ in. (113 × 87.6 cm)
Research and Cultural Collections, University of Birmingham (AO427)

This painting, the earliest surviving portrait of a Muslim made in England, is a remarkable record of the globalized diplomacy of the late Elizabethan age. It depicts 'Abd al-Wahid bin Mas'ood bin Mohammad 'Annouri, the secretary of Ahmad al-Mansur, sultan of Morocco.[1] 'Annouri spent six months in England in 1600, ostensibly to negotiate trade relations with Elizabeth I (Morocco was a prime exporter of sugar to England), but in fact with clandestine orders to propose an Anglo-Moroccan alliance against Spain. The sultan, emboldened by his recent defeat of the vast Songhai Empire in West Africa, envisioned not only the reconquest of formerly Islamic territory in Iberia, but also a joint Anglo-Moroccan campaign to expel the Spanish from their colonial possessions in both the East and West Indies.[2]

The ambassador and his entourage had their first audience with Elizabeth I at Nonsuch Palace on August 19, 1600. In the words of one observer:

> here was a roiall Preparacion in the manner of his receiving; rich Hangings and Furnitures sent for from *Hampton* Court; the Gard very strong, in their rich Coates; the Pentioners with their Axes; the Lords of the Order with their Collers; a full Court of Lords and Ladies. He passed thorough [*sic*] a Gard of Albards [halberds] to the Cownsell Chamber, where he rested; he was brought to the Presence, soe to the Privy Chamber, and soe to the Gallery; where her Majestie satt at the further End in very great State, and gave them Audience.[3]

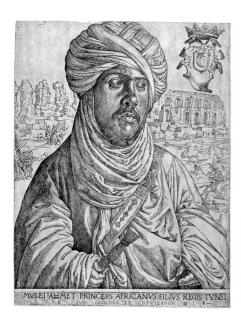

Fig. 112. Jan Cornelisz Vermeyen (ca. 1504–1559), *Mulay Ahmad*, ca. 1536. Etching, 18¼ × 14¹³⁄₁₆ in. (46.4 × 37.7 cm). Albertina Museum, Vienna (DG1949/467)

This description vividly evokes the importance of portable furnishings, livery, arms and armor, and the "great State" of the queen herself in impressing awe-inspiring magnificence upon her foreign visitors as a tool of international diplomacy. Likewise, the punctuated spatial sequence of the audience, moving from council chamber to privy chamber to presence chamber to gallery, demonstrates the effectiveness of Tudor palace architecture in demarcating status and ever-more restricted spaces of royal favor and access.

In his portrait, the ambassador wears a turban and robe of white linen, a black cloak, and a *nimcha*, or scimitar. He rests one hand upon his chest and extends the index finger of the other toward the ground, in a gesture that draws attention to his prominent (and, to English eyes, exotic) weapon. Inscriptions framing the sitter record his age and the portrait's date, as well as giving an approximate transliteration of the ambassador's name and identifying him as "the king of Barbary's legate to England." Given its English provenance and Islamic prohibitions against figurative portraiture, previous commentators have argued that the portrait was most likely painted at the behest of Elizabeth or her courtiers to commemorate the ambassador's visit.[4] They have also generally assumed that the ambassador sat in person for his portrait, but this need not have been the case in a culture in which painters often based portraits of crowned heads and other dignitaries upon spurious or nonexistent prototypes. Indeed, similarities between the ambassador's attire and Jan Cornelisz Vermeyen's famous etched portrait of Mulay Ahmad, king of Tunis, reveal one possible source for the image (fig. 112).[5] Although the artist of the portrait remains unknown, dendrochronological and stylistic evidence suggests that the portrait was made in the same workshop as one depicting Thomas Neville, master of Trinity College, Cambridge.[6]

From the time of the portrait's rediscovery in the mid-twentieth century, its sitter and his embassy have fascinated scholars as a possible inspiration for Shakespeare's *Othello*, which was written within a few years of the ambassador's visit as part of a general fashion for plays with "Moorish" or Islamic themes.[7] As noted elsewhere in this volume (see "England, Europe, and the World: Art as Policy"), England already had a significant population of African origins by this date.[8] 'Annouri himself left England in February 1601, having achieved few concrete results from his diplomatic mission, and whatever prospects remained of a grand Anglo-Moroccan alliance quickly faded with the deaths of Elizabeth and al-Mansur, both in 1603. AE

Notes to this entry appear on p. 317.

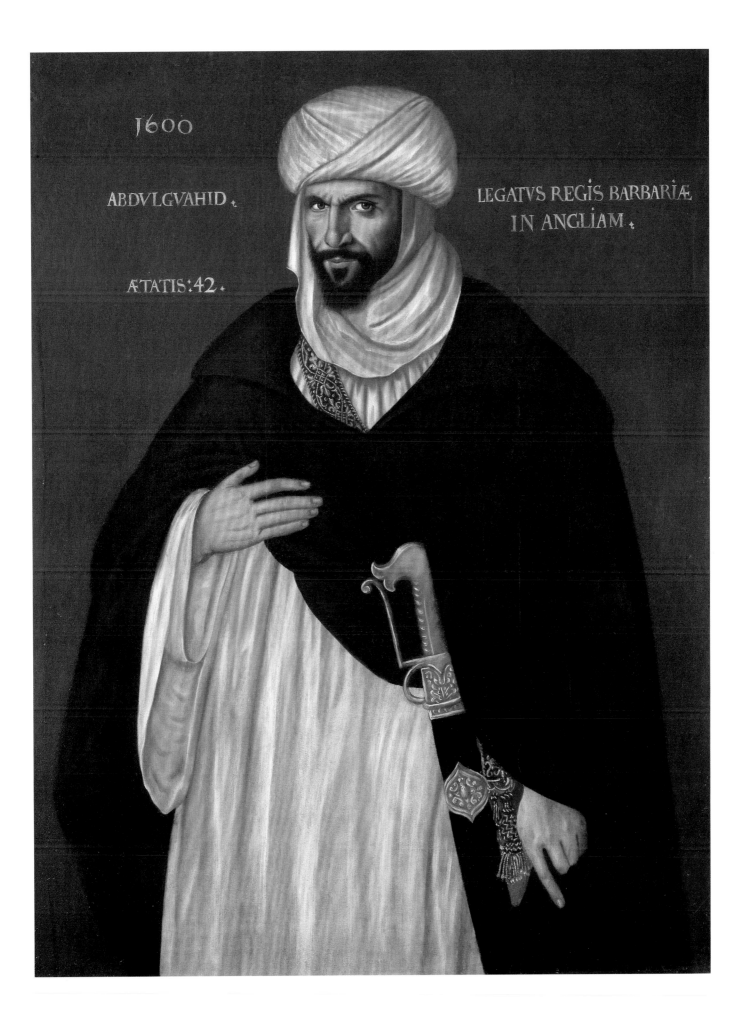

1600

ABDVLGVAHID .

ÆTATIS : 42 .

LEGATVS REGIS BARBARIÆ
IN ANGLIAM .

102. Ellen Maurice

Marcus Gheeraerts the Younger (1561–1635/36)

1597

Oil on panel, 35⅝ × 29¼ in. (90.6 × 74.2 cm)

The Metropolitan Museum of Art, New York, Purchase, Theodocia and Joseph Arkus and University Place Foundation Gifts; Gift of Victor G. Fischer, by exchange; Marquand Fund; Elizabeth and Thomas Easton Gift, in memory of their mother, Joan K. Easton; Gift of Mary Phelps Smith, in memory of her husband, Howard Caswell Smith, by exchange; and The Alfred N. Punnett Endowment Fund, 2017 (2017.249)

Exhibited New York only

Marcus Gheeraerts the Younger was the most important member of an Anglo-Flemish artistic family that had a major impact on English painting at the end of the sixteenth century.[1] Born in Bruges, he came to England in 1568 as a child in the company of his father, Marcus the Elder, seeking religious freedom and a haven from the repressive Spanish occupation of the Low Countries (see cat. 106). In London father and son joined a large community of enterprising and educated Dutch-speaking refugees. Marcus the Younger likely trained under his father or another Netherlandish artist working in England. In 1595 he married Magdalen de Critz, whose brother John was himself a successful painter with Flemish origins. (Another brother-in-law was the celebrated miniaturist Isaac Oliver; see cats. 111, 117.) By the 1590s Gheeraerts had established himself as a favored portraitist of the aristocracy; in particular, the patronage of Sir Henry Lee, the Queen's Champion, introduced him to courtly patrons (see, for example, cat. 119).

Gheeraerts's sitter in this portrait, Ellen (Welsh: Elin) Maurice, was an heiress claiming direct descent from the ancient princes of Wales.[2] In the sixteenth century the Welsh gentry, unlike their Irish counterparts, largely embraced the Protestant Reformation and the ascendance of the (originally Welsh) Tudor dynasty, seeing in the latter the fulfillment of bardic prophecies about the restoration of ancient, Celtic Britain.[3] The sitter's grandfather Sir William Maurice of Clenneny served in the House of Commons and is said to have coined the title "King of Great Britain" for his friend James I. Ellen Maurice's first husband, John Owen, was a Welshman who amassed a fortune while serving as private secretary to Sir Francis Walsingham, Elizabeth I's "spymaster." Walsingham engaged Gheeraerts's brother-in-law John de Critz as a courier in the 1580s, and it may have been through her husband's employer that Ellen Maurice was introduced to the De Critz/Gheeraerts family of artists.[4] At the time the portrait was painted, the sitter was roughly nineteen years old; the likeness may commemorate either her marriage or her presentation at court.

Following John Owen's death in 1611, Ellen Maurice married Sir Francis Eure, a justice of the circuit court of North Wales. She died in 1626 and was buried at Saint Mary's Church in Selattyn, Shropshire, having devoted a portion of her wealth to the foundation of almshouses that survive to this day in Oswestry.[5] Of her many children who lived to adulthood, her son and heir, Sir John Owen, became a noted soldier for the Royalist cause during the English Civil War. Her portrait remained in the possession of her direct descendants until its recent acquisition by The Met.[6]

As her grandfather's heiress, Ellen Maurice continued her family's practice of patronizing bardic poetry in Welsh; elegies addressed to her by Richard Cynwal and Huw Machno are preserved in manuscript at the National Library of Wales.[7] In one such poem Cynwal praises Lady Eure's lineage, wealth, and beauty, declaring, "Whenever there came to the same place . . . / the estate of the Kingdom and its most handsome dignitaries /

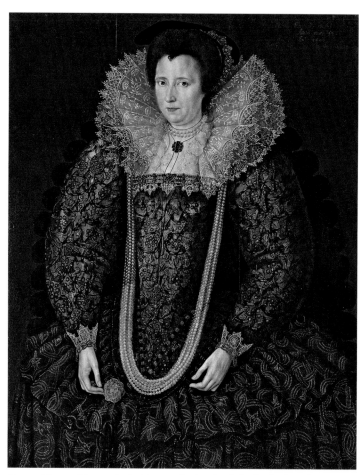

Fig. 113. Marcus Gheeraerts the Younger (1561–1635/36), *Elizabeth Finch, Countess of Winchelsea*, 1600. Oil on panel, 44 × 35 in. (111.8 × 88.9 cm). Collection of the Earl of Radnor, Longford Castle, Bodenham

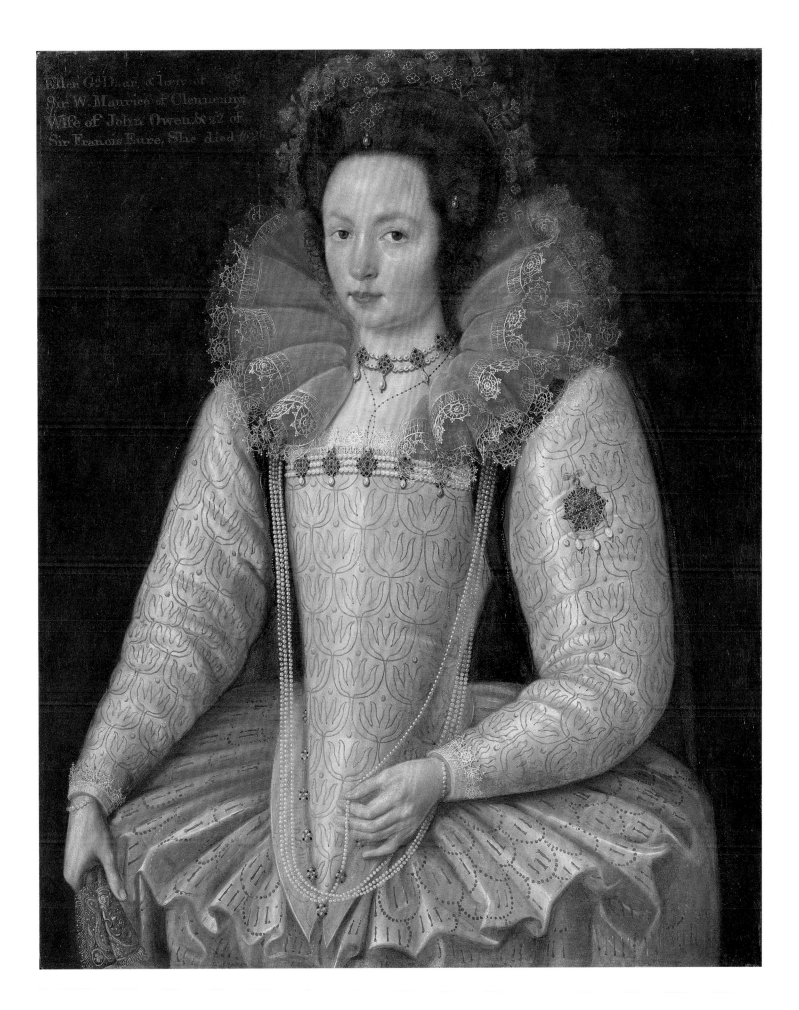

and the daughters of great dukes of the fairest pedigrees / and the best, most attractive, ladies / in elegant London . . . / she was judged fairest."[8]

Gheeraerts's portrait pays similar tribute to the young sitter's beauty. Holding a richly decorated glove in one hand, she caresses a long strand of pearls in the other. Her long, stiff bodice, bulbous sleeves, and wheel farthingale emulate the silhouette promoted by Queen Elizabeth in such images as the Ditchley portrait (cat. 119). As in that painting, an astonishing amount of pearls conveys the wealth of the sitter; her gesture of pinching one long strand between thumb and index finger enlivens the portrait and evokes the courtier's refined movements. A starched standing ruff collar of transparent gauze and lace frames the sitter's head and offsets the dark locks of hair that tumble down her cheeks. Typical for Gheeraerts's depictions of women are the prominent eye sockets and vein visible in the sitter's right temple, calling attention to her aristocratic pallor. Ellen Maurice's pose, costume, and jewelry all closely resemble those in Gheeraerts's 1600 portrait of Elizabeth Finch, Countess of Winchelsea (fig. 113), although Maurice's youth and beauty distinguish her likeness within Gheeraerts's oeuvre.

Following its acquisition by The Met, the present portrait underwent extensive conservation and technical examination.[9] They revealed that, while the sitter's face and hands are well preserved, her costume underwent a previous campaign of restoration. It is estimated that this work took place early in the nineteenth century, most likely to compensate for the deleterious visual effects caused by the significant development of lead soaps in the original paint layers. The meticulous re-creation of Ellen Maurice's costume at a time when her portrait was still in the possession of her descendants attests to its continued value as a dynastic image long after her death. AE

Notes to this entry appear on pp. 317–18.

103. *Pair of Gloves*

London, ca. 1600
Leather; satin worked with silk and metal threads; seed pearls; satin, couching, and darning stitches; metal bobbin lace; and paper, each 12¼ × 6¼ in. (31.1 × 15.9 cm)
The Metropolitan Museum of Art, New York, Gift of Mrs. Edward S. Harkness, 1928 (28.220.7, .8)
Exhibited New York only

A weeping, disembodied eye, a green parrot with pearled wings, and shimmering pansies emerge from materials as diverse as satin, metal, and paper to deliver an evocative message of love and longing.[1] Taken together, the three motifs and the medium indicate that these gloves were a love token. Like other textiles worn on the body, gloves shaped and were shaped by their wearer, conjuring a sense of presence long after their giver or owner had departed.[2]

The tearful eye—here embroidered in expensive silk, silver, and gilded-silver threads—was associated with the fashionable trope of a melancholy, unrequited love (see cat. 110). In the emblem book *Minerva Britanna* (1612), Henry Peacham depicted the eye alongside brooding phrases of unworthiness: "ah I feare me, I too high aspire, / Then wish those beames, so bright had never shin'd."[3] The verses recall Romeo's besotted pining for Juliet's gloved hand in *Romeo and Juliet* (2.1.66–67): "See how she leans her cheek upon her hand. / O, that I were a glove upon that hand / That I might touch that cheek!"

Punning on the French word *pensée* (thought), the pansy symbolized amorous introspection, noted in its alternate names: "love-in-idleness" and "heartsease." Its three petals correlate to a love object encircled by two devoted suitors but, perhaps surprisingly, also have associations of chastity.[4] A favorite flower of Queen Elizabeth I, pansies dapple her fanciful bodice in the Rainbow portrait (cat. 120) and her variegated skirt in the Hardwick portrait (cat. 118), as well as the gauzy, puffed headdress of the fabled "Persian lady" (cat. 112). They also featured in numerous New Year's gifts, such as a cloth of silver muff embroidered "all ouer Lyke Paunces [pansies] of Venis golde" that was offered to the queen in 1594.[5]

Parrots commonly appear in images of the Virgin and Child or the Garden of Eden, or in elaborate garden compositions, but it is possible that they here signify a "parroting" of the gift giver—a desire that the bird act as a surrogate in their absence (see "The Tudor Art of the Gift" in this volume). Alternatively, parrots may suggest heartwarming domestic compatibility, as seen in the portraits of the high-ranking courtiers Lord and Lady Cobham calmly dining among their children and pets.[6]

The style, intentions, and motifs of these gloves are consistent across surviving English examples. The tabbed gauntlets

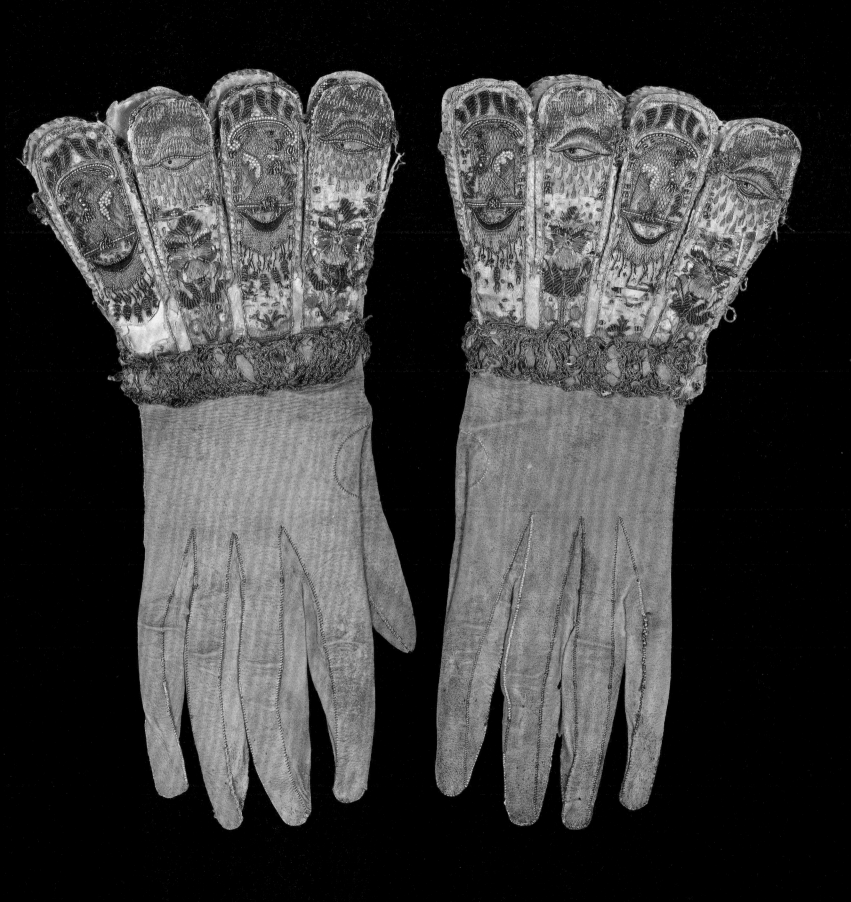

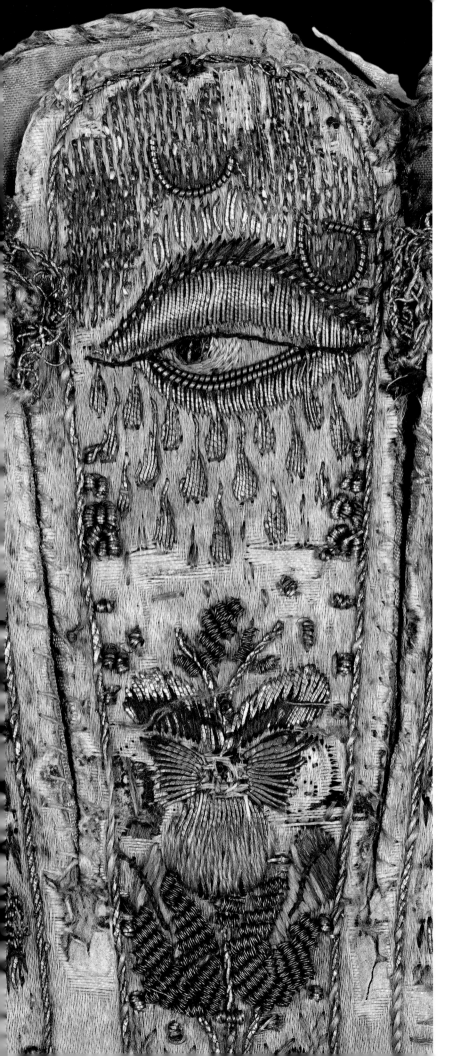

speak to the elaborate mixed proportions of dress—the variation between a building-out of the body and an emphasis on natural physique—and the use of textiles as a platform for emblematic self-presentation. The specific imagery, *impresa*-like quality, and natural motifs also highlight the late Elizabethan visual vocabulary, shared across mediums (see "Honing the Tudor Aesthetic" in this volume). It is difficult to determine the intended wearer's gender, but owing to the symbolism and relatively small size of these gloves, it seems likely they were a gift from a man to a woman.

Although gloves could be functional, pairs such as cat. 103, with its evocative gauntlets wrought by a professional hand, existed mainly to fulfill symbolic and social functions.[7] During diplomatic audiences Queen Elizabeth sometimes pulled her gloves on and off multiple times to draw attention to her "very beautiful & very white" hands.[8] And in the tiltyard, the Earl of Cumberland's sporting of the queen's glove in his hat (see cat. 73) trumpeted her intimacy and favor.[9] Inventories and letters reveal that it was common for gloves to be perfumed (or "washed") with sweet-smelling jasmine, orange water, cloves, nutmeg, or vanilla-like benzoin oil, a practice adopted from continental Europe.[10]

Of course, gloves such as these could also confirm or encourage a courtship. In the early modern period, the exchange of love tokens and gifts was an essential rite and, as the circumstances progressed, attested to a binding marital contract.[11] Coins, rings, and gloves—or, coins and rings concealed within a glove—all provided material reminders of affection and, less romantically, of social obligation.[12] SB

Notes to this entry appear on p. 318.

104. *Portrait Medal of Richard Martin and Dorcas Eglestone*

Steven Cornelisz. van Herwijck (ca. 1530–ca. 1565)
London, 1562
Cast and chased silver, Diam. 2¼ in. (5.7 cm)
The British Museum, London (M.6869)

105. *Portrait Medal of William Herbert, 1st Earl of Pembroke, with Allegory of Virtue*

Steven Cornelisz. van Herwijck (ca. 1530–ca. 1565)
London, 1562
Cast and chased silver, Diam. 1¾ in. (4.4 cm)
The British Museum, London (BNK,EngM.16)

With the suggestion of beautifully made clothing and headgear, decorous but not ostentatious, the husband and wife immortalized on cat. 104 radiate affluent respectability, embodying the prosperous middle classes of Elizabethan London. Richard

Cat. 104, obverse

Cat. 104, reverse

Cat. 105, obverse

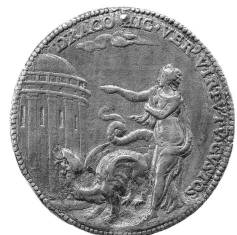

Cat. 105, reverse

Martin was warden and master at the Royal Mint and a future Lord Mayor of London; his wife, Dorcas Eglestone, was a respected intellect in her own right, with a subsequently published translation of a French catechism to her credit.[1]

William Herbert, 1st Earl of Pembroke, portrayed on cat. 105, on the other hand, epitomizes armor-clad aristocratic grandeur. A minor nobleman from Wales, he had risen to prominence at Henry VIII's court (see cat. 23), thanks principally to the efforts of his erstwhile sister-in-law Katherine Parr, Henry's final queen. He was knighted in 1544, elected to the Order of the Garter in 1548, and created Earl of Pembroke (of the second order) in 1551. He also managed the fine tightrope of surviving Edward VI's reign as one of his twelve Privy Counsellors, as well as his own rehabilitation under Mary, despite his ill-advised support of Lady Jane Grey's claim to the throne.[2] The rousing inscription, which translates as, "This dragon is the true guardian of the

virtues," on the allegorical reverse of his medal would doubtless have appealed to the aging Welsh knight, who prided himself during his retirement from Elizabeth's court on the cultivation of his gardens—inspiration for his brother-in-law Philip Sidney's *Arcadia* (written, in its first version, in 1577–80)—at his country seat, Wilton.[3] (Those with long memories, however, might have detected a certain irony, Pembroke's virtues having been tested in the preceding decade, not least by the hasty annulment of his son's brief marriage to Catherine Grey, Lady Jane's sister, when Mary's accession grew imminent.)

Yet despite the sitters' differing status, these two medals are united in the stunning quality of their artistry: the portraits capture not only facial features but personalities, with just the right amount of surface detail to evoke trappings as diverse as linen, fine wool, fur, or iron. Subtle engraving and relief work, expertly chased, reveal the hand of a master designer and goldsmith.

The portrait medalist and sculptor Steven Cornelisz. van Herwijck, native of Utrecht, citizen of Antwerp, could have made a glorious career for himself in Flanders or at the Polish court of Sigismund II Augustus.[4] He chose instead to settle in London. During a visit in 1562, he introduced fine portrait medals like these examples—previously in England an area of artistic commission explored only by royalty (cats. 94, 95)—to wealthy members of the general populace. He may have brought some contacts from Antwerp; one of his sitters was Maria Newce, daughter of a mercer and wife of the Londoner John Dimock, whose daughter-in-law was Beatrice van Cleve, the Antwerp painter Jan van Cleve's daughter.[5] Others he doubtless nurtured because of their connections to Elizabeth's court. Among his clients were the merchant, moneylender, and politician Edmund Withipool; Richard Martin's colleague Thomas Stanley, goldsmith and comptroller at the Royal Mint; Anne Poyntz Heneage, a gentlewoman of Elizabeth's Privy Chamber; and Pembroke's former in-laws, William and Elizabeth, Marquess and Marchioness of Northampton.[6]

Van Herwijck called himself both a "portraitist in medals and a sculptor."[7] His experiences in the splendid tapestry-hung court at Kraków, in addition to his time in Antwerp (where he was a member of the Guild of Saint Luke from 1558), are reflected in his designs. The texturing of Dorcas Eglestone's apparel matches the achievements of Jacques Jonghelinck (cat. 95), while the restrained chasing and elegant, Italianate allegorical composition of Pembroke's medal suggests some knowledge of Jacopo da Trezzo's work (cat. 94). Though none of Van Herwijck's sculpture is known for certain to have survived, a delicate relief-carved mantle shelf in Utrecht has been linked to him and does share some stylistic characteristics with his figurative medals, not least the willowy female Vice threatening Pembroke's temple of Virtues.[8] After a brief return to Flanders and to the province of Utrecht in 1564, Van Herwijck moved to London, declaring his intention to the Antwerp guild to undertake large projects for Queen Elizabeth.[9] His Antwerp-born wife, Jonekin, and their two sons, Abraham and Steven, traveled with him and were stranded in the city following his untimely death sometime between 1565 and 1567. The support structure of professional obligations, however, intervened, and Van Herwijck's family, though members of the Dutch Reformed Church and in touch with their Utrecht cousins, stayed in England. Van Herwijck's erstwhile client John Dimock not only acted as executor of his will, but also provided housing to his widow as her landlord.[10] Abraham van Herwijck became a merchant; Steven the younger apparently died in Rome; and records suggest that, in November 1573, while still in London, Jonekin married another Flemish artist, Gillis Seghers van Enghien.[11] EC

Notes to this entry appear on p. 318.

106. *The Unfortunate Painter and His Family*

Marcus Gheeraerts the Elder (ca. 1520–ca. 1590)
1577
Pen and wash, heightened with white, on prepared paper, 9½ × 14¹⁵⁄₁₆ in. (24.2 × 37.9 cm)
Bibliothèque Nationale de France, Paris (Rés. B 12)
Exhibited New York only

The misfortunes that befell continental artists in the sixteenth century as sectarian conflict and iconoclastic violence engulfed much of Europe often redounded to England's gain. In 1526 Hans Holbein the Younger left Basel, where Protestant opposition had dried up patronage of the arts (see "Hans Holbein and the Status of Tudor Painting" in this volume). Hans Eworth fled Antwerp for London in 1544, proscribed as a heretic.[1] During the reign of Elizabeth I, seen throughout Europe as a protector of Protestantism (see cat. 122), many Dutch-speaking artists relocated to London, forming a vibrant community centered on the Reformed church at Austin Friars that became a major conduit for ideas and images into England.[2]

Among the artists belonging to the Austin Friars congregation was the Flemish painter and printmaker Marcus Gheeraerts the Elder. Having served on the Calvinist Council in his native Bruges, Gheeraerts fled to London in 1568 along with his young son Marcus (see cats. 102, 112, 119, 120).[3] Very little of the elder Gheeraerts's work before his exile has survived, but the recent reattribution of two village scenes to him provides a better understanding of his oeuvre and his attempts to ingratiate himself to English patrons in the years after his arrival in London. In these works Gheeraerts the Elder mapped English motifs—the

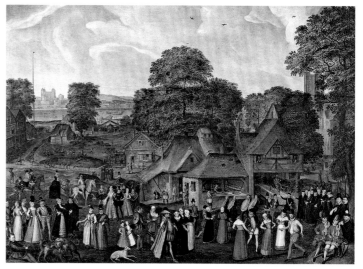

Fig. 114. Marcus Gheeraerts the Elder (ca. 1520–ca. 1590), *A Fête at Bermondsey*, 1571. Oil on panel, 28¹⁵⁄₁₆ × 39¾ in. (73.5 × 101 cm). Marquess of Salisbury, Hatfield House, Hertfordshire

Tower of London; costumes observed by his friend and fellow artist Lucas de Heere (see fig. 32)—onto the Flemish genre of the kermis, or village festival scene (fig. 114). By the early 1580s Gheeraerts had attracted elevated patronage and portrayed Elizabeth I, perhaps on a commission from the Earl of Leicester.[4] Gheeraerts also played a significant role in introducing the practice of etching to England, executing a multisheet depiction of the procession of the Knights of the Garter at Windsor in 1576.[5]

Without being a traditional self-portrait, Gheeraerts's drawing of *The Unfortunate Painter and His Family* gives a rare insight into an Elizabethan artist's own self-conception.[6] It combines realistic details of a studio scene, such as the easel and the pigment grinder in the background, with classicizing and allegorical elements. The central figure is a painter, in a form of pseudo-classical dress, who is seated at his easel. He is in the process of painting a live model whose pose and attributes, such as books and a pair of compasses, suggest an allegorical depiction of learning and the liberal arts. Distracting the painter from his task are his wife, who nurses a child on her lap; an older woman (perhaps his mother or mother-in-law); and a swarm of playing children. Meanwhile, Mercury, a god associated with both the arts and commerce, reaches around the easel to tap the painter on the head with his caduceus. A putto likewise reaches up from under the easel to prod the painter with a maulstick. The background opens onto a landscape containing two figures, one with wings and an hourglass. While the painter is torn between the demands of his family and his muse, time is swiftly passing.

The finished nature of the drawing and its inscription suggest that it was intended as a gift for a learned friend or patron. As such, it may have been a witty attempt to secure financial support, recalling the later gift books of another Protestant refugee, Esther Inglis (cat. 59). The inscription at the bottom of the sheet comes from Juvenal's *Satires* and may be translated as, "Not easily do they emerge from obscurity whose worth is hindered by poverty at home."[7] While the drawing uses allegory to elevate or cloak the realities of penury and exile, it nevertheless offers a tantalizing glimpse into one artist's attempts to secure his place in the competitive world of Elizabethan patronage. A E

Notes to this entry appear on p. 318.

107. *Robert Dudley, Earl of Leicester*

Federico Zuccaro (1540/41–1609)
1575
Black and red chalk, 12¾ × 8⅝ in. (32.4 × 21.9 cm)
The British Museum, London (Gg,1.418)
Exhibited New York and Cleveland only

108. *Elizabeth I*

Federico Zuccaro (1540/41–1609)
1575
Black and red chalk, 12¹⁄₁₆ × 8¾ in. (30.7 × 22.2 cm)
The British Museum, London (Gg,1.417)
Exhibited Cleveland only

These two drawings document a rare instance of English aristocratic patronage of an Italian artist in the second half of the sixteenth century. They also provide evidence for the collecting and ambition of the Earl of Leicester, one of the most significant figures at the court of Elizabeth I.

Robert Dudley, 1st Earl of Leicester, was the fifth son of the disgraced Duke of Northumberland, executed for his rebellion against Mary I.[1] Leicester succeeded in restoring his family to a position of wealth and honor as the first and one of the most

Fig. 115. Hans Holbein the Younger (1497/98–1543), *Christina of Denmark, Duchess of Milan*, 1538. Oil on panel, 70½ × 32½ in. (179.1 × 82.6 cm). National Gallery, London (NG2475)

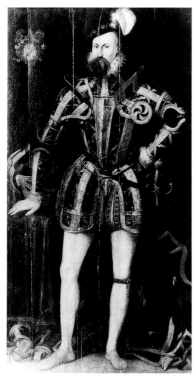

Fig. 116. Unknown artist after Federico Zuccaro (1540/41–1609), *Robert Dudley, Earl of Leicester*, ca. 1575. Oil on panel (destroyed 1940)

enduring of Elizabeth I's favorites. Nonetheless, he was disappointed in his hopes of ever becoming a royal consort, either to Elizabeth herself or to Mary, Queen of Scots. A high point of Leicester's court career was the queen's visit to his seat at Kenilworth Castle in 1575, where he orchestrated several weeks of entertainment aimed at presenting himself as a princely figure worthy of the queen's hand in marriage.[2] These revels provide the essential context for Federico Zuccaro's paired portrait drawings of Leicester and the queen.

Leicester's collecting and patronage were essential to his attempt to project an image worthy of a potential prince consort; as early as 1565, he had sought to lure a Florentine portrait painter to England.[3] A decade later, in advance of the Kenilworth festivities, he succeeded in securing the services of Zuccaro, who had already enjoyed success as a painter in Rome, Florence, and Venice (though not especially as a portraitist). Zuccaro arrived in London sometime in the spring of 1575, bearing a letter of recommendation from Chiappino Vitelli, an Italian military commander and diplomat in Antwerp.[4] According to the Dutch writer and painter Karel van Mander, Zuccaro was received by the Earl of Pembroke at Baynard's Castle, where he admired Holbein's portrait of Christina of Denmark, Duchess of Milan, which subsequently provided a model for his drawing of Elizabeth (fig. 115).[5]

The drawings themselves can be dated precisely on the basis of Zuccaro's own inscriptions, recording that he drew them in London in 1575 (the queen's specifically in May of that year).[6] The drawings depict the queen and her favorite at full-length, in black and red chalk. Elizabeth's portrait adopts the elegantly crossed hands, held at the waist, from Holbein's portrait of Christina of Denmark. Zuccaro only roughly sketched the details of the queen's dress, although he did pay close attention to the construction of her veil and fan. She wears a flower, likely a rose, pinned or tucked to her bodice, much as in the Hampden portrait (cat. 30). Zuccaro was much more precise in capturing Leicester's armor, so that it can be identified with a specific russet suit of tournament armor, also illustrated in the so-called *Almain Armourer's Album* (1557–87; see fig. 75).[7] Dudley rests a gauntleted hand on a table, with heaped pieces of armor and a rapier appearing alongside him. Elizabeth's attributes are more erudite—the snake twined about the column suggests prudence and constancy, and the dog and ermine perched atop it, fidelity and purity, respectively.[8]

It remains an open question whether Zuccaro ever painted portraits on the basis of these drawings. A panel depicting Leicester in the same pose as Zuccaro's drawing, but wearing different armor, was destroyed during a bombing raid at Christie's,

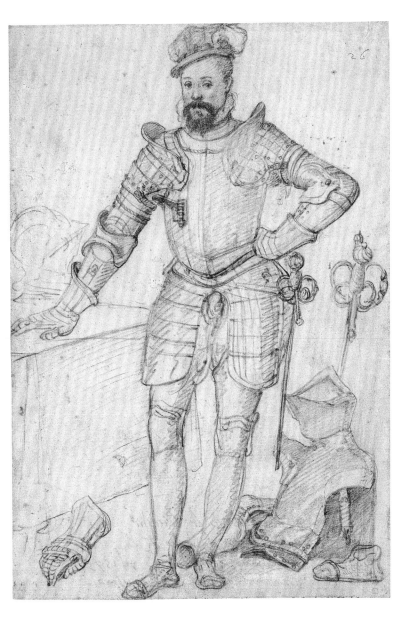

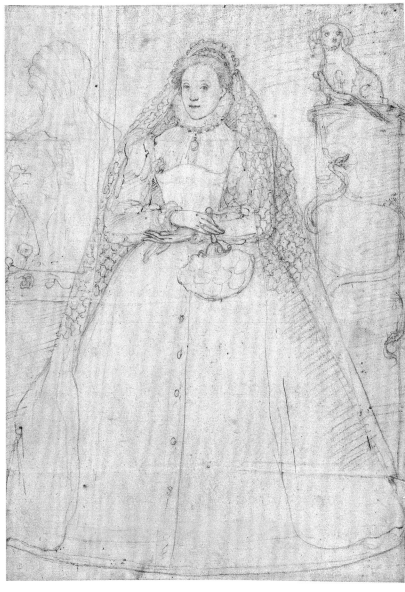

London, in 1940 (fig. 116).[9] Although the surviving black-and-white photograph poses a challenge to connoisseurship, the Christie's picture seems clearly to be the work of an English or assimilated Netherlandish painter, with no resemblance to Zuccaro's known work. On the basis of the Kenilworth inventory, it has been suggested that Zuccaro did complete life-size paintings that were exhibited at Kenilworth as a "quartet" with two other portraits of Dudley and the queen.[10] However, the Kenilworth inventory does not identify the artists of any of these paintings. If the destroyed portrait of Leicester was indeed one of the four paintings displayed at the castle, it would seem to indicate that another artist, probably Anglo-Flemish, worked

up a life-size portrait on the basis of Zuccaro's drawing. Despite the lack of any surviving painted portraits, the possibility that a major Italian Renaissance artist painted Elizabeth I has continued to tantalize historians, with fanciful candidates for the lost portrait including the Darnley and Sieve likenesses (cats. 113, 114). AE

Notes to this entry appear on p. 318.

109. *Portrait of a Young Man, Probably Robert Devereux, 2nd Earl of Essex*

Nicholas Hilliard (ca. 1547–1619)
1588
Watercolor on vellum, laid on card, 1⅝ × 1⅜ in. (4 × 3.3 cm)
The Metropolitan Museum of Art, New York, Fletcher Fund, 1935 (35.89.4)
Exhibited New York and Cleveland only

With his dark curls, smoldering eyes, and jawline haloed with stubble, the young sitter of this miniature embodies the ideal of male beauty at the Elizabethan court. Indeed, a number of previous commentators have identified him as Robert Devereux, 2nd Earl of Essex, who was Elizabeth I's late favorite and the protagonist of one of the most tragic episodes of her reign.[1]

In most previous discussions, The Met's miniature has provided supporting evidence for interpretations of a more famous portrait by Nicholas Hilliard, the so-called *Young Man Among Roses*, now at the Victoria and Albert Museum, London (fig. 117). The strong resemblance between the two sitters led to the proposal that they were one and the same young man;[2] the inscription on the present miniature recording the sitter's age as twenty-two in 1588 later prompted his identification as the Earl of Essex, born in November 1565.[3] By the year this portrait was painted, Essex, the stepson of Robert Dudley, Earl of Leicester (see cat. 107), was firmly established in the queen's favor. Exploiting that status to its utmost for the better part of a decade, Essex eventually grew frustrated at a decline in his political power and the queen's esteem; his abortive rebellion against her led to his beheading in 1601.

In his identification of the *Young Man Among Roses*, Roy C. Strong relied on the present miniature as the cornerstone for his interpretation of Essex's self-presentation as a wounded and melancholy lover, embodying "in one image all the splendour, romance, poetry and wistful sadness of England's greatest age."[4] More recently, Elizabeth Goldring has proposed that it "must, in view of the date of 1588 inscribed on it, have been designed to mark Essex's emergence that year as the heir to the legacies of [the Earl of] Leicester and [Sir Philip] Sidney," previous paragons of chivalry at the Elizabethan court who also patronized Hilliard.[5] Despite the appeal of these interpretations, the resemblance between the two Hilliard miniatures and later, securely identified portraits of Essex leaves much room for uncertainty.[6] Hilliard's art, dedicated to the glorification and idealization of the monarch and her courtiers, does not appear to have been strikingly faithful to the appearance of individual sitters. Yet even without their likely identification as Essex, both the New York and London miniatures exemplify the "Petrarchan politics" of Elizabeth's court, whereby men transmuted their quest for

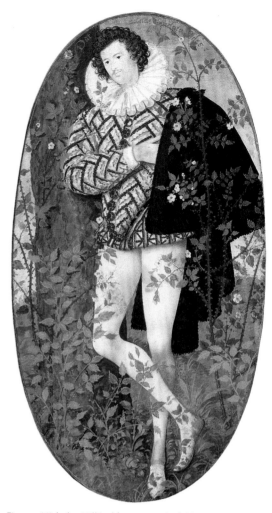

Fig. 117. Nicholas Hilliard (ca. 1547–1619), *Young Man Among Roses*, ca. 1587. Watercolor on vellum, laid on card, 5¼ × 2⅞ in. (13.5 × 7.3 cm). Victoria and Albert Museum, London (P.163-1910)

political favor into (at least performatively) romantic courtship of the queen.[7]

The format of cat. 109, an "oval head-and-shoulders . . . portrait against a plain blue background . . . with a Latin inscription in gold identifying the sitter's age and the year of execution," typified Hilliard's production in the final years of Elizabeth's reign.[8] The miniature is an exquisite example of his use of tiny strokes of brown pigment to model the underlying layer of flesh color, known as the carnation. Likewise, the lace collar, painted with "a brush loaded with thick but fluid white pigment," is a textbook example of Hilliard's ability to mimic "the texture of a crisp, starched ruff."[9] This combination of idealized beauty and attention to fashionable detail has left behind some of the most enduring likenesses of the Elizabethan court. A E

Notes to this entry appear on p. 318.

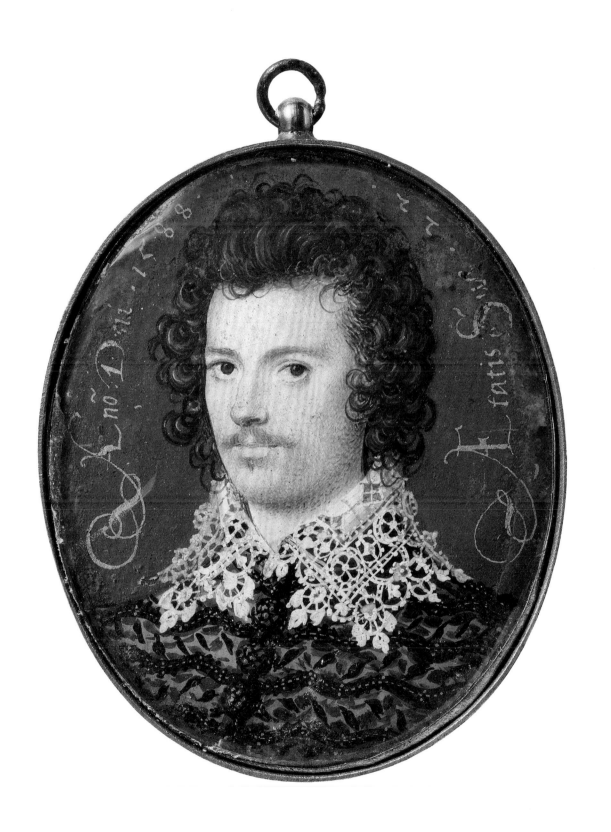

110. *Henry Percy, 9th Earl of Northumberland*

Nicholas Hilliard (ca. 1547–1619)

ca. 1590–95

Watercolor and bodycolor on vellum, laid on card, 10⅛ × 6⅞ in.
(25.7 × 17.3 cm)

Rijksmuseum, Amsterdam (RP-T-1981-2)

Exhibited New York and Cleveland only

Between about 1585 and 1595, Nicholas Hilliard experimented with painting larger miniatures that depicted the subject at full length within a carefully described setting (see also cats. 73, 74). Unlike smaller, more intimate miniatures, designed to be enclosed in a case and worn or carried on the person (see cat. 109), these ambitious, freestanding limnings were typically kept in a small cupboard or room hung with similar small paintings.[1] Part of the appeal of the so-called cabinet miniature was its potential for incorporating a more extensive iconographic program alluding to a sitter's passions, allegiances, or individual life circumstances. Most, if not all, of Hilliard's half dozen or so extant cabinet miniatures depict members of the Protestant elite, up-and-coming courtiers at the court of Elizabeth I.[2] The present work, one of Hilliard's most curious and complex cabinet miniatures, depicts a young man reclining within a rectangular garden enclosure planted at regular intervals with trees and overlooking a distant mountainous landscape. Near the man's head are a hat and a large book; by his legs, a discarded pair of gloves. Suspended from a tree branch is a rod balancing a large, spherical object (variously identified as the moon, a globe, a weight, or a cannonball) against a feather, below which is inscribed the word "TANTI."

The miniature was convincingly identified as a portrait of Henry Percy, 9th Earl of Northumberland: not only did the miniature descend in the Percy family, but the earl was a known patron of Hilliard.[3] Percy became earl upon the death, possibly by suicide, of his father in 1585. During the 1590s he enjoyed the queen's favor and in 1593 was made a Knight of the Garter, but he ran afoul of her successor, James I. From 1605 until 1621, Northumberland was imprisoned in the Tower of London for suspected (but unproven) complicity in the Gunpowder Plot. A friend of Walter Raleigh, patron of the mathematician and astronomer Thomas Harriot, Northumberland earned the nickname "the Wizard Earl" for his avid interest in natural science, mathematics, philosophy, astronomy, and the occult.

A poem celebrating the earl's election to the Order of the Garter in 1593 seems to echo some of the distinctive details of Hilliard's composition, solidifying the argument that the miniature indeed depicts the "Wizard Earl."[4] The poem praises his erudition and how by "following in the ancient reverend steps / Of Trismegistus and Pythagoras"—in other words, through an assiduous study of mathematics and a sincere desire to understand the natural world—he has ascended to "the spacious pleasant fields / Of divine science and philosophy."[5] The man in Hilliard's miniature does inhabit a "spacious pleasant field," occupying a lofty perch above a distant landscape. He wears a black doublet, hose, stockings, and shoes; such sober dress was frequently expressive of a melancholic temperament, but black and white were also the colors favored by Elizabeth I. The loosened, slightly disheveled dress and the pose of resting the head in one hand are also associated with melancholy. The weighty tome by the young man's head suggests that this is not the despondence of a lovelorn romantic, however, but a more pleasurable, intellectual melancholy, a "mood of arcane scientific speculation."[6]

From the young man's elegant form, the eye is drawn to the *impresa* suspended from a tree branch: a deliberate artificial element within an otherwise naturalistic landscape that is not easily explained. It seems to relate to a proposition put forth in Archimedes's treatise *On the Equilibrium of Planes*, which postulates that unequal weights will balance at unequal distances, the greater weight being closer to the fulcrum,[7] and in this instance may refer to the choices one is presented with in life. A narrower interpretation would necessarily rest on a more precise identification of the balanced objects: is the sphere a globe or a cannonball? Does the feather represent a quill pen? The single-word motto—"TANTI"—is no less ambiguous: it could be either

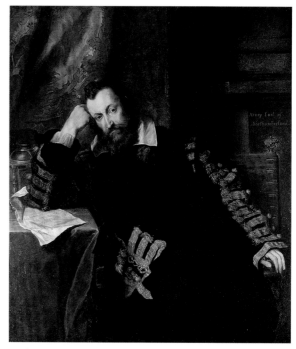

Fig. 118. Anthony van Dyck (1599–1641), *Henry Percy, Earl of Northumberland*, 1635. Oil on canvas, 54 × 47¼ in. (137 × 120 cm). National Trust, Petworth House and Park, West Sussex (NT486223)

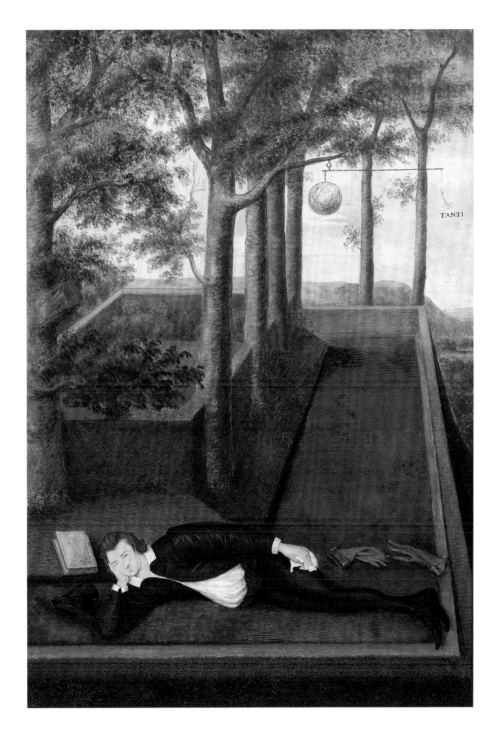

TANTI

Latin or Italian, and the two languages yield different and virtually contradictory meanings.[8] Although the original message of the *impresa* has been lost, the delicacy and playful improbability of the motif convey the era's delight in symbols, hieroglyphs, and sophisticated rebuses.

It has been argued that Hilliard's portrait must predate the earl's election to the Order of the Garter in 1593, as it was mandatory for knights to wear the insignia after election. However, this was evidently not always the case in emblematic portraits,[9]

so the present painting may have been produced after that date. A reduced variant of the Rijksmuseum miniature, attributed to Rowland Lockey, shows the subject at half-length, reclining in a flowery field with a small (poetry?) book by his head.[10] A generation later, Hilliard's miniature was the inspiration for a posthumous portrait of the earl by Anthony van Dyck (fig. 118), which offers a more literal paraphrase of the original *impresa*.[11] MEW

Notes to this entry appear on p. 318.

III. *A Party in the Open Air*

Isaac Oliver (ca. 1565–1617)

ca. 1590–95

Watercolor and bodycolor, with gold and silver, on vellum, laid on card, 4½ × 6⅞ in. (11.3 × 17.4 cm)

Statens Museum for Kunst, Copenhagen (KMS6938)

Exhibited New York and Cleveland only

On this small piece of vellum, Isaac Oliver created one of the most ambitious of Elizabethan paintings. In a woodland landscape that opens onto a view of distant buildings, he depicted a crowded company of elegant figures strolling, hunting, and making music or love. The group in the foreground on the left, composed of three decorously dressed women and a dandyish male companion, appear to be interlopers, receiving a tour of a sylvan world whose loose ways are foreign to them. In contrast to these upright and upstanding surrogates for the beholder, other figures in the scene bend, recline, or give themselves over to the violent exhilaration of the hunt. Oliver's miniature is striking in its erotic openness, with caressing couples, bare-breasted women, and a seated man who spreads his legs in suggestive proximity to a phallic flask.

The early history of the miniature, which is recorded in Denmark since at least the late eighteenth century, is unknown.[1] Along with Marcus Gheeraerts the Elder's two paintings now

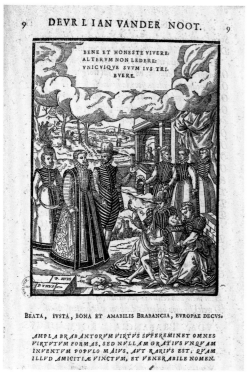

Fig. 119. "Bene et honeste vivere," in *Lofsang van Braband / Hymne de Braband* by Jan van der Noot (Antwerp, 1580). Bibliothèque Nationale de France, Paris (Rés-YI-3, p. 9)

at Hatfield House (see fig. 114) and Joris Hoefnagel's views of Nonsuch Palace (cat. 34), Oliver's miniature is one of the very earliest English landscapes. Gheeraerts, Hoefnagel, and Oliver were all born abroad, and the genre of landscape, like the word itself, was imported to England from the Dutch-speaking Low Countries.[2] The wide, watery vista of a city on the banks of a river that opens up in the background on the left of the miniature resembles the fantastic landscapes in the Bruegelian tradition.

With its contrast between forest and architecture, and between decorous town-dwellers and uninhibited revelers, Oliver's miniature recalls the "green world" of Shakespearean comedy, an Arcadian space visited by the protagonists as they work through conflicts and achieve transformation or resolution.[3] Other commentators have seen in the miniature "an allegory on conjugal love" divided into two polarized halves, with the group on the left representing "the path of righteousness" and that on the right, "misguided wantonness."[4] Such a strict division into righteous and wicked halves, however, requires perceiving the embracing pair on the ground below the gesturing man as "a mother and son who represent maternal love."[5]

Intriguingly, Oliver's primary source for his miniature appears to be a woodcut illustration to the bilingual panegyric poem *Lofsang van Braband / Hymne de Braband* by the Flemish poet Jan van der Noot, who spent the years 1567 to 1571 in exile in London (fig. 119).[6] In the woodcut the poet appears in an allegorical landscape with his beloved, drawing her attention to a pair of lovers accompanied by a lutenist, imagery derived from astrological prints of Venus.[7] Rather than offering a contrast to conjugal love, this scene of lovemaking embodies the qualities of "BEATA, IVSTA, BONA ET AMABILIS BRABANCIA" (Blessed, just, good and lovable Brabant), as enumerated below the image. Given this source material, Oliver's eye-catching imagery of lovemaking may itself have more positive connotations than previously acknowledged. While in London, Van der Noot had collaborated on editions of his poems with prominent artistic exiles like Gheeraerts the Elder and Lucas de Heere.[8] In citing an illustration from the work of an exiled Flemish Calvinist poet and drawing on the conventions of Flemish landscape painting, Oliver may have been aiming at a sophisticated patron within the émigré community.

Whatever the import of its allegory, the miniature was a clear statement of ambition on the part of Oliver. He even took the unusual step of including the Latin abbreviation "IN" (*invenit*, "invented") next to his monogram on the bottom left.[9] As with his *Elizabeth I and the Three Goddesses* (cat. 117), this work allowed Oliver to promote himself and his intention to take the art of limning in new directions. A E

Notes to this entry appear on p. 318.

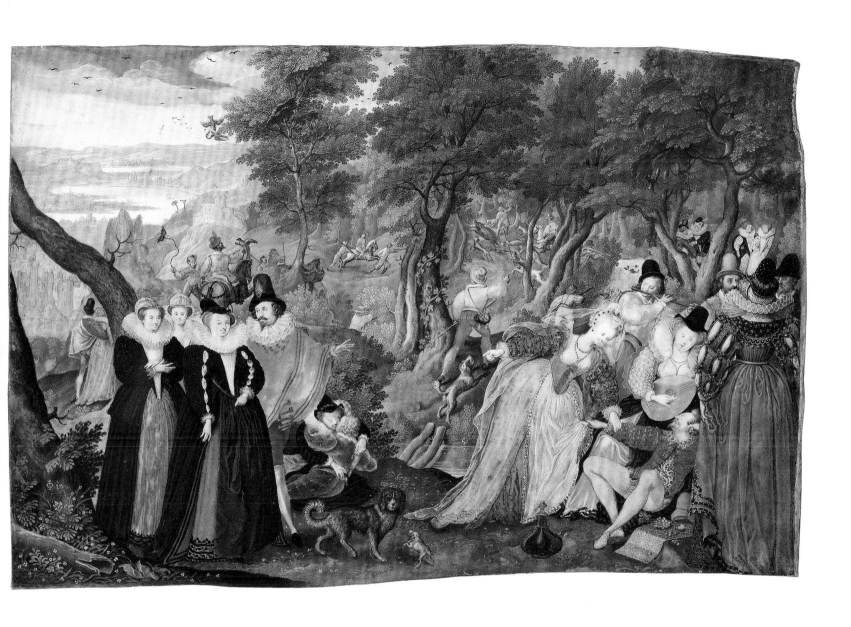

112. *Portrait of an Unknown Woman*

Marcus Gheeraerts the Younger (1561–1635/36)
ca. 1590–1600
Oil on canvas, 85⅛ × 53⁷⁄₁₆ in. (216.2 × 135.5 cm)
The Royal Collection / HM Queen Elizabeth II (RCIN 406024)
Exhibited New York and Cleveland only

Described by one scholar as "the most extraordinary of all Elizabethan allegorical portraits," this painting is also one of the most mysterious.[1] It depicts a sitter in an unusual costume, crowning a weeping stag with a garland of flowers. Latin inscriptions dot the surface of the painting, while a cartouche on the lower right contains an English-language sonnet. These texts have proved crucial to the attribution of the portrait to Marcus Gheeraerts the Younger, linking it to the group of densely symbolic portraits he painted for Sir Henry Lee of Ditchley and his circle (see cat. 119).[2]

The sitter wears a richly embroidered robe with a pattern of birds, grapes, and flowers underneath a layer of spangled gauze.[3] On her feet are bejeweled buskins, the footwear associated in antiquity with theatrical performance. Her hair hangs loose on her shoulders, topped by a tufted headdress embellished with gold and purple pansies. The headdress derives from one worn by the character of the "Persian Virgin" in a costume book published by Jean-Jacques Boissard in 1581, which also inspired the headdress worn by Elizabeth I in the so-called Rainbow portrait (cat. 120).[4] This "Persian lady," as she has been known in the scholarly literature, stands underneath a walnut tree, the trunk of which bears three Latin inscriptions: "Iniusti Justa querela" (A just complaint of injustice), "Mea sic mihi" (Thus to me mine), and "Dolor est medicina (e) d[o]lori" (Grief is medicine for grief).[5] The sonnet on the lower right elaborates on these doleful themes:

> The restles swallow fits my restles minde,
> In still reviving still renewinge wronges;
> her Just complaintes of cruelty unkinde,
> are all the Musique, that my life prolonges.
>
> With pensive thoughtes my weepinge Stagg I crowne
> whose Melancholy teares my cares Expresse;
> hes Teares in sylence, and my Sighes unknowne
> are all the physicke that my harmes redresse.
>
> My onely hope was in this goodly tree,
> which I did plant in love bringe up in care;
> but all in vanie [*sic*], for now to late I see
> the shales [shells] be mine, the kernels others are.
>
> My Musique may be plaintes, my physique teares
> If this be all the fruite my love tree beares.

Spoken in the voice of the portrait's sitter, the sonnet endows her with an anguished subjectivity. She declares herself the victim "of cruelty unkinde," racked by disappointed hopes. The weeping stag, an emblem with a long literary history, doubles and externalizes his companion's anguish.[6]

This mysterious portrait has inspired a cottage industry of interpretations, with identifications of the sitter ranging from Elizabeth I to Shakespeare's "Dark Lady." One of the most compelling theories suggests that the "Persian lady" might be Frances Walsingham, wife of Elizabeth's ill-fated favorite Robert Devereux, Earl of Essex (cat. 109).[7] In this scenario, Essex, who once impudently trespassed on the queen's private chambers, is likened to Acteon, the hunter transformed into a stag after spying on the goddess Diana. Bearing in mind the brief vogue for all things Persian inspired by the traveler Sir Anthony Shirley, the portrait might date to the autumn of 1600,[8] a time when Essex's supporters were making a final attempt to regain the queen's favor. In 1599 Frances Walsingham did present herself at court in penitential black to plead for visitation rights with her imprisoned husband,[9] but this scarcely accords with the lavish and theatrical attire of the "Persian lady." Furthermore, it seems unlikely that a supplicant seeking forgiveness would confront the queen with "Just complaintes of cruelty unkinde."

A more recent proposal identifies the sitter as Mary Sidney Herbert, Countess of Pembroke.[10] The countess was a poet and the leader of a prominent literary coterie, whose life was marked by personal tragedy in the years to which the painting can be dated on stylistic grounds. She was associated with the phoenix, whose imagery appears on the "Persian lady's" robe; furthermore, the countess figured in the guise of a Persian queen in a novel written by her niece, Mary Wroth. As an accomplished poet, the countess would have been in a position to write the sonnet recording her laments and to contribute to the dense allegorical program of the portrait. A comparison with other documented portraits of the countess is unfortunately not persuasive, but Gheeraerts's masquing portraits frequently feature stereotyped physiognomies. A E

Notes to this entry appear on p. 318.

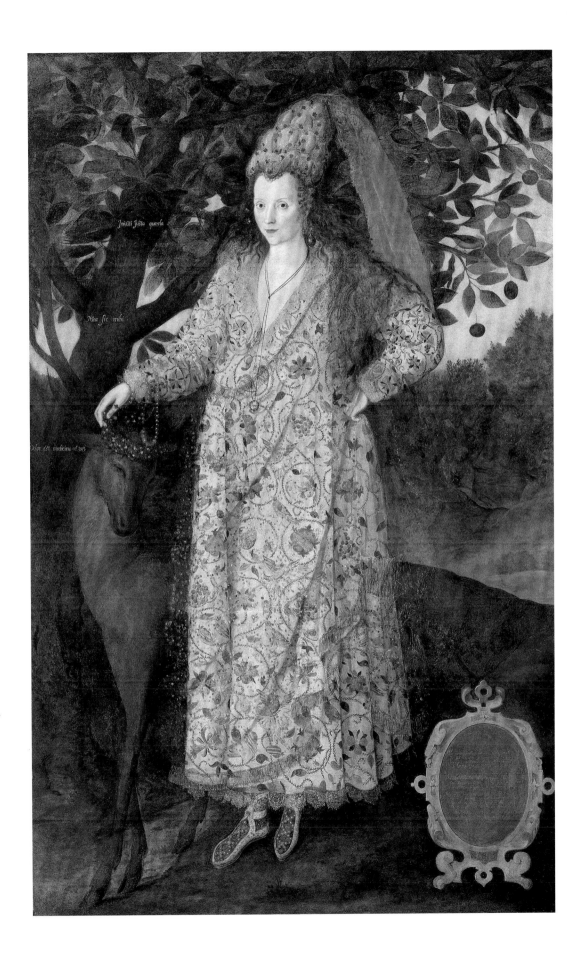

113. *Queen Elizabeth I (The Darnley Portrait)*

Unknown Netherlandish artist
ca. 1575
Oil on panel, 44½ × 31 in. (113 × 78.7 cm)
National Portrait Gallery, London (NPG 2082)
Exhibited New York only

Among Elizabeth I's surviving likenesses, the so-called Darnley portrait has one of the strongest claims to recording the queen's appearance with accuracy. Sumptuously dressed and posed next to her regalia, the queen nonetheless gives the impression of a real, middle-aged woman. With deep-set eyes, hollow cheeks, and an aquiline nose, this depiction of the queen became the prototype for numerous subsequent images.

Recent technical examination of the picture suggests that it was created by a Netherlandish artist working in London, who used a pattern or preparatory drawing based on an in-person

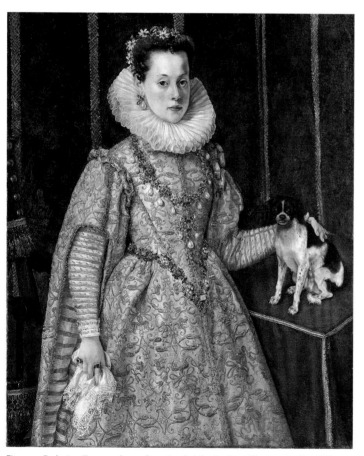

Fig. 120. Federico Zuccaro (1540/41–1609), *Margherita of Savoy*, ca. 1605. Oil on canvas, 47¼ × 39 in. (120 × 99.1 cm). Private collection

sitting for the queen's face.[1] The underdrawing of the face is far more rigid and precise than that of the costume, which was done freehand and subject to revision by the artist.[2] Many later portraits use the same pattern, indicating that it met with royal approval.[3]

Although it bears no resemblance to Federico Zuccaro's surviving drawn portrait of the queen (cat. 108), the Darnley portrait has been attributed to him in the past.[4] A lack of comparable portraits by the artist complicates this attribution. However, in addition to the technical examination discussed above, the recent rediscovery of a major female portrait by Zuccaro (fig. 120) has further diminished the likelihood that the Darnley portrait is the artist's lost painting of the queen.[5] His image of the young princess Margherita of Savoy, admittedly painted thirty years after his sojourn in London, shows the artist carefully modeling the contours of his sitter's face and hands in a way completely foreign to the flat and evenly lit surfaces of the Darnley portrait.

Elizabeth wears a costume distinguished by the lines of braided fastenings across the doublet, which past commentators have interpreted as an allusion to either masculine or Polish fashion. Likewise, her black veil and fan of dyed feathers may suggest participation in a masque, such as would be staged for a royal visit to a country house.[6] The painting's provenance goes back to Cobham Hall, which Elizabeth visited twice. The portrait was perhaps commissioned by William Brooke, 10th Baron Cobham, to commemorate the latter visit, in 1573.[7] Intriguingly, Lord Cobham traveled to Paris as the queen's ambassador in 1580, during the marriage negotiations with the duc d'Alençon (cat. 99). Frances, Lady Cobham, reported that she had shown the king and queen of France "an excellent picture" of the queen, whom they pronounced "a very fair lady."[8] From her report, the royal likeness appears to have been the kind of miniature suitable for travel and intimate viewing. Given the influence of the face pattern of the Darnley portrait, however, and its association with the Cobham family, it may well have provided the prototype for the likeness taken to Paris. A E

Notes to this entry appear on p. 318.

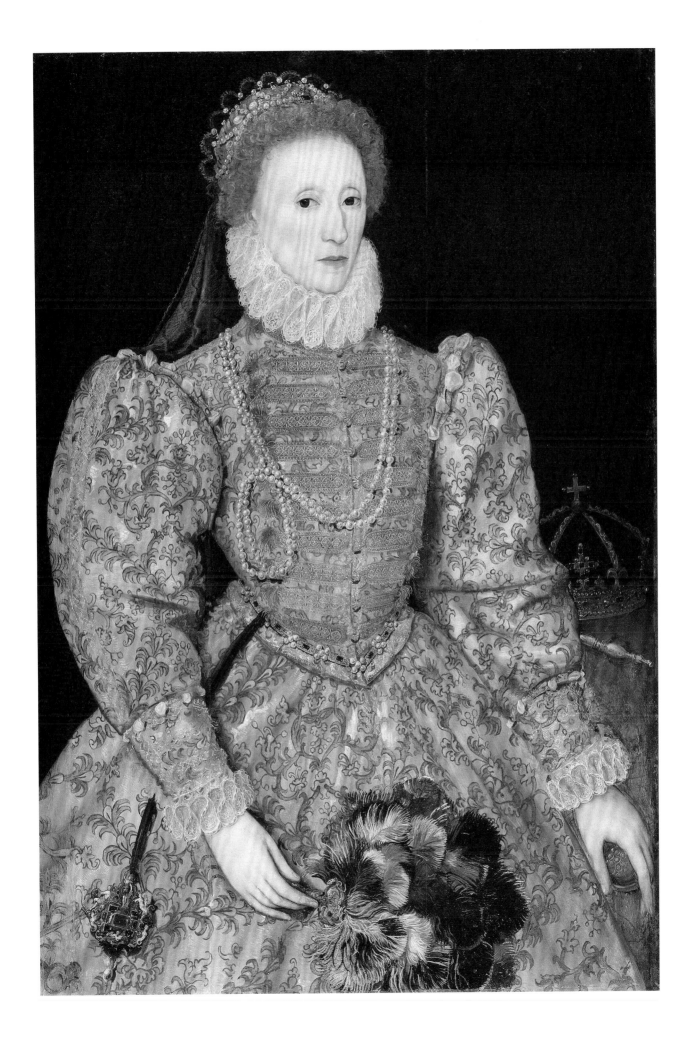

114. *Elizabeth I (The Sieve Portrait)*

Quentin Metsys the Younger (1543–1589)
1583
Oil on canvas, 49 × 36 in. (124.5 × 91.5 cm)
Pinacoteca Nazionale, Siena (454)
Exhibited New York and Cleveland only

In a room at the end of an arcaded gallery, the queen stands in isolation from the courtiers who gather behind her. Dressed in black, she carries a sieve in place of the usual accessories of a fan, book, or gloves. A jeweled column on the left displays narrative scenes, while a globe on the right is painted with ships and the cartography of western Europe and northern Africa. With its dense texture of symbols and allusions, this portrait has long occupied a central role in discussions of Elizabeth's iconography as the Virgin Queen and the embodiment of English imperial aspirations.

The most immediately striking feature of the portrait is the sieve. Silhouetted against the black of the queen's dress, the sieve calls attention to itself and the Italian inscription it bears: "A TERRA IL BEN / MAL DIMORA IN SELLA" (On earth, it's hard for the good to stay in the saddle). Another inscription flanks the queen on the left edge of the canvas, a quotation from Petrarch that may be translated as, "Weary I rest and having rested I am still weary."[1] Together the inscriptions convey a cynicism and world-weariness that is further reinforced by the text on the globe, roughly, "I see everything, and much is lacking."

These texts position the queen as vigilant and guarded, but the Petrarchan citation also offers a clue to the sieve's meaning. The quote comes from Petrarch's *Triumph of Love* (*Triumphus cupidinis*), while the sieve recalls a figure from his *Triumph of Chastity* (*Triumphus pudicitie*), the Roman vestal virgin Tuccia. According to the first-century historian Valerius Maximus, Tuccia was falsely accused of "the crime of unchastity. . . . She grabbed a sieve and said: 'Oh Vesta [goddess of the hearth and home], if I have always brought chaste hands to your rites, grant that I may with this sieve fetch water from the Tiber, and carry it back to your shrine.' The rules of the natural world gave way before the priestess' bold and reckless vows."[2] Juxtaposing the words of a wearied lover with an emblem of chastity held in front of the queen's lower body, the portrait argues that the "Triumph of Love, with its pains and struggles, is over for her; and she is joining, in the character of the Vestal Virgin Tuccia, in the Triumph of Chastity."[3]

The so-called Sieve portrait, dated 1583, builds on an earlier group of portraits associated with the workshop of George Gower that adopted the sieve as an emblem of chastity in promoting the image of Elizabeth as the Virgin Queen.[4] The scenes from the doomed love affair of Dido and Aeneas, depicted in relief on the column, add another dimension to this theme. Dido, whose suicide on a pyre appears at the top, embodies self-destructive erotic pursuit, and Aeneas, noble abstention in the service of imperial duty. In a reverse of typical gender dynamics, it is the male hero who provides Elizabeth's model, not the passionate queen.[5]

The extended and fruitless negotiations for Elizabeth's hand in marriage give one context for the portrait's complex iconographic celebration of virginity, but it may also promote English imperial expansion. The only one of the courtiers in the background to look out toward the viewer is Sir Christopher Hatton, an identification based on the heraldic device of the white hind visible on his dangling sleeve.[6] Hatton, one of a group of courtiers who saw the entanglement of a foreign marriage as a disaster for England's imperial destiny, was vehemently opposed to Elizabeth's proposed marriage to the duc d'Alençon (see cat. 99). Instead, Hatton encouraged Elizabeth's aspirations with gifts of jewels depicting imperial crowns, an emblem that also appears in the lowermost medallion of the jeweled column in the Siena portrait.[7]

Depicting the queen in a private chamber at the end of a long gallery in which courtiers gather, the portrait reproduces the hierarchical divisions of space at Tudor palaces. The portrait gives a relatively realistic depiction of the middle-aged sovereign, conveying her prominent nose and weary eyes in a manner more associated with her foreign-born portraitists than the indigenous tradition associated with Nicholas Hilliard. Conservation treatment in the 1980s revealed the signature of Quentin Metsys the Younger, scion of an Antwerp dynasty of painters, for whom only a very small oeuvre survives.[8] Recorded living in London in the 1580s, Metsys may have left Antwerp to avoid religious persecution.[9] Several years before, Elizabeth had attempted to buy a celebrated triptych by Metsys's grandfather from Antwerp cathedral,[10] and the prestige of his family name may have helped him establish himself in London.

Nothing is known of the painting before its discovery, rolled up in the attic of Siena's Palazzo Reale, in 1895. It may have arrived in Italy with the estate of Catherine de' Medici, Queen of France, after her death in 1589.[11] With its celebration of perpetual virginity, however, the portrait fits uneasily with the likenesses that circulated between the French and English courts at the time of the d'Alençon marriage negotiation. The English traveler Fynes Moryson was surprised to encounter a portrait of Elizabeth I in Florence at the Palazzo della Signoria in 1594, learning that "the Duke of Florence much esteemed her picture, for the admiration of her vertues."[12] With its abundance of Italian mottoes and classical allusions, the Sieve portrait was well suited to convey Elizabeth's chastity and steadfast stewardship of her kingdom to a Florentine audience. A E

Notes to this entry appear on pp. 318–19.

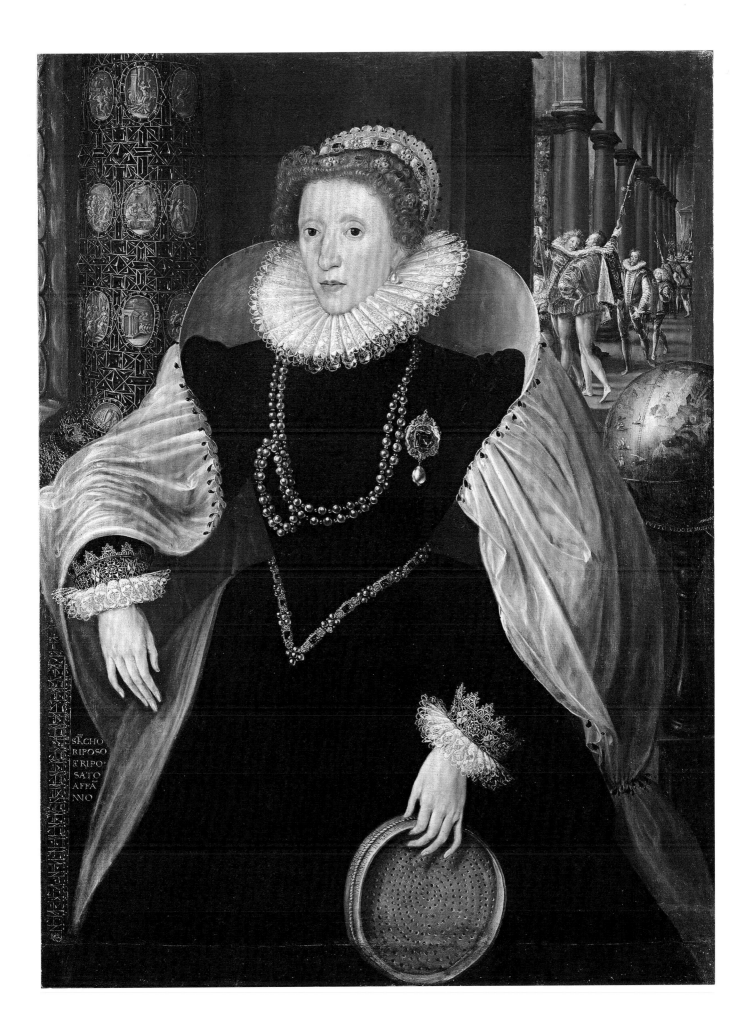

Fig. 121. Attributed to John de Critz the Elder (1551/52–1642), *Sir Francis Walsingham*, ca. 1589. Oil on panel, 30 × 25 in. (76.2 × 63.5 cm). National Portrait Gallery, London (NPG 1807)

115. *Elizabeth I*

Unknown artist, perhaps English
ca. 1575–80
Engraved sardonyx, set in gold, 2⅛ × 1½ × ¼ in. (5.5 × 3.8 × 0.6 cm)
Victoria and Albert Museum, London (1603-1855)

Like the portrait of Queen Elizabeth I by Quentin Metsys the Younger (cat. 114), this cameo uses the iconographic attribute of a sieve to emphasize Elizabeth's virginity, associating her with the legendary Roman vestal virgin Tuccia. Here, the medium of the cameo further heightens the link between Elizabeth and the prestige of classical antiquity, adopting a format and a technique associated with Roman imperial rule.

Some thirty cameo portraits of the queen dating from the last quarter century of her reign survive, most likely manufactured by the same workshop.[1] The cutter of this gem has skillfully carved the banded dark and light layers of a sardonyx to sculpt the queen's image, even conveying the effect of rouge on her cheek. The embellishment of her costume is particularly intricate, using

low relief to depict raised embroidery. As in other cameos, the queen appears in profile, an intentionally classicizing formula that distinguishes many of her sculpted and medallic representations from painted portraits. The jewel cutter may have based his representation on portrait medals, such as one from 1574 that bears Elizabeth's device of the phoenix on its reverse.[2]

Roman and Hellenistic cameos were coveted by Renaissance collectors; they served as source material for antiquarians and appear often in Italian portraits of the period.[3] Modern cameos conferred the legitimacy of ancient origins on contemporary rulers and provided an equivalent of the holy medal for loyal subjects to display on their bodies.[4] At the same time, the banded dark and white layers of a cameo lent themselves to depictions of Black figures and to the development of a racialized aesthetic of extreme fairness, a significant feature of the cult of Elizabeth's beauty.[5]

In a portrait by John de Critz, dated to about 1589, Sir Francis Walsingham, Elizabeth I's "spymaster," displays a similar cameo of the queen at his waist (fig. 121),[6] while Sir Christopher Hatton, the likely patron of the Sieve portrait by Metsys, wears a similar cameo on a chain in another painting.[7] The portrait reveals the analogous functioning of both cameos and jeweled miniatures as luxurious tokens of loyalty. In some cases a limned portrait and a cameo might be combined in a single locket, as in the so-called Drake and Gresley jewels featuring classicizing cameos in combination with miniatures by Nicholas Hilliard.[8] A E

Notes to this entry appear on p. 319.

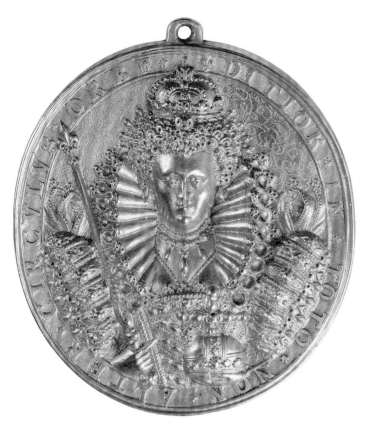

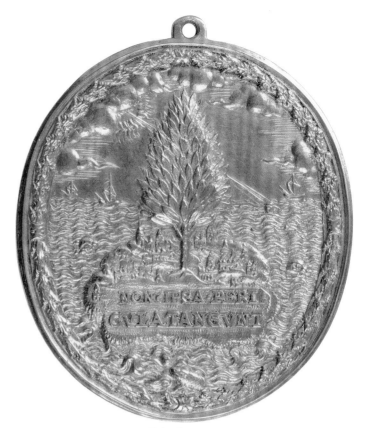

116. *Portrait Medal of Queen Elizabeth I with Allegory of Dangers Averted*

Attributed to Nicholas Hilliard (ca. 1547–1619)
London, ca. 1588
Cast and chased gold, Diam. 2⁷⁄₁₆ × 2 in. (5.9 × 5.1 cm)
Fitzwilliam Museum, Cambridge (CM.YG.1401-R)
Exhibited New York and Cleveland only

Elizabeth I's frontal gaze feels strikingly, arrestingly direct compared with the classically inspired profiles in most sixteenth-century medals, portrayed to such elegant advantage by the likes of Jacopo da Trezzo (cat. 94) and Steven Cornelisz. van Herwijck (cats. 104, 105). The artist responsible for this daringly unconventional representation was almost certainly Nicholas Hilliard. Indeed, it is likely that Hilliard cast and expertly chased this medal himself, coming as he did from a family of goldsmiths; having apprenticed with the queen's jeweler, Robert Brandon (and married his daughter); and having been enrolled as a freeman of the London Goldsmiths' Company since 1569.[1] Elizabeth's successor, James I, even named Hilliard, in 1617, "our principal Drawer for the small portraits and Imbosser of our Medallies of Gold."[2]

As the external relief-cast gold portrait of Elizabeth on the Heneage Jewel (cat. 58) suggests, Hilliard's work as a jeweler was

as fine as the miniature painting at which he excelled (cats. 73, 109, 110). In this medal, however, rather than predicting the aloof profile of the Heneage exterior, Hilliard returned to his design for Elizabeth's Great Seal (cat. 97), discarding the seal's extraneous details of setting and armorials to pull the focus directly to the monarch's head and upper torso, drawing in her arms just enough to show the orb and scepter in her hands. The Latin inscription encompassing the Virgin Queen appropriately translates as, "There is no richer circle in all the world."[3] The reverse of the medal continues this theme of contained, safely isolated abundance: its inscription celebrates how, for the represented island with its storm-sheltering bay (laurel) tree, "Not even dangers affect it." Usually called the "Dangers Averted Medal," or sometimes the "Armada Medal," it was probably made to celebrate England's 1588 defeat of the Spanish Armada.[4] The uppermost ring suggests that it was originally intended to be suspended for display, perhaps worn on a ribbon or chain, rather than stored in a casket or medals cabinet.

By revisiting his design for the sovereign's Great Seal rather than looking to other medals and cameos for inspiration, Hilliard managed to eschew mainland European conventions of aesthetic beauty in favor of something entirely new, unexpected, and distinctly English. As such, this portrayal of the queen

is perfectly suited to this sumptuous celebration of England as independent, prosperous, and protected against European onslaughts. The medal was cast at least twice in gold.[5] However, the design, perhaps too shocking, was apparently amended: a variant, also cast at least twice in gold, duplicates the reverse of the Dangers Averted Medal but, lacking the courage of Hilliard's core design, flattens the deep relief of the portrait, drops the orb and scepter, and, most markedly, twists Elizabeth's head to face the left in a more conventional, three-quarter view.[6] EC

Notes to this entry appear on p. 319.

117. Elizabeth I (Elizabeth I and the Three Goddesses)

Attributed to Isaac Oliver (ca. 1565–1617)
London, ca. 1588
Watercolor and bodycolor, with gold and silver, on vellum, laid on card,
4½ × 6⅛ in. (11.5 × 15.7 cm)
National Portrait Gallery, London (NPG 6947)
Exhibited New York only

Elizabeth I stands at the left of this diminutive work, poised upon a step and surrounded by her ladies-in-waiting. Hierarchically framed by massive architecture and sheltered beneath a velvet canopy, she confronts an entirely different world: a dreamy, verdant landscape inhabited by svelte mythologized beings. The women to the right—identified by their attributes as the goddesses Juno (at center, with her peacock), Minerva (clad in armor and holding a battlefield standard), and Venus (with her son, Cupid, by her side)—react to the queen's presence with varying degrees of surprise. This recently rediscovered painting is a sophisticated reworking by the miniaturist Isaac Oliver of a painting created approximately twenty years earlier by Hans Eworth (fig. 122).[1] Although the painting is not signed, the delicate stipple technique and the mannered elegance of the figures support an attribution to Oliver; it probably predates his more complex *Party in the Open Air* (cat. 111). While Oliver's miniature is plainly based on Eworth's composition, it is far from a slavish copy: details of the original are freely altered to present an updated conception of the queen and her political situation, as they had evolved over the intervening years.

The paintings by Eworth and Oliver both center on a reworking of the classical legend of the Judgment of Paris, in which Paris, a Trojan mortal, was charged with awarding a golden apple to whomever he judged to be the fairest of three goddesses: Juno (queen of heaven and goddess of marriage), Minerva (goddess of war), or Venus (goddess of love). Paris chose Venus, a decision that led inevitably to the Trojan War. Both paintings cast Elizabeth in the role of Paris: imperious and immobile, she holds

a large golden orb—symbol of her divine authority—instead of a golden apple. Elizabeth retains the orb for herself, because she alone combines the three qualities that the contentious goddesses embody separately, thus avoiding the conflict incited by Paris in choosing one goddess over another. Her absolute stillness and the stiff, formal garments that armor her body like a jewel-encrusted carapace symbolize both her regal authority and the relatively peaceful equanimity of her reign.

In literary, visual, and performative courtly allegories from the Renaissance onward, the Three Goddesses theme provided an elegant vehicle for praising the subject's supposed embodiment of every conceivable art and skill. It was, for example, invoked in pageants celebrating the coronation of Elizabeth's mother, Anne Boleyn, which "established an association between triumph over the three goddesses and assertion of imperial aspirations and dominion."[2] References to the theme in entertainments prepared for Elizabeth in 1563 and 1566 were presumably made with deliberate awareness of those pageants dedicated to her mother a generation earlier.

Eworth's painting was not only the first image to associate Elizabeth with the Three Goddesses theme, but also the earliest allegorical portrait of the queen.[3] At the time it was created, Elizabeth had just successfully defended her spiritual authority to rule by quashing the short-lived Northern Rebellion, which sought to place the Catholic Mary, Queen of Scots, upon England's throne. Elizabeth's sovereign right is expressed here by means of her imperial crown; the cross-topped orb and scepter she wields as emblems of her divine and worldly authority; and the fortified presence of Windsor Castle in the background. In

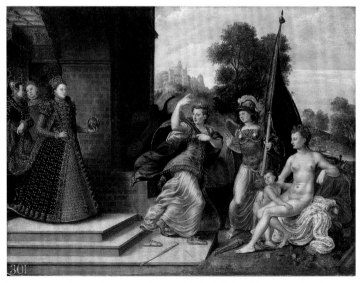

Fig. 122. Hans Eworth (ca. 1525–after 1578), *Elizabeth I and the Three Goddesses*, 1569. Oil on panel, 24¾ × 33¼ in. (62.9 × 84.4 cm). The Royal Collection / HM Queen Elizabeth II (RCIN 403446)

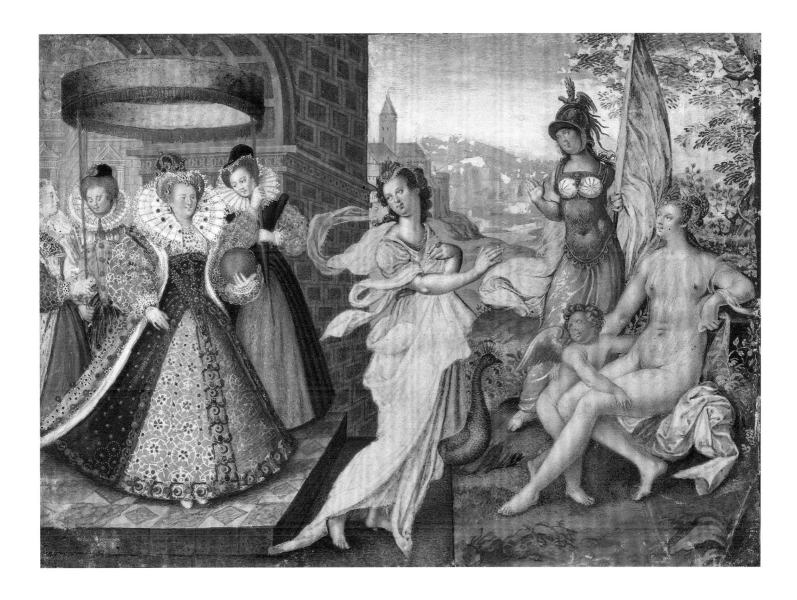

the face of this indisputable authority, even the goddesses scatter in disarray. The allegorical meaning is elaborated in the Latin verse inscribed on the frame: "Pallas was keen of brain, Juno was queen of might, / the rosy face of Venus was in beauty shining bright, / Elizabeth then came. / And, overwhelmed, Queen Juno took to flight; / Pallas was silenced; Venus blushed for shame."[4] According to Roy C. Strong, the painting opposes Elizabeth and Venus, the goddess of unchaste love; Juno, goddess of marriage, mediates between the two, her gesture implying heavenly sanction of her effort to bring them together. In addition to asserting the sovereignty of the young queen, the painting presents a veiled injunction that she should consider marriage and embrace love in addition to wisdom and martial power.[5]

From at least 1600 Eworth's painting was displayed at Whitehall Palace amid other portraits of English and European monarchs in "one very fine gallery or dining hall."[6] Important

visitors would have had the opportunity to contemplate a mythologized image of a particularly awe-inspiring entrance by the queen as they awaited her actual arrival.[7] The very visibility of the painting may have inspired Oliver to paint his jewel-like update.

By the end of the 1580s, marriage was no longer on the table for the Virgin Queen, and the alterations in Oliver's composition reflect a changed image of her queenship. The style of Elizabeth's cloth-of-gold gown and broad lace ruff reflect fashions of the late 1580s or early 1590s, yet (predictably) her features retain their perpetually youthful beauty. The figure of Juno, in the center of the composition, is the most changed: she no longer seeks to impress upon the queen the benefits of marriage, but seems more concerned to ward off Venus in defense of Elizabeth's solo rule.[8] It is probably no accident that Elizabeth's golden orb is substantially larger here, more akin to a globe than the monarch's traditional symbol of spiritual authority. Oliver's painting was

created in the wake of England's crushing defeat of the Spanish Armada—a signature event of Elizabeth's reign and a key step in England's rise to global power.

Because the early history of Oliver's painting is not known, it is impossible to determine the circumstances of its creation, although the exquisite quality of the work suggests a courtly context. Several possible scenarios have been mooted.[9] Elizabeth could have commissioned Oliver to create a revised, small-scale version of Eworth's painting, either as a portable memento for herself or as a gift; equally, one of her devoted courtiers may have commissioned the work for themselves or as a gift to the queen.[10] However, no painting of this description is noted in any of the surviving rolls of gifts given to or by the queen at the New Year.[11] Alternatively, Oliver himself—in the late 1580s just embarking upon his career—may have devised the miniature as a demonstration of his technical skill and ability to craft up-to-the-minute iconography for the queen and her court, in the hope of securing royal patronage. MEW

Notes to this entry appear on p. 319.

118. *Elizabeth I*

Attributed to the workshop of Nicholas Hilliard (ca. 1547–1619)
ca. 1599
Oil on canvas, 88 × 66½ in. (223.5 × 168.9 cm)
National Trust, Hardwick Hall, The Devonshire Collection (NT 1129128)

Among the most ambitious and successful courtiers at the late Tudor court, Elizabeth Talbot, Countess of Shrewsbury, known as Bess of Hardwick, was also one of the greatest architectural patrons of the Tudor age.[1] Her legacy survives above all in the so-called New Hall at Hardwick, built by Robert Smythson between 1590 and 1597 (see also "Furnishing the Palace" in this volume). One of the best-preserved Elizabethan "prodigy houses," Hardwick also contains a remarkable collection of textiles and paintings going back to the builder's day. In the portrait exhibited here, likely commissioned for Hardwick, the countess's careful cultivation of royal favor and her attention to the communicative power of embroidery combine in a likeness emblematic of late Elizabethan style.

In the Hardwick portrait, Elizabeth appears in full-length beside a throne, in front of a red velvet cloth of state. She stands atop a Turkish carpet, carrying a glove in one hand and a feather fan in the other. Her costume is ornate and richly bejeweled, with striking imagery of flora and fauna embroidered on the petticoat. Given its size, this portrait is perhaps the likeness of the queen whose transportation in a carriage from London to Hardwick

in 1599 is recorded in the Countess of Shrewsbury's accounts, and almost certainly one of the portraits of Elizabeth mentioned in the 1601 inventory of Hardwick New Hall; it is thus a rare example of a Tudor portrait still displayed in situ (fig. 123).[2] The portrait's context at Hardwick extended beyond the architectural setting to the luxurious interior of the house (see cat. 71). The 1601 inventory records not only numerous portraits of the queen and her relatives but also many of the same kinds of luxurious textiles that appear in the portrait itself. For example, the gallery featured "a foote Carpet of turkie worke" and "a Chare of nedle-worke with golde and grene silk frenge."[3] These overlapping, opulent textures contributed to Hardwick's "orchestrated representation of power, a totalizing image composed of intricately patterned and highly colored architecture, painting, furnishings, and textiles."[4] Furthermore, the decorative scheme at Hardwick emphasized the achievements of women, providing a context both for Bess of Hardwick's dynastic activity and for an imposing full-length image of the female monarch she served.[5]

The question of Bess of Hardwick's emulation of Elizabeth I is a complex one. Although they shared a remarkable success in defying the patriarchal norms of their age, their careers were as divergent as the circumstances of their birth. Bess was born to the minor gentry, and her dynastic ambitions were realized through a series of shrewd marriages and the birth of male heirs. She enjoyed periods of royal favor alternating with conflict and suspicion regarding her husband's longtime custody of Mary, Queen of Scots, during the latter's English imprisonment. In cultivating the queen's favor, Bess pursued a conscious strategy of gift giving, seeking the guidance of her well-placed contacts at court, who might specify the type of garment or embroidered motif most likely to please Elizabeth.[6] It has been speculated that the richly embroidered petticoat in the Hardwick portrait was "a New Year's gift worked by the donor," thus associating its design with "an imaginative and enthusiastic domestic embroiderer, rather than the carefully planned, usually geometrically arranged design of a professional."[7] Bess of Hardwick was herself a gifted embroiderer, raising the possibility that the Hardwick portrait may commemorate her own work.[8]

The symbolic language of flowers, which could convey both private passion or public loyalties, played an important role at the Elizabethan court (see "Honing the Tudor Aesthetic" in this volume), and the Hardwick portrait is characteristic in its juxtaposition of the "real" flowers at the queen's neckline or in her hair with the embroidered flowers of her dress.[9] The imagery of the petticoat extends beyond this floral imagery to include such fanciful devices as sea monsters or a spouting whale, derived, like much of the decorative imagery at Hardwick, from printed sources.[10]

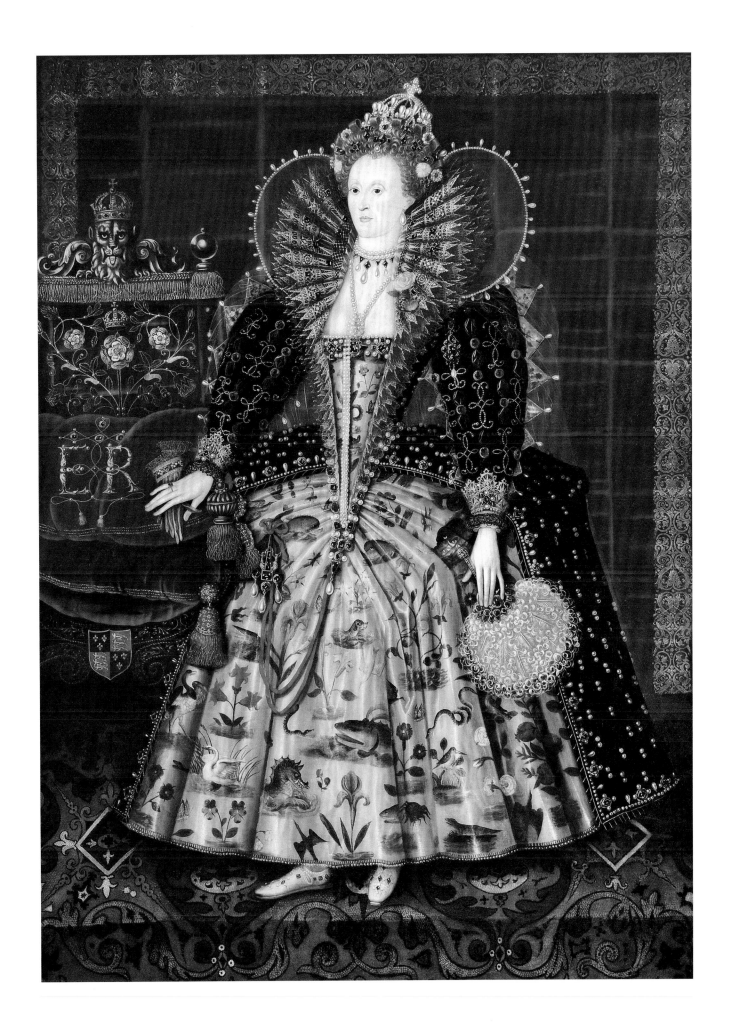

Fig. 123. Hardwick Hall, interior view of the long gallery

With its striking combination of flatness and minute ornamental detail, the Hardwick portrait has played a role in the debate about Nicholas Hilliard's production of works "in great"—that is, large-scale portraits on panel or canvas—with early commentators attributing the portrait to him, and others asserting that its technical shortcomings point to the work of an imitator.[11] The recent establishment of a convincing corpus of half-length panel portraits by Hilliard has clarified the nature of his work in oils.[12] Compared to such works as the Phoenix or Pelican portraits, the Hardwick portrait lacks convincing plasticity or volume.[13] Nevertheless, the precise attention to details of costume, the folded cloth as backdrop, and the rhythmic play of surface effects make an attribution to Hilliard's workshop plausible. In any case, Bess of Hardwick is known to have engaged Hilliard for two miniatures of her granddaughter in 1592, and it would not be surprising for her to turn to his workshop for an ambitious image of the sovereign to decorate her grand new gallery.[14] AE

Notes to this entry appear on p. 319.

119. *Elizabeth I (The Ditchley Portrait)*

Marcus Gheeraerts the Younger (1561–1635/36)
ca. 1592
Oil on canvas, 95 × 60 in. (241 × 152 cm)
National Portrait Gallery, London (NPG 2561)
Exhibited New York only

In late September 1592, Elizabeth I visited Oxfordshire, where she was entertained by Sir Henry Lee at Ditchley.[1] During the revels organized by Lee, the queen encountered a knight sleeping in a pavilion surrounded by "charmed pictures."[2] A page invited the queen to examine these images, in which "some secreats [were] conscealed," so that her decipherment might awaken the knight.[3] With its esoteric iconography and a provenance going back to Ditchley, the portrait shown here is likely one of the paintings presented for the queen's examination.

The Ditchley portrait is the largest surviving full-length portrait of Elizabeth, despite being cut down from its original size. It depicts the queen standing atop a map of southern England.

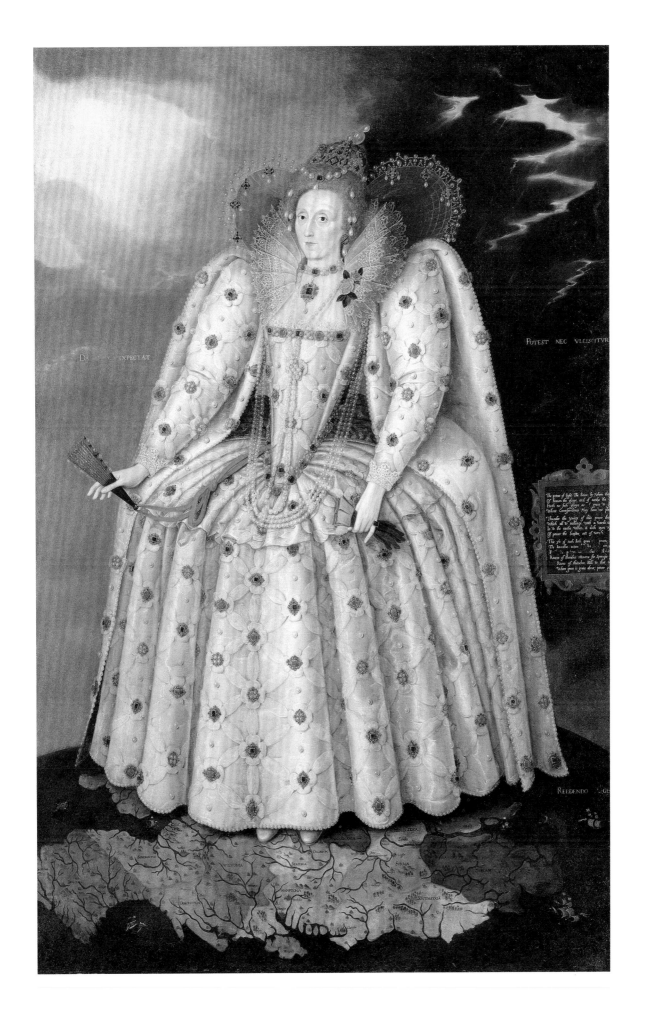

The figure of the queen bisects the background, so that one half depicts a tempest and the other, the sun breaking through clouds. The various inscriptions reflect the queen's power and beneficence. Latin texts declare, "She gives and does not expect"; "She can but does not take revenge"; and "In giving back she increases."[4] The cartouche to the far right contains an English-language sonnet, now fragmentary due to the painting's truncated state and previous overcleaning. The text that remains, however, accords with the imagery of the painting, declaring Elizabeth to be "The prince of light . . . / Of heaven the glorye."[5] These texts are precisely the sort of panegyrics that a savvy courtier like Lee, dependent on Elizabeth's favor, would present for her entertainment. Meanwhile, the calligraphy of the sonnet has been essential in attributing the portrait to the Flemish émigré painter Marcus Gheeraerts the Younger and connecting it to other of his paintings, such as the so-called Persian lady (cat. 112).[6]

The queen's appearance in the portrait, with sunken eyes, lined brow, and thin lips, has led most commentators to assume that Gheeraerts based the likeness on a sitting from life. Yet if, as has been argued persuasively, the portrait was intended to surprise the queen during her visit to Ditchley,[7] then Gheeraerts may not have had the benefit of a preparatory sitting. A comparison with Gheeraerts's portrait of Ellen Maurice (cat. 102) likewise shows the Ditchley portrait to be relatively stiff and stylized. Instead, the

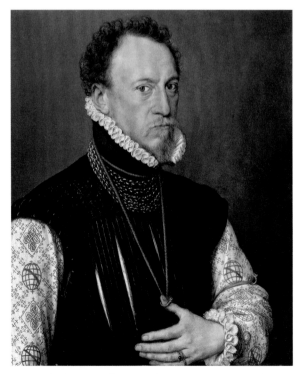

Fig. 124. Anthonis Mor (1519–1575), *Sir Henry Lee*, 1568. Oil on panel, 25¼ × 21 in. (64.1 × 53.3 cm). National Portrait Gallery, London (NPG 2095)

"realism" of the likeness may rely on a famous image of the queen by Gheeraerts's future brother-in-law Isaac Oliver, also dated to 1592 and devised as a prototype for prints (see fig. 125). The Ditchley portrait is not identical to Oliver's portrait and reverses its orientation, but can still be read as a revision of Oliver's frank depiction. In any case, Gheeraerts's presentation of the aging royal physiognomy does not appear to have found favor; subsequent copies of the portrait replace the queen's face with the "mask of youth" familiar from Nicholas Hilliard's portraits.[8]

Sir Henry Lee, the courtier who commissioned cat. 119, was Gheeraerts's key patron in the 1590s, when he built up a significant collection of full-length portraits at Ditchley.[9] Lee was the nephew of the great Henrician poet-soldier Sir Thomas Wyatt and served, like his uncle before him, as an embodiment of chivalry at court. According to his epitaph, Lee served "five succeeding princes, and kept himself right and steady in many dangerous shocks, and three utter turns of state."[10] Lee's greatest contribution to court culture was the creation of the Accession Day tilts in honor of Elizabeth's rule (see p. 118).[11] In these theatrical tournaments, Lee served as both impresario and Queen's Champion. He retired from his post in 1590, to be succeeded by George Clifford, 3rd Earl of Cumberland (cats. 72, 73). The 1592 royal visit to Ditchley, therefore, provided Lee with an important opportunity to remind the queen of his continuing devotion; in the revel's iconography, Lee "looks back down the arches of the years which he had decorated with his pageantry, and reminds the Queen of his part in the building of her legend, of the chivalrous romance which he had woven around her."[12]

In 1568, during a visit to Antwerp, Lee sat for a portrait by Anthonis Mor in which he wears sleeves embroidered with the device of an armillary sphere (fig. 124). This device, as a representation of the cosmos, had a long association with monarchs in general and Elizabeth in particular.[13] It recurs in the earring the queen wears in the Ditchley portrait, perhaps an actual gift from Lee. Along with her earring, the queen wears a costume with an exaggerated silhouette of padded sleeves, dramatically tapered bodice, and monumental farthingale. Her dress has a latticework of ornamentation decorated with pearls and jeweled rosettes in three repeating designs. Janet Arnold, who has connected elements of Elizabeth's costume and jewelry with entries in her inventories, estimates that the queen wears "at least forty-five buttons of each design . . . and over three hundred and seventy pearls to outline the edge of each hanging sleeve."[14] Transforming the queen's body into an expanse of bejeweled white silk, the painter made her into a supernatural apparition befitting her role within the pageant at Ditchley. A E

Notes to this entry appear on p. 319.

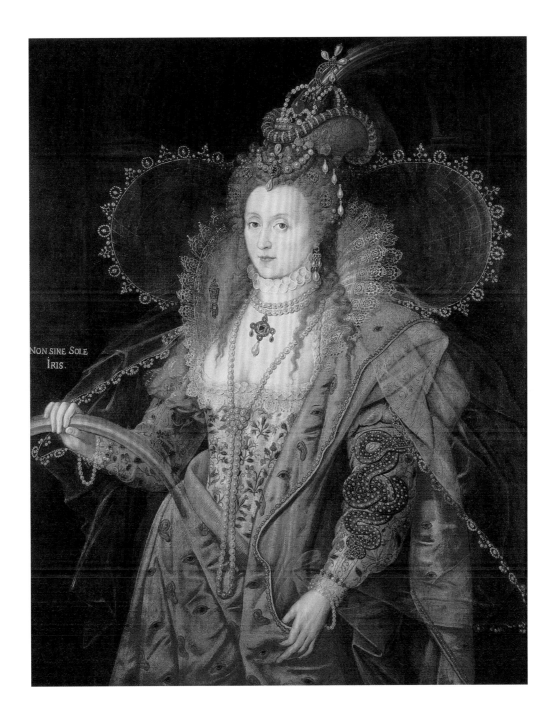

NON SINE SOLE
IRIS.

120. Elizabeth I (The Rainbow Portrait)

Attributed to Marcus Gheeraerts the Younger (1561–1635/36)
ca. 1602
Oil on canvas, 50⅜ × 40 in. (128 × 101.6 cm)
Marquess of Salisbury, Hatfield House, Hertfordshire
Exhibited New York and Cleveland only

Painted at the end of Elizabeth's reign, this portrait presents her as an ageless and unreal beauty, swathed in symbolic attire. This image of the queen, with red locks spilling onto her nearly exposed bosom, is one of a ravishing masquer whose body becomes an allegorical text glorifying her reign.

With its dense layering of symbols, the so-called Rainbow portrait has been among the most analyzed of Elizabeth's images. The first convincing iconographic reading of the painting, based primarily on Cesare Ripa's influential allegorical handbook, the *Iconologia* (1593), asserts that "every detail in this picture is significant."[1] Among these symbolic elements are the juxtaposition of the serpent and the armillary sphere as a representation of the queen's intelligence, both lofty (the sphere) and profound (the burrowing serpent). Subsequent theories build on an association between the portrait's iconographic motifs and the poetry of John Davies, who was employed by Robert Cecil, Earl of Salisbury, the

likely first owner of this portrait.[2] This line of scholarship anchors cat. 120 concretely in the cultural politics of the Elizabethan court with its transactions of patronage, gift giving, and pageantry. Other scholars have read the portrait in religious terms, or provided distinctly post-Freudian interpretations of its bodily imagery.[3] One intriguing interpretation associates the eyes and ears of the queen's cloak with the vast surveillance apparatus that she and her advisers imposed on Tudor society.[4] The most convincing interpretations remain those that link the portrait to Davies's panegyric verse on the occasion of royal visits. Two of those visits, both made in 1602, were to Thomas Egerton and his wife, Alice, at Harefield (Middlesex); and to Salisbury, the presumed first owner of cat. 120, at his new London home. During these visits Elizabeth is known to have received gifts of items of clothing reminiscent of her attire in the portrait, such as a "Gowne of Raynbows very Riche embradrid" and "a riche mantle."[5] Whether these items are literally depicted in the Rainbow portrait or not, the queen's clothing and jewelry are clearly meant to evoke the kind of symbolically laden gifts that Elizabeth would have received when visiting a courtier at home, just as her appearance is that of the ideal virgin beauty praised on such occasions.

The queen's clothing in the portrait has been associated with documented items from her inventories, and the striking decoration of eyes and ears may in fact have been "stained," or painted, on the fabric rather than embroidered.[6] The fanciful headdress, on the other hand, goes back to a printed source, the so-called Thessalonian Bride depicted in a 1581 costume book by Jean-Jacques Boissard.[7] Such evidence further ties the portrait to court practices of masquing and performance.

Almost certainly commissioned by Salisbury, the portrait was most likely one of a number of paintings of Elizabeth listed in a 1612 inventory of Hatfield House, where it remains today.[8] Elizabeth had spent part of her girlhood in the Old Palace at Hatfield, and the Cecil family's rise to preeminence was inextricable from their loyal service to her. Indeed, given her ageless appearance in the painting, it is possible that Cecil commissioned it as a "posthumous tribute to his late mistress," commemorating the favor she showed him in visiting his home.[9]

The attribution of the portrait remains problematic. With his sophistication and interest in masque imagery, Marcus Gheeraerts the Younger remains the most likely candidate, although Elizabeth here bears no resemblance to the realistically aged figure of his Ditchley portrait (cat. 119). A comprehensive technical examination of the portrait remains a major desideratum. A E

Notes to this entry appear on p. 319.

121. *Elizabeth I*

Crispijn de Passe the Elder (1564–1637)
London, 1592
Engraving, 7⅞ × 5¾ in. (20 × 14.6 cm)
The Metropolitan Museum of Art, New York, Harris Brisbane Dick Fund, 1928 (28.97.101)

With discernible wrinkles, a prominent hooked nose, and weary eyes, the Queen Elizabeth I of Crispijn de Passe's engraving is sobering and mortal compared with her appearance in more famous, highly allegorical paintings. She rests under the weight of her rigid ruff, sleeves, scepter, and orb, while shadows pick up the delicate ridges of her flesh. This version of Elizabeth represents a visual identity the queen deliberately rejected.

Jan Woutneel, a Dutch book- and printseller who relocated to London, commissioned the engraving from De Passe, who had moved between Zeeland and Antwerp before settling in Cologne, where he produced this engraving.[1] Perhaps best remembered for establishing a dynasty of talented engravers, De Passe maintained business connections across Europe and created widely distributed portrait engravings for the English market. Those connections enabled him to depict the queen from afar for more than a decade. Indeed, the miniaturist (and Woutneel's neighbor in Blackfriars) Isaac Oliver, who provided drawings for a 1603 print by De Passe, may have been involved in the production of this engraving, which shares a facial type with an unfinished miniature by him.[2]

In all likelihood Elizabeth would not have been pleased with the engraving, though De Passe still intended to flatter his sitter. In this image of fashionable dignity, the queen wears silk patterned with floral motifs and a stomacher elegantly encrusted

Fig. 125. Jakob Lederlein (b. ca. 1565), "Queen Elizabeth I," from *De excellentissima quondam Ostrogothica Italiae regina Amalasuenta . . .* by Martin Crusius (Tübingen, 1599). Houghton Library, Harvard University (GEN Ital 258.10)

POSVI DEVM
ADIVTOREM MEVM

NATA GRONEWICIAE
ANN. ℞ M.D XXXIII.
VI. EID. SEPT.

ELISABET D. G. ANG. FRAN. HIB. ET VERG. REGINA
FIDEI CHRISTIANAE PROPVGNATRIX ACERRIMA

Tristia dum gentes circum omnes bella fatigant
Caecique errores toto grassantur in Orbe,
Pace beas longa, vera et pietate Britannos
Iustitiae et Regni moderans sapienter habenas.

Ô Flos labe carens, fidei sanctissima cultrix,
Chara domi, celebrisque foris, Dei et vnica cura,
Lux pietate nitens, virtus tua et inclyta facta
Sic faciant tandem te Coelica Regna videre.

Honoris ipsius causa aeri incidebat Crispianus Passieus Belga. 1592.

with jewels, paralleling those on the orb. Her wig, carefully curled, supports a hollow crown and pearls mounted on pins, while a wide, open ruff frames the arrangement, and pearls drop from her ears. The Tudor coat of arms floats behind her, circled by the motto for the Order of the Garter. Below, the inscription praises the monarch's piety and radiance amid a tense political climate.

Contrary to court-sponsored images of this period, the print conveys Elizabeth's authority through the trappings of monarchy, rather than her physical being or inherent divinity. Her comparatively diminutive stature and passive, if capable, cradling of regal relics suggest that she is human, not semidivine. The chiaroscuro and realism also offer an artistic counterpoint to her preferred flat, allegorical style of portraiture. De Passe's engraving likewise represents the increased appetite for portrait prints and the kind of reproducible image that everyday people—"all sorts of subjects and people, both noble and mean"—would have encountered, influencing their conception of the queen.[3] Even after its initial printing, artists repurposed the facial type and scene put forth in the print, for example, in a 1599 book by Martin Crusius, a professor in Tübingen (fig. 125); a 1602–4 engraving by Dominicus Custos; and a turn-of-the-seventeenth-century engraving by Frans Huys.[4]

Elizabeth struggled throughout her reign to control her public perception, suppressing and destroying unflattering and libelous pictures—among them, in Paris in 1583, "a fowle picture" of Elizabeth on horseback, pulling up her skirts and defecating beside her suitor Hercule-François, duc d'Alençon.[5] Although De Passe's engraving is far more respectable, it may have warranted the queen's concern. As an unmarried, childless, middle-aged queen regnant, Elizabeth's denial of her own mortality enabled the preservation of her "metaphoric fertility," transcendent divinity, and viability as monarch.[6] As she knew, an inadequate portrayal could confer "a deformed memory" upon "well-formed faces."[7] s b

Notes to this entry appear on p. 319.

122. *Het Spaens Europa*

Frankfurt, ca. 1598
Engraving, 10¹⁄₁₆ × 13 in. (25.5 × 33 cm)
McCord Museum, Montreal (1982.532)

In a subversion of Spanish power, this engraving represents Europe through the eyes of the rebellious Dutch, who, according to the inscription, "cannot accept the Spanish peace."[1] At right, a Dutch "sea beggar" deflects a threatening fleet headed by an infernal three-headed pope. On the queen's chest the French royal forces defeat the Catholic League and their Spanish allies, while above her shoulder the hefty Spanish Armada blazes, scatters, and sinks.

Recollecting a "greatest hits" of Spanish failures, *Het spaens Europa* (The Spanish Europe) parodies Heinrich Bünting and

Fig. 126. "Europa," from *Cosmographia* by Sebastian Münster (Basel, 1588). British Library, London (588.H.2)

Sebastian Münster's famous feminized maps personifying Spain as the head of Europe, which were iterations of an ongoing sixteenth-century trend (fig. 126).[2] The quality and vivid detail of *Het spaens Europa* render Bünting and Münster's illustrations rudimentary and misinformed by comparison, calling out tumultuous contemporary events such as the Dutch Revolt, the Wars of Religion, and the defeat of the Spanish Armada, as well as anti-Catholic propaganda. Printed in both Frankfurt and Amsterdam, *Het spaens Europa* offers a continental view of these events.[3]

Central to the map is, of course, the queen. By replacing the generic feminized body of the map with Elizabeth I, the engraver effectively declares Spain consumed by England, powerfully alluding to English involvement—albeit to varying degrees—in all the events depicted. Elizabeth's right arm manipulates Italy; her left, England and Scotland, with a muscularity totally absent in the Bünting and Münster prints. Although she apparently wears a skirt, Elizabeth is nude but for her androgynous ruff, imperial crown, sword, and orb. Baring a single breast (an attribute of the Amazons), she embodies the martial identity proposed in *Elizabetha triumphans* (1588), in which James Aske mythologized the queen, a "Trunchion in her hand," as she and her lieutenant "Come marching towards this her marching fight / In nought unlike the Amazonian Queene."[4]

The merging of Elizabeth with the Continent dislodges the representational identity of the print, pushing it into the world of Elizabeth's own rhetoric and imagery. As the "Virgin Queen," Elizabeth asserted her impenetrability and fortitude, preferring to suggest that she was one with or married to her nation. Works such as John Case's *Sphaera civitatis* (1588), the Armada portrait of 1588, and the Ditchley portrait of about 1592 (cat. 119) suggest the global identity and celestial empowerment of England via the queen's body. Aske, too, refers to the queen as the "sacred Goddesse of this English soyle."[5] Yet the conflation of body and country also casts Elizabeth's corporal being as a site of vulnerability and animosity; especially as England's imperial ambitions took shape, the rhetoric of exploration became a metaphor for the exploitation and plunder of the queen.[6] Whereas in Bünting and Münster's maps, Europe appears as an impenetrable bloc, here, Europe is broken into straggling isles, leaving open pathways for invasion. In this way *Het spaens Europa* represents an essential paradox of Elizabeth's reign, fusing the queen's own, powerful rhetoric with its inherent vulnerability, opening a confrontation between her dual-gendered reign and the generalized European discomfort with a female monarch. s b

Notes to this entry appear on p. 319.

HET SPAENS EVROPA

Onderganck Vande
Spaensche Vloot

Hibernia

Barbaria

AFRICA

Maiorca
Corsica
Francia
E
V
Germania
De Ligueuis Nederlage
Sardina
Cecilia
Italia
NARE MEDITERRANE
NATC

Anglia Scotia
London
Belgia

Dantzick

EVROPA

Bergen

NORVE
GIA

DANIA

Polonia

Gretia

Candia

maior

MOSCOVIA

Der Holländer sonderbaere Vorgemald, Vnd EntWerffung Warumb sei den Spanischen Frieden, nicht Können annemmen, 51
Von innen in Drück außgangen im Augustus Anno 1598.

123. *Henry Frederick, Prince of Wales, with Sir John Harington in the Hunting Field*

Robert Peake the Elder (ca. 1551–1619)
1603
Oil on canvas, 79½ × 58 in. (201.9 × 147.3 cm)
The Metropolitan Museum of Art, New York, Purchase, Joseph Pulitzer Bequest, 1944 (44.27)

Following the death of Elizabeth I in 1603, the arrival of a new royal family in England, complete with an athletic and charismatic male heir, had a dramatic effect on royal portraiture. Henry Frederick, Prince of Wales, became the focal point of dynastic hopes, reflected in portraits that made innovative departures from English precedent.[1] This portrait, among the first painted of Henry following his arrival in England, demonstrates the important role of Robert Peake in shaping this new Stuart iconography, in a dramatic break with the Tudor past.[2]

Peake's portrait depicts Henry in the hunting field, sheathing his sword after having delivered a ceremonial blow to the carcass of a deer.[3] The prince wears hunter's green—a color associated with hope[4]—and the jewel of the Order of the Garter around

his neck, having been invested by his father that year. The prince is flanked by companions, most prominently the young Sir John Harington, who kneels to hold the antlers of the deer. Harington is joined by a groom, the top of his head barely glimpsed behind the horse, and a panting dog. Although the wide-legged stance may derive from Henry VIII's aggressive pose in Holbein's mural at Whitehall (see fig. 92), this depiction of a royal figure in action was unprecedented. It would, however, have a long afterlife in Stuart portraiture, inspiring, to name one celebrated example, Anthony van Dyck's portrait of Henry's brother, Charles I, commonly known as *Le roi à la chasse* (fig. 127).[5]

The portrait's attribution to Peake derives from its inscriptions, and scholars have since recognized the painting as the first in a sequence of innovative portraits that Peake made of the young heir to the throne, drawing on continental prints and breaking with Tudor precedents.[6] In his fifties at the time of the Stuart accession, Peake had previously been employed for the Christmas revels at court in the 1570s but does not appear to have worked as a royal portraitist until he depicted Henry, sharing the post of Serjeant-Painter with John de Critz after 1607.[7] Despite his evident knowledge of continental prints and

Fig. 127. Anthony van Dyck (1599–1641), *Charles I ("Le roi à la chasse")*, ca. 1635. Oil on canvas, 104¾ × 81½ in. (266 × 207 cm). Musée du Louvre, Paris (1236)

Fig. 128. Robert Peake the Elder (ca. 1551–1619), *Princess Elizabeth, Later Queen of Bohemia*, 1601. Oil on canvas, 53½ × 37½ in. (135.9 × 95.3 cm). National Maritime Museum, Royal Museums Greenwich, London (BHC4237)

innovative compositions, Peake's portraits reveal his training within an indigenous English tradition, with relatively unmodulated flesh tones and doll-like features.[8] At the same time, his emblematic arrangement of figures within a landscape setting connects his large-scale paintings to the late Elizabethan cabinet miniature (see cats. 110, 111, 117).[9]

The portrait was most likely commissioned by Sir John Harington's father, 1st Baron Harington of Exton, who enjoyed great favor under James I and served as the guardian to Henry's sister, Princess Elizabeth. Peake's workshop executed a second version of the composition, in which Harington is replaced by the young Robert Devereux, 3rd Earl of Essex, indicating that the formula was clearly considered a successful representation of the prince's relationship to favored young companions.[10] A portrait by Peake of Princess Elizabeth, also dated 1603, has the same early provenance and was most likely a companion piece to The Met's portrait (fig. 128).[11] Here, the princess appears outdoors, with a diminutive depiction of her brother hunting in the background. Elizabeth Stuart's static pose and costume recall the portraits of her famous namesake, Elizabeth I, whose legacy would play a significant role in the princess's subsequent career as a heroine of the Protestant cause in Europe.[12] Meanwhile, the great hopes invested in Prince Henry were disappointed by his death of typhoid at the age of eighteen; his portraitist, Peake, is recorded as having taken part in his elaborate funeral.[13] A E

Notes to this entry appear on p. 319.

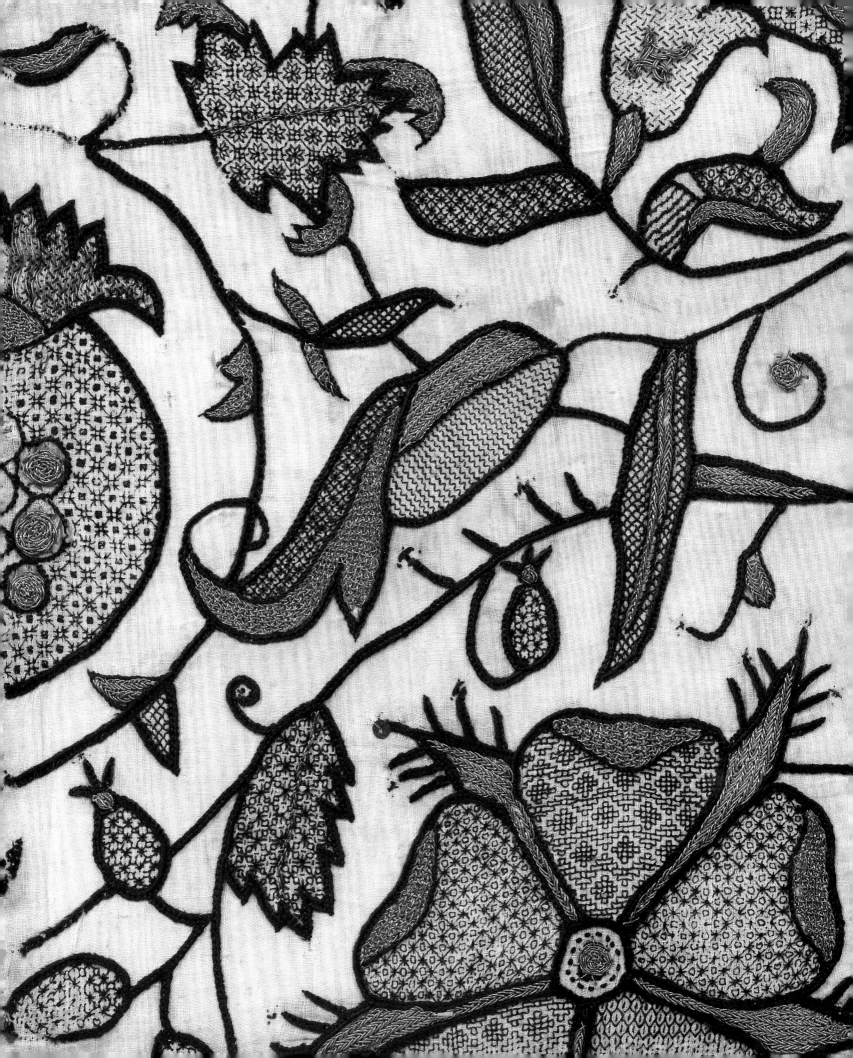

THE TUDOR LEGACY

Iterations of Elizabeth: A Seventeenth-Century Legacy

Sarah Bochicchio

On March 24, 1603, Queen Elizabeth I died at Richmond Palace. Courtiers reported that, for days, the queen would not rest, for she was persuaded that "yf she once lay downe she shold neuer rise."[1] Some claimed that she had rebuffed medical treatment and refused to speak, and that melancholy may have been the cause of death.[2] Others advised their correspondents to be wary of the variation with which subjects of warring ideologies might describe the queen's last days. One writer cautioned, "The papists do tell strange stories, as vtterly voyd of truth, as of all ciuill [civil] honestie or humanitie."[3] In a perhaps equally obfuscating turn, Henry Petowe, a poet and cloth worker, compared his sorrowful tears to rain and "Eliza" to Apollo, and he hoped for her Christlike resurrection.[4] In the ensuing weeks elegiac writers often employed wild idealizations that, for all their exaggeration, revealed a central truth of the post-Elizabethan world: Queen Elizabeth I remained very much alive in the seventeenth-century imagination.

Although her ascent to power was tenuous, by the end of her reign Elizabeth had challenged public thinking about the Crown, women, and authority. As discussed throughout this volume, to overcome the perceived illegitimacies of her reign, Elizabeth had embodied many identities, symbols, and ideas that allowed her to reframe her gender and highlight her divine authority (see, for instance, cats. 114, 117, 120). Countless works focusing on the late monarch appeared throughout the seventeenth century, across the artistic and literary spectrum: paintings, engravings, sculptures, court masques, theater, ballads, pamphlets, and ambassadorial dispatches.[5] In all these iterations, Elizabeth remained a powerful, flexible fantasy, variously embodying a sentimental protagonist, a politique, a neutered leader, a proto-feminist icon, a deferential woman, a Protestant heroine, and the personification of England itself.

Amid the mournful outpouring of 1603, King James I, simultaneously King James VI of Scotland, succeeded Elizabeth (see fig. 96). He and his wife, Anne of Denmark, did observe certain English mourning practices, but he seemed conflicted about, if not downright frustrated with, the overwhelming memory of his predecessor.[6] Elizabeth's funeral procession included more than a thousand mourners dressed in black, and while the new king had asked that the funeral take place "with as much solemnitie as hath ben vsed to any former prince," when he finally arrived in England, James banned mourning attire at court.[7] Even before his arrival, he told Anne that it would be "utterly impertinent" for her to don such "doole weede" (a term for mourning dress used in Scotland).[8] King Henri IV's special envoy attempted to defy the command, which he understood as an affront to Elizabeth, but he eventually asked his retinue to change their attire so as not to offend the court, "where so strong an affectation prevailed to obliterate the memory of that great princess."[9] The Venetian ambassador also interpreted the new king's policy as an indignity to Elizabeth's memory, since he knew how even Elizabeth had worn "strict mourning" after she had James's mother, Mary Stuart, executed.[10]

To a certain extent all the Tudor monarchs preoccupied the king, as well as his subjects who—until now—had lived their entire lives under Tudor rule; for James was cognizant of his foreignness, and of the need to emphasize his natural succession by blood, rather than election.[11] As he unified the nations of England and Scotland, James may have felt a particular kinship with his great-grandparents, James IV and Margaret Tudor, and great-great-grandparents, Henry VII and Elizabeth of York, and he recognized the expedience of proclaiming these ties (see cat. 1). At his formal entry into London, the second triumphal arch erected for the occasion depicted Henry VII

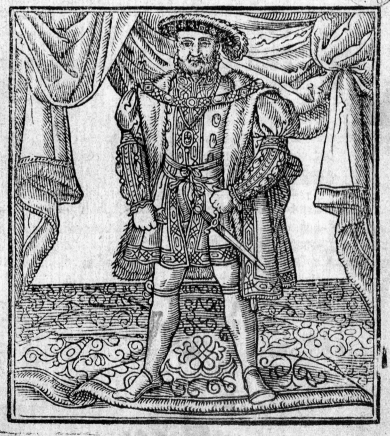

WHEN YOV SEE ME,
You know me.

Or the famous Chronicle Hiſtory of king
Henrie the Eight, with the birth and vertuous life
of E D VV A R D *Prince of Wales.*

As it was playd by the high and mightie Prince of Wales
his ſeruants.

By S A M V E L L R O V V L Y, ſeruant
to the Prince.

AT LONDON,
Printed for *Nathaniell Butter,* and are to be ſold at his ſhop in Paules
Church-vard neere S. *Auſtines* gate. **1 6 2 1.**

Fig. 129. Title page to *When You See Me, You Know Me; or, The Famous Chronicle History of King Henrie the Eight, with the Birth and Vertuous Life of Eduuard Prince of Wales . . .* by Samuel Rowley (London, 1621). Bodleian Library, University of Oxford (014374541)

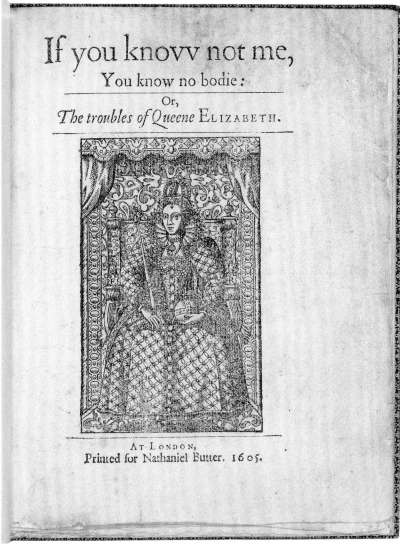

Fig. 130. Title page to *If You Know Not Me, You Know No Bodie; or, The Troubles of Queene Elizabeth* by Thomas Heywood (London, 1605). Folger Shakespeare Library, Washington, D.C. (STC 13328)

Fig. 131. William Marshall (active 1617–49), title page to *The Great Happinesse of England and Scotland, by Being Re-united into One Great Brittain* (London, 1641). The Royal Collection / HM Queen Elizabeth II (RCIN 601246)

handing the royal scepter to James as a sign of uncontested, legitimate descent.[12] In a more permanent act, James moved Elizabeth's remains from Henry VII's tomb into a new structure shared with her sister, Mary I.[13] The king then reserved Elizabeth's former place for himself, thus emphasizing his hereditary descent from Henry VII while marginalizing his three childless predecessors.[14]

Beyond the monarchy, though sometimes inspired by dissatisfaction with it, playwrights, artists, poets, ambassadors, and merchants frequently appropriated the recent past for historical documentation, entertainment, rhetorical strategy, and political agendas. Samuel Rowley's *When You See Me, You Know Me* (1605), for example, captured the physicality, intrigue,

and religious conundrums of Henry VIII's court and put forth James I's son, Henry Frederick, as the inheritor of his namesake's legacy (cat. 123).[15] The editions from 1613, 1621, and 1632 even featured on their title page a rough translation of Hans Holbein the Younger's iconic depiction of Henry from the Whitehall mural (fig. 129). The former king stands on a rippled carpet before an open stage curtain, dressed in luxurious textiles and jewels. The close cropping of the frame gives him an outsize presence even at this small scale, yet the overwhelming intimidation of the full-length portrait diminishes in this black-and-white iteration, a meager ghost of its predecessor (see cat. 11 and fig. 92). It seems possible that the mere suggestion of the image announced its power, as Sir Walter Raleigh scathingly declared, "If all the

QUEEN ELIZABETH's

Opinion concerning TRANSUBSTANTIATION, *Or the Real Presence of* Christ *in the Blessed* Sacrament; *with some Prayers and Thanksgivings composed by Her in Imminent Dangers.*

Fig. 132. *Queen Elizabeth's Opinion Concerning Transubstantiation; or, The Real Presence of Christ in the Blessed Sacrament . . .* (London, 1688). Christ Church Library, University of Oxford (Z.251/37)

pictures and Patternes of a mercilesse Prince were lost in the World, they might all againe be painted to the life, out of the story of this King."[16]

While each Tudor monarch resonated with the seventeenth-century audience, there was a specific potency with which Queen Elizabeth I entered and remained in the public imagination.[17] Thomas Heywood's play *If You Know Not Me, You Know No Bodie* (part 1, 1605) winked at this concept while alluding to Rowley's work of the same year (fig. 130). The title references an exchange from part 2 of the play (1606) but also acknowledges the uncontested celebrity of Elizabeth: if you did not know Elizabeth by name or sight, whom could you know?[18] The title page features a rectangular print of Elizabeth enthroned in front of a cloth of state, wearing an imperial crown and a jeweled, puffed dress familiar from her portraits (cat. 119) and from widely distributed engravings by Crispijn de Passe (cat. 121) and William Rogers (cat. 33). As with Henry's portrait on the Rowley title page, Elizabeth's image—her body, her imagined person—could not be separated from her renown.

Heywood's play delivered "a nostalgic panorama," beginning with Elizabeth's persecution and ending in a crescendo toward the 1588 Armada victory.[19] Based largely on John Foxe's *Actes and Monuments of These Latter and Perillous Dayes*, known as the *Book of Martyrs* (1563), part 1 of the drama, subtitled *The Troubles of Queene Elizabeth*, proffered Elizabeth as a saintlike victim of her sister's wrath. The clearly sentimentalized vision of Elizabeth appealed to audiences; part 1 was reprinted seven times by 1639, and part 2, three times by 1633. In 1667 Samuel Pepys, a naval administrator and later Member of Parliament, described seeing the play performed to an "extraordinary full"

house of spectators.[20] He confessed that the production, which included Elizabethan costume, had moved him deeply: "I have sucked in so much of the sad story of Queen Elizabeth, from my cradle, that I was ready to weep for her sometimes."[21] His comment implies familiarity not only with Elizabeth's tale, but also with this particular version—that is, of the sympathetic princess turned glorious monarch.

When portrayed as the latter, Elizabeth—framed by her ruff—became a symbol of peace, patriotism, and militaristic potential. The title page to *The Great Happinesse of England and Scotland, by Being Re-united into One Great Brittain* (1641) presents one such circular bust of Elizabeth joining two landscapes, those of Edinburgh and London (fig. 131). Below her, James I and Charles I face each other as inheritors of her harmonious legacy. This portrayal effectively skirted reality: although Elizabeth did name James her successor, English relations with Scotland were complicated during her own reign and, after her death, James was clearly ambivalent about the person responsible for his mother's execution.[22] Yet here, the engraver emphasized a physical resemblance between the three recognizable monarchs, giving them similar rounded noses and facial shapes, in a trinity of radiant political contentment.

Elizabeth's defeat of the Spanish Armada similarly became a militaristic model, emblemizing defiant Protestant victory over Catholicism. Even during the interregnum, Oliver Cromwell kept the Armada Tapestries—depicting the landmark victory—hanging in the House of Lords.[23] Yet the martial model—ascribing agency to a saturated symbol—was always somewhat awkward, as when Elizabeth's first historian, William Camden, described the queen's triumph over Spain:

Fig. 133. John Sturt (1658–1730), *Queen Elizabeth I; Queen Mary II*, ca. 1689–94. Engraving, 6⅛ × 3⅞ in. (15.6 × 9.8 cm). National Portrait Gallery, London (NPG D21066)

Fig. 134. Unknown artist after Renold Elstrack (1570–1625), *Queen Elizabeth in Parliament*, 1682. Engraving, 13¹¹⁄₁₆ × 8⅜ in. (34.8 × 21.3 cm). The Metropolitan Museum of Art, New York, Gift of Henry W. Kent, transferred from the Printing Office, 1941 (41.44.1377)

The Queen with a masculine Spirit came and took a View of her Army and Camp at Tilbury, and riding about through the Ranks of Armed men drawn up on both sides of her, with a Leader's Truncheon in her Hand, sometimes with a martial Pace, another while gently like a Woman, incredible it is how much she encouraged the Hearts of her Captains and Souldiers by her Presence and Speech to them.[24]

Here, in keeping with theories of the king's two bodies and certain Elizabethan rhetoric that dichotomized the royal and the mortal, Camden relegated leadership qualities to Elizabeth's supposed masculine side, as though a man's spirit were merely captive in a woman's form (see cat. 122). This compartmentalization

protected Elizabeth's militaristic identity from being associated with negative "feminine" traits, like disorder. The masculine–feminine queen thus became a composite, malleable symbol while still reinforcing the existing social order.

Some writers, by contrast, embraced Elizabeth's femininity, using it as a platform from which to inspire or instruct other women. In 1630 Diana Primrose addressed her pamphlet *A Chaine of Pearle* "to all noble ladies and gentlewomen," focusing on religion, chastity, prudence, temperance, clemency, justice, fortitude, science, patience, and bounty.[25] Organized almost as a rosary, with a virtue ascribed to each pearl, the text riffed on Elizabeth's penchant for the gems, which had associations with

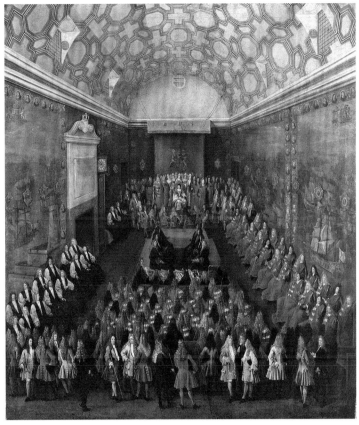

Fig. 135. Peter Tillemans (1684–1734), *Queen Anne in the House of Lords*, ca. 1708–14. Oil on canvas, 55¹/₁₆ × 48³/₈ in. (139.8 × 122.9 cm). The Royal Collection / HM Queen Elizabeth II (RCIN 405301)

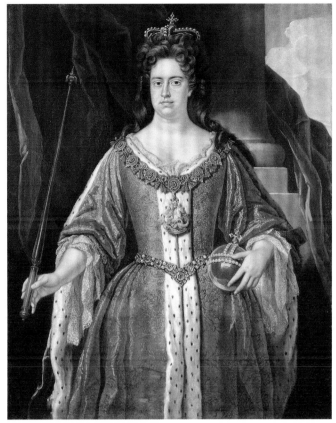

Fig. 136. Workshop of John Closterman (1660–1711), *Queen Anne*, ca. 1702. Oil on canvas, 49¼ × 40½ in. (125.1 × 102.9 cm). National Portrait Gallery, London (NPG 215)

both chastity and the goddess Diana. Primrose praised Elizabeth for virtues relating to her social, political, and personal accomplishments, citing the queen ("Englands brightest sun") as an ethical model for other women.[26] Bathsua Makin, a linguist and writer, and tutor to Charles I's daughter, argued less abstractly for the pursuit of education and public agency for women.[27] In one section of her evidence-based essay arguing for women's education, Makin "thought of Queen Elizabeth first," but intentionally mentioned her last, "as the Crown of all."[28]

Given this persistence into the seventeenth century of the Elizabethan mythos, it seems unsurprising that the accession of two Stuart princesses to the English throne at the end of the century would rekindle similar metaphors and imagery, and that both queens—Mary and Anne—would invariably become attached to the Elizabethan identity. They also, however, faced skepticism about their capacity as leaders, despite insistence on the success of Elizabeth's reign. Both monarchs were thus caught up in the effort to placate worrying political situations with a familiar metaphor.

During the 1688 dynastic crisis that followed the birth of James II's son, concerned Protestants evoked the centennial of the Armada victory to seek a new Elizabeth. At this time, the greatest hope resided in James's eldest daughter, Mary, wife of William, Prince of Orange and stadtholder in the Dutch Republic. In one 1688 broadside, a series of texts purportedly penned by Elizabeth—a poem, a prayer, the famous Tilbury speech—demonstrated a lifelong commitment to Protestantism, even in times of great danger. Contextualizing passages bridge the various texts; one pulls directly from Camden's seventeenth-century history, while others highlight the pitiful circumstances in which the young, persecuted princess once found herself. The broadside does not directly mention Mary, but the implication is clear: if only a new Protestant savior would rescue England once again. At the top of the broadside, a stiff, simplified image of Elizabeth breaks up the title, almost christening the sheet and granting her tacit approval (fig. 132).

Mary and William did assume power and, in an unprecedented arrangement, became dual monarchs.[29] After a series

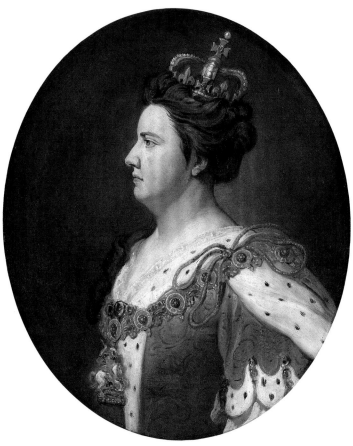

Fig. 137. Sir Godfrey Kneller (1646–1723), *Queen Anne*, ca. 1702–4. Oil on canvas, 30 x 25⅛ in. (76.1 x 63.8 cm). The Royal Collection / HM Queen Elizabeth II (RCIN 405614)

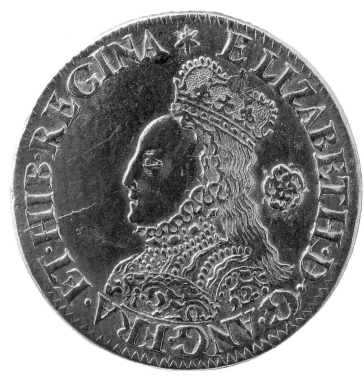

Fig. 138. *Elizabeth I Sixpence Coin*, England, 1562. Silver, Diam. 1 in. (2.5 cm). The Metropolitan Museum of Art, New York, Gift of Assunta Sommella Peluso, Ada Peluso, and Romano I. Peluso, in memory of Ignazio Peluso, 2000 (2000.601.9)

of debates, and despite Mary's stronger claim to the throne, William became the primary monarch—per Mary's own demand.[30] By this arrangement, Mary had more power than a traditional queen consort but less than a queen regnant.[31] Regardless, she was England's first queen since Elizabeth—a fact commemorated in an engraving by John Sturt, a double portrait in which Elizabeth and Mary, framed partially in laurel wreaths, are joined as "Queens of England" (fig. 133). The engraving appeared as a frontispiece to Edmund Bohun's *The Character of Queen Elizabeth, or, A Full and Clear Account of Her Policies, and the Methods of Her Government Both in Church and State* (1693), in which he referred to Mary's predecessor as "the Greatest Princess that ever sway'd this or any other Scepter."[32] Sturt seems to have based his portrayal of Elizabeth directly on a seventeenth-century depiction of the queen that better reflected Stuart-era conventions of beauty. He here imagines Mary in the updated Elizabeth's likeness, with elongated features and sloping shoulders. They each wear pearls, imperial crowns, and royal ermine, and their hooded eyes, arched brows, and small mouths

suggest a familial resemblance. Any differences in their representation have all to do with style rather than substance. The presence of a Tudor rose and their entwined monograms (*E*, *M*, and *R*) emphasize an unbreakable, inherent comingling of identities and a transference of noble qualities.

Though sermons would still call her a "Second Q. Elizabeth," Mary deliberately distanced herself from the image of the queen who, above all, embodied exceptionalism.[33] Mary instead constructed a public image that downplayed her political involvement and independence in favor of emphasizing a wifely ideal—despite being, in reality, a strong leader in her own right. In Mary's state portrait, by Sir Godfrey Kneller, she appears at her most regal, cloaked in her robes of state; one hand gathering ermine, the other on the orb, Mary is noble and sober.[34] Yet here and in the accompanying portrait of William, Kneller based the poses on Anthony van Dyck's portraits of the early Stuart monarchs Charles I and Henrietta Maria.[35] He thus emphasized dynastic continuity while styling Mary after a queen consort. As a pendant portrait, Mary is on the right, the position of

inferiority, respectfully deferring to her husband. Mary herself reinforced her subservience in her autobiographical writings, claiming, "My opinion having ever been that women should not medle in government, I have never given my self to be inquisitive into those kind of matters."[36] Adopting a more conventional role in spite of her extraordinary position was an effort to normalize her regime and promote longevity.

It was not Mary but her sister, Anne, who took up the Elizabethan legacy without reserve. When Mary and William died childless and Anne came to the throne, in 1702, her rights were not at issue, but owing to prejudices, the absence of an heir, her poor health, and an ongoing war, she still faced a number of challenges. Thus, long before her coronation, Anne invoked her relationship to Elizabeth, and, in doing so, emphasized her eternal, mythical body over her mortal one.[37]

After her coronation, Anne boldly announced her intention by adopting as her motto Elizabeth's "Semper eadem" (Always the same). She ordered that it "was her Majesty's Pleasure, that whenever there was occasion to Embroider, Depict, Grave, Carve, or Paint her Majesty's Arms, these Words, SEMPER EADEM, should be us'd for a Motto; it being the same that had been us'd by her Predecessor Queen Elizabeth, of glorious Memory."[38] Anne again consciously echoed Elizabeth at her first appearance at Parliament, in 1702. Modeling her attire on an engraving of Elizabeth (fig. 134), she wore a red velvet mantle lined with ermine, the badge of Saint George, and the ribbon of the Garter.[39] Peter Tillemans's painting of Anne in the House of Lords likewise invokes Elizabethan precedent, showing Anne, hand on scepter and with her ermine robes on her lap, leading Parliament while surrounded by the still-hanging Armada Tapestries (fig. 135). Tapping into the sartorial legacy of her predecessor, Anne highlighted consecutive queenship and the authority it endowed.

Anne's coronation portraits alluded to Elizabeth as well, deliberately employing conventions of the pre-Stuart period (see, for example, fig. 54). At her actual coronation, Anne had to be carried from Westminster Hall to the Abbey, but, as in an idealized Elizabethan portrait, the coroneted Anne appears in full health in the paintings.[40] In one version after John Closterman's original (fig. 136), a half-length queen echoes the staging and rigidity of its model (a ca. 1600 copy of a lost original portrait of Elizabeth). Like Elizabeth, Anne appears in a brocaded skirt, ermine-lined robe, and a Garter collar with Saint George. The portrait is strikingly unsentimental, emphasizing majesty over femininity. Later criticized for being wooden and unattractive, it instead offers a neo-Elizabethan proclamation of authority defined by the office and legacy that Anne inhabited. In an

oval-shaped portrait by Kneller, Anne appears in profile, similarly attired in coronation robes (fig. 137). Used to model medals and currency, the portrait invokes imperial coinage (fig. 138). More specifically, the tilt of Anne's head, the placement of her crown, and the emphasis on her dress—as well as the fact that she excluded her husband, Prince George of Denmark—point to her commitment to Elizabeth, in contrast to more recent monarchs who were more likely to appear jointly and in classical attire. Anne's invocation of Elizabeth here elevated her own fragile body.

In response to the portrait by Closterman, England's poet laureate Nahum Tate defined Anne in Elizabethan terms. Calling her a "Celestial Dame" and drawing comparisons to the formidable prophetess Deborah, he proclaimed, "Astraea is Return'd."[41] At the end of her life, another ode likewise praised Anne for undermining the Salic law of succession, "so Eliza" had. Indeed, Anne and Elizabeth had demonstrated that the Ocean "willingly obeys a Female Hand" in asserting England's naval might.[42] But, like Elizabeth, Anne's success and acceptance did not extend to other women; she was an exception. From the "dawning Beams" that gilded her days, Anne "[did] all her Sex excel."[43]

Over the course of the seventeenth century, Queen Elizabeth I became a necessary referential standard. Later Stuart engravers, painters, and monarchs recycled facial types from earlier decades, approximating Tudor images to appeal to new audiences. As each iteration of Elizabeth cultivated the next, she was molded into diverse shapes to suit seventeenth-century needs, alternately discarded and praised for her celebrity, rejected or appropriated for her power. Elizabeth's legacy—objectified, glorified, redefined—exposes just how much and how little post-Elizabethan culture understood about its historical subject. Today, Queen Elizabeth I still legitimates discussions of image, gender, and power, and these invocations highlight the stark paucity of other examples, as well as the continued attraction of Elizabeth's actual and invented legacies. In that sense, Henry Petowe may have been quite astute in predicting an Elizabethan resurrection: "She was, she is, and euermore shall bee, / The blessed Queene of sweet eternitie."[44]

Notes to this essay appear on pp. 319–20.

The Tudor Afterlife

Marjorie E. Wieseman

The catchall "Tudor Revival" seems to embrace everything from domestic architecture to the guilty pleasures of TV serials and Hollywood costume dramas. But what does "Tudor" connote, and precisely what aspect of the Tudor period is being revived? The editors of one of several recent volumes on the subject defined "Tudorism" (their preferred term) as "the post-Tudor mobilization of any and all representations, images, associations, artefacts, spaces and cultural scripts that either have or are supposed to have their roots in the Tudor era."[1] To compound the complexity, at least one historian has questioned the use of the term "Tudor," regarding it as an anachronistic attempt to suggest some sort of coherence to what was in fact a remarkably heterogeneous period encompassing more than a century of political, religious, and economic transformation.[2] Still, it can be argued—as this volume does—that the fine and decorative arts produced for the enjoyment and aggrandizement of the five monarchs bearing the Tudor name (not to mention their difficult and often turbulent personal lives) form a rich and sufficiently well-defined trove of images and events ripe for historical and antiquarian plunder.

We can identify at least some of the likely reasons why this period and its colorful personalities have intrigued and inspired successive generations in England and beyond. First and foremost, we feel a connection with the period because we have a good idea what the key protagonists looked like: the Tudors were "the first historical dynasty of which it can be said that there is a traditional and even commonplace visual depiction."[3] From as early as the mid-seventeenth century, historians and antiquaries studied the proliferation of those depictions for accuracy and understanding, appropriating them as cornerstones for their own romantic reimaginings of these royal subjects. At the same time

the ceremonial splendor evidenced in royal Tudor likenesses, especially those of Henry VIII and Elizabeth I, came to epitomize the idea of royal magnificence.

The relative unity and prosperity of England during the latter years of the Tudor dynasty has also been a powerful motivator, a recurring touchstone for kindling nationalistic pride and nostalgia for the simple pleasures of "merrie England." Particularly during unsettled moments in England's history, the Tudor era—and particularly the reign of Elizabeth I—was felt to represent the country's finest display of nationhood, community, prosperity, and optimism: an idealized vision of the past that was both comforting and inspiring. The era was not without its dark side, however, with more than its fair share of religious persecution, political machinations, shifting allegiances, and ill-starred royals prone to ending their days in prison or on the executioner's block. Accordingly, another strain of Tudorism probes with salacious and voyeuristic delight the danger, violence, and horror that stalked the sixteenth century.[4]

This essay is by no means an in-depth investigation of the complex topic of historic revivalism. Rather, it presents select manifestations of the Tudor Revival (or Tudorism) in the visual arts and popular culture over the course of four centuries as evidence of the evolution in the historical understanding of the period and the myriad ways in which this heritage was mined to satisfy aesthetic, didactic, political, emotional, or recreative goals.

As noted in the preceding essay ("Iterations of Elizabeth: A Seventeenth-Century Legacy"), fascination with this period of England's history began almost immediately after Elizabeth I's death. From the late sixteenth century, antiquaries had directed their attention to the physical traces of England's past. The destruction caused by the Dissolution of the Monasteries under

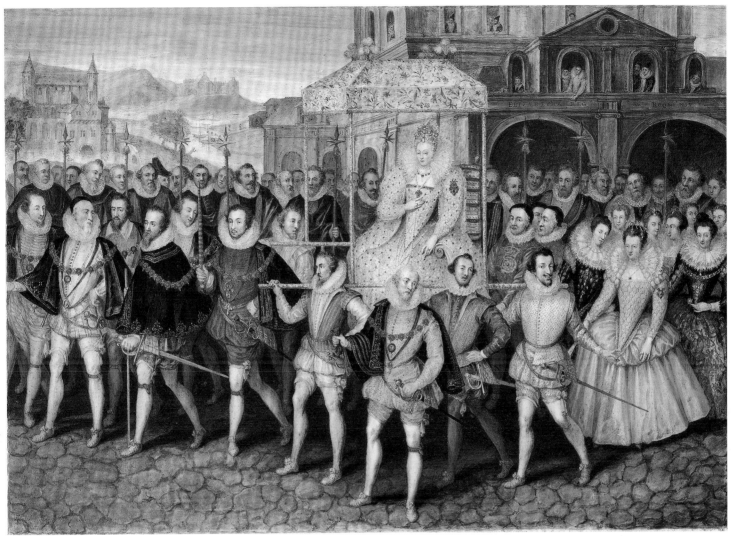

Fig. 139. George Vertue (1684–1756), *The Royal Progress of Queen Elizabeth*, 1740. Bodycolor on vellum, wrapped around panel, 16 × 22 in. (40.5 × 56 cm). J. Lonsdale Family Collection

Henry VIII and, later, by the English Civil War intensified efforts to preserve the objects that defined the nation's history. Particularly in the wake of the Act of Union of 1707, which officially joined England and Scotland to form the United Kingdom of Great Britain, study of a common British past was regarded as a means of consolidating political stability.[5] The Society of Antiquaries in London was founded in 1707 with a stated mission not solely to collect and admire the relics of Britain's pre-Jacobean past, but also to issue reproductive engravings of those antiquities, "to the end that the knowledge of them may become more universal, be preserved and transmitted to futurity."[6] George Vertue—artist, collector, and avid chronicler of the artistic scene—was appointed the society's Engraver in 1717. He was ideal for the post, as he himself "collected coppyes in Water Colours of most of the Kings of England that was any where to

be found from picture Image or limning,"[7] many of which were subsequently used as the basis for prints, some issued by the society and others independently. One of the most ambitious of the latter efforts was a series of four large engravings reproducing iconic representations of Tudor history: Hans Holbein's Whitehall mural (see fig. 92); Livinus de Vogelaare's *Memorial to Lord Darnley*; *The Battle of Carberry Hill*, from an original then at Kensington Palace; and *The Royal Progress of Queen Elizabeth*, probably by Robert Peake.[8] The engraving of the last was based on a precise, small-scale reproductive limning that Vertue had painted on commission from his patron Edward Harley, 2nd Earl of Oxford (fig. 139).[9] The reproductions all feature lengthy inscriptions recording Vertue's factual observations and diligent research. Visibly documenting his passion for preserving and disseminating information for the future advancement of

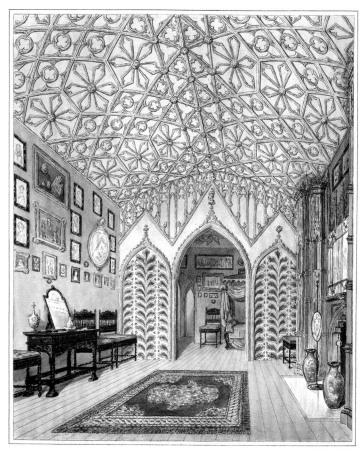

Fig. 140. John Carter (1748–1817), "Holbien [*sic*] Chamber," ca. 1788, watercolor mounted in *A Description of the Villa . . . at Strawberry-Hill* by Horace Walpole (Strawberry Hill, 1784). Lewis Walpole Library, Yale University (Folio 33 30; Copy 11, fol. 117)

scholarship, the inscriptions also offered collectors a certain guarantee of historical authenticity.

Vertue's objective antiquarian approach intentionally left little opportunity for "imaginative projection" on the part of the viewer.[10] Horace Walpole's consideration of the past, on the other hand, was almost diametrically opposed. Beginning in about 1750 and continuing for more than two decades, Walpole transformed a modest villa in Twickenham—Strawberry Hill—into his "little Gothic castle," with interiors self-consciously composed as evocative settings for his extensive and eclectic collection.[11] Although he was in fact a serious historian, Walpole had little interest in an antiquarianism that prized factual detail over aesthetics; he practiced "his own 'visionary' brand of antiquarianism, . . . in which objects (and architecture) sparked the imagination and became doorways to the past."[12] Walpole's theatrical sensibility, romantic imagination, and completist mentality resulted in highly affective scenography, but also led to wildly optimistic attributions and decidedly subjective

interpretations. For example, in his quest to assemble images of the entire Lancastrian and Tudor dynasties (which he considered the perfect complement to Strawberry Hill's neo-Gothic architecture), a seventeenth-century bust of a man became "a model in stone of the head of Henry VII in the agony of death . . . undoubtedly by [Pietro] Torregiano."[13] The bust's anguished physiognomy satisfied Walpole-the-historian's opinion of Henry VII as "a mean and unfeeling tyrant";[14] for theatrical effect he installed it in a narrow, darkened corridor that was a prelude to a larger display of dynastic history: the Holbein Chamber.

Completed in 1759, the Holbein Chamber was the most consistently themed room in the house, with contents and design evoking the momentous and turbulent years of the first half of the sixteenth century (fig. 140). The inspiration for the room—and the core of the display—was Walpole's 1757 acquisition of thirty-three copies traced by Vertue from Holbein's portrait drawings in the Royal Collection (among them, cats. 82–84).[15] Identically framed and symmetrically arranged, Vertue's copies were complemented by two dozen additional drawings by (cat. 35) or after Holbein; painted portraits of English and European royal families, including Lucas de Heere's *Allegory of the Tudor Succession* (see fig. 32); ebony furniture believed to have belonged to Cardinal Wolsey; a pseudo-Gothic screen and chimneypiece; and a papier-mâché ceiling copied from one in the queen's dressing room at Windsor.[16] Here and throughout his "castle," Walpole wove a colorful tapestry of historic reconstruction, introducing a sufficient number of authentic objects and enough accurate detail to produce a convincing historical fantasy. The affective power of the interiors he painstakingly created at Strawberry Hill strongly influenced his groundbreaking Gothic novel, *The Castle of Otranto* (1764). For Walpole, historical truth (whether textual or visual) lay not in facts but in feelings; facts and artifacts were simply building blocks to be used in constructing an emotional connection to the past. As Walpole put it, "History is a Romance that is believed."[17]

The impulse to build an emotional connection to the past through visual art (and literature) continued throughout the nineteenth century. The tremendous popularity of historical narrative during the period reflects, in part, a consciousness that certain past events could offer obvious parallels for current events, and that exploring those analogies was a way of comprehending and explicating the present. In the 1820s and 1830s the French public was gripped by Anglomania, fascinated by the early modern history of their neighbor (and recent adversary) across the Channel. The Tudor era held particular interest, perhaps because of its connotation as a golden age of prosperity and calm before the convulsions of a civil war; but

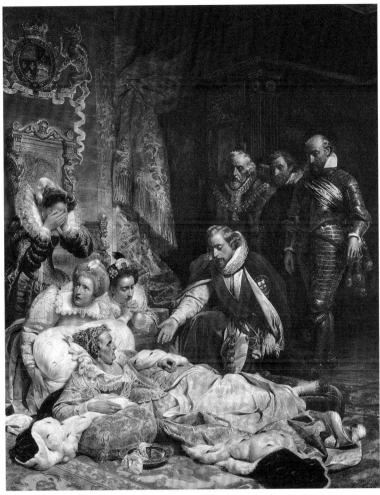

Fig. 141. Paul (Hippolyte) Delaroche (1797–1856), *The Death of Elizabeth I, Queen of England, in 1603*, 1828. Oil on canvas, 166¼ × 135⅜ in. (422 × 343 cm). Musée du Louvre, Paris (3836)

Fig. 142. Sir Thomas Lawrence (1769–1830), *Coronation Portrait of George IV*, 1821. Oil on canvas, 116⅛ × 80¾ in. (295 × 205 cm). The Royal Collection / HM Queen Elizabeth II (RCIN 405918)

perhaps also—during the period of the Restoration and the July Monarchy—because of the parallels it offered with France's own rapid dynastic turnovers, and the traumatic (and still vividly recalled) events of its recent past. Walter Scott's iconic historical romance *Kenilworth*—published in England in 1821 and immediately translated into French—was as popular on the Continent as it was in England. And scarcely a year passed without a major stage production featuring Henry VIII or Elizabeth I:[18] performances of Shakespeare's *Henry VIII* attracted huge audiences in Paris, as did Tudor-themed plays by Victor Hugo and Alexandre Dumas, and operas by Gioachino Rossini and Gaetano Donizetti.[19]

The fascination with Tudor high drama was no less evident in the fine arts, where artists like Pierre-Nolasque Bergeret (whose fanciful *Anne Boleyn Condemned to Death*, 1814, is probably the first French painting to depict a Tudor subject), Eugène Devéria, and Paul (Hippolyte) Delaroche achieved

enormous success with their powerful and consciously theatrical reimaginings of Tudor history.[20] Delaroche's massive *Death of Elizabeth I, Queen of England, in 1603* (fig. 141), exhibited at the Paris Salon of 1827–28, presents an alarmingly vivid image of the aged queen, slumped on the ground amid a heap of cushions as if already half in the tomb. In place of a beneficent "Good Queen Bess," Delaroche's grotesquely unflattering depiction reflects a tendency in French historical narrative to define the queen's character as cruel and capricious; and a refusal to either acknowledge the achievements of her reign or forgive her for the execution of Mary Stuart, once—however briefly—Queen of France.[21]

Delaroche's most powerful interpretation of a subject from Tudor history is *The Execution of Lady Jane Grey*, exhibited at the 1834 Salon to overwhelming critical and public acclaim.[22] The story of Jane Grey, although perhaps less familiar to the French public, was undeniably a compelling one: a beautiful and

Fig. 143. Westminster Palace, interior view of the Prince's Chamber

innocent victim, just sixteen years old, deposed, imprisoned, and condemned to death by her rival and successor, Mary I. The story presented a vivid analogy to the death of France's Queen Marie Antoinette, dispatched to the guillotine just forty years earlier, and Delaroche deliberately composed his painting in such a way as to encourage his French audience to meditate on their own recent past.[23] His elegant restaging of a tragic event whose meaning and impact were well contained by the past offered a calming parallel to the messy, unfinished chaos of recent history and current events.[24]

While in France, violent and emotionally charged episodes from the Tudor period entertained audiences and provided perspective on their own recent history, the era's connotations as a preindustrial golden age held the greatest appeal for nineteenth-century English audiences. Novels, popular entertainments, and paintings such as Charles Robert Leslie's *May Day in the Reign of Queen Elizabeth* (1821) celebrated the simple pleasures of a past that, while more than two centuries distant, still felt quite familiar and representative of the most admirable features of the English national character.[25]

As early nineteenth-century Britons reconnected with the imagined charms of a late Tudor "Olden Time," their king was appropriating the autocratic pomp of the dynasty's most memorable monarchs in the construction of his own public persona.[26] Flamboyant and quixotic, George IV was, like Henry VIII, a notorious womanizer and glutton, and like him, a prolific commissioner of architectural projects, many of which were designed in an eccentric Tudor Gothic style. The Elizabethan ceremonies imagined by Walter Scott, whom George IV had raised to Poet

Laureate, were the inspiration for the king's own coronation in 1821: an over-the-top display of Tudorist magnificence, with all the participants clad—by royal command—in Elizabethan costume. George IV's own sumptuous and bejeweled outfit is recorded in Thomas Lawrence's magnificent coronation portrait (fig. 142), in its scale and iconography a worthy rival to the Ditchley portrait of Elizabeth I (cat. 119).[27]

George IV's attempts to appropriate as his own the glory of his Tudor forebears often descended into farce, but his encouragement of a late Gothic "Tudoresque" style in architecture had lasting impact. One of the most important buildings in this style was the New Palace of Westminster, rebuilt in "the Tudor style of Gothic" by Charles Barry and A. W. N. Pugin following the fire that devastated London in 1834. Over several campaigns, beginning in the 1840s and lasting well into the twentieth century, the interior of the Parliamentary complex was decorated with murals depicting British historical subjects from the Dark Ages to the Battle of Waterloo (1815). Individual subjects and decorative schemes were determined with careful attention to the function of the spaces for which they were destined, revealing a great deal about the image that Parliament wished to present of Britain and its democratic processes at the height of the nation's political and economic hegemony.[28] The glories of the Tudor monarchy—credited with restoring England's fortunes after the Wars of the Roses, and recognized as the last dynasty to enjoy supreme monarchical power—were deemed an appropriate theme for the Prince's Chamber, an anteroom to the Lords Chamber and the last stage of the monarch's procession to that chamber at the opening of Parliament (fig. 143). The uppermost register of the walls was to be decorated with painted copies of the Armada tapestries, destroyed in the fire of 1834;[29] in the middle register, a series of portraits of the Tudor monarchs, their relatives, and their consorts; and in the lowest register, bronze bas-reliefs representing scenes from Tudor history.[30] The artist charged with painting the portraits, Richard Burchett, went to great lengths to secure "true effigies of the personages represented in their habits as they lived" on which to base his likenesses.[31] To impose uniformity and evoke the Tudor period, the figures are set against tooled backgrounds meant to imitate embossed gilded leather. Not all of Burchett's "true effigies" were accurately chosen, but most are readily recognizable, including Hans Eworth's portrait of Mary I (cat. 26), Holbein's iconic likeness of Henry VIII from the Whitehall mural (cat. 10 and fig. 92), and Eworth's depiction of Elizabeth I from *Elizabeth I and the Three Goddesses* (fig. 122).

A half century later (1906–10), the Tudor-themed decorations of the palace's East Corridor reflected a very different political

landscape. The program for the space, part of the public access route to the Committee Corridor in the House of Commons, and thus one of the most frequented parts of the building, was determined not by a commission appointed by the monarch (as had been the case with the Prince's Chamber), but by the Liberal government then in ascendance.[32] For Liberal historians advising on the project, the period of the Reformation was when "the modern Englishman came into definite existence,"[33] and Henry VIII was admired for reshaping the English constitution just as the Liberals themselves hoped to do. Combining historical events and Shakespearean narrative into a "living, many-coloured and romantic" history, the East Corridor paintings presented historical parallels for current Liberal concerns such as government reform, universal education, and aid to the poor (fig. 144).[34] The style of the murals was as progressive as the ideology behind the choice of subjects. Overseen by the American-born artist Edwin Austin Abbey, the project's painters worked in the modern and highly decorative "Neo-Pre-Raphaelite" style: a refreshing departure from the dominant aesthetic of academic realism, and optimistic evidence of a burgeoning rejuvenation of decorative art in Britain.

If episodes from Tudor history were considered appropriate for advancing the Liberals' agenda of public programs, it was Tudoresque domestic architecture that had the greater impact on people's everyday lives—not just in Britain, but around the world. Eclectic and infinitely accommodating, Tudoresque or Tudor Revival architecture spread organically from the mid-nineteenth century onward,[35] applied to everything from lordly rural estates to modest urban and suburban residences. The neo-Gothic fantasy of Walpole's Strawberry Hill and the imposing mass of the New Palace of Westminster were modestly influential, but their "pointed Gothic" style was considered too closely connected to Catholicism and the perceived elitism of the Middle Ages to reflect appropriately the domestic pleasures of the "Olden Time." Of greater impact were publications like Joseph Nash's four-volume *The Mansions of England in the Olden Time* (1839–49), which enlivened illustrations of sixteenth- and seventeenth-century domestic architecture with the happy activities of their imagined inhabitants, solidifying the association between architectural style and pleasurable living. The informality and irregularity of Tudor architecture (see "Honing the Tudor Aesthetic" in this volume) allowed for infinite variation: its characteristic gables, half-timbering, mullioned windows, and odd fenestration could be applied and arranged as required. Architects of the Arts and Crafts Movement, under the guidance of William Morris, were drawn to the style for its connotations of individuality and honest craftsmanship, but it also served

Fig. 144. Frank Cadogan Cowper (1877–1958), *Erasmus and Thomas More Visit the Children of King Henry VII at Greenwich, 1499*, 1910. Oil on canvas, 81 × 83 in. (205.7 × 210.8 cm). Parliamentary Art Collection (WOA 2595)

to give mass-produced housing greater appeal. Tudoresque (or, more pejoratively, "mock-Tudor") was by far the dominant style of the more than 2.5 million suburban homes built in Britain in the 1920s and 1930s,[36] many of which had been constructed intentionally to provide soldiers returning from World War I with decent housing. The promotion of a homegrown Tudoresque style for such residences was a deliberate assertion of national identity, meant to instill pride in the country's history of prosperity and self-reliance (fig. 145). Quaint Tudoresque structures also represented "typical" English architecture at international fairs and expositions, co-opting the evocative imagery of the preindustrial period to convey the longevity of British imperialism.[37]

Even the most pedestrian "mock-Tudor" home could stimulate sentiments of domesticity and nationalistic pride in England, but in the United States, the Tudoresque represented a more distant heritage, and its connotations were consequently more complex. On the one hand it was intimately associated with institutions of higher learning: between 1890 and 1930, countless university buildings in the United States were built in the "collegiate Gothic" style, patterned on colleges at Oxford and

When it was Merrie England....

Out of a raucous mechanical age into a serene and leisured past.

Only a few strides and you pass from the sound of the grinding of gears to the unhurried tranquillity of a village of Tudor times.

In this little hamlet the greensward is girdled by nine houses where every door is wide with welcome.

Here is a village where modern comfort is clothed in the traditional beauty of the spacious days of long ago.

Here you shall find the old and the new welded into your ideal home.

❖ ❖ ❖

The Tudor Village is but one of the many enthralling features of the greatest Ideal Home Exhibition yet organised.

Come to Olympia and see how once again Britain's most popular Exhibition has excelled itself.

.... The City of Light
.... The Tudor Village
.. Princess Elizabeth's House ..
.. An Old English Street ..
.. Gardens of the Novelists ..
.. The Pageant of Fashion ..
... Welcome Terrace
... Two • in • One Rooms ...
.. Homes Beyond the Seas ..
.... The Minimum Flat
.. Firesides thro' the Ages ..
Furnishing and Decoration
... Heating and Lighting ...
Refrigeration .. Labour-Saving
... Food and Cookery ...
... Music and Recreation ...
Fabrics and Fashions, etc., etc.

Daily Mail NOW OPEN—10 A.M. TO 10 P.M. DAILY
Ideal Home Exhibition

ADMISSION 2/4 (inc. Tax). AFTER 6 P.M. 1/2. **Olympia, London, W.**

Fig. 145. Advertisement for the *Ideal Home Exhibition*, from *The Illustrated London News*

Cambridge constructed during the Tudor era. As in England, the style also suggested the romance and prosperity of the late Tudor period and the genteel and dynastically stable world of the English landed gentry. However, as critics have noted, for many in the New World, the Tudoresque style was a way to subtly accentuate the nation's white, Anglo-Saxon heritage just as the number of immigrants from central, southern, and eastern Europe dramatically increased in the first decades of the twentieth century.[38]

For America's wealthy elite of the 1910s and 1920s, Tudoresque mansions—charmingly informal, yet hinting at hereditary entitlement and cultural sophistication—offered an appealing alternative to the formality of the French Renaissance style that had dominated grand domestic architecture at the close of the nineteenth century. Stan Hywet Hall in Akron, Ohio, built in 1913 for Frank Seiberling, founder of the Goodyear Tire and Rubber Company, is among the finest examples of a Tudor Revival mansion (fig. 146).[39] The generous scale and pseudo-historical quirks of these Tudoresque piles (nonetheless boasting all modern conveniences) enabled wealthy industrialists like Seiberling to envision themselves as English aristocrats enjoying the simpler pleasures of the "Olden Time."

By the 1920s a wider range of dwellings were being produced in Tudor Revival style, from exclusive suburban developments such as Shaker Heights, Ohio, or Bronxville, New York, to urban communities such as Manhattan's Pomander Walk (1921) and sprawling Tudor City residential complex (1925–28). In its more populist applications, the Tudor style represented practicality and lack of pretense, the embodiment of Arts and Crafts ideals of simplicity and domesticity. It was, moreover, a reminder of the built environment that gave rise to William Shakespeare and served as the backdrop for the romantic novels of Walter Scott.

Inspired by the stage setting of a popular romantic comedy of the same name, Pomander Walk is an unlikely fantasy: an enclave of Tudoresque cottages commissioned by a theater-loving restaurateur, lining a private walkway tucked between 94th and 95th Streets on Manhattan's Upper West Side. Although the play, which opened in Toronto in 1910 and soon enjoyed a Broadway production, was set at the turn of the nineteenth century in a fictional London suburb, and its author described the location of the action as a row of diminutive "Queen Anne" houses, the developer of Pomander Walk clearly felt that the Tudoresque style most readily communicated the "quiet, peaceful and forgotten" domesticity of the play's charming narrative.[40] On a much grander scale are the twelve high-rise brick apartment blocks (and one hotel) that comprise Tudor City, one of the first planned middle-class residential communities in New York. Adorned with abundant Tudoresque details including oriel windows, pinnacles, Tudor roses, linenfold paneling, and rampant lions carrying standards, the buildings were designed to offer a tantalizingly picturesque, yet efficient and convenient, alternative to suburban flight and the standalone Tudor Revival homes being constructed outside the urban center.

Further examples of Tudoresque architecture crop up in (among other places) former British colonial outposts around the globe, from India to Malaysia and beyond,[41] but among the most curious recent instances is Thames Town, in Songjiang, on the outskirts of Shanghai. Completed in 2006 as one of

several planned, internationally themed "New Cities" targeted at China's increasingly wealthy and cosmopolitan middle class, Thames Town's prevailing architectural style is Tudoresque, chosen as "the dominant signifier of the authentic English or British town."[42] Rather than actually living there, however, most Shanghainese treat the town like a vacation spot or theme park, a way of experiencing a commercially edited, twenty-first-century interpretation of the exotic highlights of "merrie England" without the bother or expense of international travel.

Global ubiquity of Tudor Revival architecture notwithstanding, in the late twentieth and twenty-first centuries, the realm of popular culture harbors the most vivid evidence of the Tudor afterlife. Best-selling authors have made their careers spinning tales of Tudor-era personalities, with a heavy emphasis on wives and mistresses; Hilary Mantel's *Wolf Hall* (2009), a fictionalized account of Thomas Cromwell's rise to power, and its first sequel, *Bring Up the Bodies* (2012), were each awarded the prestigious Man Booker Prize. (A third book, *The Mirror and the Light*, was published in 2020.) The dramatic intrigues of the Tudor dynasty seem custom-made for the silver screen: indeed, *The Execution of Mary Stuart* (1895) was among the first silent films ever made.[43] For more than a century, the many facets of Elizabeth I's forceful personality, and the singularity of Henry VIII's gargantuan appetites—for power, brutality, sex, or food—have been memorably portrayed in film and, more recently, television, generating not only a broad pop-cultural following but also astute scholarly analyses.[44] Although often playing fast and loose with historical

Fig. 146. Stan Hywet Hall, Akron, Ohio

fact,[45] the intent of these entertainments is not so far removed from the immersive fantasy Horace Walpole sought to create at Strawberry Hill. Whether through atmospheric recreations or meticulously researched history, the dynamic personalities and vibrant culture of the Tudor era continue to exert a powerful hold on our imagination.

Notes to the essay appear on p. 320.

NOTES · BIBLIOGRAPHY · INDEX

NOTES

An Insular Art? (p. 17)

1. Haydock, "To the Reader," in Lomazzo 1598, unpaged.
2. Preface to *Anecdotes of Painting in England*, in Walpole 1762–80 (1849 ed.), vol. 1, pp. ix–x.

England, Europe, and the World: Art as Policy (pp. 20–31)

1. Richard III's words to his troops, as reported by Edward Hall in his history *The Union of the Two Noble and Illustre Fameilies of Lancastre and York* (1550), known as *Hall's Chronicle*; see Hall 1550, unpaged; Hall 1809, p. 415; hereafter all citations are of the 1809 edition. The second quotation comes from a letter of Richard III to his subjects; see Fenn and Ramsay 1849, vol. 2, p. 152, no. 439.
2. Henry IV barred John Beaufort, Duke of Somerset, and his issue from succession to the Crown in 1407; see Bennett, M. 1998, p. 602.
3. For the royal family's very limited use of the Tudor surname, see Davies 2012.
4. The "Welsh mylkesoppe" is mentioned in Hall 1809, p. 415. Shakespeare repeats Richard's "milksop" insult in *Richard III* (5.3.326; on edition, see below, p. 310, note 12). The Westminster statue is discussed in Lindley 1995, pp. 57–58; Condon 2003a, p. 63; Condon 2003b, p. 133.
5. For the legend of Brutus, King of Britons, and Geoffrey of Monmouth's text, see Parsons 1929; Tolhurst 1998. Henry was celebrated as the true successor of Brutus and Cadwallader in Hall 1809, p. 423, and by Bernard André in his *Historia regis Henrici Septimi* (1500–1502); for the Latin, see Gairdner 1858, pp. 9–10; for an English translation, see André 2011, p. 6. For Henry's commissioned pedigree, see Williams, N. 1973, p. 13.
6. For the eleven-piece *Story of Troy*, of which at least nine editions were woven, see McKendrick 1991 and Elizabeth Cleland in Cleland and Karafel 2017, pp. 406–14, no. 93. Sets were owned by the likes of Charles the Bold, Duke of Burgundy; King Charles VIII of France; and Federico da Montefeltro, Duke of Urbino (and likely also King James IV of Scotland, King Matthias Corvinus of Hungary, and Ludovico Sforza, Duke of Milan). I am grateful to Sarah Bochicchio for bringing the flowers to my attention.
7. The velvet's motif and connection to the Tudor rose is noted by Chiostrini et al. 2022. The Tudors' love of velvets is discussed by Lisa Monnas in Marks and Williamson, P. 2003, pp. 328–29, no. 201, and in Monnas 2008, p. 2.
8. Hall 1809, p. 425.
9. For Henry VII's will, see Condon 2003b; his plans for the Lady Chapel are discussed in Condon 2003a; Lindley 2003.
10. The chapel is termed "miraculum orbis univers[al]i" in his *Commentarii in Cygneam Cantionem*; Leland 1745, vol. 9, p. 100.
11. Contemporary accounts of the construction of and the ceremonies at the Field of the Cloth of Gold appear in Anglo 1960; Russell 1969; Campbell, T. 2007a, pp. 143–55; Monnas 2012c, pp. 314–15; Richardson, G. 2013a; Richardson, G. 2013b. Stephen Bamforth and Jean Dupèbe complement their translation of Jacques Dubois's *Francisci Francorum regis et Henrici Anglorum colloquium* (1521) with a perceptive and lengthy introduction; see Bamforth and Dupèbe 1991, pp. 1–47.
12. For the young Henry VIII's relationship with the papacy, see Mitchell 1971.
13. The details of the pact are discussed in Mattingly 1938; Richardson, G. 1995, pp. 405–8.
14. See Duffy 1992 for a complete analysis of the context, and esp. pp. 406–23 for the 1538 Injunction against Popish and Superstitious Practices, which encouraged attacks on religious shrines and sculpture. *A Chronicle of England During the Reigns of the Tudors, from A.D. 1485 to 1559*, written by the herald Charles Wriothesley and published in 1875–77, describes the destruction, such as that of the roods at Boxley and Bexley; see Wriothesley 1875–77, vol. 1, pp. 74–75.
15. Melanchthon, letter to John Stigelius, August 1540, cited in Allen 2018, p. 23.
16. For Edward VI's impact on traditional religious practice in England, see Duffy 1992, pp. 448–523. For his 1549 Act of Uniformity, as well as the influence of the Lord Protector, see King, J. 1976.
17. For Mary's precedence facing challenges as a reigning female monarch, see Richards 1997.
18. Anonymous Italian agent, dispatch from London, July 20, 1553; *CSP Spain* 1862–1954, vol. 11, p. 108 (Archivo General de Simancas, E. 1322).
19. For Mary's statecraft, see Attreed and Winkler 2005, and for her reign, Loades 1989.
20. Foxe began his *Actes and Monuments of These Latter and Perillous Dayes*, popularly called the *Book of Martyrs*, in 1552 and continued to work on it during his exile in Flanders, Frankfurt, and Basel. The first, Latin edition was published in Basel in 1559, and the English edition in 1563. Amended subsequent editions appeared in 1570, 1576, 1583; see Hargrave 1982.
21. For the Pilgrimage of Grace uprising protesting Henry VIII's outlawing of centuries-old religious practice, see Liedl 1994.
22. Maurice Howard provides an account of how monastic buildings were taken over and adapted for private use, and how others were dismantled and plundered for use of their raw materials as construction supplies; Howard, M. 2007, pp. 13–45.
23. See Iain Buchanan in Cleland 2014, pp. 320–31; Concha Herrero Carretero in ibid., pp. 332–35, no. 70.
24. The episode of the snowballs is recounted by the anonymous author of *The Chronicle of Queen Jane, and of Two Years of Queen Mary, and Especially of the Rebellion of Sir Thomas Wyat*, for which, see Nichols 1850, p. 34.
25. *CSP Venice* 1864–1947, vol. 6, p. 1151, no. 927.
26. Luke Syson, verbal communication to the author, New York, March 2016.
27. Chapuys, letter to Charles V, May 19, 1536, preserved in the Vienna archives and published in *L&P* 1862–1910, vol. 10, p. 377, no. 908.
28. This speech by Elizabeth is said to have been given at York immediately following her succession and is recorded in a document in the British Library, Royal MS 17 C III, fol. 2b; quoted in the preface to *CSP Foreign, Elizabeth* 1863–1950, vol. 2, pp. ix–x.
29. Elizabeth's image is usefully discussed in Howard, M. 2004 and Howarth 1997, pp. 102–16. For her interest in monitoring the use of her representation, see Cerasano and Wynne-Davies 1992, pp. 1–24. For a detailed analysis of her annual progresses, see Cole 1999, and firsthand accounts in Nichols 1823 and Goldring et al. 2014.
30. For Elizabeth's relationship with Mary, Queen of Scots, see Fraser 1969.
31. The speech is recorded in a document in the British Library, Harley MS 6798, art. 18, fol. 87r, and discussed in Green 1997.
32. Quoted in Williams, N. 1972, p. 175.
33. Following on the trailblazing analysis by Margaret Mitchell (1971), this fruitful topic is explored in depth in Sicca 2002, Sicca 2006, Sicca and Waldman 2012, and Bolland 2015.
34. One of these fascinating contemporary sources is the diary of Henry Machyn, a self-described "Citizen and Merchant-Taylor of London"; Machyn 1848. For Pregent Meno, see Cussans 1872, p. 69; for Affabel Partridge, see Nichols 1850, p. vi; and for García de Yllán, see Ebben 2011.
35. For Linacre, see Schmitt 1977; for Colet, see Weinstein 2011 and von Eschen 1929–30.
36. Ungerer 1975 and Williamson, E. 2016 provide fascinating accounts of Bacon's work and travels.
37. The context of sixteenth-century English visitors to the Italian peninsula is discussed in Rowse 2000, pp. 3–29.
38. For Cabot and Henry VII's interest in transatlantic fisheries, see Attreed 2000; for relations between Tudor London and Russia, see Dmitrieva and Murdoch, T. 2013.
39. For the Tudors' patronage of the universities, see McConica 1973.
40. Quiller-Couch 1902, pp. 26–27 (this stanza p. 26). Dunbar and his London poem are discussed in Manley 1991, p. 209.
41. For the anonymous account of luxury goods, including the "wonderful quantity" of silverware and goldsmiths, see the "Relazione o più tosto raguaglio dell' isola d'Inghilterra," translated by Charlotte Augusta Sneyd (1847), pp. 42–43. Magno's diary of 1562 is published in Barron, Coleman, and Gobbi 1983. For the goldsmiths' district in Cheapside, see Harding 2008.
42. In a letter describing a dinner party also attended by John Colet; translation, Erasmus 1901–18, vol. 1, p. 215.
43. For the development of the cloth industry in Suffolk and the role of mainland European expertise, see Gardiner 1975, esp. p. 5. A full account of Elizabeth's Mines Royal in Cumbria is provided in the business notebooks of Daniel Hechstetter, founder of the mines, and published in full in Hammersley 1988; see Edwards, J. R., Hammersley, and Newell 1990 for further discussion thereof. In October 1571, Frederick, Elector Palatine, wrote to Elizabeth regarding "Daniel Hochsteter, who with his wife and children intends to go to England and there practise the craft of copper mining"; *CSP Foreign, Elizabeth* 1863–1950, vol. 9, p. 547, no. 2075.
44. Discussed by Kaufmann 2017, pp. 6, 48–49, 52. Kaufmann 2017, pp. 2, 175, contends that John Hawkins's transatlantic slaving voyages—the first undertaken by the English—were a short-lived aberration, not taken up again in earnest until the 1640s. Nubia 2019, p. 94, likewise asserts that "in [Tudor] England, a systematic anti-African theology did not exist until much later [in the seventeenth century]."

45. For Abd al-Wahid bin Mas'ood bin Mohammad 'Annouri, see cat. 101 and Kaufmann 2017, p. 42. For Marrion Soda, see Nubia 2019, p. 32. For Mary Fillis, see Kaufmann 2017, pp. 134–68; Nubia 2019, pp. 32, 147. For Henrie Jetto, see Nubia 2019, pp. 33, 118–19. Other named Black Tudors, mainly traceable in parish records, are cited by Kaufmann 2017, pp. 54, 246–50; Nubia 2019, pp. 119, 139, 147, 158.

46. For musicians, see Kaufmann 2017, pp. 8–31, 35, and Nubia 2019, p. 119; needle makers, Kaufmann 2017, pp. 121–23, and Nubia 2019, pp. 32–33, 145–46; the basket maker, Nubia 2019, p. 147; and the silk weaver, Kaufmann 2017, pp. 113–33. Multi-isotope analysis of the human remains of a group of *Mary Rose* mariners is published by Scorrer et al. 2021. Kaufmann 2017, pp. 33–55, discusses Jacques Francis in depth.

47. For the collection of portrait copies known as the *Recueil d'Arras*, see Campbell, L. 1977.

48. Hall 1809, p. 467.

49. Ibid., p. 468.

50. Ibid., pp. 586–91. See McSheffrey 2017, pp. 124, 135. Later rioting by apprentices under Elizabeth is discussed in Suzuki 1996. For the general context of English workers' xenophobia of foreign counterparts, see Yungblut 1996 and McSheffrey 2013. Hilary L. Turner analyzes the documentary record of immigrant tapestry weavers settling and working in London; see Turner 2012, Turner 2013.

51. Hall 1809, p. 836. Barge rental and additional expenses appear in the accounts of the Guild of Merchant Taylors of the Fraternity of Saint John the Baptist, for which, see Clode 1875, appendix 1, pp. 512–60.

52. Hall 1809, p. 801.

53. The observation appears in Raphael Holinshed's *Chronicles of England, Scotlande, and Irelande* (1577); see Holinshed 1807–8, vol. 3, p. 531.

54. Hall 1809, p. 506.

55. The description in Hall 1809, p. 507, makes special mention of the "pain, labour, and diligence [of] the Taylers, Embrouderours, and Golde Smithes" who had made the garments and trappings used at Henry VIII's coronation. Maria Hayward provides an exhaustive analysis of the tailors, hosiers, skinners, embroiderers, armorers, feather workers, jewelers, and saddlers at Henry VIII's court; see Hayward, M. 2007, pp. 317–66. Janet Arnold provides in-depth analysis of the accounting and employment of the veritable army of artisans responsible for Elizabeth I's wardrobe—her tailors, embroiderers, skinners, farthingale makers, cappers, hatters, hood makers, hosiers, shoemakers, glovers, milliners, and pinners; see Arnold 1988, pp. 177–240. The laborers at the Field of the Cloth of Gold were enumerated in the English "revels" accounts and the royal household accounts, available in the National Archives, Kew, and published, with commentary, in Russell 1969.

56. For this episode in André's Latin, see Gairdner 1858, p. 85. For the quoted English translation, see "1504–1505: English" in Sutton, D. 2019, unpaged.

57. Hall 1809, p. 805 (for the christening), p. 806 (for the clerk's suicide).

58. Sebastiano Giustiniani, in a dispatch from London to Venice of May 3, 1515, describes the moment when Henry invited him to view his calf and compare it to François I's; Giustiniani 1854, vol. 1, p. 91. In a report delivered in person to the Venetian Senate on October 10, 1519, he described Henry's glowing complexion during a game of tennis; ibid., p. 27. Burnet offers a graphic description of "the king's sickness" in his *History of the Reformation of the Church of England* (1681); see 1829 ed., vol. 1, pt. 1, p. 698.

59. In a diary entry of July 9, 1508, Richard Turpyn mentions the "buttarflyes" at Calais; see Nichols 1846, p. 7. James Gairdner notes the yellow clothing and dancing

at the news of Katherine of Aragon's death in the preface to *L&P* 1862–1910, vol. 10, p. vii. For a full account of the execution of Mary, Queen of Scots, see Fraser 1969.

Cat. 1

1. As per the inscription; see also Le Rougetel 1988.
2. Davies 2012.
3. Ibid.
4. Sharpe 2009, pp. 62, 149.
5. The full inscription reads: "AEg. P. inventor / They are to be sold at the Blacke-friars / Tho. Talbot composuit / Jodocus Hondius Flander. sculp. Londini."
6. See Mortimer 2004. *A Booke, Containing the True Portraiture of the Countenances and Attires of the Kings of England, from William Conqueror, unto our Soveraigne Lady Queene Elizabeth now Raigning*, usually attributed to Talbot, is sometimes attributed to Thomas Tymme.
7. Hind 1952, pp. 154–77; see also McConnell 2004.

Cat. 2

1. Will 2016, pp. 82–84; quote on p. 84. See also Broadway 2013; Day 1990; Jones, N. 2019, p. 67.
2. For examples by Godet, see Alcorn 1993.
3. No longer in their original bindings, these pages may have been removed and rebound here by Sylvanus Morgan, a seventeenth-century herald. See Roberts, S. 2014, p. 40. See also Kristin Bundesen in Levin, Bertolet, and Carney 2017, pp. 218–19.
4. See Whigham 1985, esp. pp. 328–30; Rockett 2000.
5. See Trevisan 2018.

Cat. 3

1. Mistakenly identified in Eichberger and Beaven 1995, p. 236, as a carnation, and described there as a traditional symbol of marriage.
2. The inscription reads "Anno 1505 29 octobre ymago heinrich VII franciege rere illustrussimi ordinate f Hermann rinck Ro regie [. . .] missarium."
3. See Eichberger 2010, pp. 2392 (for 1516), 2480 (for 1524). Traces of red paint (vermilion) still present on the reverse of the panel may relate to the painted cover mentioned in the 1516 inventory. See Strong 1969b, vol. 1, p. 150.
4. Eichberger and Beaven 1995, p. 236.
5. Weniger 2011, p. 152.
6. See the discussion of the painting in the National Portrait Gallery's Tudor and Jacobean Portraits Database, "King Henry VII" 2007.

Cat. 4

1. Though it is documented as "one tapestry with 10 borders," Campbell, T. 2007a, pp. 85–87, elucidates how this likely refers to one set, perhaps with detachable, customized borders.
2. See Cavallo 1993, pp. 421–45, for two such tapestries in the Metropolitan Museum; Bennett, A. 1992, pp. 56–76, for four in the Fine Arts Museums of San Francisco; Antoine 2007 for one in the Musée du Louvre, Paris; Elizabeth Cleland in Brosens et al. 2008, pp. 62–68, for one in the Art Institute of Chicago; Digby 1980, pp. 34–35, for a fragment in the Victoria and Albert Museum, London; and Elizabeth Cleland in Cleland and Karafel 2017, pp. 472–77, for one in the Burrell Collection, Glasgow.
3. As per the warrant issued to customs officers (E 404/84, National Archives, Kew; see Campbell, T. 2007a, p. 79) and the pre-1523 inventory of Cardinal Wolsey's collection (Harley MS 599, fol. 2r, British Library, London; published in Campbell, T. 1996a, p. 119). In contrast, Fonseca's bequest of his edition to

Burgos and Palencia calls them "tapices de las virtudes" (see Steppe 1956, p. 46). For the modern title, see Cavallo 1958.

4. Exemplified by two rare, roughly contemporaneous survivals: a program for the *Lives of Saints Urban and Cecilia* (see Kane 2010) and one for the *Seven Deadly Sins* (see Elizabeth Cleland in Cleland 2014, pp. 187–88, 198, no. 46).
5. See Cleland in Brosens et al. 2008, pp. 66–67.
6. Edith Standen suggests the Master of the View of Sainte Gudule in her unpublished draft manuscript of a catalogue of the medieval tapestry collection in the Metropolitan Museum (now in the archives of the Department of Medieval Art and The Cloisters). For De Coter, see Thomas P. Campbell in Campbell, T. 2002, p. 150, no. 12; Antoine 2007. For collaborative projects headed by the likes of Bernard van Orley, see Cleland and Karafel 2017, pp. 452–53, 490; Cleland in Cleland 2014, pp. 239–40; Iain Buchanan in Cleland 2014, pp. 324–28.
7. See, respectively, Cavallo 1993, pp. 438, 443; Quina and Moreira 2006, pp. 101, 102; Cleland and Karafel 2017, pp. 474, 477.
8. Hampton Court Palace, invs. 1035, 1088; see Campbell, T. 1996a, pp. 103–7 (Campbell also disproves the theory that this set was the "Story of the 7 Deadly Synnes" that Wolsey had purchased in 1521; see Wood, D. 1912).
9. Campbell, T. 2007a, p. 145.

Cat. 5

1. For Alberici's life and work, see Rundle 2005.
2. For an excellent synopsis of the *Tabula Cebetis* and its context, see Sonja Drimmer in McKendrick, Lowden, and Doyle 2012, pp. 328–29, no. 110.
3. For the miniatures and their relationship to the text, see Sider 1990; for a less sympathetic response, see Auerbach 1954, p. 89.
4. Polydore is discussed by Lecuppre 2001.
5. Rundle 2005 provides an account of Alberici's progress in Cambridge and his later work *De homine condito* (MS 298, Queen's College, Oxford), dedicated in 1509 to Richard Foxe, bishop of Winchester and Keeper of the Privy Seal, before his eventual return to Italy, where he died, in Naples, in 1531.

Cat. 6

1. MS WPβ/I/1, Oxford University Archives, Bodleian Libraries, University of Oxford: published in Gibson 1931, pp. 310–20; quotations on pp. 312, 318. I thank Flora Chatt for her assistance in locating this source. For chantry bequests in Tudor England, see Heard 2011.
2. For the Cambridge indenture, see Tait 1956.
3. The Cambridge funeral pall, on long-term loan to the Fitzwilliam Museum, was examined by Joelle Wickens (Wickens 2003); see Wickens and Hayward, M. 2003. For both the university funeral palls, see Monnas 1998, p. 67; Monnas 2012a, pp. 250, 252; Levey 2012, p. 163.
4. The payment to Jasper is recorded in the Lord Chamberlain's department, accounts and miscellanea, 50, fol. 231v, National Archives, Kew, cited and discussed by Hayward, M. 2007, pp. 60–61. See also Hayward, M. 2009, pp. 13–14. Tait 1956, pp. 294–95, cites a delivery record that likely refers to the Cambridge pall; delivery of the Oxford pall remains unrecorded.
5. The Hussey pall belongs to the Company of Vintners in London, donated by John Husee, Master of the Vintners' Company, on February 14, 1539; it is discussed along with the Fayrey pall (fig. 15) in Heard 2011, p. 158. For the Fayrey pall, see also Lisa Monnas in Marks and Williamson, P. 2003, p. 455, no. 349.

Cat. 7

1. The cope is thoroughly discussed by Lisa Monnas in Monnas 1989a.
2. All documents recording payments to Corsi and the Buonvisi are published in Monnas 1989a, p. 349, appendices 1 and 2.
3. Ibid., p. 346.
4. Payments to Fligh and Smyth are documented in ibid., p. 349, appendices 1 and 2.
5. Ibid., p. 346; Monnas mentions that the three remaining vestments—this cope, a chasuble, and a chalice veil—which were transferred to the Jesuits in the 1790s, underwent considerable restoration in 1827.
6. Condon 2003b, p. 134. The will (E 23/3, National Archives, Kew) was executed March 31, 1509.
7. Hewitson 1870, p. 98.
8. Monnas 1989a, p. 349. Condon 2003a, p. 68, notes the correspondence in the number of officiants at Henry VII's anniversary Mass and the number of copes ordered.
9. SP 1/19, fol. 241r, National Archives, Kew; cited in Monnas 1989a, p. 346.
10. Lisa Monnas in Marks and Williamson, P. 2003, p. 169, no. 31.
11. Ibid.

Cat. 8

1. In his will, dated March 31, 1509, Henry VII refers to "The grate for the towmbe," noting that "a grate, in maner of a closure, of coper and gilte, after the faction that we have begoune; whiche we wol be by our said executours fully accomplisshed and perfourmed." The complete will (E 23/3, National Archives, Kew) is published in Condon 2003b; this quotation p. 114. For reference to "Thomas the Dutchman," see Colvin 1963–82, vol. 3, p. 219.
2. For the arrangement, see Lindley 2003, pp. 271–74, and for the statuettes, Lethaby 1906, p. 236; Dow 1992, pp. 9–30. Lindley (p. 273) convincingly rejects Lethaby's suggestion that apostles covered the whole of the east and half of the south range, with English saints on the north, west, and rest of the south ranges.
3. See Emison 2006, p. 451.
4. For the thermoluminescence testing, see Bilbey 2002, p. 25, which nonetheless dates the statuettes to about 1505.
5. See Cocke 2001; Condon 2003a; Lindley 2003; Wilson, C. 2003.
6. For Mazzoni's design, see Meyer 1976; Lindley 1995, pp. 55–58; Lindley 2003, p. 267. For Henry VIII's changes, see Condon 2003a, p. 60; Lindley 2003, p. 267.
7. "FOELICES PROLE PARENTES HENRICUM QUIB[US] OCTAVUM TERRA ANGLIA DEBES"; see Dow 1992, p. 42. Wilson, C. 2003, p. 186n95, translates it slightly differently.
8. For Torrigiano's work in the Southern Netherlands, see Cochin 1914–19. For his work on the London tombs and other English projects, see Darr 1979; Darr 1992; Lindley 1995, pp. 47–72, 170–206; Lindley 2003, pp. 266–76; Darr 2012.

Cat. 9

1. Foister 2004, p. 187.
2. Buck and Sander 2003, p. 28.
3. Foister 2004, p. 190.
4. Buck 1997, pp. 94–100.
5. Ibid., p. 93.
6. For these diptychs, see Foister 2004, p. 187.
7. Buck 1997, p. 90.

Cats. 10, 11

1. See Foister 2004, pp. 175–96; Buck 1997, esp. pp. 82–193.
2. Brooke and Crombie 2003, pp. 32–35.
3. For the Munich drawing, see Foister 2006, p. 118, no. 130.
4. Brooke and Crombie 2003, p. 35.
5. Ibid., pp. 43–46.
6. Ibid., pp. 46–49.
7. Foister 2004, p. 65.

Cat. 12

1. Holinshed 1807–8, vol. 3, p. 559.
2. See Trapp 1983 and, for Meghen's biography, Richard Gay in Kren and McKendrick 2003, p. 520, no. 132.
3. Of the same size and format as cat. 12 and sharing the parallel columns of Vulgate and Erasmus's texts, these manuscripts are in the Cambridge University Library (Matthew and Mark, 1509; MS Dd.vii.3) and the British Library, London (Luke and John, 1509, and Epistles, 1506; Royal MS 1 E V, 2 vols.). See Gibaud 1982, p. 26.
4. Brown, A. 1984, pp. 360–61, 370–71. Trapp 1983, p. 24, not associating it with Colet's set, dates the manuscript to after 1528.
5. Thomas Kren in Kren and McKendrick 2003, p. 436, no. 132, notes, "Although the handling of the two miniatures in the manuscript seems dissimilar, they may be related."
6. Attributed to one of the Horenbouts in ibid., pp. 434–36. For the Horenbouts, see van der Haeghen 1914; Gay in Kren and McKendrick 2003, p. 434; Catherine King and Kim Woods in Richardson, C., Woods, and Franklin 2007, pp. 10–12, 20.
7. Dürer 1958, p. 120.
8. Kren in Kren and McKendrick 2003, p. 434. Brown, A. 1984, p. 361, dates it between 1518 and 1533.

Cat. 13

1. See Matthews 2008. The identification of the sitter in cat. 13 as Mary Tudor has not found universal acceptance; Matthias Weniger (2011, pp. 77–78), for example, identifies the painting as a portrait of Isabella I in the guise of a saint, while Mojmír Frinta (2009, pp. 150–51) has suggested that it depicts "a patrician's daughter in Reval."
2. Weniger 2011, p. 77. The colors in a copy of the painting in the Kunsthistorisches Museum, Vienna (GG 171), are probably closer to the original palette.
3. Friedländer 1915.
4. See, for example, National Portrait Gallery, London, NPG L246. The identification of the sitter as Katherine of Aragon was questioned also by (among others) Roy C. Strong (1969b, vol. 1, p. 40). Written accounts of Katherine vary, from lauding her youthful beauty (1501) to describing her as "rather ugly than otherwise" (Nicolo Sagudino, letter to Alvise Foscaki [sic], June 6, 1515, CSP Venice 1864–1947, vol. 2, p. 248, no. 624); see Matthews 2008, p. 143n18, with further references.
5. Glück 1933. For recent overviews of Sittow, see Weniger 2011, pp. 39–49, and Hand and Koppel 2017.
6. See Till-Holger Borchert in Hand and Koppel 2017, p. 66, no. 9.
7. See Matthews 2008, pp. 143, 145n24. While no inscription is incorporated in the jewelry Mary wears in this portrait, the thin gold halo may envoke an association with the Virgin Mary.
8. Ibid., pp. 144–45.
9. On the so-called French hood, see Høskuldsson 2018. The author suggests that it did not become fashionable at the English court until 1528 (p. 165).
10. Matthews 2005, p. 147.

11. Mary Tudor, letter to to Margaret of Austria, April 13, 1510–13, MA Unassigned (Rulers of England Box 02, Henry VIII, no. 33a), Morgan Library and Museum, New York; published in Sadlack 2011, pp. 46, 163–64. See also Reynolds, A. 2013, p. 197.
12. Borchert in Hand and Koppel 2017, p. 68. For the portraits in Margaret's inventory, taken at Mechelen in 1523–24, see Eichberger 2010, pp. 2444, 2449. Margaret also owned a portrait miniature on vellum of Mary Tudor by at least 1516, which she apparently kept among her manuscripts; see Le Glay 1839, vol. 2, p. 477.
13. Gerard de Pleine, letter to Margaret of Austria, June 30, 1514, L&P 1862–1910, vol. 1, no. 3041; cited in Matthews 2008, p. 146.
14. Gemäldegalerie, Staatliche Museen zu Berlin, 1722.

Cat. 14

1. CSP Venice 1864–1947, vol. 2, pp. 206–7, no. 510; for the Italian, see Sanuto 1879–1903, vol. 19, p. 202. I am grateful to Sarah Bochicchio for bringing this passage to my attention. For Sanuto, see Finlay 1980.
2. Another manuscript that Louis XII apparently gifted to Mary is a collection of contemporaneous French court music, with illuminations perhaps also by the Master of Claude de France, now at Magdalene College, Cambridge, MS Pepys 1760; see Robinson 2015.
3. For Mary's book of hours, see Roger S. Wieck in Wieck, Voelkle, and Hearne 2000 (pp. 26–27, 184). Wieck 2014, p. 53, suggests that Louis customized the manuscript twice, with an addition by Jean Bourdichon already in place when he regifted the book to his second wife, Anne of Brittany, and only a miniature by the Master of Claude de France added when he regifted it a second time, to Mary. For the putative hours of Henry VIII (MS H.8, Morgan Library and Museum, New York), first published by Perrat 1926, see Wieck, Voelkle, and Hearne 2000.
4. The book for Louis XII has since been dispersed; see Backhouse 1973 and Kren and Evans 2005. Before Backhouse's analysis the manuscript was erroneously believed to have been made for Henry VII and was known as the "Hours of Henry VII." See also Herman 2014 for a portrait of Louis XII by Bourdichon.
5. Wieck 2014.
6. The script can be compared with Mary's surviving correspondence, published by Sadlack 2011.

Cat. 15

1. Cut-and-voided velvet is a type of figured velvet in which the loops formed by the pile warp are cut, and areas of the ground fabric are left free of pile, or voided. For a detailed technical description of this kind of velvet weaving, see the glossary in Monnas 2012b, pp. 152–53, under "Voided Velvet."
2. For a detailed technical investigation of the textile within its historical context, see Chiostrini et al. 2022.
3. See Campbell, T. 2007a, pp. 143–55.
4. The distinctive characteristics of the Tudor rose as an element of patronage is the subject of ongoing debate among scholars, as slightly different versions of the same motif can be connected to various European dynasties, among them the Orsini and Riario families (see cat. 1).
5. In fifteenth-century England the term "tissue" was used to denote velvet, lampas, or brocatelle with gold or silver weft loops; see the glossary in Brachmann 2019, p. 227, under "Tissue."
6. Orsi Landini 2017, p. 81.
7. For a detailed description, including technical analysis of the tissues, see Bemporad and Guidotti 1981. For other similar extant textiles, see Monnas 2012b, pp. 98–101, nos. 24–25; Bemporad and Melasecchi 2019, pp. 158–59.

8. Each loom width of the Badia hangings (22⅞ in. [58 cm]) is similar to that of cat. 15 (22½ in. [57 cm]); both (excluding selvages) correspond to the Florentine *braccio* (23 in. [58.4 cm]). In addition, the selvage of each panel measures ⅝ inch (1.5 cm) and is woven in alternating green, yellow, and white threads. This combination of colors in a plain weave resembles documented velvets of Florentine production. See Orsi Landini 2017, pp. 37–44.

Cats. 16, 17

1. See Vasari 1568 (1906 ed.), vol. 4, pp. 529–36; Luporini 1964; Matucci 2012; Waldman 2012.
2. For Torrigiano's tomb project for Henry VIII and Katherine of Aragon, see Illingworth 1812; Higgins 1894, p. 142; Lindley 1991, pp. 262–63.
3. Since destroyed; see Lindley 2003, pp. 274–77.
4. Lindley 1991 and Caglioti 2012 both build on the key initial analysis by Alfred Higgins (1894). See also Hurd 2008.
5. See the introduction to Gunn and Lindley 1991, p. 3.
6. Giustiniani 1854, vol. 2, p. 314.
7. For Wolsey, see Heal 1980, p. 65; for Henry VIII's annual worth, see Giustiniani 1854, vol. 2, p. 313.
8. See Nelson 1936, p. 71, for the text and Walker, G. 1988, pp. 119–20, for audience and accessibility.
9. Giustiniani 1854, vol. 2, p. 314.
10. Benedetto da Rovezzano, letter to Cardinal Wolsey, June 30, 1529, cited and discussed in Lindley 1991, p. 264 (his translation); for Benedetto's original Latin, see *L&P* 1862–1910, vol. 4, pp. 244–45, no. 5743.
11. Lindley 1991, p. 264.
12. Higgins 1894, pp. 203–5, appendix 4, which transcribes SP1/52, fols. 22r–24v, National Archives, Kew; see also Lindley 1991, pp. 264–67. Reconstructions of Wolsey's tomb based on these lists are posited in Higgins 1894, pp. 158–60, pl. 6; Lindley 1991, pp. 271–74.
13. Lindley 1991, pp. 281–82. After Henry VIII's procurement of Hampton Court, Wolsey's coat of arms was cut away and replaced with a carving of Henry's, and his cardinal's hat covered with an iron crown; these were restored in 1845. Comparable naked putti also adorned the gatehouse and oriel of Hengrave Hall, Suffolk (1538); see Summerson 1993, p. 39.
14. Lindley 1991, pp. 274–78; Caglioti 2012, p. 183.
15. For the influence of Sansovino, particularly his tomb for Cardinal Ascanio Sforza in Santa Maria del Popolo, Rome, and Eucharistic altar in Santo Spirito, Florence, see Caglioti 2012, pp. 186–90.
16. Lindley 1991, p. 276n65.
17. Dispatch from Scarpinello to Francesco Sforza, December 2, 1530, Sforza Archives, Milan; see *CSP Venice* 1864–1947, vol. 4, 1871, p. 266, no. 637.
18. MS 74, fol. 192, Jesus College, Oxford; cited in Lindley 1991, p. 265.
19. For the alternative projects, see Mitchell 1971; Darr 1992; Sicca 2002; Sicca 2006; Gentilini and Mozzati 2012. For records of Benedetto's tomb project for Henry, see Higgins 1894, pp. 207–15, appendix 6; Caglioti 2012, pp. 191, 201n54. Waldman 2012 reveals that Benedetto's departure for Florence might have been as late as 1542.
20. Biddle 1966, pp. 110–11, 114–15.
21. Higgins 1894, p. 203, appendix 4. Caglioti 2012, pp. 191–92, identifies the candelabra as "among the last items Benedetto executed." An alternative theory, that they have at their core Benedetto's four columns for Wolsey, was proposed by the South Kensington (now Victoria and Albert) Museum's Department of Science and Art in *Guide to the Collections* 1896–97, p. 6.
22. For documented moves by Edward, Mary, and Elizabeth to construct the tomb; its transfer from Westminster to Windsor in 1565; the sale of its bronze

components in 1645 (to pay for the Windsor garrison); and the acquisition of the four candelabra by Anton Triest, bishop of Ghent, see Higgins 1894, pp. 165–66, 177–81, 215–19, appendices 7 and 8; Lindley 1991, pp. 267–68; Caglioti 2012, pp. 192–93.

Cat. 18

1. Boon 1964 first attributed the drawing to Vellert; see also Richard Marks in Marks and Williamson, P. 2003, p. 163, no. 22. For the full King's College glass project, see in particular Wayment 1972; Wayment 1979; Wayment 1996.
2. Hicks, C. 2007 provides an account of the complete project. For Henry VII's provision of £5,000 in his will for the completion of King's College Chapel, see Condon 2003a, p. 65; Condon 2003b, pp. 104, 107.
3. For Raphael's *Acts of the Apostles*, see Shearman 1972; Evans, M., and Browne 2010. For Coecke's *Saint Paul*, see Guy Delmarcel in Cleland 2014, pp. 124–35; Stijn Alsteens and Elizabeth Cleland in ibid., pp. 136–75, nos. 25–44.
4. Wayment 1996, in contrast, argues that Vellert did come to Cambridge. For Flower, Hone, and the glaziers participating in the project, see Oswald 1951; Ransome 1960; Wayment 1972; Smith, An. 1988.

Cat. 19

1. Vasari 1568 (1906 ed.), vol. 7, p. 588; Guicciardini 1567, p. 100; Dürer 1958, p. 119. See also Friedländer 1975, p. 27.
2. For Vellert's life and works, see Friedländer 1975, pp. 27–31; Konowitz 1990–91.

Cat. 20

1. Foister 2004, p. 159, discusses the title page in relation to Altdorfer's, as well as to Holbein's *Allegory of the Old and New Testaments* (cat. 90). String 2008, pp. 90–93, parses the full iconography and transcribes some of the banderole texts.
2. See String 2008, pp. 91–93, and Buck 2001, pp. 61–64.
3. King, J. 1989, pp. 54–70, esp. p. 60. Sharpe 2009, p. 141, also interprets the title page as "a visual proclamation of the supremacy" of the king.
4. For the book's complicated printing history, see Blayney 2013, pp. 344–51.
5. For the political and religious context, see Brigden 1989, esp. pp. 256–57. Susan Foister (2004, pp. 159–64) recounts the full artistic context in which the book was developed; she notes (p. 159) Cromwell's portrait and Henry's negotiations with the Lutheran princes, eased by his apparent compliance with the dissemination of biblical translations.
6. Walker, G. 1996, pp. 85–87, argues that the title page is "a persuasive rather than celebratory image" (p. 87). For Henry's reluctance, see String 2008, pp. 105–9.
7. Foister 2004, p. 163, notes the debt of most of the internal illustrations to Hans Sebald Beham.

Cat. 21

1. String 1996, p. 315, quotes Cromwell's injunction in full; see also *L&P* 1862–1910, vol. 13, pt. 2, p. 114, no. 281.
2. Blayney 2013, pp. 360–88, lays out the full circumstances of the creation of the Great Bible, including (p. 362) the letter of June 23, 1538, from Grafton and Coverdale to Cromwell. See also Willoughby, H. 1942, pp. 3–10.
3. Fry 1865, p. 1, repeated by Willoughby, H. 1942, p. 8, estimated 21,000 copies; this figure was tempered to

"more than 9,000" by Tatiana String (2008, p. 93), and in Doran 2009, p. 204, no. 201.
4. String 1996, pp. 315, 319, provides the full context of Marler's role as patent holder after Cromwell's demise. She also (pp. 319–24) suggests that the hand-painted crown and purple, ermine-lined robes on the title page of Henry's personal copy differ intentionally—in ways more "imperial"—from his less formal, more "paternal" appearance on the standard printed edition, speaking to his deep-seated opinions about images appropriate for public display and the more provocative, antipapal images he enjoyed in private. See also String 2008, pp. 98–110.
5. As attributed by Rowan Watson in Marks and Williamson, P. 2003, p. 461, no. 355, while String 2008, p. 96, suggests either Horenbout or Girolamo da Treviso. Less convincingly, King, J. 1989, p. 70, ascribes the design to Holbein's workshop, and Orth 2006 to the Master of François de Rohan.
6. String 1996, pp. 319–20, 323.
7. Campbell, T. 2007a, p. 233.
8. String 2008, p. 98, dates this change to after the initial 1539 printing, suggesting that it was motivated by Henry, Cranmer, and Cromwell's satisfaction with the success of the title page.
9. See ibid., p. 109.
10. The 1548 edition of *Hall's Chronicle* (1532) recorded the king's speech in Parliament, December 24, 1545; see Hall 1809, p. 866. See also *L&P* 1862–1910, vol. 20, pt. 2, pp. 513–14, no. 1031.
11. Foxe 1563, p. 1191.

Cat. 22

1. For more on the glamour and status of armor, see Patterson 2009 and Terjanian 2019.
2. For a full discussion of the European armorers working for Henry from 1509 onward, see Williams, A., and de Reuck 1995, pp. 26–34; Williams, A. 2002, pp. 732–36; and Terjanian 2009.
3. For the attribution to Greenwich, see Blair 1959; Gamber 1963. Nickel 1972 explores the attribution history of the armor, which includes since-rejected suggestions of production in the French royal armory or by unknown Italians working in France or Milan. Metallurgical analysis of the armor, listed under "England," is published by Williams, A. 2002, p. 733.
4. Reference to Kyrkenar's post as armorer to the king is made in the list of grants awarded in fall 1519, noted on October 27, delivered in Westminster on November 5; *L&P* 1862–1910, vol. 3, p. 181, no. 529.5.
5. Discussed by LaRocca 1995, pp. 85, 95.
6. Nickel 1972, pp. 79–120, provides a description and illustrations of the decoration and suggests some design and iconographic influences.
7. See Blair 1959; Williams, A., and de Reuck 1995, p. 31.
8. Metropolitan Museum, 41.190.471.
9. See Nello Forti Grazzini in Campbell, T. 2002, pp. 506–13, no. 59.
10. The armor, made for Henry VIII in 1540, is in the Tower of London (II.8).
11. Hall 1809, p. 719.
12. For Dodieu's narrative, written May 8, 1527, see *L&P* 1862–1910, vol. 4, pp. 1397–1415, no. 3105; for a description of the visit "to see the furniture and riches of the King," during which the armor like Henry's apparently was ordered, see ibid., p. 1402; and for the treaty signed during the visit, see ibid., p. 1382, no. 3080.

Cat. 23

1. Italian armors are discussed in detail, with metallurgical analysis, by Alan Williams; Williams, A. 2002, pp. 54–329; for this armor's period, see esp. pp. 203–59.

2. Blair and Pyhrr 2003, pp. 98, 115. For Italian gilding techniques, see Williams, A. 2002, pp. 204–5.
3. Blair and Pyhrr 2003, p. 100.
4. MS 129, fol. 433v, Society of Antiquaries of London; Starkey 1998, p. 159, no. 8262.
5. At whose home, Wilton House, it was inventoried as "a felde armor graven and gilte that was Kinge Henry theightes" on December 8, 1558; see Blair and Pyhrr 2003, p. 96, citing MSL/1982/30, fol. 116r, Victoria and Albert Museum, London.

Cat. 24

1. For a biography of Edward VI, see Loach 1999.
2. Metropolitan Museum, 49.7.31; see Maryan W. Ainsworth in Ainsworth and Waterman 2013, pp. 158–61.
3. Ibid., pp. 160–61.
4. See Strong 1969b, vol. 1, p. 93, for a list.
5. Translation from Sotheby's 2004, p. 32, no. 20. Another inscription, at upper right, reads "ALTER EGO."
6. Wark 1956; Bruyn and Emmens 1957.
7. Sotheby's 2004, p. 32, no. 20.
8. Ibid. For Stanhope's biography, see Dockray 2004.

Cat. 25

1. Gammon 1973, p. 13.
2. Ibid., p. 18; see also Jack 2004.
3. See Hume 1889, p. 147, which translates from Spanish the account of an unidentified sixteenth-century author. This chronicler may have taken some liberties with historical fact.
4. Gammon 1973, p. 53. For the devices, see Peacham 1612 (1973 ed.), pp. 11, 28.
5. Danbury 1989, pp. 159–60. See also Berenbeim 2015; Woodcock and Robinson 2000.
6. See, for example, Letters Patent to Gerard Harmond (1547), illustrated in Sharpe 2009, p. 230; Edward VI's Letters Patent to Morpeth Grammar School (1552), National Archives, Kew, FEC 1/1648.
7. Machyn 1848, p. 309.

Cat. 26

1. The Empress Matilda claimed the throne as "Lady of the English" during a period of civil war from 1141 to 1148 but was never crowned queen.
2. Sharpe 2009, p. 264.
3. An inscription on the painting reads "HE 1554."
4. Cooper, T., and Walker, H. 2015, p. 228.
5. Ibid., pp. 228, 235–36.
6. Lansd. MS 840 A 5, fol. 155b, British Library, London; Madden 1831, pp. clv–clvi; cited in Sharpe 2009, p. 265.
7. As noted in Franklin, Nurse, and Tudor-Craig 2015, p. 109, no. 15, the portrait's extensive underdrawing shows that, in the final painting, Eworth deliberately toned down the lines under Mary's chin to make her look younger.
8. Karen Hearn and Tabitha Barber in Hearn 1995, p. 66, no. 24.
9. For the practical origin of the cloth's fold pattern, see Franklin, Nurse, and Tudor-Craig 2015, p. 109, no. 15.
10. For a detailed description of Mary's costume and jewelry, see ibid. See also Carter 1984.
11. Report of Giacomo Soranzo to the Venetian Senate, August 18, 1554, *CSP Venice* 1864–1947, vol. 5, pt. 2, p. 533; cited in Franklin, Nurse, and Tudor-Craig 2015, p. 110, no. 15.
12. Trollope 1884, p. 160.
13. Cooper, T., and Walker, H. 2015, pp. 229–30.

Cat. 27

1. Kaufman 1978, p. 893. Richard Payne likely published this edition under Thomas Powell's name. Payne was not a citizen or a stationer, and he used Powell to obscure the illegality. See Blayney 2013, vol. 2, esp. pp. 787–93, no. 1056.
2. See Fantazzi 2004.
3. Ibid.
4. Vives to an unknown recipient, November 1528, *L&P* 1862–1910, vol. 4, p. 2167, no. 4990.
5. Vives 1557, sig. A2r.
6. Ibid.
7. Ibid., sig. A2v., sig. B1v, sig. P2v.
8. Ibid., sig. D1v.
9. Ibid., sig. [I4]v.
10. Eales 2013, p. 24.
11. Pollnitz 2010, pp. 133, 136, 138.
12. See Mazzola 2010; Kelly-Gadol 1977.
13. Edwards, J. 2011, p. 11.
14. From *The First Blast of the Trumpet against the Monstrous Regiment of Women*; Knox 1558, sig. C1r. For gender and the reign of Queen Elizabeth I, see esp. Levin 1994.

Cat. 28

1. The window is analyzed in de Groot 2005. For Margaret of Parma, see van Eck 2012; for Margaretha van der Marck, van Eck 2009–10; for William the Silent, Schrijver and Wesselius 1987.
2. For the Gouda project, including copious archival evidence, see van Eck and Coebergh-Surie 1997.
3. For Dirck Crabeth, see van Regteren Altena 1938; for Wouter, van den Brink 2015; for their Flemish father, as well as their continuing connections with the Southern Netherlands, see de Groot 2011. Peter Fuhring in de Groot 2005, pp. 226–21, analyzes Crabeth's contribution to the development of strapwork ornament.
4. Mary's portrayal is not considered a good likeness by de Groot 2005, p. 148. Nonetheless, Andrea C. Gasten in de Groot 2005, p. 218, suggests that Crabeth may have been given a version of the portrait of Mary by Anthonis Mor (see fig. 29 in this volume).
5. On the history of the project, see particularly Xander van Eck in van Ruyven-Zeman et al. 2011, pp. 32–45.
6. Payments, storage spaces (securely barred since at least the seventeenth century), and conservation are discussed by Henny van Dolder-de Wit in van Ruyven-Zeman et al. 2011, pp. 244–57.
7. See Jan Van Damme in de Groot 2005, pp. 131–36.
8. The mention of snowballing appears in an anonymous chronicle of the era; Nichols 1850, pp. 34–35. The French ambassador's comments were cited by Simon Renard in a letter to Charles V, October 5, 1553; *CSP Spain* 1862–1954, vol. 11, pp. 270–72.

Cat. 29

1. See Fischer 2005; Gerchow and Gorgus 2017, pp. 75–76.
2. This situation, published in pamphlet form as "The Troubles at Frankfort" in 1575, is discussed in Townsend, Geo. 1870, pp. 16–25.
3. Clare College, Cambridge; illustrated and discussed in Hayward, J. 1976, p. 396. For the panpipes master in context, see Piet Baudouin and Anne-Marie Claessens-Péré in Baudouin et al. 1988, pp. 94–96, nos. 41, 42, 43.
4. Koeppe 2017, pp. 108–9.

Cat. 30

1. Strong 1963c, pp. 57–58.
2. Strong 1987, pp. 59–61.
3. Goldring 2014, p. 70.
4. Sotheby's 2007, lot 4.
5. See Town 2014, pp. 179–81.
6. Strömbom 1933, pp. 12–48.
7. Grosvenor 2009, pp. 12–17.
8. Karen Hearn and Tabitha Barber in Hearn 1995, pp. 95–96, no. 48.
9. Town and David 2020. I am grateful to Edward Town and Jessica David for sharing their research with me in advance of its publication.

Cat. 31

1. See Evans, M. 2005, with references to earlier literature.
2. Campbell, L., and Foister 1986.
3. Rab MacGibbon in MacLeod 2019b, pp. 106–7, no. 32.
4. For Mildmay, see Ford 2004.

Cat. 32

1. See Alcorn 1993, esp. pp. 72–85. See also Oman 1978, esp. pp. 35–45.
2. On Lady Anne Clifford, see Debra Barrett-Graves in Levin, Bertolet, and Carney 2017, pp. 49–50. For her will (PROB 11/350/410, National Archives, Kew), see Williamson, G. 1922, p. 467, appendix 5.
3. See Hackenbroch 1960, pp. 18–22.
4. Alcorn 1993, p. 90.
5. Ibid., p. 95.
6. Ibid., p. 92; Glanville 1987, p. 153.
7. Collins, A. J. 1955, p. 475, no. 1017.

Cat. 33

1. Sharpe 2009, p. 390.
2. Worms 2004. For Rogers's body of work, see Hind 1952, pp. 258–72.
3. Now in Biltmore House, Asheville, N.C.; see Campbell, T. 2007a, p. 309.
4. The Royal Collection / HM Queen Elizabeth II, RCIN 600843. The version in the Bibliothèque Nationale de France, Paris (Rés. CC-101-FOL) does have numbering. For vernacular learning and diagrams, see Ferrell 2010, p. 115.

Furnishing the Palace (pp. 102–9)

1. Fisher 1914–15, vol. 2, p. 8; originally published as *This Treatise Concernynge the Fruytfull Sayinges of Dauyd the Kynge and Prophete, in the Seven Penytencyall Psalmes* (1509).
2. Thurley 1993, esp. p. 1, and Cole 1999, pp. 36–40, discuss the significance of the monarch as the embodiment of national decision making and of the movement of governance according to the monarch's location. The traditional equation of magnificence with royal authority is explored in Glanville 1990, pp. 19–45; Thurley 1993, pp. 11–18; Campbell, T. 2007a, pp. ix–x, 7–13, 45–48, 93–97.
3. For Richmond and Greenwich, see esp. Thurley 1993, pp. 27–32, 34–36. For Nonsuch, see Biddle 1966 and Biddle 2005; Colvin 1963–82, vol. 4, pp. 179–205; Thurley 1993, pp. 60–65.
4. Thurley 1993, p. 63.
5. Coope 1986, p. 46.
6. For the records of the six French clockmakers brought over to work at Nonsuch, see Page 1893, p. xliii; for the imported French pear trees in Nonsuch's gardens, see Biddle 1999, pp. 157, 165.

7. For wainscoting, see Coope 1986, p. 63, and Howard, M. 1998, p. 19, who cites documented examples, including Hardwick Old Hall's "wainscotte rounde about the gallerie" and the Bishop's Palace at Chester (1596).

8. Hall 1809, p. 509. The inventory of Henry VIII's Jewel House and receipt of all precious metalwork and jewelry in the royal collection at his death in 1547 takes up 249 double-sided folios; MS 129, Society of Antiquaries of London, published in Starkey 1998. For the inventory of Elizabeth's Jewels and Plate made in 1574 and preserved in Harley MS 1560 and Stowe MS 555, British Library, London, see Collins, A. J. 1955.

9. Sebastiano Giustiniani, dispatch of April 30, 1515; Giustiniani 1854, vol. 1, pp. 85–86.

10. For the significance of Henry VIII's Jewel House, see Glanville 1990, esp. p. 20; for his tapestry collection, see Campbell, T. 2007a.

11. For the Royal Gold Cup, see Lightbown 1978, pp. 75–82, and Bate and Thornton 2012, pp. 229, 294; for the Holbein Cup, see Hayward, J. 1958; for the Royal Clock Salt, see Toesca 1969.

12. For the looking glass, see MS 129, fol. 9r, Society of Antiquaries of London; Starkey 1998, p. 5, no. 21. The garnished shell is described in the 1574 inventory of Elizabeth's Jewels and Plate; see Harley MS 1650, fol. 18, and Stowe MS 555, fol. 19, British Library, London; Collins 1955, p. 300, no. 124.

13. The complete narrative of Philip's visit is preserved in Cotton MS Vespasian C XII, British Library, London; published in Tighe and Davis 1858, vol. 1, pp. 434–44. For the quotation, see p. 442. Gairdner 1858, p. lv, discusses the context and authorship of the description, publishing (pp. 282–303) the same account in modern English.

14. Harley MS 1419, fol. 441r, British Library, London; Starkey 1998, p. 381, no. 15276.

15. For the Haddon Hall tapestry, see Campbell, T. 2007a, p. 80; for the Great Yarmouth Cloth of Estate, see Cleland and Karafel 2017, pp. 270–73.

16. Harley MS 1419, fol. 9v, British Library, London; Starkey 1998, p. 182, no. 9033.

17. For leatherwork documented in Cromwell's house at Austin Friars, consisting of "2 images, of gilt leather, of our Lady and St. Christopher" and "an image of St. Anthony in golden leather," see the 1527 inventory published in *L&P* 1862–1910, vol. 4, p. 1456, no. 3197; for those on walls at Hardwick, see Howard, M. 1998, p. 20.

18. For Wolsey's carpet collection and the Venetian gifts, see King, D. 1985. Gallo's activities are cited by King, D. 2012, p. 133.

19. King, D. 2012 discusses Henry VIII's carpet collection. For Hardwick, see Beattie 1959, Boynton 1971, and Rowell 2016. For Boughton, and additional examples, see Impey 1989, p. 178.

20. Harley MS 1419, fol. 293v, British Library, London; Starkey 1998, p. 308, no. 12999. See Coope 1986, pp. 48, 59–63, 65, for the association of Tudor long galleries as a space for recreation and exercise.

21. In addition to the inventories of the Jewels and Plate taken in 1574 (Collins 1955), inventories of the Wardrobe of Robes under Elizabeth I, drawn up in 1600 (including clothes, silks, apparel, and personal jewels), survive in Stowe MS 557, British Library, London; MS LR 2/121, National Archives, Kew; and MS V.b.72, Folger Shakespeare Library, Washington, D.C. The manuscripts are published in Arnold 1988, pp. 251–351.

22. Glanville 1990, p. 20.

23. For the English royal tapestry collection earlier in the fifteenth century, see McKendrick 1987, McKendrick 1995, and Campbell, T. 2007a, pp. 21–64. Monnas 1989b reveals fourteenth- to fifteenth-century acquisitions of silks by Henry VII's royal predecessors.

24. For the *Story of Troy*, editions of which were also acquired from the Greniers by Duke Charles the Bold of Burgundy, King Charles VIII of France, and Duke

Federico da Montefeltro of Urbino (and likely also King James IV of Scotland, King Matthias Corvinus of Hungary, and Duke Ludovico Sforza of Milan), see McKendrick 1991 and Elizabeth Cleland in Cleland and Karafel 2017, pp. 406–14, no. 93.

25. See Junquera de Vega and Herrero Carretero 1986, pp. 1–5.

26. When Leo X's ten-piece *Acts of the Apostles* was unveiled in Rome, the estimated cost was an astronomical 16,000 to 20,000 ducats, which translates to a minimum of about 160 pounds of gold, or one-tenth the tapestries' weight; see Cleland 2007b, p. 122.

27. Campbell, T. 2007a, pp. 254, 299, notes the family's delivery to Henry of the *Story of Romulus and Remus* tapestries, as well as a set of gold-woven tapestry bed hangings for Prince Edward; Elizabeth Cleland in Cleland 2014, pp. 193–94, suggests that Henry VIII might have obtained his *Seven Deadly Sins* tapestry set from Pieter van der Walle. For the goldsmiths' billing, see Glanville 1990, p. 20; for their entrepreneurial activities in Constantinople, see Nadine M. Orenstein in Cleland 2014, pp. 176–78. The carpets they sold to Henry are listed in the 1547 inventory; see Harley MS 1419, fol. 231v, British Library, London; Starkey 1998, p. 280, nos. 12157, 12158.

28. Vezeleer sold editions and probably owned the cartoons for the tapestry series of the *Story of Jacob* and the *Life of Saint Paul*, and conceivably also, in a joint venture with the De Kempeneer weaving family, the *Story of Abraham*, of which Henry also owned sets (see Elizabeth Cleland in Cleland 2014, pp. 247, 253); for Vezeleer's transactions with François I and Henri II, see Campbell, T. 2007a, p. 221; Guy Delmarcel in Cleland 2014, pp. 126, 132; Cleland 2017, pp. 78–79.

29. For Spiering, see Thomas P. Campbell and Elizabeth Cleland in Campbell, T. 2007b, pp. 22–24 and 36–48, no. 3, respectively. For the Southwark-based weavers, see Hefford 2002, pp. 43–48; Turner 2009; Cleland 2010; Turner 2012; Turner 2013; Cleland and Karafel 2017, pp. 258–59, 627.

30. For Henry VII's financial resources, see Williams, N. 1973, pp. 169–87; Ramsey 1953.

31. As reported by Robert Fabyan in *The Great Chronicle of London* (the only copy of which is CLC/270/MS03313, London Metropolitan Archives, City of London), published in part by Boffey 2019; this record, p. 41.

32. Hayward, M. 2013 explores Henry VIII's use of confiscation to expand the royal collection. Thurley 1993, pp. 49–50, analyzes Henry VIII's patterns of acquiring homes, whether by purchase, exchange, or forfeit. Howard, M. 1998, p. 18, emphasizes how the large number of inventories detailing goods and properties forfeited to the sovereign after subjects were charged with treason augments vitally our knowledge of the interior furnishings of Tudor great houses. Campbell, T. 2007a provides a thorough analysis of Henry VIII's tapestry collecting; for appropriations, see esp. pp. 167–69, 201–3, 241–45, 314. Cleland 2007a provides a case study of one particular example.

33. Challis 1978.

34. This point is emphasized by Colvin 1963–82, vol. 4; Thurley 1993, pp. 1, 49–50; Howard, M. 1991, p. 562.

35. For firsthand accounts of the progresses (their organization, reception, and festivities), see Nichols 1823; Goldring et al. 2014. Woodworth 1945 traces the travel logistics of moving Elizabeth's court. Howarth 1997, p. 6, for example, reiterates the accepted wisdom that the progresses saved the Crown expense. In an account more sympathetic to the queen, Cole 1999, pp. 4–5, 35–38, 52–62, argues that, by still covering the costs of provisions, wider courtly accommodation, and transportation, the queen spent more on the progresses than had she remained within London and its immediate proximity. Elizabeth's Lord High Treasurer, William

Cecil, 1st Baron Burghley, is on record complaining of the unnecessary expenses incurred for aspects of the progresses, not least when Elizabeth changed plans midway; see Cole 1999, pp. 58–61.

36. For the role of the arrasmen and other tapestry workers, see Hefford 2002, pp. 43–45; Campbell, T. 2007a, pp. 212–15; Cleland 2009b, pp. 159–60. Kisby 1999 and Cole 1999, pp. 40–46, 54–57, explore the importance and duties of office holders of the royal household. Levey 2012 focuses on the work of the embroiderers for Henry VIII, noting (p. 164) the huge expense of embroidered costumes for royal staff and of liveries.

37. For the Great Wardrobe, see Ellis, L. 1947; Arnold 1988, pp. 163–76, 232–34; Campbell, T. 2007a, pp. 245–48, 325–26; Hayward, M. 2007, pp. 25–39, 241–74.

38. Coope 1986, p. 62.

39. Platter's diary, from 1599, written in German, is translated and published in Platter 1937; for the description of his party's visit to Whitehall, see pp. 163–66. Additional contemporary descriptions are provided by Baron Waldstein (1600), translated from Latin in Valdštejna 1981 (pp. 42–59), and Friedrich Gerschow, assistant to Philip Julius, Duke of Stettin-Pomerania (1602), published in German and English in von Bülow and Powell 1892 (pp. 23–25).

40. Fisher 1914–15, vol. 2, p. 8.

The Tudor Art of the Gift (pp. 110–13)

1. Hayward, M. 2005. For the lists maintained by the Elizabethan court, recording New Year's gifts given and received, see Lawson 2013. As Lawson notes (p. 6), there was one brief hiatus in the exchanges under the protectorate of Lord Somerset, owing to his hardline Protestant concerns about the ritual.

2. Fumerton 1991, esp. chapter 2, "Exchanging Gifts: The Elizabethan Currency of Children and Romance," pp. 29–66; Klein 1997; Donawerth 2000; Kelly 2007; Heal 2014.

3. For the lion, given by George Rotheridge and Robert Kingston in 1559, see Lawson 2013, pp. 12–13, 45, no. 59.218.

4. Stallybrass and Jones, A. 2001, esp. p. 124.

5. William Poyntz, letter to Lady Heneage, July 23, 1583, in *Report on Manuscripts* 1913, p. 25; cited in Howey 2007, p. 109.

6. Auerbach and Adams, C. 1971, p. 59, no. 51.

7. Bolland 2015, esp. pp. 352–54.

8. Foister 1986.

9. Hayward, M. 2016, esp. pp. 240–41.

10. Jardine 1995.

11. Bätschmann and Griener 1997, pp. 155–58.

12. Lawson 2013, p. 5.

13. Hand 1993, p. 84.

14. Lawson 2013, p. 7.

15. Howey 2009.

16. William Poyntz, letter to Sir Thomas Heneage, July 4, 1583, in *Report on Manuscripts* 1913, p. 24; cited in Howey 2007, p. 107.

17. Lawson 2007, esp. pp. 138–39; Frye, S. 2010, pp. 30–45.

18. As Lisa M. Klein writes, "The many instances of hand-wrought gifts remind us that women did enter the arena of cultural production, where they promoted their interests and praised the monarch." Klein 1997, p. 462.

19. Cole 1999.

20. Goldring 2007, p. 188.

21. Foister 2004, pp. 128–30; Petter-Wahnschaffe 2010, pp. 119–32.

22. Woodall 1991.

23. Will of Mary I, 1557, cited in ibid., p. 213. As Woodall explains (p. 223n73), the original will is lost; the transcription in Madden 1831 is from a copy, but it appears

that the quoted portion "was originally written in the queen's own hand." See also Stone 1901.

24. Mitchell 1971.

25. Account of the ambassador, Thomas Randolph, in Hakluyt 1598–1600, vol. 1, p. 377; cited in Dmitrieva 2013, p. 25.

26. MacLeod 2019a, pp. 8–9.

27. Sowerby 2015.

28. Koos 2014.

29. Sir Henry Unton, letter to Elizabeth I, February 3, 1595–96, in Murdin 1759, p. 718; cited in Fumerton 1991, p. 71.

30. Ibid.

31. Fumerton 1986.

32. Melville 1683 (1930 ed.), p. 94; cited in Fumerton 1986, p. 57.

33. On the *bijoutière* and its miniatures, see Strong 1974; Smith, Am. 2017, p. 137.

34. Mrs. Anne Lewis, note, undated (MS 1946/4/2k/1, Wiltshire and Swindon History Centre, Chippenham); cited in Strong 1974, p. 255. See also Smith, Am. 2017, p. 137.

35. Lewis, note, cited in Strong 1974, p. 255.

36. Doran 2003, p. 152, no. 162.

37. Hille 2017, esp. pp. 294–97.

38. For the Drake jewel and portrait (fig. 46), see Anna Somers Cocks's entries in *Princely Magnificence* 1980, pp. 61, 105, nos. 40, P15.

39. Howard, M. 2004, esp. pp. 264–65.

40. For Parry's court career and funerary monuments, see Howey 2007, pp. 232–53.

Honing the Tudor Aesthetic (pp. 114–21)

1. Spenser 1909, p. 202. Edmund Spenser published books 1 to 3 of the *Faerie Queene* in 1590 but returned to the plot, revised it, and added books 4 to 6 in 1596.

2. "d'une plus grant victoire / Le roy Henry que Herculles"; André, *Les douze triomphes de Henry VII*; Royal MS 16 E XVII, British Library, London. The 632-line poem (published in Gairdner 1858, pp. 131–53, with English translation, pp. 307–27; quoted passage, pp. 134, 308) is contrived to match Henry VII's deeds with the twelve labors of Hercules. Carlson 1998, p. 246, raises some alternative candidates for the work's authorship, all present at the English court in 1497.

3. For Wyatt, see Rossiter 2014, pp. 22–23.

4. Somerset's homes are discussed in Henderson 2011, pp. 53, 63. For Theobalds, see also Andrews 1993 and Sutton, J. 1999–2000.

5. Nero's wall paintings as inspiration for both Raphael's tapestries and other *grotteschi* are discussed in Karafel 2016, pp. 96–101.

6. The Cowdray fountain figure might not originally have been planned as Neptune: he is young and unbearded, and the current trident is a later replacement. Attribution to Benedetto replaces a more traditional association with Rustici; see Lindley 1991, pp. 269–70, citing the unpublished notes of Anthony Radcliffe, and Caglioti 2012, pp. 193–94. For the Hampton Court fountain, see Thurley 2003, p. 87.

7. Summerson 1993, pp. 40–42, discusses classical architectural citations in drawn designs and printed frontispieces.

8. For the treatises, see ibid., pp. 5–54, 57. For Coecke's editions of Serlio, see Nadine M. Orenstein in Cleland 2014, pp. 86–90, no. 17.

9. Summerson 1993, pp. 63, 67. Howard, M. 1987, pp. 120–35, 193–99 discusses varying degrees of engagement with classical design and ornament in English architecture. Henderson 2011, p. 42, stresses the conscious decision in Elizabethan architecture not to embrace classical style entirely, but to retain earlier forms.

10. For Smythson, see Girouard 1983.

11. Summerson 1993, pp. 64, 67. For the building campaign and design sources for Hardwick's exterior and interior, see also Cooper, N. 2016a; Cooper, N. 2016b.

12. Throughout this volume, quotations from Shakespeare's plays, and the numbering of acts, scenes, and lines, are drawn from *The New Oxford Shakespeare: Modern Critical Edition* (Taylor et al. 2016).

13. For Hawes, see the introduction by William Edward Meade in Hawes 1928. For *Arcadia*, see the introduction by Victor Skretkowicz in Sidney 1987; his earlier version of his romance, now called *The Old Arcadia*, was written about 1580, not yet including some of the most evocative scenes, including those with the queen of Corinth. The lengthier version, titled *The Countess of Pembroke's Arcadia*, now often known as *The New Arcadia*, was published in 1590. Additional revisions were included in the version published in 1593. Yates 1947 (revised and republished in Yates 1975, pp. 29–87) memorably explores literary homages to Elizabeth as Astraea.

14. Hicks, C. 2007, p. 38.

15. Wriothesley 1875–77, vol. 1, p. 99.

16. Platter visited England in 1599; for his diaries (translated from German), see Platter 1937; this quotation, p. 200, is discussed in Longstaffe-Gowan 2005, pp. 36–37. For Henry I's menagerie, see Colvin 1986, p. 18.

17. Leland 1745, vol. 1, p. 54.

18. Henderson 2011, pp. 51–52, discusses the practice of retaining and adapting medieval moats into water gardens.

19. For Richmond, see Coope 1986, p. 46; for Whitehall, see Thurley 1999, pp. 68–73; for Hampton Court, see Thurley 2003, pp. 89–97; for Leicester's banqueting house, see Clark 1983 and Goldring 2014, pp. 216–17; for Theobalds, see Andrews 1993 and Sutton, J. 1999–2000. Henderson 2011, p. 48, discusses the wooden gallery set within gardens at Thornbury Castle and, on pp. 52–53, the taste for adding secular cloisters to new gardens.

20. On the precedents for and evolution of Tudor long galleries, see Coope 1986.

21. Holinshed 1807–8, vol. 3, p. 560.

22. The silk flowers, inventoried in Harley MS 1419, fols. 33r, 58r, 155r, 168r, British Library, London, and published in Starkey 1998, pp. 193, 205, 247, 252, nos. 9251, 9548, 11125, 11388, are discussed by Levey 2012, p. 157. For the Hardwick Hall verdures, see Boynton 1971, pp. 31, 33, 42, 43.

23. Holinshed 1807–8, vol. 3, pp. 611–12.

24. For the progresses, see Cole 1999. For the queen's encounters with wildmen, see Wilson, J. 1980, pp. 42, 56–57; Henderson 2011, p. 61.

25. The Woodstock festivities were published by Pollard 1910 and discussed by Yates 1957 (revised and reprinted in Yates 1975, pp. 88–111).

26. Hall 1809, p. 518, cited in Ellis, H. 1827, vol. 1, p. 185n. The occasion was a joust held in honor of Katherine's giving birth to a son; Brandon removed his costume and donned armor for the tilting.

27. The Accession Day tilts are discussed by Yates 1957 (revised and reprinted in Yates 1975, pp. 88–111).

28. The quotation is part of a hermit's speech made during an as yet unidentified Accession Day festivity, recorded in the Ditchley Manuscript (Add MS 41499 A, British Library, London), cited by Yates 1957, p. 14.

29. See ibid.

30. For the gardens at Gorhambury, see Henderson 1992, esp. p. 116 for the statue of Henry and related literature.

31. Holinshed 1807–8, vol. 3, p. 549, records Sir Robert Dymoke's defense of Henry VIII, a role he had already played at Henry VII's and (ironically enough) Richard III's coronations. His son Sir Edward performed the honor at the coronations of Edward VI, Mary I, and Elizabeth I.

32. MacColl 2006 provides a fascinating analysis of the meaning of "Britain," according to the audience of and in response to Geoffrey of Monmouth.

33. Quotation from Hall 1809, p. 423. For Llwyd ap Llywelyn, see Williams, N. 1973, p. 26; for Owen, see Charles 1973. The theme was continued by the Elizabethan Welshman Humphrey Llwyd in his *Cronica Walliae a Rege Cadwalader ad annum 1294* (1559) and *Commentarioli Britannicae descriptionis fragmentum* (1568; published as *The Breviary of Britayne*, 1573). See Llwyd 2002; Llwyd 2011.

34. Sharpe 2009, p. 63.

35. On Arthur, see Hall 1809, p. 428. On Katherine, a long anonymous account of the festivities enacted in London to welcome her to England forms part of a manuscript in the College of Arms, London; see the published version "The Voyage, &c. of Princess Catherine" 1808, quotation on p. 273.

36. The tabletop, which includes ninth-century components, remains on view in the great hall of Winchester Castle, and is illustrated and analyzed in depth in Biddle 2000; for Henry VIII's intervention, see Pamela Tudor-Craig (pp. 285–333) and Martin Biddle (pp. 425–73) in ibid.

37. A miniature in Wellbeck Abbey, formerly attributed to either Nicholas Hilliard or Levina Teerlinc, predicts the composition (although it may also be a later work, based on a since-lost miniature); see Tarnya Cooper in Doran 2003, pp. 42–43, no. 28. Elizabeth's initial predilection for the portrait of Richard II is discussed by Orgel 2011, p. 12.

38. Three versions of the Trevelyon manuscript, all different in size and content, are known: the earliest, preserved at University College London, MS Ogden 24, is usually dated about 1603 and must have been begun before Elizabeth's death (spaces were left to fill in the year her reign ended and her place of burial). It is followed by the Trevelyon Miscellany of 1608, Folger MS V.b.232, Folger Shakespeare Library, Washington, D.C., and the Trevilian Great Book of 1616, Wormsley Library, Buckinghamshire. All are discussed in Wolfe 2012; Furlong 2015, pp. 96–99, no. 27.

39. Howard, M. 2007, pp. 7–11.

40. Discussed by Howard, M. 1987, pp. 47, 50.

41. See the opening words of Henry VIII's 1533 Act in Restraint of Appeals, which ended the practice of appealing cases to the See of Rome: "Where by dyvers sundrie autentike histories and cronicles it is manifestly declared and expressed that this Realme of Englond is an Impire, and so hath ben accepted in the worlde, governed by oon Supreme heede and King"; *Statutes* 1810–28, vol. 3, p. 427.

42. See Campbell, T. 1996a, p. 79; Cleland 2007b, p. 119.

43. For Maximilian, see Terjanian 2019; for Leo X, see Karafel 2011.

44. For Catherine de' Medici's pageants, see Yates 1959; Cleland and Wieseman 2018.

Cat. 34

1. Martin Biddle in *The Renaissance at Sutton Place* 1983, p. 92. The most complete accounts of Nonsuch are Dent 1970; Biddle and Summerson 1982; Biddle 2012.

2. On the artistic rivalry between Henry VIII and François I, see Béguin 1996.

3. No visual record of the inner court survives; reconstructions are based on written descriptions by sixteenth- and seventeenth-century visitors, excerpts of which can be found in Biddle 2012; see esp. pp. 321–44.

4. See Biddle in *The Renaissance at Sutton Place* 1983, pp. 92–93; Biddle 1984. On the decorations of the inner court, see in addition Turquet 1983.

5. Two paintings depict the palace from the north and northeast, the first in the Fitzwilliam Museum, Cambridge (PDP 95), and the second at Berkeley Castle (another version of which is at Epsom Town Hall, Surrey). Hoefnagel, a native of Antwerp, was in England in 1568–69. He came as a trader in luxury goods

and was at this stage an amateur—albeit exceptionally skilled—draftsman only; see Town 2014, pp. 108–9.

6. The southern portion of the palace was bordered by the Privy Garden, which was enclosed by a 14-foot-high wall. Although it appears grand, the palace was modest in size: only about 450 feet long, and the south facade (depicted in Hoefnagel's drawing) approximately 180 feet wide.

7. British Museum, London, 1943,1009.35.

8. Most recently on Hoefnagel's views of Nonsuch, see Vignau-Wilberg 2017, pp. 258–60.

9. Walpole 1797, p. 58, translating Latin verses cited by Paul Hentzner (1612, p. 153), who saw Nonsuch when he traveled through England in 1598. The Latin verses were composed by Nathan Chytraeus of Rostock, who visited Nonsuch in summer 1565; see Biddle 2012, pp. 308–9n5.

Cat. 35

1. Peacham 1634 (1906 ed.), p. 128, claimed the Bridewell location. Thurley 1993, p. 230, notes that Whitehall and Oatlands were Henry's only building projects with rooms large enough to accommodate such a mantel and chimney breast, given the approximate dimensions of the planned work and the date of the design.

2. Both Summerson 1993, notes to ch. 1, p. 529n7, and Foister 2004, p. 147, remark that cat. 35 is the only evidence of Holbein's architectural work in England.

3. Biddle 1966, pp. 112–13, and Béguin 1970, p. 10, suggested that the drawing should be attributed to Bellin, arguments rejected by Rowlands 1988, pp. 247–48, no. 10.

4. Thurley 1993, p. 228, notes how other known examples included bright painting and gilded terracotta.

5. For Elizabeth's building at Windsor, see Simon Thurley in Brindle 2018, pp. 186–89.

Cat. 36

1. See Acidini Luchinat 1993, p. 124; Schroder 1995 revealed the cup's Tudor roots, exploring the context of its production and hypothesizing its original function.

2. Biblioteca Nazionale, Florence, COD.PAL.C.B.3, 27 (G.F.183).

3. Schroder 1995, pp. 365–66, discusses values assigned to comparable rock-crystal items in the context of cat. 36. For a broader discussion of sixteenth-century northern European rock-crystal vessels, see Alcouffe 2001, pp. 253–55, no. 109; Koeppe 2018.

4. Schroder 1995, p. 366.

5. See Glanville 1990, p. 20; Hayward, J. 1976, p. 299; Schroder 1995, p. 359.

6. For the anonymous account of luxury goods, including the "wonderful quantity" of silverware and goldsmiths, see Sneyd 1847, pp. 42–43; for the goldsmiths' district in Cheapside, see Harding 2008.

7. MS 129, fol. 58v, Society of Antiquaries of London; Starkey 1998, p. 25, no. 532. See also Schroder 1995, p. 360.

8. Victoria and Albert Museum, London, M2680-1931; see Glanville 1990, pp. 594–97.

9. Schroder 1995.

10. Ibid., pp. 359–61.

Cats. 37–39

1. For an overview of Holbein's production in this area, see Foister 2004, pp. 137–47.

2. See Cust 1906.

3. See Tanner 1991.

4. Müller 1988, pp. 254–55, no. 82.

5. Ibid., pp. 256–57, no. 83.

6. Brown, D. 1982, p. 4, no. 3.

7. Foister 2004, p. 142; for the inventory, see Collins, A. J. 1955, p. 279, no. 47.

8. Rowlands 1988, pp. 237–38, no. 205.

9. For the clock salt's link to Holbein, see Foister 2006, p. 78, no. 82.

10. Rowlands 1988, pp. 237–38, no. 205.

11. See Müller 1990.

Cats. 40, 41

1. Petter-Wahnschaffe 2010, pp. 161–64.

2. Hall 1809, p. 468.

3. See Holman 1979; Foister 2004, pp. 128–37, 206–14; Petter-Wahnschaffe 2010.

4. He is called "John of Antwerp" in the account books and "Hans von Antwerp" by Holbein in the drawing (cat. 38) and, apparently, the portrait (fig. 63), although part of the painted inscription is indecipherable. In the Return for Subsidies of Aliens in England (1541), he was named as "John Vandergow, alias Van Andwerep" (Kirk and Kirk 1900–1908, vol. 1, p. 46), which Lionel Cust (1906, p. 359) suggests may have been a corruption of "Van der Goes."

5. See Glanville 1990, pp. 85–99, which discusses in full the relation between English goldsmiths and their foreign, often transitory, counterparts.

6. Hayward, J. 1976, p. 112, citing the Minute Books of the Worshipful Company of Goldsmiths, vol. F, pp. 61, 79. Cust (1906, p. 359) also discusses Van der Gow's application, although he cites the date of these transactions as 1541.

7. Hayward, J. 1976, p. 109.

8. Cust 1906, p. 359; see *L&P* 1862–1910, vol. 14, pt. 2, p. 339, no. 782.

9. Focke 1887–89 identified cats. 40 and 41 as London-made Hanse silver and traced their history and route from England to Bremen via Lübeck.

Cat. 42

1. Campbell, T. 2007a, p. 184.

2. All ten tapestries are discussed and illustrated in Barbier 2017 and Delmarcel 2008, pp. 12–105, following the analyses of Salet 1980 and Sophie Schneebalg-Perelman in Delmarcel and De Roo 1976, pp. 25–51.

3. On the preparatory drawing (National Gallery of Art, Washington, D.C., Corcoran Collection, 2015.143.41) and attribution to Jan van Roome, see Dhanens 1959; additional design sources, including visual references to Rogier van der Weyden and Albrecht Dürer, are provided by Delmarcel 2008, pp. 113–38.

4. Campbell, T. 2007a, pp. 117–21.

5. Campbell, T. 1996b, pp. 129, 130; Campbell, T. 2007a, pp. 121, 145–47.

6. Campbell, T. 2007a, pp. 177–79, discusses this delivery—one of many—from Gresham to the Tudor court, relating its documented size (418 sq. yd.) with that of the Ecouen set and tracing its subsequent history and probable survival.

7. Delmarcel 1999, p. 75; Delmarcel 2008, pp. 109–10.

8. Campbell, T. 2007a, pp. 145–46, 180, 187.

9. Discussed by Elizabeth Cleland and Guy Delmarcel in Cleland 2014, pp. 124–75.

10. All the David tapestries, either woven with wool and silk or wool, silk, and metal-wrapped threads, are documented in Henry's 1547 posthumous inventory, Harley MS 1419, fols. 6r, 28r, 37r, 38v, 64v, 211v, 212r, 218v, 260v, 299r, 329v, British Library, London; see Starkey 1998, pp. 180, 191, 195, 196, 207, 270, 273, 295, 311, 326, nos. 8990, 9210, 9260, 9290, 9700, 11990, 11991, 11992, 11993, 12037, 12621, 13056, 13057, 13347. Tudor-Craig 1989 discusses Henry's identification with David, particularly in relation to his psalter.

11. Campbell, T. 1996b, pp. 128, 132–34; Campbell, T. 2007a, pp. 183–84.

12. For the *Death of Oza and Transportation of the Ark into Jerusalem* in the Museo de Santa Cruz, Toledo, see *Ysabel* 2005, pp. 534–36; for the *Assembly of the Troops* in the Museo Civico, Padua, see Forti Grazzini 2000. Both are discussed in Delmarcel 2008, p. 110.

13. For David and Bathsheba in fifteenth- and sixteenth-century tapestry, see Delmarcel 1999, p. 74; Delmarcel 2008, pp. 149–53.

14. The set forms part of the Patrimonio Nacional, Series 3, I–X. See Junquera de Vega and Herrero Carretero 1986, pp. 9–12; Delmarcel 1999, p. 74.

15. Delmarcel 1999, p. 74. An example of the high caliber of Pieter de Pannemaker's work is his *Last Supper* tapestry (Metropolitan Museum, 1975.1.1915).

16. Campbell, T. 2007a, p. 179, rejects that the Ecouen set and the documented de Pannemaker set made for Maximilian were after the same series of cartoons.

17. Harley MS 1419, fol. 6r, British Library, London; see Starkey 1998, p. 180, no. 8990.

Cat. 43

1. MS 129, Society of Antiquaries of London, fols. 201v, 203r, 211v, and Harley MS 1419, fols. 54r, 55v, 58r, 62r, 111r, 115v, 116r, 117r, 117v, 151r, 152v, 153v, 155r, 157v, 168v, 188v, 250r, 253r, 253v, 293v, 315r, 317v, 358v, 414v, British Library, London; see Starkey 1998, pp. 87, 88, 92, 204–6, 232, 234, 235, 246–48, 252, 261, 290, 291, 308, 320, 341, 365, nos. 3197, 3227, 3234, 3444, 9450, 9481, 9549, 9655, 10430, 10479, 10490, 10491, 10500, 10501, 10511, 10512, 11039, 11063, 11086, 11127, 11182, 11394, 11395–11398, 11692, 12424, 12530, 12540, 12999, 13000, 13194, 13233, 13660, 14562.

2. Harley MS 1419, fol. 155r, British Library, London; see Starkey 1998, pp. 246–47, no. 11127.

3. Metropolitan Museum, 63.38. As reported by Edward, Lord Dudley, dispatch from Laredo to London, May 17, 1554; see *CSP Foreign, Mary* 1861, p. 84, no. 207.

4. Yvonne Hackenbroch, ignoring the rose, suggests that the board may have been made for the Fugger family because of the representation of a double fleur-de-lis (an opinion cited in a note on an interdepartmental memo, September 1998, archive of the Department of European Sculpture and Decorative Arts, The Metropolitan Museum of Art). However, this doubling seems to be more a result of the board's design, in which all the internal central motifs are represented in reflections, allowing both players to see the elements in correct orientation.

5. Harley MS 1419, fol. 293v, British Library, London; see Starkey 1998, p. 308, no. 12999.

6. Bayerisches Nationalmuseum, Munich, R 201, and Victoria and Albert Museum, London, 567-1899. For the former, see Himmelheber 1972, p. 44; the latter, Humphrey 2015.

7. Philadelphia Museum of Art, 1964-91-16; see Koeppe 1992.

8. See Humphrey 2015.

9. See Patterson 2009, pp. 98–100.

Cats. 44, 45

1. MS 129, fols. 175r–v, Society of Antiquaries of London; see Starkey 1998, p. 77, nos. 2612–18.

2. See Noam Andrews in Koeppe 2019, p. 176, no. 87.

3. Cited by Carley 2004, p. 73.

4. For Apianus, his *Astronomicum caesareum*, and a survey of surviving editions, see Gingerich 1995.

5. See David Loades in Starkey 1991, pp. 172–78, no. XII.6.

Cat. 46

1. Hayward, J. 1976, pp. 114, 366 (dating it to ca. 1530–40), and Farmer 1969, p. 32 (dating it to ca. 1550), both attribute it as English and link the design with others in Holbein's "English" sketchbook.
2. Discussed in Stanbury 2004, p. 205.
3. See Corry, Howard, D., and Laven 2017, p. 3.
4. Harley MS 1419, fols. 113v–r, 115r, British Library, London; see Starkey 1998, p. 233, nos. 10438, 10447, 10473.

Cat. 47

1. For more on the storage and use of such tapestries, see Cleland 2009a; Cleland 2011.
2. "PORREXIT.MANVM.SVAM.INLIBATIONEM.ET.LIBAVIT. DESANGVINE.VVE. ECCL.CI.CI.C.LO." For the iconography of this tapestry, see Wardwell 1975; Cavallo 1993, pp. 334–41; Cleland 2009b.
3. Observation made by Cristina Balloffet Carr, Conservator, The Metropolitan Museum of Art, in communication with the author; see also Cleland 2009a, pp. 131, 139.
4. On van der Weyden's close-ups, see Campbell, L. 2004, pp. 11, 25.
5. Cavallo 1993; Cleland 2009b.
6. Cleland 2007b, p. 116.
7. Discussed in detail, Cleland 2009b.
8. For the Hampton Court inventory, see Harley MS 1419, fol. 217v, British Library, London; Starkey 1998, p. 273, no. 12029. Campbell, T. 2007a, pp. 89–92, 124–45, discusses the duties and role of the royal arrasmen.

Cat. 48

1. For the delivery note of this manuscript to Henry for 2 shillings in January 1541, see Tudor-Craig 1989, p. 193. For the psalter, see Janet Backhouse in Starkey 1991, p. 162, no. 11.31; Carley 2009; James Carley in Doran 2009, p. 198, no. 194; Kathleen Doyle in McKendrick, Lowden, and Doyle 2012, p. 188.
2. For Henry's self-identification with David, see Tudor-Craig 1989; John Lowden in McKendrick, Lowden, and Doyle 2012, p. 35, notes medieval precursors of David as model for kings.
3. Walker, G. 1996, pp. 80–81, suggests the confrontational element.
4. Metropolitan Museum, 2011.353; see Croizat-Glazer 2013, which also (pp. 136–37) analyzes the use of the two kings' facial features for David. As noted in Backhouse 1967, François had an extra leaf added to a book of hours (Bibliothèque Nationale de France, Paris, MS n.a. lat. 82, fols. 152r–v, subsequently known as the Hours of Catherine de' Medici) to enable a representation of David with his features.
5. For an analysis of Henry's annotations to his *Bokes of Salomon, Namely: Proverbia, Ecclesiastes, Sapientia, and Ecclesiasticus, or Jesus the Sonne of Syrach* (ca. 1541–42), see Hattaway 1965; Tudor-Craig 1989, pp. 194–95.
6. Henry had a scribe copy into his *Bokes of Salomon*, in red ink, his marginal inscriptions from his psalter; see Tudor-Craig 1989, p. 195.
7. For the notes, including transcriptions and translations, see ibid., pp. 195–98, 200–205.

Cat. 49

1. Discussed by Hessayon 2007, para. 4.
2. For Coecke, see Cleland 2014. For the various editions of Coecke's *Life of Saint Paul*, see Guy Delmarcel in Cleland 2014, pp. 124–35; for Henry's *Saint Paul* sets, see Campbell, T. 2007a, pp. 238–40, and Elizabeth Cleland in Cleland 2014, pp. 156–61, nos. 35–37.

3. The biblical quotation uses Miles Coverdale's English translation of the Latin Vulgate.
4. Universiteitsbibliotheek, Ghent, TEK 3504; see Cleland 2014, p. 156, no. 35.
5. For Paulus van Oppenem's earlier, seven-piece *Saint Paul* series, see ibid., pp. 150–55, nos. 33–34. For Henry's *Seven Deadly Sins*, see Campbell, T. 2007a, pp. 222–26, and Cleland in Cleland 2014, pp. 191–93.

Cat. 50

1. For the miniature's provenance, see Lloyd, C., and Remington 1996, p. 50, no. 2.
2. For Richmond's biography, see Murphy 1997.
3. Poem 36 in Surrey 2012, pp. 46–47. For Richmond and Surrey's relationship, see Irish 2018, pp. 58–77.
4. For speculation on Richmond's health, see Lloyd, C., and Remington 1996, p. 50; and on his frailty, see Christopher Lloyd in Roberts, J. 2002, p. 115, no. 38.
5. For Richmond's illness and death, see Murphy 1997, pp. 189–91. Murphy speculates that the work was a preparatory study for Richmond's inclusion in the new register of the Order of the Garter, but the highly finished nature of the portrait mitigates against this; see ibid., pp. 298–99.
6. For the celebrated example of an unknown man against a background of flames (fig. 66), see Catharine MacLeod in MacLeod 2019b, pp. 94–95, no. 27.
7. The couple did not, however, cohabitate following their marriage, in light of their youth; see Murphy 1997, p. 163.
8. Surrey 2012, p. 46; for a relevant reading of this poem, see Lines 2006.

Cat. 51

1. MS Z.d.11, Folger Shakespeare Library, Washington, D.C.; cited in Hand 1993, p. 86, no. 64.
2. For Horenbout's gift, see Campbell, L., and Foister 1986, p. 722; *L&P* 1862–1910, vol. 13, pt. 2, p. 539, no. 1280.
3. For the materials used in cat. 51, see Hand 1993, p. 84.
4. The full text is translated in ibid., pp. 84–85.
5. Strong 1967, p.18.
6. Quentin Buvelot in Buck and Sander 2003, p. 130, no. 33.
7. See Ainsworth 1990, esp. pp. 182–83; Foister 2004, p. 196. The drawing for the badge is now in the Öffentliche Kunstsammlung, Basel, Kupferstichkabinett, 1662165.82.
8. Ainsworth 1990, pp. 182–83.

Cat. 52

1. Harley MS 1419, fol. 28r, British Library, London; published by Starkey 1998, p. 191, no. 9215. The tapestries are discussed by Thomas P. Campbell in Campbell, T. 2002, pp. 225–29, 246–52, no. 26; Campbell, T. 2007a, pp. 267–75. For Leo X and the Vatican commissions, see in particular Karafel 2016. Charissa Bremer-David in Bremer-David 2015, pp. 58–63, no. 2, discusses the slightly later edition, which reached the French royal collection in the seventeenth century.
2. Erkelens 1962; Campbell, T. 1996c, pp. 75–76. Karafel 2016, pp. 1–2, 27–31, discusses the Vatican inventories in detail.
3. Karafel 2011; Karafel 2013; Karafel 2016, pp. 122–29.
4. Forti Grazzini 1994, vol. 2, p. 387, identifies a third-century Roman sarcophagus as inspiring the frieze of figures; Campbell in Campbell, T. 2002, p. 249, a second-century Roman *Commodus* as the model for Hercules's head; and Karafel 2016, p. 102, a Roman statue of *Mercury* for Hercules's body. Lorraine Karafel

(2016) discusses Raphael's quotations from the Domus Aurea in the *Grotesques* tapestries (pp. 97–101) and his *all'antica* style and response to Roman excavations and artifacts in his own work (pp. 89–107).
5. See Campbell in Campbell, T. 2002, pp. 187–245 and 253–61.
6. See Karafel 2016, pp. 108–11.
7. Campbell, T. 2007a, pp. 273, 274.
8. Ibid., pp. 261–63, 271.
9. Ibid., p. 263.
10. For the weavers' mark, see Campbell, T. 1996c, pp. 76–78. For the Dermoyens, see Nadine M. Orenstein (pp. 176–82) and Iain Buchanan (pp. 214–20) in Cleland 2014.
11. Suggested by Karafel 2016, p. 136.

Cat. 53

1. Otto Kurz (1943a) first drew attention to the larger of the drawings and was the first to attribute it to Bellin (1943b). For Bellin's biography, see Biddle 1966; Thurley 1993, pp. 107–10; and Summerson 1993, pp. 34–36.
2. On the drawings' relevance in the one-upmanship between Henry VIII and François I, see Béguin 1996. For Wallop's comments, see his letter to Henry VIII, November 17, 1540, *SP* 1830–52, vol. 8, p. 484, no. 642; Kurz 1943b; Gunn 2012.
3. Sylvie Béguin (1970) was the first to recognize the link between the drawings. Dominique Cordellier has observed how the paper grain follows the same direction in both drawings (verbal communication with the author, February 2019).
4. Kurz 1943a, p. 82.
5. Payments recorded in Royal MS 14 B IV A, British Library, London; see Thurley 1993, p. 107.
6. It was Anthony Blunt (1969) who first associated the larger design with Whitehall rather than Henry's other palatial project, Nonsuch. On changes at Whitehall in the 1540s, see Thurley 1999, pp. 62–64; Campbell, T. 2007a, pp. 271–72.

Cat. 54

1. Wells-Cole 1997, p. 12, identifies the quotation as from Serlio; Howard, M. 2001, p. 24, notes the use of Coecke's edition. For Coecke's unauthorized Dutch, French, and German translations of Serlio, see Nadine M. Orenstein in Cleland 2014, pp. 86–90.
2. See Howard, M. 2001, p. 25. For the *Triumphe d'Anvers*, see Orenstein in Cleland 2014, pp. 104–7, no. 23.
3. First suggested by Howard, M. 2001, p. 26, and reiterated by Sicca 2006, p. 32; Gentilini and Mozzati 2012, p. 209.
4. Suggestions made in the literature thus far remain unconvincing: Wells-Cole 1997, p. 12, posits that it was a design for a triumphal arch; Howard, M. 2001, p. 26, perceiving a more personal than public iconography, suggests that it may have been a frontispiece to a book of hours or a personally gifted manuscript.
5. See Freyda Spira in Terjanian 2019, pp. 290–94, no. 165.

Cat. 55

1. Shute 1563, sig. Ajr.
2. Ibid.
3. Elizabeth Goldring posits that Robert Dudley, Earl of Leicester, revived the project as a means of rewriting his treasonous heritage. See Goldring 2014, p. 40. For Dudley's patronage of Italian artists, see cats. 107, 108 in this volume.
4. The treatise's title reads in full: *The First and Chief Groundes of Architecture Used in All the Auncient and*

Famous Monymentes: With a Farther and More Ample Defense upon the Same, than Hitherto Hath Been Set out by Any Other.

5. Goldring 2014, p. 38.

6. Shute 1563, sig. Aijr.

7. Scholars have suggested that the first four engravings are in copper, which would rank Shute among the first English engravers to make use of the technology (if he is their author). See Lawrence Weaver, introduction to Shute 1912, p. 15.

8. On the gendering and mythological assignment of columns, see Günther 2018.

9. Shute 1563, sigs. Biv–Biir.

10. Skelton 2015.

11. Harris, E. 2011, pp. 419–21.

12. Ibid.; Summerson 1993, p. 48; Reiff 2000, p. 7; Weaver, introduction to Shute 1912, p. 14.

13. Cooper, N. 2002, p. 294. See Bradford 1984 for the tension between native and foreign style.

14. Shute 1563, sig. Ajr.

15. Reproduced in Weaver, introduction to Shute 1912, p. 8. See also Stow 1720, vol. 1, p. 157.

16. Cooper, N. 2002, p. 301.

17. Harris, E. 2011, p. 414.

Cats. 56, 57

1. Hayward, M. 2005, p. 125.

2. Lawson 2013, p. 1.

3. See Howey 2009.

4. Ziegler 2003, p. 81.

5. Lawson 2013, p. 247, no. 79.27.

6. Ibid., p. 258, no. 79.234.

7. Ibid., p. 257, no. 79.207.

8. Ibid., p. 264, no. 79.436.

Cat. 58

1. *Princely Magnificence* 1980, p. 60, no. 38.

2. Fumerton 1986, p. 63.

3. For a biography of Sir Thomas, see Hicks, M. 2004.

4. Strong 1983a, pp. 129–30, no. 208.

5. Catharine MacLeod in MacLeod 2019b, p. 17.

6. Strong 1983a, p. 129, no. 208.

7. Spelling has been modernized; cited (in the original) in Howey 2007, p. 107; see *Report on Manuscripts* 1913, vol. 1, pp. 24–25.

8. Spelling has been modernized; cited (in the original) in Howey 2007, p. 109; see *Report on Manuscripts* 1913, vol. 1, pp. 25–26.

9. Howey 2007, p. 110.

Cat. 59

1. For Inglis's biography, see Scott-Elliot and Yeo 1990, esp. pp. 12–14.

2. *Discours de la Foy*, HM 26068, Huntingdon Library, San Marino; translation from the French, Ziegler 2000, pp. 20–21.

3. Frye, S. 2010, p. 113.

4. Ziegler 2000, p. 33.

5. See Scott-Elliot and Yeo 1990, p. 41–42, no. 12; quotation, p. 42.

6. Frye, S. 2010, p. 106.

7. For the portrait, see Tarnya Cooper and Amy Orrack in Cooper, T. 2013, p. 178, no. 70.

8. For Horenbout, see Campbell, L., and Foister 1986. Susan Frye (2010, pp. 75–115) discusses Teerlinc and Inglis together.

Cats. 60, 61

1. Victoria and Albert Museum, London, M117-1984 (for which, see Glanville 1990, pp. 398–99); The Royal Collection / HM Queen Elizabeth II, RCIN 31773.

2. Schroder 1988, p. 55; Glanville 1990, p. 322.

3. See Chaffers 1883, p. 46.

4. Warrant, September 10, 1560, Add. MS 5751 A, fol. 206, British Library, London; Collins 1955, pp. 160, 549–50, no. 1425.

5. Glanville 1990, p. 110.

6. Both references appear in Nichols 1850, p. vi, the former citing Cotton MS Titus B IV, fol. 130r, British Library, London.

7. Collins 1955, p. 592, no. 1582. The cup apparently left the royal collection when James II presented it to H. Green of Rolliston, his Groom of the Stairs; see Glanville 1990, pp. 344–46.

8. See, for example, Lucia Meoni in Cleland 2014, pp. 313–15; Elizabeth Cleland in ibid., pp. 202, 212, 316–19, nos. 49, 53, 69.

9. For the Duttons, see Willoughby, L. 1911, pp. 4, 8; Willoughby, L. 1912, p. 79, illustrates the tankard, then still at Sherborne House.

Cat. 62

1. For sixteenth-century Europe's fascination with porcelain, see Impey 1989, pp. 179–82; Glanville 1990, pp. 340–51; Degenhardt 2013.

2. Pontano's *De splendore* (Naples, 1498) is translated and discussed by Evelyn Welch (2002); this quotation, p. 215.

3. Ibid., p. 212.

4. Collins 1955, pp. 590–91, nos. 1577, 1580.

5. Metropolitan Museum, 44.14.1–.5; all bear the mark of three trefoils slipped in a shaped shield, except for 44.14.5, which has no marks.

6. Oliver Impey (1989, p. 180) cites the will, signed at Sherborne Castle, Dorset, July 1597, drawn to his attention by George Wingfield Digby.

7. Cited and discussed in ibid.; Glanville 1990, pp. 342–44.

8. I am grateful to my Met colleagues Pengliang Lu, Associate Curator, Department of Asian Art, and Iris Moon, Assistant Curator, Department of European Sculpture and Decorative Art, for speaking to me about these works.

9. Victoria and Albert Museum, London, 7915-1862; see Glanville 1990, p. 466. This same mark also appears on silver presented by Elizabeth to the czar, still in the Kremlin silver collection; see Avery 1944, p. 271.

10. These examples, shared between private and public collections, include the Trenchard Bowl (Victoria and Albert Museum, London, M945-1983); see Glanville 1990, pp. 346–48, 446–47.

11. See ibid., p. 346.

12. Hakluyt's three-volume work is discussed by Degenhardt 2013, pp. 133, 150; this quotation, Hakluyt 1598–1600, vol. 2 (pt. 2), p. 91.

13. Degenhardt 2013, p. 147.

Cats. 63, 64

1. Edited and translated, Sneyd 1847, p. 29.

2. Ibid., pp. 42–43.

3. Cat. 63: *RW*, pellet below, in a shaped shield; cat. 64: possible capital *M* with line across.

4. See Glanville 1990, pp. 319–21.

5. For Elizabeth's canny development of her role as godmother, creating a close network of beholden godchildren, see Kruse 2017. For the Bowes-Hutton Cup, see Oman 1931.

6. See Liefkes 1997, p. 82.

7. For the Vintners' Company's association with swans, see Milbourn 1888, pp. 24–27.

Cat. 65

1. Melinda Watt in Morrall and Watt 2008, pp. 110–12, no. 1, posits that the miniature is not a portrait of the queen but perhaps one of her ladies-in-waiting, posing in Elizabeth's garments and jewels. Arnold 1988, pp. 32–33, discusses the Mildmay Charter (cat. 31) in relation to the Ashbourne Charter (D3397/1, Derbyshire Record Office, Matlock), the frontispiece to Georges de la Motthe's *Poems to Queen Elizabeth I* (MS Fr.e.1, fol. 7r, Bodleian Library, University of Oxford), and a drawing of Elizabeth I attributed to Hilliard in the Victoria and Albert Museum, London, P.9-1943, for which, see also Owens 2013, p. 15.

2. I am grateful to Cristina Balloffet Carr, Conservator, The Metropolitan Museum of Art, for sharing with me the results of her exhaustive investigation and technical analysis of this object.

3. Watt in Morrall and Watt 2008, p. 110.

4. Henry's needlework portrait of the unknown sitter with a sword and scepter and the miniature tapestry portrait of Queen Katherine are both listed in his 1547 posthumous inventory: Harley MS 1419, fols. 281r, 447v, British Library, London; Starkey 1998, pp. 303, 385, nos. 12883, 15405. The likeness of Margaret of Austria appears in the 1523 inventory of her possessions published by Michelant 1870, p. 83, and discussed by Cleland 2009a, p. 132.

5. Watt in Morrall and Watt 2008, p. 112.

Cat. 66

1. Lawson 2013, pp. 42, 63, 82, 98, 110, 124, 160, 232, 389, 412; nos. 59.163, 62.168, 62.175, 63.157, 64.141, 65.86, 67.161, 67.163, 71.158–59, 78.141, 89.63, 94.109.

2. The box is discussed in Patterson 2009, pp. 96–97; Lloyd, P. 2012, p. 553; Charlotte Bolland in Cooper, T. 2013, p. 124, no. 41b. For Leicester's inventories, see Goldring 2014, esp. p. 182 for this box. For Leicester's accounts, see Adams, S. 1995, esp. p. 93, listing 6 shillings, 2 pence "for ii boxis of cumsetts which your lordship gave to my Lord of Darbye."

3. For example, the "three dozen boxes of glass to put your comfits in" sent from Anne Rouard (Madame de Bours) to Lady Lisle in June 1538; see *L&P* 1862–1910, vol. 13, pt. 1, p. 438, no. 1181. I am grateful to Sarah Bochicchio for bringing this to my attention.

4. An excited Falstaff memorably urges, "let the sky rain potatoes; let it thunder to the tune of 'Green Sleeves'; hail kissing-comfits." For a mouthwatering account of sweetmeats ordered for a 1526 banquet at Greenwich, see *L&P* 1862–1910, vol. 4, p. 968, no. 2159 (thanks to Sarah Bochicchio for this reference). For the history of comfits, see Richardson, T. 2002, pp. 124–31; for their import by Italian merchants, Ruddock 1944, p. 199.

5. Museo Nazionale del Bargello, Florence, 289B. A comparable piece is in the Metropolitan Museum, 1975.1.1458; see Scholten 2011, p. 242.

6. For the armor (Metropolitan Museum, 04.3.205), see Pyhrr 2000, p. 24. For the pistol (Victoria and Albert Museum, London, M.949-1983), see Patterson 2009, pp. 99–100.

7. Raphael's drawing, Sodoma's variant in fresco, and responding prints by Gian Giacomo Caraglio and the Master of the Die were cited in manuscript painting (see Testa 2000, pp. 118–19) and tapestry design (see Standen 1985, p. 93; Elizabeth Cleland in Furlotti, Rebecchini, and Wolk-Simon 2019, pp. 202–5, no. 41).

Cat. 67

1. An inventory of Leicester's goods (Dudley Papers VI, fol. 3v, Longleat House, Warminster) includes two references revealing that the first of the set was completed by January 1585, at which time the others were still underway: "Memorandem the xiiith of Januarie 1585. One new peece for the banketting howse with Hickes to be called for when ye rest are made"; and "Three new peces bought of Hix: with my Lo Armes in the middell therof verie large & faire: made for the banqueting howse"; see Clark 1983, p. 283. For the banqueting house, see Goldring 2014, pp. 216–17.
2. Contrary to perception, the set probably always numbered three, not four; see Cleland and Karafel 2017, pp. 261–69. The two smaller tapestries (of which cat. 67 is one) are in the Burrell Collection, Glasgow (47.1, 47.2); the larger, in the Victoria and Albert Museum, London (T.320-1977).
3. For this trip, undertaken with his nephew Sidney, see Goldring 2014, pp. 132–36, 218–20.
4. For evidence of Netherlandish tapestry weavers working in London and elsewhere in England, see Hefford 2002, pp. 43–45; Turner 2012; Turner 2013.
5. For Leicester's efforts in this area, culminating in his invitation to become Governor General of the United Provinces of the Northern Netherlands in 1586, see Adams, S. 2002, pp. 225–32.
6. Examples are in the Metropolitan Museum (06.1030a, b), for which, see Standen 1985, pp. 177–79; the City Museum, Bruges (78.1.XVII), for which, see Delmarcel and Duverger 1987, pp. 224–27, nos. 11, 12; and the Art Institute of Chicago (1968.744), for which, see Brosens et al. 2008, pp. 222–24, no. 36.
7. See Wells-Cole 1983; Wells-Cole 1997, pp. 222–23.
8. See Cleland and Karafel 2017, p. 266.

Cat. 68

1. For embroiderers working in London for the Tudors and their circle, see Arnold 1988, pp. 189–92; Levey 2012, pp. 158–66.
2. Arnold 1988, p. 191, citing LC5/36, fol. 177, National Archives, Kew.
3. The Baynard's Castle inventory is Royal MS 7 F XIV, Art. 23, British Library, London; see Nichols 1855, p. 23. For Hardwick, see PROB 11/111/213, National Archives, Kew, in Boynton 1971, p. 32.
4. Respectively, Harley MS 1419, fols. 228r and 288v, British Library, London; see Starkey 1998, p. 278, nos. 12141, 12943.
5. For vestments and other textile church furnishings, see Monnas 2012c.
6. MS 129, fol. 468r, Society of Antiquaries of London; see Starkey 1998, p. 174, no. 8946.

Cat. 69

1. Levey 2012, pp. 154–55, 176–78, discusses the distinction between Gold of Venice (metal-wrapped silk core) and Gold of Damascus (metal wire), as well as the training, design sources, and surviving examples of sixteenth-century monochromatic needlework on linen. For fine linens in Henry VIII's households, see Monnas 2012a, p. 246.
2. Jane Seymour's sleeves appear (as item 2183) in an inventory of 1542, E315/160, fols.1r–2r, 94r–98v, National Archives, Kew (see Hayward, M. 2007, p. 182; Levey 2012, p. 156). They reappear in Henry VIII's 1547 posthumous inventory (Harley MS 1419, fol. 165r, British Library, London); for the quotation, see Starkey 1998, p. 251, no. 11323. The Westminster linens are listed in the 1547 inventory (fol. 110r; see Starkey 1998, pp. 218,

231, nos. 10409, 10410, 10412), and Henry's partelettes in MS 129, fol. 456v, Society of Antiquaries of London; see ibid., p. 169, no. 8739.
3. Stowe MS 557, fols. 9v, 24r, nos. 7, 90, British Library, London; see Arnold 1988, pp. 255, 270.
4. National Museum of Scotland, Edinburgh, A.1929.152; Art Institute of Chicago, 1945.161 and 1955.1221.

Cat. 70

1. For the tapestry's heraldry and later provenance, see Standen 1962; Standen 1985, pp. 180–84.
2. Contra Standen 1962, Standen 1985, and this author (see Cleland and Karafel 2017, pp. 256–57), the fact of Elizabeth's second marriage (noted in Berry 1830, pp. 130, 343; Cooper, W. 1850, pp. 96, 100) only recently came to light. Faced with the end of her male line, Constance chose to give the tapestry to a distant cousin, Judge Richard Lewknor of West Dean, rather than to one of her many stepbrothers from her mother's second marriage.
3. See Lower 1871, esp. p. 19; Mercer 1999.
4. For Enghien tapestry design, including *Children's Games*, as well as a set of *Armorials* made for Margaret of Austria, see Delmarcel 1980.
5. Judge Richard Lewknor of West Dean's will of 1614 bequeaths to his grandson Richard "the Carpet of Arras worke and Tapestrie with the Armes of the Lewkenors and some other of my Auncestors are wroughte, togeather with six Cushions of like wroughte worke withe the like Armes"; cited by Annabelle F. Hughes in written communication to The Metropolitan Museum of Art, July 31, 2007, object file, Department of European Sculpture and Decorative Arts.

Cat. 71

1. Harley MS 1419, fols. 137r, 142r, British Library, London; see Starkey 1998, pp. 242–43, nos. 10807, 10879.
2. PROB 11/111/213, National Archives, Kew; see Boynton 1971, p. 27.
3. See Jervis 2016, pp. 87–90; p. 88, for condition.
4. For Du Cerceau's furniture designs, see Jervis 1974, pp. 60, 61; Rosenfeld 1989, p. 132. For his wider oeuvre, see Guillaume and Fuhring 2010. On the vogue for furniture after Du Cerceau, both authentic sixteenth-century pieces and nineteenth-century pastiches, see Koeppe 1994.
5. Suggested by Jackson-Stops 1985, p. 108.
6. For the table and cabinet, the Shrewsburys' conflict of ownership, and the role of Mary, Queen of Scots, see Bostwick 1995.
7. List of property submitted to the queen's commissioners as part of divorce proceedings, 1586; State Paper Office, State Papers Domestic, Elizabeth I, SP 12/207, fol. 59, National Archives, Kew; see Bostwick 1995, p. 4.
8. For the Shrewsburys' taste for French art, see Bostwick 1995, pp. 3–4. Jervis 2016, p. 90, reports the fanciful story that Elizabeth confiscated Mary's shipment.

Cat. 72

1. See in particular Williams, A., and de Reuck 1995, p. 108; Williams, A. 2002, pp. 797–98.
2. Pyhrr 2012, p. 33, calls it "the best preserved and most complete Greenwich armor known"; it was "probably a royal present," according to *The Renaissance in the North* 1987, p. 158.
3. Noted in context by Patterson 2009, pp. 7, 44–49.
4. For the album, see Dillon 1905.
5. See Grancsay 1957.

Cat. 73

1. For Cumberland's biography, see Spence 1995; Holmes 2004.
2. Spence 1995, p. 94.
3. See Christina Faraday in MacLeod 2019b, pp. 84–85, no. 21.
4. See Strong 1983a, p. 106.
5. Cited in Spence 1995, p. 94; see Williamson, G. 1920, p. 109.
6. Cited in Holmes 2004; see Williamson, G. 1920, p. 17.
7. For the *Great Picture*, see Hearn 2009.

Cat. 74

1. See Goldring 2019, p. 229; also Auerbach 1961, p. 115.
2. Goldring 2014, pp. 89, 92, 123–64, 220.
3. Bibliothèque Nationale de France, Paris, Rés. NA-22 (12)–boîte écu.
4. See Ford 2004.
5. Bindoff 1981.
6. Korkow 2013, p. 38.
7. Strong 1977, pp. 206–12, appendix 1. Although the first of the Accession Day tilts was probably held in 1572, the surviving lists of participants commence only in 1584. Mildmay's nephew, Sir Henry Mildmay, competed in the Accession Day tilt of 1621; see Knowles 1999.
8. Lady Grace Mildmay's autobiographical papers, written 1617–20, are published in Martin 1994; this quotation, p. 73. See also Pollock 1993, p. 41 (spelling modernized). According to Jean Wilson (1980, p. 28), "Elizabethan jousts were run on the same lines as those of the years jousting was at its most popular in England . . . and not on the pattern of later jousts from which most of the danger had been removed (this was especially true after Henry VIII had nearly, and Henri II of France actually, been killed in jousting accidents, both through the failure of their opponents to lower the point of their lance, so that the kings were struck on the face through the visor)." Presumably a similar accident befell Mildmay.
9. National Portrait Gallery, London, NPG 6241; see Hammer 1999, p. 206. A similar tent appears in Daniël van den Queborne's 1587 portrait of Sir William Drury, one of Leicester's officers in the Netherlands campaign; Yale Center for British Art, New Haven, B1973.1.15.
10. Thornton 1971, pp. 68–69.

Cat. 75

1. For the tapestry's design sources, dating, and regional attribution, see Cleland and Karafel 2017, pp. 254–60.
2. For example, Victoria and Albert Museum, London, 710-1904, T.134-1928, and T.151-1930; and Burrell Collection, Glasgow, 9.138.
3. Cleland and Karafel 2017, p. 258, citing Keith Lovell.
4. See Vegelin van Claerbergen 1999. For the Luttrells, see Lyte 1909, pp. 122–65.
5. Based on dye analysis, for example, of the comparable, English-attributed *Hunters in a Landscape* (Metropolitan Museum, 2009.280; see Cleland 2010), the brilliant yellows of which are owing to the use of dyers' broom, unusual in Netherlandish tapestries of the period. I am grateful to my Met colleague Nobuko Shibayama, Research Scientist, for undertaking this analysis and discussing the results with me. For Netherlandish tapestry weavers in London, see Turner 2013.

Hans Holbein and the Status of Tudor Painting (pp. 190–93)

1. Lucy Harington, letter to Lady Jane Cornwallis Bacon, March 7, 1618; D/Dby C19 fols. 81–82, Essex Record Office, Chelmsford; cited in Hearn 2003, pp. 225–26.
2. Ibid., p. 225.
3. Thomas Howard, Earl of Arundel, letter to Sir Dudley Carleton, September 17, 1619; Hervey 1921, p. 162. For Arundel's collecting of and taste for Holbein, see also Orgel 2000.
4. Haydock, "To the Reader," in Lomazzo 1598, unpaged.
5. Preface to *Anecdotes of Painting in England*, in Walpole 1762–80 (1849 ed.), vol. 1, p. ix.
6. See, for example, Strong 1967; Strong 1969a; Strong 1977.
7. Much of this scholarship was inspired by the milestone of Hearn 1995. For the findings of the seven-year *Making Art in Tudor Britain* project (The National Portrait Gallery, The Courtauld Institute of Art, and The University of Sussex), see Cooper, T., et al. 2015. The archival discoveries of Elizabeth Goldring and Edward Town, cited throughout this volume, have been particularly revelatory.
8. For an excellent introduction to the state of the field, see Cooper, T., and Howard, M. 2015, esp. pp. 7–10.
9. See Scott, J. 2013; Hepburn 2015; Bolland and Chen 2019.
10. See Cooper, T. 2012; Tittler 2012.
11. Foister 2004, p. 9.
12. Ibid., pp. 130–37.
13. Ibid., p. 18.
14. See Bätschmann and Griener 1997, esp. chapter 1, "Artistic Competition and Self-Definition," pp. 13–35.
15. For a version of this narrative focused on one particular patron, see Hille 2012.
16. Goldring 2014, p. 15.
17. This practice dated at least to the mid-fifteenth century; see Foister 2004, p. 19.
18. Ibid., p. 22.
19. MacLeod 2019a, p. 11.
20. Another was the limner Susanna Horenbout, who had been praised by both Albrecht Dürer and Giorgio Vasari, but whose body of work is difficult to reconstruct today; see Campbell, L., and Foister 1986. See also cat. 12 in this volume.
21. Hilliard 1983, p. 19. Hilliard may have first encountered Holbein's work as a child in the form of two miniatures owned by Katherine Bertie, dowager Duchess of Suffolk. Like the young Hilliard, the duchess was a Protestant exile in the German town of Wesel during the reign of Mary I; see Goldring 2019, pp. 45–47.
22. Hilliard 1983, p. 19.
23. For a recent discussion of Hilliard's technique, see Button, Coombs, and Derbyshire 2019.
24. Hilliard 1983, p. 28. See also the discussion in Kury 1995.
25. Goldring 2019, p. 133.
26. Rowlands 1985, pp. 239–40, no. RM3.
27. Van Mander 1604 (1994–99 ed.), vol. 1, fol. 221v.
28. Ibid., fols. 221v–222r. For the accuracy of Van Mander's "clearly fictitious" but suggestive account of Holbein's English career, see Foister 2004, p. 9.
29. Such anecdotes about class conflict in the studio became a staple of seventeenth-century art writing; see Eaker 2018.
30. Van Mander 1604 (1994–99 ed.), vol. 1, fols. 222v–223r.
31. For Constable's sonnet, see MacLeod 2019a, p. 12.
32. Van Mander 1604 (1994–99 ed.), vol. 1, fol. 223r.
33. On Zuccaro's portrait drawings of Elizabeth I and Robert Dudley (cats. 107, 108 in this volume), see Karen Hearn in Hearn 1995, pp. 152–53, nos. 99–100.

Fashioning the Courtier (pp. 194–97)

1. For discussions of this passage, see Greene 1995; and Stallybrass and Jones, A. 2001, esp. pp. 115–16.
2. Hayward, M. 2016, esp. pp. 225–26.
3. Bill of indictment of Henry Howard, 1547, in *L&P* 1862–1910, vol. 21, pt. 2, p. 365, no. 697; cited in Bolland 2015, p. 352. See also Moore 2001.
4. For the satin coat, see Brigden 1994, p. 529.
5. Hayward, M. 2009, p. 139.
6. See Goldring 2015.
7. Sessions 2003, pp. 340–41.
8. Sir Thomas Hoby (translator), *The Courtyer of Count Baldessar Castilio* (1561); cited in Strong 2019, p. 159.
9. See Goldring 2012.
10. See Greenblatt 2005.
11. Ibid., p. 154.
12. Naunton 1641, p. 38.
13. For the cultural significance of the codpiece, see Lüttenberg 2005.
14. For an early political crisis revolving around access to the Privy Chamber, see Walker, G. 1989.
15. See Bertrand de Salignac, letter to Catherine de' Medici, May 24, 1572; Teulet 1840, vol. 4, p. 462; cited in Goldring 2004a, p. 111n28 (her translation).
16. See Merton 1992; Howey 2007.
17. Hammer 2000.
18. Margetts 1988.
19. For Lady Rich's biography, see Wall 2004.
20. For the miniature, see Christina Faraday in MacLeod 2019b, pp. 78–79, no. 18.
21. In addition to Greenblatt 2005, see Nagel 2004.
22. See Vincent 2003, esp. chapter 4, "None Shall Wear," pp. 117–52; Hayward, M. 2009.
23. Jones, A., and Stallybrass 2000, p. 34.
24. Gent 2005, pp. 90, 99.
25. See Goldring 2005; Strong 2019, esp. the chapter "The Perturbations of Melancholy: The World out of Square," pp. 136–55.

Icons of Rule (pp. 198–201)

1. Strachey 1928, p. 10.
2. For other overviews of the politics of Tudor royal portraiture, see Howarth 1997, esp. chapter 3, "The Royal Portraits: The Tudors," pp. 77–119; Sharpe 2009.
3. Henry's wish was reported by Dr. Roderigo Gonzalva de Puebla in a dispatch to Ferdinand of Aragon and Isabella of Castile, July 1488; *CSP Spain* 1862–1954, vol. 1, p. 11, no. 21; cited in Hepburn 2015, pp. 344–46. Hepburn (p. 346) discusses the probable arrival of a portrait of Arthur at the Spanish court in 1489.
4. Scott, J. 2013, p. 25.
5. See Daunt 2015.
6. Bolland and Chen 2019.
7. For the Whitehall portrait and its copies, see Brooke and Crombie 2003.
8. Foister 2004, p. 196.
9. Van Mander 1604 (1994–99 ed.), vol. 1, fol. 222r (translation modified).
10. "Je prie Dieu que il luy done bone vie et longue"; John Clerk, dispatch to Henry VIII, June 10, 1527, Cotton MS Caligula D X, fol. 121, British Library, London; see *L&P* 1862–1910, vol. 4, p. 1441, no. 3169; cited in Richardson, G. 1996, p. 165. I am grateful to Professor Glenn Richardson of Saint Mary's University, Twickenham, for providing me with this reference.
11. Arnold 1988, pp. 42–43.
12. See Woodall 1991.
13. See Hackett 2017.
14. On the link between Elizabeth's portraits and courtly pageantry, see Goldring 2007.

15. Proclamation prohibiting portraits of the Queen (draft), 1563; *TRP* 1964–69, vol. 2, pp. 240–41, no. 516; cited in Montrose 1999, p. 109.
16. Warrant of the Privy Council to her Majesty's Serjeant-Painter, July 1596, *APC* 1902, p. 69.
17. Sir Edward Stafford to Sir Francis Walsingham, November 17, 1583; *CSP Foreign, Elizabeth* 1863–1950, vol. 18, p. 218, no. 246.
18. Ibid.

Cat. 76

1. The drawn portrait is in the Royal Collection / HM Queen Elizabeth II, RCIN 912205. The bust was identified in 1803 as "Fisher bishop of Rochester" by the son of the first documented modern owner, who purchased it and its companions about 1769; see Smith, J., and Hawkins 1807, pp. 21–23. Although the identification as Fisher has been largely accepted, Grossmann 1950 and Hepburn 2001 reject it.
2. See Cressy 1976; Rossiter 2014, pp. 8–26.
3. Fisher's funeral sermon for Henry VII is published in Hymers 1840, pp. 135–59; these quotations, pp. 136–37, 141.
4. See Cox and Forrest 1931, pp. 165–68.
5. See the owners' account cited in note 1 above.
6. Verbal communication to the author, June 12, 2019, from Jack Soultanian, Jr., Conservator, Department of Objects Conservation, The Metropolitan Museum of Art.
7. For traces of original paint on this bust's costume, see Smith, J., and Hawkins 1807, p. 22; Walford 1879, vol. 2, p. 268. Dow 1960 conversely asserts the bust to be of a young Henry VIII, as does Galvin and Lindley 1988, which posits that the livery confirms the identification.
8. Weinberger 1944, pp. 4–6.
9. Suggested by Darr 1992, p. 121, and repeated by Hepburn 2001; Darr 2012, p. 51. For Torrigiano's connections to Bardi, see Darr 1992.
10. Galvin and Lindley 1988, p. 902, identifies irregularities that reveal the effigy to be an Italian rather than English construction.
11. A new biography of Torrigiano is forthcoming from Felipe Pereda of Harvard University. For Torrigiano's work for Margaret of Austria, see Cochin 1914–19. Galvin and Lindley 1988, pp. 895–99, reveals how casts from Henry VII's death mask were used in the creation of both the Victoria and Albert Museum bust and the Westminster effigy. Sicca 2006, pp. 15–16, explores the ramifications of Torrigiano's departure from London on the Florentine merchants.
12. For the busts as part of an attempt to win the commission, see Galvin and Lindley 1988, p. 901, citing Alan Phipps Darr's unpublished PhD dissertation; Darr 1992, p. 121; Hepburn 2001; Darr 2012, p. 51. For Fisher's role as executor of Beaufort's will, see Scott, R. 1915.
13. For the Beaufort tomb, see Scott, R. 1915. For Henry VII's tomb, see Darr 1992, pp. 121–22. For the roles of Cavalcanti and the Bardi, see Sicca 2006, pp. 10–16.
14. For Torrigiano's work for John Islip, abbot of Westminster, for John Yonge, and for Sir Thomas Lovell, see Darr 1979; Darr 2012, pp. 57, 59, 61. For his lost bust of John Colet, dean of Saint Paul's Cathedral, see Grossmann 1950.

Cats. 77, 78

1. Colding 1953, p. 65.
2. Roy C. Strong in Murdoch, J., et al. 1981, p. 31.
3. See Evans, M. 2005.
4. For this episode, with references to previous literature, see Buck 2008, esp. pp. 191–92.

5. John Clerk, dispatch to Henry VIII, June 10, 1527; Cotton MS Caligula D X, fol. 121, British Library, London; *L&P* 1862–1910, vol. 4, p. 1441, no. 3169; cited in Richardson, G. 1996, p. 165. I am grateful to Professor Glenn Richardson of Saint Mary's University, Twickenham, for providing me with this reference.
6. For the Clouet, see Vanessa Remington in Heard and Whitaker 2011, p. 202, no. 92.
7. The attribution to Horenbout was first persuasively argued in Colding 1953; for Horenbout and Holbein, see van Mander 1604 (1994–99 ed.), vol. 1, fol. 222v.
8. For the documentary sources, see Campbell, L., and Foister 1986.
9. Strong in Murdoch, J., et al. 1981, p. 31.

Cat. 79

1. For an overview of Holbein's work for the Steelyard, see Petter-Wahnschaffe 2010.
2. For these portraits, see Foister 2004, pp. 206–14.
3. This entry is based on Maryan W. Ainsworth's extensive discussion in Ainsworth and Waterman 2013, pp. 133–37, no. 30.
4. See Petter-Wahnschaffe 2010, pp. 85–92.
5. Ibid.
6. Ibid.
7. Ainsworth and Waterman 2013, p. 137.

Cat. 80

1. For a modern biography, see Ackroyd 1998. More's portraits are catalogued in Morison 1963.
2. For Holbein and More, see Foister 2004, esp. pp. 11, 110, 247–51; on humanist gifts of portraits, see Jardine 1995.
3. Xavier F. Salomon in Mantel and Salomon 2018, p. 59.
4. See Smith, D. 2005; this quotation, p. 484.
5. Salomon in Mantel and Salomon 2018, p. 52.
6. For such chains of office in Holbein's portraits, see Foister 2004, pp. 231–32.
7. Cited in Salomon in Mantel and Salomon 2018, p. 60.
8. Foister 1981, esp. p. 278.
9. Hilary Mantel in Mantel and Salomon 2018, p. 11.
10. For the technique of these paintings, see Roy and Wyld 2001. *The Ambassadors* is in the collection of the National Gallery, London, NG1314.
11. For some of these copies, see Morison 1963, pp. 11–15.
12. Museo Nacional del Prado, Madrid, P001688; see Belkin 2009, vol. 1, pp. 136–43, no. 58.

Cat. 81

1. For Cheseman's biography, see Benger 1965; Quentin Buvelot in Buck and Sander 2003, p. 100, no. 19.
2. For this painting, see Buvelot in Buck and Sander 2003, pp. 140–42, no. 36.
3. For one suggestive account, see Wolfthal 2004.
4. Wyatt 1981, p. 101.
5. For the inscription, see Buck and Sander 2003, p. 169n1, no. 19.
6. Foister 2004, p. 12.
7. Buvelot in Buck and Sander 2003, p. 100, no. 19. *The Ambassadors* is in the collection of the National Gallery, London, NG1314.
8. For these provenances, see Buck and Sander 2003, pp. 169, 175, nos. 19, 36.

Cat. 82

1. See Ainsworth 1990; Button 2015; Bätschmann 2019.
2. See Foister 2004, pp. 247–51.

3. Parker, K. 1983, p. 36, no. 4.
4. Lewis 1998, p. 16.

Cat. 83

1. For a foundational reassessment of Anne's life and legacy, see Ives 2004.
2. British Museum, London, M.9010.
3. For a survey of the evidence for Anne's appearance and portraits, see Ives 2004, pp. 39–44.
4. Rowlands and Starkey 1983, esp. p. 91; Foister 2004, pp. 24–25. For doubts about Cheke's accuracy, see Ives 2004, p. 41.
5. Ives 2004, p. 40.
6. Hayward, M. 2007, p. 169.
7. For the fountain, see Foister 2004, p. 138.
8. An argument advanced in Rowlands and Starkey 1983.

Cats. 84, 85

1. This and other biographical details from Beer 2004. For Chapuys's letter to Charles V, see *L&P* 1862–1910, vol. 7, pp. 484–85, no. 1257.
2. *L&P* 1862–1910, vol. 12, pt. 2, p. 339, no. 972.
3. Ibid., vol. 10, p. 374, no. 901.
4. The drawing may originally have been larger, as it has been trimmed on all sides. A strip of paper 2⅝ inches (6.8 cm) wide has been added at the bottom edge, on which the hands and a portion of the arms have been drawn.
5. According to Ainsworth 1990, p. 181, the pen-and-ink lines are by Holbein himself, "quite possibly obscuring metalpoint lines used for transfer" of the design.
6. Parker, K. 1983, p. 47; Foister 2006, p. 99, no. 107; see also Ariane van Suchtelen in Buck and Sander 2003, p. 115, nos. 26–28.
7. Strolz 2004, pp. 11–12.
8. See van Suchtelen in Buck and Sander 2003, p. 114.
9. *Princely Magnificence* 1980, p. 65, no. 55.
10. Several of Holbein's designs for royal jewels exist, although none of the pieces themselves has survived; see Rowlands 1993, vol. 1, pp. 152–76.
11. Stephanie Buck, in Buck and Sander 2003, pp. 28–29.
12. Mauritshuis, The Hague, 278.
13. For a detailed discussion of the Mauritshuis painting, see van Suchtelen in Buck and Sander 2003, esp. p. 118.

Cat. 86

1. Foister 2004, p. 15.
2. Jones, A., and Stallybrass 2000, p. 17; see also Hayward, M. 2009, pp. 138–49.
3. Foister 2006, p. 47, nos. 39, 40.
4. Ainsworth and Waterman 2013, pp. 138–39, no. 31.
5. Ibid., p. 139; for the portrait of Melanchthon, see Foister 2006, p. 139, no. 151.

Cats. 87, 88

1. Foister 2004, p. 38; Erasmus 1906–58, vol. 10, p. 193, no. 2788.
2. Van Mander 1604 (1994–99 ed.), vol. 1, fol. 222v. In the original Dutch, Van Mander uses the term *verlichterije*, which more vividly conveys the sense of limning or illumination.
3. For Margaret Roper's biography, see Bowker 2004.
4. For recent scholarly analysis of Roper's translations and significance, see Goodrich 2008; Goodrich 2014, pp. 29–66.
5. For William Roper's biography, see Trevor-Roper 2004.

Cat. 89

1. For the coronation, see Kipling 1997; Ives 2004, pp. 172–83.
2. See Hackett 2017.
3. Hall 1809, p. 801.
4. Petter-Wahnschaffe 2010, pp. 119–32.
5. Buck 1997, p. 315.
6. Ives 2004, pp. 18–36.
7. Petter-Wahnschaffe 2010, p. 129.

Cat. 90

1. Koepplin 2006, p. 80.
2. Foister 2004, p. 155.
3. Národní Galerie, Prague, O 10732; see Foister 2004, p. 156; see also Koepplin 2003, pp. 148–50.
4. Foister 2004, p. 158.
5. Weniger 2004, p. 124; Koepplin 2006, pp. 90–91. The "Pseudo-Tory" woodcut, which exists in a single exemplar (Bibliothèque Nationale de France, Paris, Rés. AA3), has been variously dated between the early 1520s and the early 1550s. See Fleck 2010, p. 480, no. 90.
6. Koepplin 2003, pp. 149–50; Weniger 2004, p. 129; and Koepplin 2006, p. 90.
7. Foister 2006, p. 134; the X-radiograph is reproduced in Koepplin 2006, fig. 2.
8. In all other versions of the composition, John the Baptist points to the scene of Christ's crucifixion.
9. See Foister 2004, p. 154. The painting was previously attributed to the German Renaissance painter Michael Ostendorfer; see Grossmann 1961. Dates proposed for the painting have ranged from 1524/25 to 1537 or later; see Fleck 2010, pp. 81–92.
10. Although Holbein stopped in the Netherlands (where Baltic oak panel supports were common) en route to England in 1532, it is unlikely he was there long enough to have made any paintings (*pace* Fletcher and Cholmondeley Tapper 1983, pp. 89, 92, where the panel is proposed as having been executed in Antwerp about 1526; Foister 2004, p. 258. He may have brought oak panels to England with him from the Netherlands.
11. Rowlands 1985, p. 143, no. 56.
12. Dieter Koepplin (2006, p. 424) and Miriam Verena Fleck (2010, pp. 499–501) list five copies of the composition (four on panel, one on canvas); Koepplin conjectures that they originated in the Netherlands in the seventeenth century, when the painting was brought to Amsterdam (and subsequently Antwerp) by the Earl of Arundel. There is also an early copy with an illusionistic painted frame at Berkeley Castle; my thanks to Stephen Lloyd and Tico Seiffert for drawing my attention to this copy.

Cat. 91

1. For an overview of the subject's iconography, see de Meyer 1967.
2. For a wide-ranging discussion of the reformation of the devotional image, see Koerner 2004.
3. Strong 1966, esp. p. 233.
4. Sold Sotheby's, London, July 4, 1990, lot 39; for the picture's dating, see Wouk 2018, p. 600, no. 140.
5. Cooper, T., and Walker, H. 2015, esp. p. 230.
6. Gundestrup 1991–95, vol. 1, p. 371.
7. For the painting, see Karen Hearn in Hearn 1995, pp. 74–75, no. 30.
8. Jones, R., and Townsend, J. 2003–5.

Cat. 92

1. For the Dacres, see Barrett-Lennard 1908, pp. 192–207; Foister 1986.

2. Barrett-Lennard 1908, p. 196.
3. Owing to a legal loophole, the family lands were not forfeited but only placed in the possession of the king during the three-year-old heir's minority; ibid., p. 206.
4. Ibid.; see also *L&P* 1862–1910, vol. 16, p. 466, no. 953.
5. Foister 1986; Honig 1990.
6. As pointed out in Honig 1990, p. 60.
7. Harris, B. J. 2010, p. 734.
8. Susan Foister in Campbell, L., et al. 2008, p. 202, no. 58.
9. Honig 1990, p. 70.

Cat. 93

1. Von Bülow 1895, p. 235. Later visitors were also drawn to the painting's conceit; for a list of sixteenth- and seventeenth-century reactions, see Strong 1969b, vol. 1, pp. 89–90.
2. National Gallery, London, NG1314. On Holbein's skull, see (among others) Foister, Roy, and Wyld 1997, pp. 44–57.
3. Simon 1996, p. 150.
4. The inscription was recorded by George Vertue in 1713 (cited in Strong 1969b, vol. 1, p. 90), but the frame was subsequently painted over, and the inscription is presently visible only in X-radiographs. See "King Edward VI" 2007; Cooper, T., et al. 2015, p. 48. A visible inscription around the portrait image reads "TAIS·SVÆ·9 / AN.° DI. 1546."
5. Biographical information on Scrots from MacLeod 2004; Town 2014, p. 165. It may be that Scrots's prior experience as a court painter on the Continent allowed him to command a salary more than double that paid to Holbein.
6. The landscape is thinly and rapidly painted and, while contemporary with the rest of the image, was probably executed by another hand.
7. For the mathematics behind Scrots's image, see most recently Hunt and Sharp 2015. For information from technical analysis undertaken as part of the National Portrait Gallery's "Making Art in Tudor Britain" project, included in its Tudor and Jacobean Portraits Database, see "King Edward VI" 2007.

Cats. 94, 95

1. For the medal's Habsburg context, see Luke Syson in Campbell, L., et al. 2008, p. 284, no. 96; Attwood 2003b, pp. 17–18, 47, 63–64, 88, 118–20, nos. 76–80.
2. Vasari 1568 (1996 ed.), vol. 2, p. 72.
3. The inscription reads "CECIS VISUS TIMIDIS QUIES." Evelyn 1697, pp. 90–91, drew the connection to the psalm; see also Syson in Campbell, L., et al. 2008, p. 284.
4. The second gold cast, formerly in the Lawrence R. Stack Collection of Important Renaissance Medals, New York, was sold by Morton & Eden Ltd., in association with Sotheby's, at the Stack sale, Sotheby's, London (December 9, 2009), lot 136, subsequently passing into an American private collection. For Jacopo's December 1554 correspondence with Granvelle, in which the silver medal of Mary is called "the third" of its kind, see Syson in Campbell, L., et al. 2008, p. 284. Among numerous surviving editions are three examples in The Met's collection, all of about 1555; two are in bronze (36.110.21; 1975.1.1293) and one in lead (36.110.22).
5. A gilded-bronze cast, apparently also chased by Jacopo, is in the British Museum, London, M.6830.
6. Cited and discussed by Zimmerman 1971, p. 646.

Cats. 96, 97

1. For the use and importance of the Great Seal and its distinction from the Privy Seal (a physically smaller, occasional substitute thereof), see Lyte 1926, pp. 1, 103, 300–303.
2. Discussed in detail by Ailes 2018, p. 98.
3. Sharpe 2009, p. 276.
4. Mary's first seal is attached, for example, to the February 1556 Great Charter of Liberties, confirming the rights of the College of Saint George (SGC X.3.7, College of Saint George, Windsor Castle).
5. An impression of the Great Seal of Henry VIII is in the British Museum, London, OA.1574.
6. Discussed in depth by Libert 2018, pp. 5–6.
7. Illustrated in an anonymous print, dated 1632, in the British Museum, London, 1871,1209.2129.
8. Royal memorandum, July 8, 1584, *CSP Domestic, Elizabeth* 1856–72, vol. 8 (Addenda, 1580–1625), p. 125, no. 86.
9. Morgan 2004 analyzes Elizabeth's handling of the subjugation of Ireland.
10. See Ailes 2018, p. 97.
11. For the work and payments, see the account roll of Charles Anthony, Graver of the Mint, for May 22, 1600–September 30, 1609; Declared Accounts of the Exchequer, Pipe Office (E 351/2890), Audit Office (AO½120), National Archives, Kew; quoted and discussed in Blakiston 1948.

Cat. 98

1. For Surrey's biography, see Sessions 2003; his downfall is vividly detailed in Brigden 1994.
2. Surrey 2012, p. 46, poem 36.2–3; discussed in Irish 2018, p. 68.
3. For the motto, see Sessions 2003, pp. 3–4.
4. Bolland 2015.
5. Ibid., p. 358.
6. Ibid., pp. 355–57.
7. Ibid., p. 357.
8. Brigden 1994, p. 530.
9. Moore 2001; the actual arms of Edward the Confessor do not appear in this portrait, which may be one reason for its survival.
10. Sessions 2003, pp. 333–51.
11. Brigden 1994, p. 529.
12. Cited and discussed in ibid., p. 530; see also Brigden 2012, pp. 527–30. For the poem, see Wyatt 1981, p. 86, sonnet 29. This shared Petrarchan heritage is a more likely explanation of the overlap in imagery between the Surrey portrait and those by Moroni than the attribution tentatively proposed by Bolland.
13. On signifiers of melancholy in Elizabethan portraiture, see Goldring 2005.

Cat. 99

1. The date appears in an inscription at upper left, which reads in full: ".FRANCOIS.DVC. DALENCON./.EAGE.DE.XVIII. ANS LE.XIX.^E/.IONR.DE.MARS.AN.I.5.7.2/.FILS.DE. HENRŸ. II^E.DE CE./NOM.ROŸ. DE.FRANCE."
2. Goldring 2019, p. 139.
3. Ibid.; Navarre's words were recorded in the memoirs of the baron de Rosny (the future duc de Sully); see Sully 1970, pp. 92–93.
4. For the politics driving marital negotiations between Elizabeth and d'Alençon, see Mears 2001.
5. Correspondence of Bertrand de Salignac de la Mothe Fénélon; see Teulet 1840, vol. 4, pp. 461–62; translation, Goldring 2004a, pp. 110–11n28. Elizabeth worried that the twenty-year discrepancy in age was too great an obstacle to a successful alliance.

6. The portrait was first recorded in the collection of the Earl of Darnley at Cobham Hall, Kent, in 1851; see John O. Hand in Conisbee et al. 2009, p. 226.
7. Goldring 2004a.
8. The portraits of d'Alençon were in Leicester's collection as early as 1578; see Goldring 2004a, p. 109, with the quoted inventories (Dudley Papers IX, fol. 20r, and VIII, fol. 32r, Longleat House Archives, Wiltshire); Goldring 2014, pp. 79–83, 266.

Cat. 100

1. Slashes were also called "dagges," a term for a sharp blade, indicating that the fashion may have originated on the battlefield. See Denny-Brown 2004; Patterson 2009, p. 38.
2. Stubbes 1583 (1877–82 ed.), vol. 1, p. 55.
3. Giovanni Michele, dispatch to the Venetian Senate, May 13, 1557, *CSP Venice* 1864–1947, vol. 6, p. 1048, no. 884.
4. Capwell 2012, p. 125.
5. For similar doublets, now scattered in collections across Europe, see von Kienbusch and Grancsay 1933, p. 11; Arnold 1979.
6. See Low 2003. For a study of "civility" and early modern manners, see Bryson 1998.
7. Bryson 1998, p. 55.
8. Low 2003, p. 9; Butler 2015. See also Bailey 2007, pp. 45–49.
9. Proclamation regulating the use of guns and armor, July 26, 1579; *TRP* 1964–69, vol. 2, p. 444, no. 641.
10. See Jones, A., and Stallybrass 2000. See also "Fashioning the Courtier" in this volume.

Cat. 101

1. I have used here the transcription of the ambassador's name from Arabic sources provided in Matar 1999, p. 33.
2. For an account of the embassy, see Brotton 2016, pp. 1–8 and 267–76. For a broader discussion of the complex diplomatic exchanges between Elizabeth and al-Mansur, see MacLean and Matar 2011, pp. 49–61.
3. Rowland White, undated letter to Sir Robert Sidney, in Collins, A. 1746, vol. 2, p. 112.
4. See Brotton 2016, pp. 272–73.
5. For the etching, see Nadine M. Orenstein in Jenkins, Orenstein, and Spira 2019, pp. 86–88, no. 36.
6. For which, see Jane Eade in Cooper, T. 2013, pp. 114–15, no. 34.
7. See Harris, B. 2000.
8. For an account of another Moroccan resident of Elizabethan London, the servant Mary Fillis, see Kaufmann 2017, pp. 134–68.

Cat. 102

1. See Hearn 2002.
2. For Ellen Maurice's biography and background, see Bulkeley-Owen 1892, esp. pp. 7–15; Wynne 1876. The inscription on the painting is significantly later.
3. See Roberts, P. 1998.
4. For De Critz, see the biography in Town 2014, pp. 65–68.
5. The sitter's will is preserved in the National Archives, Kew; see PROB 11/150/17.
6. Bonhams 2017, lot 36.
7. Brogyntyn MS 1.3; I am grateful to Professor Gruffydd Aled Williams of the University of Wales, Aberystwyth, for examining these poems and confirming their contents.
8. Quoted in Jones, E. 1949, p. 7.

9. I am grateful to my Met colleague Michael Gallagher, Sherman Fairchild Chairman of Paintings Conservation, for discussing the conservation of this work with me.

Cat. 103

1. For more on the construction of these gloves, see Cristina Balloffet Carr in Morrall and Watt 2008, pp. 99–106. See also Morris, F. 1929.
2. See Stallybrass and Jones, A. 2001.
3. Peacham 1612 (1973 ed.), p. 142. See also Ashelford 1988; Elizabeth MacMahon and Melinda Watt in Morrall and Watt 2008, p. 180, no. 34.
4. Strong 1993, p. 116.
5. Lawson 2013, p. 414, no. 94.144.
6. There are two two versions of the portrait, one in the Devonshire Collection, Chatsworth, and one in the collection of the Marquess of Bath at Longleat House. For the parrot-familial relationship in the Chatsworth version, see Verdi 2007, p. 52.
7. Reynolds, A. 2013, p. 62.
8. "tres-belles & tres-blanches," in the words of Louis Aubery du Maurier, *Mémoires pour servir à l'histoire de Hollande* (1680); see Arnold 1988, p. 11.
9. Stallybrass and Jones, A. 2001, pp. 124–25.
10. Ashelford 1988, p. 51; Arnold 1988, p. 217. For gift examples, see Lawson 2013, esp. p. 511, nos. 03.184, 03.187–207. For gifting practice, see Klein 1997.
11. O'Hara 2000, p. 76.
12. Ibid., p. 66.

Cats. 104, 105

1. Eglestone's "An Instruction for Christians" was published by Thomas Bentley as part of the collection of religious texts *The Monument of Matrones* (1582). See White 1999; White 2005; Micheline White in Levin, Bertolet, and Carney 2017, pp. 310–11.
2. For Pembroke's biography, see Sil 1988.
3. "DRACO HIC VER' VIRTUTU CUSTOS." Pembroke's third wife was Mary Sidney. For the gardens at Wilton, see Whitaker 2014.
4. For Van Herwijck's biography, see Muller 1922; Tourneur 1922; Attwood 2003a.
5. The portrait medal of Maria Newce is in the British Museum, London, M.6871. For the Dimocks and their connections to Antwerp artists, see Walker, H. 2013, p. 68.
6. Almost all the medals are in the British Museum: M.6870 and 1875,1006.1 (both Withipool), M.6868 (Stanley), and 1844,0425.6 (Marchioness of Northampton). Though the medal of the marquess is not known to survive, its appearance is recorded in an electrotype (British Museum, 107). The medal of Heneage is not known to survive but was copied in a drawing by George Vertue, for which, see Hill, G. 1908, pl. 2.1. See also Alicia Meyer in Levin, Bertolet, and Carney 2017, p. 511.
7. "conterfeyter in madalie oft beeltsnyder"; Antwerp city archives, requestboek, 1564, I, fol. 236v; see Tourneur 1922, pp. 100–101n22.
8. See Muller 1922, p. 25.
9. His only recorded project associated with Elizabeth is, however, a medal; see van Dorsten 1969.
10. Grosvenor 2009, pp. 14–15, discusses the will and Dimock's role, hypothesizing that Van Herwijck is responsible for the painted oeuvre traditionally associated with Steven van der Meulen.
11. Per the records of the Dutch church in London; see Muller 1922, pp. 26–27 (which confuses generations, believing the elder Steven to have died in Rome).

Cat. 106

1. See Cooper, T., and Walker, H. 2015.
2. Walker, H. 2013.
3. For an overview of the archival sources for Gheeraerts's life and work, see Eva Tahon in Martens 1998, pp. 231–33.
4. Now in a private collection; see Tabitha Barber in Hearn 1995, pp. 86–87, no. 41; Goldring 2014, p. 121.
5. British Museum, London, 1892,0628.194.9. See Hind 1952, pp. 104–22.
6. See Jocelyn Bouquillard in *Dessins de la Renaissance* 2003, p. 68, no. 14; Webster 2001, pp. 207–20.
7. Satire 3.164–65, as translated in Hodnett 1971, p. 480.

Cats. 107, 108

1. Goldring 2014 offers a full biography.
2. Frye, S. 1993, pp. 56–96; Goldring 2007.
3. Goldring 2014, pp. 68–70.
4. Strong 1959.
5. Van Mander 1604 (1994–99 ed.), vol. 1, fol. 223r; Goldring 2014, pp. 104–7.
6. Gere and Pouncey 1983, pp. 191–93, nos. 300–301.
7. Goldring 2007, p. 180.
8. Karen Hearn in Hearn 1995, p. 153, no. 100.
9. Goldring 2014, p. 87.
10. Ibid., p. 100.

Cat. 109

1. For the literature on the miniature, see Reynolds, G. 1996, p. 72, no. 8. For Essex, see Hammer 2004.
2. Winter 1943, p. 26.
3. This identification was first published, with reservations, in Piper 1957.
4. Strong 1977, p. 56.
5. Goldring 2019, p. 223.
6. For a summary of doubts about the identification, see Christina Faraday in MacLeod 2019b, p. 169, no. 64.
7. Greenblatt 2005, p. 166.
8. Goldring 2019, p. 223.
9. Button, Coombs, and Derbyshire 2019, p. 23.

Cat. 110

1. A slightly later example of such a display is extant in the seventeenth-century Green Closet at Ham House, Richmond.
2. Goldring 2019, pp. 228, 230.
3. Auerbach 1961, pp. 119–24. The earl is recorded as having purchased three miniatures from Hilliard, in 1585/86, 1587/88, and 1595/96, although none can be associated with the present work, as the low price paid for each—£3—reflects the amount customarily charged by the artist for a small head-and-shoulders miniature. In 1728 George Vertue recorded seeing a miniature at Northumberland House in London, which is presumably identical to the painting now in the Rijksmuseum: "a Lord Percy a limning lying on the ground. dyd about 1585. in Syon Gardens"; Vertue 1935–36, p. 152. The miniature had previously been identified as a likeness of Sir Philip Sidney; see Strong 1983b, p. 54. More recently, Cathy J. Reed (2015) has proposed (not entirely convincingly) that it depicts Robert Devereux, 2nd Earl of Essex.
4. On the links between Hilliard's miniature and George Peele's *The Honour of the Garter*, see (among others) Roy C. Strong in Murdoch, J. et al. 1981, pp. 69–70; Strong 1983b, p. 60. For the poem, see Horne 1952, pp. 245–59.
5. Horne 1952, p. 245.
6. Peacock 1985, p. 142.

7. See ibid., p. 140. Northumberland owned a copy of Guido Ubaldo del Monte's 1588 publication of Archimedes's text in Latin; ibid., p. 155n5.
8. Ibid., pp. 146–49.
9. Strong 1983b, p. 58.
10. Fitzwilliam Museum, Cambridge, PD.3-1953.
11. See Peacock 1985.

Cat. 111

1. Colding and Andersen 1950.
2. Strong 1983c, p. 156.
3. For the classic description of the "green world," see Frye, N. 1957, pp. 182–84; for parallels between the miniature and *Love's Labour's Lost*, see Sillars 2015, pp. 103–4.
4. See, for example, Tabitha Barber in Hearn 1995, p. 131, no. 78.
5. Ibid.
6. As first observed in Finsten 1981, vol. 1, p. 103.
7. C. A. Zaalberg, introduction to van der Noot 1580 (1958 ed.), pp. xxvi–xxix.
8. See Waterschoot 1997.
9. Strong 1983c, p. 155.

Cat. 112

1. Strong 1993, p. 103.
2. Strong 1963b.
3. For this type of garment and its cultural associations, see Nunn-Weinberg 2006.
4. Yates 1959.
5. Strong 1993, p. 104.
6. See Bath 1986.
7. Strong 1993, pp. 119–24.
8. Ibid., p. 113.
9. Ibid., p. 122.
10. Sorbie 2015.

Cat. 113

1. Charlotte Bolland in Cooper, T., et al. 2015, p. 73, no. 15.
2. Billinge 2015, esp. p. 144.
3. Strong 2019, p. 45.
4. Strong 1987, pp. 85–89.
5. Petrucci 2008, vol. 3, p. 787, no. 808.
6. Arnold 1988, p. 137; Ribeiro 2015, p. 55.
7. Strong 2019, p. 41.
8. *CSP Foreign, Elizabeth* 1863–1950, vol. 14, p. 175, no. 189; cited in Turbide 2005, p. 54.

Cat. 114

1. *Triumphus cupidinis* 3.145; translation, Yates 1975, p. 115, which also (p. 116) discusses the portrait's mottoes.
2. Valerius Maximus, *Factorum ac dictorum memorabilium libri IX*, 8.1.5; cited and discussed in Baert 2019, p. 18.
3. Yates 1975, p. 115.
4. Strong 2019, p. 47.
5. For Dido's importance in Elizabethan culture, see Williams, D. 2006.
6. Strong 1987, pp. 101–7.
7. Ibid., p. 103.
8. See Alessandro Bagnoli in *Restauri* 1988, pp. 41–43, no 11. Metsys's *Martyrdom of Saint John the Evangelist* was offered at Sotheby's, New York, January 30, 2019, lot 19.
9. Town 2014, p. 142.
10. Karen Hearn and Tabitha Barber in Hearn 1995, p. 86, no. 40.

11. Strong 1987, p. 101.
12. Moryson 1907, vol. 1, p. 322.

Cat. 115

1. Diana Scarisbrick in Doran 2003, p. 195, no. 198; Natasha Awais-Dean in Cooper, T. 2013, p. 74, no. 14.
2. British Museum, London, CM M6883; see Philip Attwood in Doran 2003, p. 200, no. 204.
3. See Draper 2008; Perry 1993.
4. Strong 1987, p. 121.
5. See Schäffer 2009; Packer 2012.
6. Bolland 2018, p. 162.
7. Janet Arnold in *Princely Magnificence* 1980, p. 104, no. P13.
8. See the discussion of the interaction between cameo and miniature portrait in Koos 2014.

Cat. 116

1. For Hilliard's goldsmith connections, first discussed by Farquhar 1908, see Hearn 2005; Goldring 2019, pp. 20–27, 63–91.
2. Special license awarded in 1617, published in full in Rymer 1727–35, vol. 17, pp. 15–16 (this quotation, p. 15).
3. "DITIOR IN TOTO NON ALTER CIRCULUS ORBE"; on the reverse: "NON IPSA PERI / CULA TANGUNT." Translated and discussed by Brookes 2006, p. 251.
4. See Auerbach 1953, p. 205; Jervis and Dodd 2015, pp. 216–17.
5. The other example is in the British Museum, London, 1866,1218.1.
6. British Museum, London, M.6903, and Royal Ontario Museum, Toronto, 930.8. (I am grateful to Luke Syson, Director and Marlay Curator, Fitzwilliam Museum, Cambridge, for bringing the latter to my attention.) See Farquhar 1908, pp. 339–41.

Cat. 117

1. Previously in a private collection, the painting appeared in the sale at Christie's, London, July 3, 2012, lot 43, and was subsequently acquired by the National Portrait Gallery.
2. The present discussion is indebted to Helen Hackett's thorough analysis of the painting and the theme of the Three Goddesses in Elizabethan culture; see Hackett 2014. For Anne's coronation, see Hackett 2014, pp. 230–33; quotation, p. 233.
3. Strong 1987, p. 65.
4. Translation by G. W. Groos, in Valdštejna 1981, p. 46; cited in Strong 1987, p. 65.
5. Hackett 2014, p. 237.
6. As recorded by the Moravian nobleman Baron Waldstein on his visit to Whitehall in 1600; Valdštejna 1981, p. 47. Roy C. Strong has suggested (1987, p. 69) that the painting's prominent display contributed to the increasing frequency of allegorical and emblematic elements in royal portraiture.
7. Hackett 2014, p. 237.
8. Ibid., p. 247.
9. Discussed in detail in ibid., esp. pp. 243–44.
10. It is worth noting that Oliver's son, the miniaturist Peter Oliver, was employed by Charles I to produce copies of old master paintings, beginning in 1628; this task remained one of the primary responsibilities of the king's limner. On Peter Oliver's work as a copyist, see Jane Roberts in MacGregor 1989, pp. 117–18; Wood, J. 1998, pp. 126–27.
11. Lawson 2013.

Cat. 118

1. See Goldring 2004b; Hopkins 2019.
2. Tarnya Cooper and Amy Orrack in Cooper, T. 2013, p. 68, no. 10.
3. Levey and Thornton 2001, p. 48.
4. Friedman 1992, p. 54.
5. Frye, S. 2019.
6. Howey 2007, pp. 114–18.
7. Arnold 1988, p. 78.
8. Ibid., p. 80.
9. Hayward, M. 2010.
10. Arnold 1988, p. 79.
11. This has been the particular position of Roy C. Strong; see, *inter alia*, Strong 1983c, pp. 115–16.
12. See Bayliss, Carey, and Town 2018.
13. The Phoenix portrait is now in the National Portrait Gallery, London, NPG 190; the Pelican portrait is in the Walker Art Gallery, Liverpool, WAG 2994.
14. Goldring 2019, p. 241.

Cat. 119

1. See Goldring et al. 2014, vol. 3, pp. 680–704.
2. For these citations from the pageant's script, see ibid., p. 687.
3. Ibid; see also Goldring 2007, esp. pp. 187–88.
4. Goldring et al. 2014, vol. 3, pp. 704–5.
5. Ibid.
6. Strong 1963b.
7. Goldring 2007.
8. Strong 1987, p. 140.
9. For a recent biography, see Simpson 2014. For Lee's portrait collection, see Strong 2019, pp. 181–85.
10. Cited in Strong 1977, p. 130.
11. Ibid., pp. 129–62.
12. Yates 1975, p. 94.
13. Strong 1987, pp. 138–40; Lippincott 2002.
14. Arnold 1988, p. 43.

Cat. 120

1. Yates 1975, p. 216.
2. Strong 1977, pp. 50–54; Erler 1987.
3. See, for instance, Graziani 1972; Frye, S. 1993, pp. 101–3.
4. Fischlin 1997.
5. Garments described in Sir George Savile, letter to the Earl of Shrewsbury, August 14, 1602, MS DDSR I/D/14, fol. 26, Savile Papers, Nottinghamshire Record Office; diary of John Manningham of 1602–3 (1976, p. 150). Both cited in Erler 1987, pp. 363, 369.
6. Arnold 1988, p. 81.
7. *Habitus variarum orbis gentium*; see Yates 1975, p. 220.
8. Auerbach and Adams, C. 1971, p. 58.
9. Bracken 2002, p. 129.

Cat. 121

1. Schlueter 2008. For De Passe's body of work, see Hind 1952, pp. 281–85.
2. Strong 1983c, p. 158; Veldman 2001, p. 81. For Oliver's miniature (Victoria and Albert Museum, London, P.8-1940), see, most recently, Charlotte Bolland in MacLeod 2019b, pp. 110–11, no. 34. The collaboration between Oliver, Woutneel, and De Passe is discussed by Rab MacGibbon in MacLeod 2019b, pp. 120–23, nos. 39–40.
3. Proclamation prohibiting portraits of the Queen (draft), 1563; *TRP* 1964–69, vol. 2, p. 240, no. 516.
4. Schlueter 2008, p. 281. Editions of both the Custos and the Huys prints are in the Metropolitan Museum, 17.3.756–1618 and 17.3.756–1654.

5. The image is described by Sir Edward Stafford, letter to Sir Francis Walsingham, November 17, 1583; SP 78/10, no. 79, National Archives, Kew; cited in Montrose 1999, p. 121.
6. Frye, S. 1993, pp. 100–101.
7. Sir Walter Raleigh, preface to *The Historie of the World* (1614), sig. B2v.

Cat. 122

1. The inscription also gives the date 1598. Translation by Sebastian von Renouard.
2. Montrose 2006, pp. 154–57.
3. In Frankfurt, the map was printed for a German newsbook; Tim Bryars, correspondence with the author. See also Olid Guerrero and Fernández 2019, esp. pp. 145–50.
4. For Aske's poem, see Goldring et al. 2014, vol. 3, pp. 431–69; quoted lines, pp. 457–58; the original publication, Aske 1588, is reproduced in the Early English Books Online–Text Creation Partnership corpus. See also Schleiner 1978, p. 170. For the Amazonian breast, see Schwarz 1997.
5. Goldring et al. 2014, vol. 3, p. 454.
6. See Brookes 2006.

Cat. 123

1. Catharine MacLeod in MacLeod 2012, pp. 33–42.
2. For the literature on the painting, see Baetjer 2009, pp. 11–13, no. 5.
3. As first clarified in Held 1958.
4. MacLeod in MacLeod 2012, p. 36.
5. Held 1958.
6. Strong 1963a.
7. For Peake's biography, see Town 2014, pp.152–53.
8. For Peake's technique, see Rae 2015.
9. MacLeod in MacLeod 2012, p. 37.
10. The Royal Collection / HM Queen Elizabeth II, RCIN 40440; see MacLeod in MacLeod 2012, p. 70, no. 14.
11. See MacLeod in MacLeod 2012, p. 59, no. 8.
12. Akkerman 2013.
13. Town 2014, p. 153.

Iterations of Elizabeth: A Seventeenth-Century Legacy (pp. 286–93)

1. John Chamberlain, letter to Dudley Carleton, March 30, 1603; SP 14/1/6, National Archives, Kew; see Goldring et al. 2014, vol. 4, pp. 212–13, this quotation, p. 212.
2. Sir Robert Carey, narrative of the queen's death in his *Memoirs* (1587); see Goldring et al. 2014, vol. 4, pp. 213–17.
3. Chamberlain to Carleton; Goldring et al. 2014, vol. 4, p. 212. Elizabeth Southwell, for example, claimed that the queen's corpse exploded; see Loomis 1996. Southwell was maid of honor to Elizabeth and wife of the Earl of Leicester's son, Sir Robert Dudley.
4. Henry Petowe, *Elizabetha quasi vivens* (1603); see Goldring et al. 2014, vol. 4, pp. 229–34.
5. Hageman and Conway 2007, p. 19. See also Watkins 2000; Dobson and Watson 2002; Watkins 2002; Doran and Freeman 2003; Ziegler 2003; Jansohn 2004; Walker, J. 2004; Akkerman 2013; Levin 2014.
6. Asch 2004.
7. John Chamberlain, letter to Dudley Carleton, April 12, 1603; see Chamberlain 1939, vol. 1, p. 193, no. 63. For the funeral proceedings, see Strong 1977, pp. 14–16. For a visual representation of the funeral, see "The Funeral Procession of Queen Elizabeth I to Westminster Abbey, 28th April, 1603," Add MS 35324, fols. 26r–39r, British Library, London.

8. James I 1984, p. 215, no. 97.

9. The episode is recounted in the memoirs of Maximilien de Béthune, duc de Sully; see Sully 1817, vol. 3, pp. 67–70, this quotation, p. 69. See also Richards 2002.

10. Giovanni Carlo Scaramelli, dispatch to the Doge and Senate, May 15, 1603; see *CSP Venice* 1864–1947, vol. 10, p. 24, no. 40.

11. See Mayer 2004; Kanemura 2013.

12. Parry 1981, pp. 9–10.

13. Walker, J. 1996, p. 515. For early modern funeral rituals, see Woodward 1997.

14. Walker, J. 1996, p. 522. James dwarfed the Elizabethan construction by commissioning a larger, more sumptuous tomb for his mother (ibid., p. 523). See also Asch 2004.

15. See Noling 1993; Rankin 2011.

16. Raleigh, preface to *The Historie of the World* (1614), sig. B1v.

17. For example, in John Reynolds's pamphlet *Vox coeli* (1624), Henry VIII, Edward VI, Mary I, and Elizabeth I appear alongside Stuart figures; see Levin 2014.

18. On the play's title, see Mehl 2004, p. 155. See also Spikes 1977; Howard, J. 2002.

19. Mehl 2004, p. 170.

20. Diary entry for August 17, 1667, Pepys 1893–99, vol. 7, p. 70.

21. Ibid.

22. For a brief overview of the Scottish conflict, see Doran 2000, pp. 16–21.

23. See Rogers 1988.

24. Camden's *Annales rerum Anglicarum et Hibernicarum regnante Elizabetha* appeared in parts, in 1615 and 1625, and was soon translated into English. For this quotation, see Camden 1675, p. 416. For Camden in context, see Levin 2014, esp. p. 12.

25. Primrose 1630, sig. A2r.

26. Ibid., sig. A3v.

27. See Gim 1999.

28. Makin 1673, sig. B2r.

29. See Schwoerer 1989; Edie 1990; Zook 2008; Farguson 2014.

30. During a heated debate between Lords about whether William or Mary should hold power, it was remarked that "the Prince would not like to be his wife's gentleman usher." William was silent on the matter until finally announcing, "no man could esteem a woman more than he did the princess: but he was so made, that he could not think of holding any thing by apron-strings." Mary too rebuked the idea that she take power, for "she was the prince's wife, and would never be other than what she should be in conjunction with him and under him"; see Burnet 1833, vol. 3, pp. 393–95. See also Zook 2008.

31. Mary II did not originally have sovereignty, to the extent that, in 1690, a statute called the Regency Act was required to endow her with authority while William was away at war. See Schwoerer 1989.

32. Bohun 1693, sig. A3r. The inscription, "terque quaterque beati," means "Thrice Four Times Blessed." Sturt presumably refers to Mary II as England's third queen, but this interpretation is complicated by the origins of the phrase in Virgil's *Aeneid*. If interpreted alongside the Virgil text, the inscription would subversively indicate a real disdain for the three female monarchs. However, read in context, it seems unlikely that Sturt intended anything other than flattery.

33. For the quotation, see Edward Fowler, preface to his sermon on Job 2.10; Fowler 1695, p. 16.

34. The Royal Collection / HM Queen Elizabeth II, RCIN 405674; see Farguson 2014, p. 71.

35. All three portraits are in The Royal Collection / HM Queen Elizabeth II, RCIN 404398 (Charles I), 404430 (Henrietta Maria), 405675 (William).

36. Mary II 1886, p. 23.

37. Dr. Richard Kingston reported that, in discussing "her sufferings," she "often made a parralel betweene her self and Qu[een] El[izabeth]"; see Bickley 1913–65, vol. 4, p. 452, no. 846.

38. Boyer 1703, p. 162.

39. Winn 2014, p. 282.

40. Farguson 2014, p. 188.

41. Tate 1703, p. 12. See also Sharpe 2013, esp. pp. 578–615.

42. Johnson 1705, p. 14.

43. Ibid., p. 2.

44. Petowe, *Elizabetha quasi vivens*; see Goldring et al. 2014, vol. 4, p. 231.

The Tudor Afterlife (pp. 294–301)

1. Introduction to String and Bull 2011, p. 1. Since about 1990, a growing number of studies have been devoted to the later influence of the Tudor period on (popular) culture and the arts, including, but by no means limited to, Dobson and Watson 2002; Readman 2005; Doran and Freeman 2009; Rankin, Highley, and King 2009; and Betteridge and Freeman 2012.

2. Davies 2008; Davies 2012.

3. Woolf 2005, p. 57.

4. For example, Melman 2011; also Melman 2006.

5. Sweet 2007, p. 53.

6. From the society's first Minute Book (January 1, 1718); quoted in Evans, J. 1956, p. 58.

7. Vertue 1929–30, p. 4.

8. Alexander 2008, pp. 366–67, nos. 854–57. The society had dispatched Vertue to Kensington Palace in 1719 to inspect Remigius van Leemput's copy of Holbein's painting with a view to publishing it as an engraving, but ultimately decided the project was too difficult. Vertue included it as the first in his series, issued in 1743. The society later purchased the copperplates from Vertue's widow and reissued the prints in 1776; see Franklin, Nurse, and Tudor-Craig 2015, p. 4.

9. Harley had also commissioned a limned copy of the *Memorial to Lord Darnley* from Bernard Lens III in 1728 (now Yale Center for British Art, New Haven, B1998.9.2).

10. Myrone 1999, p. 42.

11. On Walpole's home and collection, see (among others) Snodin 2009.

12. Stephen Clarke in Snodin 2009, p. 24.

13. Walpole 1762–80 (1849 ed.), vol. 1, p. 105n1; quoted by Lisa Ford in Snodin 2009, p. 128.

14. Walpole 1768, p. xv. For an analysis of Walpole's opinions on Henry VII, see Calè 2017.

15. On Vertue's copies after the Holbein drawings (now at Sudeley Castle), see Hill, P. 1997, pp. 23–24; a list of the drawings copied is also appended in Parker, K. 1983, pp. 153–58.

16. For a more complete description of the room, see Lisa Ford in Snodin 2009, pp. 43–45, and Cynthia Roman and Emily Lanza in ibid., pp. 301–5, nos. 112–29.

17. Walpole, entry in commonplace book, about 1783; cited in Chalcraft and Viscardi 2007, p. 68.

18. Bolland and Maisonneuve 2015, p. 205.

19. Maisonneuve 2015, pp. 155–56; the exception was Hugo's *Amy Robsart*, a staging of Scott's *Kenilworth*, which closed after a single performance.

20. On French paintings of English history, see, among others, Tscherny 1996; Bann 2011; Bann and Paccoud 2014. On the relation between history painting and contemporary theater, see Maisonneuve 2015; the essays in Hibberd and Wrigley 2014, esp. Stephen Bann (2014), "Delaroche off Stage."

21. The motif of Elizabeth's mortality and decay became more prevalent in the latter part of the nineteenth century; see Melman 2011, p. 50.

22. National Gallery, London, NG1909; see Bann and Whiteley 2010.

23. See, for example, Bann 1997, p. 124; Wright 2007–8.

24. Wright 2007–8, p. 78.

25. Mandler 1997; Mandler 2011. The painting was sold at Christie's, South Kensington, March 28, 2007, lot 177.

26. Parissien 2011.

27. Ibid., p. 126.

28. Vaughn 2000, p. 225.

29. Commissioned of Richard Burchett; only one painting from the series, *The English Fleet Pursuing the Spanish Fleet off Fowey*, was ever completed, although it was never installed. In 2007 a project was initiated to complete the series with five new paintings, and the entire set of six paintings was installed in the Prince's Chamber in 2010. See *Armada Paintings* 2010.

30. For an overview of the decorative program, see Bond 1980, pp. 66–83.

31. Quoted in Bond 1980, p. 68; according to that author (p. 66), "the search for those sources was one of the contributory causes of the foundation of the National Portrait Gallery in 1856."

32. For an analysis of the paintings for the East Corridor, see Willsdon 2000, pp. 94–108.

33. Mandell Creighton, *The English National Character* (1896); quoted in Willsdon 2000, p. 100.

34. Liberal historian George Macaulay Trevelyan proclaimed that "history must be living, many-coloured and romantic if it is to be a true mirror of the past"; Trevelyan 1913, p. 39.

35. "Tudoresque" is the term commonly used in the U.K., while the same style is generally referred to as "Tudor Revival" in the U.S. Other descriptors include neo-Tudor, Elizabethan, Jacobean, Jacobethan, Old English, and even "Queen Anne"; or, in a pejorative context, mock-Tudor.

36. Ballantyne and Law 2011b, pp. 113–15; see also Stamp 2006; Woodham 2011, p. 142.

37. Woodham 2011, p. 132. This could occasionally backfire, as in the 1962 Stockholm Exhibition, when visitors mistook the British Motor Corporation's pseudo-Tudor building for an English pub; ibid., pp. 152–53.

38. Townsend, Ga. 1986, pp. 248–49.

39. See Adams, I., Taxel, and Love 2000.

40. Louis N. Parker rewrote his popular play as a novel (1911), while the play itself was published in 1915; for the quotations, see Parker, L. 1915, p. 13; Parker, L. 1911, p. 6.

41. Ballantyne and Law 2011a; Ballantyne and Law 2011b.

42. Ballantyne and Law 2011a, p. 177; see also Glancey 2006; Morris, R. 2013.

43. There is a vast body of literature on representations of the Tudor era in film and television, for example, Doran and Freeman 2009; Parrill and Robison 2013; Merck 2016. See also the selected studies in Dobson and Watson 2002; Rankin, Highley, and King 2009.

44. On Elizabeth I, see, most recently, Latham 2011; on Henry VIII, Robison 2016, among others.

45. Commenting on the pop-cultural phenomenon *The Tudors*, a television serial that ran from 2007 to 2010 and starred Jonathan Rhys Meyers as Henry VIII, the show's creator, Michael Hirst, called it "an entertainment, a soap opera, and not history," although "any confusion created by [deviations from historical fact] is outweighed by the interest the series may inspire in the period and its figures"; quoted in Gates 2008.

BIBLIOGRAPHY

Acidini Luchinat 1993
Acidini Luchinat, Cristina, ed. *Renaissance Florence: The Age of Lorenzo de' Medici, 1449–1492*. Exh. cat., Accademia Italiana delle Arti e delle Arti Applicate, London. Milan, 1993.

Ackroyd 1998
Ackroyd, Peter. *The Life of Thomas More*. London, 1998.

Adams, I., Taxel, and Love 2000
Adams, Ian, Barney Taxel, and Steve Love. *Stan Hywet Hall and Gardens: 100th Anniversary Edition*. With a foreword by John Seiberling. Akron, Ohio, 2000.

Adams, S. 1995
Adams, Simon. *Household Accounts and Disbursement Books of Robert Dudley, Earl of Leicester 1558–61, 1584–86*. London and New York, 1995.

Adams, S. 2002
Adams, Simon. *Leicester and the Court: Essays on Elizabethan Politics*. Politics, Culture, and Society in Early Modern Britain. Manchester and New York, 2002.

Adshead and Taylor 2016
Adshead, David, and David A. H. B. Taylor, eds. *Hardwick Hall: A Great Old Castle of Romance*. New Haven, 2016.

Ailes 2018
Ailes, Adrian. "Managing the Message: Royal and Governmental Seals, 1050–1714." In Cherry, Berenbeim, and de Beer 2018, pp. 95–103.

Ainsworth 1990
Ainsworth, Maryan W. "'Paternes for phisioneamyes': Holbein's Portraiture Reconsidered." *Burlington Magazine* 132, no. 1044 (March 1990), pp. 173–86.

Ainsworth and Waterman 2013
Ainsworth, Maryan W., and Joshua P. Waterman. *German Paintings in The Metropolitan Museum of Art, 1350–1600*. With Timothy B. Husband et al. New York, 2013.

Akkerman 2013
Akkerman, Nadine. "*Semper Eadem*: Elizabeth Stuart and the Legacy of Elizabeth I." In *The Palatine Wedding of 1613: Protestant Alliance and Court Festival*, edited by Sara Smart and Mara R. Wade, pp. 145–68. Wolfenbütteler Abhandlungen zur Renaissanceforschung 29. Wiesbaden, 2013.

Alcorn 1993
Alcorn, Ellenor M. "'Some of the Kings of England Curiously Engraven': An Elizabethan Ewer and Basin in the Museum of Fine Arts, Boston." *Journal of the Museum of Fine Arts, Boston* 5 (1993), pp. 66–103.

Alcouffe 2001
Alcouffe, Daniel. *Les gemmes de la Couronne*. Exh. cat., Musée du Louvre, Paris. Paris, 2001.

Alexander 2008
Alexander, David. "George Vertue as an Engraver." *Volume of the Walpole Society* 70 (2008), pp. 205–517.

Allen 2018
Allen, Amanda Wrenn. *The Eucharistic Debate in Tudor England: Thomas Cranmer, Stephen Gardiner, and the English Reformation*. Lanham, Md., 2018.

André 2011
André, Bernard. *The Life of Henry VII*. Translated and introduced by Daniel Hobbins. New York, 2011.

Andrews 1993
Andrews, Martin. "Theobalds Palace: The Gardens and Park." *Garden History* 21, no. 2 (Winter 1993), pp. 129–49.

Anglo 1960
Anglo, Sydney. "Le Camp du Drap d'Or et les entrevues d'Henri VIII et de Charles Quint." In *Les fêtes de la Renaissance*. Vol. 2, *Fêtes et cérémonies au temps de Charles Quint*, edited by Jean Jacquot, pp. 113–34. IIe Congrès de l'Association Internationale des Historiens de la Renaissance (2e section), Bruxelles, Anvers, Gand, Liège, 1957. Paris, 1960.

Antoine 2007
Antoine, Elisabeth. *La tapisserie du* Jugement dernier. Paris, 2007.

APC 1902
Acts of the Privy Council of England, Volume 26, 1596–1597. Edited by John Roche Dasent. London, 1902.

Armada Paintings 2010
The Armada Paintings. 2010. https://armada.parliament.uk/index.html. Accessed March 19, 2020.

Arnold 1979
Arnold, Janet. "Two Early Seventeenth Century Fencing Doublets." *Waffen- und Kostümkunde: Zeitschrift der Gesellschaft für historische Waffen- und Kostümkunde* 21, no. 2 (1979), pp. 107–20.

Arnold 1988
Arnold, Janet, ed. *Queen Elizabeth's Wardrobe Unlock'd: The Inventories of the Wardrobe of Robes Prepared in July 1600, Edited from Stowe MS 557 in the British Library, MS LR 2/121 in the Public Record Office, London, and MS V.b.72 in the Folger Shakespeare Library, Washington DC*. Leeds, 1988.

Asch 2004
Asch, Ronald G. "A Difficult Legacy: Elizabeth I's Bequest to the Early Stuarts." In Jansohn 2004, pp. 29–44.

Ashelford 1988
Ashelford, Jane. *Dress in the Age of Elizabeth I*. London, 1988.

Aske 1588
Aske, James. *Elizabetha triumphans: Contayning the Damed Practizes, That the Divelish Popes of Rome Have Used Ever Sithence Her Highnesse First Comming to the Crowne, by Moving Her Wicked and Traiterous Subjects to Rebellion and Conspiracies, Thereby to Bereave Her Maiestie Both of Her Lawfull Seate, and Happy Life; With a Declaration of the Manner How Her Excellency Was Entertained by Her Souldyers into Her Campe Royall at Tilbery in Essex, and of the Overthrow Had against the Spanish Fleete*. London, 1588.

Attreed 2000
Attreed, Lorraine. "Henry VII and the 'New-Found Island': England's Atlantic Exploration, Mediterranean Diplomacy, and the Challenge of Frontier Sexuality." *Mediterranean Studies* 9 (2000), pp. 65–78.

Attreed and Winkler 2005
Attreed, Lorraine, and Alexandra Winkler. "Faith and Forgiveness: Lessons in Statecraft for Queen Mary Tudor." *Sixteenth Century Journal* 36, no. 4 (Winter 2005), pp. 971–89.

Attwood 2003a
Attwood, Philip. "Herwijck, Steven van." *Grove Art Online*. 2003. https://doi.org/10.1093/gao/9781884446054.article.T037900. Accessed Feb. 4, 2020.

Attwood 2003b
Attwood, Philip. *Italian Medals c. 1530–1600 in British Public Collections*. 2 vols. London, 2003.

Auerbach 1953
Auerbach, Erna. "Portraits of Elizabeth I." *Burlington Magazine* 95, no. 603 (June 1953), pp. 196–205.

Auerbach 1954
Auerbach, Erna. "Anglo-Flemish Art under the Tudors." *Burlington Magazine* 96, no. 612 (March 1954), pp. 86, 89–90, 95.

Auerbach 1961
Auerbach, Erna. *Nicholas Hilliard*. London, 1961.

Auerbach and Adams, C. 1971
Auerbach, Erna, and C. Kingsley Adams. *Paintings and Sculpture at Hatfield House: A Catalogue*. London, 1971.

Avery 1944
Avery, Louise. "Chinese Porcelain in English Mounts." *Metropolitan Museum of Art Bulletin* 2, no. 9 (May 1944), pp. 266–72.

Backhouse 1967
Backhouse, Janet. "Two Books of Hours of Francis I." *British Museum Quarterly* 31, no. 3/4 (Spring 1967), pp. 90–96.

Backhouse 1973
Backhouse, Janet. "Bourdichon's 'Hours of Henry VII.'" *British Museum Quarterly* 37, no. 3/4 (Autumn 1973), pp. 95–102.

Baert 2019
Baert, Barbara. *About Sieves and Sieving: Motif, Symbol, Technique, Paradigm*. Berlin, 2019.

Baetjer 2009
Baetjer, Katharine. *British Paintings in The Metropolitan Museum of Art, 1575–1875*. New York, 2009.

Bailey 2007
Bailey, Amanda. *Flaunting: Style and the Subversive Male Body in Renaissance England*. Toronto, 2007.

Ballantyne and Law 2011a
Ballantyne, Andrew, and Andrew Law. "Architecture: The Tudoresque Diaspora." In String and Bull 2011, pp. 155–81.

Ballantyne and Law 2011b
Ballantyne, Andrew, and Andrew Law. *Tudoresque: In Pursuit of the Ideal Home*. London, 2011.

Bamforth and Dupèbe 1991
Bamforth, Stephen, and Jean Dupèbe, eds. "Francisci Francorum regis et Henrici Anglorum colloquium." *Renaissance Studies* 5, no. 1/2 (March/June 1991), pp. ii–237.

Bann 1997
Bann, Stephen. *Paul Delaroche: History Painted*. London, 1997.

Bann 2011
Bann, Stephen. "The Tudors Viewed by French Romantic Artists." In String and Bull 2011, pp. 183–200.

Bann and Paccoud 2014
Bann, Stephen, and Stéphane Paccoud, eds. *L'invention du Passé: Histoires de coeur et d'épée en Europe, 1802–1850*. Exh. cat., Musée des Beaux-Arts, Lyon. Paris, 2014.

Bann and Whiteley 2010
Bann, Stephen, and Linda Whiteley. *Painting History: Delaroche and Lady Jane Grey*. With John Guy, Christopher Riopelle, and Anne Robbins. Exh. cat., National Gallery, London. London, 2010.

Barbier 2017
Barbier, Muriel. *Ecouen: L'histoire de David et Bethsabée, témoignage exceptionnel de l'apparat de la Renaissance*. L'esprit curieux 24. Toulouse, 2017.

Barrett-Lennard 1908
Barrett-Lennard, Thomas. *An Account of the Families of Lennard and Barrett*. London, 1908.

Barron, Coleman, and Gobbi 1983
Barron, Caroline, Christopher Coleman, and Claire Gobbi, eds. "The London Journal of Alessandro Magno 1562." *London Journal: A Review of Metropolitan Society Past and Present* 9, no. 2 (November 1983), pp. 136–52.

Bate and Thornton 2012
Bate, Jonathan, and Dora Thornton. *Shakespeare: Staging the World*. Exh. cat., British Museum, London. London, 2012.

Bath 1986
Bath, Michael. "Weeping Stags and Melancholy Lovers: The Iconography of *As You Like It*, II, i." *Emblematica* 1, no. 1 (Spring 1986), pp. 13–52.

Bätschmann 2019
Bätschmann, Oskar. "Colored Drawings by Hans Holbein the Younger." *Master Drawings* 57, no. 4 (Winter 2019), pp. 435–52.

Bätschmann and Griener 1997
Bätschmann, Oskar, and Pascal Griener. *Hans Holbein*. Translated by Cecilia Hurley. Princeton, N.J., 1997. [Dutch edition: Bätschmann, Oskar, and Pascal Griener. *Hans Holbein*. Zwolle, 1997.]

Baudouin et al. 1988
Baudouin, Piet, et al. *Zilver uit de Gouden Eeuw van Antwerpen*. Exh. cat., Rockoxhuis, Antwerp. Antwerp, 1988.

Bayliss, Carey, and Town 2018
Bayliss, Sarah, Juliet Carey, and Edward Town. "Nicholas Hilliard's Portraits of Elizabeth I and Sir Amias Paulet." *Burlington Magazine* 160, no. 1386 (September 2018), pp. 716–26.

Beattie 1959
Beattie, May H. "Antique Rugs at Hardwick Hall." *Oriental Art* 5 (1959), pp. 52–61.

Beer 2004
Beer, Barrett L. "Jane [*née* Jane Seymour] (1508/9–1537), Queen of England, Third Consort of Henry VIII." *Oxford Dictionary of National Biography*. Sep. 23, 2004. https://doi.org/10.1093/ref:odnb/14647. Accessed Nov. 13, 2019.

Béguin 1970
Béguin, Sylvie. "A propos d'un dessin de Nicolas da Modena récemment acquis par le Louvre." *Revue du Louvre* 20 (1970), pp. 9–14.

Béguin 1996
Béguin, Sylvie. "Henri VIII et François 1er, une rivalité artistique et diplomatique." In *François 1er et Henri VIII: Deux princes de la Renaissance (1515–1547)*, edited by Charles Giry-Deloison, pp. 63–82. Collection Histoire et Littérature Régionales 13. Lille and London, 1996.

Belkin 2009
Belkin, Kristin Lohse. *Rubens: Copies and Adaptations from Renaissance and Later Artists; German and Netherlandish Artists*. 2 vols. Corpus Rubenianum Ludwig Burchard 26. London, 2009.

Bemporad and Guidotti 1981
Bemporad, Dora Liscia, and Alessandro Guidotti. *Un parato della Badia fiorentina*. Exh. cat., Museo Stefano Bardini, Florence. Florence, 1981.

Bemporad and Melasecchi 2019
Bemporad, Dora Liscia, and Olga Melasecchi, eds. *Tutti i colori dell'Italia ebraica: Tessuti preziosi dal Tempio di Gerusalemme al prêt-à-porter*. Exh. cat., Gallerie degli Uffizi, Florence. Florence, 2019.

Benger 1965
Benger, F. B. "Occasional Notes: Robert Cheseman, b. 1485 d. 1547." *Proceedings of the Leatherhead and District Local History Society* 2, no. 9 (1965), pp. 252–56.

Bennett, A. 1992
Bennett, Anna Gray. *Five Centuries of Tapestry from the Fine Arts Museums of San Francisco*. 2nd ed. San Francisco, 1992.

Bennett, M. 1998
Bennett, Michael. "Edward III's Entail and the Succession to the Crown, 1376–1471." *English Historical Review* 113, no. 452 (June 1998), pp. 580–609.

Berenbeim 2015
Berenbeim, Jessica. *Art of Documentation: Documents and Visual Culture in Medieval England*. Text, Image, Context: Studies in Medieval Manuscript Illumination 2. Toronto, 2015.

Berry 1830
Berry, William. *County Genealogies: Pedigrees of the Families in the County of Sussex*. London, 1830.

Bertolet 2017
Bertolet, Anna Riehl, ed. *Queens Matter in Early Modern Studies*. Queenship and Power. Cham and New York, 2017.

Betteridge and Freeman 2012
Betteridge, Thomas, and Thomas S. Freeman, eds. *Henry VIII and History*. Farnham, Surrey, and Burlington, Vt., 2012.

Betteridge and Lipscomb 2013
Betteridge, Thomas, and Suzannah Lipscomb, eds. *Henry VIII and the Tudor Court: Art, Politics and Performance*. Farnham, Surrey, and Burlington, Vt., 2013.

Bickley 1913–65
Bickley, Francis, ed. *Report on the Manuscripts of Allan George Finch, Esq., of Burley-on-the-Hill, Rutland*. 4 vols. London, 1913–65.

Biddle 1966
Biddle, Martin. "Nicholas Bellin of Modena: An Italian Artificer at the Courts of Francis I and Henry VIII." *Journal of the British Archaeological Association*, 3rd ser., 29 (1966), pp. 106–21.

Biddle 1984
Biddle, Martin. "The Stuccoes of Nonsuch." *Burlington Magazine* 126, no. 976 (July 1984), pp. 411–17.

Biddle 1999
Biddle, Martin. "The Gardens of Nonsuch: Sources and Dating." *Garden History* 27, no. 1, special issue, "Tudor Gardens" (Summer 1999), pp. 145–83.

Biddle 2000
Biddle, Martin. *King Arthur's Round Table: An Archaeological Investigation*. With Sally Badham et al. Woodbridge, Suffolk, and Rochester, N.Y., 2000.

Biddle 2005
Biddle, Martin, ed. *Nonsuch Palace: The Material Culture of a Noble Restoration Household*. Oxford, 2005.

Biddle 2012
Biddle, Martin. "Nonsuch, Henry VIII's Mirror for a Prince: Sources and Interpretation." In Sicca and Waldman 2012, pp. 307–50.

Biddle and Summerson 1982
Biddle, Martin, and John Summerson. "Nonsuch, Surrey." In *The History of the King's Works*. Vol. 4, *1485–1660*, edited by Howard M. Colvin, D. R. Ransome, and John Summerson, pp. 179–205. London, 1982.

Bilbey 2002
Bilbey, Diane. *British Sculpture, 1470 to 2000: A Concise Catalogue of the Collection at the Victoria and Albert Museum*. With Marjorie Trusted. London, 2002.

Billinge 2015
Billinge, Rachel. "Artists' Underdrawing and the Workshop Transfer Process." In Cooper, T., et al. 2015, pp. 138–45.

Bindoff 1981
Bindoff, S. T. "Mildmay, Anthony (c. 1549–1617), of Apethorpe, Northants, and London." In *The History of Parliament: British Political, Social, and Local History*. https://www.historyofparliamentonline.org/volume/1558-1603/member/mildmay-anthony-1549-1617. Accessed Dec. 3, 2019.

Blair 1959
Blair, C[laude]. "New Light on the Four Almain Armours: 2." *Connoisseur* 144 (December 1959), pp. 240–44.

Blair and Pyhrr 2003
Blair, Claude, and Stuart W. Pyhrr. "The Wilton 'Montmorency' Armor: An Italian Armor for Henry VIII." *Metropolitan Museum Journal* 38 (2003), pp. 9, 95–144.

Blakiston 1948
Blakiston, Noel. "Nicholas Hilliard and Queen Elizabeth's Third Great Seal." *Burlington Magazine* 90, no. 541 (April 1948), pp. 101–5, 107.

Blayney 2013
Blayney, Peter W. M. *The Stationers' Company and the Printers of London, 1501–1557*. Cambridge and New York, 2013.

Blunt 1969
Blunt, Anthony. "L'influence française sur l'architecture et la sculpture décorative en Angleterre pendant la première moitié du XVIᵉ siècle." *Revue de l'art* 4 (1969), pp. 17–29.

Boffey 2019
Boffey, Julia, ed. *Henry VII's London in the Great Chronicle*. Documents of Practice. Kalamazoo, Mich., 2019.

Bohun 1693
Bohun, Edmund. *The Character of Queen Elizabeth; or, A Full and Clear Account of Her Policies, and the Methods of Her Government Both in Church and State*. London, 1693.

Bolland 2015
Bolland, Charlotte. "'Sat super est': A Portrait of Henry Howard, Earl of Surrey." In Cooper, T., et al. 2015, pp. 352–61.

Bolland 2018
Bolland, Charlotte. *Tudor and Jacobean Portraits*. London, 2018.

Bolland and Chen 2019
Bolland, Charlotte, and Andrew Chen. "Meynnart Wewyck and the Portrait of Lady Margaret Beaufort in the Master's Lodge, St. John's College, Cambridge." *Burlington Magazine* 161, no. 1393 (April 2019), pp. 314–19.

Bolland and Maisonneuve 2015
Bolland, Charlotte, and Cécile Maisonneuve, eds. *Les Tudors*. Exh. cat., Musée du Luxembourg, Paris. Paris, 2015.

Bond 1980
Bond, Maurice, ed. *Works of Art in the House of Lords*. London, 1980.

Bonhams 2017
The Contents of Glyn Cywarch: The Property of Lord Harlech. Sale cat., Bonhams, London, March 29, 2017.

Boon 1964
Boon, K. G. "Two Designs for Windows by Dierick Vellert." *Master Drawings* 2, no. 2 (Summer 1964), pp. 153–56, 204–5.

Bostwick 1995
Bostwick, David. "The French Walnut Furniture at Hardwick Hall." *Furniture History* 31 (1995), pp. 1–6.

Bowker 2004
Bowker, Margaret. "Roper [née More], Margaret (1505–1544), Scholar and Daughter of Sir Thomas More." *Oxford Dictionary of National Biography*. Sep. 23, 2004. https://doi.org/10.1093/ref:odnb/24071. Accessed Feb. 6, 2020.

Boyer 1703
Boyer, Abel. *The History of the Reign of Queen Anne, Digested into Annals: Year the First*. London, 1703.

Boynton 1971
Boynton, Lindsay, ed. *The Hardwick Hall Inventories of 1601*. With a commentary by Peter Thornton. London, 1971.

Brachmann 2019
Brachmann, Christoph. *Arrayed in Splendour: Art, Fashion, and Textiles in Medieval and Early Modern Europe*. Turnhout, 2019.

Bracken 2002
Bracken, Susan. "Robert Cecil as Art Collector." In *Patronage, Culture, and Power: The Early Cecils*, edited by Pauline Croft, pp. 121–38. New Haven, 2002.

Bradford 1984
Bradford, Alan T. "Drama and Architecture under Elizabeth I: The 'Regular' Phase." *English Literary Renaissance* 14, no. 1, special issue, "Studies in English Renaissance Drama" (Winter 1984), pp. 3–28.

Bremer-David 2015
Bremer-David, Charissa, ed. *Woven Gold: Tapestries of Louis XIV*. Exh. cat., J. Paul Getty Museum, Los Angeles. Los Angeles, 2015.

Brigden 1989
Brigden, Susan. *London and the Reformation*. Oxford, 1989.

Brigden 1994
Brigden, Susan. "Henry Howard, Earl of Surrey, and the 'Conjured League.'" *Historical Journal* 37, no. 3 (September 1994), pp. 507–37.

Brigden 2012
Brigden, Susan. *Thomas Wyatt: The Heart's Forest*. London, 2012.

Brindle 2018
Brindle, Steven. *Windsor Castle: A Thousand Years of a Royal Palace*. London, 2018.

van den Brink 2015
van den Brink, Peter. "The Prophet Habakkuk and the Angel: A Newly Discovered Glass Panel by Wouter Crabeth." *Oud Holland* 128, no. 4 (November 2015), pp. 165–70.

Broadway 2013
Broadway, Jan. "Symbolic and Self-Consciously Antiquarian: The Elizabethan and Early Stuart Gentry's Use of the Past." *Huntington Library Quarterly* 76, no. 4 (Winter 2013), pp. 541–58.

Brooke and Crombie 2003
Brooke, Xanthe, and David Crombie. *Henry VIII Revealed: Holbein's Portrait and Its Legacy*. Exh. cat., Walker Art Gallery, Liverpool. London, 2003.

Brookes 2006
Brookes, Kristen G. "A Feminine 'Writing that Conquers': Elizabethan Encounters with the New World." *Criticism* 48, no. 2 (Spring 2006), pp. 227–62.

Brosens et al. 2008
Brosens, Koenraad, et al. *European Tapestries in the Art Institute of Chicago*. Edited by Christa C. Mayer Thurman. Chicago, 2008.

Brotton 2016
Brotton, Jerry. *This Orient Isle: Elizabethan England and the Islamic World*. London, 2016.

Brown, A. 1984
Brown, Andrew J. "The Date of Erasmus' Latin Translation of the New Testament." *Transactions of the Cambridge Bibliographical Society* 8, no. 4 (1984), pp. 351–80.

Brown, D. 1982
Brown, David Blayney. *Catalogue of the Collection of Drawings in the Ashmolean Museum*. Vol. 4, *The Earlier British Drawings: British Artists and Foreigners Working in Britain Born before c. 1775*. Oxford, 1982.

Bruyn and Emmens 1957
Bruyn, J., and J. A. Emmens. "The Sunflower Again." *Burlington Magazine* 99, no. 648 (March 1957), pp. 96–97.

Bryson 1998
Bryson, Anna. *From Courtesy to Civility: Changing Codes of Conduct in Early Modern England*. Oxford Studies in Social History. Oxford and New York, 1998.

Buck 1997
Buck, Stephanie. *Holbein am Hofe Heinrichs VIII*. Berlin, 1997.

Buck 2001
Buck, Stephanie. "International Exchange: Holbein at the Crossroads of Art and Craftsmanship." In *Hans Holbein: Paintings, Prints, and Reception*, edited by Mark Roskill and John Oliver Hand, pp. 54–71. Studies in the History of Art 60, Symposium Papers 37. Washington, D.C., 2001.

Buck 2008
Buck, Stephanie. "Beauty and Virtue for Francis I: Iohannes Ambrosius Nucetus and the Early Portrait Miniature." *Journal of the Warburg and Courtauld Institutes* 71 (2008), pp. 191–210.

Buck and Sander 2003
Buck, Stephanie, and Jochen Sander. *Hans Holbein the Younger: Painter at the Court of Henry VIII*. London, 2003. [Dutch edition: Buck, Stephanie, Jochen Sander, Ariane van Suchtelen, Quentin Buvelot, and Peter van der Ploeg. *Hans Holbein the Younger, 1497/98–1543: Portraitist of the Renaissance*. Exh. cat., Mauritshuis, The Hague. The Hague and Zwolle, 2003.]

Bulkeley-Owen 1892
Bulkeley-Owen, Fanny. "Selattyn: A History of the Parish—Chapter II, Brogyntyn in the 15th, 16th, and 17th Centuries." *Transactions of the Shropshire Archaeological and Natural History Society*, 2nd ser., 4 (1892), pp. 1–58.

von Bülow 1895
von Bülow, Gottfried, trans. and ed. "Journey through England and Scotland Made by Lupold von Wedel in the Years 1584 and 1585." *Transactions of the Royal Historical Society* 9 (1895), pp. 223–70.

von Bülow and Powell 1892
von Bülow, Gottfried, and Wilfred Powell, eds. "Diary of the Journey of Philip Julius, Duke of Stettin-Pomerania, through England in the Year 1602." *Transactions of the Royal Historical Society* 6 (1892), pp. 1–67.

Burnet 1829
Burnet, Gilbert. *The History of the Reformation of the Church of England*. 4 vols. Oxford, 1829.

Burnet 1833
Burnet, Gilbert. *Bishop Burnet's History of His Own Time: With Notes by the Earls of Dartmouth and Hardwicke, Speaker Onslow, and Dean Swift.* 2nd ed. 6 vols. Oxford, 1833.

Butler 2015
Butler, Katherine. "Noble Masculinity at the Tournaments." In *Music in Elizabethan Court Politics*, pp. 105–42. Studies in Medieval and Renaissance Music. Woodbridge, Suffolk, and Rochester, N.Y., 2015.

Button 2015
Button, Victoria. "'Pictures by the Life': The Materials and Techniques of Holbein's Portrait Drawings." In Cooper, T., et al. 2015, pp. 216–25.

Button, Coombs, and Derbyshire 2019
Button, Victoria, Katherine Coombs, and Alan Derbyshire. "Limning, the Perfection of Painting: The Art of Painting Portrait Miniatures." In MacLeod 2019b, pp. 20–29.

Caglioti 2012
Caglioti, Francesco. "Benedetto da Rovezzano in England: New Light on the Cardinal Wolsey–Henry VIII Tomb." In Sicca and Waldman 2012, pp. 177–202.

Calè 2017
Calè, Luisa. "Historic Doubts, Conjectures, and the Wandering of a Principal Curiosity: Henry VII in the Fabric of Strawberry Hill." *Word and Image* 33, no. 3 (2017), pp. 279–91.

Camden 1675
Camden, William. *The History of the Most Renowned and Victorious Princess Elizabeth, Late Queen of England: Containing All the Most Important and Remarkable Passages of State, Both at Home and Abroad (So Far as They Were Linked with English Affairs) during Her Long and Prosperous Reign.* 3rd ed. London, 1675.

Campbell, L. 1977
Campbell, Lorne. "The Authorship of the *Recueil d'Arras.*" *Journal of the Warburg and Courtauld Institutes* 40 (1977), pp. 301–13.

Campbell, L. 2004
Campbell, Lorne. *Van der Weyden.* Rev. ed. London, 2004.

Campbell, L., and Foister 1986
Campbell, Lorne, and Susan Foister. "Gerard, Lucas and Susanna Horenbout." *Burlington Magazine* 128, no. 1003, special issue, "British Art from 1500 to the Present Day" (October 1986), pp. 719–27.

Campbell, L., et al. 2008
Campbell, Lorne, Miguel Falomir, Jennifer Fletcher, and Luke Syson. *Renaissance Faces: Van Eyck to Titian.* With Philip Attwood et al. Exh. cat., National Gallery, London. London, 2008.

Campbell, T. 1996a
Campbell, Thomas P. "Cardinal Wolsey's Tapestry Collection." *Antiquaries Journal* 76 (1996), pp. 73–137.

Campbell, T. 1996b
Campbell, Thomas P. "Henry VIII and the Château of Ecouen *History of David and Bathsheba* Tapestries." *Gazette des beaux-arts*, 6th ser., 128 (October 1996), pp. 121–40.

Campbell, T. 1996c
Campbell, Thomas P. "School of Raphael Tapestries in the Collection of Henry VIII." *Burlington Magazine* 138, no. 1115 (February 1996), pp. 69–78.

Campbell, T. 2002
Campbell, Thomas P., ed. *Tapestry in the Renaissance: Art and Magnificence.* Exh. cat., The Metropolitan Museum of Art, New York. New York, 2002.

Campbell, T. 2007a
Campbell, Thomas P. *Henry VIII and the Art of Majesty: Tapestries at the Tudor Court.* New Haven, 2007.

Campbell, T. 2007b
Campbell, Thomas P., ed. *Tapestry in the Baroque: Threads of Splendor.* Exh. cat., The Metropolitan Museum of Art, New York, and Palacio Real, Madrid. New York, 2007.

Capwell 2012
Capwell, Tobias, ed. *The Noble Art of the Sword: Fashion and Fencing in Renaissance Europe.* Exh. cat., Wallace Collection, London. London, 2012.

Carley 2004
Carley, James P. *The Books of King Henry VIII and His Wives.* London, 2004.

Carley 2009
Carley, James P., ed. *King Henry's Prayer Book: BL Royal MS 2A XVI.* London, 2009.

Carlson 1998
Carlson, David R. "The Writings of Bernard André (c. 1450–c. 1522)." *Renaissance Studies* 12, no. 2 (June 1998), pp. 229–50.

Carter 1984
Carter, Alison J. "Mary Tudor's Wardrobe." *Costume* 18, no. 1 (1984), pp. 9–28.

Cavallo 1958
Cavallo, Adolph S[alvatore]. "The Redemption of Man: A Christian Allegory in Tapestry." *Bulletin of the Museum of Fine Arts* 56, no. 306 (Winter 1958), pp. 147–68.

Cavallo 1993
Cavallo, Adolfo [Adolph] Salvatore. *Medieval Tapestries in The Metropolitan Museum of Art.* New York, 1993.

Cerasano and Wynne-Davies 1992
Cerasano, S. P., and Marion Wynne-Davies, eds. *Gloriana's Face: Women, Public and Private, in the English Renaissance.* New York and London, 1992.

Chaffers 1883
Chaffers, William. *Gilda Aurifabrorum: A History of English Goldsmiths and Plateworkers, and Their Marks Stamped on Plate, Copied in Facsimile from Celebrated Examples; And the Earliest Records Preserved at Goldsmiths' Hall, London, with Their Names, Addresses, and Dates of Entry, 2500 Illustrations, also Historical Accounts of the Goldsmiths' Company and Their Hall Marks; Their Regalia; The Mint; Closing of the Exchequer; Goldsmith-Bankers; Shop Signs; A Copious Index, etc., Preceded by an Introduction on the Goldsmiths' Art.* London, 1883.

Chalcraft and Viscardi 2007
Chalcraft, Anna, and Judith Viscardi. *Strawberry Hill: Horace Walpole's Gothic Castle.* London, 2007.

Challis 1978
Challis, Christopher Edgar. *The Tudor Coinage.* Manchester and New York, 1978.

Chamberlain 1939
Chamberlain, John. *The Letters of John Chamberlain.* Edited by Norman Egbert McClure. 2 vols. Memoirs of the American Philosophical Society 12. Philadelphia, 1939.

Charles 1973
Charles, B. G. *George Owen of Henllys: A Welsh Elizabethan.* Aberystwyth, 1973.

Cherry, Berenbeim, and de Beer 2018
Cherry, John, Jessica Berenbeim, and Lloyd de Beer, eds. *Seals and Status: The Power of Objects.* British Museum Research Publications 213. London, 2018.

Chiostrini et al. 2022
Chiostrini, Giulia, Elizabeth Cleland, Nobuko Shibayama, and Federico Carò. "A Monumental-Scale Crimson Velvet Cloth of Gold at The Met: Historical, Technical, and Materials Analysis." *Metropolitan Museum Journal* 57 (2022), forthcoming.

Clark 1983
Clark, Jane. "A Set of Tapestries for Leicester House in The Strand: 1585." *Burlington Magazine* 125, no. 962 (May 1983), pp. 280–81, 283–84.

Cleland 2007a
Cleland, Elizabeth. "An *exemplum iustitiae* and the Price of Treason: How the Legend of Herkinbald Reached Henry VIII's Tapestry Collection." In *Late Gothic England: Art and Display*, edited by Richard Marks, pp. 48–56. Donington and London, 2007.

Cleland 2007b
Cleland, Elizabeth. "Tapestries as a Transnational Artistic Commodity." In *Locating Renaissance Art*, edited by Carol M. Richardson, pp. 103–32. New Haven and London, 2007.

Cleland 2009a
Cleland, Elizabeth. "Small-Scale Devotional Tapestries— Fifteenth and Sixteenth Centuries, Part 1: An Overview." *Studies in the Decorative Arts* 16, no. 2 (Spring–Summer 2009), pp. 115–40.

Cleland 2009b
Cleland, Elizabeth. "Small-Scale Devotional Tapestries— Fifteenth and Sixteenth Centuries, Part 2: The 'Mystic Grapes Group.'" *Studies in the Decorative Arts* 16, no. 2 (Spring–Summer 2009), pp. 141–64.

Cleland 2010
Cleland, Elizabeth. "Hunters in a Landscape." *Metropolitan Museum of Art Bulletin* 68, no. 2, special issue, "Recent Acquisitions, A Selection: 2008–2010" (Fall 2010), pp. 26–27.

Cleland 2011
Cleland, Elizabeth. "Ensconced behind the Arras: Documentary Evidence for Small-Scale Tapestries During the Renaissance." In *Unfolding the Textile Medium in Early Modern Art and Literature*, edited by Tristan Weddigen, pp. 43–54. Textile Studies 3. Emsdetten, 2011.

Cleland 2014
Cleland, Elizabeth. *Grand Design: Pieter Coecke van Aelst and Renaissance Tapestry.* With Maryan W. Ainsworth, Stijn Alsteens, and Nadine M. Orenstein. Exh. cat., The Metropolitan Museum of Art, New York. New York, 2014.

Cleland 2017
Cleland, Elizabeth. *"Cupid and Psyche* from Brussels to Paris: Questions of Attribution and Augmentation of Sixteenth-Century Flemish Designs Repurposed in Seventeenth-Century French Tapestries." In *Arachné: Un regard critique sur l'histoire de la tapisserie*, edited by Pascal-François Bertrand and Audrey Nassieu Maupas, pp. 77–87. Rennes, 2017.

Cleland and Karafel 2017
Cleland, Elizabeth, and Lorraine Karafel. *Tapestries from the Burrell Collection.* London, 2017.

Cleland and Wieseman 2018
Cleland, Elizabeth, and Marjorie E. Wieseman. *Renaissance Splendor: Catherine de' Medici's Valois Tapestries.* With Francesca de Luca et al. Exh. cat., Cleveland Museum of Art. New Haven, 2018.

Clode 1875
Clode, C. M., ed. *Memorials of the Guild of Merchant Taylors of the Fraternity of St. John the Baptist, in the City of London; And of Its Associated Charities and Institutions.* London, 1875.

Cochin 1914–19
Cochin, Claude. "Un lien artistique entre l'Italie, la Flandre et l'Angleterre: Pietro Torrigiani en Flandre." *Revue de l'art ancien et moderne* 36, no. 208 (1914–19), pp. 177–82.

Cocke 2001
Cocke, Thomas. "'The Repository of Our English Kings': The Henry VII Chapel as Royal Mausoleum." *Architectural History* 44, special issue, "Essays in Architectural History Presented to John Newman" (2001), pp. 212–20.

Colding 1953
Colding, Torben Holck. *Aspects of Miniature Painting: Its Origins and Development.* Copenhagen, 1953.

Colding and Andersen 1950
Colding, Torben Holck, and Jorgen Andersen. "An Elizabethan Love-Theme." *Burlington Magazine* 92, no. 572 (November 1950), pp. 324, 326–27.

Cole 1999
Cole, Mary Hill. *The Portable Queen: Elizabeth I and the Politics of Ceremony.* Massachusetts Studies in Early Modern Culture. Amherst, Mass., 1999.

Collins, A. 1746
Collins, Arthur, ed. *Letters and Memorials of State, in the Reigns of Queen Mary, Queen Elizabeth, King James, King Charles the First, Part of the Reign of King Charles the Second, and Oliver's Usurpation.* 2 vols. London, 1746.

Collins, A. J. 1955
Collins, A. Jefferies. *Jewels and Plate of Queen Elizabeth I: The Inventory of 1574, Edited from Harley Ms. 1650 and Stowe Ms. 555 in the British Museum.* London, 1955.

Colvin 1963–82
Colvin, H[oward] M., ed. *The History of the King's Works.* 6 vols. London, 1963–82.

Colvin 1986
Colvin, Howard M. "Royal Gardens in Medieval England." In *Medieval Gardens*, edited by Elisabeth B. MacDougall, pp. 7–22. Washington, D.C., 1986.

Condon 2003a
Condon, Margaret. "God Save the King! Piety, Propaganda and the Perpetual Memorial." In Tatton-Brown and Mortimer 2003, pp. 59–97.

Condon 2003b
Condon, Margaret. "The Last Will of Henry VII: Document and Text." In Tatton-Brown and Mortimer 2003, pp. 99–140.

Conisbee et al. 2009
Conisbee, Philip, Richard Rand, Joseph Baillio, John Oliver Hand, Yuriko Jackall, and Benedict Leca. *French Paintings of the Fifteenth through the Eighteenth Century.* The Collections of the National Gallery of Art: Systematic Catalogue. Washington, D.C., 2009.

Coope 1986
Coope, Rosalys. "The 'Long Gallery': Its Origins, Development, Use and Decoration." *Architectural History* 29 (1986), pp. 43–72, 74–84.

Cooper, N. 2002
Cooper, Nicholas. "Rank, Manners and Display: The Gentlemanly House, 1500–1750." *Transactions of the Royal Historical Society* 12 (2002), pp. 291–310.

Cooper, N. 2016a
Cooper, Nicholas. "The New Hall: Realising Intentions." In Adshead and Taylor 2016, pp. 18–38.

Cooper, N. 2016b
Cooper, Nicholas. "Two Hardwick Halls: Sources, Forms and Intentions." In Adshead and Taylor 2016, pp. 1–17.

Cooper, T. 2012
Cooper, Tarnya. *Citizen Portrait: Portrait Painting and the Urban Elite of Tudor and Jacobean England and Wales.* New Haven, 2012.

Cooper, T. 2013
Cooper, Tarnya. *Elizabeth I and Her People.* With Jane Eade. Exh. cat., National Portrait Gallery, London. London, 2013.

Cooper, T., and Howard, M. 2015
Cooper, Tarnya, and Maurice Howard. "Artists, Patrons and the Context for the Production of Painted Images in Tudor and Jacobean England." In Cooper, T., et al. 2015, pp. 4–28.

Cooper, T., and Walker, H. 2015
Cooper, Tarnya, and Hope Walker. "Talent and Adversity: A Reassessment of the Life and Works of Hans Eworth in Antwerp and London." In Cooper, T., et al. 2015, pp. 226–39.

Cooper, T., et al. 2015
Cooper, Tarnya, Aviva Burnstock, Maurice Howard, and Edward Town, eds. *Painting in Britain, 1500–1630: Production, Influences and Patronage.* Oxford, 2015.

Cooper, W. 1850
Cooper, William Durant. "Pedigree of the Lewknor Family." *Sussex Archaeological Collections* 3 (1850), pp. 89–102.

Corry, Howard, D., and Laven 2017
Corry, Maya, Deborah Howard, and Mary Laven, eds. *Madonnas and Miracles: The Holy Home in Renaissance Italy.* Exh. cat., Fitzwilliam Museum, Cambridge. London, 2017.

Cox and Forrest 1931
Cox, Montagu H., and G. Topham Forrest, eds. *Survey of London.* Vol. 14, *St. Margaret, Westminster.* Part 3, *Whitehall II.* London, 1931.

Cressy 1976
Cressy, David. "Educational opportunities in Tudor and Stuart England." *History of Education Quarterly* 16, no. 3 (Autumn 1976), pp. 301–20.

Croizat-Glazer 2013
Croizat-Glazer, Yassana. "Sin and Redemption in the *Hours of François I* (1539–40) by the Master of François de Rohan." *Metropolitan Museum Journal* 48, no. 1 (January 2013), pp. 121–42.

CSP Domestic, Elizabeth 1856–72
Calendar of State Papers, Domestic Series, of the Reigns of Edward VI, Mary, Elizabeth, and James I, 1547–1625, Preserved in the State Paper Department of Her Majesty's Public Record Office. Edited by Robert Lemon and Mary Anne Everett Green. 12 vols. London, 1856–72.

CSP Foreign, Elizabeth 1863–1950
Calendar of State Papers, Foreign Series, of the Reign of Elizabeth 1558–[1582], Preserved in the State Paper Department of Her Majesty's Public Record Office. Edited by Joseph Stevenson et al. 23 vols. London, 1863–1950.

CSP Foreign, Mary 1861
Calendar of State Papers, Foreign Series, of the Reign of Mary, 1553–1558: Preserved in the State Paper Department of Her Majesty's Public Record Office. Edited by William B. Turnbull. London, 1861.

CSP Spain 1862–1954
Calendar of Letters, Despatches, and State Papers Relating to the Negotiations between England and Spain, Preserved in the Archives at Simancas and Elsewhere. Edited by G. A. Bergenroth et al. 13 vols. London, 1862–1954.

CSP Venice 1864–1947
Calendar of State Papers and Manuscripts, Relating to English Affairs: Existing in the Archives and Collections of Venice, and in Other Libraries of Northern Italy, 1202–[1675]. Edited by Rawdon Brown et al. 38 vols. London, 1864–1947.

Cussans 1872
Cussans, J. E. "Notes on the Perkin Warbeck Insurrection." *Transactions of the Royal Historical Society* 1 (1872), pp. 57–71.

Cust 1906
Cust, Lionel. "John of Antwerp, Goldsmith, and Hans Holbein." *Burlington Magazine for Connoisseurs* 8, no. 35 (February 1906), pp. 356, 359–60.

Danbury 1989
Danbury, Elizabeth. "The Decoration and Illumination of Royal Charters in England, 1250–1509: An Introduction." In *England and Her Neighbors, 1066–1453: Essays in Honour of Pierre Chaplais*, edited by Michael Jones and Malcolm Vale, pp. 157–80. London and Ronceverte, W.V., 1989.

Darr 1979
Darr, Alan Phipps. "The Sculptures of Torrigiano: The Westminster Abbey Tombs." *Connoisseur* 200 (March 1979), pp. 177–84.

Darr 1992
Darr, Alan Phipps. "New Documents for Pietro Torrigiani and Other Early Cinquecento Florentine Sculptors Active in Italy and England." In *Kunst des Cinquecento in der Toskana*, edited by Monika Cämmerer, pp. 108–38. Italienische Forschungen 3.17. Munich, 1992.

Darr 2012
Darr, Alan Phipps. "Pietro Torrigiani and His Sculpture in Henrician England: Sources and Influences." In Sicca and Waldman 2012, pp. 49–80.

Daunt 2015
Daunt, Catherine. "Heroes and Worthies: Emerging Antiquarianism and the Taste for Portrait Sets in England." In Cooper, T., et al. 2015, pp. 362–75.

Davies 2008
Davies, Clifford S. L. "A Rose by Another Name." *Times Literary Supplement*, no. 5489 (June 13, 2008), pp. 14–15.

Davies 2012
Davies, C[lifford] S. L. "Tudor: What's in a Name?" *History* 97, no. 325 (January 2012), pp. 24–42.

Day 1990
Day, J. F. R. "Primers of Honor: Heraldry, Heraldry Books, and English Renaissance Literature." *Sixteenth Century Journal* 21, no. 1 (Spring 1990), pp. 93–103.

Degenhardt 2013
Degenhardt, Jane Hwang. "Cracking the Mysteries of 'China': China(ware) in the Early Modern Imagination." *Studies in Philology* 110, no. 1 (Winter 2013), pp. 132–67.

Delmarcel 1980
Delmarcel, Guy. *Tapisseries anciennes d'Enghien*. Mons, 1980.

Delmarcel 1999
Delmarcel, Guy. *Flemish Tapestry: From the 15th Century to the 18th Century*. Translated by Alastair Weir. Tielt, 1999. [Dutch edition: Delmarcel, Guy. *Het vlaamse wandtapijt van de 15de tot de 18de eeuw*. Tielt, 1999.]

Delmarcel 2008
Delmarcel, Guy. *David et Bethsabée: Un chef-d'oeuvre de la tapisserie à la Renaissance*. With Yvan Maes. Paris, 2008.

Delmarcel and De Roo 1976
Delmarcel, Guy, and René De Roo, eds. *Tapisseries bruxelloises de la pré-Renaissance*. Exh. cat., Centre de la Tapisserie Bruxelloise, Brussels. Brussels, 1976.

Delmarcel and Duverger 1987
Delmarcel, Guy, and Erik Duverger. *Bruges et la tapisserie*. Exh. cat., Musée Gruuthuse and Musée Memling, Bruges. Bruges, 1987.

Denny-Brown 2004
Denny-Brown, Andrea. "Rips and Slits: The Torn Garment and the Medieval Self." In *Clothing Culture, 1350–1650*, edited by Catherine Richardson, pp. 225–40. Aldershot, Hampshire, and Burlington, Vt., 2004.

Dent 1970
Dent, John. *The Quest for Nonsuch*. 2nd ed. London, 1970.

Dessins de la Renaissance 2003
Dessins de la Renaissance: Collection de la Bibliothèque nationale de France, département des estampes et de la photographie. Exh. cat., Fundació Caixa Catalunya, Barcelona, and Galerie Mazarine, Site Richelieu de la Bibliothèque Nationale de France, Paris. Paris and Barcelona, 2003.

Dhanens 1959
Dhanens, Elisabeth. "The David and Bathsheba Drawing." *Gazette des beaux-arts* 53 (April 1959), pp. 215–24.

Digby 1980
Digby, George Wingfield. *Victoria and Albert Museum: The Tapestry Collection, Medieval and Renaissance*. London, 1980.

Dillon 1905
Dillon, [Harold Arthur Lee-Dillon,] Viscount, ed. *An Almain Armourer's Album: Selections from an Original Ms. in Victoria and Albert Museum, South Kensington*. London, 1905.

Dmitrieva 2013
Dmitrieva, Olga. "From Whitehall to the Kremlin: The Diplomacy and Political Culture of the English and Russian Courts." In Dmitrieva and Murdoch, T. 2013, pp. 12–35.

Dmitrieva and Murdoch, T. 2013
Dmitrieva, Olga, and Tessa Murdoch, eds. *Treasures of the Royal Courts: Tudors, Stuarts and the Russian Tsars*. Exh. cat., Victoria and Albert Museum, London. London, 2013.

Dobson and Watson 2002
Dobson, Michael, and Nicola J. Watson. *England's Elizabeth: An Afterlife in Fame and Fantasy*. Oxford and New York, 2002.

Dockray 2004
Dockray, Keith. "Stanhope, Sir Michael (*b.* before 1508, *d.* 1552), Courtier." *Oxford Dictionary of National Biography*. Sep. 23, 2004. https://doi.org/10.1093/ref:odnb/26251. Accessed Nov. 26, 2019.

Donawerth 2000
Donawerth, Jane. "Women's Poetry and the Tudor-Stuart System of Gift Exchange." In *Women, Writing, and the Reproduction of Culture in Tudor and Stuart Britain*, edited by Mary E. Burke, Jane Donawerth, Linda L. Dove, and Karen Nelson, pp. 3–18. Syracuse, N.Y., 2000.

Doran 2000
Doran, Susan. *Elizabeth I and Foreign Policy, 1558–1603*. Lancaster Pamphlets. London and New York, 2000.

Doran 2003
Doran, Susan, ed. *Elizabeth: The Exhibition at the National Maritime Museum*. With David Starkey. Exh. cat., National Maritime Museum, Greenwich. London, 2003.

Doran 2009
Doran, Susan, ed. *Henry VIII: Man and Monarch*. With David Starkey and Andrea Clarke. Exh. cat., British Library, London. London, 2009.

Doran and Freeman 2003
Doran, Susan, and Thomas S. Freeman, eds. *The Myth of Elizabeth*. Basingstoke, Hampshire, and New York, 2003.

Doran and Freeman 2009
Doran, Susan, and Thomas S. Freeman, eds. *Tudors and Stuarts on Film: Historical Perspectives*. Basingstoke, Hampshire, and New York, 2009.

van Dorsten 1969
van Dorsten, Jan. "Steven Van Herwyck's Elizabeth (1565) — A Franco-Flemish Political Medal." *Burlington Magazine* 111, no. 792 (March 1969), pp. 143–45, 147.

Dow 1960
Dow, Helen J[eanette]. "Two Italian Portrait-Busts of Henry VIII." *Art Bulletin* 42, no. 4 (December 1960), pp. 291–94.

Dow 1992
Dow, Helen Jeanette. *The Sculptural Decoration of the Henry VII Chapel, Westminster Abbey*. Edinburgh, 1992.

Draper 2008
Draper, James David. "Cameo Appearances." *Metropolitan Museum of Art Bulletin* 65, no. 4 (Spring 2008).

Duffy 1992
Duffy, Eamon. *The Stripping of the Altars: Traditional Religion in England c. 1400–c. 1580*. New Haven, 1992.

Dürer 1958
Dürer, Albrecht. *The Writings of Albrecht Dürer*. Edited and translated by William Martin Conway. New York, 1958.

Eaker 2018
Eaker, Adam. "The Scene of the Sitting in Early Modern England." *Art History* 41, no. 4 (September 2018), pp. 650–79.

Eales 2013
Eales, Jackie. "'To booke and pen': Women, Education and Literacy in Tudor and Stuart England." *Historian: The Magazine of the Historical Association* 119 (Autumn 2013), pp. 24–29.

Ebben 2011
Ebben, Maurits A. "García de Yllán: A Merchant in Silver, Bread and Bullets and a Broker in Art, 1591–1655." In *Double Agents: Cultural and Political Brokerage in Early Modern Europe*, edited by Marika Keblusek and Badeloch Vera Noldus, pp. 125–46. Studies in Medieval and Reformation Traditions 154. Leiden, 2011.

van Eck 2009–10
van Eck, Xander. "Siding with Philip II: Margaretha van der Marck's Donation of Dirk Crabeth's *Judith and Holofernes* to the Sint Janskerk in Gouda." *Simiolus: Netherlands Quarterly for the History of Art* 34, no. 1 (2009–10), pp. 4–17.

van Eck 2012
van Eck, Xander. "Margaret of Parma's Gift of a Window to St. John's in Gouda and the Art of the Early Counter-Reformation in the Low Countries." *Simiolus: Netherlands Quarterly for the History of Art* 36, no. 1/2 (2012), pp. 66–84.

van Eck and Coebergh-Surie 1997
van Eck, Xander, and Christiane Coebergh-Surie. "'Behold, a greater than Jonas is here': The Iconographic Program of the Stained Glass Windows of Gouda, 1552–72." *Simiolus: Netherlands Quarterly for the History of Art* 25, no. 1 (1997), pp. 5–44.

Edie 1990
Edie, Carolyn A. "The Public Face of Royal Ritual: Sermons, Medals, and Civic Ceremony in Later Stuart Coronations." *Huntington Library Quarterly* 53, no. 4 (Autumn 1990), pp. 311–36.

Edwards, J. 2011
Edwards, John. "Sentimental Education of a Princess, 1516–1525." In *Mary I: England's Catholic Queen*, pp. 1–17. Yale English Monarchs. New Haven, 2011.

Edwards, J. R., Hammersley, and Newell 1990
Edwards, John Richard, George Hammersley, and Edmund Newell. "Cost Accounting at Keswick, England, c. 1598–1615: The German Connection." *Accounting Historians Journal* 17, no. 1 (June 1990), pp. 61–80.

Eichberger 2010
Eichberger, Dagmar, ed. *Los inventarios de Carlos V y la familia imperial / The Inventories of Charles V and the Imperial Family*. Vol. 3, *Margarita de Austria, Leonor de Austria, Isabel de Austria, Fernando I, María de Hungría, Catalina de Austria / Margaret of Austria, Leonor of Austria, Isabella of Austria, Ferdinand I, Mary of Hungary, Catherine of Austria*. Madrid, 2010.

Eichberger and Beaven 1995
Eichberger, Dagmar, and Lisa Beaven. "Family Members and Political Allies: The Portrait Collection of Margaret of Austria." *Art Bulletin* 77, no. 2 (June 1995), pp. 225–48.

Ellis, H. 1827
Ellis, Henry, ed. *Original Letters, Illustrative of English History; Including Numerous Royal Letters: From Autographs in the British Museum, and One or Two Other Collections*. 2nd ser., 4 vols. London, 1827.

Ellis, L. 1947
Ellis, L. B. "Wardrobe Place and the Great Wardrobe." *Transactions of the London and Middlesex Archaeological Society*, n.s., 10 (1947), pp. 246–61.

Emison 2006
Emison, Patricia. "The Replicated Image in Florence, 1300–1600." In *Renaissance Florence: A Social History*, edited by Roger J. Crum and John T. Paoletti, pp. 431–53. Cambridge, 2006.

Erasmus 1901–18
Erasmus, Desiderius. *The Epistles of Erasmus, from His Earliest Letters to His Fifty-First Year, Arranged in Order of Time*. Translated by Francis Morgan Nichols. 3 vols. London, New York, and Bombay, 1901–18.

Erasmus 1906–58
Erasmus, Desiderius. *Opus epistolarum Des. Erasmi Roterodami*. Edited by P. S. Allen, Helen Mary Allen, William Heathcote Garrod, and Barbara Flower. 12 vols. Oxford, 1906–58.

Erkelens 1962
Erkelens, A. M. Louise E. "Rafaëleske grotesken op enige Brusselse wandtapijtseries." *Bulletin van het Rijksmuseum* 10, no. 4 (1962), pp. 115–38.

Erler 1987
Erler, Mary C. "Sir John Davies and the Rainbow Portrait of Queen Elizabeth." *Modern Philology* 84, no. 4 (May 1987), pp. 359–71.

von Eschen 1929–30
von Eschen, Marie. "Colet as Bridge from Revival to Reformation." *Social Science* 5, no. 1 (November/December 1929–January 1930), pp. 85–90.

Evans, J. 1956
Evans, Joan. *A History of the Society of Antiquaries*. Oxford, 1956.

Evans, M. 2005
Evans, Mark. "The Pedigree of the Portrait Miniature: European Sources of an English Genre." In *Hans Holbein und der Wandel in der Kunst des frühen 16. Jahrhunderts*, edited by Bodo Brinkmann and Wolfgang Schmid, pp. 229–52. Turnhout, 2005.

Evans, M., and Browne 2010
Evans, Mark, and Clare Browne, eds. *Raphael: Cartoons and Tapestries for the Sistine Chapel*. With Arnold Nesselrath, Mark Haydu, and Adalbert Roth. Exh. cat., Victoria and Albert Museum, London. London, 2010.

Evelyn 1697
Evelyn, John. *Numismata: A Discourse of Medals Antient and Modern, Together with Some Account of Heads and Effigies of Illustrious, and Famous Persons, in Sculps and Taille-Douce, of Whom We Have No Medals Extant; and of the Use to Be Derived from Them; To Which Is Added a Digression Concerning Physiognomy*. London, 1697.

Fantazzi 2004
Fantazzi, Charles. "Vives, Juan Luis (1492/3–1540), Scholar." *Oxford Dictionary of National Biography*. Sep. 23, 2004. https://doi.org/10.1093/ref:odnb/28337. Accessed Dec. 12, 2019.

Farguson 2014
Farguson, Julie Anne. "Art, Ceremony and the British Monarchy, 1689–1714." PhD diss., University of Oxford, 2014.

Farmer 1969
Farmer, John David. *The Virtuoso Craftsman: Northern European Design in the Sixteenth Century*. Exh. cat., Worcester Art Museum. Worcester, Mass., 1969.

Farquhar 1908
Farquhar, Helen. "Nicholas Hilliard, 'Embosser of Medals of Gold.'" *Numismatic Chronicle and Journal of the Royal Numismatic Society* 8 (1908), pp. 324–56.

Fenn and Ramsay 1849
Fenn, John, and A. Ramsay, eds. *Paston Letters: Original Letters Written During the Reigns of Henry VI, Edward IV, and Richard III, by Various Persons of Rank or Consequence*. Rev. ed., 2 vols. London, 1849.

Ferrell 2010
Ferrell, Lori Anne. "Page *Techne*: Interpreting Diagrams in Early Modern English 'How-to' Books." In *Printed Images in Early Modern Britain: Essays in Interpretation*, edited by Michael Hunter, pp. 113–26. Farnham, Surrey, and Burlington, Vt., 2010.

Finlay 1980
Finlay, Robert. "Politics and History in the Diary of Marino Sanuto." *Renaissance Quarterly* 33, no. 4 (Winter 1980), pp. 585–98.

Finsten 1981
Finsten, Jill. *Isaac Oliver, Art at the Courts of Elizabeth I and James I*. Outstanding Dissertations in the Fine Arts. 2 vols. New York, 1981.

Fischer 2005
Fischer, Roman. "Churches." In *Glaube Macht Kunst: Antwerpen-Frankfurt um 1600 / Faith Power(s) Art: Antwerp-Frankfurt around 1600*, edited by Frank Berger, pp. 51–67. Exh. cat., Historisches Museum Frankfurt. Schriften des Historisches Museum Frankfurt am Main 25. Frankfurt am Main, 2005.

Fischlin 1997
Fischlin, Daniel. "Political Allegory, Absolutist Ideology, and the 'Rainbow Portrait' of Queen Elizabeth I." *Renaissance Quarterly* 50, no. 1 (Spring 1997), pp. 175–206.

Fisher 1914–15
Fisher, John. *Commentary on the Seven Penitential Psalms*. Edited by J. S. Phillimore. 2 vols. London, 1914–15.

Fleck 2010
Fleck, Miriam Verena. *Ein tröstlich gemelde: Die Glaubensallegorie "Gesetz und Gnade" in Europa zwischen Spätmittelalter und Früher Neuzeit*. Studien zur Kunstgeschichte des Mittelalters und der Frühen Neuzeit 5. Korb, 2010.

Fletcher and Cholmondeley Tapper 1983
Fletcher, John, and Margaret Cholmondeley Tapper. "Hans Holbein the Younger at Antwerp and in England, 1526–28." *Apollo* 117 (February 1983), pp. 87–93.

Focke 1887–89
Focke, Johann. "Zwei hansische Silbergeräte." *Hansische Geschichtsblätter* 16 (1887–89), pp. 117–28.

Foister 1981
Foister, Susan. "Paintings and Other Works of Art in Sixteenth-Century English Inventories." *Burlington Magazine* 123, no. 938 (May 1981), pp. 273–82.

Foister 1986
Foister, Susan. "Nobility Reclaimed." *Antique Collector* (April 1986), pp. 58–60.

Foister 2004
Foister, Susan. *Holbein and England*. New Haven and London, 2004.

Foister 2006
Foister, Susan. *Holbein in England*. With Tim Batchelor. Exh. cat., Tate Britain, London. London, 2006.

Foister, Roy, and Wyld 1997
Foister, Susan, Ashok Roy, and Martin Wyld. *Holbein's Ambassadors: Making and Meaning*. Exh. cat., National Gallery, London. London, 1997.

Ford 2004
Ford, L[isa] L. "Mildmay, Sir Walter (1520/21–1589), Administrator and Founder of Emmanuel College, Cambridge." *Oxford Dictionary of National Biography*. Sep. 23, 2004. https://doi.org/10.1093/ref:odnb/18696. Accessed Nov. 22, 2019.

Forti Grazzini 1994
Forti Grazzini, Nello. *Gli arrazi*. 2 vols. Il patrimonio artistico del Quirinale. Rome, 1994.

Forti Grazzini 2000
Forti Grazzini, Nello. "L'esercito di David scende in campo contra gli Ammoniti." In *Da Paolo Veneziano a Canova: Capolavori dei musei veneti restaurati dalla Regione del Veneto, 1984–2000*, edited by Giorgio Fossaluzza, pp. 138–43. Cataloghi di Mostre (Fondazione "Giorgio Cini," Centro di Cultura e Civiltá) 57. Exh. cat., Fondazione Giorgio Cini, Venice. Venice, 2000.

Fowler 1695
Fowler, Edward. *A Discourse of the Great Disingenuity and Unreasonableness of Repining at Afflicting Providences; And of the Influence Which They Ought to Have upon Us, on Job 2.10*. London, 1695.

Foxe 1563
Foxe, John. *Actes and Monuments of These Latter and Perillous Dayes, Touching Matters of the Church, Wherein Ar Comprehended and Described the Great Persecutions Horrible Troubles, That Have Bene Wrought and Practised by the Romishe Prelates, Speciallye in This Realme of England and Scotlande, from the Yeare of Our Lorde, a Thousande, unto the Tyme Nowe Present*. London, 1563. **1583 ed**. *Actes and Monuments of Matters Most Speciall and Memorable, Happenyng in the Church,*

with an Universall History of the Same, Wherein Is Set forth at Large the Whole Race and Course of the Church, from the Primitive Age to These Latter Tymes of Ours, with the Bloudy Times, Horrible Troubles, and Great Persecutions agaynst the True Martyrs of Christ, Sought and Wrought as well by Heathen Emperours, as Nowe Lately Practised by Romish Prelates, Especially in This Realme of England and Scotland. Rev. ed., in 2 vols. London, 1583.

Franklin, Nurse, and Tudor-Craig 2015
Franklin, Jill A., Bernard Nurse, and Pamela Tudor-Craig. Catalogue of Paintings in the Collection of the Society of Antiquaries of London. London, 2015.

Fraser 1969
Fraser, Antonia. Mary, Queen of Scots. London, 1969.

Friedländer 1915
Friedländer, Max J. "Ein neu erworbenes Madonnenbild im Kaiser-Friedrich-Museum." Amtliche Berichte aus den königlichen Kunstsammlungen 36, no. 9 (June 1915), pp. 1–2, 179–83.

Friedländer 1975
Friedländer, Max J. Early Netherlandish Painting. Vol. 12, Jan van Scorel and Pieter Coeck van Aelst. Translated by Heinz Norden. New York, 1975.

Friedman 1992
Friedman, Alice T. "Architecture, Authority, and the Female Gaze: Planning and Representation in the Early Modern Country House." Assemblage, no. 18 (August 1992), pp. 40–61.

Frinta 2009
Frinta, Mojmír. "Observation on Michel Sittow." Artibus et Historiae 30, no. 60 (2009), pp. 139–56.

Fry 1865
Fry, Francis. A Description of the Great Bible, 1539, and the Six Editions of Cranmer's Bible, 1540 and 1541, Printed by Grafton and Whitchurch; Also of the Editions, in Large Folio, of the Authorized Version of the Holy Scriptures, Printed in the Years 1611, 1613, 1617, 1634, 1640. London, 1865.

Frye, N. 1957
Frye, Northrop. Anatomy of Criticism: Four Essays. Princeton, N.J., 1957.

Frye, S. 1993
Frye, Susan. Elizabeth I: The Competition for Representation. New York, 1993.

Frye, S. 2010
Frye, Susan. Pens and Needles: Women's Textualities in Early Modern England. Philadelphia, 2010.

Frye, S. 2019
Frye, Susan. "Bess of Hardwick's Gynocracy in Textiles." In Hopkins 2019, pp. 159–80.

Fumerton 1986
Fumerton, Patricia. "'Secret' Arts: Elizabethan Miniatures and Sonnets." Representations 15 (Summer 1986), pp. 57–97.

Fumerton 1991
Fumerton, Patricia. Cultural Aesthetics: Renaissance Literature and the Practice of Social Ornament. Chicago, 1991.

Furlong 2015
Furlong, Gillian. Treasures from UCL. June 4, 2015. https://discovery.ucl.ac.uk/id/eprint/1468565/6/TREASURES_FROM_UCL.pdf. Accessed Feb. 17, 2020.

Furlotti, Rebecchini, and Wolk-Simon 2019
Furlotti, Barbara, Guido Rebecchini, and Linda Wolk-Simon, eds. Giulio Romano: Arte e desiderio. Exh. cat., Palazzo Te, Mantua. Milan, 2019.

Gairdner 1858
Gairdner, James, ed. Historia regis Henrici Septimi: A Bernardo Andrea tholosate conscripta; Necnon alia quaedam ad eundem regem spectantia. Rerum Britannicarum Medii Aevi Scriptores 10. London, 1858.

Galvin and Lindley 1988
Galvin, Carol, and Phillip Lindley. "Pietro Torrigiano's Portrait Bust of King Henry VII." Burlington Magazine 130, no. 1029 (December 1988), pp. 892–902.

Gamber 1963
Gamber, Ortwin. "Die königlich englische Hofplattnerei: Martin van Royne und Erasmus Kirkener." Jahrbuch der Kunsthistorischen Sammlungen in Wien 59 (1963), pp. 7–38.

Gammon 1973
Gammon, Samuel Rhea. Statesman and Schemer: William, First Lord Paget, Tudor Minister. Newton Abbot, Devon, 1973.

Gardiner 1975
Gardiner, Rena. The Guildhall, Lavenham, Suffolk. London, 1975.

Gates 2008
Gates, Anita. "The Royal Life (Some Facts Altered)." New York Times, March 23, 2008.

Gent 1995
Gent, Lucy, ed. Albion's Classicism: The Visual Arts in Britain, 1550–1660. New Haven and London, 1995.

Gent 2005
Gent, Lucy. "Marcus Gheeraerdts's Captain Thomas Lee." In Dealing with the Visual: Art History, Aesthetics and Visual Culture, edited by Caroline van Eck and Edward Winters, pp. 85–108. Histories of Vision. Aldershot, Hampshire, and Burlington, Vt., 2005.

Gentilini and Mozzati 2012
Gentilini, Giancarlo, and Tommaso Mozzati. "'142 Life-size Figures . . . with the King on Horseback': Baccio Bandinelli's Mausoleum for Henry VIII." In Sicca and Waldman 2012, pp. 203–33.

Gerchow and Gorgus 2017
Gerchow, Jan, and Nina Gorgus. 100 x Frankfurt: Geschichten aus (mehr als) 1,000 Jahren. Frankfurt am Main, 2017.

Gere and Pouncey 1983
Gere, J. A., and Philip Pouncey. Italian Drawings in the Department of Prints and Drawings in the British Museum. Vol. 5, Artists Working in Rome, c. 1550 to c. 1640. With Rosalind Wood. London, 1983.

Gibaud 1982
Gibaud, Henri. Un inédit d'Erasme: La première version du Nouveau Testament copiée par Pierre Meghen, 1506–1509. Angers, 1982.

Gibson 1931
Gibson, Strickland, ed. Statuta antiqua Universitatis Oxoniensis. Oxford, 1931.

Gim 1999
Gim, Lisa. "'Faire Eliza's Chaine': Two Female Writers' Literary Links to Queen Elizabeth I." In Maids and Mistresses, Cousins and Queens: Women's Alliances in Early Modern England, edited by Susan Frye and Karen Robertson, pp. 183–98. New York, 1999.

Gingerich 1995
Gingerich, Owen. "A Survey of Apian's Astronomicum Caesareum." In Peter Apian: Astronomie, Kosmographie und Mathematik am Beginn der Neuzeit; mit Ausstellungskatalog, edited by Karl Röttel, pp. 113–22. Buxheim, 1995.

Girouard 1983
Girouard, Mark. Robert Smythson and the Elizabethan Country House. New Haven, 1983.

Giustiniani 1854
Giustiniani, Sebastiano. Four Years at the Court of Henry VIII: Selection of Despatches Written by the Venetian Ambassador, Sebastian Giustinian, and Addressed to the Signory of Venice, January 12th, 1515, to July 26th, 1519. Edited and translated by Rawdon Brown. 2 vols. London, 1854.

Glancey 2006
Glancey, Jonathan. "Pubs, Privet and Parody as China Builds Little Britain by the Yangtse: UK Developers Are Helping House Shanghai Elite in a Pastiche of Olde England." Guardian, Aug. 16, 2006. https://www.theguardian.com/uk/2006/aug/16/world.china. Accessed May 24, 2019.

Glanville 1987
Glanville, Philippa. Silver in England. New York, 1987.

Glanville 1990
Glanville, Philippa. Silver in Tudor and Early Stuart England: A Social History and Catalogue of the National Collection, 1480–1660. London, 1990.

Glück 1933
Glück, Gustav. "The Henry VII in the National Portrait Gallery." Burlington Magazine for Connoisseurs 63, no. 366 (September 1933), pp. 100, 104–8.

Goldring 2004a
Goldring, Elizabeth. "The Earl of Leicester and Portraits of the Duc d'Alençon." Burlington Magazine 146, no. 1211 (February 2004), pp. 108–11.

Goldring 2004b
Goldring, Elizabeth. "Talbot [née Hardwick], Elizabeth [Bess] [called Bess of Hardwick], countess of Shrewsbury (1527?–1608), Noblewoman." Oxford Dictionary of National Biography. Sep. 23, 2004. https://doi.org/10.1093/ref:odnb/26925. Accessed Feb. 7, 2020.

Goldring 2005
Goldring, Elizabeth. "'So lively a portraiture of his miseries': Melancholy, Mourning and the Elizabethan Malady." British Art Journal 6, no. 2 (Autumn 2005), pp. 12–22.

Goldring 2007
Goldring, Elizabeth. "Portraiture, Patronage, and the Progresses: Robert Dudley, Earl of Leicester, and the Kenilworth Festivities of 1575." In The Progresses,

Pageants, and Entertainments of Queen Elizabeth I, edited by Jayne Elisabeth Archer, Elizabeth Goldring, and Sarah Knight, pp. 163–88. Oxford and New York, 2007.

Goldring 2012
Goldring, Elizabeth. "A Portrait of Sir Philip Sidney by Veronese at Leicester House, London." *Burlington Magazine* 154, no. 1313 (August 2012), pp. 548–54.

Goldring 2014
Goldring, Elizabeth. *Robert Dudley, Earl of Leicester, and the World of Elizabethan Art: Painting and Patronage at the Court of Elizabeth I*. New Haven and London, 2014.

Goldring 2015
Goldring, Elizabeth. "Heraldic Drawing and Painting in Early Modern England." In Cooper, T., et al. 2015, pp. 262–77.

Goldring 2019
Goldring, Elizabeth. *Nicholas Hilliard: Life of an Artist*. New Haven, 2019.

Goldring et al. 2014
Goldring, Elizabeth, Faith Eales, Elizabeth Clarke, and Jayne Elisabeth Archer, eds. *John Nichols's* The Progresses and Public Processions of Queen Elizabeth I: *A New Edition of the Early Modern Sources*. 5 vols. Oxford, 2014.

Goodrich 2008
Goodrich, Jaime. "Thomas More and Margaret More Roper: A Case for Rethinking Women's Participation in the Early Modern Public Sphere." *Sixteenth Century Journal* 39, no. 4 (Winter 2008), pp. 1021–40.

Goodrich 2014
Goodrich, Jaime. *Faithful Translators: Authorship, Gender, and Religion in Early Modern England. Rethinking the Early Modern*. Evanston, Ill., 2014.

Grancsay 1957
Grancsay, Stephen V. "A Miniature Portrait of the Earl of Cumberland in Armor." *Metropolitan Museum of Art Bulletin* 15, no. 5 (January 1957), pp. 120–22.

Graziani 1972
Graziani, René. "The 'Rainbow Portrait' of Queen Elizabeth I and Its Religious Symbolism." *Journal of the Warburg and Courtauld Institutes* 35 (1972), pp. 247–59.

Green 1997
Green, Janet M. "'I My Self': Queen Elizabeth I's Oration at Tilbury Camp." *Sixteenth Century Journal* 28, no. 2 (Summer 1997), pp. 421–45.

Greenblatt 2005
Greenblatt, Stephen. *Renaissance Self-Fashioning: From More to Shakespeare*. 2nd ed. Chicago, 2005.

Greene 1995
Greene, Thomas M. "Shakespeare's *Richard II*: The Sign in Bullingbrook's Window." In Gent 1995, pp. 313–23.

de Groot 2005
de Groot, Wim, ed. *The Seventh Window: The King's Window Donated by Philip II and Mary Tudor to Sint Janskerk in Gouda (1557)*. Hilversum, 2005.

de Groot 2011
de Groot, Wim. "De glazeniersfamilie Crabeth en hun werkzaamheden in Saint-Hubert d'Ardenne." *Oud Holland* 124, no. 2/3 (2011), pp. 81–111.

Grossmann 1950
Grossmann, F. "Holbein, Torrigiano and Some Portraits of Dean Colet: A Study of Holbein's Work in Relation to Sculpture." *Journal of the Warburg and Courtauld Institutes* 13, no. 3/4 (1950), pp. 202–36.

Grossmann 1961
Grossmann, F. "A Religious Allegory by Hans Holbein the Younger." *Burlington Magazine* 103, no. 705 (December 1961), pp. 491–94.

Grosvenor 2009
Grosvenor, Bendor. "The Identity of 'the famous paynter Steven': Not Steven van der Meulen but Steven van Herwijck." *British Art Journal* 9, no. 3 (Spring 2009), pp. 12–17.

Guicciardini 1567
Guicciardini, Lodovico. *Descrittione di M. Lodovico Guicciardini, patritio fiorentino, di tutti i Paesi Bassi, altrimenti detti Germania Inferiore*. Antwerp, 1567.

Guide to the Collections 1896–97
A Guide to the Collections of the South Kensington Museum, London, 1896–97.

Guillaume and Fuhring 2010
Guillaume, Jean, and Peter Fuhring. *Jacques Androuet du Cerceau: "Un des plus grands architectes qui se soient jamais trouvés en France."* Exh. cat., Musée National des Monuments Français, Paris. Paris, 2010.

Gundestrup 1991–95
Gundestrup, Bente. *Det Kongelige danske Kunstkammer 1737 / The Royal Danish Kunstkammer 1737*. 3 vols. Copenhagen, 1991–95.

Gunn 2012
Gunn, Steven J. "Anglo-Florentine Contacts in the Age of Henry VIII: Political and Social Contexts." In Sicca and Waldman 2012, pp. 19–47.

Gunn and Lindley 1991
Gunn, S[teven] J., and P[hillip] G. Lindley, eds. *Cardinal Wolsey: Church, State and Art*. Cambridge and New York, 1991.

Günther 2018
Günther, Hubertus. "Hugues Sambin and Supporting Figures in Treatises and Engravings of the Renaissance." In *Construire avec le corps humain: Les ordres anthropomorphes et leurs avatars dans l'art européen de l'antiquité à la fin du XVIe siècle / Bauen mit dem menschlichen Körper: Anthropomorphe Stützen von der Antike bis zur Gegenwart*, edited by Sabine Frommel, Eckhard Leuschner, Vincent Droguet, and Thomas Kirchner. Vol. 1, pp. 187–201. Itinéraires / Percorsi 4. Rome and Paris, 2018.

Hackenbroch 1960
Hackenbroch, Yvonne. "A Mysterious Monogram." *Metropolitan Museum of Art Bulletin* 19, no. 1 (Summer 1960), pp. 18–24.

Hackett 2014
Hackett, Helen. "A New Image of Elizabeth I: The Three Goddesses Theme in Art and Literature." *Huntington Library Quarterly* 77, no. 3 (Autumn 2014), pp. 225–56.

Hackett 2017
Hackett, Helen. "Anne Boleyn's Legacy to Elizabeth I: Neoclassicism and the Iconography of Protestant Queenship." In Bertolet 2017, pp. 157–80.

van der Haeghen 1914
van der Haeghen, V. "Notes sur l'atelier de Gérard Horenbault vers la fin du XVer siècle." *Bulletijn der Maatschappij van Geschied- en Oudheidkunde te Gent* 22, no. 1 (1914), pp. 26–30.

Hageman and Conway 2007
Hageman, Elizabeth H., and Katherine Conway, eds. *Resurrecting Elizabeth I in Seventeenth-Century England*. Madison, N.J., 2007.

Hakluyt 1598–1600
Hakluyt, Richard. *The Principal Navigations, Voyages, Traffiques and Discoveries of the English Nation*. 2nd ed. 3 vols. London, 1598–1600.

Hall 1550
Hall, Edward. *The Union of the Two Noble and Illustre Famelies of Lancastre and York*. London, 1550.

Hall 1809
Hall, Edward. *Hall's Chronicle: Containing the History of England during the Reign of Henry IV, and the Succeeding Monarchs, to the End of the Reign of Henry VIII, in Which Are Particularly Described the Manners and Customs of Those Periods*. Edited by Henry Ellis. London, 1809.

Hammer 1999
Hammer, Paul E. J. *The Polarisation of Elizabethan Politics: The Political Career of Robert Devereux, 2nd Earl of Essex, 1585–1597*. Cambridge Studies in Early Modern British History. Cambridge and New York, 1999.

Hammer 2000
Hammer, Paul E. J. "Sex and the Virgin Queen: Aristocratic Concupiscence and the Court of Elizabeth I." *Sixteenth Century Journal* 31, no. 1, special issue, "Gender in Early Modern Europe" (Spring 2000), pp. 77–97.

Hammer 2004
Hammer, Paul E. J. "Devereux, Robert, Second Earl of Essex (1565–1601), Soldier and Politician." *Oxford Dictionary of National Biography*. Sep. 23, 2004. https://doi.org/10.1093/ref:odnb/7565. Accessed Feb. 4, 2020.

Hammersley 1988
Hammersley, George, ed. *Daniel Hechstetter, the Younger: Memorabilia and Letters, 1600–1639; Copper Works and Life in Cumbria*. Deutsche Handelsakten des Mittelalters und der Neuzeit 17. Stuttgart, 1988.

Hand 1993
Hand, John Oliver. *German Paintings of the Fifteenth through Seventeenth Centuries*. With Sally E. Mansfield. The Collections of the National Gallery of Art: Systematic Catalogue. Washington, D.C., 1993.

Hand and Koppel 2017
Hand, John Oliver, and Greta Koppel. *Michel Sittow: Estonian Painter at the Courts of Renaissance Europe*. With Till-Holger Borchert, Anu Mänd, Ariane van Suchtelen, and Matthias Weniger. Exh. cat. National Gallery of Art, Washington, D.C., and Art Museum of Estonia, Tallinn. New Haven and London, 2017.

Harding 2008
Harding, Vanessa. "Cheapside: Commerce and Commemoration." *Huntington Library Quarterly* 71, no. 1 (March 2008), pp. 77–96.

Hargrave 1982
Hargrave, O. T. "Bloody Mary's Victims: The Iconography of John Foxe's Book of Martyrs." *Historical Magazine of the Protestant Episcopal Church* 51, no. 1 (March 1982), pp. 7–21.

Harris, B. 2000
Harris, Bernard. "A Portrait of a Moor." In *Shakespeare and Race*, edited by Catherine M. S. Alexander and Stanley Wells, pp. 23–36. Cambridge and New York, 2000.

Harris, B. J. 2010
Harris, Barbara J. "Defining Themselves: English Aristocratic Women, 1450–1550." *Journal of British Studies* 49, no. 4 (October 2010), pp. 734–52.

Harris, E. 2011
Harris, Eileen. *British Architectural Books and Writers, 1556–1785*. With Nicholas Savage. Cambridge and New York, 2011.

Hattaway 1965
Hattaway, Michael. "Marginalia by Henry VIII in His Copy of *The Bokes of Salomon*." *Transactions of the Cambridge Bibliographical Society* 4, no. 2 (1965), pp. 166–70.

Hawes 1928
Hawes, Stephen. *The Pastime of Pleasure: A Literal Reprint of the Earliest Complete Copy (1517) with Variant Readings from the Editions of 1509, 1554, and 1555*. Edited by William Edward Mead. Early English Text Society Original Series 173. London, 1928.

Hayward, J. 1958
Hayward, J. F. "A Rock-Crystal Bowl from the Treasury of Henry VIII." *Burlington Magazine* 100, no. 661 (April 1958), pp. 120–25.

Hayward, J. 1976
Hayward, J. F. *Virtuoso Goldsmiths and the Triumph of Mannerism, 1540–1620*. London and Totowa, N.J., 1976.

Hayward, M. 2005
Hayward, Maria. "Gift Giving at the Court of Henry VIII: The 1539 New Year's Gift Roll in Context." *Antiquaries Journal* 85 (2005), pp. 125–75.

Hayward, M. 2007
Hayward, Maria, ed. *Dress at the Court of Henry VIII: The Wardrobe Book of the Wardrobe of the Robes Prepared by James Worsley in December 1516, Edited from Harley MS 2284, and His Inventory Prepared on 17 January 1521, Edited from Harley MS 4217, Both in the British Library*. Leeds, 2007.

Hayward, M. 2009
Hayward, Maria. *Rich Apparel: Clothing and the Law in Henry VIII's England*. Farnham, Surrey, and Burlington, Vt., 2009.

Hayward, M. 2010
Hayward, Maria. "The 'Empresse of Flowers': The Significance of Floral Imagery in Two Portraits of Elizabeth I at Jesus College, Oxford." *Costume* 44, no. 1 (May 2010), pp. 20–27.

Hayward, M. 2013
Hayward, Maria. "Rich Pickings: Henry VIII's Use of Confiscation and Its Significance for the Development of the Royal Collection." In Betteridge and Lipscomb 2013, pp. 29–46.

Hayward, M. 2016
Hayward, Maria. "'We should dress us fairly for our end': The Significance of the Clothing Worn at Elite Executions in England in the Long Sixteenth Century." *History* 101, no. 345 (April 2016), pp. 222–45.

Hayward, M., and Ward 2012
Hayward, Maria, and Philip Ward, eds. *The Inventory of King Henry VIII: Society of Antiquaries MS 129 and British Library MS Harley 1419*. Vol. 2, *Textiles and Dress*. Reports of the Research Committee of the Society of Antiquaries of London 75. London, 2012.

Heal 1980
Heal, Felicity. *Of Prelates and Princes: A Study of the Economic and Social Position of the Tudor Episcopate*. Cambridge and New York, 1980.

Heal 2014
Heal, Felicity. *The Power of Gifts: Gift-Exchange in Early Modern England*. New York, 2014.

Heard 2011
Heard, Kate. "'Such stuff as dreams are made on': Textiles and the Medieval Chantry." *Journal of the British Archaeological Association* 164, no. 1, special issue, "The Medieval Chantry in England" (September 2011), pp. 157–68.

Heard and Whitaker 2011
Heard, Kate, and Lucy Whitaker. *The Northern Renaissance: Dürer to Holbein*. Exh. cat., Queen's Gallery, Palace of Holyroodhouse, Edinburgh, and Queen's Gallery, Buckingham Palace, London. London, 2011.

Hearn 1995
Hearn, Karen, ed. *Dynasties: Painting in Tudor and Jacobean England, 1530–1630*. Exh. cat., Tate Gallery, London. London, 1995.

Hearn 2002
Hearn, Karen. *Marcus Gheeraerts II: Elizabethan Artist*. With Rica Jones. Exh. cat., Tate Britain, London. London, 2002.

Hearn 2003
Hearn, Karen. "A Question of Judgement: Lucy Harington, Countess of Bedford, as Art Patron and Collector." In *The Evolution of English Collecting: Receptions of Italian Art in the Tudor and Stuart Periods*, edited by Edward Chaney, pp. 221–39. Studies in British Art 12. New Haven and London, 2003.

Hearn 2005
Hearn, Karen. *Nicholas Hilliard*. London, 2005.

Hearn 2009
Hearn, Karen. "Lady Anne Clifford's Great Triptych." In *Lady Anne Clifford: Culture, Patronage and Gender in 17th-Century Britain*, edited by Karen Hearn and Lynn Hulse, pp. 1–24. Yorkshire Archaeological Society Occasional Papers 7. Leeds, 2009.

Hefford 2002
Hefford, Wendy. "Flemish Tapestry Weavers in England: 1550–1775." In *Flemish Tapestry Weavers Abroad: Emigration and the Founding of Manufactories in Europe; Proceedings of the International Conference Held at Mechelen, 2–3 October 2000*, edited by Guy Delmarcel, pp. 43–61. Leuven, 2002.

Held 1958
Held, Julius S. "Le Roi à la Chasse." *Art Bulletin* 40, no. 2 (June 1958), pp. 139–49.

Henderson 1992
Henderson, Paula. "Sir Francis Bacon's Water Gardens at Gorhambury." *Garden History* 20, no. 2 (Autumn 1992), pp. 116–31.

Henderson 2011
Henderson, Paula. "Clinging to the Past: Medievalism in the English 'Renaissance' Garden." *Renaissance Studies* 25, no. 1, special issue, "Gardens and Horticulture in Early Modern Europe" (February 2011), pp. 42–69.

Hentzner 1612
Hentzner, Paul. *Itinerarium Germaniae, Galliae, Angliae, Italiae*. Nuremberg, 1612.

Hepburn 2001
Hepburn, Frederick. "Three Portrait Busts by Torrigiani: A Reconsideration." *Journal of the British Archaeological Association* 154 (2001), pp. 150–69.

Hepburn 2015
Hepburn, Frederick. "'Pintor Ynglés': The Earliest Evidence for Portraiture at the Court of Henry VII." In Cooper, T., et al. 2015, pp. 344–51.

Herman 2014
Herman, Nicholas. "A Newly Discovered Portrait of Louis XII by Jean Bourdichon." *Burlington Magazine* 156, no. 1337 (August 2014), pp. 507–9.

Hervey 1921
Hervey, Mary F. S. *The Life, Correspondence and Collections of Thomas Howard, Earl of Arundel*. Cambridge, 1921.

Hessayon 2007
Hessayon, Ariel. "Incendiary Texts: Book Burning in England, c. 1640–c. 1660." *Cromohs: Cyber Review of Modern Historiography* 12 (2007), pp. 1–25. https://www.cromohs.unifi.it/12_2007/hessayon_incendtexts.html. Accessed Jan. 21, 2020.

Hewitson 1870
Hewitson, Atticus. *Stonyhurst College, Its Past and Present: An Account of Its History, Architecture, Treasures, Curiosities, etc.* Preston, 1870.

Hibberd and Wrigley 2014
Hibberd, Sarah, and Richard Wrigley, eds. *Art, Theatre, and Opera in Paris, 1750–1850: Exchanges and Tensions*. Farnham, Surrey, 2014.

Hicks, C. 2007
Hicks, Carola. *The King's Glass: A Story of Tudor Power and Secret Art*. London, 2007.

Hicks, M. 2004
Hicks, Michael. "Heneage, Sir Thomas (b. in or before 1532, d. 1595), Courtier." *Oxford Dictionary of National Biography*. Sep. 23, 2004. https://doi.org/10.1093/ref:odnb/12921. Accessed Jan. 22, 2020.

Higgins 1894
Higgins, Alfred. "On the Work of Florentine Sculptors in England in the Early Part of the Sixteenth Century: With Special Reference to the Tombs of Cardinal Wolsey and King Henry VIII." *Archaeological Journal* 51, no. 1 (1894), pp. 129–220.

Hill, G. 1908
Hill, G. F. "Steven H., Medallist and Painter." *Burlington Magazine for Connoisseurs* 12, no. 60 (March 1908), pp. 355–57, 360–63.

Hill, P. 1997
Hill, Peter. *Walpole's Art Collection: Horace Walpole's Oil Paintings, Water Colours and Drawings at Strawberry Hill*. Twickenham, 1997.

Hille 2012
Hille, Christiane. *Visions of the Courtly Body: The Patronage of George Villiers, First Duke of Buckingham, and the Triumph of Painting at the Stuart Court*. Berlin, 2012.

Hille 2017
Hille, Christiane. "Gems of Sacred Kingship: Faceting Anglo-Mughal Relations around 1600." In *The Nomadic Object: The Challenge of World for Early Modern Religious Art*, edited by Christine Göttler and Mia M. Mochizuki, pp. 291–318. Leiden and Boston, 2017.

Hilliard 1983
Hilliard, Nicholas. *Nicholas Hilliard's "Art of Limning": A New Edition of A Treatise Concerning the Arte of Limning Writ by N Hilliard*. Edited by Arthur F. Kinney and Linda Bradley Salamon. Boston, 1983.

Himmelheber 1972
Himmelheber, Georg. *Spiele: Gesellschaftsspiele aus einem Jahrtausend*. Exh. cat., Bayerisches Nationalmuseum, Munich. Munich, 1972.

Hind 1952
Hind, Arthur M. *Engraving in England in the Sixteenth and Seventeenth Centuries: A Descriptive Catalogue with Introductions*. Vol. 1, *The Tudor Period*. Cambridge, 1952.

Hodnett 1971
Hodnett, Edward. *Marcus Gheeraerts The Elder of Bruges, London, and Antwerp*. Utrecht, 1971.

Holinshed 1577
Holinshed, Raphael, ed. *Chronicles of England, Scotlande, and Irelande*. With William Harrison and Richard Stanyhurst. 2 vols. London, 1577.

Holinshed 1807–8
Holinshed, Raphael, John Hooker, et al., eds. *Holinshed's Chronicles of England, Scotland and Ireland*. Based on the 1587 edition of John Hooker et al. 6 vols. London, 1807–8.

Holman 1979
Holman, Thomas S. "Holbein's Portraits of the Steelyard Merchants: An Investigation." *Metropolitan Museum Journal* 14 (1979), pp. 139–58.

Holmes 2004
Holmes, Peter. "Clifford, George, Third Earl of Cumberland (1558–1605), Courtier and Privateer." *Oxford Dictionary of National Biography*. Sep. 23, 2004. https://doi.org/10.1093/ref:odnb/5645. Accessed Jan. 22, 2020.

Honig 1990
Honig, Elizabeth. "In Memory: Lady Dacre and Pairing by Hans Eworth." In *Renaissance Bodies: The Human Figure in English Culture, c. 1540–1660*, edited by Lucy Gent and Nigel Llewellyn, pp. 60–85. London, 1990.

Hopkins 2019
Lisa Hopkins, ed. *Bess of Hardwick: New Perspectives*. Manchester, 2019.

Horne 1952
Horne, David H., ed. *The Life and Minor Works of George Peele*. New Haven, 1952.

Høskuldsson 2018
Høskuldsson, Karen Margrethe. "Hidden in Plain Black: The Secrets of the French Hood." In *Medieval Clothing and Textiles 14*, edited by Robin Netherton and Gale R. Owen-Crocker, pp. 141–77. Medieval Clothing and Textiles. Woodbridge, Suffolk, 2018.

Howard, J. 2002
Howard, Jean E. "Competing Ideologies of Commerce in Thomas Heywood's *If You Know Not Me You Know Nobody, Part II*." In *The Culture of Capital: Property, Cities, and Knowledge in Early Modern England*, edited by Henry S. Turner, pp. 163–82. New York, 2002.

Howard, M. 1987
Howard, Maurice. *The Early Tudor Country House: Architecture and Politics, 1490–1550*. London, 1987.

Howard, M. 1991
Howard, Maurice. "Henry VIII at Greenwich: London." *Burlington Magazine* 133, no. 1061 (1991), pp. 562–63.

Howard, M. 1998
Howard, Maurice. "Inventories, Surveys and the History of Great Houses, 1480–1640." *Architectural History* 41 (1998), pp. 14–29.

Howard, M. 2001
Howard, Maurice. "A Drawing by 'Robertus Pyte' for Henry VIII." *Architectural History* 44, special issue, "Essays in Architectural History Presented to John Newman" (2001), pp. 22–28.

Howard, M. 2004
Howard, Maurice. "Elizabeth I: A Sense of Place in Stone, Print and Paint." *Transactions of the Royal Historical Society* 14 (2004), pp. 261–68.

Howard, M. 2007
Howard, Maurice. *The Building of Elizabethan and Jacobean England*. New Haven, 2007.

Howarth 1997
Howarth, David. *Images of Rule: Art and Politics in the English Renaissance, 1485–1649*. Berkeley and Los Angeles, 1997.

Howey 2007
Howey, Catherine L. "Busy Bodies: Women, Power and Politics at the Court of Elizabeth I, 1558–1603." PhD diss., Rutgers University, 2007.

Howey 2009
Howey, Catherine L. "Dressing a Virgin Queen: Court Women, Dress, and Fashioning the Image of England's Queen Elizabeth I." *Early Modern Women* 4 (Fall 2009), pp. 201–8.

Hume 1889
Hume, Martin A. Sharp. *Chronicle of King Henry VIII of England: Being a Contemporary Record of Some of the Principal Events of the Reigns of Henry VIII and Edward VI. Written in Spanish by an Unknown Hand*. London, 1889.

Humphrey 2015
Humphrey, Nick. "Printed Sources for a South German Games Board." *V&A Online Journal* 7 (Summer 2015). https://www.vam.ac.uk/content/journals/research-journal/issue-no.-7-autumn-2015/printed-sources-for-a-south-german-games-board/. Accessed Jan. 21, 2020.

Hunt and Sharp 2015
Hunt, James L., and John Sharp. "Decoding William Scrots' Anamorphic Portrait of Edward VI." *BSHM Bulletin: Journal of the British Society for the History of Mathematics* 30, no. 3 (2015), pp. 200–216.

Hurd 2008
Hurd, T. M. "The Wolsey Angels Discovered." In *The Wolsey Angels*, by T. M. Hurd, P[hillip] G. Lindley, and Francesco Caglioti, pp. 4–11. N.p., 2008[?].

Hymers 1840
Hymers, J., ed. *The Funeral Sermon of Margaret, Countess of Richmond and Derby, Mother to King Henry VII, and Foundress of Christ's and St. John's College in Cambridge, Preached by Bishop Fisher in 1509*. Cambridge, 1840.

Illingworth 1812
Illingworth, William. "Transcript of a Draft of an Indenture of Covenants for the Erecting of a Tomb to the Memory of King Henry the Eighth, and Queen Katherine His Wife, Found amongst the Papers of Cardinal Wolsey, in the Chapter House at Westminster." *Archaeologia* 16 (1812), pp. 84–88.

Impey 1989
Impey, Oliver. "Eastern Trade and the Furnishing of the British Country House." In *The Fashioning and Functioning of the British Country House*, edited by Gervase Jackson-Stops, pp. 177–92. Studies in the History of Art 25; Symposium Papers 10. Washington, D.C., 1989.

Irish 2018
Irish, Bradley J. *Emotion in the Tudor Court: Literature, History, and Early Modern Feeling*. Rethinking the Early Modern. Evanston, Ill., 2018.

Ives 2004
Ives, Eric. *The Life and Death of Anne Boleyn: "The Most Happy."* Malden, Mass., 2004.

Jack 2004
Jack, Sybil M. "Paget, William, First Baron Paget (1505/6–1563), Diplomat and Administrator." *Oxford Dictionary of National Biography*. Sep. 23, 2004. https://doi.org/10.1093/ref:odnb/21121. Accessed Dec. 13, 2019.

Jackson-Stops 1985
Jackson-Stops, Gervase. "The Tudor Renaissance." In *The Treasure Houses of Britain: Five Hundred Years of Private Patronage and Art Collecting*, edited by Gervase Jackson-Stops, pp. 80–123. Exh. cat., National Gallery of Art, Washington, D.C. Washington, D.C., and New Haven, 1985.

James I 1984
James I, King of England. *Letters of King James VI and I*. Edited by G. P. V. Akrigg. Berkeley, 1984.

Jansohn 2004
Jansohn, Christa, ed. *Queen Elizabeth I: Past and Present*. Studien zur englischen Literatur und Wissenschaftsgeschichte 19. Münster, 2004.

Jardine 1995
Jardine, Lisa. "Towards Reading Albion's Classicism: An Exchange of Gifts between Northern Classical Scholars." In Gent 1995, pp. 19–28.

Jenkins, Orenstein, and Spira 2019
Jenkins, Catherine, Nadine Orenstein, and Freyda Spira. *The Renaissance of Etching*. With Peter Fuhring et al. Exh. cat., The Metropolitan Museum of Art, New York. New York, 2019.

Jervis 1974
Jervis, Simon [Swynfen]. *Printed Furniture Designs before 1650*. London, 1974.

Jervis 2016
Jervis, Simon Swynfen. "Furniture at Hardwick Hall—I." In Adshead and Taylor 2016, pp. 87–109.

Jervis and Dodd 2015
Jervis, Simon Swynfen, and Dudley Dodd. *Roman Splendour, English Arcadia: The English Taste for Pietre Dure and the Sixtus Cabinet at Stourhead*. London, 2015.

Johnson 1705
Johnson, Charles. *The Queen: A Pindarick Ode*. London, 1705.

Jones, A., and Stallybrass 2000
Jones, Ann Rosalind, and Peter Stallybrass. *Renaissance Clothing and the Materials of Memory*. Cambridge Studies in Renaissance Literature and Culture. New York, 2000.

Jones, E. 1949
Jones, E. D. "The Brogyntyn Welsh Manuscripts." *National Library of Wales Journal* 6, no. 1 (Summer 1949), pp. 1–42.

Jones, N. 2019
Jones, Norman. *Being Elizabethan: Understanding Shakespeare's Neighbors*. Hoboken, N.J., 2019.

Jones, R., and Townsend, J. 2003–5
Jones, Rica, and Joyce H. Townsend. "An Allegory of Man 1596, by British School 16th Century." *Tate: Tudor and Stuart Technical Research*. 2003–5. https://www.tate.org.uk/about-us/projects/tudor-stuart-technical-research/entries/allegory-man-1596. Accessed Nov. 10, 2019.

Junquera de Vega and Herrero Carretero 1986
Junquera de Vega, Paulina, and Concha Herrero Carretero. *Catálogo de tapices del Patrimonio Nacional*. Vol. 1, *Siglo XVI*. Madrid, 1986.

Kane 2010
Kane, Tina, trans. and ed. *The Troyes Mémoire: The Making of a Medieval Tapestry*. Medieval and Renaissance Clothing and Textiles. Woodbridge, Suffolk, and Rochester, N.Y., 2010.

Kanemura 2013
Kanemura, Rei. "Kingship by Descent or Kingship by Election? The Contested Title of James VI and I." *Journal of British Studies* 52, no. 2 (April 2013), pp. 317–42.

Karafel 2011
Karafel, Lorraine. "Site Specific? Raphael's *all'antica* Tapestries and the Vatican's Sala dei Pontefici." In *Unfolding the Textile Medium in Early Modern Art and Literature*, edited by Tristan Weddigen, pp. 55–64. Textile Studies 3. Emsdetten/Berlin, 2011.

Karafel 2013
Karafel, Lorraine. "Raphael's Tapestries: The Grotesques of Leo X and the Vatican's Sala dei Pontefici." In *Late Raphael: Proceedings of the international symposium, Madrid, Museo Nacional del Prado, October 2012*, edited by Miguel Falomir, pp. 50–57. Madrid, 2013.

Karafel 2016
Karafel, Lorraine. *Raphael's Tapestries: The Grotesques of Leo X*. New Haven, 2016.

Kaufman 1978
Kaufman, Gloria. "Juan Luis Vives on the Education of Women." *Signs* 3, no. 4 (Summer 1978), pp. 891–96.

Kaufmann 2017
Kaufmann, Miranda. *Black Tudors: The Untold Story*. London, 2017.

Kelly 2007
Kelly, Jessen. "The Material Efficacy of the Elizabethan Jeweled Miniature: A Gellian Experiment." In *Art's Agency and Art History*, edited by Robin Osborne and Jeremy Tanner, pp. 114–34. Malden, Mass., 2007.

Kelly-Gadol 1977
Kelly-Gadol, Joan. *Did Women Have a Renaissance?* Boston, 1977.

von Kienbusch and Grancsay 1933
von Kienbusch, Carl Otto, and Stephen V. Grancsay. *The Bashford Dean Collection of Arms and Armor in The Metropolitan Museum of Art*. Portland, Me., 1933.

King, D. 1985
King, Donald. "The Carpet Collection of Cardinal Wolsey." *Oriental Carpet and Textile Studies* 1 (1985), pp. 41–54.

King, D. 2012
King, Donald. "From the Exotic to the Mundane: Carpets and Coverings for Tables, Cupboards, Window Seats and Floors." In Hayward, M., and Ward 2012, pp. 131–43.

"King Edward VI" 2007
"King Edward VI." In *National Portrait Gallery: Tudor and Jacobean Portraits Database*, edited by Tarnya Cooper, Maurice Howard, Aviva Burnstock, and Sophie Plender. 2007–. https://www.npg.org.uk/collections/search/portraitConservation/mw02032/King-Edward-VI?zoom=1. Accessed Oct. 29, 2019.

"King Henry VII" 2007
"King Henry VII." In *National Portrait Gallery: Tudor and Jacobean Portraits Database*, edited by Tarnya Cooper, Maurice Howard, Aviva Burnstock, and Sophie Plender. 2007–. https://www.npg.org.uk/collections/search/portraitConservation/mw03078/King-Henry-VII. Accessed July 31, 2019.

King, J. 1976
King, John N. "Freedom of the Press, Protestant Propaganda, and Protector Somerset." *Huntington Library Quarterly* 40, no. 1 (November 1976), pp. 1–9.

King, J. 1989
King, John N. *Tudor Royal Iconography: Literature and Art in an Age of Religious Crisis*. Princeton Essays on the Arts. Princeton, N.J., 1989.

Kipling 1997
Kipling, Gordon. "'He That Saw It Would Not Believe It': Anne Boleyn's Royal Entry into London." In *Civic Ritual and Drama*, edited by Alexandra F. Johnston and Wim Hüsken, pp. 39–79. Ludus 2. Amsterdam and Atlanta, Ga., 1997.

Kirk and Kirk 1900–1908
Kirk, R. E. G., and Ernest F. Kirk. *Returns of Aliens Dwelling in the City and Suburbs of London from the Reign of Henry VIII to That of James I*. 4 vols. Publications of the Huguenot Society of London 10. Aberdeen, 1900–1908.

Kisby 1999
Kisby, Fiona. "Officers and Office-Holding at the English Court: A Study of the Chapel Royal, 1485–1547." *Royal Musical Association Research Chronicle* 32 (1999), pp. 1–61.

Klein 1997
Klein, Lisa M. "Your Humble Handmaid: Elizabethan Gifts of Needlework." *Renaissance Quarterly* 50, no. 2 (1997), pp. 459–93.

Knowles 1999
Knowles, James. "A 1621 Tilt and Its Imprese: Huntington MS. EL 7972." *Huntington Library Quarterly* 62, no. 3/4 (1999), pp. 390–400.

Knox 1558
Knox, John. *The First Blast of the Trumpet against the Monstruous Regiment of Women*. Geneva, 1558.

Koeppe 1992
Koeppe, Wolfram. "Spielbretter: Aus der Sammlung Harbeson im Philadelphia Museum of Art." *Die Weltkunst* 22, no. 15 (November 1992), pp. 3366–68.

Koeppe 1994
Koeppe, Wolfram. "French Renaissance and Pseudo-Renaissance Furniture in American Collections." *Studies in the Decorative Arts* 1, no. 2 (Spring 1994), pp. 48–66.

Koeppe 2017
Koeppe, Wolfram. "Goldsmithing and Commemorative Gifts North of the Alps." In *The Silver Caesars: A Renaissance Mystery*, edited by Julia Siemon, pp. 106–19, 200–201. New York, 2017.

Koeppe 2018
Koeppe, Wolfram. "*Artificialia* and Their Meanings in *The Paston Treasure*." In *The Paston Treasure: Microcosm of the Known World*, edited by Andrew Moore, Nathan Flis, and Francesca Vanke, pp. 120–25. Exh. cat., Yale Center for British Art, New Haven, and Norwich Castle Museum and Art Gallery, Norwich. New Haven and London, 2018.

Koeppe 2019
Koeppe, Wolfram, ed. *Making Marvels: Science and Splendor at the Courts of Europe*. Exh. cat., The Metropolitan Museum of Art, New York. New York, 2019.

Koepplin 2003
Koepplin, Dieter. "Ein Cranach-Prinzip." In *Lucas Cranach: Glaube, Mythologie und Moderne*, by Werner Schade et al., pp. 144–65. Exh. cat., Bucerius Kunst Forum, Hamburg. Ostfildern, 2003.

Koepplin 2006
Koepplin, Dieter. "On Holbein's Painting of the Pauline Creed of Law and Grace." In *Hans Holbein the Younger: The Basel Years, 1515–1532*, pp. 79–95. Exh. cat., Kunstmuseum Basel. Munich and New York, 2006.

Koerner 2004
Koerner, Joseph Leo. *The Reformation of the Image*. Chicago, 2004.

Konowitz 1990–91
Konowitz, Ellen. "Drawings as Intermediary Stages: Some Working Methods of Dirk Vellert and Albrecht Dürer Re-Examined." *Simiolus: Netherlands Quarterly for the History of Art* 20, no. 2/3 (1990–91), pp. 142–52.

Koos 2014
Koos, Marianne. "Wandering Things: Agency and Embodiment in Late Sixteenth-Century English Miniature Portraits." *Art History* 37, no. 5 (2014), pp. 836–59.

Korkow 2013
Korkow, Cory. *British Portrait Miniatures: The Cleveland Museum of Art*. With Jon L. Seydl. Cleveland and London, 2013.

Kren and Evans 2005
Kren, Thomas, and Mark Evans, eds. *A Masterpiece Reconstructed: The Hours of Louis XII*. Los Angeles and London, 2005.

Kren and McKendrick 2003
Kren, Thomas, and Scot McKendrick. *Illuminating the Renaissance: The Triumph of Flemish Manuscript Painting in Europe*. With Maryan W. Ainsworth. Exh. cat., J. Paul Getty Museum, Los Angeles, and Royal Academy of Arts, London. Los Angeles, 2003.

Kruse 2017
Kruse, Elaine. "'A Network of Honor and Obligation': Elizabeth as Godmother." In Bertolet 2017, pp. 181–98.

Kury 1995
Kury, Gloria. "'Glancing Surfaces': Hilliard, Armour, and the Italian Model." In Gent 1995, pp. 395–426.

Kurz 1943a
Kurz, Otto. "An Architectural Design for Henry VIII." *Burlington Magazine for Connoisseurs* 82, no. 481 (April 1943), pp. 80–83.

Kurz 1943b
Kurz, Otto. "An Architectural Design for Henry VIII." *Burlington Magazine for Connoisseurs* 83, no. 486 (September 1943), p. 233.

L&P 1862–1910
Letters and Papers, Foreign and Domestic, of the Reign of Henry VIII, Preserved in the Public Record Office, the British Museum, and Elsewhere in England. Edited by J. S. Brewer, James Gairdner, and R. H. Brodie. 21 vols. London, 1862–1910.

LaRocca 1995
LaRocca, Donald J. "An English Armor for the King of Portugal." *Metropolitan Museum Journal* 30 (1995), pp. 81–96.

Latham 2011
Latham, Bethany. *Elizabeth I in Film and Television: A Study of the Major Portrayals*. Jefferson, N.C., 2011.

Lawson 2007
Lawson, Jane A. "The Remembrance of the New Year: Books Given to Queen Elizabeth as New Year's Gifts." In *Elizabeth I and the Culture of Writing*, edited by Peter Beal and Grace Ioppolo, pp. 133–71. London, 2007.

Lawson 2013
Lawson, Jane A., ed. *The Elizabethan New Year's Gift Exchanges: 1559–1603*. Records of Social and Economic History, n.s., 51. Oxford, 2013.

Lecuppre 2001
Lecuppre, Gilles. "Henri VII et les humanistes italiens: Elaboration d'une légitimité princière et émergence d'un foyer culturel." In *Rapporti e scambi tra umanesimo italiano ed umanesimo europeo: "L'Europa è uno stato d'animo,"* edited by Luisa Rotondi Secchi Tarugi, pp. 51–64. Caleidoscopio 10. Milan, 2001.

Le Glay 1839
Le Glay, [André-Joseph-Ghislain], ed. *Correspondance de l'Empereur Maximilien I et Marguerite d'Autriche, sa fille, gouvernante des Pays-Bas, de 1507 à 1519*. 2 vols. Paris, 1839.

Leland 1745
Leland, John. *The Itinerary of John Leland the Antiquary; in Nine Volumes*. Edited by Thomas Hearne. 2nd ed. Oxford, 1745.

Le Rougetel 1988
Le Rougetel, Hazel. "The Rose of England." *RSA Journal* 136, no. 5386 (September 1988), pp. 742–44.

Lethaby 1906
Lethaby, W. R. *Westminster Abbey and the King's Craftsmen: A Study of Mediaeval Building*. London, 1906.

Levey 2012
Levey, Santina [M]. "The Art of the Broderers." In Hayward, M., and Ward 2012, pp. 145–85.

Levey and Thornton 2001
Levey, Santina M., and Peter K. Thornton, eds. *Of Household Stuff: The 1601 Inventories of Bess of Hardwick*. London, 2001.

Levin 1994
Levin, Carole. *The Heart and Stomach of a King: Elizabeth I and the Politics of Sex and Power*. New Cultural Studies. Philadelphia, 1994.

Levin 2014
Levin, Carole. "Elizabeth's Ghost: The Afterlife of the Queen in Stuart England." *Royal Studies Journal* 1 (2014), pp. 1–16.

Levin, Bertolet, and Carney 2017
Levin, Carole, Anna Riehl Bertolet, and Jo Eldridge Carney. *A Biographical Encyclopedia of Early Modern Englishwomen: Exemplary Lives and Memorable Acts, 1500–1650*. London, 2017.

Lewis 1998
Lewis, Lesley. *The Thomas More Family Group Portraits after Holbein*. Leominster, 1998.

Libert 2018
Libert, Marc. "The Production of Seal Matrices by Brussels Goldsmiths in the Sixteenth Century." In Cherry, Berenbeim, and de Beer 2018, pp. 4–9.

Liedl 1994
Liedl, Janice. "The Penitent Pilgrim: William Calverley and the Pilgrimage of Grace." *Sixteenth Century Journal* 25, no. 3 (Autumn 1994), pp. 585–94.

Liefkes 1997
Liefkes, Reino, ed. *Glass*. London, 1997.

Lightbown 1978
Lightbown, R. W. *Secular Goldsmiths' Work in Medieval France: A History*. Reports of the Research Committee of the Society of Antiquaries of London 36. London, 1978.

Lindley 1991
Lindley, Phillip G. "Playing Check-Mate with Royal Majesty? Wolsey's Patronage of Italian Renaissance Sculpture." In Gunn and Lindley 1991, pp. 261–85.

Lindley 1995
Lindley, Phillip [G]. *Gothic to Renaissance: Essays on Sculpture in England*. Stamford, Lincolnshire, 1995.

Lindley 2003
Lindley, Phillip G. "'The singuler mediacion and praiers of al the holie companie of Heven': Sculptural Functions and Forms in Henry VII's Chapel." In Tatton-Brown and Mortimer 2003, pp. 259–93.

Lines 2006
Lines, Candace. "The Erotic Politics of Grief in Surrey's 'So crewell prison.'" *Studies in English Literature, 1500–1900* 46, no. 1 (Winter 2006), pp. 1–26.

Lippincott 2002
Lippincott, Kristen. "Power and Politics: The Use of the Globe in Renaissance Portraiture." *Globe Studies*, no. 49/50 (2002), pp. 121–38.

Lloyd, C., and Remington 1996
Lloyd, Christopher, and Vanessa Remington. *Masterpieces in Little: Portrait Miniatures from the Collection of Her Majesty Queen Elizabeth II*. Exh. cat., The Metropolitan Museum of Art, New York, Queen's Gallery, Buckingham Palace, London, and other venues. London, 1996.

Lloyd, P. 2012
Lloyd, Paul S. "Dietary Advice and Fruit-Eating in Late Tudor and Early Stuart England." *Journal of the History of Medicine and Allied Sciences* 67, no. 4 (October 2012), pp. 553–86.

Llwyd 2002
Llwyd, Humphrey. *Cronica Walliae*. Edited by Ieuan M. Williams. Cardiff, 2002.

Llwyd 2011
Llwyd, Humphrey. *The Breviary of Britain: With Selections from "The History of Cambria."* Edited by Philip Schwyzer. Modern Humanities Research Association Tudor and Stuart Translations 5. London, 2011.

Loach 1999
Loach, Jennifer. *Edward VI*. Edited by George Bernard and Penry Williams. New Haven, 1999.

Loades 1989
Loades, David. "The Reign of Mary Tudor: Historiography and Research." *Albion: A Quarterly Journal Concerned with British Studies* 21, no. 4 (Winter 1989), pp. 547–58.

Lomazzo 1598
Lomazzo, Giovanni Paolo. *A Tracte Containing the Artes of Curious Paintinge, Carvinge and Buildinge, Written First in Italian by Jo. Paul Lomatius, Painter of Milan, and Englished by R[ichard] H[aydocke], Student in Physik*. Translated by Richard Haydock. Oxford, 1598.

Longstaffe-Gowan 2005
Longstaffe-Gowan, Todd. *The Gardens and Parks at Hampton Court Palace*. London, 2005.

Loomis 1996
Loomis, Catherine. "Elizabeth Southwell's Manuscript Account of the Death of Queen Elizabeth [with text]." *English Literary Renaissance* 26, no. 3, special issue, "Monarchs" (Autumn 1996), pp. 482–509.

Low 2003
Low, Jennifer. *Manhood and the Duel: Masculinity in Early Modern Drama and Culture*. Early Modern Cultural Studies. New York, 2003.

Lower 1871
Lower, Mark Antony. *Bodiam and Its Lords*. London, 1871.

Luporini 1964
Luporini, Eugenio. *Benedetto da Rovezzano: Scultura e decorazione a Firenze tra il 1490 e il 1520*. Milan, 1964.

Lüttenberg 2005
Lüttenberg, Thomas. "The Cod-Piece—A Renaissance Fashion between Sign and Artefact." *Medieval History Journal* 8, no. 1 (April 1, 2005), pp. 49–81.

Lyte 1909
Lyte, H. C. Maxwell. *A History of Dunster and of the Families of Mohun and Luttrell*. London, 1909.

Lyte 1926
Lyte, H. C. Maxwell. *Historical Notes on the Use of the Great Seal of England*. London, 1926.

MacColl 2006
MacColl, Alan. "The Meaning of 'Britain' in Medieval and Early Modern England." *Journal of British Studies* 45, no. 2 (April 2006), pp. 248–69.

MacGregor 1989
MacGregor, Arthur, ed. *The Late King's Goods: Collections, Possessions and Patronage of Charles I in the Light of the Commonwealth Sale Inventories*. London, 1989.

Machyn 1848
Machyn, Henry. *The Diary of Henry Machyn, Citizen and Merchant-Taylor of London, from A.D. 1550 to A.D. 1563*. Edited by John Gough Nichols. London, 1848.

MacLean and Matar 2011
MacLean, Gerald, and Nabil Matar. *Britain and the Islamic World, 1558–1713*. Oxford, 2011.

MacLeod 2004
MacLeod, Catharine. "Scrots [Stretes], Guillim (*fl.* 1537–1553), Portrait Painter." *Oxford Dictionary of National Biography*. Sep. 23, 2004. https://doi.org/10.1093/ref:odnb/26661. Accessed Nov. 26, 2019.

MacLeod 2012
MacLeod, Catharine. *The Lost Prince: The Life and Death of Henry Stuart*. With Timothy Wilks, Malcolm Smuts, and Rab MacGibbon. Exh. cat., National Portrait Gallery, London. London, 2012.

MacLeod 2019a
MacLeod, Catharine. "A Thing Apart: Elizabethan and Jacobean Portrait Miniatures." In MacLeod 2019b, pp. 6–18.

MacLeod 2019b
MacLeod, Catharine, ed. *Elizabethan Treasures: Miniatures by Hilliard and Oliver*. With Rab MacGibbon, Victoria Button, Katherine Coombs, and Alan Derbyshire. Exh. cat., National Portrait Gallery, London. London, 2019.

Madden 1831
Madden, Frederick, ed. *The Privy Purse Expenses of the Princess Mary, Daughter of King Henry the Eighth, afterwards Queen Mary: With a Memoir of the Princess, and Notes*. London, 1831.

Maisonneuve 2015
Maisonneuve, Cécile. "Les Tudors sous les feux de la rampe, Paris, 1820–1912." In Bolland and Maisonneuve 2015, pp. 155–69.

Makin 1673
Makin, Bathsua. *An Essay to Revive the Antient Education of Gentlewomen, in Religion, Manners, Arts and Tongues, with an Answer to the Objections against This Way of Education*. London, 1673.

van Mander 1604
van Mander, [K]arel. *Het schilder-boeck . . . den grondt der edel vry schilderconst*. Haarlem, 1604. **1994–99 ed.:** van Mander, Karel. *The Lives of the Illustrious Netherlandish and German Painters, from the First Edition of the* Schilder-Boeck *(1603–1604), Preceded by* The Lineage, Circumstances and Place of Birth, Life and Works of Karel van Mander, Painter and Poet, *and Likewise His Death and Burial, from the Second Edition of the* Schilder-Boeck *(1616–1618)*. Edited and translated by Hessel Miedema. 6 vols. Doornspijk, 1994–99.

Mandler 1997
Mandler, Peter. "'In the Olden Time': Romantic History and English National Identity, 1820–50." In *A Union of Multiple Identities: The British Isles, c. 1750–c. 1850*, edited by Laurence Brockliss and David Eastwood, pp. 78–92. Manchester and New York, 1997.

Mandler 2011
Mandler, Peter. "Revisiting the Olden Time: Popular Tudorism in the Time of Victoria." In String and Bull 2011, pp. 13–35.

Manley 1991
Manley, Lawrence. "Fictions of Settlement: London 1590." *Studies in Philology* 88, no. 2 (Spring 1991), pp. 201–24.

Manningham 1976
Manningham, John. *The Diary of John Manningham of the Middle Temple, 1602–1603: Newly Edited in Complete and Unexpurgated Form from the Original Manuscript in the British Museum*. Edited by Robert Parker Sorlien. Hanover, N.H., 1976.

Mantel and Salomon 2018
Mantel, Hilary, and Xavier F. Salomon. *Holbein's Sir Thomas More*. Frick Diptych Series. New York and London, 2018.

Margetts 1988
Margetts, Michele. "Lady Penelope Rich: Hilliard's Lost Miniatures and a Surviving Portrait." *Burlington Magazine* 130, no. 1027 (October 1988), pp. 758–61.

Marks and Williamson, P. 2003
Marks, Richard, and Paul Williamson. *Gothic: Art for England, 1400–1547*. Exh. cat., Victoria and Albert Museum, London. London, 2003.

Martens 1998
Martens, Maximiliaan P. J., ed. *Bruges and the Renaissance: Memling to Pourbus*. Exh. cat., Municipal Museums, Bruges. Brussels, 1998.

Martin 1994
Martin, Randall. "The Autobiography of Grace, Lady Mildmay." *Renaissance and Reformation / Renaissance et réforme* 18, no. 1 (Winter 1994), pp. 33–81.

Mary II 1886
Mary II, Queen of England. *Memoirs of Mary, Queen of England (1689–1693); Together with Her Letters and Those of Kings James II and William III to the Electress, Sophia of Hanover*. Edited by R. Doebner. Leipzig and London, 1886.

Matar 1999
Matar, Nabil. *Turks, Moors, and Englishmen in the Age of Discovery*. New York, 1999.

Matthews 2005
Matthews, Paul [G]. "Apparel, Status, Fashion: Women's Clothing and Jewellery." In *Women of Distinction: Margaret of York, Margaret of Austria*, edited by Dagmar Eichberger, pp. 147–53. Leuven, 2005.

Matthews 2008
Matthews, Paul G. "Henry VIII's Favourite Sister? Michel Sittow's *Portrait of a Lady* in Vienna." *Jahrbuch des Kunsthistorischen Museums Wien* 10 (2008), pp. 141–49.

Mattingly 1938
Mattingly, Garrett. "An Early Nonaggression Pact." *Journal of Modern History* 10, no. 1 (March 1938), pp. 1–30.

Matucci 2012
Matucci, Benedetta. "Benedetto da Rovezzano and the Altoviti in Florence: Hypotheses and New Interpretations for the Church of Santi Apostoli." In Sicca and Waldman 2012, pp. 149–76.

Mayer 2004
Mayer, Jean-Christophe, ed. *The Struggle for the Succession in Late Elizabethan England: Politics, Polemics and Cultural Representations*. Collections "Astrea" 11. Montpellier, 2004.

Mazzola 2010
Mazzola, Elizabeth. "Schooling Shrews and Grooming Queens in the Tudor Classroom." *Critical Survey* 22, no. 1 (2010), pp. 1–25.

McConica 1973
McConica, James K. "The Prosopography of the Tudor University." *Journal of Interdisciplinary History* 3, no. 3 (Winter 1973), pp. 543–54.

McConnell 2004
McConnell, Anita. "Hondius, Jodocus [Joost de Hondt] (1563–1612), Engraver and Cartographer." *Oxford Dictionary of National Biography*. Sep. 23, 2004. https://doi.org/10.1093/ref:odnb/13655. Accessed Feb. 17, 2020.

McKendrick 1987
M[c]Kendrick, Scot. "Edward IV: An English Royal Collector of Netherlandish Tapestry." *Burlington Magazine* 129, no. 1013 (August 1987), pp. 521–24.

McKendrick 1991
McKendrick, Scot. "The *Great History of Troy*: A Reassessment of the Development of a Secular Theme in Late Medieval Art." *Journal of the Warburg and Courtauld Institutes* 54 (1991), pp. 43–82.

McKendrick 1995
McKendrick, Scot. "Tapestries from the Low Countries in England during the Fifteenth Century." In *England and the Low Countries in the Late Middle Ages*, edited by Caroline M. Barron and Nigel Saul, pp. 43–60. Stroud, 1995.

McKendrick, Lowden, and Doyle 2012
McKendrick, Scot, John Lowden, and Kathleen Doyle. *Royal Manuscripts: The Genius of Illumination*. With Joanna Frońska and Deirdre Jackson. Exh. cat., British Library, London. London, 2012.

McSheffrey 2013
McSheffrey, Shannon. "Stranger Artisans and the London Sanctuary of St. Martin le Grand in the Reign of Henry VIII." *Journal of Medieval and Early Modern Studies* 43, no. 3 (Fall 2013), pp. 545–71.

McSheffrey 2017
McSheffrey, Shannon. *Seeking Sanctuary: Crime, Mercy, and Politics in English Courts, 1400–1550*. Oxford and New York, 2017.

Mears 2001
Mears, Natalie. "Love-Making and Diplomacy: Elizabeth I and the Anjou Marriage Negotiations, c. 1578–1582." *History* 86, no. 284 (October 2001), pp. 442–66.

Mehl 2004
Mehl, Dieter. "The Late Queen on the Public Stage: Thomas Heywood's *If You Know Not Me You Know Nobody*, Parts I and II." In Jansohn 2004, pp. 153–72.

Melman 2006
Melman, Billie. *The Culture of History: English Uses of the Past, 1800–1953*. Oxford and New York, 2006.

Melman 2011
Melman, Billie. "The Pleasures of Tudor Horror: Popular Histories, Modernity and Sensationalism in the Long Nineteenth Century." In String and Bull 2011, pp. 37–56.

Melville 1683
Melville, James. *The Memoires of Sir James Melvil of Halhill: Containing an Impartial Account of the Most Remarkable Affairs of State During the Last Age, Not Mention'd by Other Historians, Most Particularly Relating to the Kingdoms of England and Scotland under the Reigns of Queen Elizabeth, Mary Queen of Scots, and King James*. Edited by George Scott. London, 1683. **1930 ed.:** *Memoirs of Sir James Melville of Halhill, 1535–1617*. Edited by A. Francis Steuart. New York, 1930.

Mercer 1999
Mercer, Malcolm. "Driven to Rebellion? Sir John Lewknor, Dynastic Loyalty and Debt." *Sussex Archaeological Collections* 137 (1999), pp. 153–60.

Merck 2016
Merck, Mandy, ed. *The British Monarchy on Screen*. Manchester, 2016.

Merton 1992
Merton, Charlotte Isabelle. "Women Who Served Queen Mary and Queen Elizabeth: Ladies, Gentlewomen and Maids of the Privy Chamber, 1553–1603." PhD diss., University of Cambridge, 1992.

Meyer 1976
Meyer, Barbara Hochstetler. "The First Tomb of Henry VII of England." *Art Bulletin* 58, no. 3 (September 1976), pp. 358–67.

de Meyer 1967
de Meyer, Maurits. "De parabel van de wijze en de dwaze maagden in de kunst en in de literatuur." *Handelingen van de Koninklijke Zuidnederlandse Maatschappij voor Taal- en Letterkunde en Geschiedenis* 21 (1967), pp. 235–47.

Michelant 1870
Michelant, Henri Victor. *Inventaire des vaisselles, joyaux, tapisseries, peintures, livres et manuscrits de Marguerite d'Autriche, régente et gouvernante des Pays-Bas, 1523*. Brussels, 1870.

Milbourn 1888
Milbourn, Thomas, ed. *The Vintners' Company: Their Muniments, Plate, and Eminent Members, with Some Account of the Ward of Vintry*. London, 1888.

Mitchell 1971
Mitchell, Margaret. "Works of Art from Rome for Henry VIII: A Study of Anglo-Papal Relations as Reflected in Papal Gifts to the English King." *Journal of the Warburg and Courtauld Institutes* 34 (1971), pp. 178–203.

Monnas 1989a
Monnas, Lisa. "New Documents for the Vestments of Henry VII at Stonyhurst College." *Burlington Magazine* 131, no. 1034 (May 1989), pp. 345–49.

Monnas 1989b
Monnas, Lisa. "Silk Cloths Purchased for the Great Wardrobe of the Kings of England, 1325–1462." *Textile History* 20, no. 2 (1989), pp. 283–307.

Monnas 1998
Monnas, Lisa. "'Tissues' in England during the Fifteenth and Sixteenth Centuries." *Bulletin du Centre International d'Etude des Textiles Anciens* 75 (1998), pp. 62–80.

Monnas 2008
Monnas, Lisa. *Merchants, Princes and Painters: Silk Fabrics in Italian and Northern Paintings, 1300–1550*. New Haven and London, 2008.

Monnas 2012a
Monnas, Lisa. "'Plentie and abundaunce': Henry VIII's Valuable Store of Textiles." In Hayward, M., and Ward 2012, pp. 235–94.

Monnas 2012b
Monnas, Lisa. *Renaissance Velvets*. London, 2012.

Monnas 2012c
Monnas, Lisa. "The Splendour of Royal Worship." In Hayward, M., and Ward 2012, pp. 295–333.

Montrose 1999
Montrose, Louis A. "Idols of the Queen: Policy, Gender, and the Picturing of Elizabeth I." *Representations*, no. 68 (Autumn 1999), pp. 108–61.

Montrose 2006
Montrose, Louis [A]. *The Subject of Elizabeth: Authority, Gender, and Representation*. Chicago, 2006.

Moore 2001
Moore, Peter R. "The Heraldic Charge against the Earl of Surrey, 1546–47." *English Historical Review* 116, no. 467 (2001), pp. 557–83.

Morgan 2004
Morgan, Hiram. "'Never Any Realm Worse Governed': Queen Elizabeth and Ireland." *Transactions of the Royal Historical Society* 14 (2004), pp. 295–308.

Morison 1963
Morison, Stanley. *The Likeness of Thomas More: An Iconographical Survey of Three Centuries*. Edited and supplemented by Nicolas Barker. London, 1963.

Morrall and Watt 2008
Morrall, Andrew, and Melinda Watt, eds. *English Embroidery from the Metropolitan Museum of Art, 1580–1700: 'Twixt Art and Nature*. Exh. cat., Bard Graduate Center for Studies in the Decorative Arts, Design, and Culture, New York. New Haven and London, 2008.

Morris, F. 1929
Morris, Frances. "A Gift of Early English Gloves." *Metropolitan Museum of Art Bulletin* 24, no. 2 (February 1929), pp. 46–50.

Morris, R. 2013
Morris, Ruth. "Why China Loves to Build Copycat Towns." *BBC Magazine*, July 1, 2013. https://www.bbc.com/news/magazine-23067082. Accessed May 24, 2019.

Mortimer 2004
Mortimer, Ian. "Talbot, Thomas (c. 1535–1595x9), Antiquary." *Oxford Dictionary of National Biography*. Sep. 23, 2004. https://doi.org/10.1093/ref:odnb/26942. Accessed Nov. 13, 2019.

Moryson 1907
Moryson, Fynes. *An Itinerary Containing His Ten Yeeres Travell through the Twelve Dominions of Germany, Bohmerland, Sweitzerland, Netherland, Denmarke, Poland, Italy, Turky, France, England, Scotland and Ireland*. 4 vols. Glasgow, 1907.

Müller 1988
Müller, Christian. *Hans Holbein d.J: Zeichnungen aus dem Kupferstichkabinett der Öffentlichen Kunstsammlung Basel*. Exh. cat., Kunstmuseum Basel. Basel, 1988.

Müller 1990
Müller, Christian. "Holbein oder Holbein-Werkstatt? Zu einem Pokalentwurf der Gottfried Keller-Stiftung im Kupferstichkabinett Basel." *Zeitschrift für Schweizerische Archäologie und Kunstgeschichte* 47 (1990), pp. 33–42.

Muller 1922
Muller, S. "De medailleur Steven van Herwijck te Utrecht." *Oud Holland* 40 (1922), pp. 24–31.

Murdin 1759
Murdin, William, ed. *A Collection of State Papers Relating to Affairs in the Reign of Queen Elizabeth from the Year 1571 to 1596, Transcribed from Original Papers [. . .] Left by William Cecill Lord Burghley*. London, 1759.

Murdoch, J., et al. 1981
Murdoch, John, Jim Murrell, Patrick J. Noon, and Roy [C.] Strong. *The English Miniature*. New Haven, 1981.

Murphy 1997
Murphy, Beverley Anne. "The Life and Political Significance of Henry Fitzroy, Duke of Richmond, 1525–1536." PhD diss., Bangor University, 1997.

Myrone 1999
Myrone, Martin. "Graphic Antiquarianism in Eighteenth-Century Britain: The Career and Reputation of George Vertue (1684–1756)." In *Producing the Past: Aspects of Antiquarian Culture and Practice, 1700–1850*, edited by Martin Myrone and Lucy Peltz, pp. 35–54. Reinterpreting Classicism. Aldershot, Hampshire, and Brookfield, Vt., 1999.

Nagel 2004
Nagel, Alexander. "Fashion and the Now-Time of Renaissance Art." *RES: Anthropology and Aesthetics*, no. 46 (Autumn 2004), pp. 32–52.

Naunton 1641
Naunton, Sir Robert. *Fragmenta Regalia, or, Observations on the Late Queen Elizabeth, Her Times, and Favourites.* London, 1641.

Nelson 1936
Nelson, William. "Skelton's *Speak, Parrot.*" *PMLA* 51, no. 1 (March 1936), pp. 59–82.

Nichols 1823
Nichols, John [Gough], ed. *The Progresses, and Public Processions of Queen Elizabeth: Among Which Are Interspersed Other Solemnities, Public Expenditures, and Remarkable Events during the Reign of That Illustrious Princess; Collected from Original Manuscripts, Scarce Pamphlets, Corporation Records, Parochial Registers, Etc., Etc., Illustrated, with Historical Notes.* Rev. ed. 3 vols. London, 1823.

Nichols 1846
Nichols, John Gough, ed. *The Chronicle of Calais, in the Reigns of Henry VII and Henry VIII to the Year 1540.* London, 1846.

Nichols 1850
Nichols, John Gough, ed. *The Chronicle of Queen Jane, and of Two Years of Queen Mary, and Especially of the Rebellion of Sir Thomas Wyat: Written by a Resident in the Tower of London.* London, 1850.

Nichols 1855
Nichols, J[ohn] Gough, ed. "Inventories of the Wardrobes, Plate, Chapel Stuff, etc. of Henry Fitzroy, Duke of Richmond, and of the Wardrobe Stuff at Baynard's Castle of Katharine, Princess Dowager." *Camden Miscellany* 3 (1855), section 4.

Nickel 1972
Nickel, Helmut. "'A harnes all gilte': A Study of the Armor of Galiot de Genouilhac and the Iconography of Its Decoration." *Metropolitan Museum Journal* 5 (1972), pp. 75–124.

Noling 1993
Noling, Kim H. "Woman's Wit and Woman's Will in *When You See Me, You Know Me.*" *Studies in English Literature 1500–1900* 33, no. 2, special issue, "Elizabethan and Jacobean Drama" (Spring 1993), pp. 327–42.

van der Noot 1580
van der Noot, Jan. *Lofsang van Braband / Hymne de Braband.* Antwerp, 1580. **1958 ed.:** van der Noot, Jan. *Lofsang van Braband / Hymne de Braband.* Edited by C. A. Zaalberg. Zwolse drukken en herdrukken 24. Zwolle, 1958.

Nubia 2019
Nubia, Onyeka. *England's Other Countrymen: Black Tudor Society.* London, 2019.

Nunn-Weinberg 2006
Nunn-Weinberg, Danielle. "The Matron Goes to the Masque: The Dual Identity of the English Embroidered Jacket." In *Medieval Clothing and Textiles 2*, edited by Robin Netherton and Gale R. Owen-Crocker, pp. 151–74. Medieval Clothing and Textiles. Woodbridge, Suffolk, and Rochester, N.Y., 2006.

O'Hara 2000
O'Hara, Diana. *Courtship and Constraint: Rethinking the Making of Marriage in Tudor England.* Politics, Culture, and Society in Early Modern Britain. Manchester and New York, 2000.

Olid Guerrero and Fernández 2019
Olid Guerrero, Eduardo, and Esther Fernández, eds. *The Image of Elizabeth I in Early Modern Spain.* Lincoln, Neb., 2019.

Oman 1931
Oman, C[harles] C. "A Silver-Gilt Cup from Queen Elizabeth." *Burlington Magazine for Connoisseurs* 59, no. 343 (October 1931), pp. 194, 198–99.

Oman 1978
Oman, Charles [C]. *English Engraved Silver, 1150 to 1900.* London and Boston, 1978.

Orgel 2000
Orgel, Stephen. "Idols of the Gallery: Becoming a Connoisseur in Renaissance England." In *Early Modern Visual Culture: Representation, Race, and Empire in Renaissance England*, edited by Peter Erickson and Clark Hulse, pp. 251–83. Philadelphia, 2000.

Orgel 2011
Orgel, Stephen. "Prologue: I am Richard II." In *Representations of Elizabeth I in Early Modern Culture*, edited by Alessandra Petrina and Laura Tosi, pp. 11–43. Basingstoke, and New York, 2011.

Orsi Landini 2017
Orsi Landini, Roberta. *The Velvets: In the Collection of the Costume Gallery in Florence / I velluti: Nella collezione della Galleria del Costume di Firenze.* Florence and Riggisberg, 2017.

Orth 2006
Orth, M. "The English Great Bible of 1539 and the French Connection." In *Tributes to Jonathan J. G. Alexander: The Making and Meaning of Illuminated Medieval and Renaissance Manuscripts, Art and Architecture*, edited by Susan L'Engle and Gerald B. Guest, pp. 171–84. London, 2006.

Oswald 1951
Oswald, Arthur. "Barnard Flower, the King's Glazier." *Journal of the British Society of Master Glass-Painters* 11, no. 1 (1951), pp. 8–21.

Owens 2013
Owens, Susan. *The Art of Drawing: British Masters and Methods since 1600.* London, 2013.

Packer 2012
Packer, Daniel. "Jewels of 'Blacknesse' at the Jacobean Court." *Journal of the Warburg and Courtauld Institutes* 75 (2012), pp. 201–22.

Page 1893
Page, William, ed. *Letters of Denization and Acts of Naturalization for Aliens in England, 1509–1603.* Publications of the Huguenot Society of London. Lymington, 1893.

Parissien 2011
Parissien, Steven. "The Tudors Reinvented: The Regency and the Sixteenth Century." In String and Bull 2011, pp. 115–28.

Parker, K. 1983
Parker, K. T. *The Drawings of Hans Holbein in the Collection of Her Majesty the Queen at Windsor Castle.* With Susan Foister. London and New York, 1983.

Parker, L. 1911
Parker, Louis N. *Pomander Walk.* New York, 1911.

Parker, L. 1915
Parker, Louis N. *Pomander Walk: A Comedy in Three Acts.* New York, 1915.

Parrill and Robison 2013
Parrill, Sue, and William B. Robison. *The Tudors on Film and Television.* Jefferson, N.C., 2013.

Parry 1981
Parry, Graham. *The Golden Age Restor'd: The Culture of the Stuart Court, 1603–42.* Manchester, 1981.

Parsons 1929
Parsons, A. E. "The Trojan Legend in England: Some Instances of Its Application to the Politics of the Times." *Modern Language Review* 24, no. 3 (July 1929), pp. 253–64.

Patterson 2009
Patterson, Angus. *Fashion and Armour in Renaissance Europe: Proud Lookes and Brave Attire.* London, 2009.

Peacham 1612
Peacham, Henry. *Minerva Britanna, or A Garden of Heroical Devises.* N.p., 1612. **1973 ed.:** *Minerva Britanna, 1612.* Edited by John Horden. English Emblem Books 5. Menston, 1973.

Peacham 1634
Peacham, Henry. *The Compleat Gentleman: Fashioning Him Absolut, in the Most Necessary and Commendable Qualities Concerning Minde or Body, That May Be Required in a Noble Gentleman.* London, 1634. **1906 ed.:** *Peacham's Compleat Gentleman, 1634.* With an introduction by G. S. Gordon. Oxford, 1906.

Peacock 1985
Peacock, John. "The 'Wizard Earl' Portrayed by Hilliard and Van Dyck." *Art History* 8, no. 2 (June 1985), pp. 139–57.

Pepys 1893–99
Pepys, Samuel. *The Diary of Samuel Pepys, M.A., F.R.S.* Edited by Henry B. Wheatley. 9 vols. London, 1893–99.

Perrat 1926
Perrat, Charles. "Un livre d'heures de Marie, reine de France, et d'Henri VIII d'Angleterre." In *Documents paléographiques, typographiques, iconographiques.* Vol. 6, edited by Henry Joly, pp. 3–15. Lyon, 1926.

Perry 1993
Perry, Marilyn. "Wealth, Art, and Display: The Grimani Cameos in Renaissance Venice." *Journal of the Warburg and Courtauld Institutes* 56 (1993), pp. 268–74.

Petrucci 2008
Petrucci, Francesco. *Pittura di ritratto a Roma: Il Seicento.* 3 vols. Rome, 2008.

Petter-Wahnschaffe 2010
Petter-Wahnschaffe, Katrin. *Hans Holbein und der Stalhof in London.* Kunstwissenschaftliche Studien 165. Berlin, 2010.

Piper 1957
Piper, David. "The 1590 Lumley Inventory: Hilliard, Segar and the Earl of Essex—II." *Burlington Magazine* 99, no. 654 (September 1957), pp. 298–301, 303.

Platter 1937
Platter, Thomas. *Thomas Platter's Travels in England, 1599.* Translated and edited by Clare Williams. London, 1937.

Pollard 1910
Pollard, A. W., ed. *The Queen's Majesty's Entertainment at Woodstock, 1575: From the Unique Fragment of the Edition of 1585, Including the Tale of Hemetes the Hermit, and a Comedy in Verse, Probably by George Gascoigne.* Oxford, 1910.

Pollnitz 2010
Pollnitz, Aysha. "Christian Women or Sovereign Queens? The Schooling of Mary and Elizabeth." In *Tudor Queenship: The Reigns of Mary and Elizabeth,* edited by Alice Hunt and Anna Whitelock, pp. 127–42. New York, 2010.

Pollock 1993
Pollock, Linda. *With Faith and Physic: The Life of a Tudor Gentlewoman, Lady Grace Mildmay, 1552–1620.* London, 1993.

Primrose 1630
Primrose, Diana. *A Chaine of Pearle, or, A Memoriall of the Peerles Graces, and Heroick Vertues of Queene Elizabeth, of Glorious Memory.* London, 1630.

Princely Magnificence 1980
Princely Magnificence: Court Jewels of the Renaissance, 1500–1630. Exh. cat., Victoria and Albert Museum, London. London, 1980.

Pyhrr 2000
Pyhrr, Stuart W. *European Helmets, 1450–1650: Treasures from the Reserve Collection.* New York, 2000.

Pyhrr 2012
Pyhrr, Stuart W. "Of Arms and Men: Arms and Armor at the Metropolitan, 1912–2012." *Metropolitan Museum of Art Bulletin* 70, no. 1 (Summer 2012).

Quiller-Couch 1902
Quiller-Couch, A. T. *The Oxford Book of English Verse, 1250–1900.* Oxford, 1902.

Quina and Moreira 2006
Quina, Maria Antónia, and Rafael Moreira. *The Flemish Tapestries in the Museu de Lamego.* Lisbon, 2006.

Rae 2015
Rae, Caroline. "Marcus Gheeraerts, John de Critz, Robert Peake and William Larkin: A Comparative Study." In Cooper, T., et al. 2015, pp. 170–79.

Raleigh 1614
Raleigh, Walter. *The Historie of the World.* London, 1614.

Ramsey 1953
Ramsey, Peter. "Overseas Trade in the Reign of Henry VII: The Evidence of Customs Accounts." *Economic History Review* 6, no. 2 (1953), pp. 173–82.

Rankin 2011
Rankin, Mark. "Henry VIII, Shakespeare, and the Jacobean Royal Court." *Studies in English Literature, 1500–1900* 51, no. 2, special issue, "Tudor and Stuart Drama" (Spring 2011), pp. 349–66.

Rankin, Highley, and King 2009
Rankin, Mark, Christopher Highley, and John N. King, eds. *Henry VIII and His Afterlives: Literature, Politics, and Art.* Cambridge and New York, 2009.

Ransome 1960
Ransome, D. R. "The Struggle of the Glaziers' Company with the Foreign Glaziers, 1500–1550." *Guildhall Miscellany* 2, no. 1 (September 1960), pp. 12–20.

Readman 2005
Readman, Paul. "The Place of the Past in English Culture c. 1890–1914." *Past and Present,* no. 186 (February 2005), pp. 147–99.

Reed 2015
Reed, Cathy J. "Not Northumberland but Essex: Identifying the Sitter in Two Miniatures by Nicholas Hilliard." *British Art Journal* 16, no. 1 (Summer 2015), pp. 88–94.

van Regteren Altena 1938
van Regteren Altena, J. Q., ed. *De Goudsche glazen, 1555–1603: Beschouwingen over Gouda, haar Sint Janskerk en de gebrandschilderde glazen.* 's-Gravenhage, 1938.

Reiff 2000
Reiff, Daniel D. *Houses from Books: Treatises, Pattern Books, and Catalogs in American Architecture, 1738–1950: A History and Guide.* University Park, Penn., 2000.

The Renaissance at Sutton Place 1983
The Renaissance at Sutton Place: An Exhibition to Mark the 450th Anniversary of the Visit of King Henry VIII to Sutton Place, 18th May–15th September 1983. Exh. cat., Sutton Place, Surrey. Guildford, 1983.

The Renaissance in the North 1987
The Renaissance in the North. Introduction by James Snyder. The Metropolitan Museum of Art 5. New York, 1987.

Report on Manuscripts 1913
Report on the Manuscripts of Allan George Finch, Esq., of Burley-on-the-Hill, Rutland. Vol. 1, edited by S. C. Lomas. London, 1913.

Restauri 1988
Restauri 1983–1988: Settimana beni culturali e ambientali. Exh. cat., Pinacoteca Nazionale, Siena. Siena, 1988.

Reynolds, A. 2013
Reynolds, Anna. *In Fine Style: The Art of Tudor and Stuart Fashion.* London, 2013.

Reynolds, G. 1996
Reynolds, Graham. *European Miniatures in The Metropolitan Museum of Art.* With Katharine Baetjer. New York, 1996.

Ribeiro 2015
Ribeiro, Aileen. *A Portrait of Fashion: Six Centuries of Dress at the National Portrait Gallery.* With Cally Blackman. London, 2015.

Richards 1997
Richards, Judith M. "Mary Tudor as 'sole quene'? Gendering Tudor Monarchy." *Historical Journal* 40, no. 4 (December 1997), pp. 895–924.

Richards 2002
Richards, Judith M. "The English Accession of James VI: 'National' Identity, Gender and the Personal Monarchy of England." *English Historical Review* 117, no. 472 (June 2002), pp. 513–35.

Richardson, C., Woods, and Franklin 2007
Richardson, Carol M., Kim W. Woods, and Michael W. Franklin, eds. *Renaissance Art Reconsidered: An Anthology of Primary Sources.* Malden, Mass., Oxford, and Milton Keynes, 2007.

Richardson, G. 1995
Richardson, Glenn [John]. "Entertainments for the French Ambassadors at the Court of Henry VIII." *Renaissance Studies* 9, no. 4 (December 1995), pp. 404–15.

Richardson, G. 1996
Richardson, Glenn John. "Anglo-French Diplomatic and Cultural Relations During the Reign of Henry VIII." PhD diss., University of London, 1996.

Richardson, G. 2013a
Richardson, Glenn [John]. "'As presence did present them': Personal Gift-Giving at the Field of Cloth of Gold." In Betteridge and Lipscomb 2013, pp. 47–63.

Richardson, G. 2013b
Richardson, Glenn [John]. *The Field of Cloth of Gold.* New Haven and London, 2013.

Richardson, T. 2002
Richardson, Tim. *Sweets: A History of Candy.* New York, 2002.

Roberts, J. 2002
Roberts, Jane, ed. *Royal Treasures: A Golden Jubilee Celebration.* Exh. cat., Queen's Gallery, Buckingham Palace, London. London, 2002.

Roberts, P. 1998
Roberts, Peter. "Tudor Wales, National Identity and the British Inheritance." In *British Consciousness and Identity: The Making of Britain, 1533–1707,* edited by Brendan Bradshaw and Peter Roberts, pp. 8–42. Cambridge and New York, 1998.

Roberts, S. 2014
Roberts, Simon. "Lot 41: Heraldry." In *Books, Atlases, Manuscripts and Photographs,* pp. 39–40. Sale cat., Bonhams, London, March 19, 2014.

Robinson 2015
Robinson, Alexander. "The Manuscript Cambridge, Magdalene College, Pepys 1760: A Mirror of the Court of Louis XII (1498–1515)." *Musica disciplina* 60 (2015), pp. 7–64.

Robison 2016
Robison, William B., ed. *History, Fiction, and* The Tudors*: Sex, Politics, Power, and Artistic License in the Showtime Television Series.* Queenship and Power. New York, 2016.

Rockett 2000
Rockett, William. "*Britannia,* Ralph Brooke, and the Representation of Privilege in Elizabethan England." *Renaissance Quarterly* 53, no. 2 (Summer 2000), pp. 474–99.

Rogers 1988
Rogers, Phillis. "(2) The Armada Tapestries in the House of Lords." *RSA Journal* 136, no. 5386 (September 1988), pp. 731–35.

Rosenfeld 1989
Rosenfeld, Myra Nan. "From Drawn to Printed Model Book: Jacques Androuet Du Cerceau and the Transmission of Ideas from Designer to Patron, Master Mason and Architect in the Renaissance." *RACAR: Revue d'art Canadienne / Canadian Art Review* 16, no. 2, special issue, "Etudes sur l'architecture et son environne-ment / Studies on Architecture and Its Environment" (1989), pp. 131–45, 219–50.

Rossiter 2014
Rossiter, William T. *Wyatt Abroad: Tudor Diplomacy and the Translation of Power*. Woodbridge, Suffolk, and Rochester, N.Y., 2014.

Rowell 2016
Rowell, Christopher. "Appendix 7: Sixteenth- and Seventeenth-Century Carpets at Hardwick." In Adshead and Taylor 2016, pp. 350–51.

Rowlands 1985
Rowlands, John. *Holbein: The Paintings of Hans Holbein the Younger*. Oxford and Boston, 1985.

Rowlands 1988
Rowlands, John. *The Age of Dürer and Holbein: German Drawings 1400–1550*. With Giulia Bartrum. Exh. cat., British Museum, London. Cambridge and New York, 1988.

Rowlands 1993
Rowlands, John. *Drawings by German Artists and Artists from German-Speaking Regions of Europe in the Department of Prints and Drawings in the British Museum: The Fifteenth Century, and Sixteenth Century by Artists Born before 1530*. With Giulia Bartrum. 2 vols. London, 1993.

Rowlands and Starkey 1983
Rowlands, John, and David Starkey. "An Old Tradition Reasserted: Holbein's Portrait of Queen Anne Boleyn." *Burlington Magazine* 125, no. 959 (February 1983), pp. 88, 90–92.

Rowse 2000
Rowse, A. L. *The Elizabethan Renaissance: The Life of the Society*. London, 2000.

Roy and Wyld 2001
Roy, Ashok, and Martin Wyld. "*The Ambassadors* and Holbein's Techniques for Paintings on Panel." In *Hans Holbein: Paintings, Prints, and Reception*, edited by Mark Roskill and John Oliver Hand, pp. 97–107. Studies in the History of Art 60; Symposium Papers 37. Washington, D.C., 2001.

Ruddock 1944
Ruddock, Alwyn A. "Historical Revision No. CVI: Italian Trading Fleets in Medieval England." *History*, n.s., 29, no. 110 (September 1944), pp. 192–202.

Rundle 2005
Rundle, David. "Filippo Alberici, Henry VII and Richard Fox: The English Fortunes of a Little-Known Italian Humanist." *Journal of the Warburg and Courtauld Institutes* 68 (2005), pp. 137–55.

Russell 1969
Russell, Joycelyne G. *The Field of Cloth of Gold: Men and Manners in 1520*. London, 1969.

van Ruyven-Zeman et al. 2011
van Ruyven-Zeman, Zsuzsanna, Arjan R. de Koomen, Antonie L. H. Hage, and Jan Piet Filedt Kok, eds. *De cartons van de Sint-Janskerk in Gouda / The Cartoons of the Sint-Janskerk in Gouda*. Delft, 2011.

Rymer 1727–35
Rymer, Thomas. *Foedera, conventiones, literae, et cujuscunque generis acta publica, inter reges Angliae, et alios quosvis Imperatores, Reges, Pontifices, Principes, vel communitates, ab ineunte saeculo duodecimo, viz. ab anno 1101, ad nostra usque tempora, habita aut tractata.*

2nd ed. Edited by George Holmes and Robert Sanderson. 20 vols. London, 1727–35.

Sadlack 2011
Sadlack, Erin A. *The French Queen's Letters: Mary Tudor Brandon and the Politics of Marriage in Sixteenth-Century Europe*. Queenship and Power. New York, 2011.

Salet 1980
Salet, Francis. *David et Bethsabée: Château d'Ecouen*. Paris, 1980.

Sanuto 1879–1903
Sanuto, Marino. *I diarii di Marino Sanuto*. Edited by Rinaldo Fulin et al. 58 vols. Venice, 1879–1903.

Schäffer 2009
Schäffer, Gisela. *Schwarze Schönheit: "Mohrinnen-Kameen"; Preziosen der Spätrenaissance im Kunsthistorischen Museum Wien; Ein Beitrag aus post-kolonialer Perspektive*. Marburg, 2009.

Schleiner 1978
Schleiner, Winfried. "'Divina Virago': Queen Elizabeth as an Amazon." *Studies in Philology* 75, no. 2 (Spring 1978), pp. 163–80.

Schlueter 2008
Schlueter, June. "An Unrecorded Woodcut of Queen Elizabeth I." *Print Quarterly* 25, no. 3 (September 2008), pp. 278–83.

Schmitt 1977
Schmitt, Charles B. "Thomas Linacre and Italy." In *Essays on the Life and Work of Thomas Linacre, c. 1460–1524*, edited by Francis Maddison, Margaret Pelling, and Charles Webster, pp. 36–75. Linacre Studies. Oxford, 1977.

Scholten 2011
Scholten, Frits. *The Robert Lehman Collection*. Vol. 12, *European Sculpture and Metalwork*. New York, 2011.

Schrijver and Wesselius 1987
Schrijver, E. G. L., and J. W. Wesselius. "Het Prinsenraam in Gouda en de positie van het Hebreeuws in Noord-Nederland in de zestiende eeuw." *Studia Rosenthaliana* 21, no. 1 (May 1987), pp. 1–13.

Schroder 1988
Schroder, Timothy. *The National Trust Book of English Domestic Silver, 1500–1900*. New York, 1988.

Schroder 1995
Schroder, Timothy. "A Royal Tudor Rock-Crystal and Silver-Gilt Vase." *Burlington Magazine* 137, no. 1107 (June 1995), pp. 356–66.

Schwarz 1997
Schwarz, Kathryn. "Missing the Breast: Desire, Disease, and the Singular Effect of Amazons." In *The Body in Parts: Fantasies of Corporeality in Early Modern Europe*, edited by David Hillman and Carla Mazzio, pp. 147–69. New York, 1997.

Schwoerer 1989
Schwoerer, Lois G. "Images of Queen Mary II, 1689–95." *Renaissance Quarterly* 42, no. 4 (Winter 1989), pp. 717–48.

Scorrer et al. 2021
Scorrer, Jessica, Katie E. Faillace, Alexandra Hildred, Alexandra J. Nederbragt, Morten B. Andersen, Marc-Alban Millet, Angela L. Lamb, and Richard Madgwick.

"Diversity aboard a Tudor Warship: Investigating the Origins of the *Mary Rose* Crew Using Multi-Isotope Analysis." *Royal Society Open Science* 8, no. 5 (May 2021). https://doi.org/10.1098/rsos.202106. Accessed May 4, 2022.

Scott, J. 2013
Scott, Jennifer. "Painting from Life? Comments on the Date and Function of the Early Portraits of Elizabeth Woodville and Elizabeth of York in the Royal Collection." In *The Yorkist Age: Proceedings of the 2011 Harlaxton Symposium*, edited by Hannes Kleineke and Christian Steer, pp. 18–26. Harlaxton Medieval Studies, n.s., 23. Donington, 2013.

Scott, R. 1915
Scott, Robert Forsyth. "On the Contracts for the Tomb of the Lady Margaret Beaufort, Countess of Richmond and Derby, Mother of King Henry VII, and Foundress of the Colleges of Christ and St. John in Cambridge; With Some Illustrative Documents." *Archaeologia* 66 (1915), pp. 365–76.

Scott-Elliot and Yeo 1990
Scott-Elliot, A. H., and Elspeth Yeo. "Calligraphic Manuscripts of Esther Inglis (1571–1624): A Catalogue." *Papers of the Bibliographical Society of America* 84, no. 1 (March 1990), pp. 10–86.

Sessions 2003
Sessions, William A. *Henry Howard, the Poet Earl of Surrey: A Life*. 2nd ed. Oxford, 2003.

Sharpe 2009
Sharpe, Kevin. *Selling the Tudor Monarchy: Authority and Image in Sixteenth-Century England*. New Haven and London, 2009.

Sharpe 2013
Sharpe, Kevin. *Rebranding Rule: The Restoration and Revolution Monarchy, 1660–1714*. New Haven, 2013.

Shearman 1972
Shearman, John K. G. *Raphael's Cartoons in the Collection of Her Majesty the Queen, and the Tapestries for the Sistine Chapel*. London, 1972.

Shute 1563
Shute, John. *The First and Chief Groundes of Architecture Used in All the Auncient and Famous Monymentes: With a Farther and More Ample Defense upon the Same, than Hitherto Hath Been Set out by Any Other*. London, 1563. 1912 ed.: Shute, John. *The First and Chief Groundes of Architecture*. Edited by Lawrence Weaver. London, 1912.

Sicca 2002
Sicca, Cinzia M[aria]. "Consumption and Trade of Art between Italy and England in the First Half of the Sixteenth Century: The London House of the Bardi and Cavalcanti Company." *Renaissance Studies* 16, no. 2 (June 2002), pp. 163–201.

Sicca 2006
Sicca, Cinzia Maria. "Pawns of International Finance and Politics: Florentine Sculptors at the Court of Henry VIII." *Renaissance Studies* 20, no. 1 (February 2006), pp. 1–34.

Sicca and Waldman 2012
Sicca, Cinzia Maria, and Louis A. Waldman, eds. *The Anglo-Florentine Renaissance: Art for the Early Tudors*. Studies in British Art 22. New Haven and London, 2012.

Sider 1990
Sider, Sandra. "'Interwoven with poems and picture': A Protoemblematic Latin Translation of the *Tabula Cebetis*." In *The European Emblem: Selected Papers from the Glasgow Conference, 11–14 August, 1987*, edited by Bernhard F. Scholz, Michael Bath, and David Weston, pp. 1–17. Symbola et Emblemata: Studies in Renaissance and Baroque Symbolism 2. Leiden and New York, 1990.

Sidney 1987
Sidney, Philip. *The Countess of Pembroke's Arcadia (The New Arcadia)*. Edited by Victor Skretkowicz. Oxford, 1987.

Sil 1988
Sil, Narasingha P. *William Lord Herbert of Pembroke (c. 1507–1570): Politique and Patriot*. Lewiston, N.Y., 1988.

Sillars 2015
Sillars, Stuart. *Shakespeare and the Visual Imagination*. Cambridge, 2015.

Simon 1996
Simon, Jacob. *The Art of the Picture Frame: Artists, Patrons and the Framing of Portraits in Britain*. Exh. cat., National Portrait Gallery, London. London, 1996.

Simpson 2014
Simpson, Sue. *Sir Henry Lee (1533–1611): Elizabethan Courtier*. Farnham, Surrey, and Burlington, Vt., 2014.

Skelton 2015
Skelton, Kimberley. "The Unease of Motion." In *The Paradox of Body, Building and Motion in Seventeenth-Century England*, pp. 1–17. Rethinking Art's Histories. Manchester, 2015.

Smith, Am. 2017
Smith, Amelia. *Longford Castle: The Treasures and the Collectors*. London, 2017.

Smith, An. 1988
Smith, Angela. "Henry VII and the Appointment of the King's Glazier." *Journal of Stained Glass* 18, no. 3 (1988), pp. 259–61.

Smith, D. 2005
Smith, David R. "Portrait and Counter-Portrait in Holbein's *The Family of Sir Thomas More*." *Art Bulletin* 87, no. 3 (September 2005), pp. 484–506.

Smith, J., and Hawkins 1807
Smith, John Thomas, and John Sidney Hawkins. *Antiquities of Westminster; The Old Palace; St. Stephen's Chapel, (Now the House of Commons) &c.: Containing Two Hundred and Forty-Six Engravings of Topographical Objects, of Which One Hundred and Twenty-Two No Longer Remain*. London, 1807.

Sneyd 1847
Sneyd, Charlotte Augusta, trans. *A Relation, or rather A True Account, of the Island of England: With Sundry Particulars of the Customs of These People, and of the Royal Revenues under King Henry the Seventh, about the Year 1500*. London, 1847.

Snodin 2009
Snodin, Michael, ed. *Horace Walpole's Strawberry Hill*. With Cynthia Roman. Exh. cat., Yale Center for British Art, New Haven, and Victoria and Albert Museum, London. New Haven and London, 2009.

Sorbie 2015
Sorbie, Alison. "The Persian Lady Portrait: A New Identification." *British Art Journal* 16, no. 2 (Autumn 2015), pp. 30–41.

Sotheby's 2004
Important British Paintings, 1500–1850. Sale cat., Sotheby's, London, November 25, 2004.

Sotheby's 2007
Important British Paintings. Sale cat., Sotheby's, London, November 22, 2007.

Sowerby 2015
Sowerby, Tracey A. "Negotiating the Royal Image: Portrait Exchanges in Elizabethan and Early Stuart Diplomacy." In *Early Modern Exchanges: Dialogues between Nations and Cultures, 1550–1750*, edited by Helen Hackett, pp. 119–41. Farnham, Surrey, 2015.

SP 1830–52
State Papers Published under the Authority of His Majesty's Commission: King Henry the Eighth. 11 vols. London, 1830–52.

Spence 1995
Spence, Richard T. *The Privateering Earl: George Clifford, 3rd Earl of Cumberland, 1558–1605*. Stroud, 1995.

Spenser 1909
Spenser, Edmund. *The Poetical Works of Edmund Spenser in Three Volumes*. Vol. 2, *Spenser's* Faerie Queene, *Volume 1: Books 1–3*. Edited by J. C. Smith. Oxford, 1909.

Spikes 1977
Spikes, Judith Doolin. "The Jacobean History Play and the Myth of the Elect Nation." *Renaissance Drama* 8, special issue, "The Celebratory Mode" (1977), pp. 117–49.

Stallybrass and Jones, A. 2001
Stallybrass, Peter, and Ann Rosalind Jones. "Fetishizing the Glove in Renaissance Europe." *Critical Inquiry* 28, no. 1 (Autumn 2001), pp. 114–32.

Stamp 2006
Stamp, Gavin. "Neo-Tudor and Its Enemies." *Architectural History* 49 (2006), pp. 1–33.

Stanbury 2004
Stanbury, Sarah. "The Clock in Filippino Lippi's Annunciation Tondo." *Studies in Iconography* 25 (2004), pp. 197–219.

Standen 1962
Standen, Edith A[ppleton]. "The Carpet of Arms." *Metropolitan Museum of Art Bulletin* 20, no. 7 (1962), pp. 221–31.

Standen 1985
Standen, Edith Appleton. *European Post-Medieval Tapestries and Related Hangings in The Metropolitan Museum of Art*. New York, 1985.

Starkey 1991
Starkey, David, ed. *Henry VIII: A European Court in England*. Exh. cat., National Maritime Museum, Greenwich. London, 1991.

Starkey 1998
Starkey, David, ed. *The Inventory of King Henry VIII: Society of Antiquaries MS 129 and British Library MS Harley 1419*. Vol. 1, *The Transcript*. Reports of the Research Committee of the Society of Antiquaries of London 56. London, 1998.

Statutes 1810–28
The Statutes of the Realm: Printed by Command of His Majesty King George the Third, in Pursuance of an Address of the House of Commons of Great Britain, from Original Records and Authentic Manuscripts. Edited by A. Luders et al. 12 vols. London, 1810–28.

Steppe 1956
Steppe, J. K. "Vlaamse wandtapijten in Spanje: Recente gebeurtenissen en publicaties." *Artes textiles* 3 (1956), pp. 27–66.

Stone 1901
Stone, J. M. *The History of Mary I, Queen of England, As Found in the Public Records, Despatches of Ambassadors, in Original Private Letters, and Other Contemporary Documents*. New York, 1901.

Stow 1720
Stow, John, ed. *A Survey of the Cities of London and Westminster: Containing the Original, Antiquity, Increase, Modern Estate and Government of Those Cities*. Edited by John Strype. Rev. ed. 2 vols. London, 1720.

Strachey 1928
Strachey, Lytton. *Elizabeth and Essex: A Tragic History*. New York, 1928.

String 1996
String, Tatiana C. "Henry VIII's Illuminated 'Great Bible.'" *Journal of the Warburg and Courtauld Institutes* 59 (1996), pp. 315–24.

String 2008
String, Tatiana C. *Art and Communication in the Reign of Henry VIII*. Aldershot, Hampshire, and Burlington, Vt., 2008.

String and Bull 2011
String, Tatiana C., and Marcus Bull, eds. *Tudorism: Historical Imagination and the Appropriation of the Sixteenth Century*. Proceedings of the British Academy 170. Oxford, 2011.

Strolz 2004
Strolz, Monika. "Zu Maltechnik und Restaurierung des Porträts der Jane Seymour von Hans Holbein d. J." *Technologische Studien* 1 (2004), pp. 8–31.

Strömbom 1933
Strömbom, Sixten. "Erik XIV:s porträtt: Till ett förbisett 400-årsminne." *Nationalmusei Årsbok* 48 (1933), pp. 12–48.

Strong 1959
Strong, Roy C. "Federigo Zuccaro's Visit to England in 1575." *Journal of the Warburg and Courtauld Institutes* 22, no. 3/4 (July–December 1959), pp. 359–60.

Strong 1963a
Strong, Roy C. "Elizabethan Painting: An Approach Through Inscriptions—I: Robert Peake the Elder." *Burlington Magazine* 105, no. 719 (February 1963), pp. 53–57.

Strong 1963b
Strong, Roy [C]. "Elizabethan Painting: An Approach Through Inscriptions—III: Marcus Gheeraerts the Younger." *Burlington Magazine* 105, no. 721 (April 1963), pp. 149–50, 152–57, 159.

Strong 1963c
Strong, Roy [C]. *Portraits of Queen Elizabeth I.* Oxford, 1963.

Strong 1966
Strong, Roy [C]. "Hans Eworth Reconsidered." *Burlington Magazine* 108, no. 758 (May 1966), pp. 222, 225–31, 233.

Strong 1967
Strong, Roy [C]. *Holbein and Henry VIII.* Studies in British Art. London, 1967.

Strong 1969a
Strong, Roy [C]. *The English Icon: Elizabethan and Jacobean Portraiture.* Studies in British Art. London and New York, 1969.

Strong 1969b
Strong, Roy [C]. *Tudor and Jacobean Portraits.* 2 vols. London, 1969.

Strong 1974
Strong, Roy [C]. "The Radnor Miniatures." In *Christie's Review of the Season*, edited by John Herbert, pp. 254–57. London and New York, 1974.

Strong 1977
Strong, Roy [C]. *The Cult of Elizabeth: Elizabethan Portraiture and Pageantry.* London, 1977.

Strong 1983a
Strong, Roy [C]. *Artists of the Tudor Court: The Portrait Miniature Rediscovered, 1520–1620.* With V. J. Murrell. Exh. cat., Victoria and Albert Museum, London. London, 1983.

Strong 1983b
Strong, Roy [C]. "Nicholas Hilliard's Miniature of the 'Wizard Earl.'" *Bulletin van het Rijksmuseum* 31, no. 1 (1983), pp. 54–62.

Strong 1983c
Strong, Roy [C]. *The English Renaissance Miniature.* New York, 1983.

Strong 1987
Strong, Roy [C]. *Gloriana: The Portraits of Queen Elizabeth I.* London, 1987.

Strong 1993
Strong, Roy [C]. "'My weepinge Stagg I crowne': The Persian Lady Reconsidered." In *The Art of the Emblem: Essays in Honor of Karl Josef Höltgen*, edited by Michael Bath, John Manning, and Alan R. Young, pp. 103–41. AMS Studies in the Emblem 10. New York, 1993.

Strong 2019
Strong, Roy [C]. *The Elizabethan Image: An Introduction to English Portraiture, 1558–1603.* New Haven, 2019.

Stubbes 1583
Stubbes, Phillip. *The Anatomie of Abuses: Contayning a Discoverie, or Briefe Summarie, of Such Notable Vices and Imperfections, as Now Raigne in Many Christian Countreyes of the Worlde, but (Especiallie) in a Verie Famous Ilande Called Ailgna.* London, 1583. **1877–82** ed.: *Phillip Stubbes's Anatomy of the Abuses in England in Shakspere's Youth, A.D. 1583.* Edited by Frederick J. Furnivall. 2 vols. London, 1877–82.

Sully 1817
Sully, Maximilien de Béthune, duc de. *The Memoirs of the Duke of Sully, Prime-Minister to Henry the Great.* Translated by Charlotte Lennox. Rev. ed. 5 vols. Philadelphia, 1817.

Sully 1970
Sully, Maximilien de Béthune, duc de. *Les oeconomies royales de Sully.* Vol. 1, *1572–1594.* Edited by David Buisseret and Bernand Barbiche. Publications in octavo (Société de l'histoire de France) 476. Paris, 1970.

Summerson 1993
Summerson, John. *Architecture in Britain, 1530 to 1830.* New Haven, 1993.

Surrey 2012
Surrey, Henry Howard, Earl of. *A Critical Edition of the Complete Poems of Henry Howard, Earl of Surrey.* Edited by William McGaw. Lewiston, N.Y., 2012.

Sutton, D. 2019
Sutton, Dana F., ed. *Bernard André*, Annales regni Henrici Septimi *(1504/5 and 1507/08): A Hypertext Critical Edition.* 2019. https://www.philological.bham.ac.uk/andreannals/. Accessed Nov. 13, 2019.

Sutton, J. 1999–2000
Sutton, James M. "The Decorative Program at Elizabethan Theobalds: Educating an Heir and Promoting a Dynasty." *Studies in the Decorative Arts* 7, no. 1 (Fall/Winter 1999–2000), pp. 33–64.

Suzuki 1996
Suzuki, Mihoko. "The London Apprentice Riots of the 1590s and the Fiction of Thomas Deloney." *Criticism* 38, no. 2 (Spring 1996), pp. 181–217.

Sweet 2007
Sweet, Rosemary. "Founders and Fellows." In *Making History: Antiquaries in Britain, 1707–2007*, pp. 53–67. Exh. cat., Royal Academy of Arts, London. London, 2007.

Tait 1956
Tait, Hugh. "The Hearse-Cloth of Henry VII Belonging to the University of Cambridge." *Journal of the Warburg and Courtauld Institutes* 19, no. 3/4 (July–December 1956), pp. 294–98.

Tanner 1991
Tanner, Paul, ed. *Das Amerbach-Kabinett.* Vol. 3, *Die Basler Goldschmiederisse. Sammeln in der Renaissance.* Basel, 1991.

Tate 1703
Tate, Nahum. *Portrait-Royal: A Poem upon Her Majesty's Picture Set up in Guildhall by Order of the Lord Mayor and Court of Aldermen of the City of London, Drawn by Mr. Closterman.* London, 1703.

Tatton-Brown and Mortimer 2003
Tatton-Brown, Tim, and Richard Mortimer, eds. *Westminster Abbey: The Lady Chapel of Henry VII.* Woodbridge, Suffolk, and Rochester, N.Y., 2003.

Taylor et al. 2016
Taylor, Gary, John Jowett, Terri Bourus, and Gabriel Egan, eds. *The New Oxford Shakespeare: Modern Critical Edition.* Oxford, 2016.

Terjanian 2009
Terjanian, Pierre. "The King and the Armourers of Flanders." In *Henry VIII: Arms and the Man, 1509–2009*, edited by Graeme Rimer, Thom Richardson, and J. P. D. Cooper, pp. 155–59. Leeds, 2009.

Terjanian 2019
Terjanian, Pierre, ed. *The Last Knight: The Art, Armor, and Ambition of Maximilian I.* Exh. cat., The Metropolitan Museum of Art, New York. New York, 2019.

Testa 2000
Testa, Judith Anne. "Simon Bening and the Italian High Renaissance: Some Unexplored Sources." *Oud Holland* 114, no. 2/4 (2000), pp. 107–24.

Teulet 1840
Teulet, A., ed. *Correspondance diplomatique de Bertrand de Salignac de la Mothe Fénélon, ambassadeur de France en Angleterre de 1565 à 1575.* 7 vols. Paris and London, 1840.

Thornton 1971
Thornton, Peter [K]. "Two Problems." *Furniture History* 7 (1971), pp. 61–71.

Thurley 1993
Thurley, Simon. *The Royal Palaces of Tudor England: Architecture and Court Life, 1460–1547.* New Haven, 1993.

Thurley 1999
Thurley, Simon. *Whitehall Palace: An Architectural History of the Royal Apartments, 1240–1698.* New Haven and London, 1999.

Thurley 2003
Thurley, Simon. *Hampton Court: A Social and Architectural History.* New Haven and London, 2003.

Tighe and Davis 1858
Tighe, Robert Richard, and James Edward Davis. *Annals of Windsor, Being a History of the Castle and Town; With Some Account of Eton and Places Adjacent.* 2 vols. London, 1858.

Tittler 2012
Tittler, Robert. *Portraits, Painters, and Publics in Provincial England, 1540–1640.* Oxford and New York, 2012.

Toesca 1969
Toesca, Ilaria. "Silver in the Time of François I: A New Identification." *Apollo*, n.s., 90 (October 1969), pp. 292–97.

Tolhurst 1998
Tolhurst, Fiona. "The Britons as Hebrews, Romans, and Normans: Geoffrey of Monmouth's British Epic and Reflections of Empress Matilda." *Arthuriana* 8, no. 4 (Winter 1998), pp. 69–87.

Tourneur 1922
Tourneur, Victor. "Steven van Herwijck, médailleur anversois (1557–65)." *Numismatic Chronicle and Journal of the Royal Numismatic Society* 2 (1922), pp. 91–132.

Town 2014
Town, Edward. "A Biographical Dictionary of London Painters, 1547–1625." *Volume of the Walpole Society* 76 (2014), pp. 1–235.

Town and David 2020
Town, Edward, and Jessica David. "George Gower: Portraitist, Mercer, Serjeant Painter." *Burlington Magazine* 162, no. 1410 (September 2020), pp. 738–55.

Townsend, Ga. 1986
Townsend, Gavin Edward. "The Tudor House in America: 1890–1930." PhD diss., University of California, Santa Barbara, 1986.

Townsend, Geo. 1870
Townsend, George. "A Life and Defense of the Martyrologist." In *The Acts and Monuments of John Foxe*, 8 vols., edited by Josiah Pratt. Vol. 1, pp. 1–96. London, 1870.

Trapp 1983
Trapp, J. B. "Pieter Meghen, yet Again." In *Manuscripts in the Fifty Years after the Invention of Printing: Some Papers Read at a Colloquium at the Warburg Institute on 12–13 March 1982*, edited by J. B. Trapp, pp. 23–28. London, 1983.

Trevelyan 1913
Trevelyan, George Macaulay. *Clio, a Muse: And Other Essays Literary and Pedestrian.* London, 1913.

Trevisan 2018
Trevisan, Sara. "Genealogy and Royal Representation: Edmund Brudenell's Pedigree Roll for Elizabeth I (1558–60)." *Huntington Library Quarterly* 81, no. 2 (Summer 2018), pp. 257–75.

Trevor-Roper 2004
Trevor-Roper, Hugh. "Roper, William (1495x8–1578), Biographer." *Oxford Dictionary of National Biography.* Sep. 23, 2004. https://doi.org/10.1093/ref:odnb/24074. Accessed Feb. 6, 2020.

Trollope 1884
Trollope, Edward, ed. "King Henry VIII's Jewel Book (1521)." *Reports and Papers of the Architectural and Archaeological Societies of the Counties of Lincoln and Northampton* 17, no. 2 (1884), pp. 155–229.

TRP 1964–69
Hughes, Paul L., and James F. Larkin, eds. *Tudor Royal Proclamations.* 3 vols. New Haven, 1964–69.

Tscherny 1996
Tscherny, Nadia. "A Fascination with the Enemy: Subjects from British History." In *Romance and Chivalry: History and Literature Reflected in Early Nineteenth-Century French Painting*, edited by Nadia Tscherny and Guy Stair Sainty, pp. 106–23. Exh. cat., New Orleans Museum of Art, Stair Sainty Matthiesen, Inc., New York, and Taft Museum, Cincinnati. London and New York, 1996.

Tudor-Craig 1989
Tudor-Craig, Pamela. "Henry VIII and King David." In *Early Tudor England: Proceedings of the 1987 Harlaxton Symposium*, edited by Daniel Williams, pp. 183–205. Woodbridge, Suffolk, and Wolfeboro, N.H., 1989.

Turbide 2005
Turbide, Chantal. "Catherine de Médicis (1519–1589) et le portrait: Esquisse d'une collection royale au féminin." *RACAR: Revue d'art Canadienne / Canadian Art Review* 30, no. 1/2, special issue, "La question du portrait / The Portrait Issue" (2005), pp. 48–58.

Turner 2009
Turner, Hilary L. "Emigré Tapestry Weavers in Elizabethan London: People and Products." In *The Tapestries Called Sheldon*, edited by Hilary L. Turner. 2009. http://www.tapestriescalledsheldon.info/pdfs/Emigreweavers/pdf. Accessed Nov. 13, 2019.

Turner 2012
Turner, Hilary L. "Working Arras and Arras Workers: Conservation in the Great Wardrobe under Elizabeth I." *Textile History* 43, no. 1 (May 2012), pp. 43–60.

Turner 2013
Turner, Hilary L. "The Tapestry Trade in Elizabethan London: Products, Purchasers, and Purveyors." *London Journal: A Review of Metropolitan Society Past and Present* 38, no. 1 (March 2013), pp. 18–33.

Turquet 1983
Turquet, Josephine Clare. "The Inner Court of Nonsuch Palace." PhD diss., University of London, 1983.

Ungerer 1975
Ungerer, Gustav. "The French Lutenist Charles Tessier and the Essex Circle." *Renaissance Quarterly* 28, no. 2 (Summer 1975), pp. 190–203.

Valdštejna 1981
Valdštejna, Zdeněk Brtnický z, baron. *The Diary of Baron Waldstein: A Traveller in Elizabethan England.* Translated and annotated by G. W. Groos. London, 1981.

Vasari 1568
Vasari, Giorgio. *Le vite de' più eccellenti pittori, scultori, ed architettori.* 2nd ed. 3 vols. Florence, 1568. **1906 ed.:** *Le opere di Giorgio Vasari.* Edited by Gaetano Milanesi. 9 vols. Reprint, Florence, 1981. **1996 ed.:** *Lives of the Painters, Sculptors and Architects.* Translated by Gaston du C. de Vere. 2 vols. New York.

Vaughn 2000
Vaughn, William. "'God help the minister who meddles in art': History Painting in the New Palace of Westminster." In *The Houses of Parliament: History, Art, Architecture*, edited by Christine Riding and Jacqueline Riding, pp. 225–39. London and New York, 2000.

Vegelin van Claerbergen 1999
Vegelin van Claerbergen, Ernst, ed. *The Portrait of Sir John Luttrell: A Tudor Mystery.* London, 1999.

Veldman 2001
Veldman, Ilja M. *Crispijn de Passe and His Progeny (1564–1670): A Century of Print Production.* Translated by Michael Hoyle. Studies in Prints and Printmaking 3. Rotterdam, 2001.

Verdi 2007
Verdi, Richard. *The Parrot in Art: From Dürer to Elizabeth Butterworth.* Exh. cat., Barber Institute of Fine Arts, Birmingham. London, 2007.

Vertue 1929–30
[Vertue, George]. "Vertue's Autobiography [Add. MSS. 23,070 V. I, B.M. 81]." *Volume of the Walpole Society* 18, Vertue Note Books: Volume 1 (1929–30), pp. 1–14.

Vertue 1935–36
[Vertue, George]. "Vertue's Note Book A.x. [British Museum Add. MS. 23,072]." *Volume of the Walpole Society* 24, Vertue Note Books: Volume 4 (1935–36), pp. 101–97.

Vignau-Wilberg 2017
Vignau-Wilberg, Thea. *Joris and Jacob Hoefnagel: Art and Science around 1600.* Berlin, 2017.

Vincent 2003
Vincent, Susan J. *Dressing the Elite: Clothes in Early Modern England.* Oxford, 2003.

Vives 1557
Vives, Juan Luis. *A Very Fruteful and Pleasant Boke Called the Instruction of a Christen Woman, Made Firste in Latyne, by the Right Famous Clerke Mayster Lewes Viues, and Tourned out of Latyne into Englishe by Rychard Hyrde.* Translated by Richard Hyrde. London, 1557.

"Voyage, &c. of Princess Catharine" 1808
"The Voyage, &c. of the Princess Catharine of Arragon to England, on Her Marriage with Prince Arthur, Son to King Henry VII, with a Particular Account of Her Progress to London, &c." In *The Antiquarian Repertory: A Miscellaneous Assemblage of Topography, History, Biography, Customs, and Manners, Intended to Illustrate and Preserve Several Valuable Remains of Old Times*, new ed., edited by Francis Grose, Thomas Astle, et al. Vol. 2, pp. 248–331. London, 1808.

Waldman 2012
Waldman, Louis A. "Benedetto da Rovezzano in England and After: New Research on the Artist, His Collaborators, and His Family." In Sicca and Waldman 2012, pp. 81–147.

Walford 1879
Walford, Edward. *Londoniana.* 2 vols. London, 1879.

Walker, G. 1988
Walker, Greg. *John Skelton and the Politics of the 1520s.* Cambridge Studies in Early Modern British History. Cambridge and New York, 1988.

Walker, G. 1989
Walker, Greg. "The 'Expulsion of the Minions' of 1519 Reconsidered." *Historical Journal* 32, no. 1 (March 1989), pp. 1–16.

Walker, G. 1996
Walker, Greg. *Persuasive Fictions: Faction, Faith, and Political Culture in the Reign of Henry VIII.* Aldershot, Hampshire, and Brookfield, Vt., 1996.

Walker, H. 2013
Walker, Hope. "Netherlandish Immigrant Painters and the Dutch Reformed Church of London, Austin Friars, 1560–1580." *Nederlands Kunsthistorisch Jaarboek (NKJ) / Netherlands Yearbook for History of Art* 63, special issue, "Kunst en migratie: Nederlandse kunstenaars op drift, 1400–1750 / Art and Migration: Netherlandish Artists on the Move" (2013), pp. 58–81.

Walker, J. 1996
Walker, Julia M. "Reading the Tombs of Elizabeth I." *English Literary Renaissance* 26, no. 3, special issue, "Monarchs" (Autumn 1996), pp. 510–30.

Walker, J. 2004
Walker, Julia M. *The Elizabeth Icon, 1603–2003.* Basingstoke and New York, 2004.

Wall 2004
Wall, Alison. "Rich [née Devereux], Penelope, Lady Rich (1563–1607), Noblewoman." *Oxford Dictionary of National Biography.* Sep. 23, 2004. https://doi.org/10.1093/ref:odnb/23490. Accessed Jan. 13, 2020.

Walpole 1762–80
Walpole, Horace. *Anecdotes of Painting in England: With Some Account of the Principal Artists and Incidental Notes on Other Arts.* 4 vols. Strawberry Hill, 1762–80. **1849 ed.:** *Anecdotes of Painting in England: With Some Account of the Principal Artists and Incidental Notes on Other Arts.* Edited by Ralph N. Wornum. 3 vols. London, 1849.

Walpole 1768
Walpole, Horace. *Historic Doubts on the Life and Reign of King Richard the Third.* London, 1768.

Walpole 1797
Walpole, Horace, ed. *Paul Hentzner's Travels in England, during the Reign of Queen Elizabeth*. Translated by Richard Bentley. London, 1797.

Wardwell 1975
Wardwell, Anne E. "The Mystical Grapes, a Devotional Tapestry." *Bulletin of the Cleveland Museum of Art* 62, no. 1 (January 1975), pp. 17–23.

Wark 1956
Wark, R. R. "A Note on Van Dyck's 'Self-Portrait with a Sunflower.'" *Burlington Magazine* 98, no. 635 (February 1956), pp. 52–54.

Waterschoot 1997
Waterschoot, Werner. "An Author's Strategy: Jan van der Noot's *Het Theatre*." In *Anglo-Dutch Relations in the Field of the Emblem*, edited by Bart Westerweel, pp. 35–48. Symbola et Emblemata: Studies in Renaissance and Baroque Symbolism 8. Leiden, New York, and Cologne, 1997.

Watkins 2000
Watkins, John. "'Old Bess in the Ruff': Remembering Elizabeth I, 1625–1660." *English Literary Renaissance* 30, no. 1 (Winter 2000), pp. 95–116.

Watkins 2002
Watkins, John. *Representing Elizabeth in Stuart England: Literature, History, Sovereignty*. Cambridge and New York, 2002.

Wayment 1972
Wayment, Hilary. *The Windows of King's College Chapel, Cambridge: A Description and Commentary*. Corpus Vitrearum Medii Aevi, Great Britain, suppl. 1. London, 1972.

Wayment 1979
Wayment, Hilary. "The Great Windows of King's College Chapel and the Meaning of the Word 'Vidimus.'" *Proceedings of the Cambridge Antiquarian Society* 69 (1979), pp. 53–69.

Wayment 1996
Wayment, Hilary. "The Late Glass in King's College Chapel: Dierick Vellert and Peter Nicholson." *Proceedings of the Cambridge Antiquarian Society* 84 (1996), pp. 121–42.

Webster 2001
Webster, Erin Lynnette. "Marcus Gheeraerts the Elder and the Language of Art: Images with Text in the Elizabethan Renaissance." PhD diss., Case Western Reserve University, 2001.

Weinberger 1944
Weinberger, Martin. "A Portrait Bust by Pietro Torrigiano." *Compleat Collector* 4, no. 7 (May 1944), pp. 2–8.

Weinstein 2011
Weinstein, Donald. *Savonarola: The Rise and Fall of a Renaissance Prophet*. New Haven and London, 2011.

Welch 2002
Welch, Evelyn. "Public Magnificence and Private Display: Giovanni Pontano's *De splendore* (1498) and the Domestic Arts." *Journal of Design History* 15, no. 4, special issue, "Approaches to Renaissance Consumption" (2002), pp. 211–21.

Wells-Cole 1983
Wells-Cole, Anthony. "Some Design Sources for the Earl of Leicester's Tapestries and Other Contemporary Pieces." *Burlington Magazine* 125, no. 962 (May 1983), pp. 280–81, 284–85.

Wells-Cole 1997
Wells-Cole, Anthony. *Art and Decoration in Elizabethan and Jacobean England: The Influence of Continental Prints, 1558–1625*. New Haven, 1997.

Weniger 2004
Weniger, Matthias. "'Durch und durch lutherisch'? Neues zum Ursprung der Bilder von Gesetz und Gnade." *Münchner Jahrbuch der bildenden Kunst*, 3rd ser., 55 (2004), pp. 115–34.

Weniger 2011
Weniger, Matthias. *Sittow, Morros, Juan de Flandes: Drei Maler aus dem Norden am Hof Isabellas der Katholischen*. Kiel, 2011.

Whigham 1985
Whigham, Frank. "Elizabethan Aristocratic Insignia." *Texas Studies in Literature and Language* 27, no. 4, special issue, "The English Renaissance and Enlightenment" (Winter 1985), pp. 325–53.

Whitaker 2014
Whitaker, Jane. "An Old Arcadia: The Gardens of William Herbert, 1st Earl of Pembroke, at Wilton, Wiltshire." *Garden History* 42, no. 2 (Winter 2014), pp. 141–56.

White 1999
White, Micheline. "A Biographical Sketch of Dorcas Martin: Elizabethan Translator, Stationer, and Godly Matron." *Sixteenth Century Journal* 30, no. 3 (Autumn 1999), pp. 775–92.

White 2005
White, Micheline. "Power Couples and Women Writers in Elizabethan England: The Public Voices of Dorcas and Richard Martin and Anne and Hugh Dowriche." In *Framing the Family: Narrative and Representation in the Medieval and Early Modern Periods*, edited by Rosalynn Voaden and Diane Wolfthal, pp. 119–38. Medieval and Renaissance Texts and Studies 280. Tempe, Ariz., 2005.

Wickens 2003
Wickens, Joelle D. J. "Contract for Eternity: The Investigation and Documentation of a Hearse Cloth Made 1504/5 for Henry VII (b. 1455–d. 1509)." MA thesis, University of Southampton, 2003.

Wickens and Hayward, M. 2003
Wickens, Joelle D. J., and Maria Hayward. "Contract for Eternity: Preserving a Hearse Cloth Made in 1505 for Henry VII (b. 1455–d. 1509)." In *Tales in the Textile: The Conservation of Flags and Other Symbolic Textiles*, compiled by Jan Vuori, pp. 196–97. Preprints of the North American Textile Conservation Conference 4. Waterford, N.Y., 2003.

Wieck 2014
Wieck, Roger S. *Miracles in Miniature: The Art of the Master of Claude de France*. New York, 2014.

Wieck, Voelkle, and Hearne 2000
Wieck, Roger S., William M. Voelkle, and K. Michelle Hearne. *The Hours of Henry VIII: A Renaissance Masterpiece by Jean Poyet*. New York, 2000.

Will 2016
Will, Kathryn. "When Is a Panther Not a Panther? Representing Animals in Early Modern English Heraldry." *Early Modern Culture* 11 (2016), pp. 78–98. https://tigerprints.clemson.edu/emc/vol11/iss1/6. Accessed Feb. 17, 2020.

Williams, A. 2002
Williams, Alan. *The Knight and the Blast Furnace: A History of the Metallurgy of Armour in the Middle Ages and the Early Modern Period*. History of Warfare 12. Leiden and Boston, 2002.

Williams, A., and de Reuck 1995
Williams, Alan, and Anthony de Reuck. *The Royal Armoury at Greenwich, 1515–1649: A History of Its Technology*. Royal Armouries Monograph 4. Leeds, 1995.

Williams, D. 2006
Williams, Deanne. "Dido, Queen of England." *ELH* 73, no. 1 (Spring 2006), pp. 31–59.

Williams, N. 1972
Williams, Neville. *The Life and Times of Elizabeth I*. London, 1972.

Williams, N. 1973
Williams, Neville. *The Life and Times of Henry VII*. London, 1973.

Williamson, E. 2016
Williamson, Elizabeth. "'Fishing after News' and the *Ars Apodemica*: The Intelligencing Role of the Educational Traveller in the Late Sixteenth Century." In *News Networks in Early Modern Europe*, edited by Joad Raymond and Noah Moxham, pp. 542–62. Library of the Written Word 47. The Handpress World 35. Leiden, 2016.

Williamson, G. 1920
Williamson, G[eorge] C. *George, Third Earl of Cumberland (1558–1605), His Life and Voyages: A Study from Original Documents*. Cambridge, 1920.

Williamson, G. 1922
Williamson, George C. *Lady Anne Clifford, Countess of Dorset, Pembroke & Montgomery, 1590–1676: Her Life, Letters and Work*. Kendal, Cumbria, 1922.

Willoughby, H. 1942
Willoughby, Harold R. *The First Authorized English Bible, and the Cranmer Preface*. With Herndon Wagers. Chicago, 1942.

Willoughby, L. 1911
Willoughby, Leonard. "Sherborne House." *Connoisseur* 30 (May–August 1911), pp. 3–13.

Willoughby, L. 1912
Willoughby, Leonard. "Sherborne House, Part II." *Connoisseur* 32 (January–April 1912), pp. 77–94.

Willsdon 2000
Willsdon, Clare A. P. *Mural Painting in Britain 1840–1940: Image and Meaning*. Oxford, 2000.

Wilson, C. 2003
Wilson, Christopher. "The Functional Design of Henry VII's Chapel: A Reconstruction." In Tatton-Brown and Mortimer 2003, pp. 141–88.

Wilson, J. 1980
Wilson, Jean. *Entertainments for Elizabeth I*. Studies in Elizabethan and Renaissance Culture 2. Woodbridge, Suffolk, and Totowa, N.J., 1980.

Winn 2014
Winn, James Anderson. *Queen Anne: Patroness of Arts*. Oxford and New York, 2014.

Winter 1943
Winter, Carl. *Elizabethan Miniatures*. London and New York, 1943.

Wolfe 2012
Wolfe, Heather. "A Third Manuscript by Thomas Trevelyon/Trevilian." In *The Collation: Research and Exploration at the Folger*. Dec. 7, 2012. https://collation .folger.edu/2012/12/a-third-manuscript-by-thomas -trevelyontrevelian/. Accessed Feb. 17, 2020.

Wolfthal 2004
Wolfthal, Diane. "Picturing Same-Sex Desire: The Falconer and His Lover in Images by Petrus Christus and the Housebook Master." In *Troubled Vision: Gender, Sexuality, and Sight in Medieval Text and Image*, edited by Emma Campbell and Robert Mills, pp. 17–46. New Middle Ages. New York, 2004.

Wood, D. 1912
Wood, D. T. B. "Tapestries of *The Seven Deadly Sins*—I." *Burlington Magazine* 20, no. 106 (January 1912), pp. 210, 214–17, 220–22.

Wood, J. 1998
Wood, Jeremy. "Peter Oliver at the Court of Charles I: New Drawings and Documents." *Master Drawings* 36, no. 2 (Summer 1998), pp. 123–53.

Woodall 1991
Woodall, Joanna. "An Exemplary Consort: Antonis Mor's Portrait of Mary Tudor." *Art History* 14 (June 1991), pp. 192–224.

Woodcock and Robinson 2000
Woodcock, Thomas, and John Martin Robinson. *Heraldry in National Trust Houses*. London, 2000.

Woodham 2011
Woodham, Jonathan M. "Twentieth-Century Tudor Design in Britain: An Ideological Battleground." In String and Bull 2011, pp. 129–53.

Woodward 1997
Woodward, Jennifer. *The Theatre of Death: The Ritual Management of Royal Funerals in Renaissance England, 1570–1625*. Woodbridge, Suffolk, and Rochester, N.Y., 1997.

Woodworth 1945
Woodworth, Allegra. "Purveyance for the Royal Household in the Reign of Queen Elizabeth." *Transactions of the American Philosophical Society* 35, no. 1 (December 1945), pp. 1–89.

Woolf 2005
Woolf, Daniel R. "From Hystories to the Historical: Five Transitions in Thinking about the Past, 1500–1700." *Huntington Library Quarterly* 68, no. 1/2 (March 2005), pp. 33–70.

Worms 2004
Worms, Laurence. "Rogers, William (fl. 1584–1604), Engraver." *Oxford Dictionary of National Biography*. Sep. 23, 2004. https://doi.org/10.1093/ref:odnb/24003. Accessed Dec. 13, 2019.

Wouk 2018
Wouk, Edward H. *Frans Floris (1519/20–70): Imagining a Northern Renaissance*. Brill's Studies in Intellectual History 267; Brill's Studies on Art, Art History, and Intellectual History 19. Leiden and Boston, 2018.

Wright 2007–8
Wright, Beth S. "The Space of Time: Delaroche's Depiction of Modern Historical Narrative." *Nineteenth-Century French Studies* 36, no. 1/2 (Fall/Winter 2007–8), pp. 72–93.

Wriothesley 1875–77
Wriothesley, Charles. *A Chronicle of England During the Reigns of the Tudors, from A.D. 1485 to 1559*. Edited by William Douglas Hamilton. 2 vols. Camden Society, n.s., 11 and 20. London, 1875–77.

Wyatt 1981
Wyatt, Thomas. *Sir Thomas Wyatt: The Complete Poems*. Edited by R. A. Rebholz. English Poets 5. New Haven, 1981.

Wynne 1876
Wynne, William Watkin Edward. *Pedigree of the Families of Maurice, Owen, etc., of Clenenney in the County of Carnarvon, and of Porkington (Now Brogyntyn) in the County of Salop; Shewing the Descent of the Estates in England and Wales, of John Ralph, Lord Harlech*. London, 1876.

Yates 1947
Yates, Frances A. "Elizabeth I as Astraea." *Journal of the Warburg and Courtauld Institutes* 10 (1947), pp. 27–82.

Yates 1957
Yates, Frances A. "Elizabethan Chivalry: The Romance of the Accession Day Tilts." *Journal of the Warburg and Courtauld Institutes* 20 (1957), pp. 4–25.

Yates 1959
Yates, Frances A. "Boissard's Costume-Book and Two Portraits." *Journal of the Warburg and Courtauld Institutes* 22, no. 3/4 (July–December 1959), pp. 365–66.

Yates 1975
Yates, Frances A. *Astraea: The Imperial Theme in the Sixteenth Century*. London and Boston, 1975.

Ysabel 2005
Ysabel, la reina católica: Una mirada desde la Catedral Primada. Exh. cat., Catedral de Toledo, 2005. Toledo, 2005.

Yungblut 1996
Yungblut, Laura Hunt. *"Strangers settled here amongst us": Policies, Perceptions, and the Presence of Aliens in Elizabethan England*. London and New York, 1996.

Ziegler 2000
Ziegler, Georgianna. "'More than Feminine Boldness': The Gift Books of Esther Inglis." In *Women, Writing, and the Reproduction of Culture in Tudor and Stuart Britain*, edited by Mary E. Burke et al., pp. 19–37. Syracuse, N.Y., 2000.

Ziegler 2003
Ziegler, Georgianna, ed. *Elizabeth I: Then and Now*. Washington, D.C., 2003.

Zimmerman 1971
Zimmerman, Walter J. "The English Shilling: Its History and Portraiture." *Numismatist* 84, no. 5 (May 1971), pp. 643–56.

Zook 2008
Zook, Melinda S. "The Shocking Death of Mary II: Gender and Political Crisis in Late Stuart England." *Britain and the World* 1, no. 1 (September 2008), pp. 21–36.

INDEX

PHOTOGRAPHY CREDITS